CHARLES WARREN EATON
(1857-1937)

Charles Warren Eaton was a watercolorist and landscape painter noted chiefly for his subtle brushwork and the sensitivity and intimacy of his work. In his early years he used subdued colors, employing delicate effects of light to create vague, suggestive moods. Some say that the strength of his paintings is in his depiction of the sky.

Today Eaton is best remembered for paintings of pine trees, done in his middle years. He did so many, in fact, that he was sometimes referred to as "The Pine Tree Painter."

During his childhood in Buffalo, New York, where he was born in 1857, he showed no interest in art. In his early twenties, however, he was so attracted to it that he quit his job as a dry goods clerk, moved to New York City and studied at the Arts Students League and at the National Academy of Design. By 1882, his work was good enough to be exhibited at the National Academy and one of his paintings was purchased by Oscar Wilde, who was visiting the city.

In the mid-1880s Eaton toured Europe, visiting great museums and the countrysides that had inspired Rembrandt, Constable and Corot. On his return to America, he met George Inness, the distinguished landscape painter. Despite a disparity of ages, the two became close friends. Inness also became the most important artistic influence in Eaton's life.

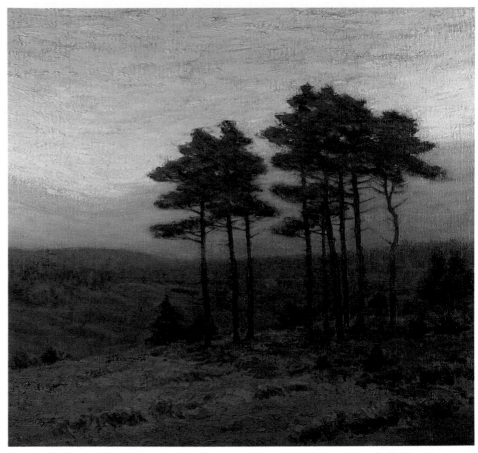

Evening Landscape, 20 x 24 in., signed l.r. Courtesy of Henry B. Holt, Inc., Essex Fells, New Jersey.

The paintings of Eaton's mature years generally fall into three groups: scenes in and around Bruges, Belgium; his paintings of pine forests; and views of hillside villages on Lake Como in Italy. Some of his paintings of canals near Bruges feature stark tree trunks as a repetitive motif.

In his Lake Como paintings, Eaton's usual understated technique gave way to impasto and choppier brush strokes, combined with a richer and much livelier palette.

After World War I Eaton went to Europe less frequently, preferring instead to paint at his summer studio in Connecticut. In 1921, he was one of several artists commissioned to paint scenes of Glacier National Park in Montana.

Realizing that both his technique and his inspiration were declining, Eaton gave up painting altogether in the decade before his death in 1937.

10-Year Average Change From Base Years '77–'78: 217%

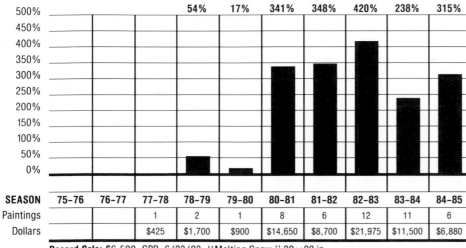

	75-76	76-77	77-78	78-79	79-80	80-81	81-82	82-83	83-84	84-85
(% change)				54%	17%	341%	348%	420%	238%	315%
SEASON	75-76	76-77	77-78	78-79	79-80	80-81	81-82	82-83	83-84	84-85
Paintings			1	2	1	8	6	12	11	6
Dollars			$425	$1,700	$900	$14,650	$8,700	$21,975	$11,500	$6,880

Record Sale: $6,500, SPB, 6/23/83, "Melting Snow," 30 x 28 in.

HARRY WILLSON WATROUS
(1857-1940)

Harry Willson Watrous was a highly successful academic portrait painter. During his distinguished career he specialized in a wide variety of subjects, including genre paintings, idealized portraits of women, landscapes, night scenes and still lifes.

Born in San Francisco in 1857, Watrous spent his childhood in New York. He attended private schools in New York City.

After a trip to California in 1881, Watrous went abroad for approximately five years. He first studied with Humphrey Moore in Malaga and traveled through Southern Spain and Morocco. He studied at the Academie Julien in Paris under Leon Bonnat, Gustave Boulanger and Jules Joseph Lefebvre. The most important influence on Watrous's early work was genre painter Jean Louis Meissonier.

Watrous established himself as an academic genre painter early in his career. He painted finely detailed genre scenes, which included men in historical costumes and decorative interiors.

Around 1905, Watrous began to lose his eyesight and he began more innovative paintings. From 1905 to 1918, Watrous specialized in painting highly stylized women in seductive costumes. These pictures often included unusual birds or insects; their symbolic content contributed to their uniqueness.

From 1918 to 1923, Watrous changed his focus from the female figure to land-

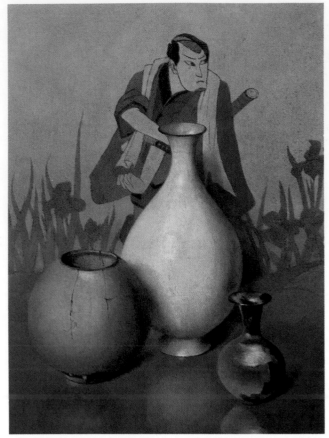

Oriental Still Life, 14 x 10 in., signed l.r. Photograph courtesy of M. Knoedler & Co., Inc., New York, New York.

scapes and night scenes. These paintings were influenced by the works of Watrous's friend, Ralph Blakelock. Both painters used contrasts of light and shadow in broad compositions.

After 1923, Watrous concentrated on detailed still lifes of decorative objects. He used antiques from his collection in these carefully observed paintings.

Regardless of subject matter, Watrous's work was rather academic in style. The surface of the oil paintings was smooth and highly polished. He drew the outlines of the objects with precision, and the compositions were classic in their simplicity.

Watrous was married to painter and author Elizabeth Snowden Nichols. He served as secretary of the National Academy of Design from 1898 to 1920, and as president of the Academy in 1933. Watrous died in New York City in 1940.

MEMBERSHIPS
American Federation of Arts
Century Association
Lotus Club
National Academy of Design
National Arts Club
Salmagundi Club
Society of American Artists
Society of Painters

PUBLIC COLLECTIONS
Brooklyn Museum
City Art Museum, St. Louis
Corcoran Gallery, Washington, D.C.
Fort Worth Museum, Texas
Metropolitan Museum of Art, New York City
Montpelier Museum, Vermont
Portland Museum, Maine

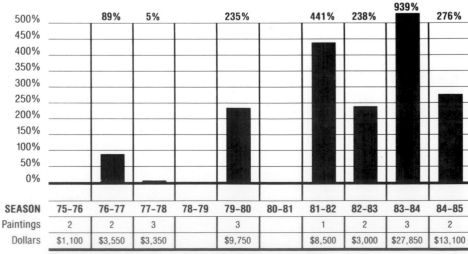

10-Year Average Change From Base Years '75-'76: 278%

	89%	5%		235%		441%	238%	939%	276%

SEASON	75–76	76–77	77–78	78–79	79–80	80–81	81–82	82–83	83–84	84–85
Paintings	2	2	3		3		1	2	3	2
Dollars	$1,100	$3,550	$3,350		$9,750		$8,500	$3,000	$27,850	$13,100

Record Sale: $16,000, SPB, 12/8/83, ''The Magician,'' 32 x 25 in.

BRUCE CRANE
(1857-1937)

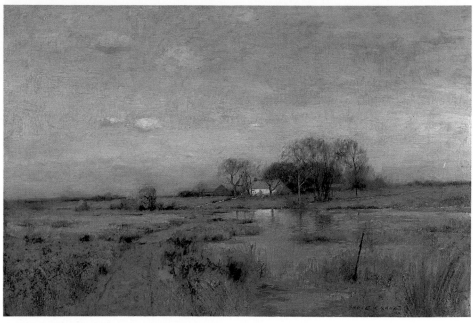

Across the Marshes, 20 x 30 in., signed l.r. Courtesy of Henry B. Holt, Inc., Essex Fells, New Jersey.

An acclaimed landscape painter of autumnal and twilight scenes, Robert Bruce Crane used a literal and detailed style before adopting the tonalism that characterized his later work. His popularity in the early 1900s attests to the continuing success of the barbizon and impressionist modes in America.

Born in New York City in 1857, Crane gained practical experience as a draftsman for an architect and builder. He began to paint in his spare time, later opening a studio in New York City. He received formal training from landscape painter Alexander H. Wyant, who influenced him to follow the barbizon style. Crane continued to study in Paris for a year and a half, painting outdoors near Grez-sur-Loing.

When he returned to New York in 1881, Crane achieved recognition for his plein-air landscapes of Eastern American scenes—the Adirondacks, Long Island, New Jersey and Connecticut. His greatest popularity, however, came in the late 1890s, when he won the Webb prize given by the Society of American Artists.

Crane spent a great number of his summers after 1904 in the popular artists' colony of Old Lyme, Connecticut. The artist sketched outdoors, as he once said, "to fill the memory with facts." He used light-tone pigments, applied to the canvas with a scrubby brush to achieve a rough, dry effect. This is well illustrated in paintings such as *Autumn Uplands* (1908, Metropolitan Museum of Art) and *March* (date unknown, Brooklyn Museum), which rely less on detail and more upon beige, russet and brown tones to achieve their effect.

In 1915, Crane joined with Emil Carlsen, Charles H. Davis, and J. Alden Weir to establish Twelve Landscape Painters, an exhibiting organization of artists working in popular representational styles. He died in Bronxville, New York in 1937.

10-Year Average Change From Base Years '75-'76: 181%

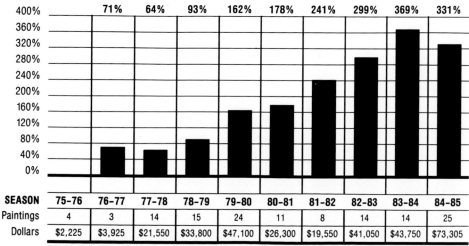

	71%	64%	93%	162%	178%	241%	299%	369%	331%	
SEASON	75-76	76-77	77-78	78-79	79-80	80-81	81-82	82-83	83-84	84-85
Paintings	4	3	14	15	24	11	8	14	14	25
Dollars	$2,225	$3,925	$21,550	$33,800	$47,100	$26,300	$19,550	$41,050	$43,750	$73,305

Record Sale: $12,000, W.W, 3/2/85, "Autumn Interlude," 38 × 47 in.

MEMBERSHIPS
American Water Color Society
Artists' Fund Society
Associate National Academy of Design
Lotus Club
National Academy of Design
Salmagundi Club
Society of American Artists
Union Internationale des Beaux-Arts et des Lettres

PUBLIC COLLECTIONS
Brooklyn Museum
Corcoran Gallery of Art, Washington, D.C.
Fort Worth Museum, Texas
Hackley Art Gallery, Muskegon, Minnesota
Metropolitan Museum of Art, New York City
Montclair Art Museum, New Jersey
National Gallery of Art, Washington, D.C.
Peabody Institute, Baltimore
Pennsylvania Academy of the Fine Arts, Philadelphia
National Museum of American Art, Washington, D.C.
Syracuse Museum of Art, New York

PHILIP LITTLE
(1857-1942)

Philip Little was a painter and etcher who achieved some measure of success in the first three decades of the twentieth century with his paintings of coastal New England.

Little was born in Swampscott, Massachusetts, the son of one of the principal owners of the Pacific Mills factory in Lawrence, Massachusetts. He resisted his father's desire for him to enter the business, choosing instead to study design at the Massachusetts Institute of Technology from 1875 to 1877.

Following an unhappy year working in the Pacific Mills office, Little obtained a job with the Forbes Lithograph Company in Boston. Soon after, he entered the school of the Museum of Fine Arts in Boston, where he studied painting and etching from 1881 to 1882.

Little said that he did not begin to find his inspiration until around 1903, when he set up his studio on Derby Wharf in the old whaling port of Salem, Massachusetts. Here, he began to paint his mature work, scenes of the New England coast, reflecting the poetic influences of the barbizon style and some impressionistic lighting techniques.

By 1911, Little had begun to receive recognition in Europe and the Americas for his paintings, exhibiting his work in Buenos Aires and Rome, and at the Paris Salon of 1912. In the United States, Little won an honorable mention from the Art Institute of Chicago in 1912, and a silver medal at the Panama-Pacific International Exhibition of 1915 in San Francisco.

Philip Little was active in Salem civic affairs, serving as a councilman and a member of the board of health. He remained socially and professionally active until his death in Salem in 1942.

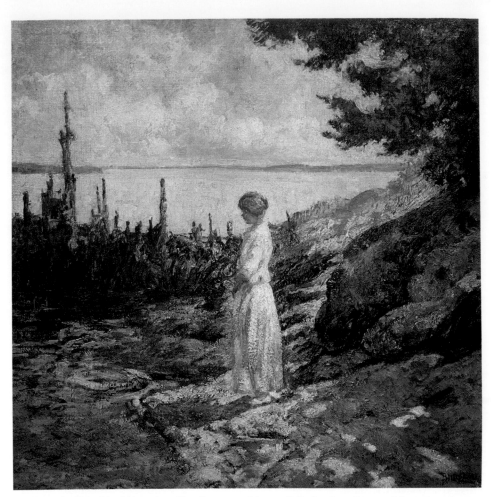

Watching the Tide, 36 x 36 in., signed l.r. Courtesy of Arvest Galleries, Inc., Boston, Massachusetts.

MEMBERSHIPS
American Society of Etchers
Minneapolis Institute of Art
National Arts Club
Portland (Maine) Society of the Arts

PUBLIC COLLECTIONS
Bowdoin College Museum of Art,
 Brunswick, Maine
Essex Institute, Salem, Massachusetts
Library of Congress, Washington, D.C.
Minneapolis Institute of Art
Museum of Fine Arts, Boston
New York Public Library, New York City
Rhode Island School of Design, Providence
St. Louis Art Museum

SEASON	75–76	76–77	77–78	78–79	79–80	80–81	81–82	82–83	83–84	84–85
Paintings				2	3	5	3	3	1	2
Dollars				$4,900	$3,475	$12,500	$4,950	$1,850	$475	$8,600

Record Sale: $8,000, BB.SF, 11/8/84, "Train Crossing a Harbor," 36 × 50 in.

ERNEST ALBERT
(1857-1946)

A distinguished theatrical and scenic designer, Ernest Albert worked in New York, St. Louis and Chicago. Born in Brooklyn in 1857, he showed early talent and received the Graham Art Medal at age 15, while he was studying at the Brooklyn Art Institute. Though Albert had some early success as a newspaper artist, his introduction to the theater world in 1877 began a career in stage design; he worked on productions starring most of the best-known performers of the day. During this time, in 1879, he employed and befriended young Jules Guerin, who went on to become the Lincoln Memorial muralist.

From New York City, Albert went to St. Louis in 1880 and five years later to Chicago. In 1892, he became involved with the World's Columbian Exposition in Chicago. He was responsible for the color schemes and ornamental design of many of the interiors of buildings in that renowned and successful fair. While in Chicago, he helped found the American Society of Scenic Painters.

In 1894, Albert returned to New York City, where his work in scenic design was centered from then on. His Albert Studios did the sets for many successful productions.

All along, he had painted whenever he could snatch the time. At the pinnacle of his career in 1905, he began to withdraw gradually from his theater work. His family was settled in the striking new house he had built in New Rochelle, New York and his financial independence was established. From then on, he devoted most of his considerable talent and energy to his landscapes.

Albert's landscapes, painted mostly in Old Lyme, Connecticut and later on Monhegan Island, Maine (as well as a few on the West Coast), are simple in composition but subtle in effect. His impressionistic rendering of color and light imbue his quiet country scenes with all the magic of the moment. The gentle strength of these pictures and of his still lifes ensured their popularity and earned him a place as one of America's respected artists.

Albert was active in several organizations and was a founder and first president of the Allied Artists of America. Ernest Albert, Jr. (1891-1955), his son, was also a painter.

Albert died at age 88 in New Canaan, Connecticut in 1946.

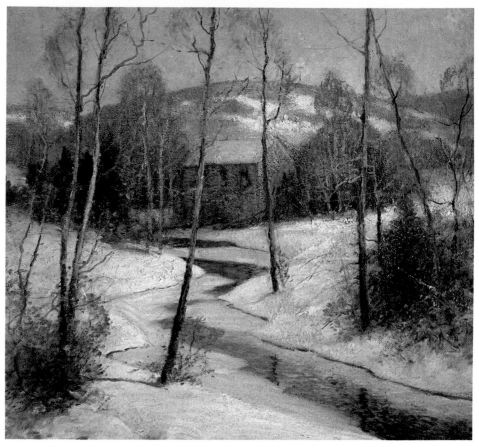

Yellow Mill, 26 x 28 in., signed l.r. Courtesy of Connecticut Gallery, Marlborough, Connecticut.

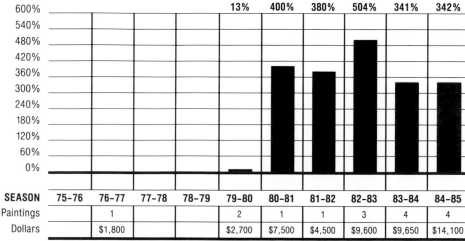

10-Year Average Change From Base Years '76-'77: 283%

SEASON	75-76	76-77	77-78	78-79	79-80	80-81	81-82	82-83	83-84	84-85
					13%	400%	380%	504%	341%	342%
Paintings		1			2	1	1	3	4	4
Dollars		$1,800			$2,700	$7,500	$4,500	$9,600	$9,650	$14,100

Record Sale: $7,500, SPB, 5/29/81, "Summer Pastoral," 30 × 40 in.

MEMBERSHIPS
Allied Artists of America
American Society of Scenic Painters
American Water Color Society
Chicago Society of Artists
Connecticut Academy of Fine Arts
Lyme Art Association
National Academy of Design
National Arts Club
New Haven Paint and Clay Club
New Rochelle Art Association
St. Louis Sketch Club
Salmagundi Club
Silvermine Guild of Artists

517

CHARLES FREDERIC ULRICH

(1858-1908)

At the Embroidery Hoop, 15¾ x 14⅝ in., signed u.l. Photograph courtesy of Hirschl & Adler Galleries, Inc., New York, New York.

Charles Frederic Ulrich was encouraged by his father, a painter and photographer, to study art. He was at the National Academy of Design in New York City in 1875. Shortly thereafter, he enrolled in the Royal Academy at Munich, learning the techniques and realistic styles of its popular artists.

Ulrich was influenced by his appreciation of the Dutch old masters. His work was characterized by detailed costumes and still lifes, and by the use of dark, rich colors. The German genre painters' scenes of peasant life also permanently influenced Ulrich's style.

Returning to the United States sometime before 1882, he exhibited at the National Academy of Design and was elected an associate a year later.

The Pennsylvania Dutch and their costumes caught Ulrich's interest, which later turned to immigrants. In 1884 his painting *In the Land of Promise—Castle Garden* (date and location unknown) won the National Academy of Design's first Thomas B. Clarke prize.

In 1885, Ulrich went to Holland, where he was influenced by the work of Vermeer and de Hooch. Venice became home in 1886, and he painted *Glass Blowers of Murano* (location unknown), which won a large cash prize and was superior to his earlier *Glass Blowers* (1883).

Critics praised Ulrich's purity of color and exquisite technique. While executing almost photographic precision and control, Ulrich tailored tonal changes and composition to his subjects. A series on workers at their crafts, sometimes painted on wood, attracted further praise and prominent collectors.

Except for a visit to New York City in 1891, Ulrich lived abroad for the rest of his life. He retained contact with Robert Blum and William Merritt Chase in the 1880s, and the 1890s and helped organize American exhibits in Munich. From 1900 until his death in Berlin in 1908, he worked and exhibited in Paris, London and Munich.

MEMBERSHIPS
National Academy of Design
Society of American Artists
Society of Painters in Pastel

PUBLIC COLLECTIONS
Corcoran Art Gallery, Washington, D.C.
Metropolitan Museum of Art, New York City

SEASON	75–76	76–77	77–78	78–79	79–80	80–81	81–82	82–83	83–84	84–85
Paintings								1		
Dollars								$27,000		

Record Sale: $27,000, SPB, 6/2/83, "Vanitas," 9 × 17 in.

WILLIAM VERPLANCK BIRNEY
(1858-1909)

William Verplanck Birney's first success seems to have charted his course for the rest of his life. He was one of two Americans who sold pictures in 1883 at the International Exhibition in Munich. His painting *A Quiet Corner* (date and location unknown) was a simple scene portraying a daydreaming young German peasant girl, but the important thing was that it told a story.

Moments in time—sentimental, poignant, sometimes merely thoughtful—are what Birney wanted to catch. The moments are occasionally painful in the extreme. In *Deserted* (date and location unknown), a village girl watches from a window with a sympathetic friend while a wedding party, including her ex-lover and his bride, enters a vine-covered church across the way.

To illustrate a variety of emotions as well as the faith of the Christian martyrs, Birney painted *The Last Token* (date and location unknown), which shows a young woman leaning down to pick up a rose in the midst of wild animals.

Birney drew his subject matter from everywhere—Germany, Italy, France, America and especially rural England. Wherever he happened to be, he painted his studies on the spot. Paintings of unusual roofs, castle kitchens, cottage and ale-cellar interiors were other subjects he explored. Authentic detail and expertise in color and composition gave his work strength.

Birney was born in Cincinnati, Ohio in 1858. He was educated in Washington, D.C., Boston, Philadelphia (the Pennsylvania Academy of the Fine Arts) and Munich (the Royal Academy). He died in 1909.

Two Men Conversing, 12 x 15¼ in. Courtesy of Vose Galleries of Boston, Inc., Massachusetts.

MEMBERSHIPS
Fine Arts Federation
Lotos Club
National Academy of Design
New York Watercolor Club
Salmagundi Club

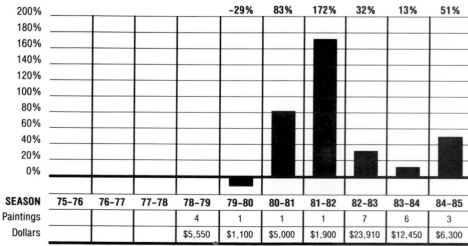

10-Year Average Change From Base Years '78-'79: 46%

SEASON	75-76	76-77	77-78	78-79	79-80	80-81	81-82	82-83	83-84	84-85
% Change					−29%	83%	172%	32%	13%	51%
Paintings				4	1	1	1	7	6	3
Dollars				$5,550	$1,100	$5,000	$1,900	$23,910	$12,450	$6,300

Record Sale: $9,500, SPB, 10/22/82, "The Ghost Story," 26 × 40 in.

HENRY WARD RANGER
(1858-1916)

A painter of idyllic landscapes, Henry Ward Ranger was born in Syracuse, New York. His formal training was in Paris at the Ecole des Beaux Arts, where he was attracted to genre painters Josef Israels and Anton Mauve, who practiced a style of heavily romantic realism. When Ranger returned to America, his dreamy New England scenes almost seemed to be replicas of the landscapes of Corot or Diaz in the late 1860s—an American adaptation of the barbizon style.

In 1884, Ranger set up a New York studio. Due to the vogue for landscapes at the turn of the century, he was soon very successful. In about 1900, the artist began spending half of his time in Old Lyme, Connecticut. There he founded the American Barbizon School, which produced no major American artists but which had a profound effect on early-twentieth-century landscapists and photographers.

Best known for woodland scenes, often in rich autumnal colors unified by controlled light and shade, Ranger excelled at creating an atmospheric effect. He arrived at an almost balletic compromise between descriptive realism and poetic vision. His approach to realism was direct only in that he sketched in the open air. He finished his work in the studio in the true academic manners usually including a dark foreground plane dappled with flecks of sunlight, an intermediate winding path or glade, and a misty, light-filled distance.

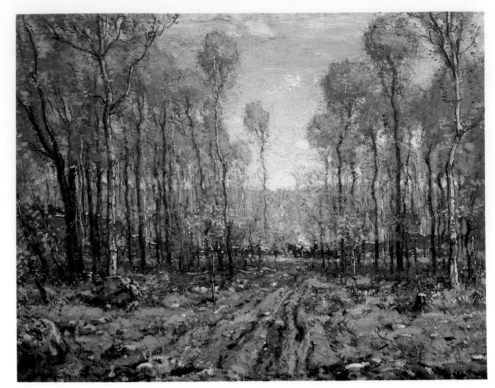

The Forest Road, Early Spring, 28 x 36 in., signed l.l. Courtesy of Connecticut Gallery, Marlborough.

Typical of Ranger's later period is *High Bridge, New York* (1905, Corcoran Gallery of Art). This romanticized interpretation of the urban landscape focuses upon the bridge itself, its curved forms mirrored in the water below. The Manhattan skyline in the distance is immersed in a luminous haze.

At Ranger's death, he bequeathed a sum of money to the National Academy of Design to create the Ranger Fund, allotted for the purchase of works by young artists.

10-Year Average Change From Base Years '76-'77: 68%

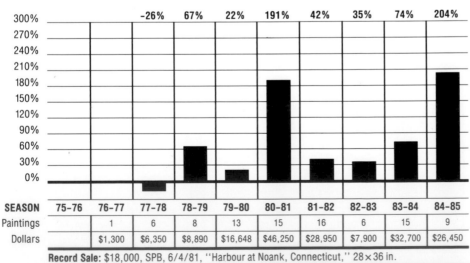

SEASON	75-76	76-77	77-78	78-79	79-80	80-81	81-82	82-83	83-84	84-85
		-26%	67%	22%	191%	42%	35%	74%	204%	
Paintings		1	6	8	13	15	16	6	15	9
Dollars		$1,300	$6,350	$8,890	$16,648	$46,250	$28,950	$7,900	$32,700	$26,450

Record Sale: $18,000, SPB, 6/4/81, "Harbour at Noank, Connecticut," 28 × 36 in.

MEMBERSHIPS
American Water Color Society
National Academy of Design

PUBLIC COLLECTIONS
Corcoran Gallery of Art,
 Washington, D.C.
Metropolitan Museum of Art, New York City
National Museum of American Art, Washington, D.C.

WILLARD LEROY METCALF
(1858-1925)

Willard Leroy Metcalf was a popular and successful painter, whose luminous and colorful New England landscapes were an extension of American impressionism.

Metcalf received encouragement in pursuing an artistic career from his parents. He was born in 1858 in Lowell, Massachusetts. At 17, he studied in Boston under landscape artist George Loring Brown and attended classes at the Lowell Institute and the School of the Museum of Fine Arts in Boston.

Accompanied by ethnologist Frank Cushing, Metcalf spent the years from 1881 to 1883 in the Southwest. Metcalf sketched illustrations of Indians and desert life in oil, watercolor and crayon. Their sale to *Harper's Magazine* enabled him to afford a trip to Europe in 1883.

At the time, impressionism was beginning to make its impact on European art. However, the instruction Metcalf received at the Academie Julien in Paris was stylistically conservative. One of the first Americans to visit the French village of Giverny where many impressionists worked, Metcalf would not incorporate their techniques in his paintings until the early 1900s.

Metcalf's one celebrated painting during his five years in Europe was *Ten Cent Breakfast* (1887, Denver Art Museum), a somber interior showing fellow artists and friends.

Settling in New York City in 1889, Metcalf supported himself primarily

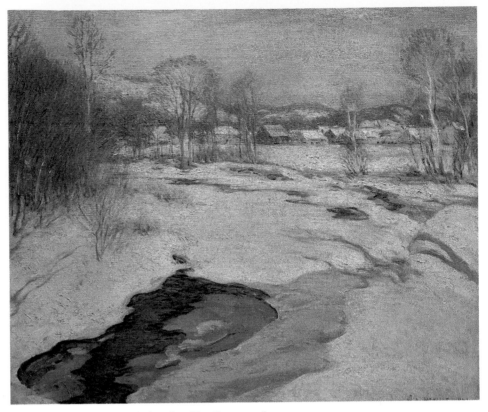

Winter's Mantle, 1922, 26 x 29 in., signed l.r. Courtesy of Vose Galleries of Boston, Inc., Massachusetts.

through teaching at Cooper Union and selling illustrations to *Scribner's* and *Century.* He continued to paint.

A 1903 trip to Maine marked a decisive change in Metcalf's artistic style. His largely seasonal landscapes were infused with heightened color and luminosity and exhibited the broken brushstrokes characteristic of impressionism. As seen in *The North Country* (1923,

Metropolitan Museum of Art), many of Metcalf's landscapes attempt to convey a specific sense of place as well as atmospheric effect.

Enthusiastic about what Metcalf himself called his impressionist "renaissance," he became one of the founding members of The Ten American Painters. For 20 years, these artists popularized impressionism through frequent group exhibits. Metcalf also became an influential member of the art colony in Old Lyme, Connecticut.

Though he maintained a studio in New York City until his death there in 1925, Metcalf spent much of his time traveling and painting in New England.

MEMBERSHIPS
American Academy of Arts and Letters
American Watercolor Society
Century Association

PUBLIC COLLECTIONS
Art Institute of Chicago
Corcoran Gallery, Washington, D.C.
Metropolitan Museum of Art, New York City
Museum of Fine Arts, Boston
Museum of New Mexico, Santa Fe
National Gallery of Art, Washington, D.C.
Pennsylvania Academy of the Fine Arts, Philadelphia

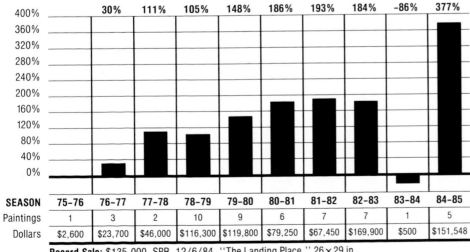

10-Year Average Change From Base Years '75-'76: 125%

	30%	111%	105%	148%	186%	193%	184%	-86%	377%	
SEASON	75-76	76-77	77-78	78-79	79-80	80-81	81-82	82-83	83-84	84-85
Paintings	1	3	2	10	9	6	7	7	1	5
Dollars	$2,600	$23,700	$46,000	$116,300	$119,800	$79,250	$67,450	$169,900	$500	$151,548

Record Sale: $135,000, SPB, 12/6/84, "The Landing Place," 26 x 29 in.

HENRY SIDDONS MOWBRAY
(1858-1928)

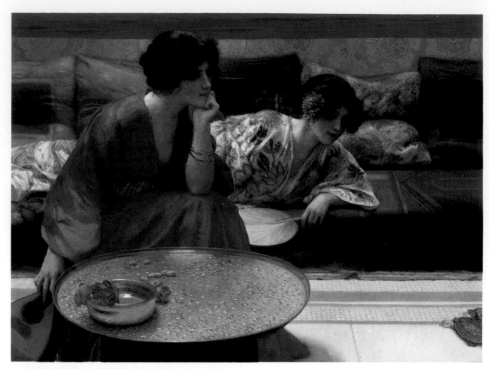

Idle Hours, 1895, 12 x 16 in., signed l.l. Courtesy of National Museum of American Art, Smithsonian Institution, Gift of William T. Evans.

Henry Siddons Mowbray was considered one of America's most versatile artists during the late nineteenth and early twentieth centuries.

Born in Alexandria, Egypt in 1858, he was brought to the United States the following year. He spent a brief and unhappy time at West Point Military Academy, where he did some illustrations for Homer Lee's *West Point Tic Tacs: A Collection of Military Verse* (1879).

After leaving the Academy, Mowbray received art instruction from Alfred Cornelius. In 1879, he went to Paris, where for the next seven years he studied under Leon Bonnat and was influenced by academic artists, particularly Jean Leon Gerome.

At first Mowbray painted genre scenes, and by 1883 his work had earned critical recognition and some commercial success. The following year, he began producing oriental figure paintings, which became his trademark for the next 15 years.

In 1886, Mowbray began a 15-year tenure as a teacher at the Art Students League.

Beginning in 1897, he devoted himself almost exclusively to painting murals, using an idealized figure style inspired by Renaissance art.

In the 1900s, Mowbray received many commissions for murals in public buildings and residences. He was so captivated by the murals and decorative designs of Pinturicchio that initially he produced close imitations; later he incorporated Pinturicchio's technique into his own style.

From 1924 until his death in 1928, Mowbray moved from decorative work to easel paintings depicting events in the life of Christ.

MEMBERSHIPS
American Academy in Rome
American Federation of Artists
National Institution of Artists

PUBLIC COLLECTIONS
Appellate Court House,
 New York City
Federal Court Room, Cleveland

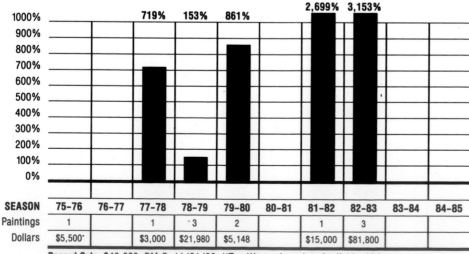

10-Year Average Change From Base Years '75-'76: 1,264%

SEASON	75-76	76-77	77-78	78-79	79-80	80-81	81-82	82-83	83-84	84-85
			719%	153%	861%		2,699%	3,153%		
Paintings	1		1	3	2		1	3		
Dollars	$5,500		$3,000	$21,980	$5,148		$15,000	$81,800		

Record Sale: $40,000, DM.D, 11/21/82, "Two Women in an Interior," 14 × 18 in.

JULIUS ROLSHOVEN
(1858-1930)

Julius Rolshoven became an award-winning painter who specialized in depicting the effects of light.

Born in 1858 in Detroit, Rolshoven attempted to enroll at the National Academy of Design in New York City, but was rejected because his work was considered unacceptable.

Undaunted, he attended Cooper Union night school in New York City in 1877. The next year he studied with Hugo Crola at the Academy of Dusseldorf, followed by three years of study with Loeffitz at the Royal Academy in Munich.

In 1812, Rolshoven studied in Paris with Robert-Fleury at the Academie Julien. He also studied briefly with Frank Duveneck in Florence.

The student turned teacher in 1890, when Rolshoven began to teach in Paris. Six years later, he taught in London.

Rolshoven traveled to Italy the next year and stayed there until World War I began, when he returned to the United States.

Having become known as one of the classic Eastern painters, Rolshoven moved West, setting up a studio in Santa Fe, New Mexico in 1916. He lived in Santa Fe for three years, and divided his final 11 years between Italy and New Mexico, until his death in 1930.

In New Mexico, Rolshoven made friends with many of the Indians by painting their portraits. He softened the harsh New Mexico light by setting up a tent as an outdoor studio. The romanticism and "old-master" look that he developed in Europe characterized his Western paintings. For example, *Sun Arrow* (date unknown, Museum of New Mexico) shows an Indian chief mounted on a prancing horse, suggesting the style of Velasquez or Rubens.

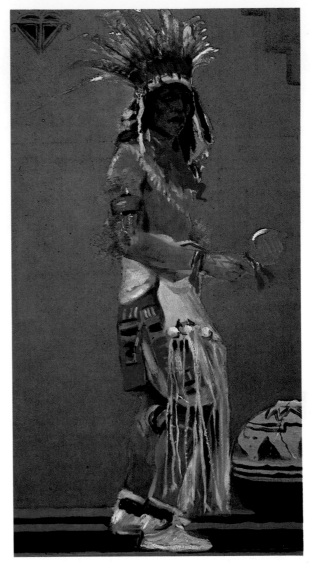

Indian Dancer, 27 x 15 in., signed l.l. Photograph courtesy of The Gerald Peters Gallery, Santa Fe, New Mexico.

MEMBERSHIPS
Foreign Arts Club
International Art Congress
National Academy of Design
National Arts Club
Paris Society of Artists and Lithographers
Society Nationale des Beaux-Arts, Paris
Taos Society of Artists

PUBLIC COLLECTIONS
Baltimore Museum of Art
Brooklyn Museum
Cincinnati Museum of Art
Detroit Institute of Arts
Minnesota Museum of Art, St. Paul
Museum of New Mexico, Santa Fe

10-Year Average Change From Base Years '75-'76: 62%

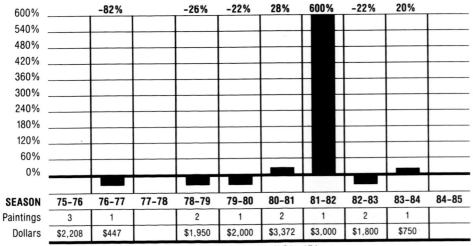

	-82%		-26%	-22%	28%	600%	-22%	20%		
SEASON	75-76	76-77	77-78	78-79	79-80	80-81	81-82	82-83	83-84	84-85
Paintings	3	1		2	1	2	1	2	1	
Dollars	$2,208	$447		$1,950	$2,000	$3,372	$3,000	$1,800	$750	

Record Sale: $3,000, SPB, 4/23/82, "Eagle Feather," 21 x 17 in.

ROBERT WILLIAM VONNOH
(1858-1933)

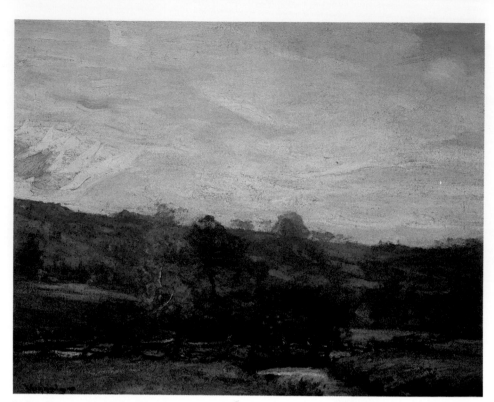

Indian Summer, 24 x 30 in., signed l.l. Courtesy of Connecticut Gallery, Marlborough.

Robert William Vonnoh was one of the earliest painters to introduce European impressionism to America. Vonnoh was a highly renowned academic portrait painter and an impressionist landscape painter. He won an impressive number of awards and was a member of a number of art organizations.

Born in Hartford, Connecticut in 1858, Vonnoh was raised in Boston. As a young man, he worked for a lithographic firm and studied with local artists. He studied at the Massachusetts Normal Art School from 1875 to 1881. From 1881 to 1883, Vonnoh studied under Gustave Boulanger and Jules Joseph Lefebvre at the Academie Julien. From 1884 to 1885, he taught at the Cowles Art School, and from 1885 to 1887, he taught at the School of the Museum of Fine Arts in Boston.

In 1887, Vonnoh returned to Paris and studied there for the next four years. He encountered French impressionism and was particularly fascinated by the work of Claude Monet. Monet's free, impressionistic style of painting strongly influenced Vonnoh's subsequent landscape paintings.

In 1891, Vonnoh returned to America and brought his enthusiasm for French impressionism to the Pennsylvania Academy of the Fine Arts. He was an instructor at the Academy until 1896; his pupils included William Glackens and Robert Henri.

Vonnoh's style was similar to that of Camille Pissarro; both preferred cool tones of muted colors and carefully balanced compositions. Vonnoh used spontaneous brushstrokes and pure colors in his realistic depictions of nature. He had the ability to capture natural light, color and atmosphere in a landscape.

In addition to his impressionistic landscapes, Vonnoh painted more than 500 commissioned portraits. Unlike his landscapes, these academic portraits were rather conventional and formal in style.

In 1899, Vonnoh married sculptor Bessie Potter. From 1918 to 1920, he again served as an instructor at the Pennsylvania Academy of the Fine Arts. He died in Nice, France in 1933.

MEMBERSHIPS
Allied Artists of America
American Art Association of Paris
Architectural League of New York
Connecticut Academy of Fine Arts
Fellowship of the Pennsylvania Academy of the
 Fine Arts
National Academy of Design
National Association of Portrait Painters
Salmagundi Club
Society of American Artists

PUBLIC COLLECTIONS
Brooklyn Museum
Cleveland Museum of Art
Los Angeles County Museum of Art
Metropolitan Museum of Art, New York City
Pennsylvania Academy of the Fine Arts,
 Philadelphia
White House, Washington, D.C.

SEASON	75-76	76-77	77-78	78-79	79-80	80-81	81-82	82-83	83-84	84-85
Paintings		2	3	1	7	2	4	4	3	2
Dollars		$15,250	$13,600	$450	$59,050	$10,150	$21,600	$17,100	$7,900	$2,400

Record Sale: $15,500, SPB, 3/17/80, "Autumn Morning, Connecticut," 30 × 25 in.

CHARLES PARTRIDGE ADAMS

(1858-1942)

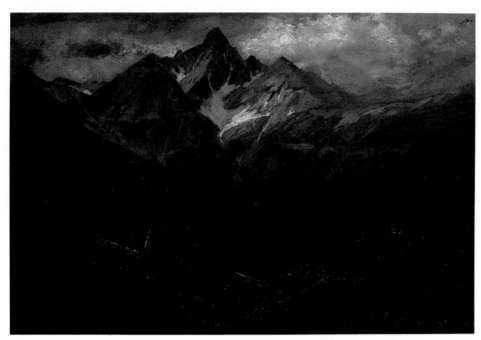

Mountain Landscape, 14 x 20 in., signed l.l. Courtesy of Grand Central Art Galleries, Inc., New York, New York.

The greater part of Charles Adams's career was devoted to capturing the drama of the Rocky Mountains and other scenes of the American West. Born in 1858, in Franklin, Massachusetts, Adams moved to Denver for health reasons in 1876; he soon became one of Colorado's favorite artists.

Employed first as an engraver in a bookstore, Adams advertised his services for landscapes and crayon portraits. He studied briefly at the Denver art school of Mrs. James Albert Chaim (or Chain), a former student of landscapist George Inness.

By the time Adams was 25, his work was in demand. He opened a summer studio, "The Sketch Box," in Estes Park near Longs Peak, Colorado—a center for his work, study and teaching for more than 40 years.

From it, he traveled to paint the Rockies, Estes Park, the Tetons and Yellowstone Park, the Spanish peaks, the San Juan and San Miguel Mountains and the New Mexico desert. With authoritative skill and realism, his work projects the natural atmosphere of these rugged Western landscapes, particularly in their changing, dramatic extremes.

Adams left the West once, to tour European galleries in 1914. He moved to California about 1916. In Laguna Beach, he turned to marine subjects, conveying the same realism and vitality his landscapes exhibited.

When Adams died in 1942, at age 84, he had completed some 800 paintings and numerous sketches.

MEMBERSHIPS
Denver Artists Club
Laguna Art Association

PUBLIC COLLECTIONS
Colorado State University, Boulder
Denver Art Association
Denver Art Museum
Kansas City Art Association, Missouri
San Diego Woman's Club

SEASON	75-76	76-77	77-78	78-79	79-80	80-81	81-82	82-83	83-84	84-85
Paintings				2	7	7	4	3	4	7
Dollars				$1,210	$8,050	$7,450	$3,700	$4,150	$4,350	$8,250

Record Sale: $2,800, CH, 12/5/80, "Near Silverton, Colorado," 10 × 14 in.

CHARLES VEZIN
(1858-1942)

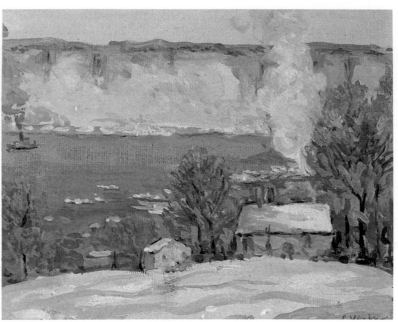

Winter Day, The Palisades, 6⅛ x 8 in., signed l.r. Florence Griswold Museum, Lyme Historical Society, Old Lyme, Connecticut. Gift of Mrs. Robert D. Graff.

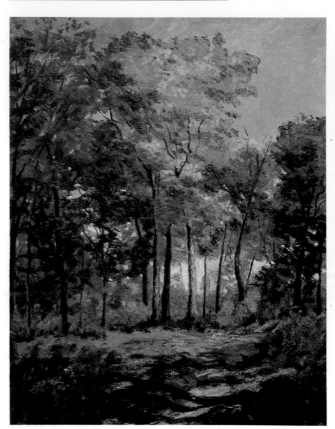

Sunlight in the Woods, 36 x 28 in., signed l.r. Courtesy of Marbella Gallery, Inc., New York, New York. Photograph by Richard Haynes.

Charles Vezin came late to the formal study of art, being nearly 40 when he enrolled at the Art Students League in New York City, but he brought to his avocation a worshipful attitude towards art, a tremendous enthusiasm, and a hearty, solid landscape style which earned him recognition and honor.

Vezin was born in Philadelphia in 1858. After military school, he studied in Germany. When he came back, he was first a salesman, then a dry goods entrepreneur.

At the same time Vezin started his business, he entered the Art Students League, studying with William Merritt Chase. He seems to have adopted some of Chase's methods, but rejected impressionism. Vezin became an energetic and controversial writer of articles outlining his theories of art and expressing his disgust for modernism.

He achieved swift success as a painter, specializing in New York cityscapes and Brooklyn waterfront scenes. His fellow artists recognized him by electing him president of the Art Students League in 1911 and of the Salmagundi Club in 1914, though he did not abandon the dry goods business for the full-time pursuit of painting until 1919.

Until his death in 1942 at his summer home in Coral Gables, Florida, Vezin exhibited widely, painted energetically, preached his gospel of art and thrived on controversy.

MEMBERSHIPS
American Federation of Arts
American Fine Arts Society
Art Alliance
Art Students League
Brooklyn Society of Artists
Century Club
National Academy of Design
New York Water Color Club
Painters and Sculptors of Brooklyn
Salmagundi Club

PUBLIC COLLECTIONS
Atlanta Art Gallery
High Museum, Atlanta
New-York Historical Society, New York City

SEASON	75-76	76-77	77-78	78-79	79-80	80-81	81-82	82-83	83-84	84-85
Paintings				1	1	2	2		1	
Dollars				$1,200	$5,500	$3,500	$5,200		$2,800	

Record Sale: $5,500, SPB, 3/17/80, "The Hudson," 28 × 36 in.

HENRY BAYLEY SNELL
(1858-1943)

Henry Bayley Snell was among the earliest artists to settle in the picturesque Delaware River Valley in Bucks County, Pennsylvania. Affiliated with the New Hope School of American impressionism, he was known throughout the region both as a painter of landscape and marine subjects and as a prominent instructor of art.

Born in Richmond, England in 1858, Snell came to New York City at age 17. He began his study at the Art Students League, supporting himself by working in the blueprint department of an engineering firm, and then by producing marine scenes for a lithography studio.

In 1888, Snell married artist Florence Francis. Before settling in New Hope, he taught art in New York City and Washington, D.C.

Snell and his wife first came to New Hope in 1898 to visit William Langson Lathrop, a prominent American tonalist painter and founder of the New Hope School. For many years Lathrop's home and studio served as the area's community center for art instruction and exhibition. Snell moved to New Hope in 1900.

He taught art at the Philadelphia School of Design for Women from 1899 to 1943. He also traveled extensively, as far as India, and regularly journeyed abroad with his students to France, England, Germany, Holland and Spain.

Snell is noted for his coastal scenes of St. Ives, Cornwall, England, a region which his New Hope colleague Walter Elmer Schofield also frequented. He also painted harbor scenes of Gloucester, Massachusetts and Boothbay Harbor, Maine. A great many of his works are of New Hope street scenes and landscapes of the rural Delaware River Valley.

Although he painted directly from nature, following the practice of New Hope painters, Snell's style is unusual; it

Late Twilight, 16 x 24 in., signed l.l. Courtesy of Marbella Gallery, Inc., New York, New York.

Near St. Ives, 11⅝ x 15⅝ in., signed l.l. Gift of the North Carolina Art Society, Raleigh, North Carolina. (Robert F. Phifer bequest.)

is not dynamic and bold like that of Edward Willis Redfield, nor is it akin to the sensitive, intricate brushwork of Daniel Garber. Instead, Snell's modest-sized canvases are painted with broad, flat passages of pigment, illuminated with soft, permeating hues.

Snell's work is not typical of the regional impressionistic style, with its emphasis on capturing seasonal and atmospheric conditions, yet he remains important as an early member of the

New Hope art colony, one whose reputation as a painter and teacher lured many younger artists to this Pennsylvania region.

MEMBERSHIPS
Allied Artists Association
American Watercolor Society
Fellowship of the Pennsylvania Academy of the Fine Arts
Lotos Club
National Academy of Design
National Arts Club
New York Watercolor Society
Salmagundi Club

PUBLIC COLLECTIONS
Albright-Knox Art Gallery, Buffalo, New York
John Herron Art Institute, Indianapolis
Metropolitan Museum of Art, New York City
Pennsylvania Academy of the Fine Arts, Philadelphia
Worcester Museum, Massachusetts

SEASON	75-76	76-77	77-78	78-79	79-80	80-81	81-82	82-83	83-84	84-85
Paintings			1			1				
Dollars			$2,750			$700				

Record Sale: $2,750, SPB, 11/8/77, "Old Windjammer," 34 × 44 in.

MARY LOUISE FAIRCHILD MacMONNIES LOW
(1858-1946)

Mary Louise Fairchild MacMonnies Low, a portrait and mural painter, was born in 1858 in New Haven, Connecticut. A descendant of Governor Bradford of the *Mayflower,* she attended St. Louis Art Academy on a scholarship after her family moved to that city. She later studied under Carolus-Duran at the Academie Julien in Paris.

In 1888 in Paris, she married sculptor Frederick MacMonnies. As successful artists who each received acclaim at the 1893 Chicago Exposition, they were part of the circle that included James McNeill Whistler. They also summered at Giverny, a popular spot in the 1890s for American artists seeking the inspiration of Monet.

By 1909, the couple had divorced, and she married Will Hickok Low, an academic mural painter. She returned to the United States with her new husband, and lived in Bronxville, New York until her death in 1946. After the divorce, she dropped her earlier name, and avoided all references to MacMonnies.

The artist's work reflects several phases of development. At first, she painted in a sunlit style reminiscent of her teacher Carolus-Duran. She then entered a misty, tonal phase. She primarily painted dark, academic portraits after her marriage to Low, but in her final years, she returned to a lighter, impressionistic style.

MEMBERSHIPS
American Women's Art Association
National Academy of Design
Society of American Artists
Societe Nationale des Beaux-Arts
Womans Art Club
Womans International Art Club

PUBLIC COLLECTIONS
Art Institute of Chicago
Musee des Beaux-Arts, Rouen, France
St. Louis Art Museum
Union League Club, Chicago
Museum of Vernon, France

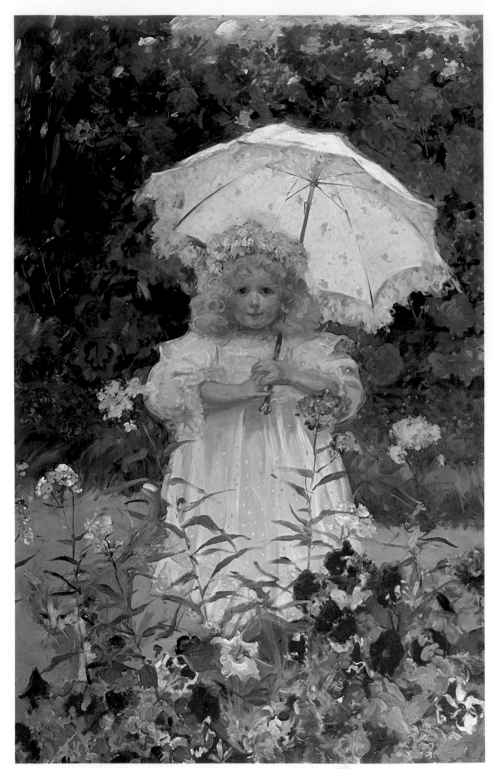

Portrait of Berthe Helene MacMonnies, 1896, 62 x 38 in., signed u.l. Private Collection. Photograph courtesy of Hirschl & Adler Galleries, Inc., New York, New York.

SEASON	75-76	76-77	77-78	78-79	79-80	80-81	81-82	82-83	83-84	84-85
Paintings							1			
Dollars							$16,000			

Record Sale: $16,000, P.NY, 12/14/81, "Portrait of Berthe Helene MacMonnies," 61 × 37 in.

528

ELBRIDGE AYER BURBANK
(1858-1949)

Elbridge Ayer Burbank created a great American heritage—an invaluable portrait gallery of American Indians of the West.

Beginning in 1895, Burbank drew and painted from life more than 1,200 pictures of leaders and members of some 125 Western tribes. He painted many chiefs, among them Geronimo, Joseph, Sitting Bull, Red Cloud and Rain in the Face. But hundreds of other subjects were chosen for their distinctive individual and tribal character. Born in 1858 at Harvard, Illinois, Burbank earned honors as a student at the Art Institute of Chicago. On graduation, an assignment from *Northeast Magazine* took him through the Rockies to the Washington State coast, painting Western scenes to promote land sales for the Northern Pacific Railway.

In 1886, Burbank went to Munich to study with Paul Nauen and Frederick Fehr. Four years later, he returned to Chicago and specialized in portraits, particularly of Negro subjects.

His major lifework was launched in 1895 by his uncle, Edward E. Ayer, first president of the Field Columbia Museum, trustee of the Newberry Library and collector of Indian lore. He commissioned Burbank to do portraits of living, prominent Indian chiefs.

Burbank traveled through Oklahoma, New Mexico and Arizona, among the Navajo, Hopi and Zuni. He portrayed numerous California tribes, and later, the Sioux, Crow, Nez Perce and Ute.

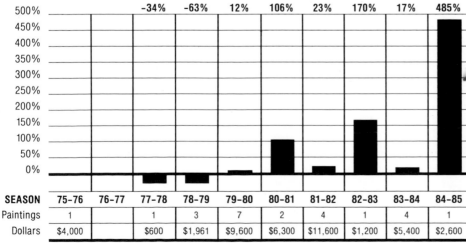

Chief Black-Coyote, 1901, 13 x 9 in., signed l.l. Courtesy of National Museum of American Art, Smithsonian Institution, Lent by Smithsonian Institution, National Museum of Natural History, Department of Anthropology.

Burbank liked the Indians; they were frequent guests at his table and in his home. Chief Geronimo, before his death in 1909, told Burbank he liked him better than any white man he had known.

Burbank's work displays not only technical maturity and extraordinary representational skill, but sympathy and genuine respect for his subjects. Working in oil, watercolor and crayon, with remarkably fresh effect, he produced strong, insightful portraits and scenes. They form the final poignant record of the proud Indian cultures on the eve of their dissolution.

Burbank died in San Francisco in 1949, at age 90.

PUBLIC COLLECTIONS
Field Museum, Chicago
Hubbell Trading Post Museum, Ganado, Arizona
National Gallery of Art, Washington, D.C.
Newberry Library, Chicago

10-Year Average Change From Base Years '75-'76: 80%

	75-76	76-77	77-78	78-79	79-80	80-81	81-82	82-83	83-84	84-85
			-34%	-63%	12%	106%	23%	170%	17%	485%
SEASON	75-76	76-77	77-78	78-79	79-80	80-81	81-82	82-83	83-84	84-85
Paintings	1		1	3	7	2	4	1	4	1
Dollars	$4,000		$600	$1,961	$9,600	$6,300	$11,600	$1,200	$5,400	$2,600

Record Sale: $5,000, CH, 12/5/80, "Chief Stinking Bear Sioux," 15 x 14 in.

529

HELEN MARIA TURNER
(1858-1958)

Helen Maria Turner was an active member of the art colony in Cragsmoor, New York, particularly well known for her oil paintings of women in gardens and interiors.

Born in Louisville, Kentucky in 1858, Turner spent her childhood and early adulthood in New Orleans. She was orphaned at age 13 and grew up in genteel poverty.

Turner began painting at age 22; she took classes at the New Orleans Art Union around 1890. From 1893 to 1895, she was an instructor at an Episcopal school for girls in Dallas, Texas.

In 1895, Turner moved to New York City and enrolled in the Art Students League, where she studied under Kenyon Cox and Douglas Volk. In 1898, she also enrolled in the Women's Art School of Cooper Union in order to continue studying portraiture with Volk. She earned a diploma from Cooper Union. From 1899 to 1900, Turner was enrolled in the Fine Arts Department of the Teachers' College of Columbia University, where she was accepted as a temporary instructor and received a scholarship.

In 1902, Turner was hired as a teacher in the Art School of the New York City Young Women's Christian Association. She taught life drawing, drawing from casts, and costume drawing. She continued to teach for 17 years and retired in 1919.

Turner was a true American impressionist painter who chose to study with American instructors. Her early work included miniature portraits, pastels, watercolors and oils. From 1900 to 1910, she concentrated on landscapes.

From 1910, Turner worked almost exclusively in oils. Most of her paintings were done without the customary preliminary sketches and studies. She was most famous for her portraits of people in their homes or other intimate environments.

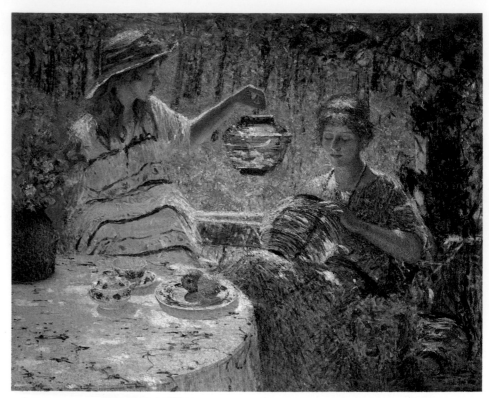

Lilies, Lanterns, and Sunshine, 1923, 35 x 43 in., signed l.l. Courtesy of The Chrysler Museum, Norfolk, Virginia. Gift of W.B.S. Grandy.

Turner spent almost every summer between 1906 and 1941 at the artists' colony in Cragsmoor, New York; she did spend several summers studying with William Merritt Chase in Italy. She died in 1958 in New Orleans.

MEMBERSHIPS
American Federation of Arts
Allied Artists of America
Association of American Women
 Painters and Sculptors
National Academy of Design
New York Water Color Club

PUBLIC COLLECTIONS
Chrysler Museum, Norfolk, Virginia
Corcoran Gallery of Art, Washington, D.C.
Detroit Institute of Arts
Museum of Fine Art, Houston
Metropolitan Museum of Art, New York City
New Orleans Museum of Art
Newark Art Museum, New Jersey
Phillips Collection, Washington, D.C.

SEASON	75-76	76-77	77-78	78-79	79-80	80-81	81-82	82-83	83-84	84-85
Paintings				1	1	1	2	1		1
Dollars				$750	$3,200	$2,800	$9,750	$2,400		$2,000

Record Sale: $6,750, SPB, 9/23/81, "Morning Call," 16 × 12 in.

JOHN HAUSER
(1859-1918)

As a painter of the American Indian, John Hauser gained recognition not only for his artistic ability, but also for the authenticity with which he recorded the details of a vanishing way of life. Among his many works are portraits of some of the most famous Indian chiefs of the day.

Born in 1859 in Cincinnati to German immigrant parents, Hauser showed an early talent for painting. He studied drawing at the Ohio Mechanics' Institute, then moved on to the Cincinnati Art Academy and the McMicken Art School.

In 1880, he went to Munich to study at the Royal Academy of Art under Nicholas Gysis. He came back to Cincinnati and taught in the public schools, but returned to Germany in 1885 for further training under Gysis and others in Munich and Dusseldorf. He finally attended the Ecole des Beaux Arts in Paris.

By the 1890s, Hauser had become interested in the American Indian; he traveled through reservation after reservation of the Apache and Pueblo Indians in Arizona and New Mexico, sketching and painting. He also came to know the Sioux. He continued these trips for more than 20 years and is credited with having done much to chronicle how the Indians lived and worshiped.

He painted a notable series of portraits of such legendary chiefs as Sitting Bull, Red Cloud, American Horse,

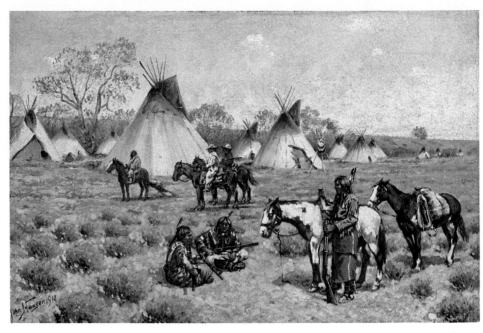

Sioux Encampment Porcupine, 1910, 12 x 18 in., signed l.l. Courtesy of Vose Galleries of Boston, Inc., Massachusetts.

Spotted Tail, High Horse and Lone Bear. He also did many large canvases of Indian hunters and village life, all painted in his careful, realistic style.

In 1901, in recognition of the trust the Indians had in him, Hauser and his wife were adopted by the Sioux nation. He was given the Indian name "Straight White Shield."

On his travels Hauser amassed a remarkable collection of Indian artifacts and art, most of which he had donated to the Cincinnati Art Museum before his death in 1918.

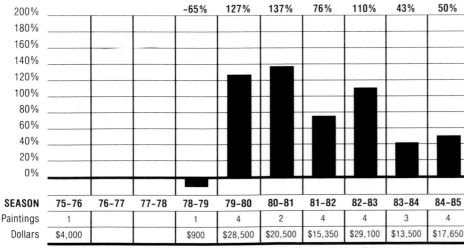

10-Year Average Change From Base Years '75-'76: 60%

| | -65% | 127% | 137% | 76% | 110% | 43% | 50% |

SEASON	75-76	76-77	77-78	78-79	79-80	80-81	81-82	82-83	83-84	84-85
Paintings	1			1	4	2	4	4	3	4
Dollars	$4,000			$900	$28,500	$20,500	$15,350	$29,100	$13,500	$17,650

Record Sale: $14,000, P.NY, 10/21/82, "In the Cheyenne Country," 11 x 18 in.

MEMBERSHIPS
Cincinnati Art Club
Muenchener Kunstler Club
Muenchener Kunstverein

PUBLIC COLLECTIONS
Cincinnati Art Museum
Thomas Gilcrease Institute of American History and Art, Tulsa

531

MAURICE PRENDERGAST
(1859-1923)

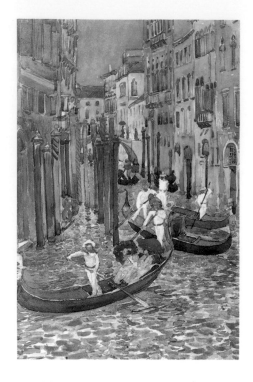

Maurice Brazil Prendergast, known for his post-impressionist watercolors, monotypes and oil paintings, was a member of The Eight. His bright, water-color scenes of urban life have a mosaic- or tapestry-like quality, achieved by presenting flat, bold areas of color in combination with a compression of perspective and scale.

Born in St. Johns, Newfoundland in 1859, Prendergast grew up in Boston. As a youth, he was apprenticed as a commercial artist, a trade he practiced into the 1880s. During this period, Prendergast sketched conventional watercolor landscapes.

Prendergast's determination to be an artist led him to the conclusion that he must study abroad. In 1886, he made his first of six trips to England, accompanied by his younger brother, Charles.

Charles, himself an artist and wood-carver, gave lifelong assistance and support to his brother's career. Upon their return to Boston in 1887, the two worked for four years to enable Maurice to travel to Paris in 1891.

During his three-year stay in France, Prendergast studied at Academie Colarossi and Academie Julien, immersing himself in contemporary art movements. At first, Prendergast was influenced by the work of James McNeill Whistler and Edouard Manet. But more important influences were the neo-impressionists, the symbolists and the nabis. Henceforth, Prendergast would express his preference for boldly-colored, flat-patterned forms in techniques aligned with post-impressionisms.

By 1895, he had returned to his brother's home in Winchester, Massachusetts, where he assisted with Charles's picture-framing business and embarked on sketching trips to nearby beaches and parks.

During another European trip from 1898 to 1900, Prendergast was inspired by Italian Renaissance painters, particularly Vittore Carpaccio. Under this influence, he produced monotypes and watercolors with complicated compositions, such as *A Bridge in Venice* (1898, Cleveland Museum of Art) and *Piazza de San Marco* (ca. 1898, Metropolitan Museum of Art).

He continued to make periodic trips to Europe to gain exposure to fresh influences. By 1913, the year of the New York City Armory Show, in which he exhibited, Prendergast had moved to New York City with his brother.

Of The Eight, with whom he exhibited in 1908, only Prendergast had an international reputation. He stood apart from the group in style as well, although he agreed with their revolutionary intentions.

The group was criticized as being radical, though Prendergast's lively and decorative qualities won some praise. More sensational accounts called his work "unadulterated slop" and "an explosion in a color factory."

Prendergast's late work included portraits, imaginary landscapes, nudes and mural decorations. He explored a mosaic-like technique influenced by Paul Signac, and introduced white opaque into his watercolors, giving them a richness equaling oils. His later oils show increasingly thick pigment application.

Prendergast died in 1923.

PUBLIC COLLECTIONS
Barnes Foundation, Merion, Pennsylvania
Carnegie Institute, Pittsburgh
Cleveland Museum of Art
Corcoran Gallery of Art, Washington, D.C.
Detroit Institute of Arts
Lehigh University, Bethlehem, Pennsylvania
Metropolitan Museum of Art, New York City
Museum of Fine Arts, Boston
Whitney Museum of American Art,
 New York City
Worcester Art Museum, Massachusetts

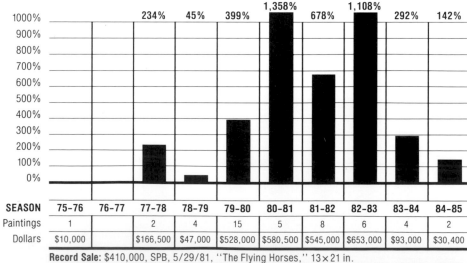

10-Year Average Change From Base Years '75-'76: 473%

SEASON	75-76	76-77	77-78	78-79	79-80	80-81	81-82	82-83	83-84	84-85
			234%	45%	399%	1,358%	678%	1,108%	292%	142%
Paintings	1		2	4	15	5	8	6	4	2
Dollars	$10,000		$166,500	$47,000	$528,000	$580,500	$545,000	$653,000	$93,000	$30,400

Record Sale: $410,000, SPB, 5/29/81, "The Flying Horses," 13×21 in.

BRYANT CHAPIN
(1859-1927)

Bryant Chapin is known for his many still lifes, although he also painted landscapes and portraits during his 40-year career. A member of the Fall River School of Massachusetts painters, he studied with Robert S. Dunning as a young man. Dunning's influence can be seen particularly in Chapin's early work.

Like Dunning, Chapin painted fruit on highly-polished tables with elaborately-carved edges and deep reflections. Grapes and peaches were favorite subjects, but Chapin also introduced the open orange. The palette in these early works is light, the forms rather hazy and the light soft.

Born in Fall River in 1859, Chapin spent most of his life there. He taught at the Evening Drawing School and lectured on art. He did travel several times, however, to paint landscapes in Europe. He died in Fall River in 1927.

Chapin was very conscientious about his paintings and imbued them with a wistful mysticism which made them popular. His later still lifes are more distinctive because they are set outdoors.

Many of these paintings are of berries, some in wooden berry boxes and some on the bare ground. The edges, especially of strawberries, were ideal for heavy highlights. Chapin's style was so fluid and soft, however, that the very paint surface suggests cushioning for the tender fruit.

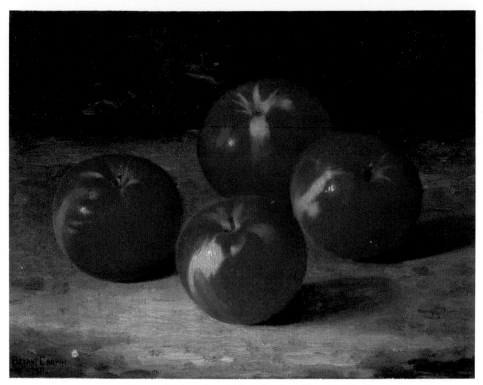

Still Life with Apples, 1911, 9¾ x 12¾ in., signed l.l. Collection of James T. Duff.

PUBLIC COLLECTIONS
Fall River Public Library, Massachusetts

10-Year Average Change From Base Years '76-'77: 56%

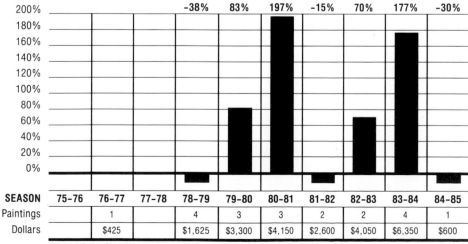

SEASON	75-76	76-77	77-78	78-79	79-80	80-81	81-82	82-83	83-84	84-85
				-38%	83%	197%	-15%	70%	177%	-30%
Paintings		1		4	3	3	2	2	4	1
Dollars		$425		$1,625	$3,300	$4,150	$2,600	$4,050	$6,350	$600

Record Sale: $2,750, BB.SF, 3/24/83, "Still Life," 24 × 19 in.

ELLIOTT DAINGERFIELD
(1859-1932)

Elliott Daingerfield is best known for his paintings of landscapes and religious subjects. His works, described as "American decorative impressionism," offer poetic representations that often were painted from memory rather than from direct observation. He was called "master of the canyon" for his subtly toned, imaginative paintings of the Grand Canyon. Daingerfield also distinguished himself as an art teacher and critic.

Born in Harper's Ferry, Virginia in 1859, Daingerfield spent most of his early years in Fayetteville, North Carolina. He first learned watercolor, then oil painting and photography. He left the South at age 21 to study in New York City, first with Walter Satterlee and then at the Art Students League. That same year, 1880, he first exhibited paintings at the National Academy of Design.

In 1884, Daingerfield became acquainted with George Inness, the American landscape painter, who took an interest in him and promoted his work. Daingerfield's early work shows the barbizon influence, as well as ideas and techniques derived from Inness. He later wrote a biography, *George Inness* (1891), in which he praised "the principles underlying his composition, the science of his balances and rhythm, his knowledge and taste in truth of sky, of tree form, of ground construction."

In the 1890s, Daingerfield moved away from his soft landscapes to undertake rich, brightly-colored religious

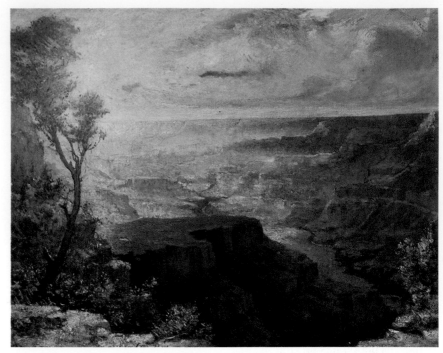

The Grand Canyon, 36¼ x 38¼ in., signed l.c. Courtesy of North Carolina Museum of Art, Raleigh.

paintings, which reflect sixteenth-century Italian style. His *The Story of the Madonna* (ca. 1900, private collection) won the National Academy of Design's Thomas B. Clarke prize for figure painting in 1902. That same year, he received an important commission for a series of large murals in the Lady Chapel of the Church of Saint Mary the Virgin in New York City.

Daingerfield returned to his landscape painting during the early years of the twentieth century, when he executed a number of small oil sketches. Work from this period shows the influence of Arthur B. Davies in composition and painting style. However, his late work, dating from 1915 to 1924, again shows the influence of Inness in scale, mood, and color.

After a 1911 visit to the Grand Canyon, Daingerfield painted what he called his chief work, *The Grand Canyon* (1912, North Carolina Museum of Art). He used the canyon as the subject for many different paintings. Many are highly imaginative, depicting nude figures on the canyon ledge.

Though he resided in New York City, Daingerfield maintained a summer studio in Blowing Rock, North Carolina. He used the vistas near this resort town in the Blue Ridge Mountains in many of his paintings, including *Slumbering Fog* (date unknown, Metropolitan Museum of Art).

The artist visited Europe in 1897 and 1924. Following the second trip, he painted scenes of Venice.

Daingerfield suffered a decline in health in 1925 and painted little work of consequence from that date until his death in 1932.

MEMBERSHIPS
Lotus Club
National Academy of Design
National Arts Club
New York Water Color Club
Society of American Artists

PUBLIC COLLECTIONS
Art Institute of Chicago
Brooklyn Museum
Butler Art Institute, Youngstown, Ohio
City Art Museum, St. Louis
Los Angeles Museum
Metropolitan Museum of Art, New York City
National Gallery, Washington, D.C.
Toledo Museum, Ohio

10-Year Average Change From Base Years '76-'77: 102%

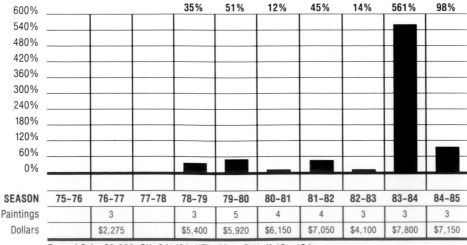

SEASON	75-76	76-77	77-78	78-79	79-80	80-81	81-82	82-83	83-84	84-85
				35%	51%	12%	45%	14%	561%	98%
Paintings		3		3	5	4	4	3	3	3
Dollars		$2,275		$5,400	$5,920	$6,150	$7,050	$4,100	$7,800	$7,150

Record Sale: $5,000, CH, 6/1/84, "The Moon Path," 16 × 12 in.

THEODORE WENDEL
(1859-1932)

Theodore Wendel was one of the first American artists to embrace the form and technique of French impressionism.

He was born in Midway, Ohio in 1859. When he was 19, after a brief period of study at the University of Cincinnati, he and a friend, Joseph De Camp, went to Munich to continue their studies. At that time, Munich was a training ground for young American artists. Wendel attended the Royal Academy there, and in 1879 became a student of Frank Duveneck. Duveneck's paintings and teaching had no lasting effect on Wendel's painting, and none of his work from this period has survived.

In the 1880s, Wendel traveled to Paris, which changed the entire course of his artistic life. He attended the Academie Julien and began to use the techniques of the impressionists.

In the summer of 1886, he went to Giverny, the home of Monet, and joined an American colony of young artists, among them Louis Ritter, W.L. Metcalf, John Breck and Theodore Robinson. Wendel did not imitate Monet. However, he did use Monet's hazy impressionism, vigorous brushwork and strong colors. He continued to use these techniques for the rest of his life.

In 1889, he returned to America and settled in Boston. He taught at Wellesley College and Cowles Art School, and maintained a studio in Boston.

In 1898, he moved to Ipswich, Massachusetts. Here he devoted his time to painting the people, architectural features and countryside, as Monet had done at Giverny.

In 1914, Wendel joined the Guild of Boston Artists, an organization of 50 local painters and sculptors. The Boston Museum of Fine Arts sponsored the Guild's exhibitions in major museums across the country to show the fine work being done by Boston artists, and Wendel's paintings were among them.

Wendel died in 1932 at Ipswich.

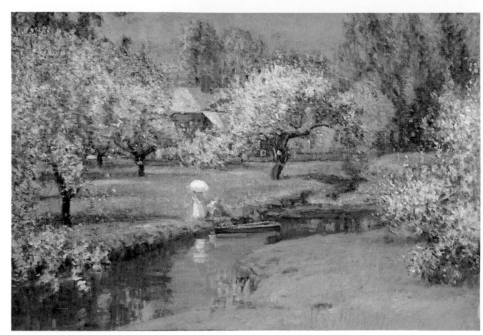

Lady with Parasol, Ipswich, ca. 1889, 20 x 30¼ in. Courtesy of Vose Galleries of Boston, Inc., Massachusetts.

MEMBERSHIPS
Guild of Boston Artists

PUBLIC COLLECTIONS
Cincinnati Museum of Art
Museum of Fine Arts, Boston
Pennsylvania Academy of the Fine Arts,
 Philadelphia

SEASON	75-76	76-77	77-78	78-79	79-80	80-81	81-82	82-83	83-84	84-85
Paintings				1	1	2	1		1	2
Dollars				$3,050	$600	$5,500	$37,000		$3,500	$14,500

Record Sale: $37,000, S.BM, 11/19/81, "Harbour Scene," 25 × 30 in.

JOHN FERY
(1859-1934)

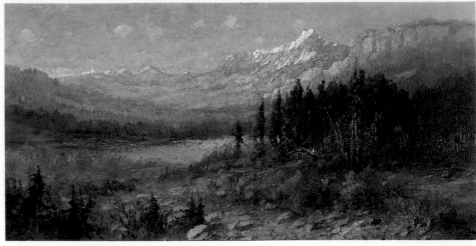

Near Lost Lake, Wyoming, 18 x 35 in., signed l.r. Courtesy of Braarud Fine Art, La Conner, Washington.

John Fery was born in 1859 into a prominent and wealthy Austrian family, and grew up on his father's estate, located between Linz and Salzburg. He studied art in Vienna with Gripenkerl, in Dusseldorf with Peter Jansen, and in Karlsruhe with Schwenlehr.

Fery also studied in Munich. He declined a permanent position at the famous Dusseldorf Academy, preferring to come to the United States to practice his art and to follow his interest in wilderness scenery.

Fery came to America in 1886 and he lived on the Eastern seaboard for about five years. He quickly established himself as a successful painter of American landscape and hunting scenes, living for several years at Lake George and in the Catskill Mountain region, and later in Milwaukee, Wisconsin and New Jersey. Around 1890 he had a studio in Cleveland, Ohio. In 1891 he returned briefly to Europe.

It appears that the result of his return to Europe was the organization of a hunting party led by Fery, which spent the years 1892 and 1893 traveling through the Midwest and far West United States in search of wilderness scenery and wild game. An undated article from the *Milwaukee Journal* provides a glimpse of the tour: "John Fery, a native of Hungary (sic), and as such a sportsman of the word's best meaning, conceived the idea, of organizing a party of lovers of the chase, selected from the European gentry and members of the aristocracy, for a hunting trip in the virgin hunting grounds of the Northern Rockies of America, which the completion of the Northern Pacific (Railroad) had brought into the lime-light of European notice at that time. A call issued to that effect by Mr. Fery in Hunter's Journals was soon answered by Count Bleuchar, by Count Zepplin, Harry Meisenback, inventor of the half-tone process, and four other persons who together with Mr. Fery made up a party of eight huntsmen and started for the U.S. in 1893."

The itinerary of the group included Lake Michigan, New Mexico, Arizona, the Grand Canyon of the Colorado, California, Oregon and Wyoming. Fery published an article recounting his experiences in the European *Hunter's Journal* under the title "Eine Jagt in Wyoming." He led a second expedition to the West in 1895, and these adventures were the beginning of his career as a painter of the Western landscape.

Fery's greatest patron was the Great Northern Railroad. He was commissioned to do paintings of the scenery along the railroad's route through the West, particularly in Glacier National Park. He was an important artistic stimulant in the creation of Glacier National Park, just as Moran had been earlier in the creation of Yellowstone National Park and Grand Canyon of the Colorado Park.

Fery died in Everett, Washington in 1934.

Many of Fery's paintings were on a grand scale, as large as 10 by 12 feet in size, but his smaller works are still sought by collectors for their vivid rendering of the Western landscape. In 1944, the Great Northern did an inventory of works by Fery in its collection. Over the years, they had purchased 362 works by the artist; they were located in hotels, railway stations, travel and ticket offices and office buildings.

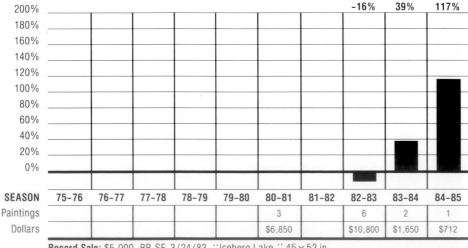

10-Year Average Change From Base Years '80-'81: 35%

SEASON	75-76	76-77	77-78	78-79	79-80	80-81	81-82	82-83	83-84	84-85
Paintings						3		6	2	1
Dollars						$6,850		$10,800	$1,650	$712

-16% 39% 117%

Record Sale: $5,000, BB.SF, 3/24/83, "Iceberg Lake," 45 × 52 in.

PUBLIC COLLECTIONS
St. Louis County Historical Society, Duluth, Minnesota

ABBOTT FULLER GRAVES
(1859-1936)

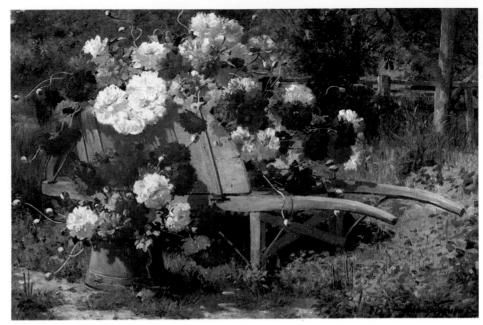

Load of Poppies, 48¼ x 72¼ in., signed l.r. Photograph courtesy of Hirschl & Adler Galleries, Inc., New York, New York.

Abbott Fuller Graves was a renowned specialist in decorative open-air garden paintings and floral still lifes. His use of thick, impasto brushstrokes, bright colors and natural light, most evident in his later garden paintings, shows the influence of European impressionism.

Born in Weymouth, Massachusetts in 1859, Graves studied both in New England and abroad. He attended, but did not graduate from, the Massachusetts Institute of Technology. Although already considered one of the best flower painters in Boston, Graves went to Paris and Italy in 1884 to continue his studies. In Europe, he roomed with Edmund C. Tarbell and studied still-life painting.

After returning to Boston in 1885, Graves became an instructor at the Cowles Art School. Also teaching there was his close friend and colleague, Childe Hassam. The two painters undoubtedly influenced one another. In 1887, Graves returned to Paris to study figure painting at the Academie Julien. There he studied under Cromon, Laurens and Gervais until 1891.

After 1891, the majority of Graves's works depict gardens and floral landscapes. Often these oils, pastels and watercolors include female figures. Some portray exotic gardens of Spain and South America. The bright sunlight and bold use of color and paint, as well as the subject matter of the garden paintings, reflect the influence of European impressionism on Graves's work.

Throughout his career, Graves continued his travels between New England and Paris. In 1891, he opened his own art school in Boston. The school moved to Kennebunk, Maine and closed in 1902. From 1902 to 1905, Graves was employed as a commercial illustrator for magazines in Paris. When Graves died in 1936, he had achieved wide acclaim as a specialist in garden painting, both in New England and Paris.

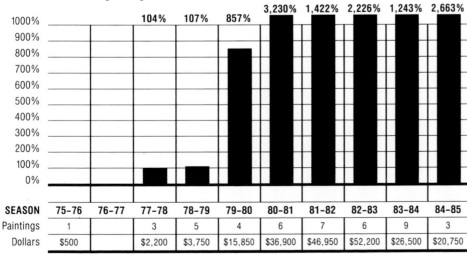

10-Year Average Change From Base Years '75-'76: 1,317%

SEASON	75–76	76–77	77–78	78–79	79–80	80–81	81–82	82–83	83–84	84–85
			104%	107%	857%	3,230%	1,422%	2,226%	1,243%	2,663%
Paintings	1		3	5	4	6	7	6	9	3
Dollars	$500		$2,200	$3,750	$15,850	$36,900	$46,950	$52,200	$26,500	$20,750

Record Sale: $21,000, S.BM, 5/20/82, "Afternoon at the Pond," 30 × 40 in.

CHILDE HASSAM
(1859-1935)

Landscape and cityscape painter Frederick Childe Hassam (he was later to drop Frederick) was born into a prominent Massachusetts family whose forebears came to New England in the seventeenth century. He received his early training in Boston and, during the 1880s and 1890s, did illustrations for publications such as *Scribner's* and *Harper's*. Meanwhile, he studied at the Boston Art Club and the Lowell Institute, and later with a young German painter, Ignaz Gaugengigl.

In 1886, he began a three-year sojourn in Paris, where he enrolled in the Academie Julien. While in Paris, Hassam fell under the spell of the French impressionists; his subsequent work bears testimony to his fascination with artists such as Claude Monet and Camille Pissarro.

Returning to the United States, Hassam settled in New York City, where he became one of the most successful of the American impressionists. Strangely, he disliked the term impressionism intensely, and never acknowledged his debt to French painting. Instead, he saw himself as a devotee of the English watercolorists, Turner and Constable. Yet, his light, sparkling palette, broken brushstrokes and unconventional subjects are unmistakably French-inspired, albeit with a generous helping of American realism. Hassam, for example, never stressed light vibrations to the detriment of form.

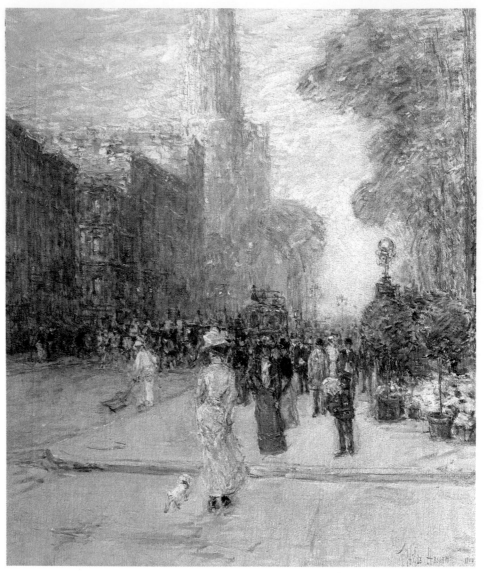

New York Street Scene, 1900, 24¼ x 20¼ in., signed l.r. Photograph courtesy of Hirschl & Adler Galleries, Inc., New York, New York.

After the turn of the century, Hassam's work increasingly began to show the effects of post-impressionism. His palette became harsher and more vivid, and he dropped the broken brushstrokes that characterized his earlier paintings in favor of firm contours. His underlying conservatism became more apparent as the years went on; although he was represented in the innovative 1913 New York City Armory Show, he later renounced its radical tendencies.

Besides his New England landscapes, Hassam is also noted for his views of New York City streets and apartment interiors. During 1917 and 1918, he turned out a series of lithographs reminiscent of the work of Whistler. His charming versions of rain-drenched cityscapes are among his most popular works.

At the height of his popularity, Hassam joined a number of other New York impressionists in forming a group called Ten American Painters or, more simply, The Ten. He was also a member of several artist's organizations. His work was honored by a number of prestigious institutions, including the National

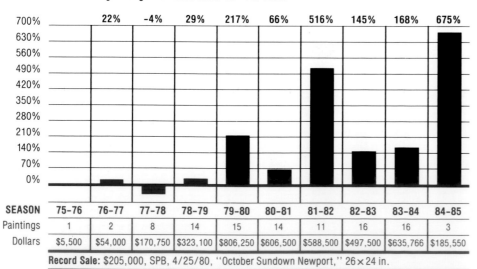

10-Year Average Change From Base Years '75-'76: 183%

	22%	-4%	29%	217%	66%	516%	145%	168%	675%

SEASON	75-76	76-77	77-78	78-79	79-80	80-81	81-82	82-83	83-84	84-85
Paintings	1	2	8	14	15	14	11	16	16	3
Dollars	$5,500	$54,000	$170,750	$323,100	$806,250	$606,500	$588,500	$497,500	$635,766	$185,550

Record Sale: $205,000, SPB, 4/25/80, "October Sundown Newport," 26 × 24 in.

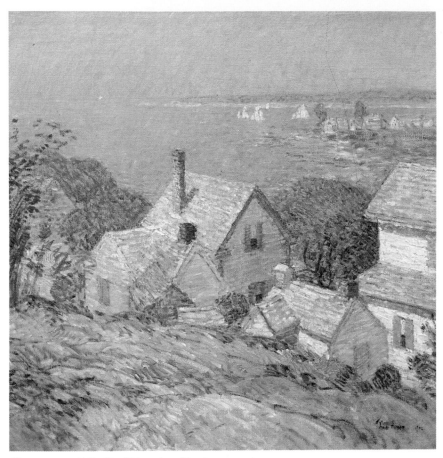

Gloucester, ca. 1902, 27 x 27 in., signed l.r. Courtesy of
Vose Galleries of Boston, Inc., Massachusetts.

Academy of Design, the Carnegie Institute and the Pennsylvania Academy of the Fine Arts.

Hassam died in 1935.

MEMBERSHIPS
American Academy of Arts and Letters
American Water Color Society
Boston Art Club
Munich Secession
National Academy of Design
National Institute of Arts and Letters
New York Water Color Club
Societe Nationale des Beaux Arts
Ten American Painters

PUBLIC COLLECTIONS
Albright-Knox Art Gallery, Buffalo
Art Institute of Chicago
Carnegie Institute, Pittsburgh
Cincinnati Art Museum
Corcoran Gallery of Art, Washington, D.C.
Detroit Institute of Arts
Los Angeles County Museum
Metropolitan Museum of Art, New York City
Minneapolis Institute of Art
Musee d'Orsay
Museum of Fine Arts, Boston
Pennsylvania Academy of the Fine Arts,
 Philadelphia
Phillips Academy, Andover, Massachusetts
St. Louis Art Museum
Toledo Museum of Art
Rhode Island School of Design, Providence
Worcester Art Museum, Massachusetts

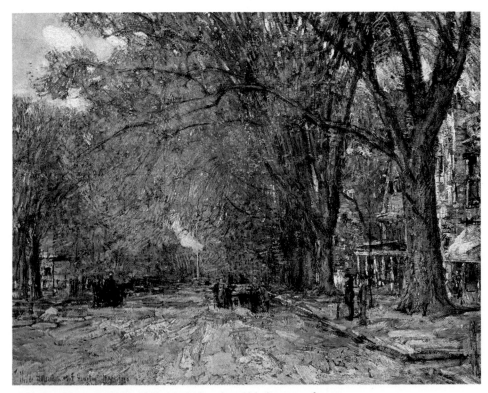

Elms, East Hampton, N.Y., 1920, 16 x 20 in., signed l.l. Courtesy of
Vose Galleries of Boston, Inc., Massachusetts.

539

LEONARD PERCIVAL ROSSEAU
(1859-1937)

Leonard Percival Rosseau drew upon his lifelong passion for hunting and sports and his knowledge of animals to become America's foremost painter of field and hunting dogs.

Rosseau, a peripatetic adventurer, was born in 1859 in Louisiana. Before going abroad to study at age 35, Rosseau was a cowboy, cattle driver and commodities broker. Though he painted periodically, he received his first formal training at the Academie Julien in Paris, where he studied for six years under Jules Lefebvre, Tony Robert-Fleury and Herman Leon.

Like many academy-trained artists, Rosseau initially painted nudes. "All studying in an academy is done from the nude," he said, "except by those who are going in for landscape work." It was, in fact, a nude for which Rosseau received his first critical award in 1900.

Ironically, however, the artist found it difficult to find a market for his work. An artistic turning point came for Rosseau when, in 1904, he painted *Diana Hunting* (location unknown), in which he put animals on the canvas for the first time.

Immediately sensing that animals were his forte, Rosseau submitted pictures of two bird dogs in the field for the next Paris Salon opening. "The day after the Salon opened, I received 11 telegrams asking my price for the pictures, and I sold both in a few hours," Rosseau said.

From 1910 to 1914, Rosseau spent his winters in the United States. He was widely exhibited and worked largely on commissions for thoroughbred dog breeders. He returned permanently to the United States in 1915.

Rosseau contended that his knowledge of dogs ensured his success as an animal painter. "I have run hounds from childhood and have at my fingertips the thorough knowledge of dogs necessary to picture them faithfully. It takes years to acquire this," he claimed.

The artist also conceded that his subjects could sometimes be nervous and difficult to work with and said he never tried "to get them to 'sit' for a portrait." His paintings, therefore, were largely attitudinal reconstructions—an attempt, he said, to capture the dog's unique temperament.

Rosseau died in 1937 at his North Carolina summer home.

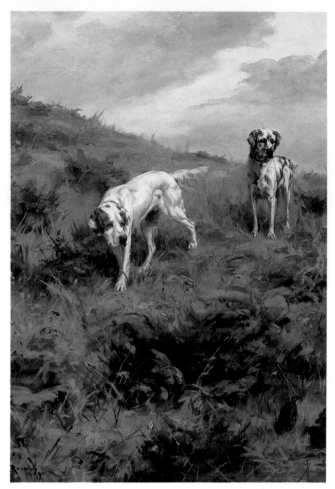

Hunting Dogs, 1908, 40 x 26 in., signed l.l. Courtesy of Connecticut Gallery, Marlborough, Connecticut.

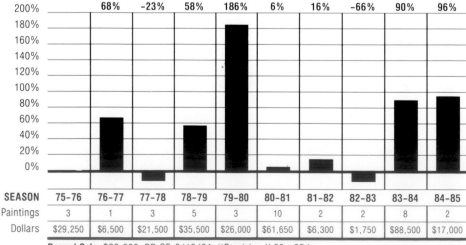

10-Year Average Change From Base Years '75-'76: 43%

	68%	-23%	58%	186%	6%	16%	-66%	90%	96%

SEASON	75-76	76-77	77-78	78-79	79-80	80-81	81-82	82-83	83-84	84-85
Paintings	3	1	3	5	3	10	2	2	8	2
Dollars	$29,250	$6,500	$21,500	$35,500	$26,000	$61,650	$6,300	$1,750	$88,500	$17,000

Record Sale: $22,000, BB.SF, 2/16/84, ''Precision,'' 28 × 35 in.

HENRY OSSAWA TANNER
(1859-1937)

Henry Ossawa Tanner was a successful artist in a variety of forms, from landscapes to genre paintings to religious portraits. He was often considered the dean of American painters living in Paris during the early twentieth century.

Many artists sought Europe's creative freedom, patronage and well-developed exhibition system, over America's limited opportunities and conservative atmosphere. Tanner had an additional reason to stay abroad: racial prejudice.

Tanner was born in 1859 in Pittsburgh. He was raised in Philadelphia, where his father was an outspoken but respected bishop. Deciding to become an artist in 1872 after observing a landscape painter in the city's Fairmount Park, he spent considerable time sketching, sculpting and painting animals and seascapes.

In 1880, after meeting with resistance from both the white art community and his family, Tanner was accepted at the Pennsylvania Academy of the Fine Arts. He studied under Thomas Eakins, whose influence was evident in his work after he left the Academy. His paintings featured the realistic, somber tones often associated with Eakins.

Disheartened by his failures in Philadelphia, and later in Atlanta, Tanner all but gave up painting for a period. However, a trip to the mountains in North Carolina gave him renewed inspiration.

Tanner produced many sketches of blacks in the area, attracting the atten-

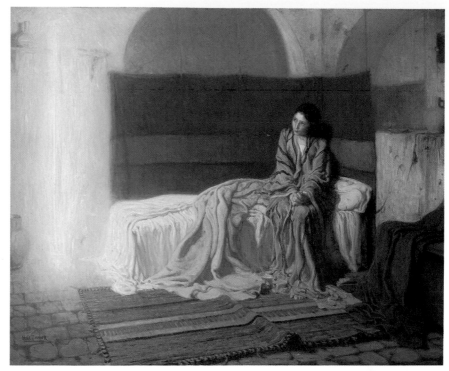

Annunciation, 1898, 57 x 71¼ in., signed l.l. Philadelphia Museum of Art, Pennsylvania. The W. P. Wilstach Collection.

tion of Bishop Joseph Hartzell, who became the first of several white benefactors. Through the financial support of various patrons, Tanner was able to study in Paris, a major turning point in his career.

Under Laurens and Constant at the Academie Julien, Tanner's approach became more personal. He created a series of poignant, sensitive paintings, based on his North Carolina sketches and the peasants around Brittany. He made good use of light modulation to define mood.

By 1893, Tanner had added religious scenes to the genre paintings that had

preoccupied him. His work received a great deal of acceptance at the Salon in Paris, and one Philadelphia patron, Rodman Wanamaker, sent Tanner to the Holy Land in 1897 to further his religious work.

After 1898, Tanner's style changed significantly. His Middle-Eastern experience, coupled with an appreciation of impressionist innovation in color, light and form, were the basis of his more mature religious paintings, such as *Abraham's Oak* (1905, location unknown).

Tanner remained in Paris, producing and refining large-scale religious paintings, until his death in 1937. He had returned to the United States for only a brief time in the early 1900s.

MEMBERSHIPS
National Academy of Design
Paris Society of American Painters
Pennsylvania Academy of the Fine Arts Fellowship
Societe International de Peinture et Sculpture

PUBLIC COLLECTIONS
Art Institute of Chicago
Carnegie Institute, Pittsburgh
Des Moines Association of Fine Arts, Iowa
Frederick Douglass Institute, Washington, D.C.
Hackley Art Gallery, Muskegon, Michigan
Hampton Institute, Hampton, Virginia
Louvre, Paris
Luxembourg Museum, Paris
Metropolitan Museum of Art, New York City
Pennsylvania Academy of the Fine Arts, Philadelphia
Philadelphia Museum of Art

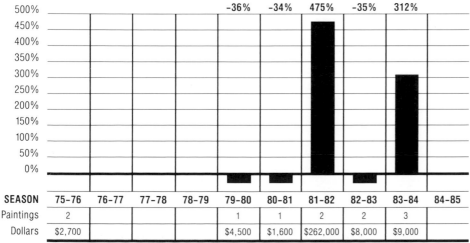

10-Year Average Change From Base Years '75-'76: 114%

				−36%	−34%	475%	−35%	312%	

SEASON	75-76	76-77	77-78	78-79	79-80	80-81	81-82	82-83	83-84	84-85
Paintings	2				1	1	2	2	3	
Dollars	$2,700				$4,500	$1,600	$262,000	$8,000	$9,000	

Record Sale: $250,000, SPB, 12/10/81, "The Thankful Poor," 35 x 44 in.

WILLIAM LANGSON LATHROP
(1859-1938)

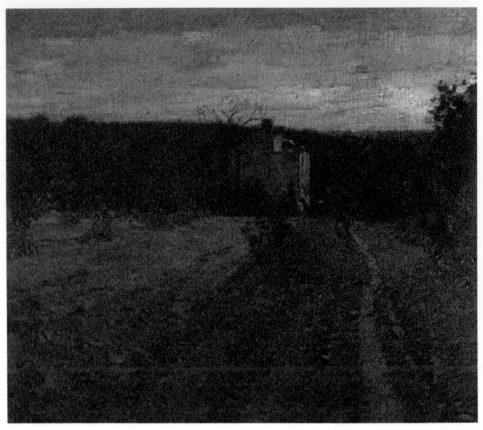

A major figure of the American tonalist movement, William Langson Lathrop is credited with founding the New Hope School of American impressionism, which rose to prominence along the banks of the Delaware River in Bucks County, Pennsylvania. Painter, etcher, and dedicated art instructor, he devoted himself to painting the tranquil countryside of the Delaware River Valley, inspiring his many students to do the same.

Born in Warren, Illinois in 1859, Lathrop grew up on his grandparents' farm in Painesville, Ohio. He strengthened his inherent artistic abilities by painting the rugged Ohio landscape, and by producing detailed drawings of farm implements and machinery.

In 1874, Lathrop moved to New York City to seek employment as an artist. He first worked as a graphic assistant for *Harper's Monthly* and *Century Magazine,* and then for a photoengraving company during the 1880s.

Largely self-taught, Lathrop briefly studied at the Art Students League in New York City in 1886, under William Merritt Chase. In 1888, he traveled to England, France and Holland. He had little interest in cities and museums, but was captivated by Europe's quaint villages and rural landscapes.

Returning to New York City in 1889, Lathrop developed enduring friendships with many of the American impression-

Farm House, 22 x 35 in., signed l.r. Courtesy of Newman Galleries, Philadelphia, Pennsylvania.

ist artists who called themselves The Ten. He roomed that year with John Twachtman. In the late 1890s, he lived with Julian Alden Weir in Branchville, Connecticut.

Lathrop moved to New Hope in 1899. His home near the Delaware River soon became a flourishing art school, where he taught landscape painting. In 1929, he founded the Phillips Mill Community Association, and served as its first president. The Mill hosted annual exhibitions organized by Lathrop, Edward Willis Redfield and others.

Lathrop's art, eventually influenced by the lighter-color palette of impressionism, remained essentially tonalistic. Until the early 1920s, he preferred dominant, earth-colored tones, which gave his works a "poetic" richness likened to Corot and Daubigny. When tonalism fell out of vogue in the 1920s, Lathrop adopted the lighter hues characteristic of impressionism. Even then his works retained their subdued mood, with a seriousness which at times borders on melancholy.

Lathrop was an influential teacher, the founder of a legacy of New Hope artists who flourished for many years after his death in 1938.

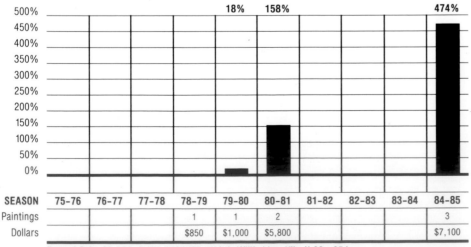

10-Year Average Change From Base Years '78-'79: 163%

SEASON	75-76	76-77	77-78	78-79	79-80	80-81	81-82	82-83	83-84	84-85
Paintings				1	1	2				3
Dollars				$850	$1,000	$5,800				$7,100

Percentages above bars: 18% (79-80), 158% (80-81), 474% (84-85)

Record Sale: $3,500, D.NY, 4/24/85, "Little Will's Lime Kiln," 22 x 25 in.

ELIZABETH NOURSE
(1859-1938)

Born in Cincinnati, Elizabeth Nourse was trained in art at the Cincinnati School of Design. She studied under Thomas S. Noble and Louis T. Rebisso. In 1879, she became a member of the Cincinnati Pottery Club, and in 1881 she helped found the Cincinnati Etching Club.

Despite being offered a position as drawing instructor at the Cincinnati School of Design, Nourse left America to study in Paris. She expected to stay no more than a few years, but like many of her compatriots in the latter years of the nineteenth century, once settled in France she stayed for a lifetime.

Nourse's professor at the Academie Julien, Gustave Boulanger, found her much further advanced than most of his other students and advised her to work on her own. After only three months at the academy, she started painting independently, and within a year she had a painting accepted for hanging "on the line" (at eye level) at the Paris Salon. Soon, she was exhibiting regularly.

In 1885, Nourse became the first American woman accepted into the Societe National des Beaux Arts, and the first to have one of her paintings purchased by the French government for the permanent collection of the Luxembourg Museum. Before long, her work began to win many awards. On her only trip home, in 1891, she enjoyed a successful solo show at the Cincinnati Museum; two years later her paintings scored a hit at the Chicago Exposition.

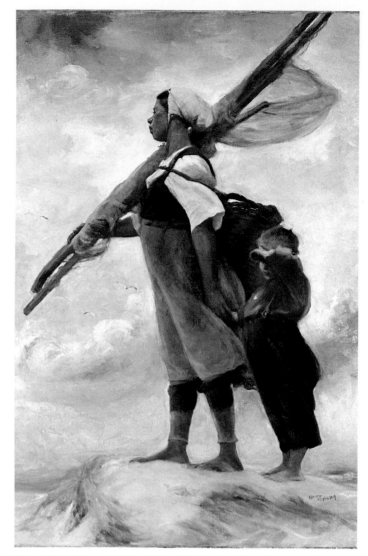

Fisher Girl of Picardy, 1889, 46¾ x 32⅜ in., signed l.r. Courtesy of National Museum of American Art, Smithsonian Institution, Gift of Elizabeth Pilling.

Nourse painted landscapes and some portraits, but her favorite subjects were hard-working peasant women and their children. She was widely recognized as a major figure among the American expatriates, and her work has been described as being a forerunner of social realism.

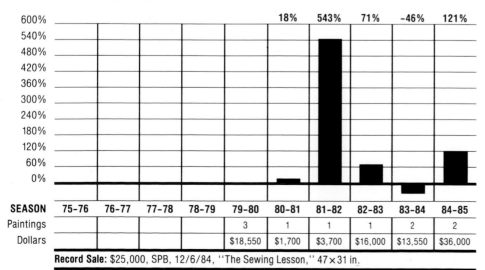

10-Year Average Change From Base Years '79–'80: 118%

	18%	543%	71%	–46%	121%

SEASON	75-76	76-77	77-78	78-79	79-80	80-81	81-82	82-83	83-84	84-85
Paintings					3	1	1	1	2	2
Dollars					$18,550	$1,700	$3,700	$16,000	$13,550	$36,000

Record Sale: $25,000, SPB, 12/6/84, "The Sewing Lesson," 47×31 in.

543

HENRY RANKIN POORE
(1859-1940)

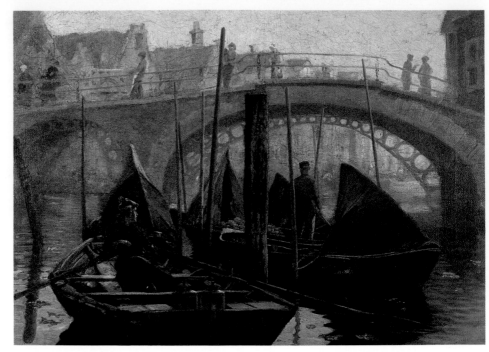

Canal Scene, ca. 1885, 23½ x 26 in. Florence Griswold Museum, Lyme Historical Society, Connecticut, Gift of Dr. and Mrs. Gerald Freedman.

Henry Rankin Poore was a spirited and versatile artist, able to paint on diverse themes and noted for his sporting pictures as well as genre and landscape paintings. His well-traveled and educated life, which he recorded as a painter, illustrator and writer, helped him become a respected teacher and critic.

Born in Newark, New Jersey in 1859, Poore was raised in California, expecting to become a minister. His plans changed, however, after he saw the Philadelphia Centennial art show.

He spent a year at the National Academy of Design, then trained with Peter Moran at the Pennsylvania Academy of the Fine Arts until 1880. During this period he was very popular for his paintings of dogs and hunting, as well as Western mining scenes.

After receiving a degree from the University of Pennsylvania in 1883, he studied for two and a half years with Luminais and Bouguereau in Paris.

Upon returning to his Philadelphia studio, Poore began to reevaluate his work. After a year in Paris in 1891, followed by a year of sketching foxhunting in England, he began to paint more humble and unassuming subjects. His work became suggestive of the work of J.F. Millet.

Poore became a professor at the Pennsylvania Academy of the Fine Arts around 1886, later writing a number of books on art criticism. He spent his final years at his studio in Orange, New Jersey, where he died in 1940.

MEMBERSHIPS
American Federation of Arts
National Academy of Design
Lotus Club
Pennsylvania Academy of Fine Arts,
 Fellowship
Philadelphia Art Club
Philadelphia Sketch Club
Salmagundi Club

PUBLIC COLLECTIONS
National Museum, New Zealand
Philadelphia Art Club
St. Louis Art Museum
Worcester Art Museum, Massachusetts

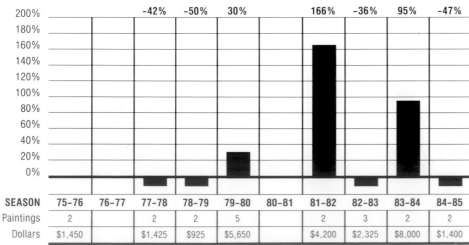

10-Year Average Change From Base Years '75-'76: 15%

		-42%	-50%	30%		166%	-36%	95%	-47%

SEASON	75-76	76-77	77-78	78-79	79-80	80-81	81-82	82-83	83-84	84-85
Paintings	2		2	2	5		2	3	2	2
Dollars	$1,450		$1,425	$925	$5,650		$4,200	$2,325	$8,000	$1,400

Record Sale: $7,250, SPB, 1/27/84, "Diana and the Hounds," 52 x 46 in.

JOSEPH HENRY SHARP
(1859-1953)

A painter, illustrator and teacher, particularly noted for his depictions of Indians, Joseph Henry Sharp was born in Bridgeport, Ohio in 1859.

In *El Palacio* in 1922, Laura H. Davies wrote of Sharp's portrayal of Indians: "He feels the thrill of things that thrill his subjects and so he puts the living spirit, not merely the technically exact portrait, upon his canvas."

Sharp was an avid student, first at the McMicken School of Design and then at the Cincinnati Art Academy. In 1881 he went to Europe, studying with Charles Verlat in Antwerp, and on successive trips with Carl Marr in Munich and Benjamin Constant and Jean Paul Laurens in Paris. From 1892 to 1902, he taught the life class at the Cincinnati Art Academy during the winter, leaving his summers free for sketching trips which covered the entire West.

Sharp's paintings of Indians are distinguished by their accuracy. The differences between various tribes—in facial structures, costumes, artifacts and ceremonials—are so carefully noted in his work that his paintings are prized by anthropologists and art lovers alike.

Just prior to 1900, Sharp went to Sioux country in Southeastern Montana, where he took copious notes on the ceremonies and lifestyles he observed. He transformed a shepherd's wagon into a studio and called it "The Prairie Dog."

"I guess it was Fenimore Cooper who first attracted me to the Indian," Sharp

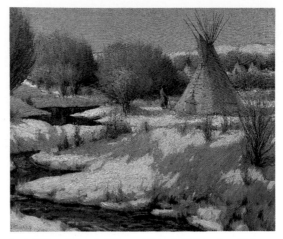

Red Willow Camp in Winter, 19⅜ x 23⅜ in., signed l.l. Courtesy of Wunderlich and Company, Inc., New York, New York.

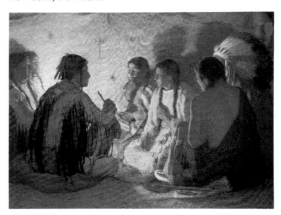

Old Chiefs Query, 30 x 40 in., signed l.r. Photograph courtesy of The Gerald Peters Gallery, Santa Fe, New Mexico.

said in an interview for *New Mexico Magazine.* "Perhaps they attracted me as subjects to paint because of their historical value as First Americans."

A year later, President Theodore Roosevelt had his Indian Commissioners build Sharp a studio and cabin at the Crow Agency on the old Custer battle-field. Despite the cold, Sharp traveled throughout the plains country doing hundreds of Indian paintings.

In 1902, Sharp began spending several months each year in Taos, New Mexico, painting the Pueblo Indians. In 1909, he acquired a permanent studio there, and became a charter member of the Taos Society of Artists in 1912.

Sharp's visits to Hawaii produced brilliant landscapes, seascapes and florals, known for their pastel shades and feathery touch. He died in Pasadena in 1953.

MEMBERSHIPS
American Federation of Artists
California Art Club
California Print Makers Society
Cincinnati Art Club
Salmagundi Club
Taos Society of Artists

PUBLIC COLLECTIONS
Academy of Natural Sciences, Philadelphia
Amon Carter Museum of Western Art, Fort Worth
Butler Museum, Youngstown, Ohio
Cincinnati Art Museum
Herron Art Institute, Indianapolis
Houston Museum of Fine Art
Museum of Santa Fe, New Mexico
Smithsonian Institution, Washington, D.C.

10-Year Average Change From Base Years '77-'78: 97%

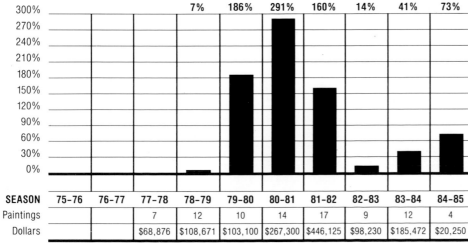

	7%	186%	291%	160%	14%	41%	73%

SEASON	75-76	76-77	77-78	78-79	79-80	80-81	81-82	82-83	83-84	84-85
Paintings			7	12	10	14	17	9	12	4
Dollars			$68,876	$108,671	$103,100	$267,300	$446,125	$98,230	$185,472	$20,250

Record Sale: $100,000, SPB, 10/22/81, "Elk Foot Taos," 25 x 30 in.

545

ADDISON THOMAS MILLAR
(1860-1913)

Addison Thomas Millar was a painter and etcher, remembered chiefly as a student of William M. Chase and as a member of the Silvermine group of artists.

Millar was born, and began his artistic career, in Warren, Ohio. He studied under local artist John Bell. In 1877 and the next two years, he won prizes in a landscape competition sponsored by a young people's magazine, *The Youth's Companion.*

In 1879, Millar moved to Cleveland, where he studied under DeScott Evans and began painting portraits in addition to his landscapes. In 1883, he moved to New York City. He studied painting and etching at the Art Students League.

In 1892, Millar entered the Shinnecock School, conducted by noted landscapist William M. Chase. He exhibited his work regularly for the next three years at the National Academy of Design, the Society of American Artists, and private galleries in Boston, Philadelphia and Chicago.

In 1894, Millar opened a studio in Paris. He studied under Benjamin Constant, Henri Martin and Boldini, and exhibited a painting at the Salon Champs de Mars. Millar spent the following summer painting scenes of Holland; in 1895 he traveled to Spain, where he renewed his studies under Chase.

Returning to New York City, Millar continued to exhibit etchings and paint-

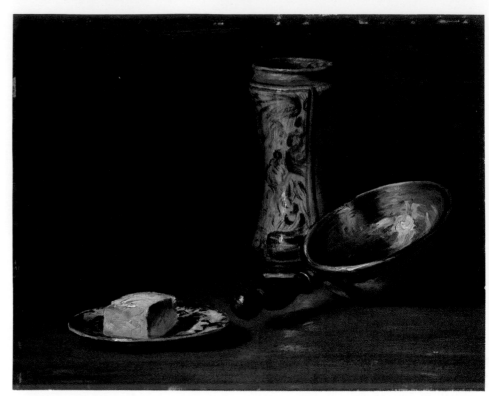

Still Life, 8 x 10 in., signed l.l. Photograph courtesy of M. Knoedler & Co., Inc., New York, New York.

ings at the National Academy of Design, until his death in an automobile accident in 1913.

MEMBERSHIPS
Salmagundi Club

PUBLIC COLLECTIONS
Detroit Institute of Arts
Library of Congress, Washington, D.C.
New York Public Library,
 New York City
Rhode Island School of Design,
 Providence

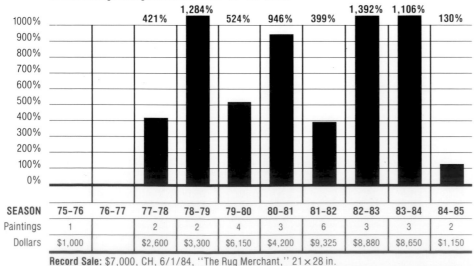

10-Year Average Change From Base Years '75-'76: 689%

SEASON	75-76	76-77	77-78	78-79	79-80	80-81	81-82	82-83	83-84	84-85
			421%	1,284%	524%	946%	399%	1,392%	1,106%	130%
Paintings	1		2	2	4	3	6	3	3	2
Dollars	$1,000		$2,600	$3,300	$6,150	$4,200	$9,325	$8,880	$8,650	$1,150

Record Sale: $7,000, CH, 6/1/84, "The Rug Merchant," 21 × 28 in.

HENRY JOSEPH BREUER
(1860-1932)

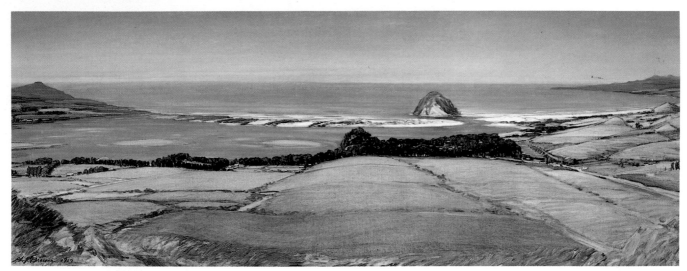

Moro Bay, 1919, 18 x 46 in., signed l.l.
Courtesy of Petersen Galleries,
Beverly Hills, California.

Henry Breuer was a California landscape painter and illustrator whose subject was the magnificent natural scenes of that state, particularly Yosemite Valley and the high Sierras. Breuer also painted coastal scenes of Morro Bay and the nearby Santa Inez Mountains, as well as California sunsets and the Busch gardens in Santa Barbara.

Born in Philadelphia, Breuer studied in Paris; he was influenced by Corot and the barbizon painters. His style, however, was more realistic than theirs. He began landscape painting in 1893, after his trip abroad. Before that, he worked as a Rookwood-pottery decorator and lithographic designer in Cincinnati, later moving to New York City as a mural decorator in the mid-1880s. In 1890,

he moved to California to become an artist on the *San Francisco Chronicle.* Later he was art editor of a California magazine.

Breuer was commissioned to paint views of the San Gabriel Valley in Southern California for the St. Louis Exposition in 1904.

His love affair with the State of California, particularly its mountains, was evident in many paintings of the Sierra Nevada Mountains. In 1926, Breuer lived in Lone Pine, California, a small town along the eastern edge of the mountain range, remote from any urban settlement but close to the grandeur of the granite peaks.

He died in 1932.

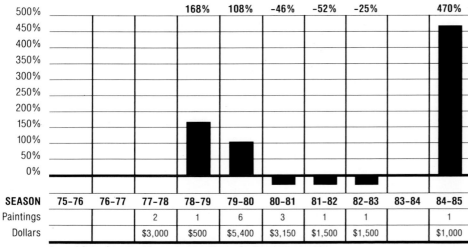

10-Year Average Change From Base Years '77-'78: 89%

	75-76	76-77	77-78	78-79	79-80	80-81	81-82	82-83	83-84	84-85
				168%	108%	−46%	−52%	−25%		470%
SEASON	75-76	76-77	77-78	78-79	79-80	80-81	81-82	82-83	83-84	84-85
Paintings			2	1	6	3	1	1		1
Dollars			$3,000	$500	$5,400	$3,150	$1,500	$1,500		$1,000

Record Sale: $2,500, PB, 11/8/77, "Mount Sir Donald," 48×36 in.

547

GARI MELCHERS
(1860-1932)

Gari Melchers was a leading figure and genre painter who enjoyed considerable success, both in Europe and the United States. He is best known for the Dutch figure paintings of his early years, as well as for his later murals and portraits of prominent men, including Theodore Roosevelt, Lloyd George and Andrew Mellon.

Melchers was born in 1860 in Detroit, the son of Westphalian sculptor and woodcarver Julius Melchers. He received his earliest instruction from his father, then went to Germany in 1877 and studied under Karl von Gebhardt at the Dusseldorf Academy. In 1881, Melchers moved to Paris to study under Gustave Boulanger and Jules Lefebvre at the Academie Julien.

By 1884, Melchers had established a studio at the Dutch fishing village of Egmond-aan-Zee, where he enjoyed great success over the next 30 years.

Melcher's motto of this period, "true and clear," manifested itself in paintings of Dutch peasants, often mother and child, with frequent religious motifs. Stylistically, his paintings evolved over time from austere interior settings reminiscent of Vermeer, to more brightly colored plein-air scenes, painted in a decorative style, with impressionistic influences.

In 1914, Melchers returned to the United States, and for the remainder of his career proved adept as a painter of American themes. Settling down on the estate of "Belmont," near Fredericksburg, Virginia, he produced many fine paintings of regional and domestic scenes.

Melchers remained highly active throughout his later years, traveling widely to execute portraits of the rich and famous, as well as historical murals for the Detroit Public Library and the Missouri State Capitol. He died in 1932 at "Belmont," which remains open to the public today and houses an impressive collection of his work.

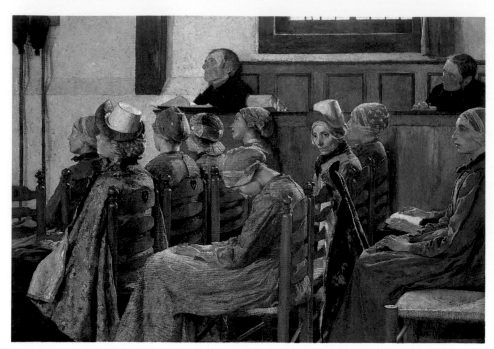

The Sermon, 1886, 62⅝ x 86½ in., signed l.r. Courtesy of National Museum of American Art, Smithsonian Institution, Bequest of Henry Ward Ranger through the National Academy of Design.

MEMBERSHIPS
National Academy of Design
International Society of Artists
National Institute of Arts and Letters

PUBLIC COLLECTIONS
Corcoran Gallery of Art, Washington, D.C.
Mary Washington College, Fredericksburg, Virginia
National Gallery, Washington, D.C.

SEASON	75–76	76–77	77–78	78–79	79–80	80–81	81–82	82–83	83–84	84–85
Paintings		1	1	1	2	1		2	2	1
Dollars		$900	$3,500	$1,000	$18,600	$800		$17,400	$28,800	$950

Record Sale: $26,000, CH, 12/9/83, "Young Mother," 25 × 21 in.

JOHN KANE
(1860-1934)

A legend in his own time, John Kane was a self-taught modern American primitive painter who spent most of his life as a manual laborer and was past age 65 before his first painting was accepted for exhibition. Then, almost overnight, he was recognized for what he was—a painter of raw power and originality. He recorded in painstaking detail the steel mills, structures and landscapes of Pittsburgh, where he spent much of his life.

Born in Scotland in 1860, he was baptized John Cain. Years later, when a bank teller made an error, he adopted the different spelling. After his father died, he left school at 10 to work in the coal mines and came to the United States at 19.

Kane was tall and strong but unskilled, and he took a long succession of tough, physical jobs, sometimes working seven days a week. Several times, he went back to mining coal.

At 31, he lost his left leg in a railroad accident, but learned to walk again with an artificial limb. In 1897, he married, and over the next few years fathered two daughters and a son. The son he had prayed for, however, lived only a day. In his grief, Kane began to drink heavily and his wife soon left him. They remained estranged for nearly 25 years.

For a time, he had a job painting railroad cars. During lunch he would paint landscapes on the sides of the cars, then paint them out. He also earned a few extra dollars by coloring photographs for working people, usually of dead loved ones.

In middle age, he learned carpentry and house painting. Salvaging scraps of beaverboard, he began to paint rather stiff but meticulously accurate landscapes and industrial scenes. Twice during all these years, he tried to enroll in art school, but each time he could not afford it.

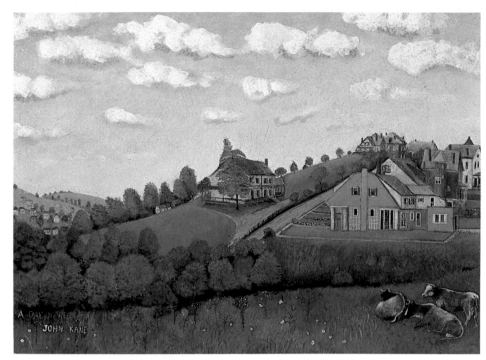

Day of Rest, ca. 1928, 15 x 20 in., signed l.l. Courtesy of La Salle University Art Museum, Philadelphia, Pennsylvania.

After two previous rejections, in 1927 Kane finally had a painting accepted for the prestigious Carnegie International Exhibition in Pittsburgh. He was then 67. When word of his past became known, he became an instant celebrity, with dealers and the press courting him.

Kane, now reunited with his wife, continued to live in modest quarters in Pittsburgh until his death from tuberculosis in 1934. His paintings, however, now were exhibited regularly and were bought by wealthy collectors and museums. In all, 140 of his paintings have been recorded.

PUBLIC COLLECTIONS
Albright-Knox Art Gallery, Buffalo
Barnes Foundation, Merion, Pennsylvania
Carnegie Museum of Art, Pittsburgh
Chrysler Museum, Norfolk, Virginia
Detroit Institute of Arts
Metropolitan Museum of Art, New York City
Whitney Museum of American Art,
 New York City

SEASON	75-76	76-77	77-78	78-79	79-80	80-81	81-82	82-83	83-84	84-85
Paintings		1			2	4				
Dollars		$12,000			$7,750	$35,250				

Record Sale: $23,000, SPB, 5/29/81, ''Scot's Day at Kennywood,'' 19 × 27 in.

THEODORE EARL BUTLER
(1860-1936)

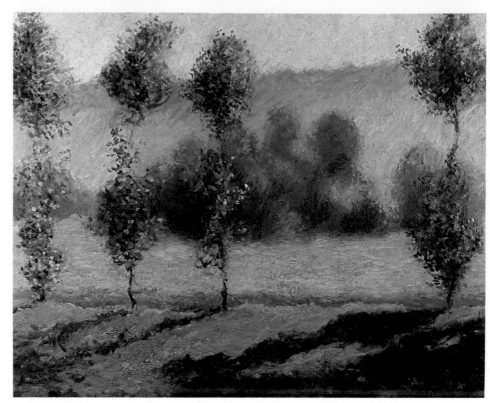

Le Jeunes Peopliers, 22½ x 29 in., signed l.r. Courtesy of Henry B. Holt, Inc., Essex Fells, New Jersey.

Although Theodore Butler is considered an American impressionist, he spent his entire life—except for his youth and a few years during World War I—in Giverny, the town in the North of France that Claude Monet made famous. The lack of appreciation of Butler's work may possibly be ascribed to the fact that he was differently regarded on the two sides of the Atlantic, and to the fact that he became part of the Monet household. He married not one of the famous impressionist's step-daughters, but two of them.

Butler was born in Columbus, Ohio in 1860. He attempted to follow a business career like his father, and even took a job in a warehouse after graduating from Marietta College in 1880. But the experience ended badly, with Butler "defacing" the walls of the warehouse with paintings.

From 1882 to 1885, Butler studied at the Art Students League in New York. In 1885 he went to Paris, where he studied at the Academie Julien, the Atelier Colarossi and the Grande Chaumiere.

Butler began his artistic career as a rather conservative Salon painter, but was profoundly influenced by Monet's impressionism. After meeting Monet in Giverny, Butler lightened his palette, used thicker paint and adopted the technique of using broken color. In general, however, his subject matter differs from Monet's; Butler was much more a chronicler of Giverny itself, and especially of his own family life. (He had married one

of Monet's step-daughters in 1892. She died in 1899, and he married her sister in 1900.) *Bathing the Child* (1893, Janet Fleisher Gallery) is an example.

In a catalog of paintings in the collection of the Metropolitan Museum of Art, Butler's *Un Jardin, Maison Bap-*

tiste (1895) is described as a scene similar to those painted by Monet, but "distinguished from that of his accomplished French mentor by its soft pastel palette, less forceful brushwork, and lack of an effective compositional focus."

He returned to New York City with his family in 1913 to install some historical murals he had completed, and also contributed two canvases to the Armory Show. Because of World War I, the Butlers remained in New York until 1921. While there, Butler organized the Society of Independent Artists with John Sloan.

The quality of Butler's paintings declined in the final 15 years of his life. He died in 1936 in Giverny.

MEMBERSHIPS
Societe des Artistes Independents
Societe du Salon d'Automne
Society of Independent Artists

PUBLIC COLLECTIONS
Metropolitan Museum of Art, New York City

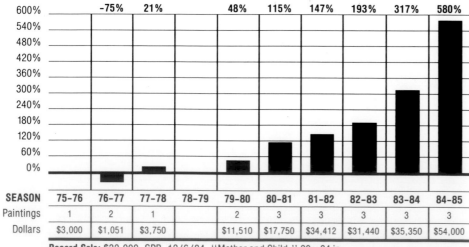

10-Year Average Change From Base Years '75-'76: 150%

	-75%	21%		48%	115%	147%	193%	317%	580%	
SEASON	75-76	76-77	77-78	78-79	79-80	80-81	81-82	82-83	83-84	84-85
Paintings	1	2	1		2	3	3	3	3	3
Dollars	$3,000	$1,051	$3,750		$11,510	$17,750	$34,412	$31,440	$35,350	$54,000

Record Sale: $32,000, SPB, 12/6/84, "Mother and Child," 20 × 24 in.

CHARLES P. GRUPPE
(1860-1940)

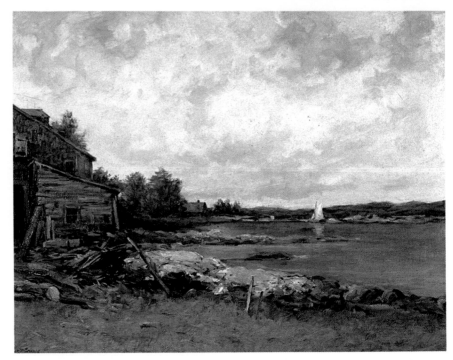

Old Lyme Landscape, 30 x 40 in., signed l.l. Courtesy of Henry B. Holt, Inc., Essex Fells, New Jersey.

Primarily a landscape artist, Charles Paul Gruppe is closely identified with the Dutch School of painting. His sympathetic portrayal of Hollanders and their muted, subtle environment is so authentic that Gruppe was elected into the exclusive Pulchre Studio in the Netherlands, an unusual honor for an American.

In the more than 20 years he lived in the Netherlands, Gruppe painted portraits of people, interiors, farms, boats, fishermen and coastal waterways, using a low-keyed, softly colored palette, with the rich, dark tonal qualities of the Netherlands.

Gruppe was born in 1860 in Picton, Ontario. When he was 10, his family moved to Rochester, New York following the death of his father. Gruppe had no training as an artist, but his innate drawing talent was nurtured by early employment as a sign painter. He learned to sketch; in his spare time, painting out-of-doors, he also learned to use watercolors and oils. His work was good and he began to sell.

At age 21, Gruppe went to Europe. Although he had no money for art school, he showed his work to the director of the academy in Munich, who told him his drawing was exceptional. Gruppe stopped in Holland and was captivated; thereafter, he began to live and paint like a Dutchman. Eight years later, he settled in The Hague and did not return permanently to the United States until 1914, when World War I broke out in Europe.

Gruppe's excellence as a landscape painter is based on his careful, fine drawing and subtle colors. As a colorist, he was thoroughly Dutch, full of harmonious effects that lend a soft atmosphere, as in his use of low-hanging, luminous clouds. Many of his paintings depict marine life on the Zuider Zee, and at Sheveningen where fishing boats dock. Gruppe built a villa there to be close to the fleet.

Very quickly, Gruppe was recognized as a painter of the Dutch School. Queen Emma and later Queen Wilhelmina bought his paintings. Of 18 artists who applied for membership in the Pulchre studio, Gruppe was the only one elected. The other 17 applicants were all Hollanders.

Because of his genuine identification with the mind and spirit of the Netherlands, Gruppe is sometimes mistakenly identified with the Hague School. His subject matter differs, however, from the domestic topics of Hague School artists, who depict primarily family scenes and children. Gruppe also did many portraits in oil, watercolor, chalk and pencil, but it is his landscape and marine painting for which he earned his lasting reputation.

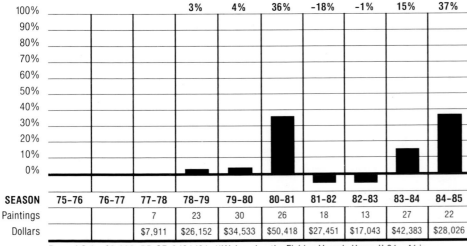

10-Year Average Change From Base Years '77-'78: 10%

			3%	4%	36%	−18%	−1%	15%	37%	
SEASON	75-76	76-77	77-78	78-79	79-80	80-81	81-82	82-83	83-84	84-85
Paintings			7	23	30	26	18	13	27	22
Dollars			$7,911	$26,152	$34,533	$50,418	$27,451	$17,043	$42,383	$28,026

Record Sale: $9,000, BB.SF, 6/24/81, "Welcoming the Fishing Vessels Home," 31 x 41 in.

MEMBERSHIPS
American Federation of Arts
American Water Color Society
National Arts Club
New York Water Color Club
Philadelphia Art Club
Pulchre Studio
Rochester Art Club
Salmagundi Club

PUBLIC COLLECTIONS
Brooklyn Museum
Butler Institute of American Art,
 Youngstown, Ohio
Detroit Institute of Arts
Maryland Institute, Baltimore
National Arts Club, New York City
National Gallery of Art, Washington, D.C.
St. Louis Art Museum

EDWIN WILLARD DEMING
(1860-1942)

Edwin Willard Deming dedicated his life to the artistic preservation of American Indian culture. Primarily a painter, he was also a muralist, illustrator and sculptor of Indian and animal subjects.

He was born in Ashland, Ohio in 1860, but his family moved to Western Illinois while he was a boy. The area was still populated by Indians, and Deming grew up with Indian playmates. As a teenager, he traveled even further West, by train and stagecoach to Indian territory, to sketch the inhabitants.

His parents sent Deming to Chicago to study business law, but he was set on becoming an artist. He sold most of his possessions to get money for a trip to New York City and enrolled at the Art Students League. Next came a year in Paris at the Academie Julien.

Back in the United States, Deming began to paint cycloramas for a living. In 1887, he made the first of many trips to the Southwest to paint the Apache and Pueblo. He then traveled to Oregon to paint the Umatilla.

On a later trip he lived for a year with the Indians, learning their ways of life, their culture and their religion. It is said that no other painter knew more about the American Indian than Deming. In 1916, he painted murals of Indian life for the American Museum of Natural History in New York City.

When the United States entered World War I, Deming, though then 57, volunteered and was commissioned as a cap-

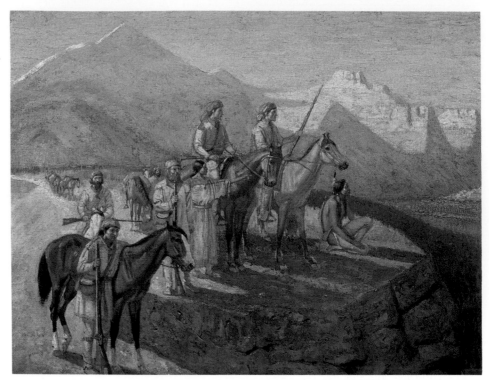

Bird Woman Meeting Lewis and Clark on the Upper Missouri, 27 x 34 in., signed l.l. Courtesy of Kennedy Galleries, New York, New York.

tain. He was active in camouflage work and also painted targets. After his return he lived and worked in New York City until his death in 1942.

MEMBERSHIPS
National Arts Club
National Society of Mural Painters
Washington Art Club

PUBLIC COLLECTIONS
American Museum of Natural History,
 New York City
Art Museum, Montclair, New Jersey
Brooklyn Museum
National Gallery of Art, Washington, D.C.

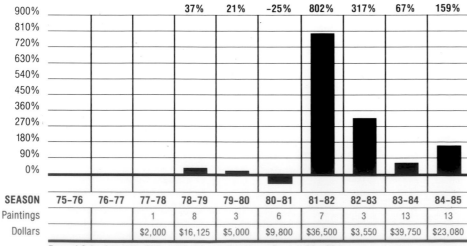

10-Year Average Change From Base Years '77–'78: 172%

			37%	21%	–25%	802%	317%	67%	159%

SEASON	75–76	76–77	77–78	78–79	79–80	80–81	81–82	82–83	83–84	84–85
Paintings			1	8	3	6	7	3	13	13
Dollars			$2,000	$16,125	$5,000	$9,800	$36,500	$3,550	$39,750	$23,080

Record Sale: $30,000, SPB, 4/23/82, "Indian Horse Race," 20 x 36 in.

ARTHUR FRANK MATHEWS
(1860-1945)

A major turn-of-the-century painter of imaginative landscapes in Northern California, Arthur Frank Mathews was a highly versatile artist who also made an impact in crafts, furniture, interiors, mural painting, architecture and publishing. Through furniture designs, he developed a version of art nouveau called the California decorative style, which dominated Northern California art during the early twentieth century.

Mathews's paintings, primarily California landscapes, have a poetic, romantic quality, derived from his use of color tonalities. He emphasized the formal rather than the realistic qualities of his subject, using flat areas of color, closely related in tone and intensity. In this, Mathews was influenced by oriental art and by Puvis de Chavannes and Whistler. Like Whistler, Mathews believed that art represents a refinement of nature. Like Puvis, he drew themes from biblical and mythological sources.

Born in 1860 in Markesan, Wisconsin, Mathews moved as a child to Oakland, California with his family. His architect father enrolled him in private drawing lessons when Mathews was six and later took him on as an apprentice. In 1885, Mathews went to Paris, where he stayed for four years, studying under Jules Joseph Lefebvre and Gustave Boulanger at the Academie Julien. Upon his return to San Francisco, he was appointed director of the California School of Design, a position he held for 16 years.

Following the 1906 earthquake, Mathews and his wife, Lucia, opened the Furniture Shop, where they infused art nouveau with Western motifs—including the California poppy—carved into and painted on furniture and decorative objects. They also published a magazine, *Philopolis,* which helped give direction to the rebuilding of San Francisco.

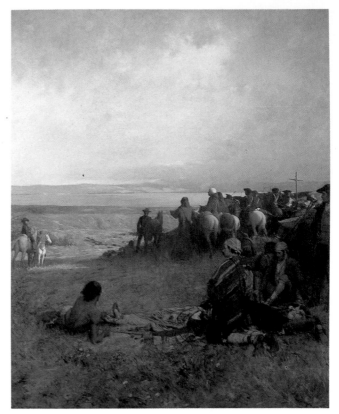

Discovery of San Francisco Bay by Portola, 1896, 70¼ x 58½, signed l.l. Courtesy of John H. Garzoli Gallery, San Francisco, California.

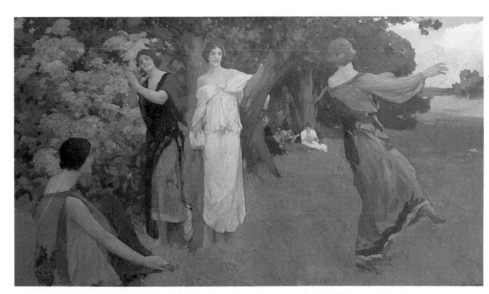

Ladies of the Dance, 1926, 34½ x 59½ in., signed l.r. Courtesy of John H. Garzoli Gallery, San Francisco, California.

Among his several mural paintings, Mathews did 12 panels on California history for the state capitol building in Sacramento.

SEASON	75-76	76-77	77-78	78-79	79-80	80-81	81-82	82-83	83-84	84-85
Paintings				1	1	1			1	
Dollars				$17,000	$28,000	$2,000			$2,750	

Record Sale: $28,000, BB.SF, 1/10/80, "Ladies on the Grass," 48 × 52 in.

MEMBERSHIPS
Philadelphia Art Club

PUBLIC COLLECTIONS
Metropolitan Museum of Art, New York City
Oakland Museum, California

ANNA MARY ROBERTSON MOSES
("GRANDMA MOSES")
(1860-1961)

Anna Mary Robertson Moses, or Grandma Moses, was the quintessential American folk artist. She was also the embodiment of the American success story.

In her late seventies, she began painting primitive scenes recalled from her youth. Within a few years her work was being bought by avid collectors and shown in museums.

Like Currier and Ives, who inspired some of her early work, her paintings evoked a nostalgic response from the public. In brightly-colored, well-organized compositions, she depicted a simpler way of life that had vanished.

Moses was born on a farm near Eagle Bridge in upstate New York in 1860. At age 12 she worked as a hired girl, housekeeping, cooking and tending the sick and elderly. After 15 years of this, she married farmhand Thomas Moses and moved to Virginia, where they rented a farm.

She bore 10 children, five of whom died in infancy. Her life was typical of a farmwife of the day—constant work. After 18 years, the family returned to Eagle Bridge and bought a dairy farm. The children grew up and married. In 1927, Thomas Moses died.

Grandma Moses stayed on the farm, now run by one of her sons. When she became too old to work outside, she

Red Barn #1745, 11 x 14 in., signed l.l. Courtesy of Henry B. Holt, Inc., Essex Fells, New Jersey.

began stitching worsted-yarn pictures to pass the time; when arthritis made stitching too painful, her family suggested she try painting.

In 1938, three of her paintings in the window of a drugstore in nearby Hoosick Falls caught the eye of a knowledgeable collector. They launched her career as a painter.

At first her paintings were somewhat limited in scope, with few figures and the emphasis on content. By the 1940s, however, feeling more confident in her new medium, she became more expansive, painting landscapes with rolling hills and many small figures engaged in a variety of activities.

Grandma Moses was extraordinarily prolific, producing an estimated 1,600 paintings. With old-time frugality, she painted them in batches to avoid wasting paint. Sometimes she completed as many as five pictures in a single week.

She continued to paint until a few months before her death in 1961 at age 101.

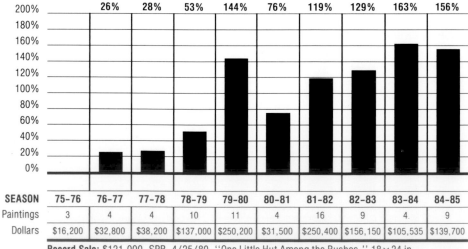

10-Year Average Change From Base Years '75-'76: 89%

	26%	28%	53%	144%	76%	119%	129%	163%	156%	
SEASON	75-76	76-77	77-78	78-79	79-80	80-81	81-82	82-83	83-84	84-85
Paintings	3	4	4	10	11	4	16	9	4	9
Dollars	$16,200	$32,800	$38,200	$137,000	$250,200	$31,500	$250,400	$156,150	$105,535	$139,700

Record Sale: $121,000, SPB, 4/25/80, "One Little Hut Among the Bushes," 18 x 24 in.

PUBLIC COLLECTIONS
Bennington College Museum, Vermont
Phillips Collection, Washington, D.C.
White House, Washington, D.C.

DENNIS MILLER BUNKER
(1861-1890)

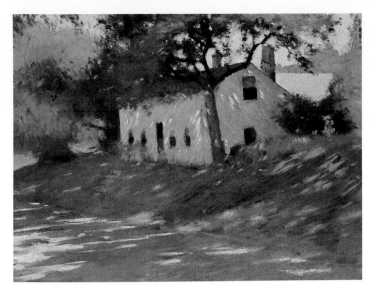

Roadside Cottage, Medfield, 1890, 18 x 24 in. Courtesy of Vose Galleries of Boston, Inc., Massachusetts.

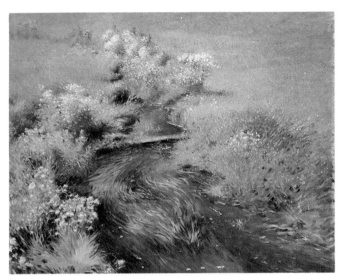

Wild Asters, 1884, 25 x 30 in., signed l.r. Courtesy of Vose Galleries of Boston, Inc., Massachusetts.

Although he did not live long—he died at age 29—Dennis Miller Bunker left enough portraits, landscapes and still lifes of sufficient merit to rank him as a painter of major significance. He did remarkably sensitive portraits of women, employing compositional elements from Whistler in some. Others were influenced more by Abbott Thayer, whom Bunker greatly admired. His early landscapes followed the style of Courbet and the barbizon painters, but after a summer of painting in England with John Singer Sargent, Bunker veered sharply toward impressionism in the last two years of his life.

Bunker was born in Garden City, Long Island in 1861. He studied at the National Academy of Design, at the Art Students League under William Merritt Chase and also for a time with Charles Dewey, a barbizon landscapist. In the summers of 1881 and 1882, he went to Nantucket to paint with his friends, Abbott Thayer and Joe Evans, both of whom had already studied in Paris. This convinced Bunker that he, too, should go to Paris.

In the fall of 1882, he left for France to study with Antoine Hebert at the Academie Julien and then with Gerome at the Ecole des Beaux Arts. In summer he traveled to Brittany to paint with other Americans. His early plein-air landscapes showed a marked talent for handling the play of light across green fields and coastal villages.

Back in Boston in 1885, he joined the faculty of the Cowles Art School. A one-man show of his work attracted the attention of Isabella Stewart Gardner, the noted collector, and he enjoyed her patronage for the remainder of his short life.

In 1887, Bunker met Sargent and the following year joined him for a summer of painting landscapes at Calcot, a village near Reading, England. Sargent, much taken with Monet's work at the time, was developing his own form of modified impressionism. Bunker's work turned in the same direction and he followed Sargent's lead in using a more open form of composition and a much brighter, though still limited, color palette. He carried this still further forward the following summer in a group of charming landscapes painted at Medford, Massachusetts.

In 1889, Bunker became engaged and shortly afterward moved to New York, hoping to find more portrait commissions. They did not come easily, however, and worry and diminishing savings both took a toll on his health. He was married in the fall of 1890, but, while home in Boston for the Christmas holidays, he collapsed and died of heart failure.

PUBLIC COLLECTIONS
Fenway Court, Isabella Stewart Gardner Museum, Boston
Metropolitan Museum of Art, New York City
Museum of Fine Arts, Boston

SEASON	75-76	76-77	77-78	78-79	79-80	80-81	81-82	82-83	83-84	84-85
Paintings		1		2		1			1	1
Dollars		$18,000		$8,300		$10,000			$10,000	$40,000

Record Sale: $40,000, SPB, 12/6/84, "In the Greenhouse," 18 × 24 in.

FREDERIC REMINGTON
(1861-1909)

Frederic Sackrider Remington was a very significant artist, skilled as a writer and lauded as an illustrator, painter and sculptor. His subtle and powerful work made him the premier chronicler of the late-nineteenth-century American West.

The son of a newspaper publisher, Remington was born in Canton, New York in 1861. He began sketching as a boy. After attending a Massachusetts military academy from 1876 to 1878, he entered the newly formed Yale University Art School in New Haven, Connecticut. His father's death in 1880 induced him to leave school and briefly take on clerical work in Albany, New York.

During a short journey West in 1881, Remington received a glimpse of the life and land that would influence and inspire the rest of his life. The trip, consisting of sketching, prospecting and cowpunching from Montana to Texas, resulted in his first published illustration in *Harper's Weekly* in 1882.

In 1883, he bought a sheep ranch in Kansas, which served as a home base for more trips throughout the Southwest, where he sketched horses, cavalrymen, cowboys and Indians. Remington sold the ranch in 1884, and established a studio in Kansas City, Missouri.

Returning to New York City in 1885, Remington quickly became a successful illustrator, his work appearing in many publications. He began writing and illustrating his own books and articles as well, giving Eastern America what became the accepted vision of the American West.

Wanting greater acceptance as a fine artist, he studied at the Art Students League in New York City for a few months in 1886. Remington began submitting his paintings to exhibitions, but his illustrations remained the primary source of his remarkable reputation.

Remington did start winning prizes for his paintings in the early 1890s. His

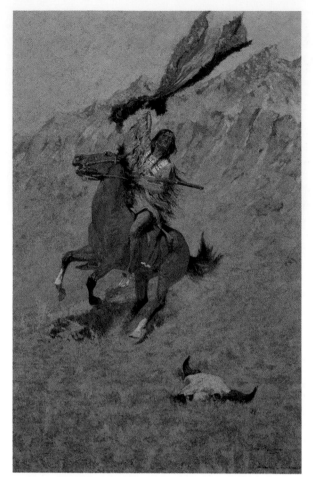

If Skulls Could Speak (The Signal), 1900, 40 x 27 in., signed l.r., Courtesy of Wunderlich and Company, Inc., New York, New York.

work consisted of visual narratives of the old West, with landscape secondary to the figure.

In 1895, Remington produced his first bronze sculpture: *The Bronco Buster* (a cast in the Metropolitan Museum of Art), which immediately became popular and was followed by 24 other bronzes. His ability to exhibit a strong sense of life and movement in a three-dimensional work was recognized.

After moving to a farm in Connecticut, where he established an art gallery and library surrounded by collected Western memorabilia and artifacts, Remington began to experiment with a kind of impressionism around 1905. Many American artists were attracted to the style during that period, but

Remington never really ceased to be a realist.

Remington died in Ridgefield, Connecticut in 1909 after a sudden attack of appendicitis, leaving a legacy of more than 2,750 paintings and drawings and 25 sculptures from which multiple casts were made.

In addition, he had written eight books and numerous articles about the American West, and served in the Spanish-American War as a war correspondent. He was the most important artist ever to record the vanishing Western frontier.

MEMBERSHIPS
National Academy of Design
National Institute of Arts and Letters

PUBLIC COLLECTIONS
Amon Carter Museum, Fort Worth, Texas
Buffalo Bill Memorial Association, Cody, Wyoming
Metropolitan Museum of Art, New York City
Museum of Fine Arts, Houston
Remington Art Museum, Ogdensburg, New York
Rockwell Museum, Corning, New York
Whitney Gallery of Western Art, Cody, Wyoming

SEASON	75-76	76-77	77-78	78-79	79-80	80-81	81-82	82-83	83-84	84-85
Paintings	1		3	9	9	9	10	11	6	6
Dollars	$155,000		$164,000	$253,540	$396,800	$220,000	$228,250	$679,400	$568,700	$21,959

Record Sale: $500,000, SPB, 5/30/84, "Coming to the Call," 27 × 40 in.

CHARLES SCHREYVOGEL
(1861-1912)

After years of struggle to make a living in art, Charles Schreyvogel was surprised by sudden nationwide success as he turned 40.

His reputation was made overnight by one oil painting, *My Bunkie* (date unknown, Metropolitan Museum of Art), a dramatic Western scene of a cavalryman rescuing an unhorsed comrade from pursing Indians. Schreyvogel had not been able to sell the painting or even give it away. On impulse, he entered it in the 1900 National Academy of Design exhibition. It captured first prize.

Catapulted into fame, Schreyvogel specialized in now-sought-after Western scenes of Indians and troopers. His work was compared favorably to that of the famous contemporary he admired, Frederic Remington, much to Remington's chagrin.

When Remington died in 1909, Schreyvogel wore the mantle of premier Western artist for the brief remainder of his life.

Born to German immigrants in New York City in 1861, Schreyvogel grew up poor. In his teens, he was a gold engraver's apprentice and a meerschaum carver.

He studied at the Newark Art League with portrait painter H. August Schwabe. In 1886, he began three years' study at the Royal Academy in Munich.

Back in New York City in 1890, Schreyvogel earned a meagre living with lithographs, portraits, landscapes and

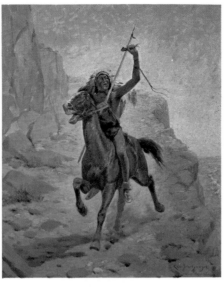

The Triumph, 1908, 20 x 16⅛ in. Courtesy of Wunderlich & Company, Inc., New York, New York.

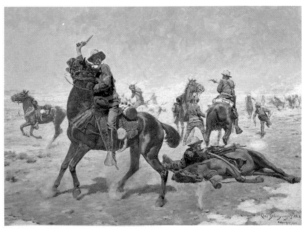

The Lost Dispatches, 1909, 25 x 34 in., signed l.r. Photograph courtesy of The Gerald Peters Gallery, Santa Fe, New Mexico.

ivory miniatures. Interested in Western themes, he sketched the 1890 Buffalo Bill show. With W.R. Fisher's patronage, he made his first trip West.

He spent five months in Colorado and Arizona, where he painted scenes of

cowboy and Indian life. But his Western paintings did not sell, and his straitened existence continued until he won the 1900 Academy prize.

Schreyvogel traveled West many times to research his paintings. His *Custer's Demand* (1903, Gilcrease Institute) was acclaimed. Some critics thought his composition and color sense superior to Remington's. Schreyvogel's flair for drama (some say melodrama), as well as the numerous reproductions of his work, gained him a wide following.

Schreyvogel died in Hoboken in 1912 of blood poisoning. In all, he left fewer than 100 known paintings and a few bronzes.

MEMBERSHIPS
National Academy of Design

PUBLIC COLLECTIONS
Library of Congress, Washington, D.C.
Metropolitan Museum of Art, New York City
National Cowboy Hall of Fame and Western
 Heritage Center, Oklahoma City
Thomas Gilcrease Institute of American
 History and Art, Tulsa

10-Year Average Change From Base Years '76-'77: 153%

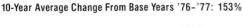

						109%		10%	807%	218%	-74%

SEASON	75-76	76-77	77-78	78-79	79-80	80-81	81-82	82-83	83-84	84-85
Paintings		1		1	2		1	3	2	1
Dollars		$1,700		$5,250	$8,700		$6,250	$363,400	$11,900	$4,500

Record Sale: $180,000, SPB, 6/2/83, "Doomed," 25 x 34 in.

GEORGE GARDNER SYMONS
(1861?-1930)

Landscape and marine artist George Gardner Symons was one of the most successful of the plein-air painters, whose works were produced outdoors rather than in the studio. His style combined elements of impressionism and realism and was extremely popular.

Little is known of Symons's early life. The most likely date for his birth is 1861. He may have studied at the Art Institute of Chicago; he is known to have worked as a commercial artist in the Chicago area early in his career. He also studied in Paris, Munich and London.

Although he traveled and painted in California with artist William Wendt in 1886, Symons spent many years before 1906 in Europe, settling in St. Ives, Cornwall. There he adopted the plein-air technique of such artists as Julius Olsson, Adrian Stokes and Rudolph Hellwag. Elmer Schofield also joined the artists' colony at St. Ives, and he and Symons became friends. Their work bears comparison in many aspects.

Returning to the United States in 1906, Symons set up a studio near Laguna Beach, California, and became active in Western art societies. Most of his time, however, was spent in New York City or in Colerain, Massachusetts.

Symons believed in drawing his inspiration directly from nature. Particularly in California and the Southwest, he wandered considerable distances to paint scenes of the ocean coast or the Grand Canyon. He executed many snow scenes, for which he became especially well known, and views of the Berkshires.

Like Schofield, Symons used an impressionistic style, characterized by energy and simplicity. His canvases were usually large, and he favored sweeping, panoramic views with wide brushstrokes and large areas of bright color. Good examples of his snow scenes are *An*

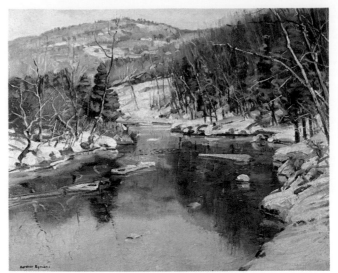

New Hope Winter Scene, 25 x 30 in., signed l.l. Courtesy of Henry B. Holt, Inc., Essex Fells, New Jersey.

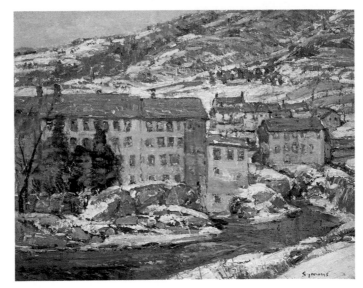

Winter - New England, 16 x 20¼ in., signed l.r. Courtesy of John H. Garzoli Gallery, San Francisco, California.

Opalescent River (1908, Metropolitan Museum of Art), with thick impasto and coarse canvas imparting texture, and *The Winter Sun* (date unknown, Art Institute of Chicago).

Symons's greatest critical success occurred in the years immediately following 1909. He remained successful throughout his career, however, and exhibited widely in New York City, California and London. He died in 1930 in Hillside, New Jersey.

MEMBERSHIPS
American Federation of Artists
California Art Club
Century Association
Chicago Gallery Association
Chicago Society of Artists
Institute of Arts and Letters
National Academy of Design
Royal Society of British Artists
Salmagundi Club
Union Internationale des Beaux-Arts
 et des Lettres

PUBLIC COLLECTIONS
Art Institute of Chicago
Brooklyn Museum
Butler Art Institute, Youngstown, Ohio
Carnegie Institute, Pittsburgh
Cincinnati Museum
City Art Museum, St. Louis
Corcoran Gallery, Washington, D.C.
Des Moines Art Association
Los Angeles Museum of Art
Metropolitan Museum of Art, New York City
Toledo Museum, Ohio

SEASON	75-76	76-77	77-78	78-79	79-80	80-81	81-82	82-83	83-84	84-85
Paintings		3	9	15	24	31	17	14	6	8
Dollars		$37,150	$34,350	$58,500	$89,699	$117,925	$59,150	$49,730	$13,300	$12,175

Record Sale: $33,200, PB, 10/28/76, "Winter Scene, Pennsylvania," 30 × 38 in.

WALTER P.S. GRIFFIN
(1861-1935)

Walter P.S. Griffin was an American impressionist whose work was strongly influenced by Childe Hassam.

He was born in Portland, Maine in 1861. He studied first at the Museum School of Art in Boston and then at the Art Students League in New York City. Later he went to Paris and studied at the Academie Colarossi under Collin and Laurens.

He then settled in Brittany for seven years to paint that rugged corner of France. His familiarity with and empathy for French art combined to give his work an authentic impressionist look—although it also displayed some traces of barbizon sentimentality.

On his return to the United States, Griffin divided his time between teaching and painting, first in Hartford, Connecticut for a year, and then at an art school he founded in Quebec. By the time he had moved to Old Lyme, Connecticut in 1905, however, he seems to have abandoned teaching to concentrate on painting.

It was in Old Lyme that he met and became a close friend of Hassam. Hassam's influence can be seen in Griffin's work of this period. The barbizon traces faded further.

In 1911, Griffin returned to Brittany and stayed until 1918, strengthening his impressionist technique. He also returned frequently during the post-war period and painted in Norway and Venice as well.

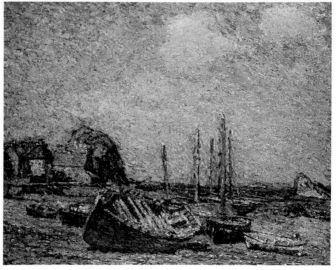

Beached Boats Finnisterre, France, 27 x 32 in. Courtesy of Vose Galleries of Boston, Inc., Massachusetts.

Old Lyme, 27 x 32 in., signed l.l. Courtesy of Vose Galleries of Boston, Inc., Massachusetts.

Shortly before his death in Maine in 1935, Griffin showed a growing interest in expressionism. His final paintings are rich with thick, bright colors, applied with a palette knife.

MEMBERSHIPS
Allied Artists of America
Allied Artists of Paris
American Art Club
American Water Color Society
National Institute of Arts and Letters
New York Water Color Club
Salmagundi Club

PUBLIC COLLECTIONS
Albright-Knox Art Gallery, Buffalo, New York
Brooklyn Museum
Luxembourg Gallery, Paris
Memorial Art Gallery, Rochester, New York

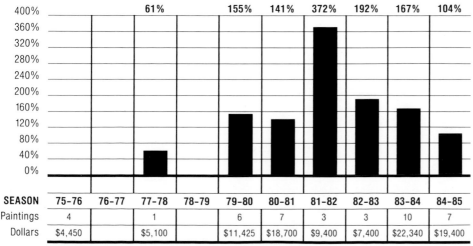

10-Year Average Change From Base Years '75-'76: 149%

	75-76	76-77	77-78	78-79	79-80	80-81	81-82	82-83	83-84	84-85
			61%		155%	141%	372%	192%	167%	104%
SEASON	75-76	76-77	77-78	78-79	79-80	80-81	81-82	82-83	83-84	84-85
Paintings	4		1		6	7	3	3	10	7
Dollars	$4,450		$5,100		$11,425	$18,700	$9,400	$7,400	$22,340	$19,400

Record Sale: $7,000, W.W, 12/13/81, "Rural Landscapes," 9 × 13 in.

559

FREDERICK JUDD WAUGH
(1861-1940)

Frederick Judd Waugh was among the most popular academic painters of marine subjects of his time. He painted approximately 2,500 seascapes and achieved international recognition.

Born in 1861 in Bordentown, New Jersey, Waugh was raised by an artistic family. His father, Samuel B. Waugh, was a portrait and landscape painter. His mother, Eliza Young Waugh, was a miniaturist. His half-sister, Ida Waugh, was a figure painter. Oddly, his father discouraged the young Frederick from becoming a painter, and it was only after a good deal of teenage protest that Frederick was permitted to attend the Pennsylvania Academy of the Fine Arts in Philadelphia.

From 1880 to 1883, Waugh studied at the Academy under Thomas Eakins and Thomas Anshutz. Waugh then went abroad and studied under Adolphe William Bougereau and Tony Robert-Fleury at the Academie Julien in Paris. In the summer, Waugh painted at an artists' colony near Fontainebleau.

Waugh's early work consisted of figurative compositions which were conventional and decorative in style. He first began painting the sea while in England, and it soon became his primary subject.

Waugh remained in Europe from 1892 to 1907, and then returned to the United States. From 1901 to 1907, he lived in England and worked as an illustrator for the *Graphic* and various London papers and magazines. There he gained

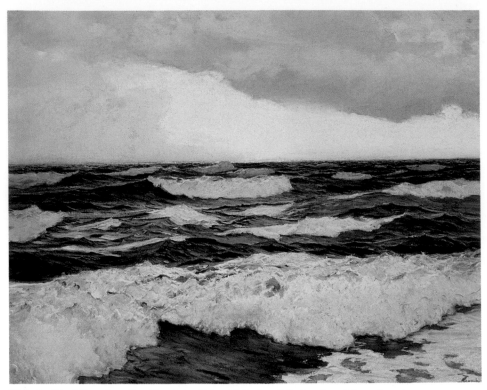

Westerly, 40 x 50 in., signed l.r. Courtesy of Vose Galleries of Boston, Inc., Massachusetts.

success as a marine painter as well as an illustrator.

Already a renowned artist, Waugh returned to America in 1907 and settled in Provincetown, Massachusetts, on Cape Cod. In addition to Waugh's tremendous number of marine paintings, he also did some award-winning portraits and genre paintings.

Waugh worked with both watercolors and oils in a plein-air style. He applied heavy, impasto brushstrokes on the canvas. The colors were often applied directly out of the tubes without prior mixing. This use of pure unmixed colors added to the freshness of Waugh's paintings. The waves look bright and wet, and the quality of light in the seascapes is amazingly realistic. Through the years, Waugh's seascapes gradually progressed from realistic, clearly defined depictions of large panoramic views to more abstract, broadly defined portrayals of smaller areas of sea, rocks and sky.

Waugh received wide recognition and praise during his lifetime. He was elected an associate member of the National Academy of Design in 1909 and academician in 1911. He also won many prestigious awards, including the Popular Prize from the Carnegie International Exhibition of Paintings, in five consecutive years from 1934.

Waugh died in 1940 in Provincetown.

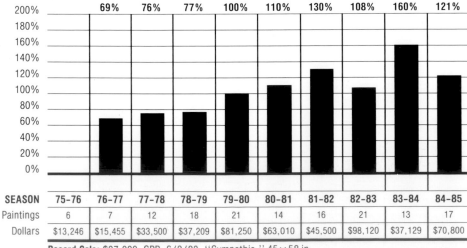

10-Year Average Change From Base Years '75-'76: 95%

		69%	76%	77%	100%	110%	130%	108%	160%	121%

SEASON	75-76	76-77	77-78	78-79	79-80	80-81	81-82	82-83	83-84	84-85
Paintings	6	7	12	18	21	14	16	21	13	17
Dollars	$13,246	$15,455	$33,500	$37,209	$81,250	$63,010	$45,500	$98,120	$37,129	$70,800

Record Sale: $37,000, SPB, 6/2/83, "Sympathie," 45 × 58 in.

MEMBERSHIPS
National Academy of Design

PUBLIC COLLECTIONS
Bristol Academy, England
City Art Museum, St. Louis
Metropolitan Museum of Art, New York City
National Gallery of Art, Washington, D.C.
Walker Art Gallery, Liverpool, England

CHARLES COURTNEY CURRAN

(1861-1942)

Charles Courtney Curran, a prolific and popular painter all his life, was among the artists responsible for the rebirth of the genre tradition in late nineteenth century American art.

Born in 1861 in Hartford, Kentucky, Curran spent his formative years in Sandusky, Ohio, where his family had moved in 1881. Curran studied briefly at the Cincinnati School of Design.

The following year, Curran moved to New York City. There he enrolled in the National Academy of Design, worked under the tutelage of Walter Satterlee, and later attended the Art Students League.

Curran achieved early artistic recognition. He had his first exhibit at age 23 at the National Academy of Design. Five years later, the Academy awarded him Third Hallgarten Prize for *A Breezy Day* (date and location unknown), designated most "meritorious painting in oil."

Curran's two years of study at the Academie Julien in Paris, from 1889 to 1891, likely influenced the impressionistic use of form and light in his subsequent works.

He spent the remainder of his life dividing his time between New York City and his house and studio in the Cragsmoor region of New York State. Curran died in 1942.

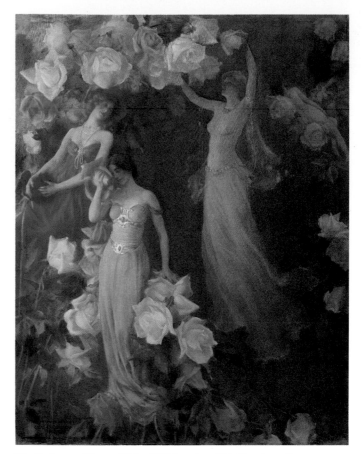

The Perfume of Roses, 29¼ x 23⅜ in., signed l.l. Courtesy of National Museum of American Art, Smithsonian Institution, Gift of William T. Evans.

In addition to teaching art and painting, Curran was a leader of the Cragsmoor Art Colony. For several years, he and his wife co-edited the art student publication *Palette and Brush.*

During his life, Curran received much recognition for his figure paintings, but his style was not limited exclusively to that genre. The widely traveled artist also painted landscapes, portraits and a series of views of the Imperial Temples of Peking.

He is perhaps best known for those works which combine sweeping vistas of the Cragsmoor area with the almost whimsical delicacy of the female form, as in *Two Women in a Landscape* (1916, location unknown).

MEMBERSHIPS
Allied Art Association
American Water Color Society
National Academy of Design
Lotos Club
MacDowell Club
National Arts Club
New York Water Color Club
Salmagundi Club
Society of American Artists

PUBLIC COLLECTIONS
Albright-Knox Art Gallery, Buffalo
Art Association of Richmond, Indiana
Columbus Museum of Art, Ohio
Dallas Museum of Fine Arts
Fort Worth Art Museum, Texas
Metropolitan Museum of Art, New York City
Montclair Art Museum, New Jersey
National Gallery of Art, Washington, D.C.
Pennsylvania Academy of the Fine Arts, Philadelphia
Toledo Museum of Art, Ohio
Witte Memorial Museum, San Antonio

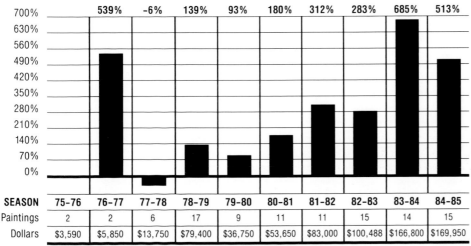

10-Year Average Change From Base Years '75-'76: 274%

	75-76	76-77	77-78	78-79	79-80	80-81	81-82	82-83	83-84	84-85
		539%	-6%	139%	93%	180%	312%	283%	685%	513%
SEASON	75-76	76-77	77-78	78-79	79-80	80-81	81-82	82-83	83-84	84-85
Paintings	2	2	6	17	9	11	11	15	14	15
Dollars	$3,590	$5,850	$13,750	$79,400	$36,750	$53,650	$83,000	$100,488	$166,800	$169,950

Record Sale: $80,000, CH, 6/1/84, "Chrysanthemums," 9 × 12 in.

IRVING RAMSEY WILES
(1861-1948)

When Irving Ramsey Wiles painted a portrait of actress Julia Marlowe in 1901, he captured the essence of America's Gilded Age. The painting (National Gallery of Art) was as renowned as the actress herself.

Wiles delighted in portrait painting, and was best known for his elegant portraits of women and celebrities. President Theodore Roosevelt and William Jennings Bryant sat for Wiles, who was the son of landscape painter and art instructor Lemuel M. Wiles. His daughter, Gladys Wiles, also distinguished herself as a painter.

Born in Utica, New York in 1861, he was raised in New York City. He considered a career as a violinist; however, at age 17 he was studying art with his father, and by the next year he had exhibited at the National Academy of Design. He then studied at the Art Students League under James Carroll Beckwith and William Merritt Chase from 1879 to 1881. Chase not only influenced his style, but also became a lasting friend, choosing Wiles to complete the portrait commissions left unfinished at his death.

Wiles went to Paris in 1882, attending the Academie Julien, where Boulanger and Lefebvre taught him. He also studied under Carolus-Duran. Paris street scenes in watercolors were painted during his student years.

When Wiles returned to New York City in 1884, he found it necessary to divide his time between painting and illustrating for *Century, Harper's* and *Scribner's* magazines, since portrait work was not sufficiently lucrative. He also taught classes in his New York studio, and at his father's Silver Lake Art School in Ingham, New York in the summers.

More time was devoted to portraiture and oil figure studies after his election to the National Academy of Design in 1897. Wiles's technique followed that of

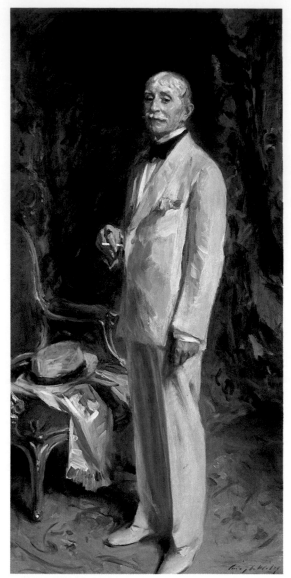

John Gellatly, 1930-1932, 79⅛ x 38½ in., signed l.r. Courtesy of National Museum of American Art, Smithsonian Institution, Washington, D.C. Gift of Irving R. Wiles.

Chase, who advocated a direct approach, in that he rarely made studies and painted directly on the canvas. He used fluid brushwork, illuminating colors brightly against dark backgrounds.

Peconic, Long Island, where his summer classes were moved during the late 1890s, eventually became his home. Many of the seascapes done at Peconic reveal a sense of freedom and informality. For recreation, Wiles sailed and collected model ships.

Wiles died at age 87 in 1948.

MEMBERSHIPS
Allied Artists of America
American Federation of Arts
American Water Color Society
Century Association
National Academy of Design
National Arts Club
National Association of Portrait Painters
National Institute of Arts and Letters
Society of American Artists

PUBLIC COLLECTIONS
Butler Art Institute, Youngstown, Ohio
Chase Bank, New York City
Corcoran Gallery of Art, Washington, D.C.
Metropolitan Museum of Art, New York City
National Gallery of Art, Washington, D.C.
West Point Military Academy, New York

SEASON	75-76	76-77	77-78	78-79	79-80	80-81	81-82	82-83	83-84	84-85
Paintings		1	2	5	10	8	5	7	2	3
Dollars		$2,600	$7,200	$19,750	$21,050	$23,050	$11,250	$16,100	$6,250	$2,827

Record Sale: $8,500, CH, 3/18/83, "In the Garden," 9 × 5 in.

CHARLES D. CAHOON
(1861-1951)

Charles Drew Cahoon flourished as a successful painter of Cape Cod landscapes, seascapes and vignettes during the first three decades of the twentieth century. Although his work is little known today, recognition and appreciation for it appear to be growing.

Cahoon was born in 1861 in Harwich, Massachusetts. His father was a sea captain and amateur artist; Cahoon gained drawing experience by copying some of his father's sketches. He also went to sea for a few years as a young man.

He studied the new art of photography and worked in Boston in 1886 as a photograph retoucher, a profession he followed until he was able to paint fulltime in the early 1900s. It may be that his photographic work guided him toward his detailed, realistic painting style.

At first, Cahoon painted conventional subjects, such as his *Burning of the Exchange Building, Harwich* (date and location unknown), a depiction of a local tragedy. He also executed portraits, including one of New Hampshire governor Frank Rollins and one of General Ayling of Centerville, Massachusetts. He received commissions for copies of Gilbert Stuart's portraits of George and Martha Washington and of Franz Hals's *Laughing Cavalier*.

As Cahoon's style matured, he turned to the subject for which he was to become best known: gentle, carefully detailed pictures of Cape Cod sights—

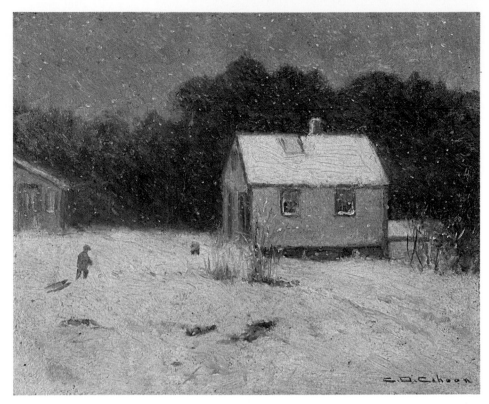

Cape Cod Snowfall, 8 x 10 in., signed l.r. Courtesy of The Cahoon Museum of American Art, Cotuit, Massachusetts.

fishermen, boats, weather-beaten houses, all suffused with mellow light. He maintained a studio in Boston and painted there and in Harwich. Summer visitors to the Cape bought many of his paintings, and Cahoon prospered until the stock market collapse of 1929, in which he lost his investments. He returned to Harwich to live and contin-

ued to paint. According to his son, Alvin, Cahoon once described painting as "a poor man's career."

Cahoon died in Harwich in 1951. Alvin Cahoon, who also became a professional painter, estimates that his father produced between 2,500 and 3,000 paintings.

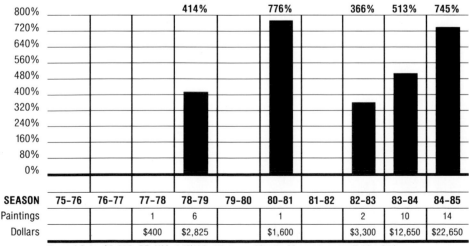

10-Year Average Change From Base Years '77-'78: 469%

SEASON	75-76	76-77	77-78	78-79	79-80	80-81	81-82	82-83	83-84	84-85
				414%		776%		366%	513%	745%
Paintings			1	6		1		2	10	14
Dollars			$400	$2,825		$1,600		$3,300	$12,650	$22,650

Record Sale: $3,800, RB.HM, 8/9/83, "Autumn Marsh, Massachusetts," 10 × 24 in.

MINA FONDA OCHTMAN
(1862-1924)

During her lifetime, Mina Fonda Ochtman's work was largely subordinated to, and eclipsed by, that of her husband, painter Leonard Ochtman. Now, however, critics regard her work as a fine blending of the American landscape with French impressionism.

Born in Laconia, New Hampshire in 1862, Ochtman moved to New York City when she was 24. She set up a studio with a friend, and took courses at the Art Students League, before meeting and marrying her husband in 1891.

Shortly after their marriage, the Ochtmans moved to the Greenwich, Connecticut area—their home for the remainder of their lives. There, each became active in the influential Cos Cob art colony.

For the next 20 years, Ochtman's time was devoted to raising the couple's three children and caring for their home. Her art was eclipsed by the work of her husband who, by 1910, had established a reputation as one of the foremost landscape painters in the United States.

In 1911, the Ochtmans founded the Greenwich Society of Artists. Mina Ochtman's work, which she resumed after her children were older and continued until her death in 1924, was exhibited at the Society, as well as at the National Academy of Design.

Although the couple frequently relied upon the same landscape setting for inspiration, Mina Ochtman's paintings were crisper and brighter than her husband's.

Before the 1920s, however, after the 1913 Armory Show, modernists trends superseded impressionism as practiced by Ochtman. Until recent revivals, often in joint exhibition, the paintings of both Ochtmans were either forgotten or disregarded.

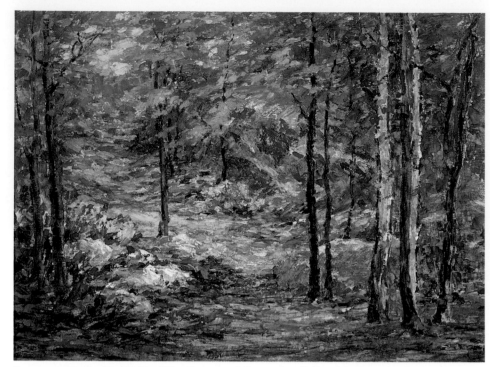

Summer in Nearby Woods, 12 x 16 in. Courtesy of Connecticut Gallery, Marlborough, Connecticut.

MEMBERSHIPS
American Water Color Society
National Association of Women Painters and
 Sculptors
Greenwich Society of Artists

SEASON	75-76	76-77	77-78	78-79	79-80	80-81	81-82	82-83	83-84	84-85
Paintings								1		
Dollars								$800		

Record Sale: $800, P.NY, 6/1/83, "Forest Interior," 16 × 20 in.

564

ARTHUR B. DAVIES
(1862-1928)

A visionary painter of dancing nudes in mythical landscapes, Arthur Davies occupies an important position in American art. He is accorded a leading role both for his painting and for his brilliance in organizing the 1913 Armory Show in New York City. The historic show brought together on a grand scale 1,600 pieces of American and European art, exposing the public for the first time to the scope of modern trends. The show affected the course of art history in the United States.

Davies's own canvases, often described as "decorative," depict arcadian landscapes populated by Botticelli-like nudes and mythical unicorns. The paintings are considered to be in the symbolist tradition, comparable to the work of Pierre Puvis de Chavannes.

Born in Utica, New York, Davies worked in Mexico as an engineer before studying art with Dwight Williams, and later at the Chicago Academy of Design. In 1886, he moved to New York City, making a living as a magazine illustrator and gaining influence among wealthy women who liked his romantic, dreamlike paintings, untouched by realism or modernism. In two trips to Europe, Davies studied works by the Venetians, the pre-raphaelites and the German romantics.

In style, Davies's work bears some resemblance to the frescoes of Pompeii, which he admired. He used long, horizontal canvases, crossed by processions of nudes or dancing figures who seem to

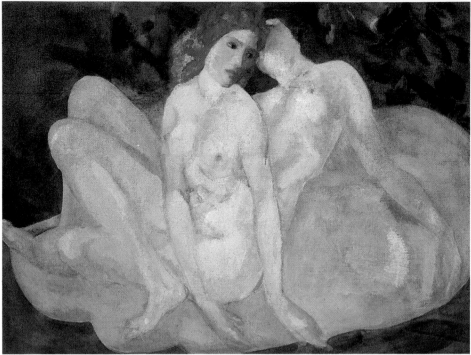

Two Spirits, 21½ x 29 in. Courtesy of La Salle University Art Museum, Philadelphia, Pennsylvania.

be holding their breath. Davies believed this technique—painting figures at the moment of inhalation—would capture a lifelike quality that was present in Greek sculpture. Some authorities have described his figures and their poses as "eerie"; others say they are languorous.

Through the 1890s, Davies painted conventional landscapes, moving in 1913 to a cubist style in which his dancing nudes are presented as geometric forms with superficial facets. In 1918, he developed an interest in lithography, aquatint and etching, returning in his last decade of work to the misty romantic canvases of his early period.

Davies's personality was a study in contrasts. His reclusive, romantic streak, revealed in the paintings, hid strong executive capabilities that emerged when he was given control of organizing the Armory Show.

Originally planned as an exhibit of American work, the show was expanded by Davies to include "a few" items of radical European art. Before he was done, he had launched one of the largest international exhibits of its kind, unerringly choosing the finest modern artists. His own work, in contrast, shows few signs of modernism, although he exhibited among the progressive painters called The Eight.

Davies liked fairy tales and baseball. He had an almost morbid dislike of crowds and led a secretive private life. Other artists did not even know the location of his studio, perhaps because for more than two decades Davies carried out a secret liaison with a mistress in New York City, who bore him a daughter. Davies spent weekends in rural Congers, New York, with his wife and two sons, who knew nothing of the second family until Davies's death in 1928 of heart failure.

MEMBERSHIPS
National Academy of Design

PUBLIC COLLECTIONS
Art Institute of Chicago
Metropolitan Museum of Art, New York City

10-Year Average Change From Base Years '75-'76: 251%

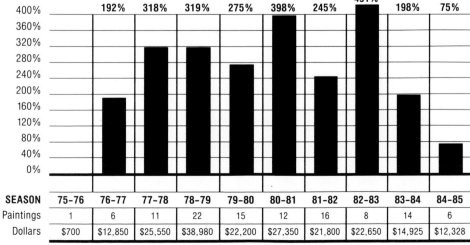

SEASON	75-76	76-77	77-78	78-79	79-80	80-81	81-82	82-83	83-84	84-85
		192%	318%	319%	275%	398%	245%	491%	198%	75%
Paintings	1	6	11	22	15	12	16	8	14	6
Dollars	$700	$12,850	$25,550	$38,980	$22,200	$27,350	$21,800	$22,650	$14,925	$12,328

Record Sale: $13,000, SPB, 5/29/81, "Fantasy," 33 × 26 in.

CHARLES ROLLO PETERS
(1862-1928)

Nocturne, ca. 1920, 19½ x 25¼ in., signed l.l. Photograph courtesy of Petersen Galleries, Beverly Hills, California.

Charles Peters was a successful San Francisco landscape artist noted primarily for his nocturnal paintings. Throughout his career, he had the opportunity to study and exhibit both in the United States and Europe.

Born in 1862 to a wealthy family, Peters studied at the Urban Academy under Jules Tavernier and at the San Francisco Art Association's California School of Design under Virgil Williams and Chris Jorgensen.

In 1886, he went to Europe, attending the Ecole des Beaux Arts and the Academie Julien, studying with Boulanger and Lefebvre, among others. He returned to San Francisco in 1890, but made frequent trips to Europe. During these years, Peters began to paint night scenes.

He settled in Monterey, California in 1895, becoming part of the Carmel art colony, a loosely knit collection of free spirits, including Maynard Dixon and Jo Mora. At the urging of Alexander Harrison, Peters concentrated on the nocturnals, with which he ultimately achieved his greatest success. Many of his subjects were found among the adobe houses and old missions dotting the Bay area.

Peters's one-man exhibitions in New York City and London earned him enough to purchase the 32-acre Doud tract in 1900. There he built an estate which included a studio and gallery. Following the San Francisco earthquake in

1906, he cared for the homeless of the art community at the estate.

During the early 1900s, Peters joined William Keith and Eugene Neuhaus to found the Del Monte Art Gallery. Despite this, he suffered financial setbacks which forced him to sell his estate in 1911. He returned to San Francisco, where he organized the first exhibition

of painting and sculpture by California artists at the Golden Gate Park Memorial Museum.

Peters went to Europe again in 1923, and continued to paint there until illness caused a return to San Francisco in 1926.

MEMBERSHIPS
Lotos Club
Salmagundi Club

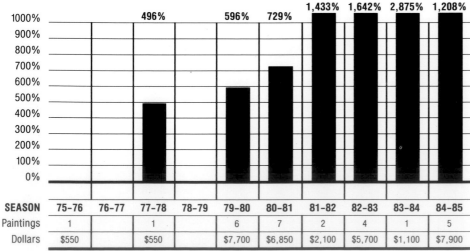

10-Year Average Change From Base Years '75-'76: 1,122%

SEASON	75-76	76-77	77-78	78-79	79-80	80-81	81-82	82-83	83-84	84-85
			496%		596%	729%	1,433%	1,642%	2,875%	1,208%
Paintings	1		1		6	7	2	4	1	5
Dollars	$550		$550		$7,700	$6,850	$2,100	$5,700	$1,100	$7,900

Record Sale: $4,250, BB.SF, 2/28/85, "Moonlight on the Adobe," 31 × 43 in.

ROBERT REID

(1862-1929)

The work of figure painter and muralist Robert Reid reveals an impressionistic use of light and vivid color. Reid was a founding member of Ten American Painters, a group formed to promote impressionism in the United States.

Reid was born in Stockbridge, Massachusetts in 1862. From 1880 to 1884, he was a student and assistant instructor at the school of the Museum of Fine Arts in Boston. (Fellow students Edmund Tarbell and Frank Benson were later to join him in the Ten American Painters.) He also studied at the Art Students League in New York City.

In 1886, Reid went to Paris, where he studied at the Academie Julien for three years. His instructors included Gustave Boulanger and Jules Lefebvre. He also exhibited annually in the Salon.

Returning to the United States, he gained a reputation for murals, which often featured neoclassical female figures and flowers. He painted a series of panels depicting the five senses for the Library of Congress, contributed to the decoration of numerous public and exposition buildings, and produced designs for 20 stained-glass church windows.

Reid's easel works, such as *Fleur-de-Lys* (ca. 1899, Metropolitan Museum of Art), *Violet Kimono* (ca. 1910, National Museum of American Art), and *The Mirror* (ca. 1910, National Museum of American Art), display greater boldness of design than

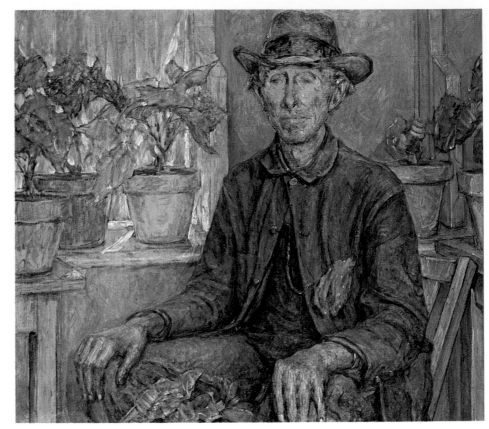

The Old Gardener, 36¼ x 40¼ in., signed u.l. Courtesy of The Brooklyn Museum, Gift of the Fellow Members in the Players and Lambs Clubs.

do his murals, although they employ the same conventional subjects. Brushwork is vigorous, usually on coarse canvas, and rich colors are used, especially strong blues.

In 1927, Reid moved to Colorado Springs, Colorado. There he worked as a portraitist and founded the Broadmoor Art Academy. After a paralyzing stroke in 1927, he learned to paint with his left hand. He exhibited in 1928, a year before his death.

MEMBERSHIPS
National Academy of Design
National Institute of Arts and Letters
Ten American Painters

PUBLIC COLLECTIONS
Albright-Knox Art Gallery, Buffalo
Brooklyn Museum
Cincinnati Art Museum
Corcoran Gallery of Art, Washington, D.C.
Library of Congress, Washington, D.C.
Massachusetts State House
Metropolitan Museum of Art, New York City
National Gallery of Art, Washington, D.C.
National Museum of American Art, Washington, D.C.

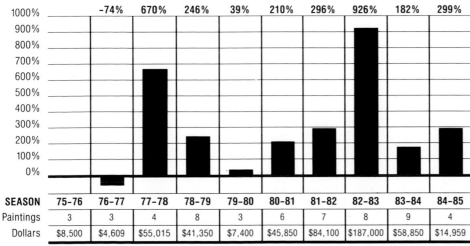

10-Year Average Change From Base Years '75-'76: 279%

SEASON	75-76	76-77	77-78	78-79	79-80	80-81	81-82	82-83	83-84	84-85
		-74%	670%	246%	39%	210%	296%	926%	182%	299%
Paintings	3	3	4	8	3	6	7	8	9	4
Dollars	$8,500	$4,609	$55,015	$41,350	$7,400	$45,850	$84,100	$187,000	$58,850	$14,959

Record Sale: $60,000, CH, 12/3/82, "Tending the Garden," 22 × 19 in.

EDWARD PERCY MORAN
(1862-1935)

The Lost Drummer Boy, ca. 1915, 24 x 36 in., signed l.l. Courtesy of Petersen Galleries, Beverly Hills, California.

Edward Percy Moran, who preferred to be known as Percy Moran, was born in Philadelphia in 1862. His father, Edward Moran, was a well-known marine painter who emigrated to the United States with three brothers, also artists. Thomas Moran is known for his Rocky Mountain pictures, Peter was a painter, etcher, and illustrator, and John was a painter.

Percy Moran continued in the family tradition by excelling as a genre and landscape painter and as an etcher. He was equally adept in oil and watercolor.

Although he attended public school in Philadelphia, Moran spent most of his youth studying at his father's studio in New York City. In 1894, father and son traveled to Paris, where the young Moran attended and graduated from military school and then studied art for a year. Returning home, he continued his art studies at the National Academy of Design in New York City and then at the Pennsylvania Academy of the Fine Arts under S.J. Ferris. This was followed by four years of study in Paris and London.

Returning to New York City, Moran opened a studio and soon attracted notice with his watercolor sketches. His earliest work consists of scenes of children and peasant life, and portraits of pretty women. Later, he turned to the subject for which he is best remembered: the customs and homelife of colonial America. These quiet paintings, telling stories of love or of domestic incidents, are distinguished by great attention to detail. Many were reproduced in colored etchings, photogravures and mezzotint, and were published in books and magazines.

Percy Moran died in New York City in 1935.

MEMBERSHIPS
National Water Color Society

PUBLIC COLLECTIONS
Philadelphia Museum of Art, Pennsylvania
Walker Art Center, Minneapolis, Minnesota

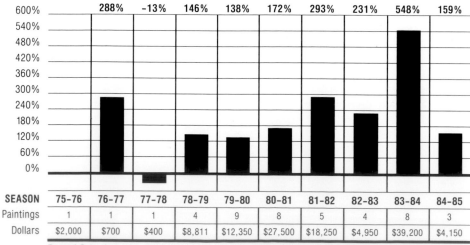

10-Year Average Change From Base Years '75-'76: 196%

SEASON	75-76	76-77	77-78	78-79	79-80	80-81	81-82	82-83	83-84	84-85
		288%	-13%	146%	138%	172%	293%	231%	548%	159%
Paintings	1	1	1	4	9	8	5	4	8	3
Dollars	$2,000	$700	$400	$8,811	$12,350	$27,500	$18,250	$4,950	$39,200	$4,150

Record Sale: $12,000, P.NY, 10/13/83, "Battle of New Orleans," 26 x 36 in.

WILL SPARKS
(1862-1937)

Will Sparks was a multi-talented individual best known for his colorful landscapes of the West. Educated to enter the medical profession, Sparks instead chose art, and produced some 3,000 murals, portraits and oils in his 50-year career.

Sparks was born in St. Louis in 1862. He was educated in the public schools, at Washington University and at the St. Louis School of Fine Arts. He majored in anatomy at the St. Louis Medical College, and nearly chose a career in medicine. His innate abilities and inclinations led him back to art, however, and Sparks rapidly established himself as a local talent.

He went to New York City in 1884, then on to Paris, where he studied at the Academies Julien and Colarossi under Bouvert and Cazin. He met Louis Pasteur, and combined his medical and artistic skills to produce several anatomy drawings for the famous scientist.

Sparks returned to America and traveled West, working for various newspapers along the way. He arrived in California in 1888, and settled in San Francisco in 1891. He joined the San Francisco Bohemian Club, a carefree group of struggling local artists. To support his painting, he worked as a feature writer for the San Francisco *Evening Call* and, in 1904, joined the University of California faculty as a teacher of anatomical drawing.

Most of Sparks's paintings were scenes of California, New Mexico, Arizona and Mexico. His most significant work was a series of 36 paintings, done between 1887 and 1919, paying tribute to California's many original Spanish missions. He completed a second series of paintings in 1933.

Sparks died in San Francisco in 1937, survived by his second wife.

Jacklin House, 8 x 10 in., signed l.r. Photograph courtesy of George Stern, Fine Arts, Encino, California. Collection of James Zidell.

MEMBERSHIPS
San Francisco Art Association
San Francisco Bohemian Club
Sequoia Club
Society of California Artists

PUBLIC COLLECTIONS
Bohemian Club, San Francisco
Fine Arts Guild, San Diego
M.H. de Young Memorial Museum, San Francisco
St. Louis Art Museum
Toledo Museum of Art, Ohio

SEASON	75-76	76-77	77-78	78-79	79-80	80-81	81-82	82-83	83-84	84-85
Paintings					3	7		5		3
Dollars					$4,000	$9,400		$4,600		$2,450

Record Sale: $2,000, BB.SF, 5/4/80, "October Day," 20 × 28 in.

EDMUND C. TARBELL
(1862-1938)

At the turn of the century, Edmund C. Tarbell was the undisputed leader of the Boston School of impressionist painters—so influential, in fact, that those who comprised the inner circle of his many followers were often referred to as "Tarbellites."

Despite his predisposition toward impressionism, however, he never sacrificed precise realism in his work. Rendering the beauty of the thing seen, he believed its color, its drawing and its values were what counted in painting.

Some observers dubbed him the "impressionist Vermeer" because of his penchant for painting serene, light-filled interiors, with well-polished furniture and gleaming floors, peopled by genteel young ladies reading, sewing or chatting together. It was a well-bred world where nothing unseemly ever happened. Besides those genre scenes he also painted many portraits, usually of the rich and powerful.

Tarbell was born in West Newton, Massachusetts in 1862. When his father died young and his mother remarried, he was left with his grandparents in Boston. At age 15, he was apprenticed to a leading local lithographer.

Three years later he enrolled in the School of the Boston Museum to study under Otto Grundmann. There he met Frank Benson, who was to become another commanding figure in the Boston School of painters. He and Benson

Girl with Sailboat, 40 x 30 in., signed l.l. Courtesy of Vose Galleries of Boston, Inc., Massachusetts.

also attended the Academie Julien in Paris, and toured Europe together. During this trip, Tarbell's admiration for the French impressionists blossomed, although he was drawn more to the subtle tones of Degas than to the higher-keyed colors of Pissaro and Monet.

In 1889, Tarbell joined the faculty of the Boston Museum School, a position he held until 1913. Despite the placid nature of his paintings, he was a peppery, assertive man with strong opinions. He became one of the most respected and feared art instructors of his day, and his influence was felt far beyond Boston.

Tarbell's insistence on the all-importance of technique, however,

brought him into conflict with some of his noted contemporaries. John Singer Sargent, for one, sneered at the idea, even while seeking advice on painting from Tarbell.

In addition to his interior genre paintings, Tarbell also did many outdoor scenes, some of them reminiscent of Renoir.

By 1918, Tarbell's polished, well-crafted portraits were in such demand in Washington, D.C. that he moved there to work. Among others, he painted Presidents Wilson and Hoover. While in Washington, he also was asked to become director of the Corcoran School of Art.

In 1925, Tarbell retired to his summer home in New Castle, New Hampshire, where he continued to paint until his death in 1938.

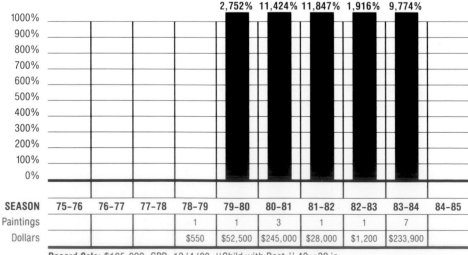

10-Year Average Change From Base Years '78-'79: 6,286%

				2,752%	11,424%	11,847%	1,916%	9,774%	

SEASON	75–76	76–77	77–78	78–79	79–80	80–81	81–82	82–83	83–84	84–85
Paintings				1	1	3	1	1	7	
Dollars				$550	$52,500	$245,000	$28,000	$1,200	$233,900	

Record Sale: $185,000, SPB, 12/4/80, "Child with Boat," 40 × 30 in.

FRANK WESTON BENSON
(1862-1951)

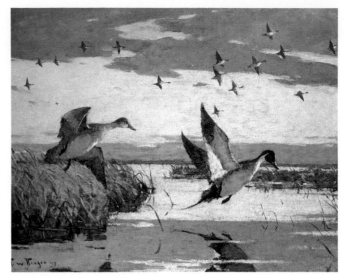

Ducks in Flight, 1937, 32 x 40 in., signed l.l. Courtesy of Vose Galleries of Boston, Inc., Massachusetts.

Frank Weston Benson was born in Salem, Massachusetts in 1862. One of the first American impressionists, he became known for his portraits of women and children, especially in outdoor settings. He was a member of Ten American Painters, a group of early impressionists.

Benson's early training was at the Museum of Fine Arts in Boston, followed by study with Boulanger and Lefebvre in Paris at the Academie Julien. He taught throughout his career, first in Portland, Maine, then in his own studio in Boston, and later at the Museum of Fine Arts, where he had first studied.

In contrast to the subdued interiors of his close friend, Edmund Tarbell, Benson painted women and children at play in cheerful, brightly colored outdoor settings. The subjects were rich, beautiful and leisurely, untouched by any unpleasant realism—they were people, as one critic commented, "on holiday."

One of his most frequently mentioned paintings, *Portrait in White* (1889, National Gallery), a first-anniversary portrait of his wife, is considered a study in tone similar to works by James Whistler—an "art-for-art's-sake treatment." The portrait is a special study of two types of white, the blue-white of his wife's dress and the yellow-white of the chair in which she poses.

Benson also painted some of the murals in the Library of Congress in Washington, D.C. In later life he turned to still lifes and sporting scenes, particularly depicting duck hunting and other waterfowl. He died in 1951 in Salem.

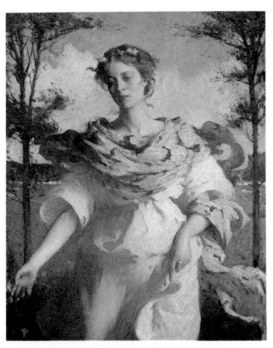

Summer, 1890, 50⅛ x 40 in., signed l.r. Courtesy of National Museum of American Art, Smithsonian Institution, Gift of John Gellatly.

SEASON	75-76	76-77	77-78	78-79	79-80	80-81	81-82	82-83	83-84	84-85
Paintings		1	1	2	7	4	7	5	2	2
Dollars		$24,000	$1,100	$16,000	$43,500	$66,500	$174,800	$24,000	$30,000	$80,700

Record Sale: $85,000, SPB, 12/10/81, "Portrait of Mary Sullivan," 84 × 54 in.

EDWARD AUGUST BELL

(1862-1953)

Painter Edward August Bell was born in New York City. He studied at the National Academy of Design between 1877 and 1879, then attended the Art Students League for two years, before sailing to Germany in 1881. There, he studied with Ritter L. von Loefftz at the Bavarian Royal Academy in Munich. He painted in Europe until his return to New York City in 1891.

Bell's work was usually symbolic or decorative. Early in his career, he stopped using models in an attempt to make his paintings creative rather than imitative.

He received many awards, including a silver medal from the Bavarian Royal Academy; the Second Hallgarten Prize from the National Academy in 1893; a bronze medal at the Paris Exposition of 1899; and silver medals at the Pan-American Exposition at Buffalo in 1901 and at the Louisiana Purchase Exposition at St. Louis in 1904.

Bell's work is held by the Cincinnati Art Museum and represented in several other institutions.

He died in Long Island, New York in 1953.

MEMBERSHIPS
Art Students League
National Academy of Design
Salmagundi Club
Society of American Artists

PUBLIC COLLECTIONS
Cincinnati Art Museum
Indianapolis Museum of Art
Smith College Museum of Art,
 Northampton, Massachusetts

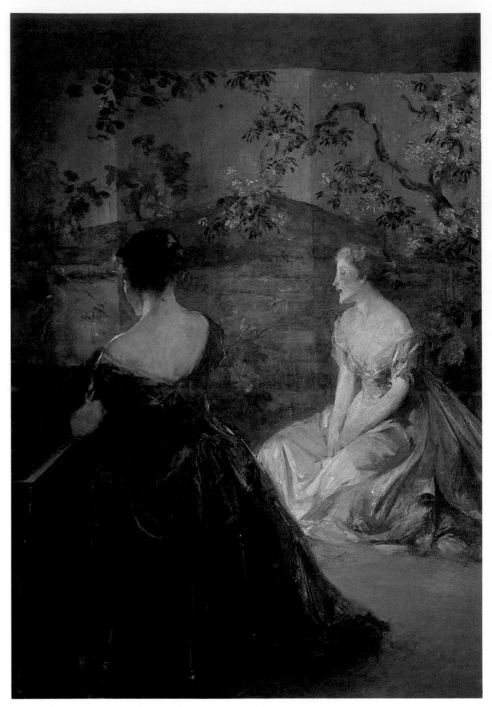

At the Piano, 20 x 14 in., signed l.l. Courtesy of Grand Central Art Galleries, Inc., New York, New York.

SEASON	75-76	76-77	77-78	78-79	79-80	80-81	81-82	82-83	83-84	84-85
Paintings	1			2	1	4				
Dollars	$1,100			$6,250	$3,600	$6,700				

Record Sale: $3,600, CH, 3/20/80, "Dancers," 22 × 33 in.

JOHN MARSHALL GAMBLE
(1863-1937)

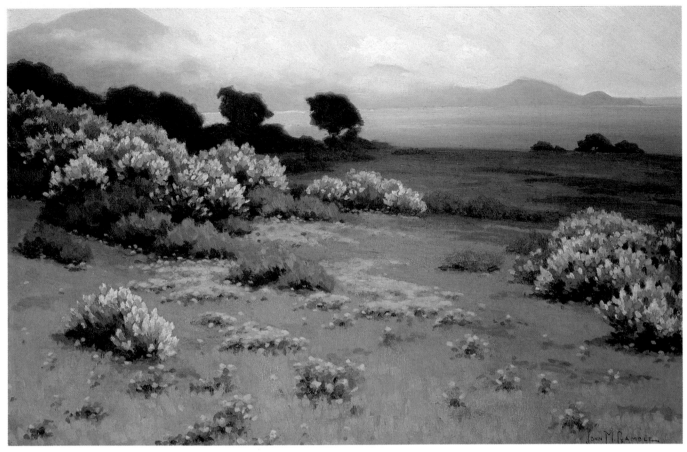

Poppies and Yellow Lupins, ca. 1959, 20 x 30 in., signed l.r. Collection of Paul Bagley. Photograph courtesy of Petersen Galleries, Beverly Hills, California.

Although he was also a successful portrait painter, John Marshall Gamble is best known for his landscapes of California wildflowers. They are admired today particularly because he painted them in the late nineteenth and early twentieth centuries, at a time when large-scale real estate development had not yet started, and he showed the flowers covering hillsides, canyons and dunes in all their original profusion. Whether it was the bright light blue of wild lilacs leaning over a footpath, or a golden-brown field of buckwheat blossoms stretching toward the mountains in the distance, Gamble caught the sunny splendor of the scene on his canvas.

He was born in Morristown, New Jersey in 1863, but moved to California when he was 20. He studied at the San Francisco School of Design with Emil Carlsen, who seemed to have a stronger influence on him than anyone else. Later, he went to Paris to study under Jean Paul Laurens and Benjamin Constant, and at the Academie Julien.

On his return to California, Gamble settled down to paint the wild beauty of the hills and coastline. After the contents of his studio in San Francisco were destroyed in the fire that followed the great 1906 earthquake, he moved to Santa Barbara and lived there until his death in 1937. When the noted Fox-

Arlington Theatre was built in Santa Barbara, Gamble painted an enormous California landscape on the stage curtain.

He was especially well known for his many paintings of the brilliant yellow California poppies that blanket the hills and valleys in the spring and contrast with the vivid hues of other wildflowers, such as the blue lupine. As a counterpoint to these floral paintings, he also did interesting studies of Pacific sunsets over the long stretches of gray sand that mark the mouths of rivers along the coast.

SEASON	75-76	76-77	77-78	78-79	79-80	80-81	81-82	82-83	83-84	84-85
Paintings					1	2	3	3	2	
Dollars					$750	$3,242	$3,700	$3,350	$2,250	

Record Sale: $2,600, SPB, 6/23/81, "California Coastline," 20 × 30 in.

MEMBERSHIPS
San Francisco Art Association
Santa Barbara Art League

PUBLIC COLLECTIONS
Museum of Art, Auckland, New Zealand

573

JEAN MANNHEIM
(1863?-1945)

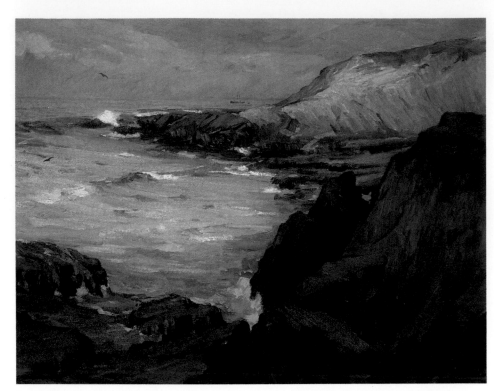

Laguna Seascape, 28 x 36 in., signed l.l. Courtesy of George Stern, Fine Arts, Encino, California.

Jean Mannheim was one of the few Western landscape painters who continued to paint portraits and genre figure compositions throughout his career. His early work showed the influence of Bouguereau in its soft tones and delicate technique, but after he began to work in California, Mannheim's paintings became bolder and more expressive and his palette considerably brighter.

Mannheim was born in Kreuznach, Germany, probably in 1863, to a German father and a French mother. He had already been trained as a bookbinder when he was drafted into the German army. He hated the army and deserted, fleeing to France.

In Paris, Mannheim worked as a bookbinder to get money to study painting, first at the Ecole Delecluse, then at the Academie Colarossi and finally with Bouguereau and several others. In 1881, he came to the United States, the first of several trips, and stayed with a married sister in Chicago. There he painted portraits for prices ranging from $20 to $40 until he had saved enough to return to France for more study. Eventually he came to Illinois to stay, painting portraits and teaching.

A few years later, he moved his second wife and their two daughters to London, where he taught at the Brangwyn School of Art. It was a pleasant association for Mannheim, but the damp English climate was bad for his wife. After two years, he resigned and returned to the United States.

He taught briefly in Denver and then, in 1908, moved on to Pasadena, California. At first he had a studio in Los Angeles; when his wife died, he moved his studio close to home in Pasadena so he could look after his daughters.

In 1913, Mannheim founded the Stickney Memorial School of Art and took his students on regular trips to paint the surrounding farmland and coastal views. Mannheim himself was particularly struck by the rugged beauty of the coast around Monterey, where he often painted. His landscapes painted there and elsewhere in California were noted for their strength and simplicity.

He continued to combine portrait commissions and figure studies with plein-air landscape painting until his death in 1945.

MEMBERSHIPS
California Art Club
Laguna Beach Art Association
Long Beach Art Association
Pasadena Art Club

PUBLIC COLLECTIONS
Denver Art Museum
Laguna Beach Museum of Art, California
Long Beach Museum of Art, California
Springville Museum of Art, Utah

SEASON	75–76	76–77	77–78	78–79	79–80	80–81	81–82	82–83	83–84	84–85
Paintings					1	7	1	1		1
Dollars					$2,300	$9,200	$1,100	$800		$2,500

Record Sale: $3,000, SPB, 3/16/81, "Spirit of the Night," 30 × 36 in.

ALBERT STERNER
(1863-1957)

Although he executed and exhibited oil paintings throughout his career, Albert Sterner was recognized primarily as an illustrator and lithographer. His background combined training in the printing trade with academic European artistic study; both influences are visible in his work.

Sterner was born in London in 1863, of American parents. He attended drawing classes at the Birmingham Art Institute until his family moved to the United States in the late 1870s, leaving him in the care of relatives in Germany. After working as a clerk in Gaggenau, he lived for a time in Freiburg, then joined his family in Chicago sometime between 1879 and 1882. In Chicago, he worked for several lithographers, helped Walter Wilcox Burridge paint theater scenery, and collaborated on illustrated articles for a local paper.

Sterner settled in New York City in 1885, but spent much time in Europe during the following two decades. He studied under Gustave Boulanger and Jules Lefebvre at the Academie Julien in Paris in 1886, and executed numerous magazine illustrations. In 1892, he illustrated George Curtis's *Prue and I* with 100 pen-and-ink and wash drawings; many similar commissions followed.

Sterner strongly maintained that illustrators deserved credit as serious artists. He produced watercolors, red-chalk drawings, lithographs and monotypes.

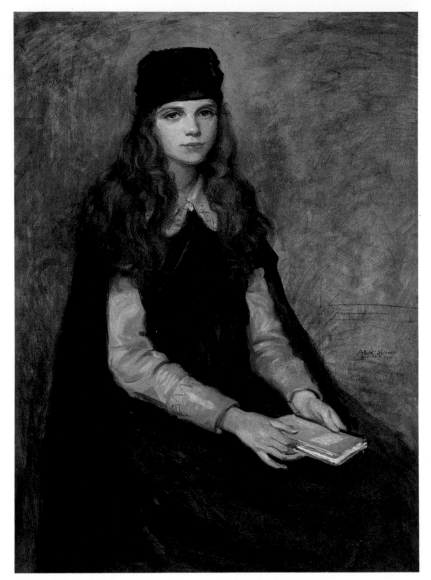

Olivia, 1918, 30 x 40 in., signed c.r. Courtesy of Frank S. Schwarz & Son, Philadelphia, Pennsylvania.

His work shows strong draftsmanship, as well as suggestions of symbolist and expressionist influence. He also painted still lifes, portraits and landscapes, which took on a decorative quality late in his career.

Sterner continued to paint until his death in 1957 at age 94.

MEMBERSHIPS
American Water Color Society
Art Association of Newport
National Academy of Design
Painter-Gravers of America
Society of Illustrators

PUBLIC COLLECTIONS
Brooklyn Museum
Carnegie Institute, Pittsburgh
Kupferstitch Kabinet, Dresden
Kupferstitch Kabinet Pinakothek, Munich
Metropolitan Museum of Art, New York City
New York Public Library, New York City
Toronto Museum of Fine Arts

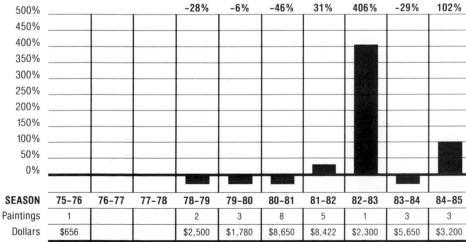

10-Year Average Change From Base Years '75-'76: 54%

	75-76	76-77	77-78	78-79	79-80	80-81	81-82	82-83	83-84	84-85
%				-28%	-6%	-46%	31%	406%	-29%	102%
SEASON	75-76	76-77	77-78	78-79	79-80	80-81	81-82	82-83	83-84	84-85
Paintings	1			2	3	8	5	1	3	3
Dollars	$656			$2,500	$1,780	$8,650	$8,422	$2,300	$5,650	$3,200

Record Sale: $4,000, CH, 6/1/84, "Self-Portrait," 24 x 19 in.

HENRY GOLDEN DEARTH
(1864-1918)

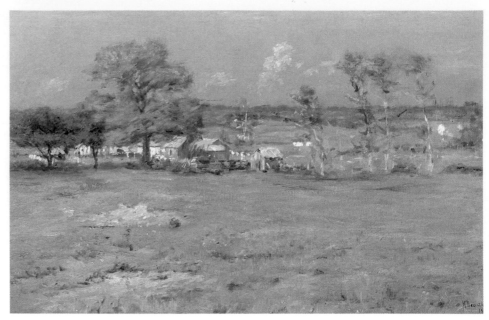

A Farm in Summer, 1891, 18½ x 28¾ in., signed l.r. Photograph courtesy of Hirschl & Adler Galleries, Inc., New York, New York.

Henry Golden Dearth, noted as a great technician by American collectors, painted landscapes and figures.

Born in Bristol, Rhode Island in 1864, Dearth received early instruction in painting from Horace Johnson, a Connecticut portrait painter. Later he studied in Paris for about four years at the Ecole des Beaux-Arts and in the atelier of Aime Morot.

He returned to America briefly in 1887, and opened a studio in New York City the following year. He first exhibited at New York City's National Academy of Design in 1888. In 1896, he married Cornelia Van Rensselaer.

During the last two decades of his life, Dearth spent his winters in New York City and summers in Normandy. He had a summer studio at Montreuil-sur-Mer near Boulogne, which he used as headquarters for his sketching trips along the coasts of Normandy and Brittany.

Dearth's specialty became landscapes of the coast of Normandy. The keynote of his work was simplicity, suggesting detail, as in *Sunset in Normandy* (date and location unknown).

From about 1900 until his death, he changed his mode of expression drastically. He became a collector of oriental, Near Eastern and early European art, and often used items from his collection in his paintings. He devoted himself almost entirely to works featuring these objects and elegantly-dressed women painted in bright, broken colors.

Dearth died at his home in New York City in 1918, at age 54. He was honored after his death by a memorial exhibition that traveled to 19 of the most important museums and galleries in America.

MEMBERSHIPS
National Academy of Design

PUBLIC COLLECTIONS
Art Institute of Chicago
Carnegie Institute, Pittsburgh
Detroit Institute of Arts
Indianapolis Museum of Art
Metropolitan Museum of Art, New York City
National Gallery of Art, Washington, D.C.
St. Louis Art Museum

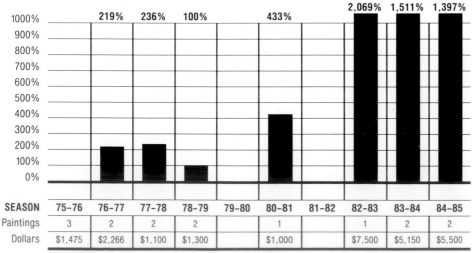

10-Year Average Change From Base Years '75-'76: 746%

	219%	236%	100%		433%		2,069%	1,511%	1,397%	
SEASON	75-76	76-77	77-78	78-79	79-80	80-81	81-82	82-83	83-84	84-85
Paintings	3	2	2	2		1		1	2	2
Dollars	$1,475	$2,266	$1,100	$1,300		$1,000		$7,500	$5,150	$5,500

Record Sale: $7,500, CH, 12/3/82, "Dusk," 24×40 in.

PAUL CORNOYER
(1864-1923)

Paul Cornoyer's artistic legacy includes both his award-winning New York City scenes and the many grateful students to whom he gave his time, attention and affection.

Born in St. Louis, Missouri in 1864, Cornoyer went to Paris in 1889 to study in the Academie Julien, under painters Jules Lefebvre, Benjamin Constant and Louis Blanc. He remained in Paris until 1894, painting and exhibiting; he won a prestigious gold medal from the American Art Association.

He returned to St. Louis in 1894, and there won a gold medal from the St. Louis Association of Painters and Sculptors in 1895. However, it was when he went to New York City, teaching at the Mechanics' Institute, that he began to establish his lifelong reputation as teacher and painter.

Cornoyer's New York City street scenes, dispassionate and calm, capture overall light effects with a carefully limited range of colors. His technical skill and capacity for observation create striking effects.

Though his prestige as a painter was won in New York City, Cornoyer also taught summer courses in Connecticut and Massachusetts. In 1917, he moved to East Gloucester, Massachusetts, where he continued to paint and exhibit until his death in 1923. He was involved in setting up an exhibition for the local art association at the time of his death.

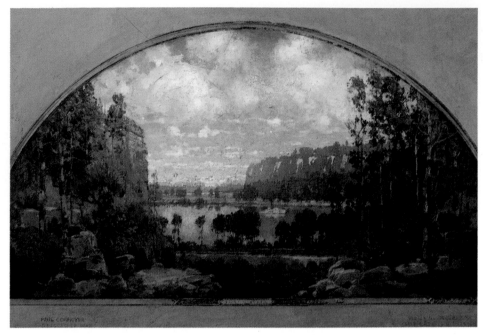

Missouri Landscape, 32 x 36 in., signed l.c. Courtesy of Raydon Gallery, New York, New York.

MEMBERSHIPS
Allied Artists Association
National Academy of Design
National Arts Club
Newark Art Association
North Shore Arts Association of Gloucester
Salmagundi Club
Society of Western Artists

PUBLIC COLLECTIONS
Brooklyn Museum
Dallas Art Association
Fine Arts Institute of Kansas City, Missouri
Newark Art Association, New Jersey
St. Louis Art Museum

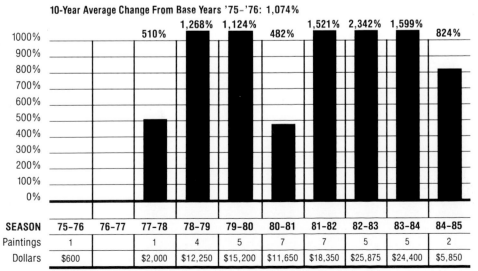

10-Year Average Change From Base Years '75-'76: 1,074%

SEASON	75-76	76-77	77-78	78-79	79-80	80-81	81-82	82-83	83-84	84-85
			510%	1,268%	1,124%	482%	1,521%	2,342%	1,599%	824%
Paintings	1		1	4	5	7	7	5	5	2
Dollars	$600		$2,000	$12,250	$15,200	$11,650	$18,350	$25,875	$24,400	$5,850

Record Sale: $20,000, SPB, 5/31/84, "Rainy Day, Madison Square," 32 x 36 in.

CHARLES M. RUSSELL
(1864-1926)

Charles M. Russell lived the life he depicted during his prolific career as painter, sculptor and illustrator of Western scenes. He spent his youth living and working in the American West; the public grew to know him as the "Cowboy Artist."

Born in 1864 in what is now the Oak Hill section of St. Louis, Russell went to Montana at age 16. He worked as a sheepherder, trapper and cowboy. He had begun to draw many years earlier and to paint on wood and model figures for his own pleasure and that of his friends. He always thought of himself as a cowboy who painted.

In 1888, he rode to Canada with a friend, and on the return trip he wintered with a tribe of Blood Indians, members of the Blackfoot nation. He spent almost six months with the Blood, gaining a deep insight into Indian life, which was reflected in his later works.

Russell's artistic reputation was established in the 1890s when he displayed his works in frontier saloons throughout the Montana territory. In 1890, he published *Studies of Western Life,* a portfolio of 12 paintings. In 1893, he was commissioned by manufacturer and rancher William Niedringhaus to produce several paintings—his first serious art assignment.

When Russell married 18-year-old Nancy Cooper in 1896, she became the motivating force in his art career. They settled in Great Falls, Montana, which

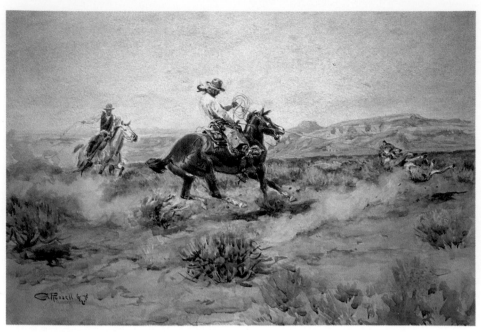

Roping the Wolf, 18 x 24 in., signed l.l. Photograph courtesy of The Gerald Peters Gallery, Santa Fe, New Mexico.

was his permanent headquarters. "Mame," as he called her, insisted that he limit his cowboy-style drinking and observe regular working hours. She also encouraged him to write for magazines, as a way to sell the illustrations he painted. In 1903, he visited New York City and continued to do so annually. His first one-man show was held there in 1911.

That year, the Montana state legislature commissioned Russell to create two murals for its House of Representatives. In 1912, *Lewis and Clark Meeting the*

Indians at Ross' Hole was installed. The painting hints at the changes soon to come in the West.

Russell was also skilled in pen-and-ink drawing, watercolor and sculpture. He produced more than 100 bronze statues, a natural outcome of his practice of modeling in clay and wax for his paintings.

His work was often exhibited in New York City, Chicago and London; he held 28 one-man shows. In 1904, he exhibited at the St. Louis World's Fair, and in 1925, at the Corcoran Gallery of Art in Washington, D.C.

Magazines expanded Russell's popularity, and *Harper's Weekly* featured his illustrations as early as 1888. He was soon published in *McClure's* and in *Leslie's.* In addition, his works were reproduced on numerous calendars.

Widely acclaimed by critics and the public, Russell died in 1926 in Great Falls.

PUBLIC COLLECTIONS
Amon Carter Musuem of Western Art, Fort Worth
Gilcrease Institute, Tulsa
Montana Historical Society, Helena
National Cowboy Hall of Fame, Oklahoma City
Norton Gallery, Shreveport, Louisiana
State Capitol Building, Helena, Montana
Trigg C. M. Russell Gallery, Great Falls, Montana
Whitney Gallery of Western Art, Cody, Wyoming
Woolaroc Museum, Bartlesville, Oklahoma

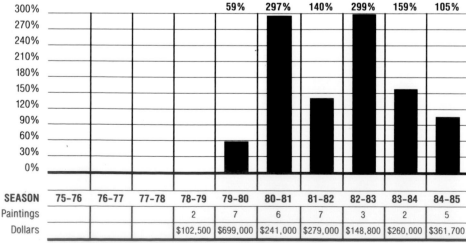

10-Year Average Change From Base Years '78–'79: 151%

	75–76	76–77	77–78	78–79	79–80	80–81	81–82	82–83	83–84	84–85
					59%	297%	140%	299%	159%	105%
SEASON	75–76	76–77	77–78	78–79	79–80	80–81	81–82	82–83	83–84	84–85
Paintings				2	7	6	7	3	2	5
Dollars				$102,500	$699,000	$241,000	$279,000	$148,800	$260,000	$361,700

Record Sale: $250,000, SPB, 4/25/80, "The War Party," 22 × 36 in.

FRANZ ARTHUR BISCHOFF
(1864-1929)

An early Southern California landscape painter, Franz Bischoff ranks among the best of the plein-air painters. His impressionistic studies of the region's scenery, particularly around his home in a wooded Pasadena canyon, won critical acclaim at a time when California was experiencing its first wave of impressionistic work, during the early years of the twentieth century.

Bischoff was born in Northern Bohemia, in what was then Austria. He immigrated to the United States as a young ceramic decorator in 1885 and took a job as a designer in a New York City china factory. During the next two decades, he owned and operated ceramics studios there and in Michigan, formulating many of his own colors and earning an award-winning reputation as "King of the Rose Painters."

Bischoff moved to California in 1906, after 20 years as a ceramicist and china painter. Like other artists who arrived in the benevolent, sun-kissed state at that time, Bischoff turned immediately to landscapes. His style ranged from impressionistic in the early works to post-impressionistic and somewhat expressionistic in later paintings. He is noted for his superb colors, a legacy of his years as a ceramicist.

He continued to do some ceramic work in a fully-equipped workshop he built into his home in Pasadena's Arroyo Seco canyon.

Besides the ceramics workshop, Bischoff also built a large gallery and a painting studio at his canyon home, which itself was a work of art, done in Italian Renaissance style. His environment was a superb, open-air studio; views of canyon and mountain were depicted in many of his paintings, which were sometimes oil and sometimes tempera on canvas.

Associated with the Eucalyptus School, Bischoff won critical and public recognition almost as soon as he set

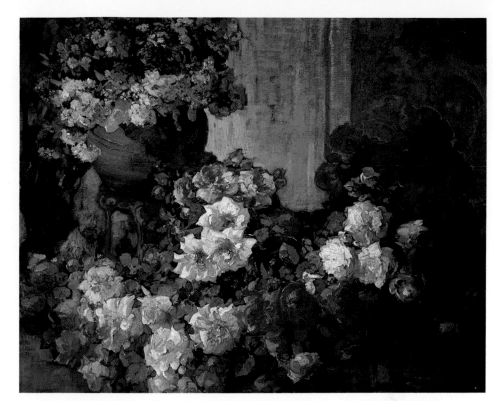

Roses, ca. 1912, 40 x 50, signed l.r. Private Collection, Photograph courtesy of Petersen Galleries, Beverly Hills, California.

color to canvas. He gradually expanded his explorations of the natural environment to the Sierra Nevadas, the coastal region and Northern California. The year before he died, he painted his last canvas, a bold portrayal in stunning colors of Zion National Park in Utah.

PUBLIC COLLECTIONS
Laguna Beach Museum of Art, California
Oakland Museum, California
Terra Museum of American Art, Evanston, Illinois

SEASON	75-76	76-77	77-78	78-79	79-80	80-81	81-82	82-83	83-84	84-85
Paintings					3	1	3	4	2	2
Dollars					$2,350	$750	$9,200	$6,650	$3,950	$2,150

Record Sale: $4,250, SPB, 6/29/82, "Milking Time," 19 × 26 in.

ELMER WACHTEL
(1864-1929)

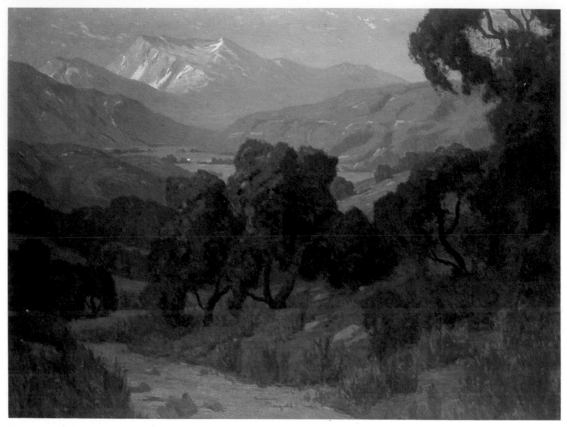

Upper Ojai Valley, California, 30 x 40 in., signed l.l. Courtesy of David and Sons Fine Arts, Laguna Beach, California.

Elmer Wachtel was one of the foremost Southern California landscape painters of the nineteenth and early twentieth centuries. Along with his wife, landscape painter Marion Kavanagh, Wachtel received an extraordinary amount of praise from contemporary critics.

Born in Baltimore in 1864, Wachtel was raised in Lanark, Illinois, and worked as a hired farm hand. In 1882, he moved to his brother's ranch in Los Angeles.

In Los Angeles Wachtel taught himself to play the violin and viola. By 1888,

he was the first violin in the Los Angeles Philharmonic Orchestra. Because he did not earn much as a violinist, he also worked as a store clerk in his brother's furniture store.

Wachtel began sketching still lifes in his spare time, and after saving enough money to go to New York, he studied at the Art Students League. He worked under William Merritt Chase, but left the school because he objected to its methods. He remained in New York and sketched the city streets, bringing his work in to be critiqued by Chase.

Wachtel then sailed to England and

completed his studies by working in a London art school for one year. When he returned to Los Angeles, he set up a studio in the back of his parents' house and began to devote himself to painting. In 1904, he married Marion Kavanagh and the two spent the next 25 years painting landscapes together.

Wachtel's subjects were usually the deserts, mountains and High Sierras of California, and occasionally the landscapes of other areas, such as Arizona and New Mexico. He painted primarily with oils and used impressionistic brushstrokes. His early works were tonalist with moody dark colors, while his later paintings were lighter in color and more decorative and lyrical in composition.

Wachtel died in 1929.

SEASON	75-76	76-77	77-78	78-79	79-80	80-81	81-82	82-83	83-84	84-85
Paintings							2	3	5	1
Dollars							$6,100	$4,650	$5,050	$800

Record Sale: $3,800, SPB, 10/3/81, "South Lake, High Sierras," 28 × 36 in.

PUBLIC COLLECTIONS
Laguna Beach Museum of Art, California

DE COST SMITH
(1864-1939)

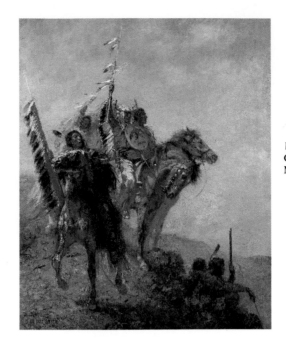

War Party, 1904, 37¼ x 30½ in., signed l.l. Courtesy of Vose Galleries of Boston, Inc., Massachusetts.

De Cost Smith was one of the group of late-nineteenth- and early-twentieth-century illustrators who compiled an exceptionally valuable pictorial record of the life and ways of the American Indian.

As a result of growing up close to an Indian reservation and traveling among the Indians in the West while still a young man, Smith developed sympathy and understanding which won him their confidence and respect. This, in turn, enabled him to paint them with accuracy and candor. He made many trips to visit various tribes, and with Edwin Willard Deming, another noted painter of Indians, collaborated on a noteworthy series of articles for *Outing Magazine.*

Smith was born in Skaneateles in Western New York State in 1864. As a boy he came to know the Indians at the nearby Onandaga Reservation, and eventually was initiated into the tribe. He studied art in New York City. After seeing the Indian paintings of George De Forest Brush, he decided that he too would become a painter of Indians.

He made his first trip to sketch Indians in what was still the Dakota Territory in 1884. In time he became so interested in Indian culture that he learned to speak several dialects.

Later, Smith went to Paris to study at the Academie Julien. While there, he exhibited some of his earliest Indian paintings at the Paris Salon. Before his death in 1939, he illustrated many articles on the American West for such leading magazines as *Century.* It is for his Indian paintings, however, that he was best known.

Winter Hunt, 23 x 30 in., signed l.r. Courtesy of Vose Galleries of Boston, Inc., Massachusetts.

MEMBERSHIPS
American Ethnological Society
Salmagundi Club

PUBLIC COLLECTIONS
American Museum of Natural History,
 New York City
Museum of the American Indian, New York City

SEASON	75-76	76-77	77-78	78-79	79-80	80-81	81-82	82-83	83-84	84-85
Paintings					1		1			
Dollars					$1,500		$800			

Record Sale: $1,500, SPB, 6/24/80, "Moving Camp," 15 × 21 in.

CHARLES HERBERT WOODBURY
(1864-1940)

Charles Herbert Woodbury, a marine painter and etcher, was born in Lynn, Massachusetts in 1864. He received an engineering degree from Massachusetts Institute of Technology in 1886, but abandoned the profession for painting soon after graduation.

He made several trips abroad, and studied under Boulanger and Lefebvre at the Academie Julien in Paris in 1891.

Woodbury established a studio in Boston. He also painted during the summer at Perkins Cove, near Ogunquit, Maine, where he conducted a school for more than 30 years. He also was a visiting lecturer at Dartmouth College, Wellesley College and the Art Institute of Chicago.

The coast near his summer studio inspired many of his seascapes, including *Ogunquit, Maine* (date unknown, Metropolitan Museum of Art) and *The North Atlantic* (date unknown, Worcester Art Museum).

Woodbury received many prizes and awards for his watercolors, oils and etchings. He won a gold medal in oil painting at the 1915 Panama-Pacific Exposition in San Francisco, as well as a medal of honor in watercolor. He was elected to full membership by the National Academy of Design in 1907.

Woodbury was a respected instructor and art educator. In 1919, he wrote *Painting and Personal Equation* with E.W. Perkins. He also wrote *The Art of Seeing* in 1925.

Woodbury died in Boston in 1940.

Boat in Marshy Inlet, 10 x 14 in., signed l.r. Courtesy of Arvest Galleries, Inc., Boston, Massachusetts.

Three Umbrellas, 20 x 27 in. Courtesy of Vose Galleries of Boston, Inc., Massachusetts.

MEMBERSHIPS
American Watercolor Society
Boston Water Color Club
National Academy of Design
New York Water Color Club
Society of American Artists
Society of American Etchers

PUBLIC COLLECTIONS
Carnegie Institute, Pittsburgh
Corcoran Gallery of Art, Washington, D.C.
Detroit Institute of Arts
Library of Congress, Washington, D.C.
Metropolitan Museum of Art, New York City
Museum of Fine Arts, Boston
Rhode Island School of Design, Providence
St. Louis Art Museum
Telfair Academy of Arts and Sciences, Savannah, Georgia
Worcester Art Museum, Massachusetts

SEASON	75-76	76-77	77-78	78-79	79-80	80-81	81-82	82-83	83-84	84-85
Paintings	1		1	1	6	4	5	2	4	10
Dollars	$2,600		$500	$325	$9,080	$6,800	$4,125	$1,200	$3,000	$15,850

Record Sale: $3,800, S.BM, 5/15/85, "View of Boston Common," 23 x 19 in.

JOHN LEON MORAN
(1864-1941)

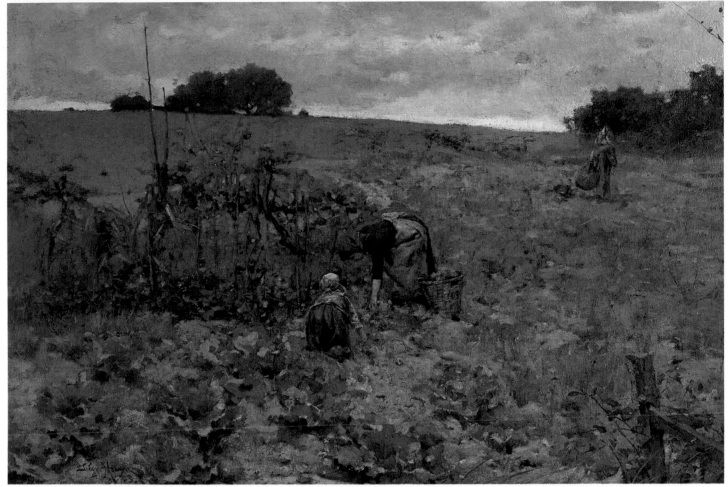

Cabbage Pickers, 18 x 26 in., signed l.l. Photograph courtesy of Vose Galleries of Boston, Massachusetts.

It might be said that John Leon Moran, figure and landscape painter, came by his art naturally. His father and four uncles all were painters and etchers, as were his brothers, Percy and Peter.

Born in 1864 in Philadelphia, Moran received his first art instruction from his father, British-born painter Edward Moran. He then moved to New York City, where he studied at the National Academy of Design.

Moran made several trips to Europe in the late 1870s, before establishing a stu-dio in New York City in 1883. The Euro-pean trips enabled Moran to study art in innumerable continental studios, gal-leries and museums.

For a number of years, Moran painted exclusively in watercolor. In the mid-1880s, he traveled to Virginia, where, like artists Jacob O. Ward and David Johnson, he studied and painted that state's Natural Bridge. His *Natural Bridge, Virginia, 1885* hangs in the Gov-ernor's Mansion in Richmond.

However, Moran was best known as a figure painter, and many of his early landscapes are critically regarded as inferior to the bulk of his work.

Frequently exhibited by the National Academy of Design and New York's American Water Color Society, Moran received his first artistic award in 1893 from the Art Club of Philadelphia. A second award followed 11 years later—a gold medal from the American Art Soci-ety in Philadelphia.

Moran died in Watchung, New Jersey in 1941.

SEASON	75-76	76-77	77-78	78-79	79-80	80-81	81-82	82-83	83-84	84-85
Paintings	2			1	2	1	1	1	2	2
Dollars	$1,850			$575	$7,800	$8,000	$4,500	$1,600	$2,000	$2,850

Record Sale: $8,000, BB.SF, 1/21/81, "Gypsies," 30 × 48 in.

MEMBERSHIPS
American Water Color Society
Plainfield Art Association

583

LOUIS MICHEL EILSHEMIUS
(1864-1941)

The visionary paintings of Louis Michel Eilshemius attracted little notice until after he had stopped painting them.

The disciplined impressionist landscapes of his early career, in the 1880s and 1890s, gained some modest success. But shortly before 1900, Eilshemius's technique became sketchy, even feathery, representative of no artistic period or tradition. His increasingly eccentric subjects were drawn from dreams and nightmares, echoing the disintegration of his personality.

Eilshemius was born in 1864 at the family estate near Arlington, New Jersey. He was educated in Geneva, Switzerland and Dresden, Germany. He also studied agriculture at Cornell University from 1882 to 1884.

He studied art for the next four years, first at the Art Students League in New York City, later at the Academie Julien in Paris and with landscapist Joseph Van Luppen in Antwerp.

A few of Eilshemius's landscapes, whose effects of clear light are in the barbizon mode, were accepted for exhibit by the National Academy of Design and the Philadelphia Academy of the Fine Arts. However, Eilshemius did not receive the public and critical attention he thought he deserved. His entry for the 1893 World's Columbian Exposition was turned down and his 1897 gallery exhibition was ignored. His isolation and eccentricity, fed by bitterness, began to govern his work and life.

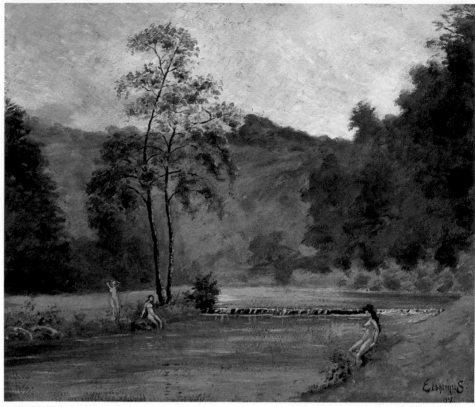

Three Girls and River, 1907, 23 x 27 in., signed l.r. Courtesy of National Museum of American Art, Smithsonian Institution, Gift of Louis and Annette Kaufman.

Eilshemius became obsessed with speed. It is said he completed 3,000 paintings between 1882 and 1920. He besieged dealers with paintings in the ever more exaggerated primitivism of his new style, signing them with a changed spelling, "Elshemius."

Periodically, Eilshemius was preoccupied with poetry, letters to newspapers and prose (he had 30 books printed at his own expense). Drawing his inheritance, he traveled extensively. The South Seas provided themes for paintings between 1905 and 1909.

After a failed studio exhibition in 1909, Eilshemius's delusions took over. He called himself "Mahatma, Mightiest of the Mighty," and passed out leaflets listing grandiose accomplishments.

Marcel Duchamp praised Eilshemius's *Supplication* (date and location unknown) at a 1917 exhibition, but the embittered artist stopped painting in 1921.

Recognition came in the early 1930s, when his work was acquired by several leading museums, but Eilshemius could not benefit from it. He was left an invalid by a 1932 automobile accident. Ill and impoverished, he died at New York City's Bellevue Hospital in 1941.

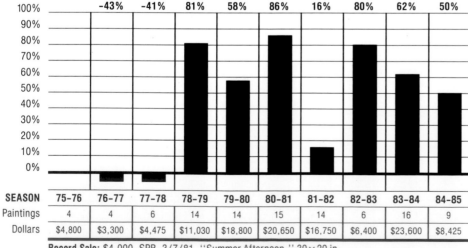

10-Year Average Change From Base Years '75-'76: 35%

SEASON	75-76	76-77	77-78	78-79	79-80	80-81	81-82	82-83	83-84	84-85
		-43%	-41%	81%	58%	86%	16%	80%	62%	50%
Paintings	4	4	6	14	14	15	14	6	16	9
Dollars	$4,800	$3,300	$4,475	$11,030	$18,800	$20,650	$16,750	$6,400	$23,600	$8,425

Record Sale: $4,000, SPB, 3/7/81, "Summer Afternoon," 30 × 20 in.

MEMBERSHIPS
Modern Art Association
American Federation of Arts
Salmagundi Club
Salons of America
Societe Anonyme

PUBLIC COLLECTIONS
Hirshhorn Museum and Sculpture Garden,
 Washington, D.C.
Metropolitan Museum of Art,
 New York City
Museum of Modern Art, New York City
Phillips Collection, Washington, D.C.
Whitney Museum of American Art,
 New York City

GEORGE HENRY BOGERT
(1864-1944)

George Henry Bogert, often confused with painter George Hirst Bogart (1864 to 1923), was a landscape artist, born in New York City in 1864.

He began his studies at the National Academy of Design in the early 1880s. In 1884, he traveled to Paris, where he studied with such prominent artists as Puvis de Chavannes, Raphael Collin and Aime Morot.

After a four-year hiatus he returned to the United States, continuing his studies under Thomas Eakins in New York from 1888 to 1895.

In the 1890s, Bogert again sojourned in Europe, painting landscapes of Venice, the Isle of Wight and particularly Etaples (in Northern France), where he was taught and influenced by plein-air landscapist Eugene Boudin.

Like Boudin, Chavannes and Turner, Bogert employed loose brushwork and the use of cool blue tones to achieve blurred form and soft half-light effects, further accentuated by the application of dense impasto.

Much of his later work seems to emulate the soft-focus photography which evolved at the turn of the century, demonstrating that either camera or brush could produce synthesized and interpretive views of nature.

Although his works were often romantic, Bogert did not execute his work with sentimental subjectivity. Nor did he adhere to stark objectivity. Rather, he incorporated elements of

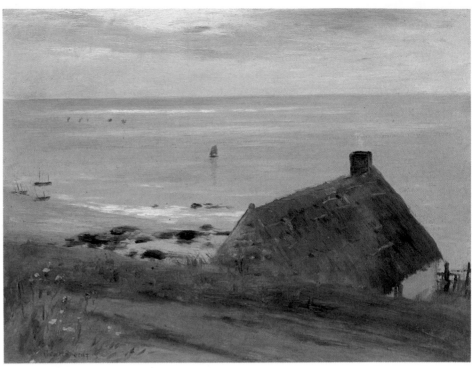

Irish Seascape, 12 x 16 in., signed l.l. Courtesy of La Salle University Art Museum, Philadelphia, Pennsylvania, Given by Donald E. Smith.

each. Bogert identified himself with the barbizon landscape painters.

September Evening (1898, Metropolitan Museum of Art), one of Bogert's most successful works, is representative of his tonalist style. The *Art Interchange* of May 1899 said it was "one of the most tender and beautiful landscapes that has come from his easel."

Despite Bogert's growing appeal in the late 1880s, little is known of him after the turn of the century, except that he made several summer painting expeditions to Holland. He finally settled into the artists' colony at Old Lyme, Connecticut.

Bogert died in New York City at age 80, after a brief illness.

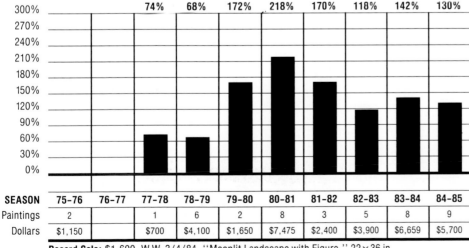

10-Year Average Change From Base Years '75-'76: 121%

	75-76	76-77	77-78	78-79	79-80	80-81	81-82	82-83	83-84	84-85
			74%	68%	172%	218%	170%	118%	142%	130%
SEASON	75-76	76-77	77-78	78-79	79-80	80-81	81-82	82-83	83-84	84-85
Paintings	2		1	6	2	8	3	5	8	9
Dollars	$1,150		$700	$4,100	$1,650	$7,475	$2,400	$3,900	$6,659	$5,700

Record Sale: $1,600, W.W, 3/4/84, "Moonlit Landscape with Figure," 22 x 36 in.

WILLIAM RITSCHEL
(1864-1949)

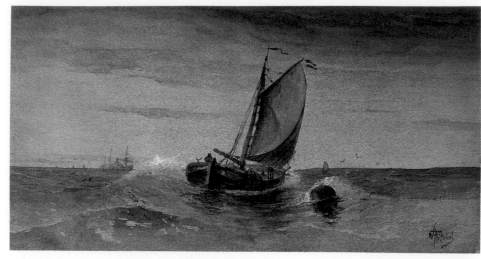

Fishing Off the Coast, 14 x 26 in., signed l.r. Courtesy of Raydon Gallery, New York, New York.

William Ritschel was a noted marine painter whose seascapes drew on both his technical training as an artist and his experiences as a sailor.

Ritschel was born in Nuremberg, Germany in 1864. He studied under Friedrich August von Kaulbach and Karl Raupp at the Royal Academy in Munich for six years. He also traveled the world as a sailor. In 1895, he left Germany and, after spending time in France and Italy, settled in New York City.

Working first in watercolor and later in oil, Ritschel was exhibiting in national shows by 1914. He received a number of awards and was a member of many artists' organizations. His reputation was built on his expressive treatments of the sea, such as *Rocks and Breakers* (date unknown, Pennsylvania Academy of the Fine Arts) and *Inrush of the Tide* (date unknown, Albright-Knox Art Gallery).

By 1911, Ritschel was exhibiting in California; he may have moved to that state as early as 1909. By 1918, he had constructed a stone studio-home in Carmel Highlands, overlooking the Pacific Ocean, where he was to live for the rest of his life.

He was given a one-man exhibition in Oakland in 1931, and another in Los Angeles in 1942. Two paintings shown at the latter were singled out for special praise by Arthur Millier of the *Los Angeles Times: Song of the Sea* (date and location unknown) was described as

"playful" and "lyrical," while *Carmel Highlands Coast* (date and location unknown) was termed "powerful" and "dramatic," and was cited for the painter's use of light to capture the conflict between sun and fog.

Ritschel traveled to the South Seas, the Orient and Capri. He continued to paint until his death in Carmel in 1949.

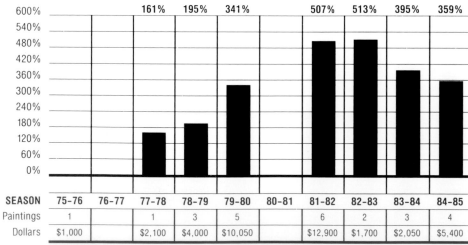

10-Year Average Change From Base Years '75-'76: 309%

SEASON	75-76	76-77	77-78	78-79	79-80	80-81	81-82	82-83	83-84	84-85
			161%	195%	341%		507%	513%	395%	359%
Paintings	1		1	3	5		6	2	3	4
Dollars	$1,000		$2,100	$4,000	$10,050		$12,900	$1,700	$2,050	$5,400

Record Sale: $6,250, SPB, 6/24/80, "Coral Reefs, Glorious Pacific," 30 × 40 in.

586

ERNEST L. MAJOR
(1864-1951)

Born in Washington, D.C. in 1864, Ernest L. Major studied at the Art Students League in New York City, and with Boulanger and Lefebvre in Paris. For most of his life he identified with Boston, where he maintained a studio and taught at the Massachusetts School of Art. His subjects included figure studies, portraits, still lifes and landscapes.

Among the characteristics of Major's work, his ability with composition and design was noted by critics. Contrived backgrounds lending themselves to flamboyant colors were used repeatedly. He strongly preferred artificial to natural light.

In *Nineteen-Nineteen* (date and location unknown), a mantel shelf with a porcelain parrot and other decorative ornaments are combined with the central subject, a colorfully dressed girl, while not overwhelming the subject.

His *Shower of Gold* (date and location unknown) utilizes many features of his distinctive style. The central subject is a nude reclining on a tiger-skin rug, positioned with her head toward the viewer. The foreshortening required in the face and body is nicely executed. The subject is endowed with a cascade of beautiful golden-red hair. The tiger's head is painted in excellent detail. Carefully detailed roses are scattered about. Lights and shadows are dramatic. Dark, spangled draperies are in the background.

Major's work could be termed dramatic and decorative, blended with colorful individuality. His long life ended in 1951.

MEMBERSHIPS
Boston Art Club
Guild of Boston Artists

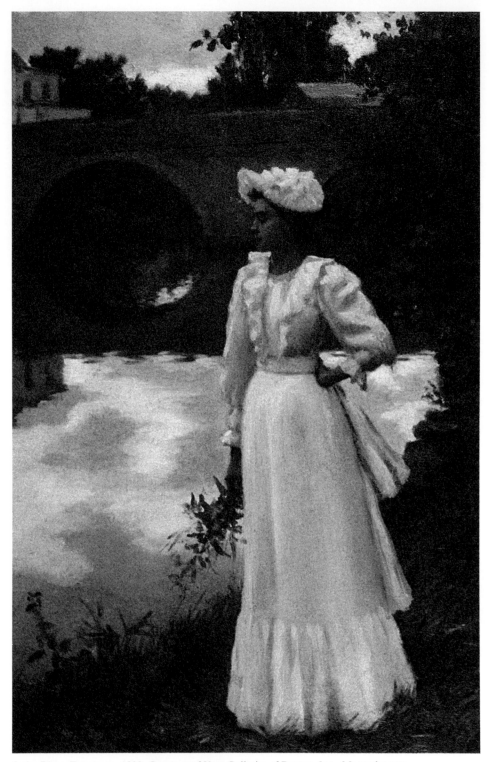

Loire River, France, ca. 1890. Courtesy of Vose Galleries of Boston, Inc., Massachusetts.

SEASON	75-76	76-77	77-78	78-79	79-80	80-81	81-82	82-83	83-84	84-85
Paintings		1	1						13	
Dollars		$1,100	$1,400						$16,350	

Record Sale: $2,800, S.BM, 11/17/83, "Portrait of Artist's Wife," 24 × 18 in.

CARLE J. BLENNER
(1864-1952)

Carle J. Blenner's enduring success, first as an international society portraitist and later as a painter of floral still lifes, rested firmly on a precocious talent and impeccable training.

Born in 1864 in Richmond, Virginia, Blenner was educated at Marburg, Germany and was graduated from the Yale University Art School.

He studied for six years at the Academie Julien in Paris, under Bouguereau, Robert-Fleury and Aman-Jean. He first exhibited at the Paris Salon in 1887, at age 23, and for the next three years. From the 1890s, he maintained a working studio for more than 50 years on 57th Street in New York City.

Blenner was in demand as a portraitist of the wealthy, titled and famous—particularly women. His subjects included Lady Hamilton, granddaughter of the Duke of Cambridge; Mrs. Raymond White; Lady Chetwynde; and Mme. Nordica, Isabel Irving and Evelyn Nesbitt of the theater. His male portraits were of such personages as the Duke of Cambridge, the Earl of Yarmouth, Richard Henning and Henry Clay Pierce.

Blenner turned to still-life studies of flowers, probably about 1915, and continued to reap awards for these and other works—the last in 1932, when he was 70.

His florals reflect his superb training. However, his own sense of textures and his superior use of pigment in the service

Portrait of Arturo Toscanini, 1902, 15½ x 11½ in., signed u.l. Photograph courtesy of Hirschl & Adler, Inc., New York, New York.

Studio Model, 28¾ x 25¾ in., signed l.r. Courtesy of Grand Central Art Galleries, Inc., New York, New York.

of light create not only unlabored representations, but revelations of the flowers' essence.

Blenner died in New Haven, Connecticut in 1952, at age 90.

MEMBERSHIPS
American Federation of Arts
Connecticut Academy of Fine Arts
Greenwich Art Association
New Haven Paint and Clay Club
Newport Art Association, Rhode Island
Salmagundi Club, New York City
Washington Arts Club, Washington, D.C.

PUBLIC COLLECTIONS
Fort Worth Art Museum
Houston Museum of Fine Arts
Rutgers University, New Brunswick, New Jersey
University of Vermont, Burlington

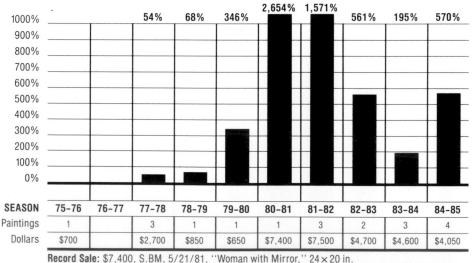

10-Year Average Change From Base Years '75-'76: 669%

		54%	68%	346%	2,654%	1,571%	561%	195%	570%	
SEASON	75-76	76-77	77-78	78-79	79-80	80-81	81-82	82-83	83-84	84-85
Paintings	1		3	1	1	1	3	2	3	4
Dollars	$700		$2,700	$850	$650	$7,400	$7,500	$4,700	$4,600	$4,050

Record Sale: $7,400, S.BM, 5/21/81, "Woman with Mirror," 24 x 20 in.

588

WARREN B. DAVIS
(1865-1928)

Like Frank W. Benson in Boston, Warren B. Davis had two careers in art, first as a painter and then, when he was past middle age, as an etcher. In his early years, he was known primarily for his paintings and pastels of neoclassical goddesses and dancing maidens, draped and undraped. Many of these were reproduced as covers and illustrations for *Vanity Fair.* He executed several murals on the same theme that were known for their rhythm, balance and beauty. His etchings followed in the same poetic vein, with such evocative titles as *Evening, Crescent* and *Nocturne.*

Davis was born in New York City in 1865. As a boy he studied the piano seriously, but gave it up in favor of painting. Throughout his life, however, he continued to devote most of his leisure hours to playing the piano. He got his training as a painter at the Art Students League.

Graceful, auburn-haired nymphs, dancing against backgrounds of russet, black or gold, early became his specialty. Some critics at the time thought that the fluidity with which he painted the filmy draperies of his female figures had never been equalled.

Davis never touched a copper plate or an etcher's needle until he was 50. When he decided to learn etching, however, he applied himself as seriously as he had with paint and pastels. His etchings

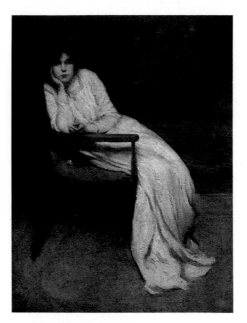

Studio Reflections, 26 x 20 in. Courtesy of Grand Central Art Galleries, Inc., New York, New York.

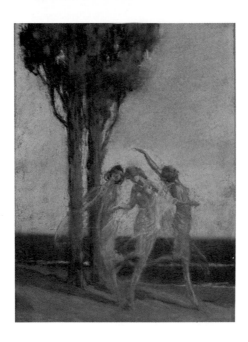

The Three Graces, 15½ x 11¾ in., signed l.l. Courtesy of Marbella Gallery, Inc., New York, New York. Photograph by Richard Haynes.

proved even more popular than his earlier work. They sold well both in this country and abroad.

Davis died at his home in Brooklyn in 1928.

MEMBERSHIPS
Allied Artists of America
Salmagundi Club

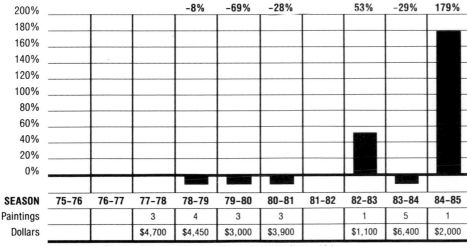

10-Year Average Change From Base Years '77-'78: 14%

				-8%	-69%	-28%		53%	-29%	179%
SEASON	75-76	76-77	77-78	78-79	79-80	80-81	81-82	82-83	83-84	84-85
Paintings			3	4	3	3		1	5	1
Dollars			$4,700	$4,450	$3,000	$3,900		$1,100	$6,400	$2,000

Record Sale: $2,800, SPB, 10/27/78, "Woman in White," 14 × 10 in.

589

ROBERT HENRI
(1865-1929)

Robert Henri was an early-twentieth-century portrait and cityscape painter who, as the leader of the Ashcan School, inspired two generations of artists between the World Wars.

Henri was instrumental in breaking the hold of traditionalists on the world of art. He painted ordinary and exotic people, rather than the social elite, and his paintings of city streets and urban slums helped inaugurate the modern era.

Henri was born Robert Henry Cozad and given the name of Robert Henri by his father, a gambler who shot a man in a fight and had to flee for his life from a lynching mob. Henri revered his father and emulated his flair for life. His studio was not only a lecture hall where Henri espoused his philosophy of life and art, but a beer hall where he and his followers played poker and held indoor scrimmages with pots of spaghetti.

Raised in the midwestern states of Ohio and Nebraska, Henri later moved to Atlantic City, New Jersey. He trained at the Pennsylvania Academy of the Fine Arts, where he became a devotee of Thomas Eakins and a student of Thomas Anshutz, picking up the thread of realism started by Eakins.

In 1888, Henri traveled to Paris, where he studied at the Academie Julien and at the Ecole des Beaux-Arts. He temporarily adopted impressionistic techniques, but by the mid-1890s he had abandoned them for the darker tonal qualities of Hals, Velazquez and

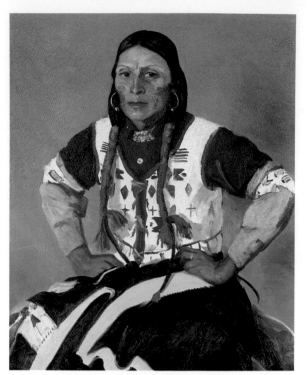

Indian Portrait, 40 x 32 in., signed l.l. Photograph courtesy of The Gerald Peters Gallery, Santa Fe, New Mexico.

Rembrandt—colors more suited to the leader of the urban realists.

Despite their subject and tone, Henri's paintings are not morose, nor do they carry a social message. On the contrary, they sparkle with life, reflecting Henri's conviction that human dignity and joy can be found anywhere. Many of his portraits were of children.

Henri attacked his canvases aggressively, focusing on personality, gesture and glance, rather than anatomy. He painted as rapidly as he could with single, dramatic brushstrokes, suggesting rather than defining the forms. His aim was to capture feeling and sensation—the spirit of life—rather than to compose well-designed canvases.

Henri's landscape paintings express

the artist's emotional responses to the moods of nature. His portraits are marked by expressive faces and eyebrows; he could suggest a piece of clothing with a dab of color.

A vocal and forceful man, Henri led a generation of artists to break away from conservative traditions and to reject the elite, academic subject matter of his day. In Philadelphia and later in New York City, his studio became a center of activity, attracting Glackens, Luks, Sloan and Shinn, as well as many other young artists inspired by the new realism. He taught at the New York School of Art, among others, as well as at a school established under his own name.

In 1908, he organized an exhibition of paintings by The Eight, which shocked the conservative art world with its strong realism. Hundreds flocked to view the revolutionary work. Critics called the group the "black gang"; they were later to be known as the Ashcan School.

MEMBERSHIPS
National Academy of Design
Art Students League
National Institute of Arts and Letters

PUBLIC COLLECTIONS
Art Institute of Chicago
Brooklyn Museum
Carnegie Institute, Pittsburgh
Carolina Art Association, Charleston
Dallas Art Association
Fine Arts Gallery, Columbus, Ohio
Kansas City Art Institute
Metropolitan Museum of Art, New York City
New Orleans Art Association
Pennsylvania Academy of the Fine Arts, Philadelphia
San Francisco Institute

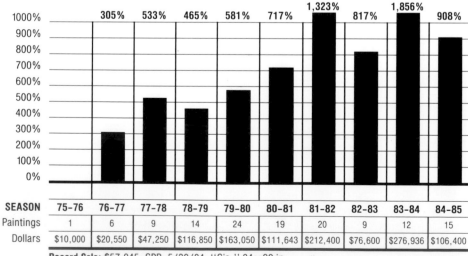

10-Year Average Change From Base Years '75-'76: 751%

| | 305% | 533% | 465% | 581% | 717% | 1,323% | 817% | 1,856% | 908% |

SEASON	75-76	76-77	77-78	78-79	79-80	80-81	81-82	82-83	83-84	84-85
Paintings	1	6	9	14	24	19	20	9	12	15
Dollars	$10,000	$20,550	$47,250	$116,850	$163,050	$111,643	$212,400	$76,600	$276,936	$106,400

Record Sale: $57,045, SPB, 5/30/84, "Sis," 24 × 20 in.

PHILIP L. HALE
(1865-1931)

Painter, teacher and writer, Philip Leslie Hale is recognized for his decorative paintings of the female figure. His technique is derived from the impressionists and suggests the influence of French impressionist Edgar Degas.

Born in Boston in 1865, he was the son of a clergyman and patriotic writer, the Reverend Edward Everett Hale.

Philip Hale studied with J. Alden Weir at the Art Students League in New York City, and then went to Paris for further studies at the Academie Julien and the Ecole des Beaux-Arts.

While in France, he lived at Giverny and knew Claude Monet well. Traveling throughout Europe, Hale visited the major museums, and copied the works of Ingres, Vermeer, Watteau and Michelangelo.

After studying abroad for 15 years, Hale returned to America around 1895, and was given a one-man show in New York City.

Like many artists, Hale underwent stages in his choice of subjects. In the 1890s, he painted sporting scenes. He then turned to studies of women and painted them in the nude, in landscapes and indoors. During the 1920s, he painted larger allegorical subjects, reflecting the theme of man versus the overwhelming forces of nature. He also painted portraits.

Hale taught at the Boston Museum School for many years, where he also studied with teacher and painter Edmund C. Tarbell. He also spent a few years teaching at the Pennsylvania Academy of the Fine Arts.

Hale was known as a teacher who did not encourage questions from his students about his paintings or private life. He was more interested in painting universal human situations than in the character of the individuals.

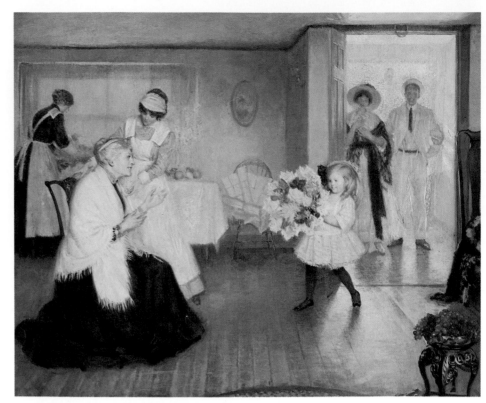

Grandmother's Birthday, 30 x 36 in., signed l.l. Courtesy of Vose Galleries of Boston, Inc., Massachusetts.

He died in Boston in 1931, of a ruptured appendix. Boston's famed Vose Galleries held a retrospective exhibition of Hale's work in 1966.

MEMBERSHIPS
Fellowship of the Pennsylvania Academy
 of the Fine Arts
Guild of Boston Artists
National Academy of Design
National Arts Club
National Association of Portrait Painters
Philadelphia Art Club
St. Bololph Club
San Francisco Art Club

PUBLIC COLLECTIONS
Cooper-Hewitt Museum, New York City
Corcoran Gallery of Art, Washington, D.C.
Delaware Art Museum, Wilmington
Pennsylvania Academy of the Fine Arts,
 Philadelphia

SEASON	75-76	76-77	77-78	78-79	79-80	80-81	81-82	82-83	83-84	84-85
Paintings		1	1	1	1		2		2	
Dollars		$9,500	$1,200	$2,000	$9,000		$9,700		$15,500	

Record Sale: $9,500, PB, 4/21/77, "The Rub Down," 48 × 30 in.

WILLIAM S. HORTON
(1865-1936)

William S. Horton was a gifted impressionist who was little-known in his time, but whose oils, pastels, watercolors and drawings are highly valued today. They are exhibited in leading American and European museums and art galleries.

Horton was born into a wealthy family in Grand Rapids, Michigan in 1865. While still in his early teens, he left his academic schooling to study at the Art Institute of Chicago, and then at the Art Students League and the National Academy of Design in New York City. Next, he studied under Benjamin Constant at the Academie Julien in Paris; it was under Constant that his unique style of impressionism began to emerge. Horton used vivid colors, while those of other impressionists were muted.

Horton first exhibited at the Salon des Artistes Francaises. He was encouraged when one of his paintings won a gold medal at Nantes in 1904 and a bronze at Orleans in 1905 in provincial salons.

Since he was financially secure, Horton was never forced to sell his paintings. He was, however, his own taskmaster, and painted on a strict schedule to satisfy his own sense of accomplishment.

Since Horton rarely sold a painting, when he died in Paris in 1936 a great many of his works were bequeathed to his son, W. Gray Horton, who had no need to sell them either. They were not put on the auction block, and for this reason the works of William S. Horton

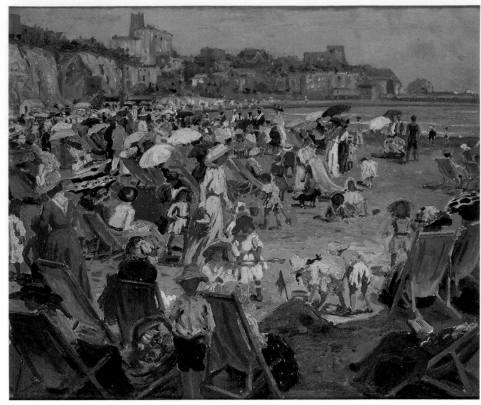

Beach Scene, signed l.r. Courtesy of Vose Galleries of Boston, Inc., Massachusetts.

are modestly priced compared to those of other impressionists of his time. There is, however, a growing group of collectors who would prefer a Horton painting to one by one of his contemporaries.

10-Year Average Change From Base Years '76-'77: 53%

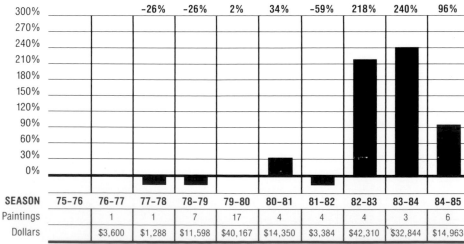

SEASON	75–76	76–77	77–78	78–79	79–80	80–81	81–82	82–83	83–84	84–85
(% change)			-26%	-26%	2%	34%	-59%	218%	240%	96%
Paintings		1	1	7	17	4	4	4	3	6
Dollars		$3,600	$1,288	$11,598	$40,167	$14,350	$3,384	$42,310	$32,844	$14,963

Record Sale: $37,000, SPB, 6/2/83, "Concert on the Sand, Hythe," 25 × 30 in.

592

GRACE CARPENTER HUDSON
(1865-1937)

A genre painter who specialized in paintings and illustrations of American Indians, Grace Carpenter Hudson was born in Potter Valley, California.

She began studying art at age 13 and progressed so rapidly that two years later she won the Alvord Gold Medal from the San Francisco Art Association for a figure drawing. She continued to study at the Mark Hopkins Institute in San Francisco under Virgil Williams.

The artist settled in Ukiah, California, where she painted, taught and created illustrations for such magazines as *Sunset, Cosmopolitan* and *Western Field*. In 1890, she married John Hudson, a physician who eventually gave up his practice to do research and writing on the language and art of the Pomo Indians of Mendocino County. He also acted as Pacific Coast ethnologist for the Field Museum of Natural History in Chicago.

In 1893, Hudson exhibited paintings of her favorite Pomo subjects in the Women's Department of the California State Building at the World's Columbian Exposition in Chicago. In 1901, she spent nearly a year in Hawaii, painting native children.

Then, in 1904, Hudson was commissioned by the Field Museum in Chicago to paint a series of pictures of the Pawnee Indians of Oklahoma. Of this series, the best known was her portrait of Eagle Chief, the leader of four Pawnee tribes and an honored guest of Theodore Roosevelt at the White House. In 1905, she and her husband made the first of two extended tours of Europe to visit museums and galleries.

The artist had a special talent for capturing the volatile moods of childhood. Her work has a quiet enchantment and an abiding realism. It is also considered an important historical, if sometimes too sentimental, record of the Pomo Indians.

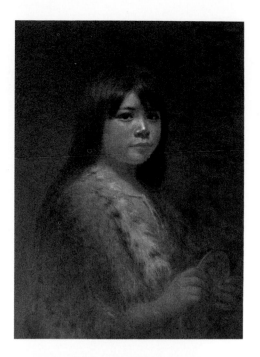

Indian Woman (A Daughter of the Quail-Woman), 1918, 22 x 16 in., signed l.l. Courtesy of Monterey Peninsula Museum of Art, California.

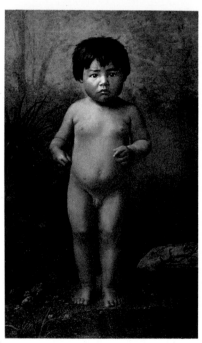

The Interrupted Bath—Quail Baby, 1892, 38 x 33 in., signed l.r. Courtesy of Monterey Peninsula Museum of Art, California.

PUBLIC COLLECTIONS
Field Museum of Natural History, Chicago
Oakland Museum, California
National Gallery of Art, Washington, D.C.

SEASON	75-76	76-77	77-78	78-79	79-80	80-81	81-82	82-83	83-84	84-85
Paintings		1	3	10	5	8	9	4	4	2
Dollars		$3,200	$34,500	$85,350	$5,235	$109,100	$143,500	$24,600	$10,700	$11,509

Record Sale: $33,000, SPB, 10/22/81, "Ray of Light," 16 × 10 in.

SYDNEY LAURENCE
(1865-1940)

Sydney Laurence was a painter and adventurer best known for his landscapes of Mt. McKinley and other scenes of the Alaskan frontier. Having painted most of his known work between 1912 and 1940, Laurence has been called one of the last of the Rocky Mountain School of landscape artists.

Born in Brooklyn, Laurence is said to have run off to sea in his teens, and to have returned to New York after several years as a seaman. Sometime in the 1880s, he enrolled in the National Academy of Design, where he studied under Edward Moran. In 1889, he traveled to Paris and entered the Ecole des Beaux Arts.

During the next 10 years, Laurence painted in both England and France, maintaining a residence at St. Ives, a fishing village on the coast of Cornwall. Working primarily as a marine painter, Laurence exhibited paintings at the Royal Academy of Arts in London and the Paris Salon of 1894, receiving an honorable mention at the latter for *Setting Sun, Coast of Cornwall* (date and location unknown).

By 1898, Laurence had returned to New York City, where he exhibited his work at the National Academy of Design. He became a war correspondent for several years, covering the Spanish-American War for the *New York Herald* and working for the English journal *Black and White* during the Boer War and the Boxer Rebellion.

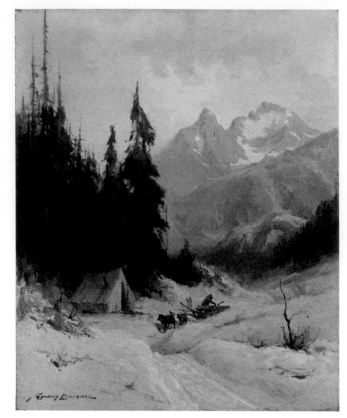

Alaska Trail, 20 x 16 in., signed l.l. Courtesy of Green's Show Print, Los Angeles, California.

By 1903, Laurence had abandoned his correspondent's and painting careers to follow the gold rush to Alaska, where he supported himself for 10 years in odd jobs as cook, carpenter, photographer and part-time gold prospector.

Laurence renewed his career as a landscape painter only after 1912, when he was able to finance a painting expedition to Mt. McKinley, which was at that time unclimbed and unpainted. From this expedition, Laurence returned with some 40 color sketches, which he repainted on larger canvases over the following year.

Laurence exhibited his work successfully at the 1915 Panama-Pacific Exposition in San Francisco. The same year, his backers purchased two large canvases, which were subsequently hung in the National Museum of American Art of the Smithsonian Institution.

For the remainder of his career, Laurence enjoyed the patronage of art collectors on the East and West coasts. By 1925, he could afford to open a winter studio in Los Angeles, where he continued to paint much of his work on Alaskan subjects. He remained active until his death in 1940 in Seattle.

MEMBERSHIPS
Royal Society of British Artists
Salmagundi Club

PUBLIC COLLECTIONS
Anchorage Historical and Fine Arts Museum, Alaska
Alaska Bank of Commerce, Anchorage

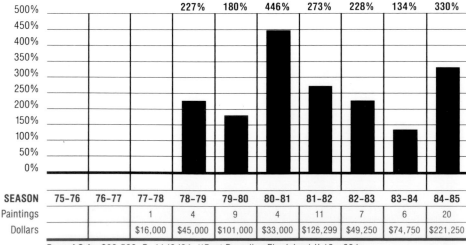

10-Year Average Change From Base Years '77-'78: 227%

SEASON	75-76	76-77	77-78	78-79	79-80	80-81	81-82	82-83	83-84	84-85
				227%	180%	446%	273%	228%	134%	330%
Paintings			1	4	9	4	11	7	6	20
Dollars			$16,000	$45,000	$101,000	$33,000	$126,299	$49,250	$74,750	$221,250

Record Sale: $32,500, B, 11/8/84, "Boat Rounding Fire Island," 16 × 20 in.

RODERICK D. MacKENZIE

(1865-1941)

Roderick MacKenzie was a versatile painter whose work ranged from oil portraits, landscapes and scenes of the imperial splendor of British India in its heyday, to a series of pastels showing the industrial might of the steel mills of Alabama. He handled all subjects with equal finesse. He also did etchings, and was commissioned to do eight large murals and bas-relief panels for the Alabama State House.

MacKenzie was born in London in 1865. He came by his bent for colorful pageantry naturally because his father was a painter of heraldry and carriages. When he was seven, however, his family moved to Mobile, Alabama. He received his art training at the School of the Museum of Fine Arts in Boston, and then the Academie Julien and the Ecole des Beaux Arts, both in Paris.

From 1893 until 1913, MacKenzie lived and worked most of the time in India. His paintings of such splendid occasions as the coronation of King Edward VII and the state entry into Delhi during the durbar of 1903 were widely acclaimed. His portraits of various potentates were applauded when they were exhibited in London and Paris.

He left the pomp of India behind in 1913, however, and returned to Alabama, where he lived until his death in 1941. He was fascinated by the drama of the steel industry that was beginning to transform the South. Working at various sites at night, he caught the contrast of cavernous, dark interiors of mills suddenly brilliantly illuminated by white-hot molten metal being poured and shaped. His work was praised by art critics and steel industrialists alike.

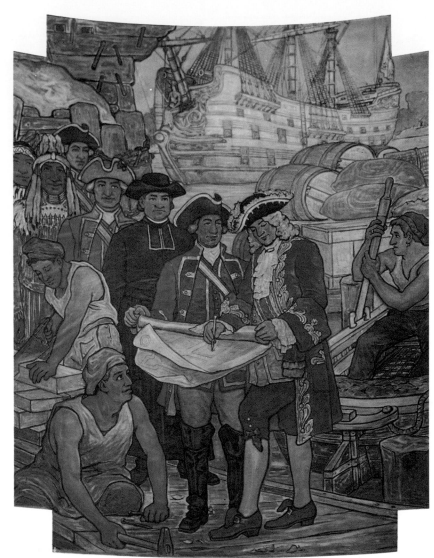

From a mural in the rotunda of the Alabama State Capitol, *The Founding of Mobile,* featuring d'Iberville and Bienville. Courtesy of the Alabama Department of Archives and History, Montgomery, Alabama.

MEMBERSHIPS
Alabama Hall of Fame
American Federation of Arts
Royal Society of Arts, London

PUBLIC COLLECTIONS
Alabama State House, Montgomery
Indian Museum, Calcutta

SEASON	75-76	76-77	77-78	78-79	79-80	80-81	81-82	82-83	83-84	84-85
Paintings						1				
Dollars						$12,600				

Record Sale: $12,600, B, 6/18/81, "The State Entry into Delhi in 1902," 132 × 218 in.

WILLIAM WENDT
(1865-1946)

Called the dean of California artists, William Wendt spent his mature life painting landscapes of the rolling hills and arroyos of the Southern part of that state. At first he worked with rather tentative, feathery brushstrokes, but later he developed a bold, self-confident style which one critic termed "masculine impressionism." A deeply religious man, he found peace and satisfaction in painting lovely, natural settings.

Born in Germany in 1865, he came to the United States at age 15 to join an uncle in Chicago. His only art training was some evening classes at the Chicago Art Institute, but he managed to find work in a commercial art shop, painting formula pictures and display scenery.

In his free time he took up easel painting. When he won the second prize of $200 at the Chicago Society of Artists exhibition in 1893 it was enough, he decided, to allow him to work full-time as an easel painter.

He liked to sketch in the field and then return to his studio to paint large landscapes. In 1894, seeking new scenes to paint, he made his first trip to California. He returned there two years later, the second time with George G. Symons, another painter who became a long-time painting companion.

In 1898, the two went to England together, visiting galleries and painting for several months along the coast of Cornwall. Afterward, Wendt had an exhibition of his work from California

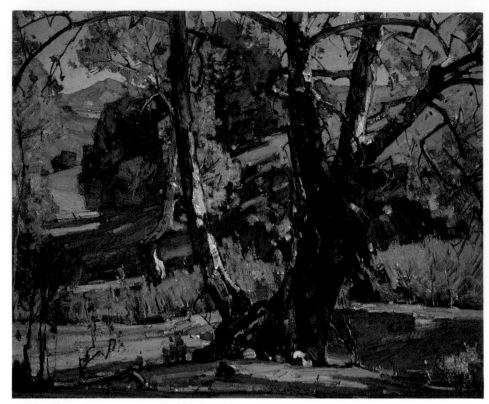

Serenity, 1934, 30 x 36 in., signed l.l. Courtesy of Petersen Galleries, Beverly Hills, California.

and England, which was enthusiastically received in Chicago. Over the next few years he made several other trips to California and Europe.

In 1906, Wendt married Julia Bracken, a sculptor from Chicago, and then settled into a combination home and studio he had bought in Los Angeles. The two worked harmoniously together, she in the studio and he wandering the hills sketching, then returning

to translate his sketches into finished landscapes.

Wendt painted exactly what he saw in nature with warm colors and outstanding effects of light and shadow. The tranquility, strength and sense of well-being of his work appealed to a wide audience. It had a sober sort of poetry about it, one critic wrote, like a fine, familiar hymn.

In 1912, Wendt built a studio in Laguna Beach, California, where he worked steadily until his death in 1946. He and his wife shared their knowledge with aspiring artists, and had much to do with the growth of Laguna Beach as a center of the arts.

MEMBERSHIPS
American Federation of Arts
California Art Club
Chicago Society of Artists
Laguna Beach Art Association
National Academy of Design
National Arts Club
Society of Western Artists

PUBLIC COLLECTIONS
Art Institute of Chicago
Cincinnati Art Museum
Des Moines Art Center, Iowa
Indianapolis Museum of Art
Los Angeles County Museum of Art

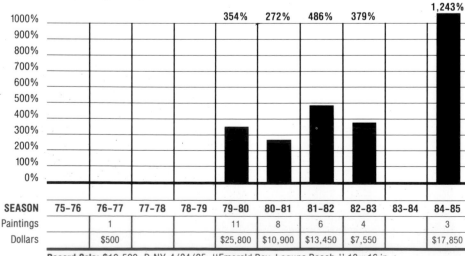

10-Year Average Change From Base Years '76-'77: 456%

	75-76	76-77	77-78	78-79	79-80	80-81	81-82	82-83	83-84	84-85
					354%	272%	486%	379%		1,243%
SEASON	75-76	76-77	77-78	78-79	79-80	80-81	81-82	82-83	83-84	84-85
Paintings		1			11	8	6	4		3
Dollars		$500			$25,800	$10,900	$13,450	$7,550		$17,850

Record Sale: $10,500, D.NY, 4/24/85, "Emerald Bay, Laguna Beach," 12 × 16 in.

596

EANGER IRVING COUSE
(1866-1936)

Although trained in classical art in Paris, Eanger Irving Couse was bent on creating an art that was purely American in subject matter. He came home to make his reputation painting Indians, especially the Pueblo Indians around Taos, New Mexico.

Indians had long since lost their image as savages and Couse portrayed them almost poetically as tranquil, unthreatening, and indeed beautiful. Most of his work contains definite, recognizable characteristics. A sparsely-clad Indian crouches or squats on his heels, lit by firelight, sidelight or sometimes moonlight to accentuate his muscularity. Usually he is engaged in some domestic activity and has a pensive, withdrawn expression.

Couse came by his interest in Indians naturally. Born in Saginaw, Michigan in 1866, when it was still a remote logging center, he grew up surrounded by them.

Intent on becoming an artist, Couse first worked as a housepainter to earn money for study. In 1884, he was able to afford three months at the Art Institute of Chicago. Then it was back to housepainting for another season.

For two years he studied at the National Academy of Design in New York City, doing odd jobs to pay his way. Both years he won awards in student exhibitions.

Returning to Saginaw, Couse painted portraits of townspeople until he had enough money to go to Paris. There he studied at the Academie Julien under

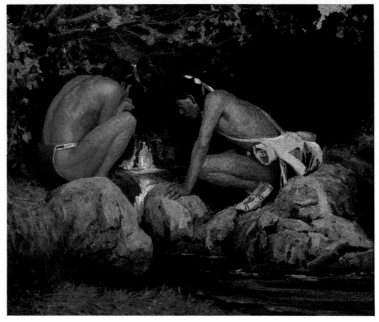

At the Spring, 1918, 30 x 36¼ in., signed l.l. Courtesy of Wunderlich and Company, Inc., New York, New York.

Tony Robert-Fleury and Adolphe Bouguereau.

In Paris, Couse married a fellow student whose father had a ranch in Oregon. Visiting there, Couse delighted in painting the Indians in deep pastel hues reminiscent of the French barbizon painters.

Because there was as yet little interest in pictures of Indians, however, Couse returned to France and settled in a village on the English Channel, where he painted more marketable scenes of coastal fishing and shepherds.

Hearing of the isolation and pageantry of the Pueblo Indians from two Americans studying in Paris, Couse visited Taos in 1902. It was a turning point; he had found the subject matter that he would paint for the rest of his life.

In Taos he often sketched outdoors,

sometimes taking along one of his favorite Indian models, but his paintings were composed and executed on an easel in his commodious studio. The imprint of his French academic training never left him.

From 1922 until 1934, paintings by Couse were used on calendars distributed by the Santa Fe Railway and prints hung in every Santa Fe waiting room. They formed the nucleus of an impressive collection of his work owned by the railroad.

Couse's wife died in 1929. Although he continued to paint, friends say that he had lost his spark. He died in Taos in 1936.

MEMBERSHIPS
Allied Artists of America
American Federation of Arts
Lotos Club
National Academy of Design
National Arts Club
Society of Painters
Taos Society of Artists

PUBLIC COLLECTIONS
Brooklyn Museum
Butler Art Institute,
 Youngstown, Ohio
Cleveland Museum
Dallas Museum
Detroit Institute of Arts
Fort Worth Museum, Texas
Gilcrease Institute of Art, Tulsa
Metropolitan Museum of Art, New York City
Milwaukee Art Institute, Wisconsin
Montclair Museum, New Jersey
Nashville Museum, Tennessee
National Gallery of Art, Washington, D.C.
Philbrook Art Center, Tulsa
St. Paul Museum, Minnesota
San Diego Museum, California
Santa Barbara Museum, California
Toledo Museum, Ohio

10-Year Average Change From Base Years '75-'76: 536%

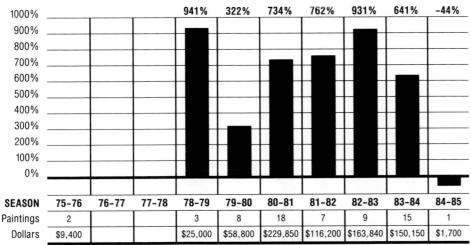

SEASON	75-76	76-77	77-78	78-79	79-80	80-81	81-82	82-83	83-84	84-85
				941%	322%	734%	762%	931%	641%	-44%
Paintings	2			3	8	18	7	9	15	1
Dollars	$9,400			$25,000	$58,800	$229,850	$116,200	$163,840	$150,150	$1,700

Record Sale: $60,000, BB.SF, 2/16/84, "Voice of the Falls," 35 x 46 in.

ALLEN TUCKER
(1866-1939)

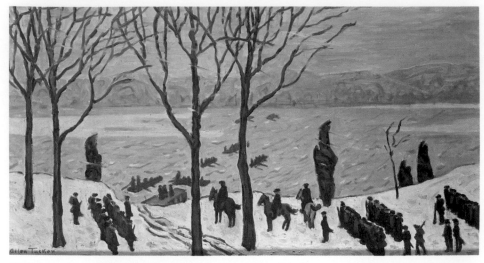

Washington Crossing the Delaware, 1931, 20 x 36 in., signed l.l. Courtesy of Collection The Whitney Museum of American Art, New York, New York, Purchase.

Architect and painter Allen Tucker was one of the founders of the Society of Independent Artists. His widely exhibited paintings are reminiscent, in their brushwork and use of light, of the work of Vincent Van Gogh.

Born in Brooklyn in 1866, Tucker graduated with a degree in architecture at Columbia University. While working as an architectural draftsman in New York City, he began studying painting under John H. Twatchman at the Art Students League. When he was 38, Tucker abandoned architecture altogether and devoted himself to painting full-time.

Tucker based his studio in New York City but spent summers traveling and painting in Europe, along the New England coast, in New Mexico or in the Canadian Rockies.

In 1911, Tucker secured his place in art history by becoming a charter member of the Association of American Painters and Sculptors. The Association was responsible for a major exhibition—the 1913 New York City Armory Show—which included five paintings by Tucker. Six years later, he helped found the Society of Independent Artists.

Tucker's first comprehensive one-man show was held in 1918 at the Whitney Studio Club (later the Whitney Museum of American Art). He was subsequently exhibited in the Paris Salon and in Philadelphia.

As exemplified by his *A Book of Verse* (1916, The Allen Tucker Memorial), the artist's crude but passionate use of light, inspired by Van Gogh, was stylistic pioneering in American art.

From 1920 to 1928, Tucker was a teacher and lecturer at the Art Students League, and until his death in New York in 1939 he published extensively.

MEMBERSHIPS
Architectural League of New York
Association of American Painters and Sculptors

PUBLIC COLLECTIONS
Albright-Knox Art Gallery,
 Buffalo, New York
Art Institute of Chicago
Brooklyn Museum
Metropolitan Museum of Art, New York City
Phillips Collection, Washington, D.C.

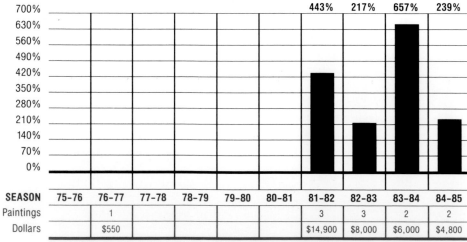

10-Year Average Change From Base Years '76–'77: 311%

							443%	217%	657%	239%

SEASON	75–76	76–77	77–78	78–79	79–80	80–81	81–82	82–83	83–84	84–85
Paintings		1					3	3	2	2
Dollars		$550					$14,900	$8,000	$6,000	$4,800

Record Sale: $9,500, D.NY, 4/21/82, "Fir Tree Shadows," 28 × 34 in.

598

ARTHUR CLIFTON GOODWIN
(1866-1929)

Arthur Clifton Goodwin, a little-known American impressionist, is considered the painter par excellence of the city of Boston.

Born in 1866 in Portsmouth, New Hampshire, Goodwin grew up in Chelsea, Massachusetts. Known as the "Beau Brummel of Chelsea," he worked as a salesman in a wholesale paper establishment, and often drank to excess. He began to paint at age 30.

With the help of Louis Kronberg, who allowed him to use his studio and colors, Goodwin remained in Boston until 1920, painting the city in all its moods and colors. One of his favorite subjects was "T" wharf, a pier at which the boats of many Portuguese and Italian fishermen were docked. In 1914, Goodwin was admitted to membership in the Guild of Boston Artists, which gave him an opportunity to exhibit his work.

He continued to drink, and his erratic lifestyle—his appearance alternated between that of a tramp and a dandy—caused him to lose patrons frequently. He was always able to sell his paintings, but his fees were inconsistent.

Between 1902 and 1920, the painter's style changed slowly; it was a process of perfecting his vision rather than changing direction. His delicate sensitivity to nuances of light and color allowed him to blend his human figures into the natural landscape, to achieve an unusual harmony between man and his surroundings. His vigorous, spontaneous and optimistic paintings were owned by such notables as John Singer Sargent.

Goodwin was particularly fascinated by those places where the city abruptly meets the natural landscape, and preferred to paint piers, plazas and river bridges. One of the few American impressionists who chose urban subjects, he never experienced the influence of the French masters directly. Rather, he absorbed the already common idiom

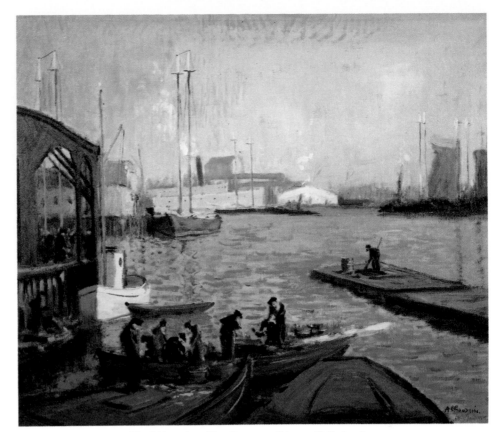

T. Wharf Basin, Boston, 29 x 36 in., signed l.r. Courtesy of Arvest Galleries, Inc., Boston, Massachusetts.

without reflecting a specific artist's style.

In 1920, the artist moved to New York City and married. He lived with his wife on a farm in Chatham, New York. In 1929, Goodwin returned to Boston alone, and also returned to his bohemian way of life. He died unexpectedly that year and was discovered in his home by friends, his trunk packed and a steamship ticket to France propped up next to it.

MEMBERSHIPS
Guild of Boston Artists

PUBLIC COLLECTIONS
Addison Gallery of Arts, Andover, Massachusetts
Colby College Art Museum

SEASON	75-76	76-77	77-78	78-79	79-80	80-81	81-82	82-83	83-84	84-85
Paintings	1	3	8	12	26	18	13	9	14	3
Dollars	$1,400	$6,700	$15,100	$28,508	$59,675	$109,550	$61,100	$25,900	$43,775	$4,900

Record Sale: $26,000, SPB, 5/29/81, "Boston, Arlington Street in Winter," 25 × 30 in.

ALBERT LOREY GROLL
(1866-1952)

The traditional poverty of the art student prevented Albert Lorey Groll from being a figure painter: he could not afford to pay for models, so he turned to landscape. He was to become a master painter of the American desert.

Groll's origins were urban, his training academic and European. Born in 1866 in New York City, he studied art in London and in Munich, where his teachers were Nickolaus Gysis and Ludwig Von Loefftz.

When he returned to the United States, he painted on the Northeast coast for a time. He lived in New York City all his life, but when he accompanied a Brooklyn Museum of Arts and Sciences expedition to the Southwest, he discovered the Arizona desert.

Groll's sketches from that trip led to a painting which won him a gold medal from the Pennsylvania Academy of the Fine Arts. He returned many times to Arizona and New Mexico for the source material of his paintings and etchings. Much respected and rewarded as "America's sky painter," he died in New York City in 1952.

Albert Groll produced poetry from the arid desert landscape. The sweep of his skies awakened Americans to the grandeur of the Southwest. The Pueblo Indians of New Mexico particularly respected his accuracy and sensitivity, bestowing on him the name "Chief Bald Head—Eagle Eye."

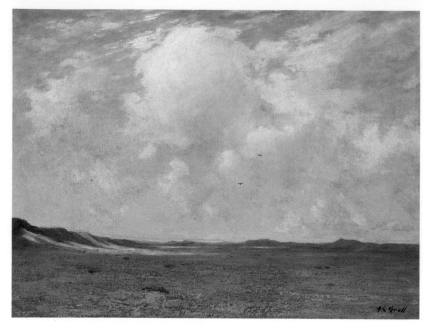

Flying Clouds, Navajo Desert, Arizona, 28 x 36 in., signed l.r. Courtesy of National Academy of Design, New York, New York.

MEMBERSHIPS
Allied Art Association
American Water Color Society
Artists' Fund Society
Lotos Club
National Academy of Design
National Arts Club
New York Water Color Club
Salmagundi Club
Society of Painters of New York

PUBLIC COLLECTIONS
Brooklyn Museum
Carnegie Institute, Pittsburgh
Corcoran Gallery of Art, Washington, D.C.
Lotos Club, New York City
Metropolis Institute of Arts, Minnesota
Montclair Art Museum, New Jersey
Museum of Fine Arts, Boston
National Gallery of Art, Washington, D.C.
St. Louis Art Museum

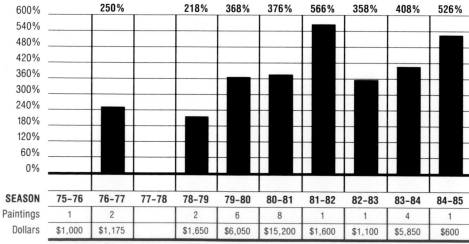

10-Year Average Change From Base Years '75-'76: 341%

		250%		218%	368%	376%	566%	358%	408%	526%
SEASON	75-76	76-77	77-78	78-79	79-80	80-81	81-82	82-83	83-84	84-85
Paintings	1	2		2	6	8	1	1	4	1
Dollars	$1,000	$1,175		$1,650	$6,050	$15,200	$1,600	$1,100	$5,850	$600

Record Sale: $3,750, SPB, 6/19/81, "Horsemen in Landscape," 25 × 35 in.

WILLIAM ROBINSON LEIGH
(1866-1955)

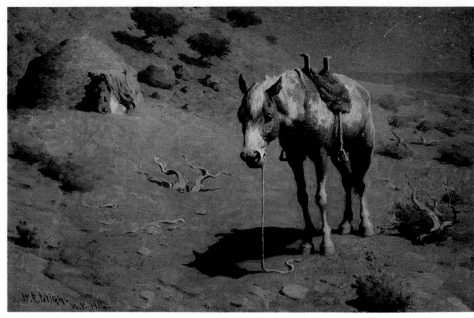

Waiting, 1914, 16 x 24 in., signed l.l. Courtesy of Vose Galleries of Boston, Massachusetts.

William Robinson Leigh was one of the most prolific and accomplished painters of the American West. He is especially well known for his dramatic paintings of Western plains, mountains, canyons, cavalry, cowboys and Indians.

Born near Falling Waters, West Virginia in 1866, Leigh spent his childhood on a farm. He began his artistic training at age 14, when he went to study under Hugh Newell at the Maryland Institute in Baltimore. Despite Leigh's poverty, he was able to go to Europe, and he spent 12 years studying at the Royal Academy in Munich. He studied under Raupp, Gysis, Von Lindenschmidt and Von Loefftz.

The painting technique that Leigh learned and mastered in Germany remained with him throughout his career. He began with a detailed charcoal drawing and painted over it. Starting with the most distant objects, such as the horizon and sky, Leigh slowly painted each object until he reached the foreground.

Leigh's bold colors and clear lighting add to the dramatic intensity of his works. Because he used traditional European techniques in painting the American West, he was known as the "Sagebrush Rembrandt."

Although Leigh had always wanted to paint the American West, it was not until he was around 40 years old that he

finally realized his dream. He traveled to Chicago and offered the Santa Fe Railroad Company a painting of the Grand Canyon in exchange for a ride to New Mexico. The company was so pleased with the finished painting that they commissioned five more pictures, giving

Leigh more time to roam the West before he was forced to return to New York City to earn a living. Leigh returned to the West to paint whenever he could.

Back in New York City, Leigh supported himself by illustrating scenes from American history for *Scribner's* and *Collier's.* In 1921 he married Ethel Traphagen, a women's-clothing designer, and together they founded the Traphagen School of Fashion in New York City.

After Leigh's death in 1955, his widow gave his entire collection of work to the Gilcrease Institute of American History and Art in Tulsa, Oklahoma.

MEMBERSHIPS
Allied Art Association
American Watercolor Society
Salmagundi Club

PUBLIC COLLECTIONS
Academy of Natural Sciences, Philadelphia
American Museum of Natural History, New York City
Thomas Gilcrease Institute of American History and Art, Tulsa, Oklahoma

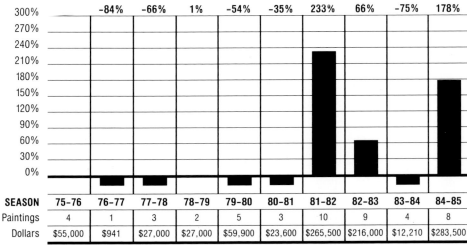

10-Year Average Change From Base Years '75-'76: 16%

	−84%	−66%	1%	−54%	−35%	233%	66%	−75%	178%

SEASON	75-76	76-77	77-78	78-79	79-80	80-81	81-82	82-83	83-84	84-85
Paintings	4	1	3	2	5	3	10	9	4	8
Dollars	$55,000	$941	$27,000	$27,000	$59,900	$23,600	$265,500	$216,000	$12,210	$283,500

Record Sale: $135,000, SPB, 10/22/81, "Zuni Pottery Painter," 25 × 30 in.

PINCUS MARCIUS-SIMONS
(1867-1909)

Pincus Marcius-Simons (popularly known as "Pinkey") was an expatriate painter and one of the few American symbolist artists exhibited in the Paris salons.

Born in 1867 in New York City, Marcius-Simons was taken to Europe while still an infant, returning to the United States only once before he was 25. After spending part of his childhood in Spain and Italy, he was educated at Vaugirard College in Paris, and studied art under J.G. Vibert.

Marcius-Simons's earliest paintings were historical and sentimental genre scenes. He exhibited them at the Paris Salon in 1882.

By his twenties, however, Marcius-Simons abandoned his earlier, academic style, turning to a near-poetic style reminiscent of Turner and the French symbolists. Whether landscapes or more imaginative, mystical subjects, Marcius-Simons's works were characterized by their remarkable coloration.

Although he was regarded in Paris as the standard-bearer of the symbolist movement in America, Marcius-Simons did not follow the restrictions of subject matter decided by the leaders of that movement in France, despite the fact that he occasionally borrowed from their symbolism and was exhibited in their galleries.

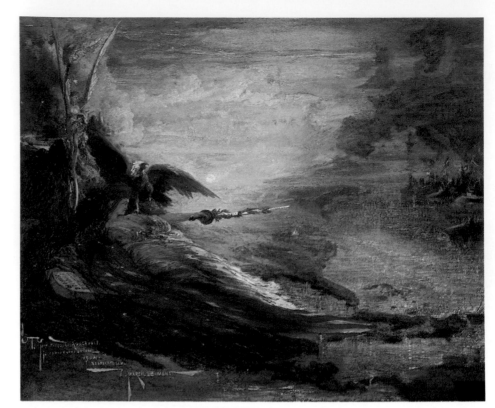

Victory, 1904, signed l.l. Courtesy of the National Park Service, Sagamore Hill National Historic Site, Oyster Bay, New York.

Beginning in 1894, he turned his attention to illustrating operatic themes. He worked as a set designer in Bayreuth, Germany at the Wagner Theatre until his death there in 1909.

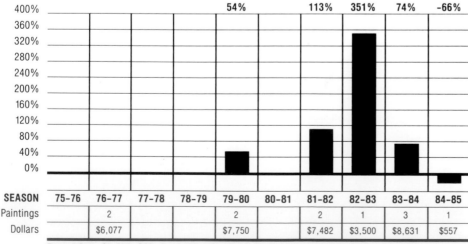

10-Year Average Change From Base Years '76-'77: 88%

SEASON	75-76	76-77	77-78	78-79	79-80	80-81	81-82	82-83	83-84	84-85
					54%		113%	351%	74%	−66%
Paintings		2			2		2	1	3	1
Dollars		$6,077			$7,750		$7,482	$3,500	$8,631	$557

Record Sale: $5,250, SPB, 6/12/80, "Parsifal & the Knights of the Holy Grail," 44 × 57 in.

GUY ROSE
(1867-1925)

Guy Rose was a successful painter and teacher in the early 1900s. His major contribution was introducing and developing the French impressionistic style among California painters.

Rose, the son of a wealthy rancher, was born in San Gabriel, California in 1867. He revealed a skill for drawing during a convalescence from a near-fatal gun accident, and developed this talent by studying with Emil Carlsen at San Francisco's California School of Design. Lefebvre, Constant and Doucet were Rose's instructors when he traveled to France to study at the Academie Julien.

In 1891, Rose worked as a magazine illustrator in New York City. He made the first of many return trips to France in 1893.

In 1894, Rose's *One Flight Into Egypt* (date and location unknown) won an honorable mention in an exhibition at the Paris Salon. His citation made Ross the first Californian to receive a Salon honor.

A severe attack of lead poisoning interrupted Rose's career in 1894. Unable to paint for years, he lived first in Los Angeles, then in New York City, for the next five years.

In New York Rose taught at Pratt Institute, and illustrated for *Harper's, Scribner's, Century* and *Youth's Companion.*

His love of French impressionist painting never dimmed and he returned to Paris in 1899. Although he was not a

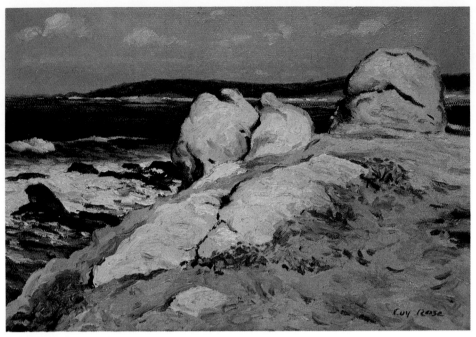

Coastal Scene, 10½ x 14 in., signed l.r. Courtesy of Maxwell Galleries, LTD., San Francisco, California.

formal student of Monet, Rose met the French impressionist and received his critical evaluation.

In France, Rose produced luminous, lightly brushed paintings. He crossed the Atlantic for the last time in 1914, and returned to California.

In California Rose painted scenes of Carmel, Point Lobos, Laguna Beach and San Gabriel. He became an instructor, and later director, of the Stickney Memorial School of Art in Pasadena. In Southern California between 1914 and 1920, Rose was considered the equal of any American painter of his time.

Another attack of lead poisoning ended his career in 1921, and he died four years later. However, his influence had spread throughout California.

10-Year Average Change From Base Years '77-'78: 49%

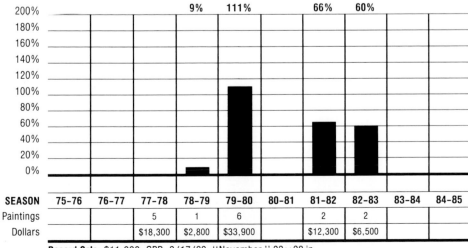

SEASON	75-76	76-77	77-78	78-79	79-80	80-81	81-82	82-83	83-84	84-85
Paintings			5	1	6		2	2		
Dollars			$18,300	$2,800	$33,900		$12,300	$6,500		

Record Sale: $11,000, SPB, 3/17/80, "November," 23 x 28 in.

MEMBERSHIPS
California Art Club

PUBLIC COLLECTIONS
Cleveland Museum of Art
Laguna Beach Museum of Art, California
Oakland Museum, California

GEORGE B. LUKS
(1867-1933)

George Luks's lack of sentimentality and his understanding of the cruder and coarser strata of civilization made him one of the most powerful realists of the Ashcan School, the group of painters who were tremendously influential in creating realism in twentieth-century American painting.

Luks's habit of embroidering or even manufacturing his past makes it difficult to trace his life. The son of two amateur painters, he was born in Williamsport, Pennsylvania in 1867. His father was a doctor. In 1884, he attended the Pennsylvania Academy of the Fine Arts in Philadelphia, where he studied under Thomas Anshutz. He then proceeded to Europe to study in Dusseldorf, Paris and London.

In 1894, Luks joined the art department of the Philadelphia *Press*. He covered the Cuban front as artist correspondent for the Philadelphia *Evening Bulletin* in 1896. He also did comic strips and caricatures.

With Everett Shinn, William Glackens, John Sloan and their mentor, Robert Henri, Luks became one of the famous Eight. This group was later known as the Ashcan School, for the darkness of their palette and the urban dinginess of their subject matter. Luks drew his technique from Frans Hals and Rembrandt, and his subjects from the city streets.

He continued to work as a newspaper artist, the equivalent of today's news photographer. As one by one his fellow artists left Philadelphia for New York City, he joined the New York *World* as a cartoonist.

Simultaneously, Luks developed into an accomplished painter, working swiftly and with great energy. His street urchins, wrestlers and coal miners were painted with brutal vitality and uncompromising affection. *The Wrestlers* (1905, location unknown), perhaps his most widely-reproduced work, illus-

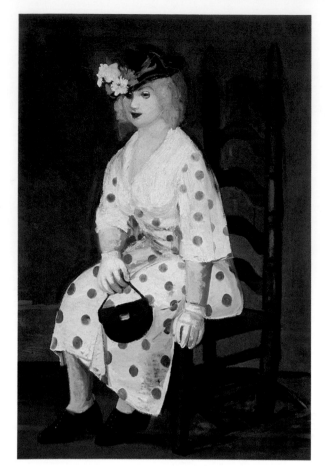

The Polka Dot Dress, 1927, 58⅛ x 37 in. Courtesy of National Museum of American Art, Smithsonian Institution, Gift of Mrs. Howard Weingrow.

trates both his ability to capture with absolute clarity the essence of a moment, and his reckless and slapdash approach to technique and anatomy.

In 1908, with Maurice Prendergast, Ernest Lawson and Arthur B. Davies, Luks and the other members of his group exhibited at the Macbeth Gallery in New York City, a show which was intended as a rebuke to the conservative art establishment. This show by The Eight became a rallying point for the forces of change, which eventually resulted in the Armory Show of 1913, in which Luks also exhibited. Ironically, the vigor and new ideas of the modernist foreign painters who participated in the Armory Show overshadowed the American realists who had organized it, and Luks and his friends were passed by.

Luks taught for several years at the Art Students League, and then founded his own school, where the students divided their time between painting under his inspiration and keeping their bellicose master under control. He was found dead in a New York street at age 66.

MEMBERSHIPS
American Painters and Sculptors
National Association of Portrait Painters
New York Water Color Club

PUBLIC COLLECTIONS
Addison Gallery of American Art, Andover, Massachusetts
Barnes Museum, Merion, Pennsylvania
Brooklyn Museum
Chattanooga Art Association
Cleveland Art Museum
Delgado Museum, New Orleans
Detroit Art Institute
Harrison Gallery, Los Angeles
Metropolitan Museum of Art, New York City
Milwaukee Art Institute
Munson-Williams-Proctor Institute, Utica, New York
Museum of Fine Arts, Boston
National Gallery, Washington, D.C.
New York Public Library, New York City
Phillips Gallery, Washington, D.C.
Whitney Museum of American Art, New York City

SEASON	75-76	76-77	77-78	78-79	79-80	80-81	81-82	82-83	83-84	84-85
Paintings	1	2	15	15	16	10	14	8	15	7
Dollars	$13,000	$11,250	$74,300	$41,144	$61,900	$37,100	$345,150	$53,600	$111,100	$82,650

Record Sale: $235,000, SPB, 12/10/81, "Lily Williams," 40 × 39 in.

WILLIAM DE LEFTWICH DODGE
(1867-1935)

Early in the twentieth century, William de Leftwich Dodge was one of the most prominent muralists in America. His works were created on the grand scale for buildings as distinguished as the Library of Congress, the Brooklyn Academy of Music, New York City's Surrogate Court Building and the Waldorf-Astoria Hotel. At that time murals were considered an essential ingredient in the architectural planning of theaters, world's-fair exposition halls, and many private homes.

Dodge was also commissioned for portraits and murals by such notables as King Faisal I, railroad-car designer George Pullman and art critic Sadakichi Hartmann.

Dodge's style was midway between classical academic and impressionistic modes, as might be expected from his American and European training.

He was born in 1867 in Bedford, Virginia; but he grew up in Munich and Paris where his mother had gone to study painting.

In 1885, Dodge was admitted to the Ecole des Beaux-Arts in Paris, where he studied under Jean Leon Gerome. Students' work was expected to conform to the academic style of the master, but Dodge managed to adapt his style in some ways. In many of his early paintings—*The Conquest of Mexico* (date and location unknown), for instance—he departed from the usual classical mythological pictures fashionable at the time.

One of Dodge's best-known works was done in 1885 when he was only 19 years old: *The Death of Minnehaha,* an 8-by-10-foot painting that, when shipped to New York, earned him a gold medal from the American Art Association.

In 1893, for the Columbian Exposition held in Chicago, Dodge was responsible for decorating the interior of the

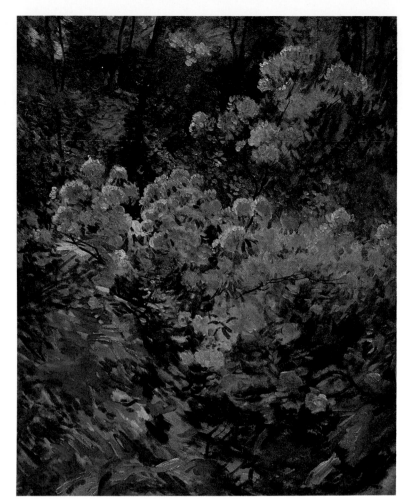

Forest with Wild Laurels, 43 x 34 in., signed l.r. Photograph courtesy of Balogh Gallery, Inc., Charlottesville, Virginia.

dome—100 feet in diameter—atop the administration building. This commission helped him decide to be a muralist.

Dodge had settled in New York City by 1900; he had a studio on West Fourteenth Street. He had also married in 1897.

Dodge's style was in transition in 1900, when he painted the beautiful *La Sainte Ivresse.* It is a celebration of young love, a mixture of flowery beaux-arts realism and the free palette and shorter strokes of impressionism.

All of Dodge's work was done from life, including his working drawings. He researched everything for historical accuracy (probably not an onerous task, as archaeology and history were two of his passions). Dodge was also an inventor; the Smithsonian Institution owns one of his model helicopters.

At the same time he was at work on large murals, Dodge executed smaller watercolors and oils: landscapes and family portraits, book illustrations and magazine covers. *The Southern Pine* (date and location unknown), with its aquamarine sky, slender dark green trees and russet shadows, is typical of his paintings.

In 1907 Dodge moved into the "Villa Francesca," in Setauket, Long Island. It was an elaborate building in the classical tradition, with Ionic columns and caryatids, which he had designed.

Dodge died in New York City in 1935.

MEMBERSHIPS
American Watercolor Society
Beaux Arts Society
Fencers Club
Players Club
Society of Mural Painters

PUBLIC COLLECTIONS
Metropolitan Museum of Art, New York City
National Academy of Design, New York City
Smithsonian Institution, Washington, D.C.

SEASON	75-76	76-77	77-78	78-79	79-80	80-81	81-82	82-83	83-84	84-85
Paintings			1	1	1	2	3	1	1	2
Dollars			$1,300	$525	$1,600	$7,500	$12,850	$550	$3,800	$4,000

Record Sale: $7,500, S.W, 6/6/82, "Georgette in Giverny, 1900," 39 x 24 in.

OSCAR FLORIANUS BLUEMNER
(1867-1938)

Oscar Bluemner's training as an architect in Germany, where he was born in 1867, influenced his later work as an early modernist painter.

Bluemner studied at the Academy of Fine Arts in Berlin, and was awarded a royal medal for an architectural painting in 1892. Reportedly, a disagreement on art with Emperor William II led Bluemner to emigrate to America in that same year; he sought commissions at the Columbian Exposition of 1893.

By 1901, Bluemner was living in New York City, where he won a competition for the design of the Bronx Borough Courthouse. Disillusioned with architecture after a disagreement with his partner, he then made painting his major career.

Visiting Europe in 1912, Bluemner was honored by Berlin's Gurlitt Galleries with a one-man show. He became known as "the vermillionaire" because of his liking for bright reds and greens. Often painting houses, barns and buildings, he possessed the touch of a draftsman.

Exposure to cubism could have occurred during his European trip, when his style changed; however, he never became radically cubist. His *Cubistic Village* (1918, Metropolitan Museum of Art) shows the influence of analytical cubism. *Old Canal Port* (1914, Whitney Museum of American Art) expresses his changing style.

In 1913, Bluemner showed five

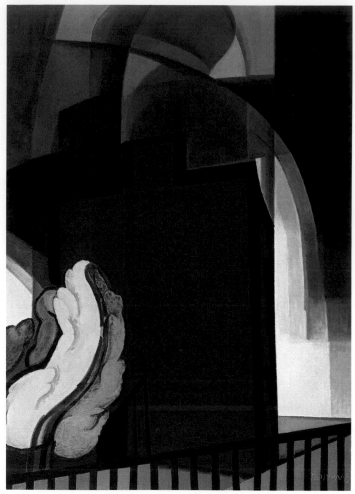

Blue Above, 51 x 36 in., signed l.r. Photograph courtesy of Hirschl & Adler Galleries, Inc., New York, New York.

brightly-colored landscapes at New York City's Armory Show. By 1915, he was intermittently part of the Stieglitz group of painters, and Stieglitz sponsored his first American one-man show. Bluemner shared an interest, with the Stieglitz painters like Dove, O'Keeffe and Hartley, in emotionally-charged forms of abstraction. He wrote: "Every color has a specific effect on our feelings. . . . A color and shape produces an emotion."

Another important show was the Forum Exhibition of Modern American Painters in March of 1916, where Bluemner was one of 16 artists featured. The Bourgeois Gallery in New York regularly showed his work from 1917 to 1923.

Despondent over his financial situation, compounded by failing eyesight, Bluemner ended his life by suicide in 1938.

PUBLIC COLLECTIONS
Museum of Fine Arts, Boston
Museum of Modern Art, New York City
Phillips Gallery, Washington, D.C.
Whitney Museum of American Art,
 New York City

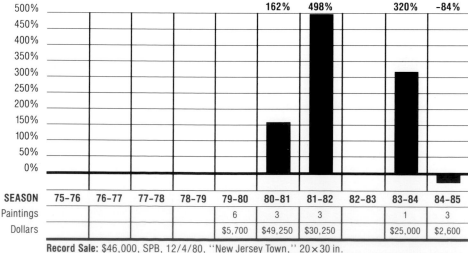

10-Year Average Change From Base Years '79-'80: 179%

SEASON	75-76	76-77	77-78	78-79	79-80	80-81	81-82	82-83	83-84	84-85
						162%	498%		320%	-84%
Paintings					6	3	3		1	3
Dollars					$5,700	$49,250	$30,250		$25,000	$2,600

Record Sale: $46,000, SPB, 12/4/80, "New Jersey Town," 20×30 in.

606

PAUL KING
(1867-1947)

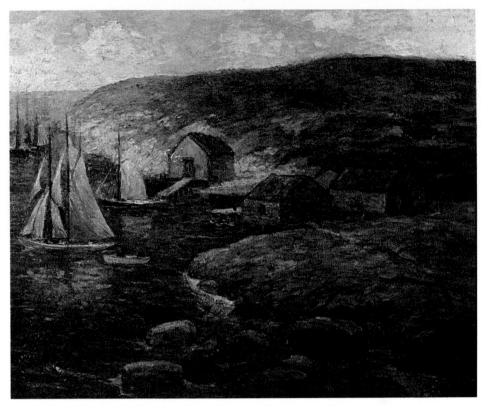

Peggy's Cove, Nova Scotia. Courtesy of Vose Galleries of Boston, Inc., Massachusetts.

Versatility, artistic maturity, and mastery of technique and medium are hallmarks of Paul King's art. His diverse works—portraits, landscapes, seascapes, rural scenes and illustrations—established his reputation in the first quarter of the century.

In every canvas, technique and approach are adapted to the subject with great confidence and naturalness. Each of King's paintings reflects the artist's distinctive personality, style and sensitive perceptions, as well as his fine draftsmanship.

From 1906, when his oil *Hauling in the Anchor Line* (date and location unknown) captured the Salmagundi Club's two top prizes, King regularly received prestigious recognition. His merit was freely acknowledged by his artist peers, as well as by critics and the public.

King was born in 1867 to a Buffalo, New York goldsmith. Apprenticed there to the lithography firm of Cosack & Company, he became an accomplished lithographer while still in his teens.

King later studied at the Art Students League of Buffalo and, from 1901 to 1904, at the New York Art Students League with H. Siddons Mowbray. While still a student, he was an illustrator for *Life* and *Harper's* magazines and for American Book Company publications.

For almost two years, in 1905 and 1906, King studied in Holland with Willy Sluiter, Evert Pieters and Bernard Bloomers.

From 1908 to 1921, King was a board member of the Philadelphia School of Design for Women, serving as vice president and acting president from 1915 to 1918. During World War I, he worked in the camouflage unit. King's pictures, often of everyday outdoor life or common rural scenery, are invested with freshness and insight. His landscapes, especially his winter scenes, became particular favorites. In 1923, *Early Winter* won the National Academy of Design Altman prize. King was named an academician in 1933.

He moved in 1921 from his long-time home in the Germantown section of Philadelphia to Stony Brook, Long Island, where he died in 1947.

MEMBERSHIPS
Allied Artists of America
American Federation of Arts
Artists Aid Society
Artists Fund Society
International Society of Arts and Letters
National Academy of Design
National Arts Club
Pennsylvania Academy of the Fine Arts
Philadelphia Art Club
Salmagundi Club

PUBLIC COLLECTIONS
Albright-Knox Gallery, Buffalo
Butler Art Institute, Youngstown, Ohio
National Gallery of Art, Washington, D.C.
Reading Museum, Pennsylvania

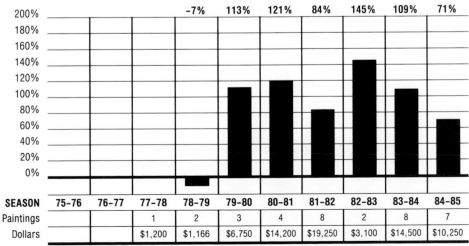

10-Year Average Change From Base Years '77-'78: 80%

			-7%	113%	121%	84%	145%	109%	71%

SEASON	75-76	76-77	77-78	78-79	79-80	80-81	81-82	82-83	83-84	84-85
Paintings			1	2	3	4	8	2	8	7
Dollars			$1,200	$1,166	$6,750	$14,200	$19,250	$3,100	$14,500	$10,250

Record Sale: $6,000, S.BM, 5/20/82, "Midsummer, Keene Valley," 32 × 40 in.

JEROME MYERS
(1867-1940)

A painter allied with the New York realists, Jerome Myers depicted slum life on the Lower East Side with a sentimentality that belies the oppressive conditions of the ghetto. His forms are soft, his settings picturesque and his colors muted, with light, jewel-like touches. The subjects—Italian and Jewish immigrants—resemble European peasants rather than the inhabitants of a New York City slum.

Myers began painting lower-class life in 1887, 20 years before the Ashcan School had its impact on American art. He chose to depict market scenes, children at play and people enjoying a summer's concert. His work possesses a light-hearted quality, leading some critics to accuse him of trivializing his subjects.

Born in 1867 in Petersburg, Virginia, Myers moved with his family to Philadelphia and then to Baltimore, where he worked as a sign painter. In New York City, after 1886, he studied at night at the Cooper Union and the Art Students League, earning a living during the day by painting theater sets and working in the art department of the *Herald Tribune*. He traveled to Paris briefly in 1896 and again in 1914. He held his first one-man show in 1908.

Myers became associated with the emergent realists. Despite his urban subject matter, however, he was not considered one of The Eight. Although he depicted the poor with dignity, his can-

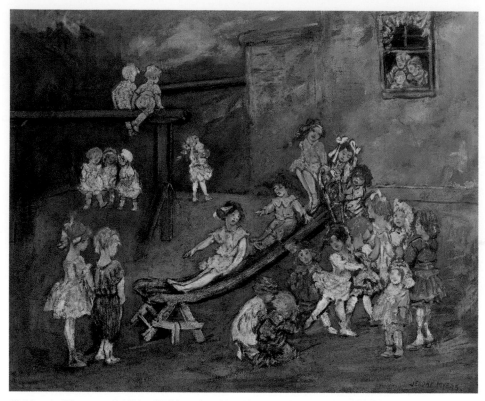

Children in Playground, 19½ x 23½ in., signed l.r. Photograph courtesy of Kennedy Galleries, New York, New York.

vases lack the powerful dark colors and psychological insight of the Ashcan painters.

His early work is composed primarily of drawings, pastels and watercolors. In mid-career, he turned increasingly to oil painting and then to etching. He illustrated numerous articles and he exhibited in the 1913 New York City Armory Show—an idea that was hatched in his studio.

A few years before his death in 1940, Myers published his autobiography, *Artist in Manhattan*.

MEMBERSHIPS
National Academy of Design
New Society of Artists

PUBLIC COLLECTIONS
Art Institute of Chicago
Brooklyn Museum
Delaware Art Museum, Wilmington
Los Angeles County Museum of Art
Metropolitan Museum of Art, New York City
Milwaukee Art Museum, Wisconsin
Memorial Art Gallery of the University of
 Rochester, New York
New Orleans Museum of Art
Phillips Collection, Washington, D.C.

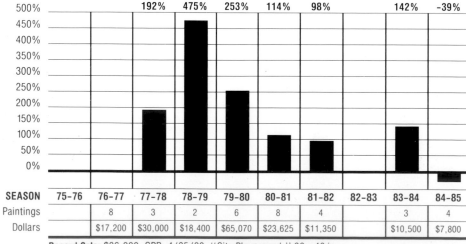

10-Year Average Change From Base Years '76-'77: 154%

SEASON	75–76	76–77	77–78	78–79	79–80	80–81	81–82	82–83	83–84	84–85
		192%	475%	253%	114%	98%		142%	-39%	
Paintings		8	3	2	6	8	4		3	4
Dollars		$17,200	$30,000	$18,400	$65,070	$23,625	$11,350		$10,500	$7,800

Record Sale: $36,000, SPB, 4/25/80, "City Playground," 30 × 40 in.

HERMANN DUDLEY MURPHY
(1867-1945)

With his subtle, harmonious land-scapes and beautiful floral paintings, Hermann Dudley Murphy was a major figure in the Boston School, the painter who comes closest to its aesthetic ideals. A portraitist turned landscape artist, Murphy was successful early in his career, and his canvases, particularly the later floral still lifes, are still in great demand. His approach combines realism with the quest for ideal beauty, expressed through the harmony of color and design.

Born in 1867 in Marlboro, Massachusetts, Murphy studied at Boston's Museum School under Tarbell and Benson. In 1891, he traveled to Paris, where he became a student of Laurens at the Academie Julien. But the strongest influence on his work came from Whistler; Murphy's early portraits and landscapes show a concern for delicate color tonalities and careful compositions. The compositions are simplified, conveyed through graduated bands of color.

Also like Whistler, Murphy believed that the frame should harmonize with the painting in size and color. He became a leading frame manufacturer in Boston, producing many hand-carved, gold-leaf frames of his own design.

In his early period, Murphy concentrated on portraits and figure studies, but his aesthetic touch and soft colors were not particularly well suited for the

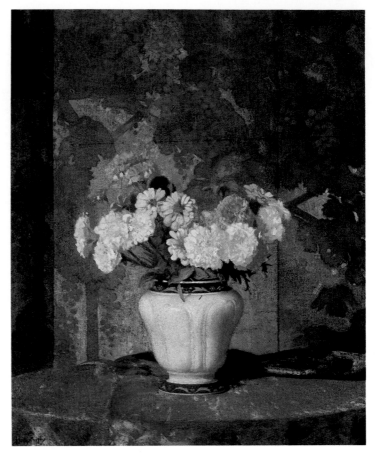

Zinnias and Marigolds, 30 x 20 in., signed l.l. Courtesy of the Museum of Fine Arts, Boston, Massachusetts, Charles Henry Hayden Fund.

boardroom. He turned to sea views and landscapes with large skies and cloud formations. They are marked by beautiful, almost abstract patterns of line and color.

In mid-career, Murphy went to the tropics, finding there a new, sun-drenched environment of sea, sky and flowers. His landscapes from that

period demonstrate greater color range and vibrancy. In the 1920s, he entered his last and most successful period, with floral and still-life canvases. Impressionistic principles can be seen in his work, especially in this late phase.

Murphy worked from his house and studio, "Carrig Rohane," in Winchester, Massachusetts, taught at Harvard University and was an avid canoeist. He died in 1945.

MEMBERSHIPS
Boston Society of Arts and Crafts
Boston Society of Water Color Painters
Boston Water Color Club
Copley Society
Guild of Boston Artists
Massachusetts State Art Commission
National Academy of Design
National Arts Club
New York Water Color Club
Painters and Sculptors Gallery Association
Salmagundi Club

PUBLIC COLLECTIONS
Albright-Knox Art Gallery, Buffalo
Art Institute of Chicago
Cleveland Art Museum
Dallas Museum of Fine Arts
Museum of Fine Arts, Boston
National Academy of Design, New York City
Springville Museum of Art, Utah
St. Louis Art Museum

10-Year Average Change From Base Years '76-'77: 117%

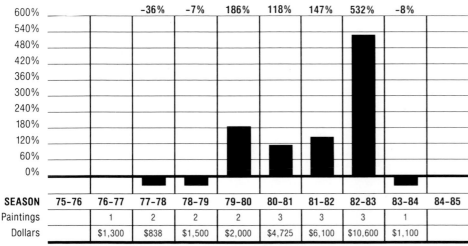

| | -36% | -7% | 186% | 118% | 147% | 532% | -8% | |

SEASON	75-76	76-77	77-78	78-79	79-80	80-81	81-82	82-83	83-84	84-85
Paintings		1	2	2	2	3	3	3	1	
Dollars		$1,300	$838	$1,500	$2,000	$4,725	$6,100	$10,600	$1,100	

Record Sale: $7,000, CH, 3/18/83, "Along the Venetian Canal," 20 x 27 in.

WALTER ELMER SCHOFIELD
(1867-1944)

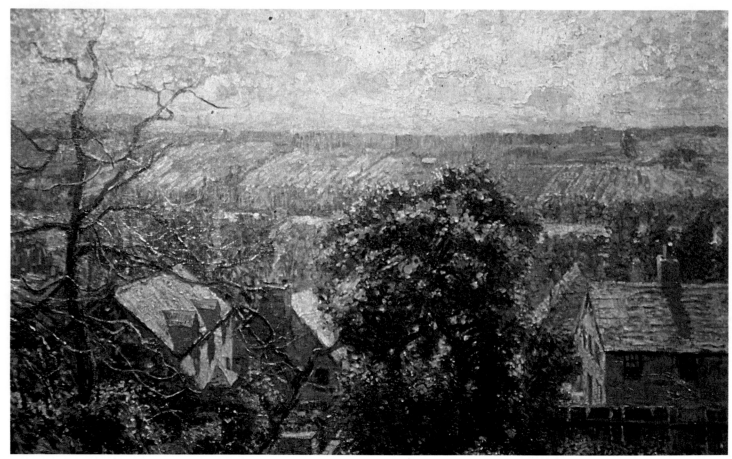

Landscape, 50 x 58 in., signed l.r. Courtesy of Newman Galleries, Philadelphia, Pennsylvania.

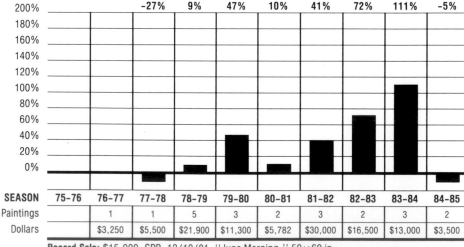

10-Year Average Change From Base Years '76-'77: 29%

		-27%	9%	47%	10%	41%	72%	111%	-5%

SEASON	75-76	76-77	77-78	78-79	79-80	80-81	81-82	82-83	83-84	84-85
Paintings		1	1	5	3	2	3	2	3	2
Dollars		$3,250	$5,500	$21,900	$11,300	$5,782	$30,000	$16,500	$13,000	$3,500

Record Sale: $15,000, SPB, 12/10/81, "June Morning," 50 × 60 in.

Walter Elmer Schofield painted powerful impressionistic landscapes of the Bucks County, Pennsylvania countryside, as well as turbulent seascapes of the Cornish coast of England. His most popular works, dramatic snow scenes of the hills and woodlands of Bucks County, established Schofield as a prominent member of that region's New Hope School of American impressionism.

Born in Philadelphia in 1867, Schofield attended Swarthmore College. He then enrolled at the Pennsylvania Academy of the Fine Arts, where he studied with Thomas Anshutz from 1889 to 1892.

At the Academy he met Edward Willis Redfield, the acknowledged leader of the New Hope School, and Robert Henri, leader of a group of urban real-

ists who later would exhibit with others as "The Eight." Along with Redfield, Schofield began attending meetings at Henri's studio, where he became friendly with other future members of The Eight, including John Sloan, Everett Shinn and William Glackens.

In Paris at the Ecole des Beaux Arts and the Academie Julien from 1892 to 1895, Schofield studied in the ateliers of William Adolphe Bouguereau, Gabriel Ferrier and Henri Lucien Doucet. Like other American artists of that time, Schofield considered Paris training essential to his career, but his work never assumed the elevated subject matter and degree of technical refinement characteristic of Salon painting. Like Redfield, who also studied under Bouguereau, Schofield soon tired of this strict, academic training and retreated to the Forest of Fontainbleau to paint directly from nature.

After 1902, Schofield spent the months of October through April in Philadelphia, and the remainder of the year with his wife in England. Enamored of the rugged English coastline, he traveled throughout the country and lived in Southport, Yorkshire, Bedfors and Otley. Schofield's favorite painting spot was St. Ives, Cornwall, which was an established artists' colony in his time. A considerable portion of his work consists of bold coastal scenes of St. Ives, with the sea battering against massive cliff formations.

Schofield was familiar with New Hope, Bucks County from an early age, as the region is located just north of Philadelphia. Although he did not live in New Hope, and never exhibited at the community center, Phillips Mill, he did exhibit with Redfield, Daniel Garber, and other regional impressionist painters at the Pennsylvania Academy annual shows. While visiting Bucks County, Schofield often stayed with his old Academy colleague, Redfield, at his home in Center Bridge. This friendship, which ended in rivalry in 1904, was essential to the development of Schofield's mature style. He adopted Redfield's technique of completing a large canvas in a single sitting and applying paint in thick, long brushstrokes. Schofield's canvases were enormous,

and it was quite a feat to keep them anchored in stormy weather, part of the challenge Schofield loved in plein-air painting.

Schofield's landscapes were executed with lavish amounts of paint, enthusiastically applied. Detail was suppressed in favor of general atmospheric effect. He often employed a high horizon line which emphasized the active surface brushwork and imparted a bold, decorative quality to the picture plane.

A unique combination of the realist tradition of direct observation of nature with the broken brushwork and vivid hues of impressionism, Schofield's style remains the most dashing of the New Hope School. He died in 1944.

MEMBERSHIPS
Century Association
Chelsea Arts Club
Fellowship of the Pennsylvania Academy of the
 Fine Arts
Institute of Arts and Letters
National Academy of Design
National Arts Club
National Institute Arts League
Philadelphia Art Club
Royal Society of British Artists
Royal Society of Oil Painters
Salmagundi Club
Society of American Artists
St. Ives Arts Club

PUBLIC COLLECTIONS
Albright-Knox Art Gallery, Buffalo, New York
Art Institute of Chicago
Brandywine River Museum, Pennsylvania
Brooklyn Museum
Carnegie Institute, Pittsburgh
Cincinnati Art Museum
Corcoran Gallery of Art, Washington, D.C.
Delaware Art Museum, Wilmington
Fine Arts Museum of San Francisco
Indianapolis Museum of Art
Metropolitan Museum of Art, New York City
National Academy of Design, New York City
National Arts Club, New York City
National Museum of American Art, Washington, D.C.
Pennsylvania Academy of the Fine Arts,
 Philadelphia

JULES EUGENE PAGES
(1867-1946)

Jules Eugene Pages, an impressionist painter, was born in San Francisco in 1867. He first studied art at the San Francisco Art Association's California School of Design. By about 1888, Pages made his first trip to Paris, where he studied at the Academie Julien with Constant, Lefebvre and Robert-Fleury.

Pages financed his study trips to Paris by working in San Francisco as a newspaper illustrator. However, by the mid-1890s, he lived permanently in Paris and only visited California. Pages frequently traveled to Brittany, Spain and Belgium on sketching trips. Other subject matter included Paris street scenes, and the people and vistas of California.

Pages's work incorporates the pure colors and broad brushstrokes of impressionism with drawing, and is characterized by a sensitivity to natural form and effects of light. He believed that impressionism was the renaissance of modern art.

In 1902, he became an instructor at the Academie Julien. Five years later, he became an administrator. He also began to win numerous awards at the Paris Salons, and was named a chevalier in the French Legion of Honor in 1910.

Pages's work was exhibited in both Europe and California. He participated as a member of the International Jury of Award and as an exhibitor at the 1915 Panama-Pacific International Exposition in San Francisco. He was made a member of the Bohemian Club of San

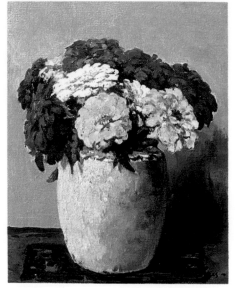

Zinnias in Crock, 16¼ x 13 in., signed l.r. Private Collection Photograph courtesy of WIM Fine Arts, Oakland, California.

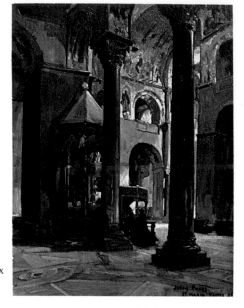

Interior of St. Marco, Venice, ca. 1906-1908, 24 x 18¼ in., signed l.r. Courtesy of WIM Fine Arts, Oakland, California.

Francisco, and was honored with a one-man exhibition there in 1924.

Pages left Paris permanently in 1941, in advance of the Nazi occupation. He lived in San Francisco until his death in 1946.

MEMBERSHIPS
International Society of Paris
Painters and Sculptors

PUBLIC COLLECTIONS
Fine Arts Museum of San Francisco
Luxembourg Museum, Paris
Museum of Pau, France
Museum of Toulouse, France
Oakland Art Museum, California

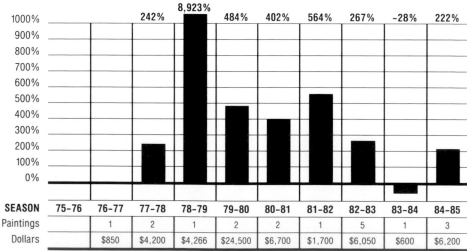

10-Year Average Change From Base Years '76-'77: 1,231%

SEASON	75-76	76-77	77-78	78-79	79-80	80-81	81-82	82-83	83-84	84-85
		242%	8,923%	484%	402%	564%	267%	-28%	222%	
Paintings		1	2	1	2	2	1	5	1	3
Dollars		$850	$4,200	$4,266	$24,500	$6,700	$1,700	$6,050	$600	$6,200

Record Sale: $17,000, BB.SF, 6/18/80, "Washington Alley, Charcuterie Chinoise," 40 x 31 in.

612

REYNOLDS BEAL
(1867-1951)

American impressionist Reynolds Beal had a gift for capturing air movement and seasonal quality in his lively watercolors and crayon drawings.

Born in New York City in 1867, Beal showed early artistic talent, but attended Cornell University and graduated with a degree in naval architecture. Although he retained a lifelong interest in the sea and in yachts, he turned permanently to the fine arts after his 1887 graduation.

With the encouragement of his younger brother, well-known painter Gifford Beal, he studied in Europe, primarily in Madrid. In 1890, he began the formal study of art under William Merritt Chase in Chase's Long Island school.

Beal's work has none of the bravura of technique or dark palette of Chase. Beal's colors are fresh, light and juicy. His fascination with boats and with the sea is evident. Although he was intimately acquainted with yacht construction, his artist's eye was less concerned with the seaworthiness of a vessel than with its evanescent wind-governed relationship to water and air. Another favorite Beal subject was the circus.

A man of independent means, Beal was able to travel through the waterways of the world all his life, painting and drawing to his heart's content until his death in 1951. In spite of this relative ease, Beal was no dilettante Sunday painter; he had his first one-man show in 1905 at the Clauson Gallery in New York

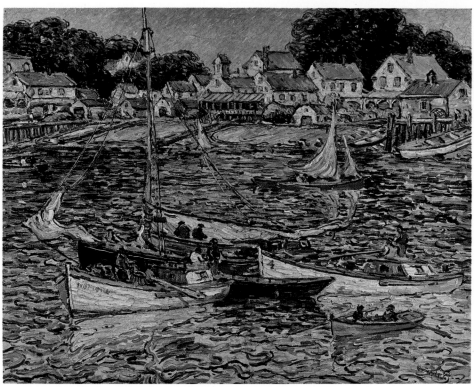

Provincetown Waterfront, 1916, 29 x 36 in., signed l.l. Courtesy of Vose Galleries of Boston, Inc., Massachusetts.

City, and was elected an associate member of the National Academy of Design in 1909. He was involved in founding the Society of Independent Artists and the New Society of Artists.

Beal's traveling companions included, at one time or another, the well-known American impressionist painters Ernest Lawson and Childe Hassam, as well as

H. Dudley Murphy and Henry Ward Ranger. He visited the Caribbean Islands and Central America, the West Coast of America and all of Europe, but much of his work was done in the Northeastern United States. His bright, cheerful palette was well suited to the crisp colors and brisk skies of the Atlantic seashore; but even in his most landlocked landscape, water usually appeared somewhere.

MEMBERSHIPS
American Watercolor Society
Boston Art Club
Century Club
Lotos Club
National Academy of Design
National Arts Club
New Society of Artists
New York Water Color Club
Salmagundi Club
Society of Independent Artists
Worcester Art Museum

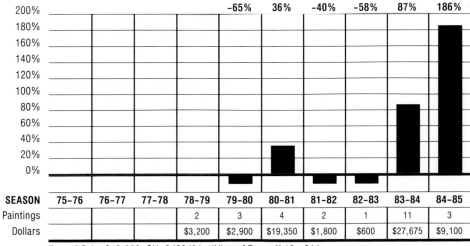

10-Year Average Change From Base Years '78-'79: 21%

	75-76	76-77	77-78	78-79	79-80	80-81	81-82	82-83	83-84	84-85
					−65%	36%	−40%	−58%	87%	186%
SEASON	75-76	76-77	77-78	78-79	79-80	80-81	81-82	82-83	83-84	84-85
Paintings				2	3	4	2	1	11	3
Dollars				$3,200	$2,900	$19,350	$1,800	$600	$27,675	$9,100

Record Sale: $12,000, CH, 3/23/84, ''View of Essex,'' 18 × 24 in.

LOUIS PAUL DESSAR

(1867-1952)

Called the "Millet of America" by contemporaries because of his tonalist, pastoral landscapes with workers and animals, Louis Paul Dessar was known to spend as long as two years perfecting a canvas.

Born in Indianapolis, Indiana in 1867, Dessar graduated from City College in New York City and then from the National Academy of Design in the same city. He journeyed abroad to Paris, where he studied under Bouguereau and Tony Robert-Fleury. Dessar became a competent story-painter and portraitist, and upon his return to New York City in 1892 proceeded to earn his living in that way for nearly 10 years.

Dessar's artistic conversion came as he was painting a portrait of the wife of a prominent art collector, posing in a room full of landscapes by the barbizon painters. Surrounded by those paintings, Dessar decided that in comparison his portraits and genre pieces had only ephemeral value; that landscape, modified by human and animal presence and rendered in the wisest traditions of art, contained the seeds of more lasting excellence. After finishing that portrait, Dessar returned to France to immerse himself in his chosen subject.

Back in the United States once more, he became one of a number of artists who were called tonalists, including Kost, Minor and Bogert.

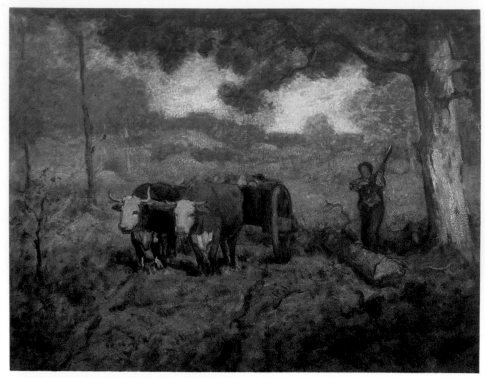

The Wood Chopper, 1906, signed l.l. Florence Griswold Museum, Lyme Historical Society, Old Lyme, Connecticut.

Dessar spent his winters in New York and summered in Becket Hill near Old Lyme, Connecticut, part of the artists' colony that, while under leader Henry Ranger, concentrated on painting directly from nature in the barbizon ton-

alist mood (soon eclipsed by artists of impressionist persuasion). His canvases embody the values he sought to convey; they combine a lucid peacefulness with an impersonal perspective, and his interminable search for perfection of light and color produced a diffused brightness that seems to come from beyond the picture plane.

Dessar worked slowly and exhibited rarely; he taught at the National Academy of Design in 1946, not long before his death in 1952, but most of his time was spent in his studio working on his paintings.

MEMBERSHIPS
Artists Fund Society
Lotos Club
Lyme Art Association
National Academy of Design
Salmagundi Club
Society of American Artists

PUBLIC COLLECTIONS
City Art Museum, St. Louis
Lyons Art Museum, France
Metropolitan Museum of Art, New York City
Montclair Art Museum, New Jersey
National Gallery of Art, Washington, D.C.
Omaha Museum, Nebraska

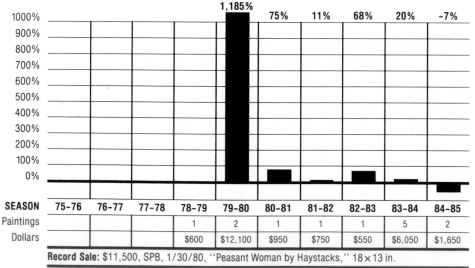

10-Year Average Change From Base Years '78-'79: 193%

SEASON	75-76	76-77	77-78	78-79	79-80	80-81	81-82	82-83	83-84	84-85
					1,185%	75%	11%	68%	20%	-7%
Paintings				1	2	1	1	1	5	2
Dollars				$600	$12,100	$950	$750	$550	$6,050	$1,650

Record Sale: $11,500, SPB, 1/30/80, "Peasant Woman by Haystacks," 18 × 13 in.

614

ALFRED H. MAURER

(1868-1932)

Alfred H. Maurer is known as one of the very first American modernist painters. A transitional figure in American art, Maurer was already producing mature paintings in a Whistlerian mode at the time of his conversion, first to fauvism, then to cubism.

Alfred Maurer was born in New York City, the son of successful lithographer and genre painter Louis Maurer. After studying for several years at the National Academy of Design, Maurer traveled to France, where he worked for most of the next 14 years.

In France, he studied briefly at the Academie Julien. By 1901, he was winning medals at major exhibitions in Europe and the United States for his Whistlerian studies of women, decoratively posed, and following Japanese motifs.

Around 1905, Maurer became acquainted with Leo and Gertrude Stein and their circle of friends in Paris, and soon thereafter began painting in a brightly-colored fauvist manner inspired by the work of Paul Cezanne. Maurer's paintings of this period were exhibited in New York City at Alfred Stieglitz's Photo-Secession Gallery in 1909 and at the New York City Armory Show in 1913.

Maurer returned to New York City permanently in 1914. By the end of World War I he was painting still lifes and figure studies in a cubist manner, employing flattened planes and distorted shapes. His studies of twinned and inter-

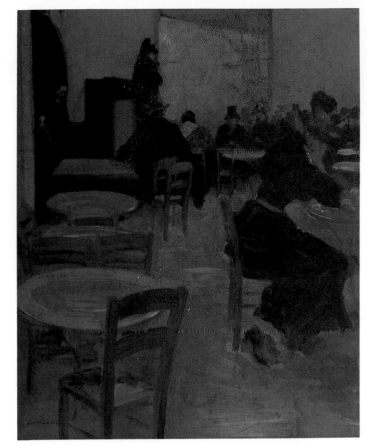

A French Cafe, 1901, 24 x 20 in., signed l.l. Courtesy of Wunderlich and Company, Inc., New York, New York.

penetrating heads have been said to reflect his unhappy relationship with his father. Maurer committed suicide in 1932 at his home in New York City.

MEMBERSHIPS
Paris Society of American Painters

PUBLIC COLLECTIONS
Barnes Collection, Merion, Pennsylvania
Museum of Modern Art, New York City
Phillips Collection, Washington, D.C.

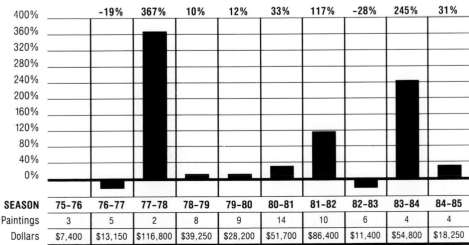

10-Year Average Change From Base Years '75-'76: 77%

		-19%	367%	10%	12%	33%	117%	-28%	245%	31%
SEASON	75-76	76-77	77-78	78-79	79-80	80-81	81-82	82-83	83-84	84-85
Paintings	3	5	2	8	9	14	10	6	4	4
Dollars	$7,400	$13,150	$116,800	$39,250	$28,200	$51,700	$86,400	$11,400	$54,800	$18,250

Record Sale: $115,000, PB, 3/22/78, "Jeanne," 74 x 37 in.

GEORGE OVERBURY ("POP") HART
(1868-1933)

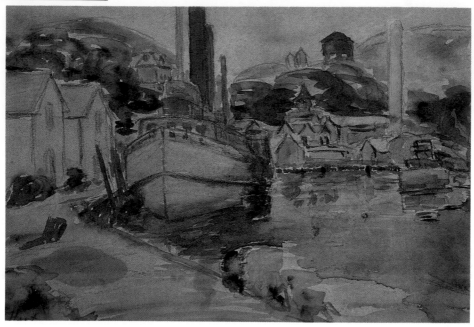

Mexican Port, 9½ x 13 in., signed l.l. Courtesy of Marbella Gallery, Inc., New York, New York, Photograph by Richard Haynes.

George Overbury Hart, known simply as "Pop," was a largely self-taught painter and etcher who wandered the world, recording scenes of everyday life with a deft hand.

He preferred watercolors to oils and, when he was past 50, turned to prints, lithographs and etchings. His drypoint prints, in particular, were admired because of his handling of dark-light contrasts.

Hart was born in Cairo, Illinois in 1868. Two brothers, both much older, were artists; this probably kindled a desire in him to be one. He struck out on his own at an early age, supporting himself as best as he could. His only formal training was a brief stint at the Chicago Art Institute and another at the Academie Julien in Paris.

From 1907 to 1912, Hart painted signs for amusement parks around New York City and then, until 1920, painted stage sets for the motion picture studios in Fort Lee, New Jersey. Between jobs, however, he managed to travel to Europe, Egypt, the South Seas, Mexico and South America, sketching and painting wherever he happened to be.

Hart was the classic wandering bohemian. Much of his work was undisciplined—genre scenes of the every-day folk he encountered on his travels. Some of it was racy, some poignant, but he knew how to capture the revealing gesture and the flavor of a locale to make his work interesting.

It was not until the 1920s that his work began to be regarded seriously. His reputation continued to grow until his death in New York City in 1933.

MEMBERSHIPS
American Watercolor Society
Brooklyn Society of Etchers
New York Water Color Society
Society of Independent Artists

PUBLIC COLLECTIONS
Art Institute of Chicago
British Museum, London
Brooklyn Museum
Cincinnati Art Museum
Los Angeles County Museum of Art
Metropolitan Museum of Art, New York City
National Museum of American Art, Washington, D.C.
Newark Museum, New Jersey
New York Public Library, New York City

SEASON	75-76	76-77	77-78	78-79	79-80	80-81	81-82	82-83	83-84	84-85
Paintings					3	1	1	2	2	1
Dollars					$1,950	$1,300	$2,400	$1,800	$1,200	$600

Record Sale: $2,400, SPB, 12/10/81, "Summer Weekend," 14 × 22 in.

WILLIAM HENRY SINGER, JR.
(1868-1943)

Although he was considered an American impressionist, William H. Singer, Jr. spent nearly all of his life as a painter in Europe, especially in Norway. Most of his work was devoted to capturing on canvas the solitude and majestic grandeur of the Norwegian mountains and fjords. His landscapes were notable on two counts: first for the vitality of the brushwork and vibrancy of color; and second, for the absence of any figures in them. It was nature that interested Singer, not man.

He was born to a prosperous steel-making family in Pittsburgh, Pennsylvania in 1868. He showed an early interest in art, but his father insisted that he enter the family business, where he stayed for 11 years.

In his free time, however, he sketched and painted in the countryside and studied with Martin Borgord, a Norwegian painter then living in Pittsburgh who later was to introduce Singer to Norway. When two of his paintings were accepted for the Carnegie International Exhibition in 1900, Singer was sufficiently encouraged to leave his job and go to Monhegan Island, off the coast of Maine, to paint.

The following autumn Singer, his wife and Borgord sailed for Paris. He enrolled at the Academie Julien, but disliked the emphasis on figure painting and left after a few months. He also studied with Jean-Paul Laurens, but left for the same reason.

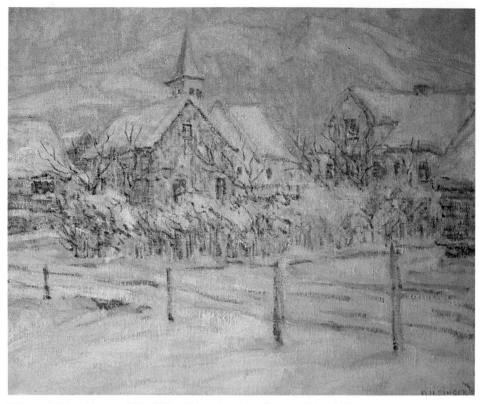

Village of Olden, Norway, 1919, 18¼ x 22 in., signed l.r. Florence Griswold Museum, Lyme Historical Society, Gift of Joseph and Renate Szymanski.

The Singers and Borgord went to Laren, a small artists' community in Holland, called the "Dutch Barbizon" of its day. There, he was able to concentrate on developing his technique as a landscape painter. After a few years, however, he wearied of the flatness of the Dutch countryside, and he longed for something different.

It was Borgord who suggested a trip to Norway, and this proved to be the turning point in Singer's career. He was overwhelmed by the vastness of the mountains and the stillness of the valleys and fjords. Here were all the elements of solidity, majesty and timelessness that he had been searching for.

At first the Singers spent springs and summers in Norway, and returned to Holland for the winters. Later, after building a mansion near Olden, a fishing village on the West coast, they lived there all year.

Singer inherited a considerable fortune, and he and his wife were known for their generosity to the Norwegians. During World War II, when the Germans occupied Norway, the Olden villagers cared for them and prevented Germans from imprisoning them. In 1943, however, Singer suffered a heart attack at his home there and died before a doctor could reach him.

MEMBERSHIPS
Allied Artists of America
American Art Association
National Academy of Design
Pittsburgh Art Society
St. Lucas Art Association

PUBLIC COLLECTIONS
Art Institute of Chicago
Brooklyn Museum
Delgado Museum, New Orleans
Gemeente Museum, The Hague
Metropolitan Museum of Art, New York City
Musee du Luxembourg, Paris
Pennsylvania Academy of the Fine Arts, Philadelphia
Royal Museum, Antwerp, Belgium
Stedelijk Museum, Amsterdam

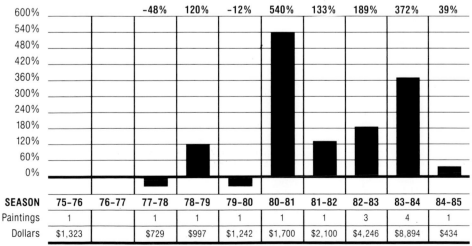

10-Year Average Change From Base Years '75-'76: 148%

		-48%	120%	-12%	540%	133%	189%	372%	39%	
SEASON	75-76	76-77	77-78	78-79	79-80	80-81	81-82	82-83	83-84	84-85
Paintings	1		1	1	1	1	1	3	4	1
Dollars	$1,323		$729	$997	$1,242	$1,700	$2,100	$4,246	$8,894	$434

Record Sale: $6,500, BB.SF, 2/16/84, "End of the Fjord," 18 × 22 in.

CHAUNCEY FOSTER RYDER
(1868-1949)

Chauncey Foster Ryder was a prolific and active artist, skilled as an etcher and lithographer and very respected as a landscape painter. His early desire to become a portraitist, which gave way to specializing in landscape compositions, gave an added dimension to his work.

Born in Danbury, Connecticut in 1868, Ryder decided to become an artist before he entered his teens. To fulfill that goal, he later took night courses at the Art Institute of Chicago while working by day as an accountant to support himself. In 1892, he married Mary Keith Dole in Chicago, and soon started working as an illustrator.

Wanting to learn more of portrait painting, he attended the Academie Julien in Paris in the early 1900s, training with Raphael Collin and Jean Paul Laurens as well. However, Ryder's interest in landscapes steadily grew as he traveled in France, Italy and Holland. He won a Paris Salon award in 1907, and returned to the United States in 1908, establishing his studio in New York City.

His favorite place, however, was his summer home in Wilton, New Hampshire, where he could spend all of his time painting much of the relatively untouched New England countryside. Ryder, a modest man, found solace in depicting the idyllic aspects of nature.

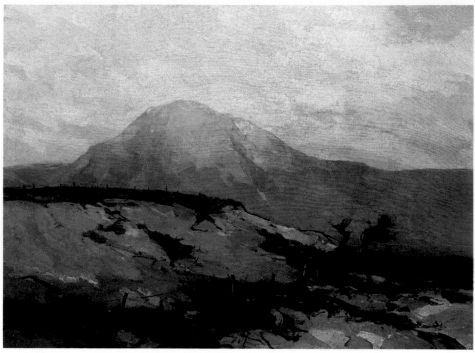

Mt. Lafayette, 45 x 60 in. Courtesy of Vose Galleries of Boston, Inc., Massachusetts.

He applied paint to canvas thickly, with sweeping strokes of color, frequently using a palette knife to shape the subject matter. Ryder's work was always a spaciously solid depiction of nature's lasting attributes. That same spaciousness and concern also applied to his prints, notwithstanding the confining boundaries of the copper plates.

Ryder died in Wilton, New Hampshire in 1949, leaving numerous examples of his work in Europe and the United States.

MEMBERSHIPS
Allied Artists of America
American Federation of Arts
American Water Color Society
Brooklyn Society of Artists
Chicago Society of Etchers
Lotos Club
National Academy of Design
National Arts Club
New York Water Color Club
Salmagundi Club

PUBLIC COLLECTIONS
Art Institute of Chicago
Brooklyn Museum
Corcoran Gallery, Washington, D.C.
Dayton Museum of Arts, Ohio
Metropolitan Museum of Art, New York City
National Gallery, Washington, D.C.
St. Louis Art Museum

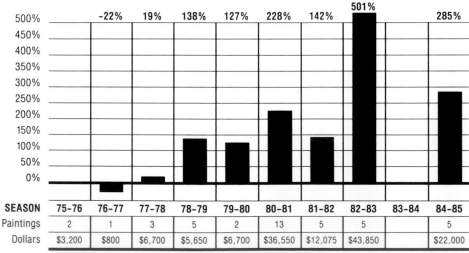

10-Year Average Change From Base Years '75-'76: 158%

	-22%	19%	138%	127%	228%	142%	501%		285%

SEASON	75-76	76-77	77-78	78-79	79-80	80-81	81-82	82-83	83-84	84-85
Paintings	2	1	3	5	2	13	5	5		5
Dollars	$3,200	$800	$6,700	$5,650	$6,700	$36,550	$12,075	$43,850		$22,000

Record Sale: $32,000, CH, 6/3/83, "Road to Raymond," 28 x 36 in.

618

HARRY ROSELAND
(1868-1950)

Genre painting enjoyed tremendous popularity in nineteenth-century America. It was a style that allowed a painter to tell a story, evoke an emotion, tell a joke, or educate. Largely superseded in the twentieth century by changes in popular taste and improvements in photographic technology, genre painting nevertheless remains a strong subcurrent in popular taste. One of the most notable painters in this mode was Harry Roseland.

Roseland, born in Brooklyn, New York in 1868, matured as an artist while waves of change were sweeping over the art world. Largely self-taught, he chose to paint what he saw.

He received some education in art under J.B. Whittaker in Brooklyn, and at first painted some landscapes and still lifes, but his natural flair was for telling a story in his paintings.

His subject matter was at first highly sentimental and heavily influenced by fashionable taste: smartly turned-out young women, old folks, and idealized farm scenes. He abandoned the mawkishness that is the downfall of so many self-educated artists when he found a topic that was close to home and yet largely unnoticed: the post-Civil War blacks who formed the underpinnings of Northeastern society.

Roseland's clever, skillful scenes of homely activities—such as checker-playing or letter-reading—were remarkably dispassionate and candid for the

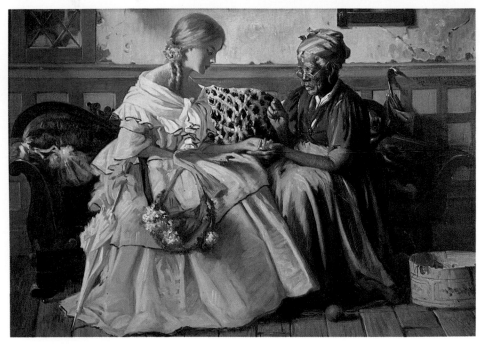

A Bright Future, 1906, 14 x 20 in., signed u.l. Courtesy of Henry B. Holt, Inc., Essex Fells, New Jersey.

time, though to modern eyes they seem condescending and dated. The capture with gentle humor of a way of life that existed through the first half of the twentieth century and has now vanished.

Roseland never left his native Brooklyn, dying in New York in 1950, but he enjoyed a remarkable success as an artist in his chosen specialty, improving and maturing continually. The archetype of the independent American artist, he never even traveled to Europe to study or observe, choosing to carve his own path.

10-Year Average Change From Base Years '75–'76: 63%

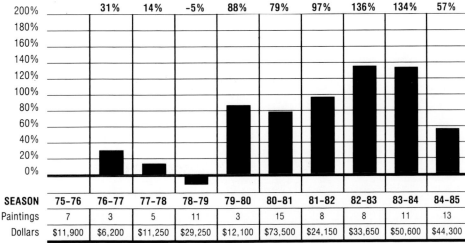

SEASON	75-76	76-77	77-78	78-79	79-80	80-81	81-82	82-83	83-84	84-85
		31%	14%	-5%	88%	79%	97%	136%	134%	57%
Paintings	7	3	5	11	3	15	8	8	11	13
Dollars	$11,900	$6,200	$11,250	$29,250	$12,100	$73,500	$24,150	$33,650	$50,600	$44,300

Record Sale: $22,000, SPB, 12/8/83, "Wake Up, Dad," 16 x 24 in.

MEMBERSHIPS
Brooklyn Arts Club
Brooklyn Society of Artists
Brooklyn Painters Society
Salmagundi Club

PUBLIC COLLECTIONS
Brooklyn Institute of Arts and Sciences
Brooklyn Museum
Charleston Art Museum
Heckscher Museum, Long Island, New York

BERT GREER PHILLIPS
(1868-1956)

Although he was not the first artist to visit Taos, New Mexico, Bert Greer Phillips was the first to settle there permanently.

Some fellow members of the famed Taos Society of Artists became modernists. But Phillips portrayed his beloved pueblo people and landscapes in an idealized, traditional style. He was successful, and a mainstay of the society, but he did not attain the level of celebrity and affluence of other Taos artists.

Born in Hudson, New York in 1868, Phillips won art prizes as a child. In 1884, at age 16, Phillips began five years' study at the Art Students League and the National Academy of Design in New York City.

An established artist by 1889, he was a successful Western illustrator before he had set foot in the West.

In 1894, Phillips traveled abroad, painted some appealing watercolor English landscapes, and arrived in Paris in 1895 to study at the Académie Julien. There he met American artists Joseph Sharp, who had visited Taos, and Ernest Blumenschein.

Back in New York City, Phillips and Blumenschein shared a studio. In the summer of 1898, they headed West. Stranded on the way to Mexico by a broken wagon wheel, they stayed in Taos to paint. In the fall, Blumenschein returned to New York, but Phillips remained in Taos.

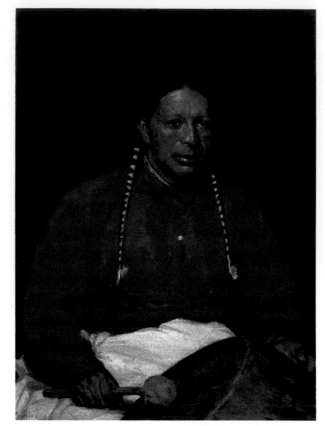

Indian Portrait, 16 x 12 in., signed l.l. Photograph courtesy of The Gerald Peters Gallery, Santa Fe, New Mexico.

Phillips painted his Indian subjects in their own pueblos. He was one of the few non-Indians invited to share their pastimes, and accumulated a museum-quality collection of Indian art and artifacts. He also championed Indian causes, and worked successfully to restore Indian rights to traditional lands near Taos.

Other artists came to live in Taos. In 1912, Phillips was among the six founders of the Taos Society. Others were Blumenschein, Sharp, Oscar Berninghaus, Herbert Dunton and Irving Couse.

Phillips's romance with "pure-aired" Taos never flagged, and his paintings reflect it. They have a visionary, dreamy quality, possessing lyrical charm.

Phillips died in 1956, in San Diego, California.

MEMBERSHIPS
Chicago Gallery
Salmagundi Club
Society of Western Artists
Taos Society of Artists

PUBLIC COLLECTIONS
Museum of New Mexico, Santa Fe
Polk County Courthouse, Des Moines, Iowa
San Marcos Hotel, Chandler, Arizona
State Capitol, Jefferson City, Montana

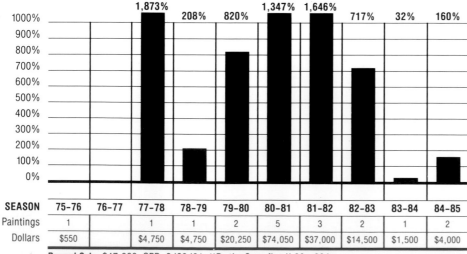

10-Year Average Change From Base Years '75-'76: 756%

SEASON	75-76	76-77	77-78	78-79	79-80	80-81	81-82	82-83	83-84	84-85
			1,873%	208%	820%	1,347%	1,646%	717%	32%	160%
Paintings	1		1	1	2	5	3	2	1	2
Dollars	$550		$4,750	$4,750	$20,250	$74,050	$37,000	$14,500	$1,500	$4,000

Record Sale: $47,000, SPB, 6/23/81, "By the Campfire," 30 x 20 in.

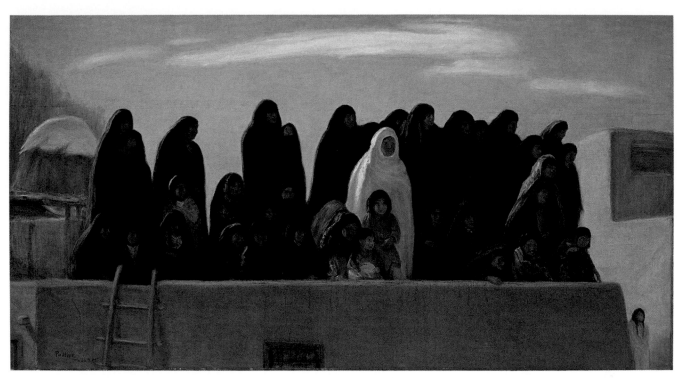

Spectators at Winter Ceremonial, Taos Pueblo, 24⅞ x 46¾ in., signed l.l. Courtesy of Stark Museum of Art, Orange, Texas.

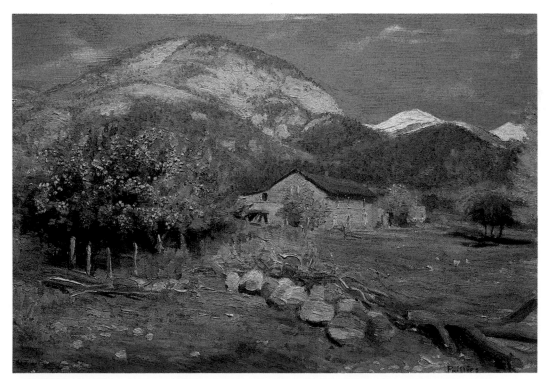

Scene Near Arroyo Seco, Taos, N.M., 12 x 16 in., signed l.r. Photograph courtesy of The Gerald Peters Gallery, Santa Fe, New Mexico.

LAWTON S. PARKER
(1868-1954)

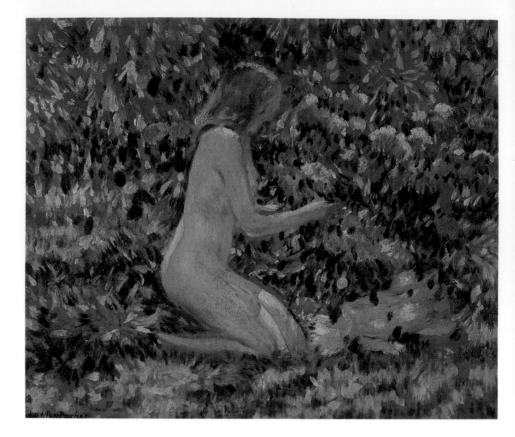

A portrait and landscape painter, Lawton S. Parker was a member of the Giverny Group, six relatively young American painters who, after study in Paris, fell under the spell of Claude Monet and lived and worked for a time near his studio-home in Giverny, France. A solid, academic painter to begin with, Parker adopted what some called a new kind of impressionism. Despite Monet's influence, he did not see nature the same way as did the major French impressionists, nor did he use broken colors to convey a sense of light as they did. His was a more conventional approach, with his colors matched as closely as possible to those of nature.

Parker was born in Fairfield, Michigan in 1868. He started his long training at the Art Institute of Chicago, then went to Paris in 1889 to study at the Academie Julien with Bouguereau and Tony-Fleury. Back in New York City, he enrolled at the Art Students League and studied with Mowbray and William Merritt Chase. Then it was back to Paris for training in mural painting with Besnard and finally, in 1897, a stint at the Ecole des Beaux Arts under Gerome. He also studied for a time with Whistler.

His life was not all uninterrupted study, however. To support himself Parker also taught at the St. Louis School of Fine Arts, at Beloit College in Wisconsin and at the New York School of Art. And in 1900 he opened his own academy of painting in Paris.

In 1902, Parker arrived in Giverny to join the succession of American artists who had lived there since 1887. Guy Rose, Frederick Frieseke and Richard Miller were there at the time. The four became close friends, criticized each other's work and eventually exhibited together in New York as impressionists, although some critics at the time referred to them as luminists.

Determined to become an even better portrait painter than he already was, Parker's purpose in coming to Giverny was to get his models out of the studio and into the sunlight. While he painted colors as he saw them, his work showed how varied color can be when viewed at different angles or in different positions in relation to the sun. His flesh tones, so conventional when seen in the subdued light of his studio, became refreshingly alive when seen in this new environment.

In 1913, Parker was the first American to be awarded the coveted Gold Medal at the Paris Salon. He died in Pasadena in 1954.

MEMBERSHIPS
Allied Artists of America
Chicago Society of Artists
National Academy of Design
National Arts Club

PUBLIC COLLECTIONS
Art Institute of Chicago
Los Angeles County Museum of Art
National Collection, France

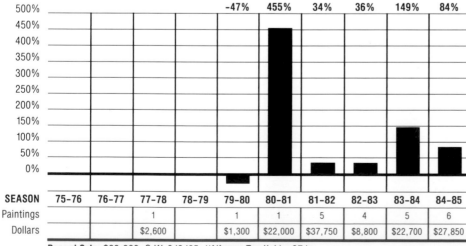

10-Year Average Change From Base Years '77–'78: 102%

	75–76	76–77	77–78	78–79	79–80	80–81	81–82	82–83	83–84	84–85
%					−47%	455%	34%	36%	149%	84%
SEASON	75–76	76–77	77–78	78–79	79–80	80–81	81–82	82–83	83–84	84–85
Paintings			1		1	1	5	4	5	6
Dollars			$2,600		$1,300	$22,000	$37,750	$8,800	$22,700	$27,850

Record Sale: $23,000, S.W, 2/3/85, "Alfresco Tea," 41 × 37 in.

LEON DABO
(1868-1960)

An eminent academician is said to have remarked at an exhibition of Leon Dabo's paintings, "Surely these glorious things have never been rejected by an intelligent jury." In fact, the works had been consistently spurned by juries of which the speaker had been a member. Leon Dabo—painter of landscapes and murals, illustrator, lithographer, lecturer—was recognized and honored abroad before he was appreciated in his own country.

Born in Grosse Pointe, Michigan in 1868, of French parents, Dabo was introduced to art by his father, who had been a professor of aesthetics in France and who owned a substantial art collection.

In 1884, Dabo studied with John La Farge in New York City. In 1885, he went to Paris, studying architecture and decoration at the Ecole des Arts Decoratifs, working under Puvis de Chavanne, Daniel Vierge and Pierre Galland, and attending the Ecole des Beaux-Arts and the Academie Julien.

Dabo studied under Galliardi in Rome in 1887, and also copied the masters in Florence and Venice. In 1888, he went to London, where he often visited Whistler's studio. Returning to the United States in 1890, he was assistant to La Farge, learning stained-glass techniques. He painted in the mornings and evenings.

In the work of Whistler, of Redon and the French impressionists, and of the

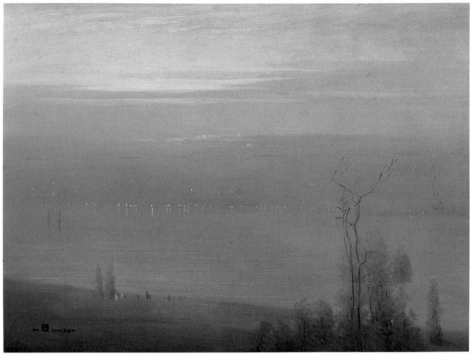

Evening on the Hudson, 1909, 27⅛ x 36⅛ in., signed l.l. Courtesy of National Museum of American Art, Smithsonian Institution, Gift of William T. Evans.

great Japanese masters, the young artist discovered intellectual and emotional stimuli that fused to become uniquely Dabo. And the time spent painting every morning and evening improved his technique. Over the years, his painting evolved from tight, rather ordinary work, to impressionistic studies of light and atmosphere, to the relationships of color, line and arrangement that are Dabo's own.

Called "the poet in color" by Bliss Carman, Dabo saw nature with the poet's eye. His landscapes convey the broad and powerful in nature, as well as the sensitive and intimate. His color effects are luminous and transparent.

There are no violent contrasts, only nuances of light and color, harmonious tones that blend. Hardly a brushstroke shows.

Dabo described his landscapes as pretexts for beautiful color arrangement; their purpose was to evoke feelings. His depictions of nature have a sense of mystery suggestive of great spiritual power.

Dabo's career spanned 76 years. He died in New York City in 1960 at age 92.

MEMBERSHIPS
Allied Artists Association Limited of London
Brooklyn Society of Artists
Hopkin Club of Detroit
Les Amis des Arts
Les Mireilles
National Academy of Design
National Arts Club
National Society of Mural Painters
Royal Society of Arts and Sciences
School Art League of New York
Society des Amis du Louvre
Society of Pastellists
Three Arts Club

PUBLIC COLLECTIONS
Art Institute of Chicago
Baltimore Art Association
Brooklyn Museum
Delgado Museum, New Orleans
Detroit Institute of Arts
Imperial Museum of Art, Tokyo
Metropolitan Museum of Art, New York City
Minneapolis Art Museum
Montclair Art Museum, New Jersey
National Arts Club, New York City
National Gallery, Ottawa, Canada
National Gallery, Washington, D.C.
Newark Museum, New Jersey
Reading Art Gallery, Pennsylvania
Toledo Museum of Art, Ohio

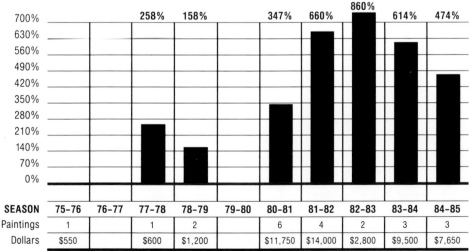

10-Year Average Change From Base Years '75-'76: 421%

	75-76	76-77	77-78	78-79	79-80	80-81	81-82	82-83	83-84	84-85
(% change)			258%	158%		347%	660%	860%	614%	474%
SEASON	75-76	76-77	77-78	78-79	79-80	80-81	81-82	82-83	83-84	84-85
Paintings	1		1	2		6	4	2	3	3
Dollars	$550		$600	$1,200		$11,750	$14,000	$2,800	$9,500	$7,650

Record Sale: $7,000, CH, 6/1/84, "Long Island Sound," 30 x 34 in.

623

PERCY GRAY
(1869-1952)

Percy Gray was a California landscape painter who, in his mature years, specialized in watercolor and became known for his distinctive perspectives, as well as for a unique technique he developed for building up paint to capture the essence of the scene he was painting. He worked in other media as well—pencil, oils, etching and lithography—but it was watercolor that he liked best.

Gray was born in San Francisco in 1869. He attended the California School of Design, worked as a stockbroker's clerk for a time and then became a newspaper sketch artist. After moving to New York in 1895, he joined the staff of the *Journal* as a sketch artist, and soon became head of the whole art department.

After hours, he studied at the Art Students League under William Merritt Chase, whose ideas on landscape painting influenced Gray for the rest of his life. Following the earthquake and fire in San Francisco in 1906, Gray returned home to work for the *Examiner*, again as a sketch artist. After four years he was able to give it up and concentrate on his painting.

Most of his scenes were of the countryside immediately surrounding San Francisco. Very occasionally he would travel to the deserts of Arizona and the mountains of Oregon and Washington. At one time he also did 20 portraits of

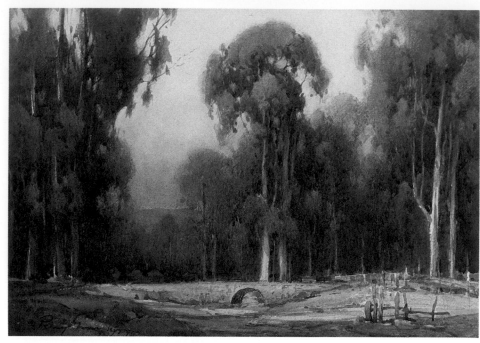

Bridge in Landscape, 1929, 15 x 21½ in., signed l.l. Courtesy of Maxwell Galleries, Ltd., San Francisco, California.

American Indians, but for the most part he eschewed portrait work; he did not like it.

Gray loved to roam the hills and meadows of the San Francisco Bay area, sketching the essential elements of a scene on the spot. Back in his studio, he would lightly pencil in the outline of his composition, then set to work with his watercolors.

In the last few years before his death in 1952, Gray lost much of his flair for color-filled landscapes, however, and his work took on a more somber, contemplative quality.

MEMBERSHIPS
Bohemian Club
San Francisco Art Association
Society of Western Artists

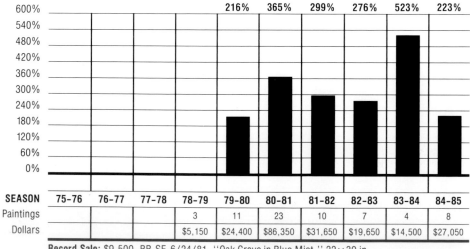

10-Year Average Change From Base Years '78-'79: 272%

| | | 216% | 365% | 299% | 276% | 523% | 223% |

SEASON	75-76	76-77	77-78	78-79	79-80	80-81	81-82	82-83	83-84	84-85
Paintings				3	11	23	10	7	4	8
Dollars				$5,150	$24,400	$86,350	$31,650	$19,650	$14,500	$27,050

Record Sale: $9,500, BB.SF, 6/24/81, "Oak Grove in Blue Mist," 22 x 30 in.

624

WILSON H. IRVINE
(1869-1936)

Wilson Henry Irvine, known primarily for his landscapes, was a prolific master of a variety of subjects and media. Never one to be content with the traditional, he is known for his experimentation during the 1920s and 1930s.

Born in Byron, Illinois in 1869, Irvine took up journalism after high school. It wasn't until he moved to Chicago that he developed an interest in art. He acquired a job as manager of the art department of the Chicago Portrait Company and attended classes at the Art Institute of Chicago at night. During this time, he specialized in recording on canvas the rural Illinois where he grew up.

In 1917, Irvine and his wife spent more than a year traveling around Britain and France. There he expanded his repertoire, painting the quaint fishing villages that dotted the British and French coasts.

Irvine returned to the United States and settled in Old Lyme, Connecticut. He became associated with Guy Wiggins and Everett Warner as part of the Old Lyme Art Colony. In these years, he pursued pure landscape painting.

Irvine was always on the cutting edge of the art world until his death in 1936. In 1927, he successfully mastered the technique of etching in aquatint. Three years later, Irvine began producing what he termed prismatic painting—landscapes and still lifes as seen through a glass prism. This accentuated the

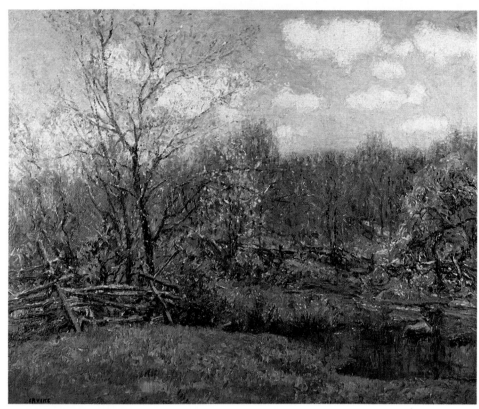

Spring Landscape, Old Lyme, 24¼ x 30 in., signed l.l. Courtesy of Henry B. Holt, Inc., Essex Fells, New Jersey.

effect of light on the edges of any object viewed.

The style was slow to find acceptance, but Irvine kept with it. In 1934, he won the best-picture award in the annual exhibition of the Lyme Art Association with *Indolence* (date and location unknown), a prismatic rendering of a nearly life-size nude.

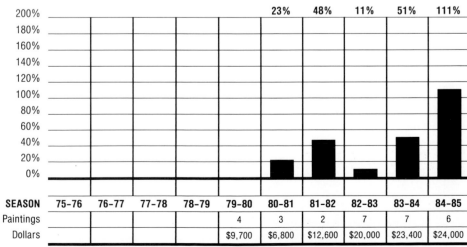

10-Year Average Change From Base Years '79–'80: 41%

SEASON	75–76	76–77	77–78	78–79	79–80	80–81	81–82	82–83	83–84	84–85
						23%	48%	11%	51%	111%
Paintings					4	3	2	7	7	6
Dollars					$9,700	$6,800	$12,600	$20,000	$23,400	$24,000

Record Sale: $13,000, P.NY, 10/3/84, ''Maine Street, Essex,'' 24 × 27 in.

MEMBERSHIPS
Allied Artists of America
Chicago Society of Artists
Chicago Water Color Club
Cliff Dwellers
Lyme Art Association
National Academy of Design
Palette and Chisel Club
Salmagundi Club
Society of Western Artists

PUBLIC COLLECTIONS
Art Institute of Chicago
Corcoran Gallery of Art, Washington, D.C.
Sears Memorial Museum, Elgin, Illinois
Union League Club, Chicago

MARIE DANFORTH PAGE
(1869-1940)

Marie Danforth Page was a noted portraitist who resided in Boston all her life. Daughter of a prominent Boston businessman and wife of a physician, she was trained in the conservative Boston tradition of painting, but she carved a distinct niche for herself with her sensitive portraits of children and her perceptive treatment of the mother-and-child theme.

Danforth's art training began in 1886 when she took drawing lessons from Helen Knowlton, a pupil of Boston's leading artist, William Morris Hunt. From 1890 to 1896, Danforth studied at the School of the Museum of the Fine Arts in Boston, under Frank Benson and Edmund Tarbell.

Tarbell's influence is evident in her modified impressionist color palette and in the broad, soft brushstrokes of her early works. However, unlike Tarbell, she seldom painted women quietly engaged in some domestic activity. Instead, she concentrated on portraits and, in time, developed the theme of mother and child.

Danforth lived in an age when the only career deemed proper for a married woman (especially an upper-class woman) was that of homemaker. Nevertheless, even after her 1896 marriage to Dr. Page, her career as a portraitist grew ever more successful.

Her paintings were characterized by simplified settings, shallow space and few accessories. She specialized in children and young girls, but from 1914 on, Page returned again and again to the mother-and-child theme. Her best-known painting on this subject, *The Tenement Mother* (ca. 1914, George Walter Vincent Smith Art Museum, Springfield, Massachusetts), was critically acclaimed and established her position.

After 1917, Page's work underwent significant changes. Her colors became brighter, with lighter flesh tones and patchy brushwork. This was due in part to her exposure to European modernism. Still, she maintained the solid, straightforward approach to painting admired by her following.

Page died in 1940.

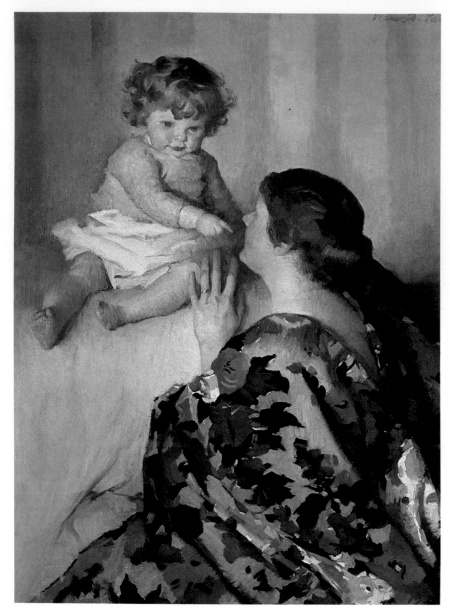

The Gay Gown, 45 x 35 in., signed u.r. Courtesy of Vose Galleries of Boston, Inc., Massachusetts.

MEMBERSHIPS
Boston Guild of Artists
Copley Society
National Academy of Design

PUBLIC COLLECTIONS
Erie Museum of Art, Pennsylvania
George Walter Vincent Smith Museum, Springfield, Massachusetts
Harvard University, Cambridge, Massachusetts
Montclair Art Museum, New Jersey
Santa Barbara Museum of Art, California

SEASON	75-76	76-77	77-78	78-79	79-80	80-81	81-82	82-83	83-84	84-85
Paintings							1	1	1	
Dollars							$11,000	$3,500	$4,000	

Record Sale: $11,000, S.BM, 5/20/82, "The Gay Gown," 45 × 33 in.

WILLIAM McGREGOR PAXTON

(1869-1941)

Prominent Boston painter William McGregor Paxton is known for his portraits, murals and genre paintings, although he experimented widely in other media, including etching and lithography.

Born in 1869 in Baltimore, Paxton grew up in Newton, Massachusetts. He studied art at the Cowles School in Boston under Dennis Miller Bunker and then at the Ecole des Beaux-Arts in Paris with Jean-Leon Gerome.

Returning to Boston, Paxton supplemented his income by designing newspaper ads while studying with Edmund Tarbell, Frank Benson and Joseph DeCamp; he then joined them on the faculty at the school of the Museum of Fine Arts of Boston.

Paxton, well known for his portraits, was dubbed the "court painter of Philadelphia" for those he painted during the brief period he lived there. Among his prominent works are portraits of Presidents Grover Cleveland and Calvin Coolidge. Also notable are murals he executed for the Army and Navy Club of New York City and for the St. Botolph Club of Boston.

However, it is his paintings of attractive young women of the leisure class, presented in an artful and idealized fashion, for which he is best remembered. These paintings recall the works of Jan Vermeer in their extraordinary

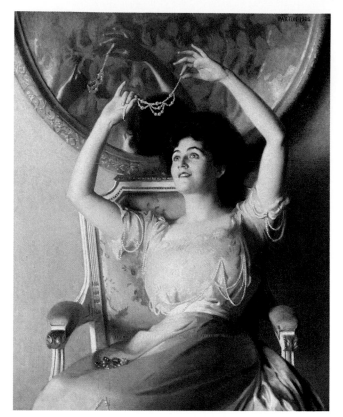

The String of Pearls, 1908, signed u.r. Courtesy of Vose Galleries of Boston, Inc., Massachusetts.

attention to details of flesh and textiles and the effects of reflected light, and are characterized by highly finished surfaces in the beaux-arts manner. While these paintings focused on the content of daily life, the emphasis on the details of material surroundings was criticized as imitating the superficiality of society pictures by European painters, which were fashionable at the time.

However, this emphasis on detail resulted from Paxton's theory of "bin-

ocular vision," a way of seeing about which he commented: ". . . a man looking out through two eyes sees things with a certain single focus, and outside that focus, all vertical lines and vertically inclined spots double." This led him to paint objects outside his focus by slightly blurring them.

Always academically oriented, Paxton became a full member of the National Academy of Design in 1928. He died in Boston in 1941.

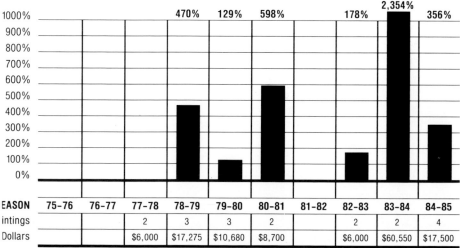

10-Year Average Change From Base Years '77-'78: 584%

SEASON	75-76	76-77	77-78	78-79	79-80	80-81	81-82	82-83	83-84	84-85
%				470%	129%	598%		178%	2,354%	356%
Paintings			2	3	3	2		2	2	4
Dollars			$6,000	$17,275	$10,680	$8,700		$6,000	$60,550	$17,500

Record Sale: $60,000, SPB, 12/8/83, "Reverie," 36 × 29 in.

MEMBERSHIPS
Allied Artists of America
American Federation of Arts
Beachcombers Club
Boston Arts Club
Copley Society of Boston
Guild of Boston Artists
National Academy of Design
National Arts Club
North Shore Art Association
Pennsylvania Academy of the Fine Arts
Philadelphia Art Center

PUBLIC COLLECTIONS
Army and Navy Club, New York City
Cincinnati Art Museum
Corcoran Gallery of Art, Washington, D.C.
Delaware Art Museum, Wilmington
Detroit Institute of Arts
Metropolitan Museum of Art, New York City
Museum of Fine Arts, Boston
Pennsylvania Academy of the Fine Arts, Philadelphia
Wadsworth Atheneum, Hartford, Connecticut

CARL RUNGIUS
(1869-1959)

Carl Clemens Moritz Rungius was a spirited and effective artist, skilled as a draftsman and hightly esteemed as a visual historian and naturalist. His full knowledge of anatomy, coupled with distinct composition and color sense, made him the foremost painter of Western North American big-game subjects.

Born near Berlin, Germany in 1869, Rungius was fascinated with big-game animals from childhood. He started painting in 1889, attending the Berlin Art School. His boyhood dream of studying and painting American big game was realized in 1894 when he emigrated to the United States, establishing a winter studio in New York City, and a summer studio in Banff, Alberta, Canada.

Rungius spent most of his time in the wilderness, and always painted directly from nature. His first sketching expedition was to Yellowstone Park and other parts of Wyoming in 1895, which he followed by over 50 years of stalking and painting wildlife from Arizona to Alaska.

Rungius documented the life and habitat of the antelope, elk, deer, goat and mountain sheep, as well as his favored larger subject matter—the grizzly bear, moose and caribou. These works are still considered to be important natural-history records.

Occasionally, he crossed the path of cowboys on a roundup or cattle drive. His depictions of their life-style were executed with immediacy and honesty.

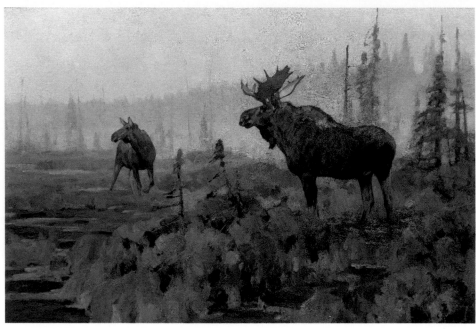

Moose Near Long Lake, ca. 1925, 30 x 45 in., signed l.r. Courtesy of Wunderlich and Company, Inc., New York, New York.

In 1913, Rungius was elected an associate of the National Academy, becoming an academician in 1920.

Among his friends and admirers was Theodore Roosevelt, who purchased many Rungius paintings. Rungius apparently died in New York City at age 90 in 1959, leaving behind an opulent and unsurpassed record of North American big-game animals.

MEMBERSHIPS
American Federation of Arts
Lotus Club
National Academy of Design
National Arts Club
Salmagundi Club
Society of American Animal Painters
 and Sketchers
Society of Men Who Paint the Far West

PUBLIC COLLECTIONS
Glenbow Museum, Calgary, Alberta, Canada
New York Zoological Society, New York City
Shelburne Museum, Vermont

10-Year Average Change From Base Years '77-'78: 54%

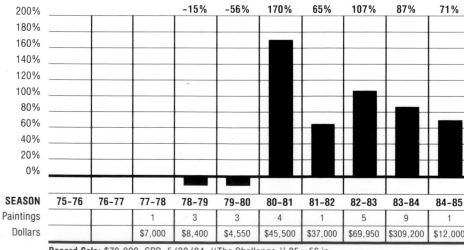

SEASON	75-76	76-77	77-78	78-79	79-80	80-81	81-82	82-83	83-84	84-85
				-15%	-56%	170%	65%	107%	87%	71%
Paintings			1	3	3	4	1	5	9	1
Dollars			$7,000	$8,400	$4,550	$45,500	$37,000	$69,950	$309,200	$12,000

Record Sale: $70,000, SPB, 5/30/84, "The Challenge," 35 × 56 in.

HENRY HOBART NICHOLS
(1869-1962)

Subtle and muted, the landscapes of. Henry Hobart Nichols are not exaggerated, outrageous or faddish. They exhibit a truly personal style. Yet he was a supportive comrade to his more radical artistic peers, and a man respected by all.

Born in Washington, D.C. in 1869, Nichols studied at the Art Students League and under Howard Helmick in Washington, then traveled to Paris to attend the Academie Julien and train with Claudio Castellucho. When he returned to the United States he based himself in New York City, although he painted in upper New York State and in New England.

He also devoted himself all his life to the welfare and promotion of his fellow artists. In 1900, he was involved with United States support for the Paris Exposition. From 1939 to 1949, he was president of the National Academy of Design. He was also a director and trustee of the Tiffany Foundation, and a trustee of the Metropolitan Museum of Art in New York. He died in New York City in 1962 at age 93.

In an age when traditional formulas are often rejected, the richness and diversity possible within a formal manner may not be fully appreciated. Hobart Nichols painted for the love of painting and the love of the landscape; his quiet paintings and illustrations, spare and academic as they are, have poetry and truth in them.

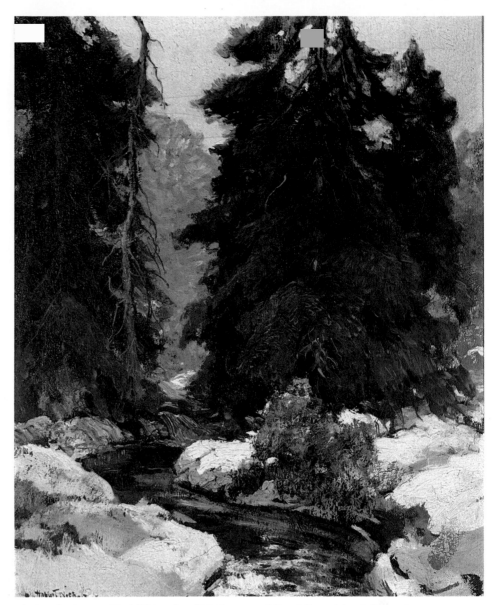

The Brook—Winter, 22 x 17¾ in., signed l.l. Courtesy of Grand Central Art Galleries, Inc., New York, New York.

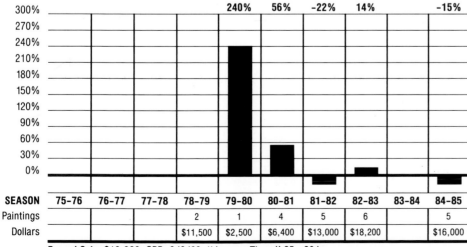

10-Year Average Change From Base Years '78-'79: 46%

	75-76	76-77	77-78	78-79	79-80	80-81	81-82	82-83	83-84	84-85
					240%	**56%**	**-22%**	**14%**		**-15%**
SEASON	75-76	76-77	77-78	78-79	79-80	80-81	81-82	82-83	83-84	84-85
Paintings				2	1	4	5	6		5
Dollars				$11,500	$2,500	$6,400	$13,000	$18,200		$16,000

Record Sale: $10,000, SPB, 6/2/83, "January Thaw," 25 x 30 in.

EDWARD WILLIS REDFIELD
(1869-1965)

Edward Willis Redfield was the acknowledged leader of the New Hope School of American impressionism. His bold and vigorous landscape paintings, especially his snow scenes of Bucks County in the Delaware River Valley of Pennsylvania, distinguished him as one of this country's foremost painters. Redfield's exuberant, impressionistic style was emulated by several generations of New Hope artists, many of whom settled in this picturesque area due to his tremendous influence.

Born in Bridgeville, Delaware in 1869, Redfield moved to Philadelphia at an early age. He soon became familiar with Bucks County, just a short jaunt North of the city. Determined to become an artist, he studied painting under a Mr. Rolf, in preparation for entrance into the prestigious Pennsylvania Academy of the Fine Arts.

From 1885 to 1889, Redfield followed a traditional course of study at the Academy under Thomas Anshutz, James Kelley and Thomas Hovenden. He developed a lifelong friendship with fellow student Robert Henri, an influential teacher and founder of the Ashcan School.

Redfield sailed with Henri for Paris in 1889, where he continued his studies at the Academie Julien and Ecole des Beaux Arts. He received rigorous training as a figure painter and portraitist under Adolphe William Bouguereau and Tony Robert-Fleury.

Old Stover Mill, 50 x 56 in., signed l.r. Courtesy of Newman Galleries, Philadelphia, Pennsylvania.

Valley of the Delaware, 50 x 56 in., signed l.r. Courtesy of Newman Galleries, Philadelphia, Pennsylvania.

Stifled within this rigid academic system, Redfield retreated from Paris to the village of Brolles in the Forest of Fountainebleu, where he pursued landscape painting.

Redfield and his French wife returned to Pennsylvania in 1898, settling in Center Bridge, near New Hope. Particularly taken with the rolling hills and graceful woodlands of the region, he worked in semi-isolation on his farm, situated near the Delaware River. Here, he gradually developed his own original, impressionistic style.

Like the French impressionists, Redfield was interested in capturing the effects of atmosphere and light, although his technique did not depend on the juxtaposition of contrasting colors to stimulate the picture surface. He applied his paint in long brushstrokes of

10-Year Average Change From Base Years '76-'77: 110%

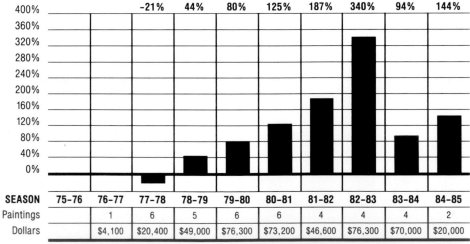

	-21%	44%	80%	125%	187%	340%	94%	144%

SEASON	75-76	76-77	77-78	78-79	79-80	80-81	81-82	82-83	83-84	84-85
Paintings		1	6	5	6	6	4	4	4	2
Dollars		$4,100	$20,400	$49,000	$76,300	$73,200	$46,600	$76,300	$70,000	$20,000

Record Sale: $48,000, CH, 3/18/83, "The Ferry Road at Point Pleasant," 32 × 40 in.

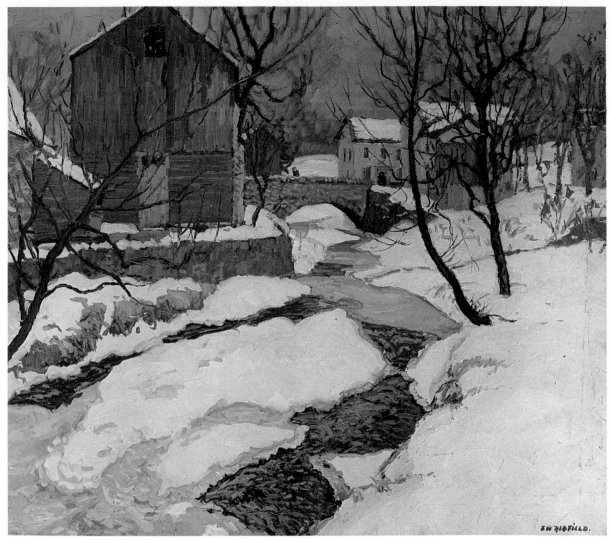

The Brook at Carversville, 28 x 32⅛ in., signed l.r. Courtesy of National Museum of American Art, Smithsonian Institution, Bequest of Henry Ward Ranger through the National Academy of Design.

thick impasto, rather than with the short, feathery brushstrokes characteristic of French impressionism.

He developed a method of painting which enabled him to complete a large (50-by-56-inch) canvas in a single day's work. This technique, achieved after years of formal study, allowed Redfield to record the ever-changing weather and atmospheric conditions.

Celebrated as a painter of the winter landscape, Redfield was exposed to every harshness the season could muster. A plein-air painter, he often stood knee-deep in snow, his canvas strapped to a tree, in order to work directly from nature.

Like Monet, whom he greatly admired, Redfield painted relentlessly throughout his long life, which ended in 1965. His influence, particularly upon younger New Hope impressionists, has proven enduring; today, traces of his style appear in the works of contemporary artists of the region.

MEMBERSHIPS
American Federation of Arts
National Institute Artists League
Pennsylvania Academy of the Fine Arts
Philadelphia Art Club
Salmagundi Club
Society of American Artists

PUBLIC COLLECTIONS
Albright-Knox Art Gallery, Buffalo
Art Institute of Chicago
Brooklyn Museum
Carnegie Institute, Pittsburgh
Cincinnati Art Museum
Corcoran Gallery of Art, Washington, D.C.
Dallas Museum of Fine Arts
Detroit Institute of Arts
Los Angeles County Museum of Art
Metropolitan Museum of Art, New York City
Minneapolis Institute of Arts, Minnesota
Musee d'Orsay, Paris
National Gallery of Art, Washington, D.C.
New Jersey State Museum, Trenton
Pennsylvania Academy of the Fine Arts,
 Philadelphia
Philadelphia Museum of Art
St. Louis Art Museum

BEN
AUSTRIAN
(1870-1921)

Hailed in London as "the Landseer of chickens," Ben Austrian may be the only American artist whose reputation was built on paintings of chickens. One of his early depictions of a baby chick, just hatched from its shell, caught the eye of a director of a new soap company. Along with the slogan "Hasn't Scratched Yet!!!," it became the trademark for Bon Ami cleanser. In the years that followed, Austrian painted all the chicks featured in Bon Ami advertisements. He enlisted his wife as the model for the contented housewife shown using the product for household cleaning chores.

Austrian was born in Reading, Pennsylvania in 1870. He showed an early aptitude for drawing and was given his first box of watercolor paints when he was only five. Except for a brief time as a student of local artist Frederick Spang, however, he was entirely self-taught.

After working as a salesman in Williamsport, Pennsylvania, Austrian returned to Reading as a traveling representative for one of his father's businesses. In return for an order, Austrian would give customers one of his own early paintings.

When his father died in 1897, Austrian had to take over the operation of the family steam laundry. He despaired of ever becoming a painter. Before long, however, he persuaded his mother to let him sell the laundry, giving her the proceeds, so that he could paint full-time.

He hatched three chicks in his studio and, as they grew, trained them to pose for him. These were the first models for his many paintings of chickens. He also painted some trompe l'oeil paintings of game hanging after the hunt which attracted considerable attention. *A Day's Hunt* (1898, location unknown), was purchased by a Reading industrialist in 1904 for $2,500, a high price at that time.

Sunrise in the Florida Wetlands, ca. 1915, 19½ x 15½ in., signed l.r. Courtesy of Private Collection, Radnor, Pennsylvania.

From the 1890s on, Austrian regularly did paintings for Bon Ami advertisements and later formed his own lithographic printing company to sell reproductions of them. In 1902, he went to Paris to paint and then to London for several years. It was then that his work was compared to Landseer's.

Austrian had a winter studio in Palm Beach, Florida. He died there of a stroke in 1921.

SEASON	75-76	76-77	77-78	78-79	79-80	80-81	81-82	82-83	83-84	84-85
Paintings						1		1		1
Dollars						$850		$3,750		$800

Record Sale: $3,750, S.BM, 5/12/83, "The Stranger," 20 × 26 in.

PUBLIC COLLECTIONS
Historical Society of Berks County, Pennsylvania
Kutztown State University, Pennsylvania
Walker Art Museum, Liverpool, England

Motherhood, 1897, 29½ x 30 in., signed l.r.
Courtesy of the Reading Public Museum, Pennsylvania.

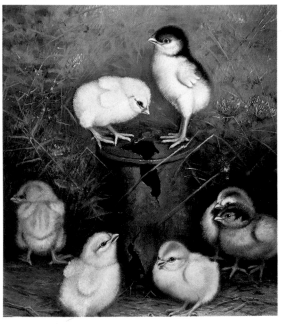

Chicks, 1901, 11 x 9½ in., signed l.r.
Courtesy of Henry B. Holt, Inc., Essex Fells, New Jersey.

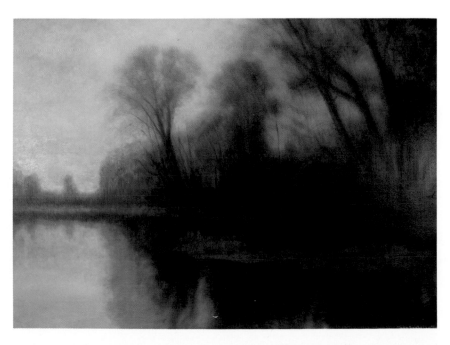

Sunrise Near Palm Beach, Florida, 1918,
25½ x 35½ in., signed l.r.
Courtesy of Private Collection, Radnor, Pennsylvania.

ALEXANDER JOHN DRYSDALE
(1870-1934)

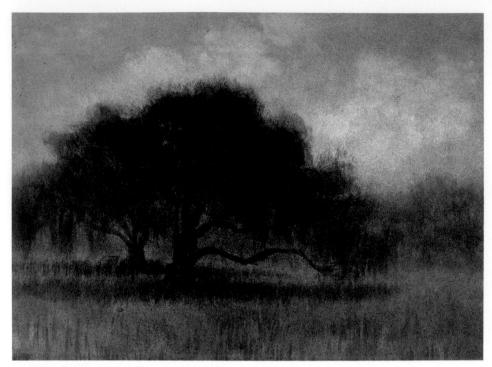

Audubon Park, 17½ x 23½ in., signed l.l. Courtesy of Raydon Gallery, New York, New York.

A true product of the South, Alexander Drysdale spent all of his adult life in and around New Orleans, painting the bayous in moody, misty tones much like those of the symbolists. He was greatly influenced by George Inness, whose "transitory effects of nature" he much admired.

Drysdale was born in Marietta, Georgia in 1870, but moved to New Orleans when his father was appointed dean of Christ Church Cathedral there. He gave up a budding career as an accountant to study painting with Paul Poincy in New Orleans. Later he studied at the Art Students League in New York under Charles Curran and Frank Vincent Dumond.

On his return to New Orleans, Drysdale devoted himself to landscapes, capturing in soft, evocative tones the mystery of moss-draped oaks and still bayou waters. He developed a distinctive technique, using kerosene-thinned oil paint almost as if it were watercolor.

Drysdale was a prolific painter, sometimes finishing two paintings in a single day. He was sensitive to the criticism that much of his work was repetitive, but he pointed out that the same could be said about other artists of the day—John Singer Sargent, Robert Henri and William Merritt Chase among them. When he died in 1934, so much of his work existed that its value plunged.

Drysdale was his own best salesman, frequently persuading wealthy women and successful cotton brokers to invest in his work. One of his paintings hangs in "Sagamore Hill," Theodore Roosevelt's summer home on Long Island.

MEMBERSHIPS
Artists Association of New Orleans
Arts & Crafts Club of New Orleans

PUBLIC COLLECTIONS
Louisiana State Museum
New Orleans Museum of Art
Sagamore Hill National Historic Site, Oyster Bay, New York

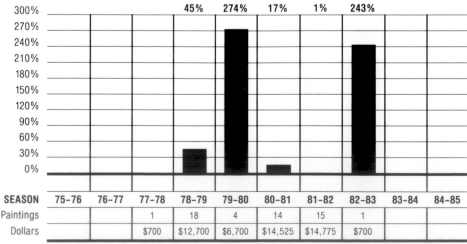

10-Year Average Change From Base Years '77-'78: 97%

	75-76	76-77	77-78	78-79	79-80	80-81	81-82	82-83	83-84	84-85
				45%	274%	17%	1%	243%		
SEASON	75-76	76-77	77-78	78-79	79-80	80-81	81-82	82-83	83-84	84-85
Paintings			1	18	4	14	15	1		
Dollars			$700	$12,700	$6,700	$14,525	$14,775	$700		

Record Sale: $4,250, M.NO, 10/2/81, "Bayou Teche Country," 35×91 in.

WILLIAM GLACKENS
(1870-1938)

William Glackens was a painter and illustrator, one of The Eight who transformed American art with their new realism in the early twentieth century.

Glackens painted middle-class urban subjects—usually well-dressed people in restaurants, cafes, parks and clothing stores—people who were enjoying their lives in the city. There is pleasure in his work and a touch of elegance. In his later career, Glackens—influenced by the impressionistic style of Renoir—painted nudes, portraits of women, and summer landscapes in shimmering brushstrokes of red, green, orange and yellow. He has been called "the American Renoir."

Like other members of the Ashcan School who congregated around Robert Henri, Glackens began as a newspaper artist, working in his hometown for the *Philadelphia Press* and *Record*. He was extremely talented at drawing, with a near-photographic memory for detail, working quickly and rarely lingering over an assignment. Friends used to play a game with Glackens, asking him to describe a room they had just left—which he would do, down to the last detail, including the style of molding on the ceiling. It was said that he never bothered to sketch a scene on the spot because he could remember it so well.

In 1891, the year he began as an artist-reporter, Glackens met Henri, who urged him to take up painting. The young illustrator attended night classes

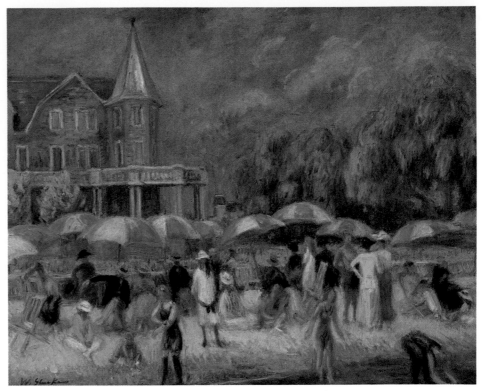

Beach Umbrellas at Blue Point, ca. 1915, 26 x 32 in., signed l.l. Courtesy of National Museum of American Art, Smithsonian Institution, Gift of Mr. and Mrs. Ira Glackens.

at the Pennsylvania Academy of the Fine Arts. In 1895, he went to Europe with Henri and Elmer Schofield to travel and paint. On his return, Glackens settled in New York City, earning his living with magazine illustrations and devoting his free time to painting. For Glackens the city represented, not ashcans and squalor, but the good life of restaurants, theaters and entertainment.

In 1905, he produced his masterpiece, *Chez Mouquin* (1905, Chicago Art Institute)—a picture of a couple seated in a French cafe that rivals the best of

the impressionists. The work shows Glackens's extraordinary drawing ability and his exquisite sense of detail. Until 1905, Glackens painted in the dark tones of the new realism; but after another visit to France, he adopted vivid rainbow colors. He liked bright sunlight and increasingly turned away from urban scenes to breezy, lyrical landscapes and seaside paintings.

Glackens was a quiet man who did what he wanted with apparent ease. Good-humored and tolerant, he lived in Greenwich Village with his wife, a daughter of William Merritt Chase, and his children. Good meals and good times are reflected in the family groups Glackens painted.

In 1912, Glackens went abroad with $20,000 from his friend, Albert C. Barnes, to purchase a series of paintings that would become the nucleus of the distinguished Barnes Foundation collection in Merion, Pennsylvania. Glackens chose works by the major impressionists: Renoir, Degas, Van Gogh and Cezanne.

He died in 1938.

MEMBERSHIPS
National Academy of Design

PUBLIC COLLECTIONS
Art Institute of Chicago
Detroit Museum of Arts
Metropolitan Museum of Art, New York City

10-Year Average Change From Base Years '75-'76: 165%

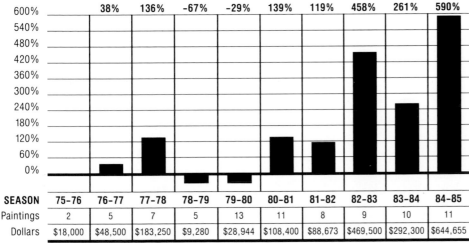

SEASON	75-76	76-77	77-78	78-79	79-80	80-81	81-82	82-83	83-84	84-85
		38%	136%	-67%	-29%	139%	119%	458%	261%	590%
Paintings	2	5	7	5	13	11	8	9	10	11
Dollars	$18,000	$48,500	$183,250	$9,280	$28,944	$108,400	$88,673	$469,500	$292,300	$644,655

Record Sale: $345,455, CH, 12/7/84, "Beach at Annisquam," 25 × 30 in.

HENRY SALEM HUBBELL
(1870-1949)

A portrait and still-life painter influenced by French impressionists, Henry Salem Hubbell was born in Paola, Kansas in 1870. He studied at the Art Institute of Chicago. Later Hubbell went to Paris; he worked with Whistler, Constant, Collin and Laurens, and exhibited at the famed Paris Salon.

American author Booth Tarkington saw Hubbell's painting *The Goldfish* (date and location unknown) in the Paris Salon of 1910; his purchase of the painting enabled Hubbell to take his family to Venice for a holiday.

Returning to the United States in the early part of the twentieth century, Hubbell worked as an illustrator for *The Women's Home Companion*. Later he was named professor of painting and director of the School of Painting and Decoration at Carnegie Institute of Technology in Pittsburgh, where he served from 1918 to 1921.

At the invitation of the federal government, Hubbell painted the official portraits of 15 secretaries of the interior. He also painted a portrait of President Franklin D. Roosevelt.

In 1924, Hubbell decided to make Miami his home, and a year later became a founding member of the Board of Regents of the University of Miami. He spent the next 25 years in Miami and died there in 1949.

In 1971, three of his works were included in an exhibition of American artists who were influenced by French impressionists, held at the University's Lowe Art Museum in Coral Gables, Florida.

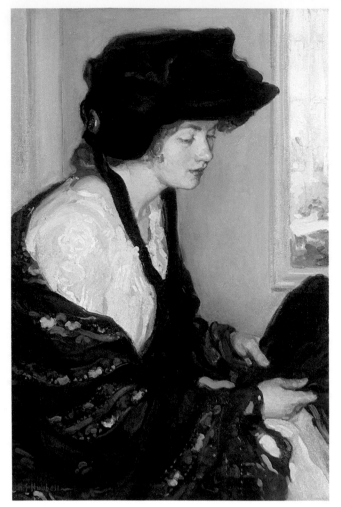

Black Fan, 33 x 22 in., signed l.l. Courtesy of Grand Rapids Art Museum, Michigan.

MEMBERSHIPS
Allied Artists of America
American Art Association of Paris
Board of Regents, University of Miami
Century Association of New York
National Academy of Design
National Arts Club
National Association of Portrait Painters
Paris Society of American Painters
Salmagundi Club

PUBLIC COLLECTIONS
Grand Rapids Art Museum, Michigan
Lowe Art Museum, University of Miami
Musee d'Orsay, Paris
Museum of Lille, France
Philadelphia Museum of Art
Union League Club, Philadelphia

SEASON	75-76	76-77	77-78	78-79	79-80	80-81	81-82	82-83	83-84	84-85
Paintings							1	1	3	1
Dollars							$750	$32,000	$5,400	$13,000

Record Sale: $32,000, SPB, 6/2/83, "Tea Time," 33 × 22 in.

HARRIET RANDALL LUMIS
(1870-1953)

American impressionist Harriet Randall Lumis painted bucolic landscape scenes and the harbors of New England. Although she never studied in Europe, she began her career when impressionism was an avant-garde movement in the United States. Lumis remained faithful to the tenets of impressionism, and did not adopt the style of the modern abstractionists who exhibited at the New York Armory Show in 1913.

Born in Salem, Connecticut in 1870, Lumis evidenced an interest in art at an early age. She married at 22 and moved to Springfield, Massachusetts with her draftsman-architect husband. There she studied drawing with Mary Hubbard and James Hall, and painting with tonalist Willis S. Adams. Under his tutelage, Lumis's first serious landscapes evoked the tonalists' mistiness and poetic mood, which often contrasted with colorful sky effects.

Lumis later studied with tonalist painters Leonard Ochtman and Edward Parker Hayden. Then, trying to free herself from the dark tonalist palette, she enrolled in the New York Summer School in Connecticut.

Influenced by French impressionist Claude Monet's work, Lumis learned to dissolve form in light by breaking up her daubs of color. She used a high-key palette, almost monochromatic, as in *A Wet Day Gloucester* (ca. 1917, private collection).

In the 1920s, she exhibited at local and national shows. Her brushwork became looser, her palette brighter, and her canvases larger. At age 50, she studied with Hugh Breckenridge; her technique became still freer, yet she remained true to the tenets of basic composition and accurate draftsmanship.

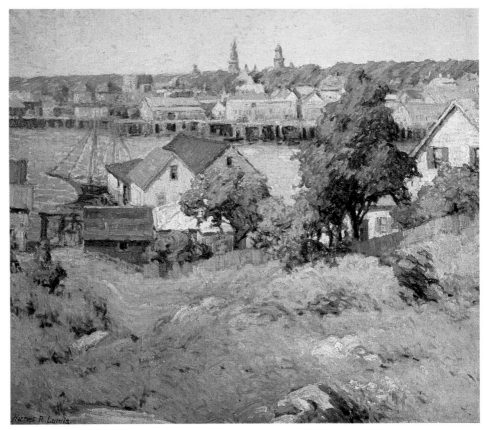

Gloucester, ca. 1918, 24 x 28 in., signed l.l. Photograph courtesy of R.H. Love Galleries, Inc., Chicago, Illinois. Private Collection.

During the Depression, sales of Lumis's paintings dropped. She produced little work and her husband died in 1937. To keep herself solvent, Lumis began to teach.

In 1949, she and other painters formed the American Artists Association to promote traditional or realistic styles of painting, rather than modern abstraction.

Although Lumis continued teaching and painting until her death in 1953, she received little recognition later in her career, and there was little demand for her work.

In 1977 and 1978, Lumis was rediscovered. Her work was shown at an exhibit which traveled to museums in Missouri, Wisconsin and Ohio.

MEMBERSHIPS
Connecticut Academy of Fine Arts
Gloucester Society of Artists
National Association of Women Painters
 and Sculptors
Philadelphia Art Alliance
Springfield Art League

PUBLIC COLLECTIONS
Museum of Fine Arts, Springfield,
 Massachusetts

SEASON	75-76	76-77	77-78	78-79	79-80	80-81	81-82	82-83	83-84	84-85
Paintings							2	1	1	1
Dollars							$21,000	$650	$2,200	$4,700

Record Sale: $19,000, SPB, 6/4/82, "Gloucester," 24 × 28 in.

JOHN MARIN
(1870-1953)

John Marin was an important early American modernist, widely regarded as the best American watercolorist since Winslow Homer. His paintings are notable for their expression of dynamic forces in collision, whether the forces are man-made Manhattan skyscrapers or natural rocks and waves.

Marin was born in 1870 in Rutherford, New Jersey, and received early training as an architect before deciding to pursue a career in art. Having worked for several years as an architect, in 1899 Marin enrolled at the Pennsylvania Academy of the Fine Arts, where he studied for two years under Thomas Anshutz. Subsequently, Marin spent another two years studying under Frank DuMond at the Art Students League in New York City.

In 1905, Marin sailed to Europe, where he spent most of the next six years working in Paris and touring extensively in Italy, Belgium, Holland and Austria. His paintings of this period show the predominant influence of Japanese painting and of James A.M. Whistler, especially in their emphasis on soft forms, their reserved tonality, and an economy of brushwork resembling calligraphy.

In 1909, Marin had his first New York City show at Alfred Stieglitz's Gallery 291, the most progressive gallery of its time in the United States. Stieglitz thought well of Marin's work, and did much to promote him throughout his career.

In 1911, Marin returned to the United States, dividing the next 20 years between New York City and the coast of Maine, both of which he painted with vigor and an increasing taste for experimentation. This period marks the beginning of Marin's modernism, which is most apparent in his portrayal of Manhattan skyscrapers painted in the cubist or futurist manner.

Marin's paintings of the coast of Maine share with his cityscapes such modernist techniques as sight lines, contrasting weights and rapid brushwork in order to represent the flux and collision of natural elements, such as waves and rocks. In contrast to his Maine pieces, Marin also painted a series of New Mexico landscapes in 1929 and 1930, notable for their desert ambience.

Having begun his formal career late in life, at age 40 Marin began to achieve the success that eluded many of his contemporaries among the first generation of American modernists. With Alfred Stieglitz as his faithful dealer, Marin's work sold well and at high prices from the mid-1920s on. He was honored with a retrospective exhibit at the Museum of Modern Art in 1936, and remained active until his death at age 83 at his home in Cape Split, Maine.

Region of Brooklyn Bridge Fantasy, 1932, 18¾ x 22¼ in., signed l.r. Courtesy of Collection The Whitney Museum of American Art, New York, New York.

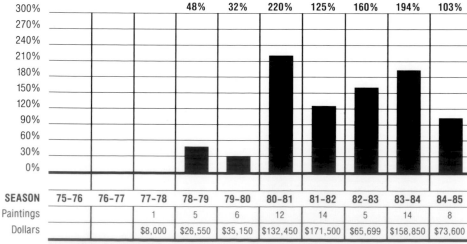

10-Year Average Change From Base Years '77-'78: 110%

SEASON	75-76	76-77	77-78	78-79	79-80	80-81	81-82	82-83	83-84	84-85
				48%	32%	220%	125%	160%	194%	103%
Paintings			1	5	6	12	14	5	14	8
Dollars			$8,000	$26,550	$35,150	$132,450	$171,500	$65,699	$158,850	$73,600

Record Sale: $36,000, SPB, 12/10/81, "Lower Manhattan, River Front," 26 x 21 in.

MEMBERSHIPS
American Academy of Arts and Letters

PUBLIC COLLECTIONS
Art Institute of Chicago
Museum of Modern Art, New York City
National Gallery of Art, Washington, D.C.

MAXFIELD PARRISH
(1870-1966)

Maxfield Parrish was an enterprising and prosperous artist, skilled as a painter and highly esteemed as an illustrator. His decorative and whimsical works, which grew from his early interest in the English pre-raphaelite tradition, made him one of the most popular and sought-after illustrators in the history of American art.

Born in Philadelphia in 1870, the son of successful painter Stephen Parrish, he was exposed to art from childhood. His first intention was to be an architect, but his talent and love for art intervened and he entered the Pennsylvania Academy of the Fine Arts in 1889. He studied with renowned illustrator Howard Pyle at the same time.

In 1894, he exhibited at the Pennsylvania Academy of the Fine Arts. One of his drawings was featured on the cover of *Harper's Weekly* in 1895; his penchant for combining sentiment, naturalism and fantasy soon had many publishers wanting Parrish illustrations.

A bout with typhoid fever in the late 1890s sent Parrish on a trip to recuperate; it included Arizona, where he honed his colorist ability in 1902, and Italy, where he worked on his first published color illustrations for Edith Wharton's *Italian Villas* in 1903.

Thereafter, making his studio in Windsor, Vermont, he illustrated many magazine covers and children's books, sold millions of color prints and became a popular muralist. His most famous murals are in the St. Regis Hotel in New York City and the Palace Bar in San Francisco.

Parrish left illustration in 1930 to paint landscapes, which he did for the following 30 years. Two years before his death in 1966, there was a strong revival of interest in, and sales of, his early works. Decorative compositions with fantasy-laced photographic details, characterized by meticulous draftsmanship and a perfect finish, were the legacy of Maxfield Parrish.

Lady Ursula Informs the King, 20½ x 16¼ in., signed l.l. Courtesy of Vose Galleries of Boston, Inc., Massachusetts.

MEMBERSHIPS
National Academy of Design
National Institute Art League
Pennsylvania Academy of the Fine Arts
Society of American Artists
Union Internationale des Beaux
　　Arts et Lettres

PUBLIC COLLECTIONS
Brandywine River Museum,
　　Chadds Ford, Pennsylvania
Delaware Art Museum, Wilmington
Hotel Sherman, Chicago
Palace Hotel, San Francisco
St. Regis Hotel, New York City

SEASON	75-76	76-77	77-78	78-79	79-80	80-81	81-82	82-83	83-84	84-85
Paintings		2	4	5	4	3	4	9	7	4
Dollars		$77,500	$92,000	$51,250	$115,750	$51,000	$115,000	$135,050	$82,400	$36,800

Record Sale: $62,500, SPB, 10/25/79, "Egypt," 33 × 21 in.

FRANK P. SAUERWEIN
(1871-1910)

Frank P. Sauerwein, or Sauerwen, as he signed most of his work, painted landscapes, Indian scenes and genre scenes of the American Southwest. He worked in both watercolor and oil.

Sauerwein was born in 1871. Sources differ as to whether he was born in Maryland, New York or New Jersey. His father was Charles D. Sauerwein, a European-trained artist and his son's first teacher.

Sauerwein was raised in Philadelphia and graduated from the Philadelphia Museum School of Art in 1888. He also studied at the Pennsylvania Academy of the Fine Arts, the Philadelphia School of Industrial Arts, and the Art Institute of Chicago.

Seeking a healthier climate for his tuberculosis, Sauerwein moved to Denver in 1891; his sister, also tubercular, lived there. He became involved in the artistic life of the city and sketched in the Rockies. With artist Charles Craig, Sauerwein visited a Ute Indian reservation in Colorado Springs in 1893; he also traveled throughout the West as he became interested in Western subjects.

Sauerwein and his sister moved to California in 1901. After her death, he traveled in Europe. Upon his return to the United States, he lived at various times in Denver, California and New Mexico, eventually settling in Taos.

He became known for his realistic, competent renderings of Western landscapes and Indian life. His work was straightforward, with well-handled brushstrokes and color. One of his paintings was purchased by the Santa Fe Railway; others were sold by the El Tovar Hotel at the Grand Canyon.

Finally too ill to paint, Sauerwein moved to Connecticut in the hope of a cure. He died in Stamford in 1910.

Firelight, 10 x 13½ in., signed l.r. Photograph courtesy of The Gerald Peters Gallery, Santa Fe, New Mexico.

PUBLIC COLLECTIONS
Museum of New Mexico, Santa Fe
Panhandle-Plains Historical Museum,
 Canyon, Texas
Southwest Museum, Los Angeles

SEASON	75-76	76-77	77-78	78-79	79-80	80-81	81-82	82-83	83-84	84-85
Paintings				1	3	2			2	
Dollars				$4,250	$3,950	$12,500			$1,650	

Record Sale: $9,000, SPB, 10/17/80, "Taos Indians Bathing," 18 × 26 in.

GRANVILLE REDMOND
(1871-1935)

California Beauties, 30 x 40 in., signed l.l. Courtesy of Maxwell Galleries, LTD., San Francisco, California.

A California artist known primarily for his poppy scenes and brilliant sunsets, Grenville Richard Seymour Redmond was born in Philadelphia. Deaf by age three from scarlet fever, he attended the California School for the Deaf, where Theophilius Hope, a deaf philosopher and teacher, encouraged him to study art.

Redmond studied under Arthur Mathews and Amedee Joulin at the San Francisco Art Association's California School of Design for three years. He then worked under Benjamin Constant and Jean-Paul Laurens at the Academie Julien in Paris. Upon his return to Los Angeles in 1889, Redmond changed his first name to Granville and opened a studio, painting scenes of Laguna Beach, San Pedro and Catalina Island.

In the years between 1908 and 1917, the artist moved between Northern and Southern California. In Los Angeles in 1917, he met Charlie Chaplin, who sponsored his work in film. Chaplin gave Redmond a studio on the movie lot, and utilized his skills both for his private collection and for cinematic scenery work. He also cast his friend as the sculptor in *City Lights.*

Characterized as a colorist and delineator of nature's moods, Redmond had a distinctive style akin to pointillism in feeling. Considered California's first resident impressionist, the artist believed that details should be realistic, but that the whole should reflect a personal conception of form, design and color. He said, in a 1931 interview with Arthur Miller, "Fifteen minutes. No one should sketch longer than that from nature. By that time everything has changed."

MEMBERSHIPS
Bohemian Club
California Art Club
Laguna Beach Art Association
San Francisco Art Association

PUBLIC COLLECTIONS
Laguna Beach Museum of Art, California
Los Angeles County Museum of Art
Museum of the City of New York
Oakland Museum, California
San Diego Museum of Art, California
Stanford Museum of Art, California
Washington State Capitol, Olympia

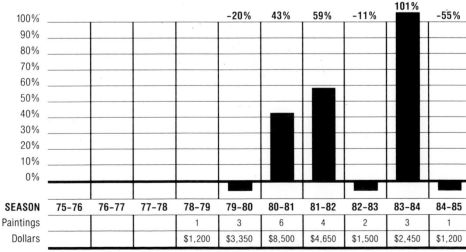

10-Year Average Change From Base Years '78-'79: 17%

SEASON	75-76	76-77	77-78	78-79	79-80	80-81	81-82	82-83	83-84	84-85
					-20%	43%	59%	-11%	101%	-55%
Paintings				1	3	6	4	2	3	1
Dollars				$1,200	$3,350	$8,500	$4,650	$1,500	$2,450	$1,200

Record Sale: $2,750, BB.SF, 6/24/81, "California Landscape," 20 × 27 in.

GEORGE ELMER BROWNE
(1871-1946)

George Elmer Browne was a popular American impressionist of the late nineteenth and early twentieth centuries. He was also a skilled teacher and administrator, active in many capacities in the international art world.

Browne was probably influenced by Constable. His skies were always interesting; typically his landscapes are two-thirds sky, with much cloud movement. He had a strong and innate sense of composition.

Color and force were other dominant elements in Browne's work. He used wide masses of color, with only suggestions of detail in the foreground. He liked to stress the use of keynotes to his students: picking one idea or color and carrying it out to completion.

Browne was born in Gloucester, Massachusetts in 1871. After attending public school in Salem and revealing artistic talent at an early age, he studied at the Museum of Fine Arts and the Cowles School of Art in Boston. This was the time of the great artistic exodus to Paris, and Browne went to study at the Academie Julien with Jules Lefevbre and Tony Robert-Fleury.

When he returned to this country, he set up a studio in New York City and began painting. He won his first award—a bronze medal—at the Mechanics Fair in Boston in 1895. He founded the Browne Art Classes. Many summers were spent at Provincetown, Massachusetts. A famous quote of

Haying, 20½ x 25¾ in., signed l.l. Courtesy of Arvest Galleries, Inc., Boston, Massachusetts.

Browne's: "Drawing should be like writing a letter to a friend. It should aim more at conveying a personal reaction to the subject matter rather than a display of virtuosity."

According to an article that appeared in the *American Magazine of Art* in November 1926, "Browne's sympathies are wholly academic. . . . Cubism and futurism he regards as merely 'Faddism.' The idea of the Faddist, 'that an

egg is square,' he thinks, is analogous with the primitive faith of the ancients that the earth was flat."

Browne was highly regarded in France, where he was named Officer of Public Instruction and Fine Arts. In 1926, he was made Chevalier of the French Legion of Honor. One of his paintings, *Bait Sellers of Cape Cod* (date and location unknown), was bought in 1904 in the Paris Salon by the French Government.

Browne died in Provincetown in 1946.

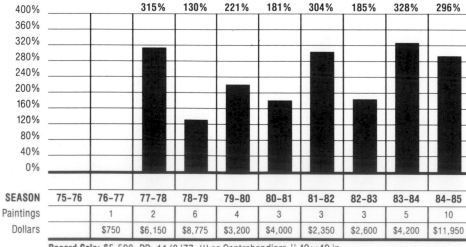

10-Year Average Change From Base Years '76–'77: 218%

	75-76	76-77	77-78	78-79	79-80	80-81	81-82	82-83	83-84	84-85
			315%	130%	221%	181%	304%	185%	328%	296%
SEASON	75-76	76-77	77-78	78-79	79-80	80-81	81-82	82-83	83-84	84-85
Paintings		1	2	6	4	3	3	3	5	10
Dollars		$750	$6,150	$8,775	$3,200	$4,000	$2,350	$2,600	$4,200	$11,950

Record Sale: $5,500, PB, 11/8/77, "Les Contrabandiers," 49 × 49 in.

MEMBERSHIPS
Allied Artists of America
American Watercolor Society
Century Club
National Academy of Design
National Arts Club
National Commission to Advance American Art
National Institute of Arts and Letters
Paris-American Art Association
Salmagundi Club

PUBLIC COLLECTIONS
Art Institute of Chicago
High Museum of Art, Atlanta
Los Angeles Art Museum
Luxembourg Gallery, Paris
Metropolitan Museum of Art, New York City
Milwaukee Art Institute, Wisconsin
Montclair Museum of Art, New Jersey
National Gallery of Art, Washington, D.C.
New York Public Library, New York City

JOHN SLOAN
(1871-1951)

John Sloan loved ordinary people; as a member of the Ashcan School in the early twentieth century, he painted and sketched hundreds of them in the rhythms of private life—hanging out the wash, drying their hair or sleeping on rooftops during a summer's night in New York City.

The most politically active of the American realists, Sloan joined the Socialist Party and served for a period as art editor of *The Masses,* a literal magazine. His drawings and paintings, however, are apolitical, revealing only a strong and often joyous interest in city life. He never made a good living from his art; academics recoiled from his intimate recordings of ordinary events, and it wasn't until the last decade of his life that Sloan could support himself by painting.

Like other painters who gathered around Robert Henri to revolutionize artistic tastes, Sloan, born in 1871 in Lock Haven, Pennsylvania, began as a newspaper illustrator for the Philadelphia *Inquirer* and the *Press.* He entered the Pennsylvania Academy of the Fine Arts in 1892 to study for a year under Thomas Anshutz. The same year he met and was captivated by Henri and the new realism. Thereafter, he began painting dark, warm, almost monochromatic scenes of city life, using the color scheme of Franz Hals, recommended by Henri, that was characteristic of the Ashcan artists.

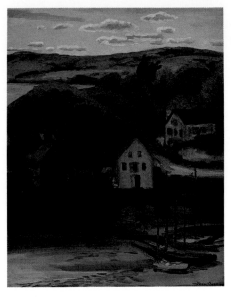

Toward Evening, Gloucester, 24 x 20 in., signed l.r. Courtesy of Arvest Galleries, Inc., Boston, Massachusetts.

In 1904, Sloan settled in New York City, developing skills as an etcher. His vignettes of backyards, restaurants, bars, street corners and parks on Fifth Avenue and in the tenderloin district were the first of their kind in this country.

The American Water Color Society returned four of his etchings as "too vulgar." Barred from exhibiting in conventional channels, Sloan joined his friends in the 1908 showing by The Eight, which turned the art world upside down overnight. Recognized then as a prominent artist, praised as an "American Hogarth," Sloan still did not sell a painting until he was 40. "The only reason I am in this profession is because it's fun," he once said.

After the showing by The Eight, Sloan adopted the color theory of Hardesty Maratta, and his palette brightened with new, colorful landscapes painted in Gloucester, Massachusetts. He also made summer painting trips to Santa Fe,

New Mexico from 1919 on. Although he painted the glorious Western environment, Sloan maintained his predilection for people. Much of his Santa Fe work focuses on Mexican-Americans and American Indians.

Beginning in 1928, Sloan turned increasingly to figure studies and nudes, using oil glazes over tempera, overlaid with a network of red lines. The result was an almost metallic or plastic surface, highly personal and not very popular with the public, who by now wanted his early work.

Sloan taught for most of his career, associated with the Art Students League, where he was elected director in 1931. In 1939, he painted a mural for the Bronxville, New York post office, entitled *The First Mail Arrives at Bronxville, 1846.* That same year he published a treatise on his field, *Gist of Art.*

Depending upon the observer, Sloan was either a judicious man who weighed every action, or he was hard-bitten and unbending. But his etchings of New Yorkers, seen from the rear window of his studio, reveal a warm and generous heart. He died in 1951.

MEMBERSHIPS
American Academy of Arts and Letters
New Society of Artists
Society of Independent Artists

PUBLIC COLLECTIONS
Art Institute of Chicago
Barnes Foundation, Merion, Pennsylvania
Brooklyn Museum
Carnegie Institute, Pittsburgh
Cincinnati Museum of Art
Delaware Art Museum, Wilmington
Detroit Institute of Arts
Hood Museum, Dartmouth College
Museum of New Mexico, Santa Fe
Newark Museum, New Jersey
Phillips Gallery, Washington, D.C.
Whitney Museum of American Art, New York City

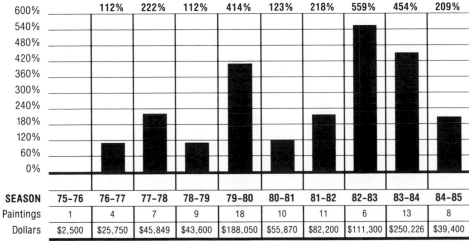

10-Year Average Change From Base Years '75-'76: 242%

	112%	222%	112%	414%	123%	218%	559%	454%	209%

SEASON	75-76	76-77	77-78	78-79	79-80	80-81	81-82	82-83	83-84	84-85
Paintings	1	4	7	9	18	10	11	6	13	8
Dollars	$2,500	$25,750	$45,849	$43,600	$188,050	$55,870	$82,200	$111,300	$250,226	$39,400

Record Sale: $130,000, SPB, 4/25/80, "Spring Planting, Greenwich Village," 26 x 32 in.

WILLIAM KAULA
(1871-1953)

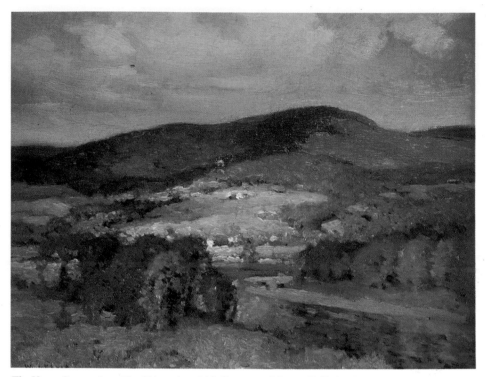

The Upper Connecticut, 10 x 13 in., signed l.l. Courtesy of Arvest Galleries, Inc., Boston, Massachusetts.

William Kaula, who specialized in painting New England landscapes, was born in Boston in 1871. He studied at the Massachusetts Normal Art School and the Cowles Art School in Boston and at the Academy Colarossi and the Academie Julien in Paris. Around the turn of the century he became a student of Edmund Tarbell, a fellow Bostonian who remained a major influence on Kaula's work throughout his life.

Best known for his striking interpretations of cloud-filled skies and broadly-defined New Hampshire hills, Kaula seldom ventured far from his beloved New England.

In 1902 he married painter Lee Lufkin, and in 1904 the two participated in a joint exhibition at the Cobb Gallery in Boston. Kaula also had one-man shows at the prestigious Copley Gallery in Boston and at the Christopher Hungington Gallery in Mt. Vernon, Maine.

He served for a time as president of the Boston Society of Water Color Painters and was a member of the Boston Art Club and the New York Water Color Club. Besides watercolors, Kaula also painted in oils and pastels. He died in 1953 at age 82.

MEMBERSHIPS
American Art Association of Paris
Boston Art Club
Boston Guild of Artists
Boston Society of Water Color Painters
Boston Water Color Club
New York Water Color Club

PUBLIC COLLECTIONS
Museum of Fine Arts, Boston

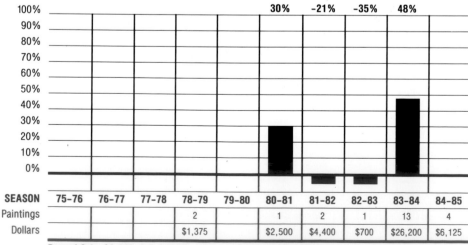

10-Year Average Change From Base Years '78-'79: 4%

SEASON	75-76	76-77	77-78	78-79	79-80	80-81	81-82	82-83	83-84	84-85
						30%	-21%	-35%	48%	
Paintings				2		1	2	1	13	4
Dollars				$1,375		$2,500	$4,400	$700	$26,200	$6,125

Record Sale: $6,600, B.P, 7/9/83, "Brink of Spring," 35 × 46 in.

644

LYONEL FEININGER
(1871-1956)

Dead End, 1951, 17 x 24 in., signed l.r. Courtesy of Kennedy Galleries, New York, New York.

Born in New York City, the son of distinguished concert artists, Lyonel Feininger first planned to be a musician, and music was profoundly important in his artistic career. Feininger said, "The whole world is nothing but order," and cited Johann Sebastian Bach as the most important artistic influence in his life.

In 1887, Feininger traveled to Germany to study music, but soon switched to painting. He studied at the Kinstgewerbeschule in Hamburg, at the Berlin Academy and at the Academie Collarossi in Paris. From 1883 until 1907, he was an illustrator and satirical cartoonist for many German periodicals, as well as a comic-strip artist for the *Chicago Sunday Tribune.* He also illustrated children's books. His style at this time was flat and decorative.

In 1907, he met Jules Pascin and Robert Delaunay in Paris and, inspired by their avant-garde example, began to devote himself to serious painting influenced by Van Gogh, Cezanne, Delaunay and cubisn. While the effects of cubism were apparent in his work, his emotive experimentation with light, color and space added a dimension of depth and lyricism.

In 1918, the artist began doing woodcuts, some of his most spontaneous and delightful work. In 1919, he joined architect Walter Gropius at the Bauhaus, the German center for design studies. He was on the faculty with Paul Klee and Vasily Kandinsky, and later became an artist-in-residence, remaining there until 1933.

By 1921, Feininger had perfected a romantic style that fused aspects of cubism and expressionism. In 1924, he joined Klee, Kandinsky and Alexij von Jawlensky in the group known as "the Blue Four," and participated with them in many exhibitions in New York City and Germany.

In the mid 1930s, Feininger returned to America because of the political situation in Germany, where, under Hitler, his works were to be characterized as "degenerate art." He taught at Mills College for a year in 1936, and then settled in New York City until his death in 1956.

PUBLIC COLLECTIONS
Baltimore Museum of Art
Metropolitan Museum of Art, New York City
Museum of Modern Art, New York City
Philadelphia Museum of Art
Rhode Island School of Design, Providence
Seattle Art Museum
Solomon R. Guggenheim Museum, New York City
Toledo Museum of Art, Ohio
Whitney Museum of American Art,
 New York City

SEASON	75-76	76-77	77-78	78-79	79-80	80-81	81-82	82-83	83-84	84-85
Paintings								34	37	25
Dollars								$607,641	$500,795	$158,240

Record Sale: $220,000, CH, 11/3/82, "Gelmeroda III," 39 × 31 in.

FREDERICK BALLARD WILLIAMS
(1871-1956)

A Glade by the Sea, 1908, 30⅛ x 45⅛ in., signed l.r. Courtesy of National Museum of American Art, Smithsonian Institution, Gift of William T. Evans.

Landscape and figure painter Frederick Ballard Williams combined romantic subjectivity with representational execution to produce an original statement, which sought to elevate nature to a status it did not hold in itself. Decorative in appearance, his works were modern in sentiment and spontaneity.

Williams was born in 1871 in Brooklyn, New York. He was educated in the public schools of Bloomfield and Montclair, New Jersey, and studied art in night classes at the Cooper Union in New York City and at the New York Institute of Artists and Artisans. Williams studied briefly under John Ward Stimson, described as "an idealist," before attending the School of the National Academy of Design.

He traveled to England and France, then settled in Glen Ridge, New Jersey. He had his first exhibition at the National Academy in 1901, and won a bronze medal at the Pan-American Exposition in Buffalo the same year.

Williams basically produced two types of paintings. Many of them, such as *The Rendezvous* (date and location unknown), portrayed nature peopled by idealized figures—usually women—who were present only to add beauty. He was best known for landscapes like *Garrets Mountain, N.J.* (date and location unknown), a broad vista, seen from an elevated perspective.

Williams was the recipient of many medals and awards throughout his career, including the Isidor Gold Medal of the National Academy of Design in 1909 for his figure painting *Chant d'Amour* (date and location unknown). In 1910, he was part of a group of artists who went West to paint the Grand Canyon and other Western sites. He later spent a summer producing a series of paintings of California landscapes.

Although Williams was a representational painter, he did not paint from nature. He studied nature, as one might study a language, but his paintings were produced in the studio. This physical separation reveals Williams's philosophy: the technical craft of painting, and even the subject itself, is distinct from and subservient to the artistic vision. However, Williams also believed that the subject was served by the art, that the artistic vision of beauty elevated and completed the object of its expression.

After a productive and successful career, Williams died in Glen Ridge in 1956.

MEMBERSHIPS
American Federation of Arts
Lotus Club
Montclair Art Association
National Academy of Design
National Arts Club
New York Water Color Club
Salmagundi Club

PUBLIC COLLECTIONS
Albright-Knox Art Gallery, Buffalo
Art Institute of Chicago
Atlanta Art Museum
Brooklyn Museum
City Art Museum, St. Louis
Dallas Art Association
Harrison Gallery, Los Angeles Museum
Metropolitan Museum of Art, New York City
Milwaukee Art Institute
Montclair Art Museum, New Jersey
National Gallery of Art, Washington, D.C.

SEASON	75–76	76–77	77–78	78–79	79–80	80–81	81–82	82–83	83–84	84–85
Paintings	1		1	1	1	2	2		6	1
Dollars	$301		$600	$650	$1,800	$1,800	$1,780		$5,600	$575

Record Sale: $1,800, S.W, 6/8/80, "Ladies in a Garden," 16 × 24 in.

CHARLES W. HAWTHORNE

(1872-1930)

Portrait and genre painter Charles W. Hawthorne continued to work in the solid, disciplined style of the academicians long after other artists had turned to modernism in revolt against academic strictures. Hawthorne is frequently called a conservative. His careful, well-painted portraits reflect the influence of his teacher, William Merritt Chase.

But there is another side to this important painter, for his primary subjects were the rugged Yankee and Portuguese fishermen of New England, and Hawthorne's naturalistic depiction of their harsh life places him within the traditions of realism. Hawthorne was not one of the New York realists; rumor has it that Robert Henri rejected Hawthorne from The Eight. Nevertheless, he took his share of abuse from critics for his "brutal" paintings of Provincetown fishermen. It was several years before these paintings—treatments of a strong but sad people, struggling to make a meager living—were critically accepted. They are now considered Hawthorne's most important work, and he is credited with establishing the Cape Cod School of Art.

Born in 1872 in Lodi, Illinois, Hawthorne grew up in Richmond, Maine, a small town on the Kennebec River. His father was a sea captain and Hawthorne's youth was spent among the seafaring people he later depicted.

The School, 48 x 60 in., signed l.l. Courtesy of Vose Galleries of Boston, Inc., Massachusetts.

He moved to New York City, enrolling in the Art Students League as a night student in 1894, working during the day at menial jobs. Later he studied with Chase; as an associate, he helped Chase organize his New York school. In 1898, Hawthorne went to Holland, and was strongly influenced by the tonal style of Franz Hals.

Hawthorne's portraits, primarily of women and children, reflect an introspective, sometimes sad mood. Faces are solidly modeled in a conservative style.

Around 1910, Hawthorne picked up traces of impressionism, but the bright, happy face of impressionism did not suit the tragic look of people who daily risked their lives on the sea. Hawthorne remained a realistic painter, acutely observing and representing the nature and people. His depictions of fishermen were so exact that a medical doctor once used a Hawthorne canvas to illustrate skin cancer caused by exposure to the elements.

Hawthorne won numerous awards and made a comfortable living from his painting. He died in 1930.

MEMBERSHIPS
American Water Color Society
Century Association
National Academy of Design
National Arts Club
National Institute of Arts and Letters
Salmagundi Club

PUBLIC COLLECTIONS
Brooklyn Museum
Carnegie Institute, Pittsburgh
Corcoran Gallery of Art, Washington, D.C.
Metropolitan Museum of Art, New York City
Museum of Fine Arts, Boston

10-Year Average Change From Base Years '76-'77: 505%

		−61%	66%	147%	205%	450%	863%	176%	2,695%	
SEASON	75-76	76-77	77-78	78-79	79-80	80-81	81-82	82-83	83-84	84-85
Paintings		1	6	3	5	4	6	3	5	2
Dollars		$1,900	$12,250	$8,850	$58,900	$32,150	$99,200	$90,000	$52,200	$125,500

Record Sale: $110,000, CH, 12/7/84, "June," 24 x 20 in.

AARON HARRY GORSON
(1872-1933)

Aaron Harry Gorson was a landscape artist best known for his paintings of the steel mills around Pittsburgh, Pennsylvania. Gorson enjoyed a successful career from around 1902 until his death in 1933, and is remembered today as one of the pioneers of the American industrial landscape.

Gorson was born in Lithuania, and emigrated to the United States at age 18. He began his formal studies at the Pennsylvania Academy of the Fine Arts under Thomas Anshutz, and in 1899 went to Paris, where he studied under Benjamin Constant at the Academie Julien and Jean Paul Laurens at the Academie Colarossi.

In 1903, Gorson returned to Pittsburgh, where he established his home for the next 18 years, and became well known for his dramatic portrayals of the smelting and manufacturing processes of the steel industry, and for his glowing nocturnes of Pittsburgh and the Monongahela Valley.

Gorson himself testified eloquently in his own writings to the beauty and excitement that he found in the surroundings of the Monongahela Valley—in the gracefully curving Monongahela and Allegheny Rivers, framed by dark hills and lit by millions of lights, and in the variegated clouds of smoke.

Gorson found enthusiastic patronage for his work in Pittsburgh, New York City, Philadelphia and other major art centers. For the next 30 years, his paintings were exhibited widely in major American art museums, including the Pennsylvania Academy of the Fine Arts, the Corcoran Gallery of Washington, D.C., the Art Institute of Chicago and the National Academy of Design.

In 1921, Gorson moved to New York, where he continued to enjoy an active social life and professional career until his death of pneumonia in 1933.

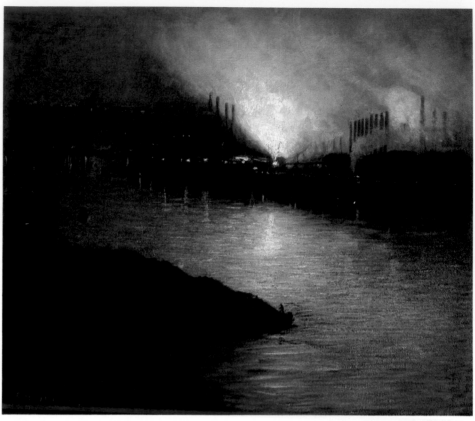

Industrial Night Scene, 36 x 42 in., signed l.l. Courtesy of Kennedy Galleries, New York, New York.

MEMBERSHIPS
Art Alliance of America
Associated Artists of Pittsburgh
Brooklyn Art Association
L'Union Internationale des Beaux Arts
et Lettres

PUBLIC COLLECTIONS
Heckscher Museum, Huntington, Long Island
Newark Museum, New Jersey
Worcester Art Museum, Massachusetts

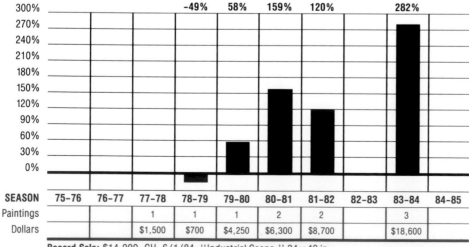

10-Year Average Change From Base Years '77-'78: 95%

		-49%	58%	159%	120%		282%	

SEASON	75-76	76-77	77-78	78-79	79-80	80-81	81-82	82-83	83-84	84-85
Paintings			1	1	1	2	2		3	
Dollars			$1,500	$700	$4,250	$6,300	$8,700		$18,600	

Record Sale: $14,000, CH, 6/1/84, "Industrial Scene," 34 × 42 in.

648

GEORGE AMES ALDRICH
(1872-1941)

Landscape painter and etcher George Ames Aldrich was born in Worcester, Massachusetts in 1872. As a member of the Chicago Galleries Association, he was established as a Chicago talent and exhibited there regularly. His early art experience was as a magazine illustrator in the 1890s, when he did illustrations for *The London Times* and *Punch* magazine.

Aldrich was enrolled at the Art Students League in New York City and at the Massachusetts Institute of Technology, where he may have studied architecture. His art studies continued in Paris, where he was a pupil at the Academies Julien and Colarossi.

Aldrich won four prizes from the Hoosier Salon in Chicago, the first in 1923 for a snow scene. Many of his landscapes were painted in Normandy and Brittany, probably in 1909 and 1910, when he lived in Dieppe.

A critic who saw Aldrich's works in a Chicago show wrote that his painting had "... a sense of a romantic approach to each subject, a spirit of adventure in painting it...." His American landscapes were painted with imagination and "faithful observance of the original."

In 1924, Aldrich received an architectural-club traveling scholarship for a European study trip. During that time he spent six months in residence at the American Academy in Rome, and three months at the Fontainebleau School of Fine Arts in France. He then

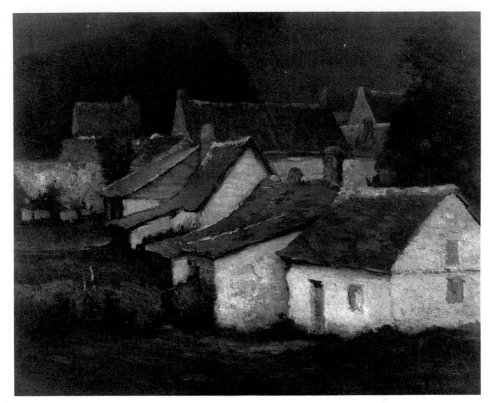

Nocturne, Montreuil sur Mer, 20 x 24¼ in., signed l.r. Courtesy of Marbella Gallery, Inc., New York, New York.

traveled and sketched in Italy, France, Spain, Germany and England.

Aldrich died at his home in Chicago in 1941, at age 68.

MEMBERSHIPS
Chicago Society of Painters and Sculptors
Chicago Gallery of Art
Hoosier Salon, Chicago
Societe des Artistes Francais

PUBLIC COLLECTIONS
Ball States Teachers College, Muncie, Indiana
Decatur Museum, Illinois
Houston Museum of Fine Arts
Musee de Rouen

10-Year Average Change From Base Years '80-'81: 107%

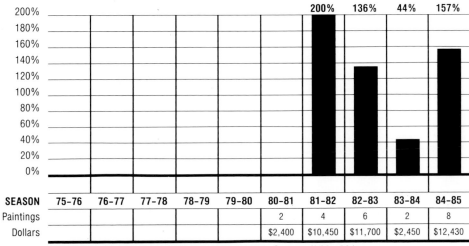

SEASON	75-76	76-77	77-78	78-79	79-80	80-81	81-82	82-83	83-84	84-85
							200%	136%	44%	157%
Paintings						2	4	6	2	8
Dollars						$2,400	$10,450	$11,700	$2,450	$12,430

Record Sale: $5,500, D.NY, 9/23/81, "Millstream in Summer," 36 × 36 in.

EDWARD BOREIN
(1872-1945)

Vigor and authenticity characterize the thousands of etchings, drawings and paintings of Western life created by Edward Borein during his long and successful career. A native Californian and a cowboy in his youth, Borein was self-taught. He drew from direct observation the horses, cattle drives, cowhands, Indians and ranch life he found fascinating.

The son of a county politician in San Leandro, California, Borein attended grade schools in Oakland and began to draw at an early age. At age 17, he became a ranch hand. For the next 13 years, he developed his skills as a cowboy, sketching whenever he could on the cattle ranges of California and Mexico.

In 1891, Borein briefly attended the San Francisco Art Association School, where he met artists James Swinnerton and Maynard Dixon, who became his lifelong friends. Borein made his first sale in 1896, to Charles Lummiss, who also became a close friend.

After a sketching trip to Mexico with Dixon, Borein became a staff artist on the *San Francisco Call* in 1900. He also opened an Oakland studio. With Dixon, he took another sketching trip through the Sierra Mountains, Oregon and Idaho in 1901. On a 1903 trip to Mexico and through Pueblo Indian country, he began painting watercolors. In these Oakland years, Borein also produced oils described as uneven in quality.

In 1907, Borein went to New York

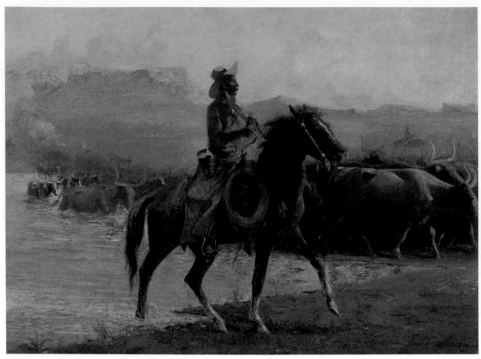

The Trail Boss, 22 x 28 in., signed l.r. Courtesy of Wunderlich and Company, Inc., New York, New York.

City, where he remained to work and study until 1919, with brief trips to the West. He became an illustrator for *Harper's, Collier's, Western World* and *Sunset* magazines, and was in demand for other commissions and for advertising work.

It was in this period, considered by some to be his finest and most productive, that Borein began to etch, studying under Childe Hassam and later with Preisig at the Art Students League of New York. He is best known for his etchings, a medium he chose in order to make his portrayals of the Western way of life most accessible to a wide audience.

Borein returned to Oakland in 1919; married in 1921; and settled in Santa Barbara. He continued until his death in 1945 to produce an abundance of etchings, drawings and watercolors.

Many biographies note Borein's great personal popularity, stemming from an unaffected simplicity of manner and an attractive personality.

Borein was friendly with many prominent artists of the day, as well as with such celebrities as Will Rogers and Theodore Roosevelt.

He died in 1945.

MEMBERSHIPS
Art Students League of New York City
Brooklyn Society of Etchers
Print Makers Society of California

PUBLIC COLLECTIONS
Gallery of Western Art,
 Montana Historical Society
New York Public Library, New York City

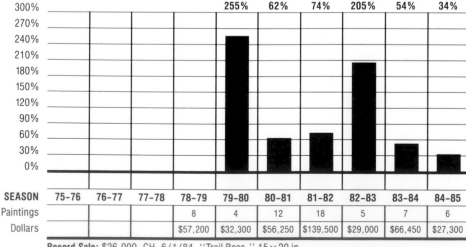

10-Year Average Change From Base Years '78-'79: 98%

	75-76	76-77	77-78	78-79	79-80	80-81	81-82	82-83	83-84	84-85
					255%	62%	74%	205%	54%	34%
SEASON	75-76	76-77	77-78	78-79	79-80	80-81	81-82	82-83	83-84	84-85
Paintings				8	4	12	18	5	7	6
Dollars				$57,200	$32,300	$56,250	$139,500	$29,000	$66,450	$27,300

Record Sale: $26,000, CH, 6/1/84, "Trail Boss," 15 x 20 in.

650

JOSEPH RAPHAEL
(1872-1950)

Although he spent much of his working life in Europe, Joseph Raphael was considered essentially a California painter because his work was exhibited there regularly. His early work was academic, very much in the vein of Dutch genre painting. Later he developed a style that was basically impressionist, but with elements of pointillism and expressionism as well. The result was paintings that brimmed with color and light.

Raphael was born in Jackson, California in 1872. He studied first at the California School of Design. Then, thanks in part to support from a wealthy patron, he went to Paris to study at the Ecole des Beaux Arts and the Academie Julien. During World War I, he spent part of the war years in Belgium and the rest in Holland.

He was thoroughly Europeanized by the end of the war and continued to live abroad, sending his paintings back to his agent in San Francisco. Besides oils, he also did watercolors, etchings, pen-and-ink drawings and wood-block prints.

Raphael's work was vigorous and fresh. In his floral paintings, for instance, details of individual flowers are overwhelmed in lavish explosions of color.

Just as in World War I he had been stranded in Europe, so Raphael was in San Francisco on a visit when World War II broke out in Europe and he had to remain in the United States. He con-

The Garden, ca. 1915, 28 x 30 in., signed l.l. Courtesy of John H. Garzoli Gallery, San Francisco, California.

tinued to live in San Francisco until his death in 1950.

PUBLIC COLLECTIONS
Fine Arts Museum of San Francisco

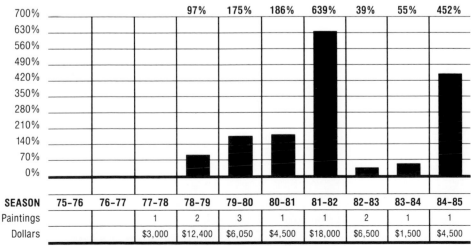

10-Year Average Change From Base Years '77–'78: 205%

| | | 97% | 175% | 186% | 639% | 39% | 55% | 452% |

SEASON	75-76	76-77	77-78	78-79	79-80	80-81	81-82	82-83	83-84	84-85
Paintings			1	2	3	1	1	2	1	1
Dollars			$3,000	$12,400	$6,050	$4,500	$18,000	$6,500	$1,500	$4,500

Record Sale: $18,000, BB.SF, 3/17/82, "Tulip Field," 26 x 31 in.

651

EDWARD DUFNER
(1872-1957)

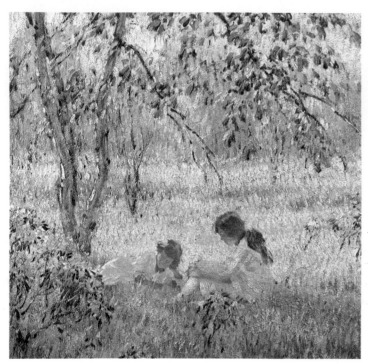

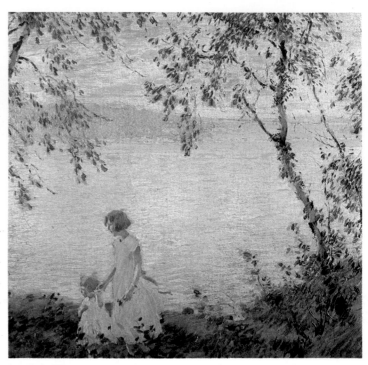

A Morning in June, 14 x 14 in., signed l.r. Courtesy of Henry B. Holt, Inc., Essex Fells, New Jersey.

Along the Bay, 14 x 14 in., signed l.r. Courtesy of Henry B. Holt, Inc., Essex Fells, New Jersey.

Edward Dufner was an art instructor and prolific painter, whose work was critically recognized and widely displayed during his lifetime.

Born in Buffalo, New York in 1872, Dufner entered the Buffalo Art Students' League when he was 18 years old. Three years later, he received an Albright Scholarship, enabling him to move to New York City. He studied there and worked as a magazine illustrator for four years, before traveling to Paris.

During his five years abroad, Dufner traveled through England, France and Spain, and studied under Jean Paul Laurens and James McNeill Whistler. Whistler significantly influenced Dufner with his artistic balance and his unique color harmonies.

Dufner exhibited in the Paris Salon annually while he lived abroad. In 1900, he received the first Wanamaker prize at the American Art Association in Paris.

In 1903, Dufner became an instructor at the Art Students' League in Buffalo, where he taught for three years. As a teacher, he disdained academic art and conventional composition, focusing instead on encouraging individual expression in his students.

Dufner was elected an associate member of the National Academy of Design in 1910, and subsequently taught at the Art Students League in New York City, where he lived until his death in 1957.

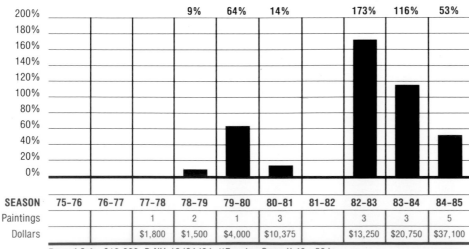

10-Year Average Change From Base Years '77-'78: 61%

SEASON	75-76	76-77	77-78	78-79	79-80	80-81	81-82	82-83	83-84	84-85
				9%	64%	14%		173%	116%	53%
Paintings			1	2	1	3		3	3	5
Dollars			$1,800	$1,500	$4,000	$10,375		$13,250	$20,750	$37,100

Record Sale: $18,000, D.NY, 10/24/84, "Evening Song," 40 × 50 in.

HOWARD LOGAN HILDEBRANDT
(1872-1958)

Howard Hildebrandt was known primarily as a portrait painter, whose clients included many prominent politicians, business executives and intellectuals. The artist also painted a lesser number of still lifes, landscapes and genre paintings, in oil and watercolor.

Hildebrandt was born in 1872 in Allegheny, Pennsylvania, the son of a tailor. After receiving his early education in the Allegheny public schools, Hildebrandt studied painting at the National Academy of Design in New York City, at the L'Ecole des Beaux Arts in Paris, and at the Academie Julien in Paris under Benjamin Constant and Jean Paul Laurens.

In 1904, Hildebrandt returned to the United States. He maintained a studio in Pittsburgh until 1906, after which he worked primarily in New York City and New Canaan, Connecticut.

Hildebrandt's portraits are notable for their naturalistic modeling. His portrait of W.B. Thayer, chairman of the board of American Telephone and Telegraph, depicts the subject relaxing out-of-doors, seated in a lawn chair, before an impressionistic background dappled with sunlight.

Hildebrandt died in a rest home in Stamford, Connecticut at age 86 in 1958.

Eliot Clark, 1947, 32¼ x 25⅞ in., signed l.l. Courtesy of National Museum of American Art, Smithsonian Institution, Washington, D.C. Gift of Mrs. Eliot Clark.

10-Year Average Change From Base Years '78-'79: 786%

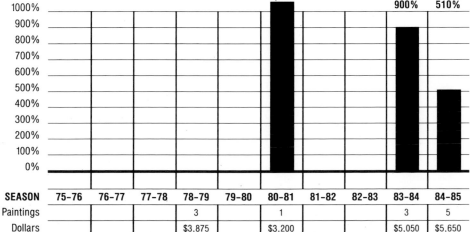

SEASON	75-76	76-77	77-78	78-79	79-80	80-81	81-82	82-83	83-84	84-85
Paintings				3		1			3	5
Dollars				$3,875		$3,200			$5,050	$5,650

Record Sale: $3,500, S.BM, 11/17/83, "Esmeralda," 27 × 27 in.

MEMBERSHIPS
Allied Artists of America
American Federation of Arts
American Water Color Society
Artist's Fellowship, Inc.
Century Club
Lotus Club
National Arts Club
National Academy of Design
New York Water Color Society
Pittsburgh Art Association
Salmagundi Club
Society of Independent Artists

PUBLIC COLLECTIONS
Butler Art Institute, Youngstown, Ohio
Herron Art Institute, Indianapolis
Lotus Club, New York City
National Academy of Design, New York City

LOUIS KRONBERG
(1872-1964)

Louis Kronberg, popular portraitist of the early twentieth century, became best known for his specialty: pictures of the theater and its performers, particularly dancers and dancing.

Kronberg, who lived for many years in Paris, was born in 1872 in Boston. He attended the School of the Museum of Fine Arts in Boston, and the Art Students League in New York City, where he studied under William Merritt Chase.

A Longfellow traveling scholarship enabled him to study abroad for three years. From 1894 to 1897, he attended the Academie Julien in Paris, studying under Benjamin Constant, J.P. Laurens and Raphael Collin. In Paris, stimulated by the original works of the impressionists, he began to paint in a freer, lighter mode.

Kronberg's early oil paintings were in the academic mode, somewhat dark, with a subdued tonal effect. However, influenced by the techniques of James McNeill Whistler, the composition of Edgar Degas, and his own interest in oriental woodcuts and engravings, Kronberg evolved a new personal style—animated, dramatic, adventurous in design.

He worked increasingly in watercolors and pastels to create portraits and scenes of the ballet. A trip to Spain in 1921 and 1922 led to a renowned series of Spanish and Gypsy folk dancers, in watercolor, pastel and oil.

Popular well into the first third of the twentieth century, Kronberg made portraits of many notables of the United States and Europe. His paintings were shown in important exhibitions and acquired by leading museums.

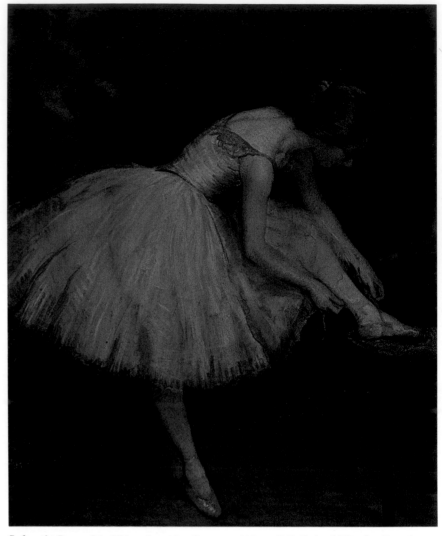

Before the Dance, 24 x 20 in., signed l.r. Courtesy of Maxwell Galleries, LTD., San Francisco, California.

MEMBERSHIPS
American Water Color Society
Boston Art Club
Boston Society of Water Color Painters
Copley Society
London Pastel Society
New York Water Color Club
Society of Odd Brushes

PUBLIC COLLECTIONS
Albright-Knox Art Gallery, Buffalo
Butler Institute of American Art, Youngstown, Ohio
Isabella Stewart Gardner Museum, Boston
Indianapolis Museum of Art, Indianapolis
Metropolitan Museum of Art, New York City
Musee d'Orsay, Paris, France
Museum of Fine Arts, Boston
Pennsylvania Academy of the Fine Arts, Philadelphia
San Diego Museum of Art

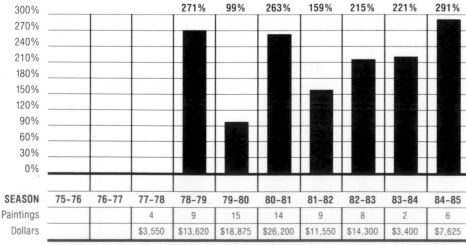

10-Year Average Change From Base Years '77-'78: 190%

SEASON	75-76	76-77	77-78	78-79	79-80	80-81	81-82	82-83	83-84	84-85
				271%	99%	263%	159%	215%	221%	291%
Paintings			4	9	15	14	9	8	2	6
Dollars			$3,550	$13,620	$18,875	$26,200	$11,550	$14,300	$3,400	$7,625

Record Sale: $5,000, CH, 12/3/82, "The Ballerina," 52 x 34 in.

654

ERNEST LAWSON
(1873-1939)

Ernest Lawson was an American impressionist who was attracted to such unconventional landscape subjects as squatters' huts, railroads and bridges across New York's Harlem River. He preferred landscapes to city streets and painted them in thick, smooth impasto, applied with a palette knife. His highly-personal use of color led one critic to comment that he seemed to paint from "a palette of crushed jewels."

Lawson was born in Nova Scotia in 1873, the son of a doctor. When his father went to practice in Kansas City, Missouri, young Lawson was left behind and raised by an aunt in Ontario.

He rejoined his parents in Kansas City when he was 15, and accompanied his father on a trip to Mexico in 1889. Once there, he worked as a draftsman and studied at the Santa Clara Art Academy in his spare time. This was followed by study at the Art Students League in New York City, and then by work in Connecticut with impressionists John Twachtman and J. Alden Weir.

Lawson also studied at the Academie Julien in Paris, but for most of his two-year stay in France, he painted on his own. While there he met Alfred Sisley, who advised him to be more assertive in his brushwork. For a time his work wavered between the conflicting influences of Sisley and Twachtman.

After settling in New York City, Lawson met Robert Henri and was invited to participate in the exhibition of The Eight

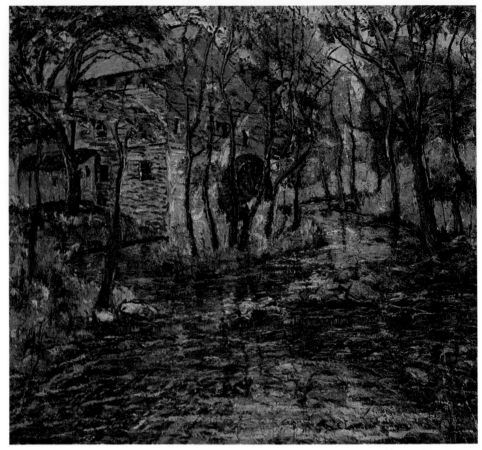

The Old Mill, 25 x 30 in., signed l.r. Courtesy of John H. Garzoli Gallery, San Francisco, California.

held in 1908. Lawson also was involved in planning the 1913 New York City Armory Show, where the work he exhibited brought him national recognition.

Like Monet, Lawson often selected a single subject and painted it in different lights and different weather conditions. Early on, he painted many such views of the Harlem River.

Troubled with arthritis in his later years, Lawson moved to Florida where he died in 1939.

MEMBERSHIPS
Century Association
National Academy of Design
National Arts Club
National Institute of Arts and Letters

PUBLIC COLLECTIONS
Art Gallery of Toronto
Art Institute of Chicago
Barnes Foundation, Merion, Pennsylvania
Brooklyn Museum
Corcoran Gallery of Art, Washington, D.C.
Delaware Art Museum, Wilmington
Detroit Institute of Arts
Metropolitan Museum of Art, New York City
Nelson-Atkins Museum of Art, Kansas City, Missouri
Whitney Museum of American Art, New York City

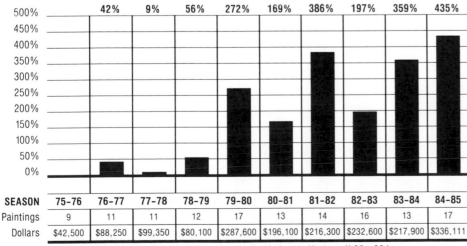

10-Year Average Change From Base Years '75-'76: 193%

	42%	9%	56%	272%	169%	386%	197%	359%	435%

SEASON	75-76	76-77	77-78	78-79	79-80	80-81	81-82	82-83	83-84	84-85
Paintings	9	11	11	12	17	13	14	16	13	17
Dollars	$42,500	$88,250	$99,350	$80,100	$287,600	$196,100	$216,300	$232,600	$217,900	$336,111

Record Sale: $110,000, CH, 12/7/84, "Across the Hudson to Yonkers," 25 × 30 in.

JACK WILKINSON SMITH
(1873-1949)

Jack Wilkinson Smith was one of the earliest and most successful painters of Southern Californian scenery. He is best known for his impressive depictions of valleys, mountains and seascapes.

Born in Paterson, New Jersey in 1873, Smith was the son of a painter. He studied at the Cincinnati Art Institute with Frank Duveneck, and at the Art Institute of Chicago.

Smith was a commercial artist before he became a fine artist. He worked as a scene painter in Chicago, and as a scene and sign painter in Lexington, Kentucky. As a staff artist for the *Cincinnati Enquirer,* in 1898 Smith won national recognition for his front-line sketches of the Spanish-American War. In 1906, he went to California and settled in Alhambra.

While Smith's early paintings were primarily watercolors of landscapes and figures, his later works were almost all oil landscapes. His style was impressionistic in the sense that he painted from life and emphasized the natural light, colors and atmosphere of the countryside. However, unlike the European impressionists' paintings, Smith's landscapes were more sharply defined by light and shadow. This caused them to have a somewhat photographic quality.

Smith was a very active member of the Southern Californian art community. He was a founding member of the California Art Club, the Laguna Beach Art

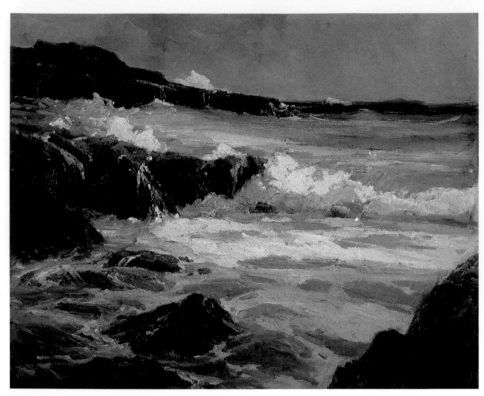

Thundering Surf, ca. 1925, 25 x 30 in., signed l.l. Courtesy of Petersen Galleries, Beverly Hills, California.

Association, and the Sketch Club. He was the recipient of numerous awards before his death in 1949.

MEMBERSHIPS
Allied Artists of America
California Art Club
California Water Color Society
Laguna Beach Art Association
Salmagundi Club

PUBLIC COLLECTIONS
Laguna Beach Museum of Art, California
Springville Museum of Art, Utah

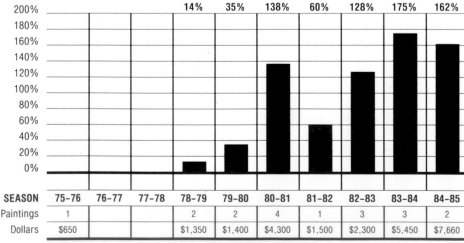

10-Year Average Change From Base Years '75-'76: 89%

	75-76	76-77	77-78	78-79	79-80	80-81	81-82	82-83	83-84	84-85
				14%	35%	138%	60%	128%	175%	162%
SEASON	75-76	76-77	77-78	78-79	79-80	80-81	81-82	82-83	83-84	84-85
Paintings	1			2	2	4	1	3	3	2
Dollars	$650			$1,350	$1,400	$4,300	$1,500	$2,300	$5,450	$7,660

Record Sale: $7,000, CH, 3/15/85, "Mountain Trail," 28 × 34 in.

656

HOWARD CHANDLER CHRISTY

(1873-1952)

Howard Chandler Christy, while notable as a painter, achieved his greatest acclaim as a book and magazine illustrator. Christy exhibited tremendous range in his drawings—from action-filled wartime depictions to the rendering of a woman who would become the prototype of femininity in the early 1900s.

Christy left his native Ohio in 1893, at age 20, to study under William Merritt Chase at the Art Students League in New York City. He chose illustration as his artistic focus.

Christy's trip to Cuba in 1898, and his subsequent action renderings of Theodore Roosevelt's "Rough Riders" in the Spanish-American War, first brought him recognition. The drawings, along with Christy's narrative, were published in *Scribner's Magazine.* The military motif was also exhibited in a later series, "Men of the Army and Navy."

It was not long before Christy was a regular artistic contributor to the most popular publications of his day, among them *Harper's Magazine* and *Collier's Weekly.* In these periodicals, Christy introduced a feminine figure of striking beauty and luminescence; known as the "Christy Girl," she captured the style and standard of a decade.

During that period, Christy's work was not solely restricted to magazines.

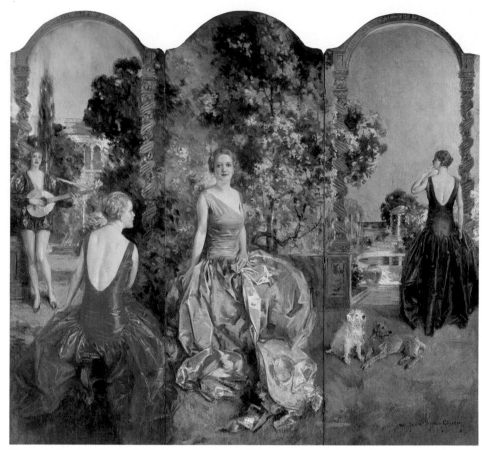

Women in Fanciful Garden Setting (open front), 66 x 72 in., signed l.r. Private Collection, Photograph courtesy of Kennedy Galleries, New York.

He also illustrated books by James Whitcomb Riley and Richard Harding Davis.

From 1920 until his death in New York City in 1952, Christy turned his attention to portrait painting. Many of his subjects were notable contemporaries, including aviator Amelia Earhart, Prince Humbert of Italy, and the wife of newspaper magnate William Randolph Hearst.

One of Christy's most impressive and ambitious works, *Signing of the Constitution* (date unknown), is hung in the House of Representatives of the United States Capitol in Washington.

MEMBERSHIPS
Society of Illustrators

PUBLIC COLLECTIONS
United States Capitol, Washington, D.C.

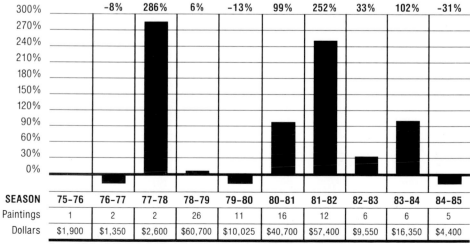

10-Year Average Change From Base Years '75-'76: 73%

	75-76	76-77	77-78	78-79	79-80	80-81	81-82	82-83	83-84	84-85
		-8%	286%	6%	-13%	99%	252%	33%	102%	-31%
SEASON	75-76	76-77	77-78	78-79	79-80	80-81	81-82	82-83	83-84	84-85
Paintings	1	2	2	26	11	16	12	6	6	5
Dollars	$1,900	$1,350	$2,600	$60,700	$10,025	$40,700	$57,400	$9,550	$16,350	$4,400

Record Sale: $19,000, D.NY, 4/21/82, "Nymphs in Summer," 24 x 28 in.

LOUIS BETTS
(1873-1961)

Louis Betts is known for his sensitive portraits of prominent individuals in public and professional life. In a long and productive career that began with his first painting at age 14, Betts did portraits of Hamlin Garland, Booth Tarkington, George Eastman, the Mayo brothers and many others in Chicago, New York and Europe.

Born in 1873 in Little Rock, Arkansas, Betts grew up in Chicago. He was the son of a landscape painter, who gave him his first artistic training. He was nearly 30 when he enrolled in the Pennsylvania Academy of the Fine Arts to study for a year under William Merritt Chase.

In 1902, the Academy awarded Betts a travel fellowship and he left for Europe to travel and study art, particularly the work of Hals and Velasquez. Betts stayed in Holland and Spain for several years, engaged in a lucrative portrait business based on contacts provided by Chase.

On his return to the United States, Betts found himself in constant demand as a portraitist. He devoted himself very seriously to this art form, never deviating into other channels or following up the landscape painting he had done earlier. In the next 25 years, he produced a succession of important portraits of men, women and children, many of which won awards from major art institutions in the United States.

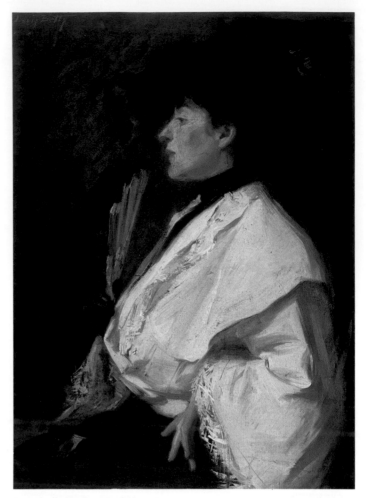

Demoiselle Barthe, 32 x 24 in., signed u.l. Courtesy of Grand Central Art Galleries, Inc., New York, New York.

Betts possessed an extraordinary ability to portray character. The personality of his subject radiates from the canvas through the gleam in the eyes and the posture of the body, as though the person were present in the room. That presence is no accident of talent; Betts's stated ambition was to capture the physical and spiritual character of his subjects, and he would labor for hours to absorb and convey those features.

Betts and his wife, also an artist, lived in a heady world in Chicago and New York City, on intimate terms with other artistic celebrities. Betts was a violinist and an avid fisherman, drawing inspiration from his retreats into nature. He died in 1961.

MEMBERSHIPS
National Academy of Design
National Art Club
National Institute of Arts and Letters
Salmagundi Club
Union League Club

PUBLIC COLLECTIONS
Art Institute of Chicago
Corcoran Gallery, Washington, D.C.
Little Rock Art Museum, Arkansas
Mayo Foundation, Rochester, Minnesota
Toledo Museum, Ohio

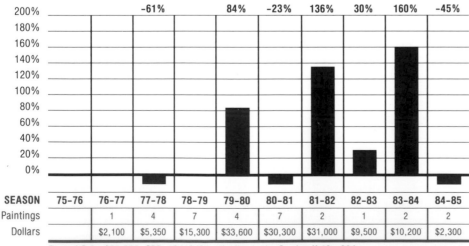

10-Year Average Change From Base Years '76-'77: 31%

SEASON	75–76	76–77	77–78	78–79	79–80	80–81	81–82	82–83	83–84	84–85
			−61%		84%	−23%	136%	30%	160%	−45%
Paintings		1	4	7	4	7	2	1	2	2
Dollars		$2,100	$5,350	$15,300	$33,600	$30,300	$31,000	$9,500	$10,200	$2,300

Record Sale: $25,000, SPB, 12/10/81, "Ladies in the Garden," 40 x 30 in.

LOUIS AGASSIZ FUERTES
(1874-1927)

Louis Agassiz Fuertes is considered to be the foremost American illustrator of birds, surpassing even John James Audubon.

Named after the great naturalist of the nineteenth century, Louis Agassiz of Harvard, Fuertes was born in Ithaca, New York in 1874. He graduated from the College of Architecture at Cornell University in 1897. Rather than pursue the engineering career his father had intended for him, he went on to study art with Abbot Thayer.

In addition to illustrating numerous books, pamphlets and magazines, including several series in *National Geographic,* Fuertes prepared habitat groups for the American Museum of Natural History in New York City and painted murals. He is best known for his series of plates entitled *The Birds of New York* (1910), which includes most species native to Eastern North America. At the time of his death in 1927, Fuertes was at work on a complementary series entitled *The Birds of Massachusetts.*

The material for Fuertes's illustrations was drawn from his ornithological expeditions throughout North America, Mexico, Colombia, the West Indies, Europe and Africa. The life studies of birds made during his 1926 expedition to Ethiopia, sponsored by the Field Museum of Natural History in Chicago, are among his best work.

Fuertes's meteoric career was the result of his extraordinary ability to observe and re-create from memory all aspects of a bird's appearance and behavior. Ornithologists praised his illustrations for their accurate representation of anatomy and pose, while others drew attention to their strength of composition and effective use of color and light. His work amply demonstrates his extensive knowledge of birds and their environs, his fidelity to nature and his

Bald Eagle Juvenile. Photograph courtesy of the Brandywine River Museum, Chadds Ford, Pennsylvania, Collection of Laboratory of Ornithology, Cornell University.

great technical skills, as well as his particular gift of investing these technical studies with a sensitive and subjective sense of a bird's individual characteristics.

PUBLIC COLLECTIONS
Academy of Natural Sciences, Philadelphia
American Museum of Natural History,
 New York City
Field Museum of Natural History, Chicago
New York State Museum, Albany

SEASON	75-76	76-77	77-78	78-79	79-80	80-81	81-82	82-83	83-84	84-85
Paintings				2				1	2	1
Dollars				$2,650				$1,000	$15,800	$14,000

Record Sale: $15,000, SPB, 1/27/84, "Northern Phalarope; Flickers," 8 × 13 in.

FRANCIS JOHN McCOMAS
(1874-1938)

Francis McComas was an Australian-born painter who came to be regarded as one of the best watercolorists in the United States during the early twentieth century. Although he is remembered chiefly as a painter of the American Southwest, McComas also traveled and painted many works in Europe, Mexico and the South Seas.

McComas was born in Tasmania, and educated at the Sydney Technical Institute. He came to America in 1898, studying briefly with Arthur Matthews at the San Francisco School of Design. In 1899, he traveled to Paris for an additional year of study at the Academie Julien.

In 1907, McComas painted studies in Greece, and exhibited them to critical praise in London the following year. Returning to the United States, the artist began painting his landscapes of the American Southwest, for which he soon became well known. Some of his better-known subjects from this period include the mesas of New Mexico, scenes from Navajo country and California oaks and gnarled cypresses.

McComas participated in the 1913 New York Armory Show, and was appointed a jurist for the art competition of the 1915 Panama-Pacific Exposition held in San Francisco. Although best known for his American landscapes, he is said to have produced some of his best works on trips to Tahiti in 1927, Spain in 1928 and Mexico in 1932 and 1935.

McComas's work sold readily and at good prices throughout his career. Among his better-known commissions were works painted for the Metropolitan Museum of Art in New York, and for the private collections of Marshall Field and Irenee Dupont. The artist remained professionally active until his death in Monterey, California in 1938.

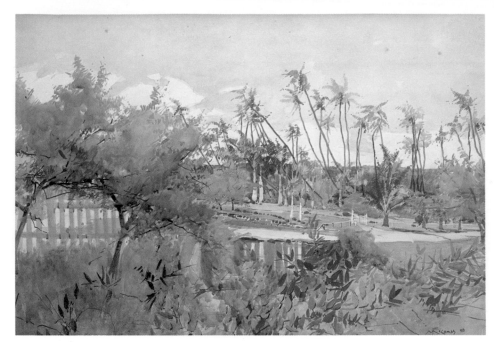

Hawaii, 1898, 14½ x 20¾ in., signed l.r. Courtesy of John H. Garzoli Gallery, San Francisco, California.

MEMBERSHIPS
American Water Color Society
Bohemian Club of San Francisco
Philadelphia Water Color Club

PUBLIC COLLECTIONS
Metropolitan Museum of Art, New York City
Portland Art Society, Oregon

SEASON	75-76	76-77	77-78	78-79	79-80	80-81	81-82	82-83	83-84	84-85
Paintings					2		7		2	
Dollars					$1,850		$37,100		$2,117	

Record Sale: $18,000, BB.SF, 10/3/81, "Monterey, California," 42 × 61 in.

FREDERICK CARL FRIESEKE
(1874-1939)

Frederick Carl Frieseke was one of the leading American impressionists. Until the early 1930s, the expatriate's international reputation was such that he was called "America's best-known contemporary painter." His relative anonymity today is due to the prettiness and sentimentality of his canvases; his work fell out of favor because his subject matter was considered cloying by post-World War I sensibilities.

Born in Owasso, Michigan in 1874, Frieseke went to France in 1898. He remained there until his death in 1939. Though Frieseke preferred to say that he was self-taught, he actually studied at the Art Institute of Chicago and the Art Students League in New York City before entering the French Academie Julien.

It was the study of the work of other artists that enriched Frieseke, rather than the academic routine. He spent time in the atelier of Constant and Laurens, and in Paris received criticism from James Abbott McNeill Whistler. Whistler's influence can be seen in Frieseke's dark, early work. The contemporary art nouveau movement, with its strong linear emphasis and decorative style, was a continuing influence on his paintings.

In 1906, Frieske moved to Giverny, where Monet was his neighbor. Under the influence of Monet, Frieseke began to use the prismatic, rich color spectrum of the impressionists in garden and inte-

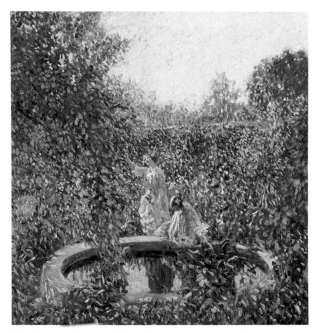

The Blue Garden, 32 x 32 in. Photograph courtesy of Hirschl & Adler Galleries, Inc., New York, New York.

rior scenes. His choice of subject matter was more similar to Renoir's, though: voluptuous, sensuous female nudes.

But Frieseke borrowed from the post-impressionists as well, by enveloping his figures in patterns made by colored flowers, garden furniture and sunlight. *Lady Trying on a Hat* (1909, Art Institute of Chicago) and *On The Bank* (ca. 1915, Art Institute of Chicago) exemplify his technique.

Frieseke's adopted impressionist style never compromised his solid sense of composition. He was apt to unify the whole with a dominant color, as in *The Yellow Room* (date and location unknown). Another example is the lavender hue that permeates every other

color in *Memories, 1915* (location unknown).

In particular, Frieseke was fascinated by the effects of sunlight. In a 1914 interview he said, "It is sunshine, flowers in sunshine, girls in sunshine, the nude in sunshine, which I have been principally interested in. . . ."

He thought of himself as a realist, reproducing on canvas what he saw in nature. However, some of his contemporaries regarded his paintings as "tea cakes," or "confections."

Frieseke enjoyed acclaim during his life. His paintings were purchased for the French National Collection, and he was represented at the Venice Bienniale with 17 pictures. He was commissioned to paint several large murals for buildings in New York City and Atlantic City. At the Panama-Pacific International Exposition of 1915 in San Francisco, Frieseke received the grand prize.

MEMBERSHIPS
National Academy of Design
Societe National des Beaux Arts, Paris
Paris Art Association
New York Water Color Club
Chevalier of the Legion of Honor

PUBLIC COLLECTIONS
Art Institute of Chicago
Cincinnati Art Museum
Corcoran Gallery of Art, Washington, D.C.
Los Angeles County Museum of Art
Metropolitan Museum of Art, New York City
Minneapolis Institute of Arts, Minnesota
Musee d'Orsay, Paris
Museum of Odessa, Soviet Union
Telfair Academy of Arts and Sciences, Savannah, Georgia

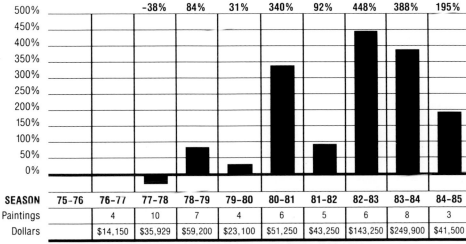

10-Year Average Change From Base Years '76-'77: 171%

		-38%	84%	31%	340%	92%	448%	388%	195%	
SEASON	75-76	76-77	77-78	78-79	79-80	80-81	81-82	82-83	83-84	84-85
Paintings		4	10	7	4	6	5	6	8	3
Dollars		$14,150	$35,929	$59,200	$23,100	$51,250	$43,250	$143,250	$249,900	$41,500

Record Sale: $85,000, CH, 6/1/84, "Woman Sewing in Garden," 28 × 36 in.

FRANK TENNEY JOHNSON
(1874-1939)

Frank Tenney Johnson was one of the most successful early-twentieth-century frontier painters and illustrators. He specialized in painting cowboys, Indians and early settlers.

Born in 1874, Johnson apprenticed himself at age 14 to panoramic painter F.W. Heine in Milwaukee. A year later, Johnson was greatly influenced while studying under Richard Lorenz.

Johnson then painted portraits and worked on the staff of a Milwaukee newspaper. In 1902, he went to New York City and studied under Robert Henri at the Art Students League. He soon became a newspaper and fashion artist.

The desire to return West never left him, and after improving his skills, he settled on a ranch in Colorado, where he painted the Western subjects he liked best.

Johnson's Western work began receiving notice from New York City publishers. He established himself as a successful illustrator for magazines and for books by such prominent writers as Zane Grey.

In the 1920s, Johnson and his friend Clyde Forsythe formed a studio which attracted many noted artists, including Charles Russell, Ed Borein, Dean Cornwell and Norman Rockwell. During this era, Johnson and Forsythe founded the Biltmore Art Gallery in the Biltmore Hotel in Los Angeles.

Johnson, who won numerous awards

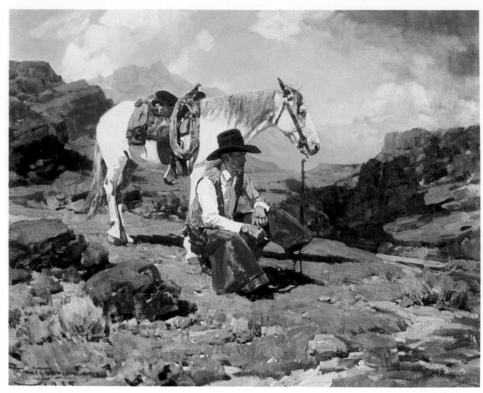

Don, The Horse Wrangler, 1935, 24 x 30 in., signed l.l. Collection of S. Hallock duPont, Jr., Photograph courtesy of Kennedy Galleries, New York, New York.

during his career, was celebrated for his paintings of cowboys under stars; his treatment was termed the Johnson "moonlight technique."

His career was ended in 1939, when he died of spinal meningitis. He had contracted the disease from kissing his hostess at a dinner party; both died within two weeks.

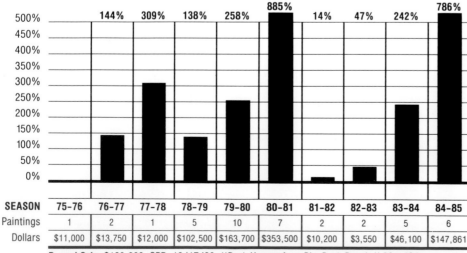

10-Year Average Change From Base Years '75-'76: 282%

SEASON	75-76	76-77	77-78	78-79	79-80	80-81	81-82	82-83	83-84	84-85
		144%	309%	138%	258%	885%	14%	47%	242%	786%
Paintings	1	2	1	5	10	7	2	2	5	6
Dollars	$11,000	$13,750	$12,000	$102,500	$163,700	$353,500	$10,200	$3,550	$46,100	$147,861

Record Sale: $120,000, SPB, 10/17/80, "Pack Horses from Rim Rock Ranch," 36 x 46 in.

MEMBERSHIPS
American Federation of Artists
Allied Artists of America
American Water Color Society
California Art Club
Laguna Beach Art Association
National Academy of Design
New York Water Color Club
Painters of the West
Salmagundi Club
Society of Painters

PUBLIC COLLECTIONS
Dallas Art Association
Fort Worth Art Center, Texas
National Gallery of Art, Washington, D.C.
Phoenix Museum of Art, Arizona

FRANCIS LUIS MORA
(1874-1940)

Francis Luis Mora, son of one painter and sculptor and brother of another, was an illustrator, muralist and portraitist whose work reflects a blend of Spanish and modern-American influences.

Mora was born in 1874 in Uruguay. His father, Domingo Mora, was a well-known artist who gave Mora his early artistic training. The family moved to the United States, and Mora attended school in New Jersey, New York City and Boston. He studied drawing and painting under Frank Benson and Edmund Tarbell at the Boston Museum of Fine Arts School; later he studied under H. Siddons Mowbray at the Art Students League in New York City. He also traveled to Europe to study the great paintings of the old masters.

By age 18, Mora was illustrating for leading periodicals. He began exhibiting two years later, and in 1900 he received a commission for a mural in the public library of Lynn, Massachusetts. In 1904, he painted the Missouri State Building mural for the Louisiana Purchase Exposition in St. Louis. He also painted portraits of Andrew Carnegie and President Warren G. Harding; the latter hangs in the White House.

Mora worked in oil, watercolor, charcoal and pastel; in addition, he produced etchings and sculpture. His subjects were generally interiors, seascapes and landscapes with figures. Like Tarbell and Benson, Mora captured the flavor of leisured life, particularly in outdoor scenes. He also painted Indian and Western scenes (his brother, Joseph Jacinto Mora, also received considerable recognition for his paintings and sculptures of Western subjects).

Mora taught at the Art Students League, the Grand Central School of Art and the New York School of Art, all in New York City. He died in 1940.

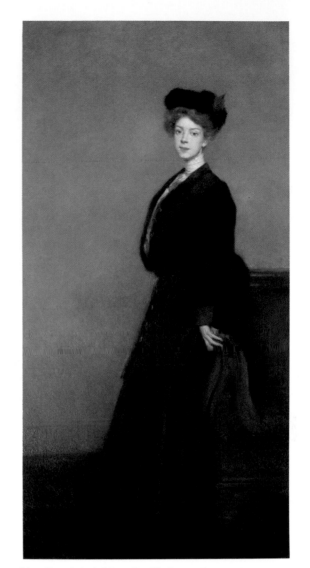

Mrs. Francis Luis Mora (Sophia Brown Compton), ca. 1900, 84 x 41½ in., signed l.r. Courtesy of Kennedy Galleries, New York, New York.

MEMBERSHIPS
Allied Artists of America
American Federation of Arts
American Water Color Society
Architectural League of New York
Art Students League
Ceramic Society
National Academy of Design
National Arts Club
National Association of Portrait Painters
New York Water Color Club
Salmagundi Club
Society of American Artists
Society of American Etchers
Society of Illustrators

PUBLIC COLLECTIONS
Butler Institute of American Art,
 Youngstown, Ohio
Museum of Modern Art,
 New York City
National Academy of Design,
 New York City
National Gallery of Canada, Ottawa
Newark Museum, New Jersey
Oakland Museum, California
Toledo Museum of Art, Ohio
White House, Washington, D.C.

SEASON	75-76	76-77	77-78	78-79	79-80	80-81	81-82	82-83	83-84	84-85
Paintings		3	3	6	9	14	19	10	8	4
Dollars		$12,100	$6,100	$13,990	$9,500	$52,950	$50,500	$21,620	$13,800	$4,350

Record Sale: $15,000, D.NY, 9/24/80, "The Sun Screen," 48 × 36 in.

JOHN F. CARLSON
(1874-1945)

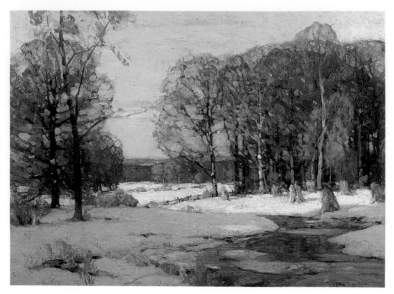

Across the Meadow, 18 x 24 in., signed l.r. Courtesy of Henry B. Holt, Inc., Essex Fells, New Jersey.

Prolific nature painter John F. Carlson is recognized as one of America's foremost landscape artists. As founder of the John F. Carlson School of Landscape Painting, he was known for teaching his students to juxtapose tone, light and shadow to reflect the myriad moods of nature.

His work was characterized by crisp form, intense color and complex webs of swirling shapes. The overall effect was realistic.

Carlson acquired a predilection for trees and winter as a child in Kalmar Lan, Sweden, a sylvan land of snow-crested mountains. His early interest in art developed as he gazed, transfixed, while his uncle painted idyllic landscapes.

The family immigrated to America when Carlson was 10 or 11. They settled first in Brooklyn, New York, where Carlson attended public schools, and then in Buffalo. Carlson's afterschool hours were often spent sketching scenes of Sweden from memory.

To support his son's interest in art, Carlson's father hired a private tutor, John Mayer, who provided lessons in life drawing and nature sketching. Carlson later attended Buffalo's Albright Art School, where he trained under Lucius Hitchcock.

In 1902, Carlson was awarded a scholarship to study at the Art Students League in New York City. His instructors were Frank V. Dumond and Birge Harrison. Harrison became not only Carlson's mentor, but a good friend. In 1903, Carlson received his first honor, the Ralph Radcliffe Whitehead Prize.

The same year, Harrison was asked to teach at Byrdcliffe, a newly-founded arts and crafts community in Woodstock, New York, and Carlson was granted a scholarship to the school. Woodstock was at first enchanting to the young student, but the regimented lifestyle of the community was anathema to Carlson's creativity; he re-established quarters in nearby Rock City, New York.

In 1906, Carlson came back to Woodstock as Harrison's assistant. Three years later, he held his first one-man show at Katz Gallery in New York City. In 1911, he was elected an associate of the National Academy of Design and also became director of the Art Students League summer school, a position he held until 1918.

Carlson traveled through the United States, capturing its beauty on canvas, before returning to Woodstock in 1922 to found his own school. He often spent hours painting in sub-freezing conditions without mittens. During this period, he also helped found the Broadmoor Art Academy in Colorado Springs.

The years after Carlson's reappearance at Woodstock were busy, fruitful and happy. In 1925, he was made a full academician of the National Academy. Three years later, he completed his famous book, *Elementary Principles of Landscape Painting,* later changed to *Carlson's Guide to Landscape Painting.*

Carlson continued his painting and teaching careers in Woodstock, New York City, the Canadian Rockies and Gloucester, Massachusetts until his death in 1945.

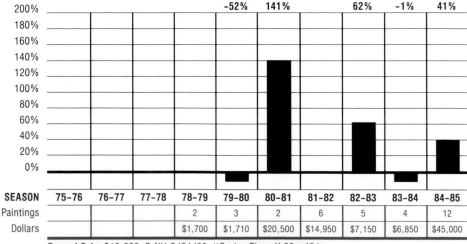

10-Year Average Change From Base Years '78-'79: 27%

			-52%	141%		62%	-1%	41%

SEASON	75-76	76-77	77-78	78-79	79-80	80-81	81-82	82-83	83-84	84-85
Paintings				2	3	2	6	5	4	12
Dollars				$1,700	$1,710	$20,500	$14,950	$7,150	$6,850	$45,000

Record Sale: $13,000, D.NY, 9/24/80, "Spring Thaw," 30 × 40 in.

JOSEPH CHRISTIAN LEYENDECKER
(1874-1951)

Joseph Christian (J.C.) Leyendecker generated a rich heritage of Americana by illustrating hundreds of magazine covers. From 1899 to 1943, he painted 322 covers for the *Saturday Evening Post*. His original symbol for the New Year, a cherubic baby, was immortalized on *Post* covers. Creator of some of the most popular advertisements and poster designs of his time, he was regarded as one of America's most talented illustrators.

Born in 1874 in the German village of Montabour, Leyendecker and his family emigrated to Chicago when he was nine. His brother, Frank Xavier Leyendecker, was also an artist; later they studied and worked together.

At age 16, Leyendecker, who had busied himself since age eight painting on oilcloth, landed an unpaid apprentice's job at J. Manz & Company, a Chicago engraving house. Soon he earned two dollars weekly as artist/errand boy, which enabled him to attend the Art Institute at night. He studied for five years with John H. Vanderpoel. At age 20, he completed 60 illustrations for an edition of the Bible, published in 1894.

Leyendecker made an outstanding impression in Paris, where the brothers studied at the Academie Julien in 1896 and 1897. He was awarded four prizes by the Academie, and in 1897 had a one-man exhibition at the Salon Champs du

Baby Mechanic, 1925, 28 x 20 in. Photograph courtesy of Borghi & Co. Fine Art Dealers, New York, New York.

Mars. Undoubtedly, the Parisian period was important in forming the distinct Leyendecker style.

Recognition as a successful poster designer came when Leyendecker's poster won *The Century* magazine's 1896 contest; well-known Maxfield Parrish placed second.

J.C. Leyendecker had great versatility, varying his themes to play upon sentiments of the occasion. His abandoned, spontaneous freedom of style accentuated the muscles of the young men in his posters. He created the popular "Arrow Collar Man" advertisement in 1905; it was followed by work for many well-known companies.

He did covers for *Collier's, The American Weekly* and *Inland Printer.* His work during the World Wars included allegorical posters from 1917 to 1919 and a series of war bond posters in 1944.

A private person who shied from publicity, J.C. Leyendecker died in New Rochelle, New York in 1951.

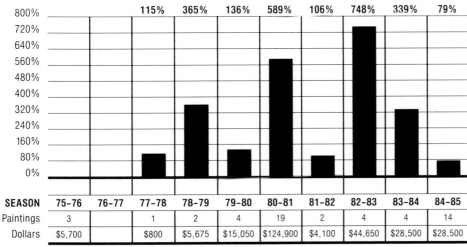

10-Year Average Change From Base Years '75-'76: 275%

		115%	365%	136%	589%	106%	748%	339%	79%

SEASON	75-76	76-77	77-78	78-79	79-80	80-81	81-82	82-83	83-84	84-85
Paintings	3		1	2	4	19	2	4	4	14
Dollars	$5,700		$800	$5,675	$15,050	$124,900	$4,100	$44,650	$28,500	$28,500

Record Sale: $26,000, P.NY, 4/2/81, "Yule," 30 x 22 in.

MEMBERSHIPS
Salmagundi Club

OSCAR E. BERNINGHAUS
(1874-1952)

Oscar Edmund Berninghaus worked successfully as both a fine artist and a commercial artist during most of his life. He divided his time between his hometown of St. Louis, Missouri and Taos, New Mexico. As one of the founders of the Taos Society of Artists, he believed that the Southwest, and Taos in particular, would figure prominently in the development of a uniquely American art.

Berninghaus trained as a lithographer for a large St. Louis printing firm, while taking night art classes at Washington University and the St. Louis School of Fine Arts.

At age 25, while on vacation, he discovered Taos in a most unorthodox manner: from the top of a railroad car. Fascinated by Berninghaus's station-side sketches, a railroad employee had arranged for a chair to be lashed to the train's roof, to afford Berninghaus an unparalleled view of the New Mexico landscape.

Often compared to Western painters Charles M. Russell and Frederic Remington, Berninghaus was best known for his paintings of horses and Indians. He painted the Indians of Taos in natural, unsentimentalized settings, revealing an understanding of their life in a twentieth-century world. In his paintings, man never occupied a dominant position relative to the natural landscape, and in later years

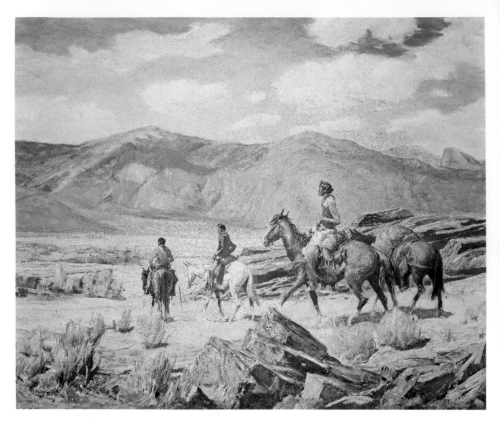

Indians Returning to Taos (after Trading Expedition), 30 x 36 in., signed l.r. Photograph courtesy of The Gerald Peters Gallery, Santa Fe, New Mexico.

Berninghaus still further reduced man's participation in his scenes.

As an independent commercial artist, Berninghaus was most successful with the advertisements he illustrated for the Anheuser-Busch Brewery. Berninghaus called this work "common commercialism," but it is now known as the Berninghaus collection, 50 of his works

donated by the Busch family to the St. Louis City Art Museum.

In the 1920s, Berninghaus moved to Taos permanently, changing his style somewhat to employ deeper pigmentation and more complicated composition. As he grew older, he abandoned his camping and sketching trips in favor of painting from memory. Because of the flux of colors in spring and fall, Berninghaus most often used those seasons for his landscapes.

He died in Taos in 1952.

MEMBERSHIPS
National Academy of Design
2 x 4 Club
Salmagundi Club
St. Louis Art Guild
Taos Art Association
Taos Society of Artists
Taos Students' Association

PUBLIC COLLECTIONS
Anschutz Collection, Denver
City Art Museum, St. Louis
Cowboy Hall of Fame, Oklahoma City
Erie Museum, Pennsylvania
Fort Worth Museum, Texas
Gilcrease Institute of Art, Tulsa
Harrison Eiteljorg Collection, Indianapolis
Los Angeles County Museum
Museum of New Mexico, Santa Fe
San Diego Museum

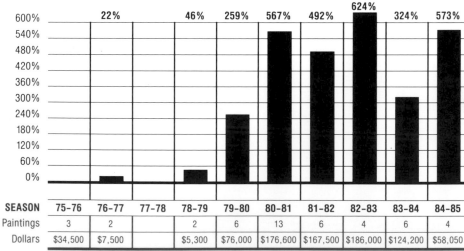

10-Year Average Change From Base Years '75-'76: 323%

	75-76	76-77	77-78	78-79	79-80	80-81	81-82	82-83	83-84	84-85
(% change)	22%		46%	259%	567%	492%	624%	324%	573%	
SEASON	75-76	76-77	77-78	78-79	79-80	80-81	81-82	82-83	83-84	84-85
Paintings	3	2		2	6	13	6	4	6	4
Dollars	$34,500	$7,500		$5,300	$76,000	$176,600	$167,500	$186,000	$124,200	$58,050

Record Sale: $75,000, SPB, 4/23/82, "Domain of Their Ancestors," 25 x 30 in.

VOLUME III
1874-1930

ESSAYS

AMERICAN PAINTERS ABROAD

DAVID SELLIN

Matthew Pratt, *Portrait of a Woman,* 36 x 27 in. Courtesy of Frank S. Schwarz & Son, Philadelphia, Pennsylvania.

From the beginning of colonial settlement in America, immigrants have imposed their own familiar cultures on new territory as it was mapped. When the country's early portraitists, or limners, no longer filled the artistic needs of its growing provincial centers, talented painters aspiring to higher art had no choice but to go back to Europe or England for education.

Art study throughout Europe was based on a pattern established in sixteenth-century Bologna, Italy. At its core was the nude human figure, and the representation of the human figure in ancient sculpture and Renaissance painting. None of this was available for study in America until the first decade of the nineteenth century. John Singleton Copley never saw a naked model before leaving Boston for England in 1774, and a life class failed in Philadelphia in 1795 for lack of models. Proper drawing from the antique was possible only after Emperor Napoleon I provided Philadelphia and New York City with splendid casts from ancient sculpture in the Louvre. Only after 1876 did those cities have schools comparable to the best in Europe.

Benjamin West followed the example of his London contemporaries when he sailed directly from Philadelphia to Italy for an art education in 1760. He was soon followed by Henry Benbridge. Pompeo Battoni admitted the

Charles Bird King, *The Rope Walk,* ca. 1830, 39 x 54¼ in. Courtesy of Bayly Museum of the University of Virginia, Charlottesville, Virginia.

Americans to his studio in Rome, where he was much admired. But the modern movement was a neoclassical reaction to prevailing baroque tastes. It was stimulated by the discoveries in Pompeii, and promoted by Winckelmann and Mengs, Germans in the employ of Cardinal Albani. West was introduced to Albani's great collection. Under Mengs's direction, he drew from life and ancient reliefs; he copied paintings by Carracci in Bologna, Correggio in Parma, Titian in Venice, Raphael and Michelangelo in Rome—he was the first American artist to make the "Grand Tour."

West settled in London, where his studio became the first American art school. He welcomed his countrymen, and eased their admission to the Royal Academy: Matthew Pratt, Charles Willson and Raphaelle Peale, Gilbert Stuart, John Singleton Copley, John Trumbull, Robert Fulton, Charles Bird King, Thomas Sully, William Dunlap, Washington Allston, Samuel F.B. Morse. Successive generations brought back to the United States aspects of his teaching, as he passed from the neoclassical "Stately Mode," to the dramatic "Dread Manner," to a serene "Grecian" style influenced by the Elgin marbles from the Parthenon. The first proper art schools and

museums in the United States, the first history of American art, and the first photographic studio, were accomplishments of his students, several of whom lived until 1872.

Of the three American painters in Paris in 1797, two were West students. Trumbull (there on business) was received by Jacques-Louis David as an accomplished master of Revolutionary history; Fulton established an "endless picture" panorama of Paris, admissions to which financed his early experiments with submarine, torpedo and steamboat; the third, John Vanderlyn, was the first American to enroll for study in the Ecole des Beaux-Arts. (Napoleon awarded medals to West and Vanderlyn in 1802 and 1808, respectively.) But Paris was attractive less for instruction than for its great collections. Indeed, Rome was the goal of all French art students.

"In Rome," Copley wrote, "there is an agreeable association of English, . . . so much at the English Coffee House that I need not be alone except from choice." The Caffe Greco was the haunt of artists, their mail address for generations. In the nearby Piazza di Spagna models congregated—Christs, madonnas, devils, monks, bandits, peasants who would pose in costume, or in no costume at

Thomas Sully, *William Fry*, 1809, 28⅞ x 23¹⁵/₁₆ in., signed verso. Courtesy of Frank S. Schwarz & Son, Philadelphia, Pennsylvania.

all, for about 10 cents an hour. In 1806 Vanderlyn and Allston, the only two American artists then in Rome (soon joined by Washington Irving), drew from the nude at the French Academy. At the Caffe Greco, 30 years later, Vanderlyn reminisced. "There sat Allston opposite me; that was Turner's corner; and there I was told, Sir Joshua Reynolds and West sat." By then he could have added Morse and his friends James Fenimore Cooper, John G. Chapman and Thomas Cole, a host of sculptors, and Russian, Scandinavian and German artists. Among the latter was the future King Ludwig I, who would make Munich the art capital of Germany.

Artists rambled alone or in groups through the sun-drenched, relic-strewn landscape. Allston, Cole, George Inness, Albert Bierstadt, Jasper Cropsey, William Haseltine and others were fundamentally conditioned by their Italian experience; George Loring "Claude" Brown, John Rollin "Tintoretto of Rome" Tilton and many more made Italy, from Como to Capri, their permanent "sketching grounds." Few of them were innovators.

The only American since West to discover the avant-garde in Italy was Elihu Vedder. After Paris study in 1856, more by accident than design, he joined a group centered at the Caffe Michelangelo in Florence: the macchiaioli, equivalent to French tachist blot painters (like Troyon and Couture) but with a lighter palette—Italian sun does not suffer tonalism in landscape. Around 1870 Vedder was in Rome with a large colony of Americans who attended life class at "Gigi's Academy" on via Margutta in the artist quarter. He described it as "a good-sized semi-circular amphitheatre, seating about a hundred students. . . . We had no regular artistic criticism, but worked out our own salvation as best we could, except that we profited by the very frank opinions of our neighbors."

They lived an Arcadian dream, in apartments once inhabited by Claude or Rosa, in the Palazzo Barberini, or in the cavernous vaults of Diocletian's Baths. Poets, writers and sculptors were their comrades. As long as they stayed clear of religion and politics, the artists' lives remained relatively unchanged until the final overthrow of the Vatican's temporal power, which corresponded with the fall of the Second Empire in France and the consolidation of Germany—in other words, until the arrival of modern times around 1870.

Another type of roaming American artist was born of popular and scientific demand created by the "voyages of

Washington Allston, *Isabella of Spain,* 11½ x 8⅝ in. Courtesy of Vose Galleries of Boston, Inc., Massachusetts.

exploration." Titian Peale accompanied the Wilkes Expedition to the South Seas. Frederick Edwin Church traveled in the steps of von Humboldt to Ecuador and Colombia. Paying spectators traveled vicariously by viewing Church's detailed panoramas through opera glasses or "viewing tubes," which permitted a leisurely passage from fertile, populated regions to wilder reaches and finally to barren crags and belching volcanoes. Successfully exhibited in New York City and London in 1865 and Paris in 1867, Church's work was considered "flat as yesterday's soda-water" at the Philadelphia Centennial in 1876. By then artists engaged in exotic travel mainly to search for new Salon motifs.

Two American artist-naturalists were accorded special recognition abroad for their originality: John J. Audubon (once a student of David in Paris) and George Catlin. Cat-

lin, with his paintings and performing Indians, was by far the most conspicuous American in Paris around 1845. He obtained an audience at court; the King, who had visited among Indians in America, received them all and commissioned history paintings. Poe's translator, Baudelaire, was enthralled with the vitality of Catlin's color, with his unconventionality and with the natural nobility of his subjects.

Around 1840, Germany began to attract artists from areas of Pennsylvania, Ohio and Missouri where German immigrants had concentrated in large numbers. The artists came to Dusseldorf from 1840 to 1860, and to Munich in the 1870s. (In New York City, the Dusseldorf Gallery promoted the city on the Rhine.) Both Dusseldorf and Munich had academies organized around a curriculum which admitted students to elementary drawing, from

Emmanuel Leutze, *Washington Crossing the Delaware*, 1851, 149 x 255 in., signed l.r. Courtesy of The Metropolitan Museum of Art, Gift of John Stewart Kennedy, 1897.

which they advanced to intermediate life study and composition, and finally to a meisterklasse with the professor of their choice. Technical proficiency was stressed.

Emmanuel Leutze came from Philadelphia to enroll in the Dusseldorf Academy in 1841. He soon established a large studio, to which he welcomed fellow Americans, and founded an art club that was the focus of all artistic activity. Worthington Whittredge and Eastman Johnson helped him paint his *Washington Crossing the Delaware*, and in the summers Leutze joined them, Bierstadt, Haseltine and others on sketching trips on the Rhine and in Italy.

The Dusseldorf style, which became part of the mainstream of American painting, tends to frontality, sharply defined planes in space, crisp outline and high surface finish and detail. The American painters who studied there were deeply influenced by the Europeans. Leutze's history paintings reflect those of Lessing; Richard Caton Woodville's small genre paintings in box-like interiors are from Hasenclever; Bierstadt, who could barely draw when he came, absorbed the landscape style, as did Whittredge. Going on to the Hague, Johnson roughened his surfaces and edges after the example of Rembrandt.

William Morris Hunt left Dusseldorf for Paris in 1845 and discovered Thomas Couture. Of all of Leutze's American circle, he was the only one untouched by the Dusseldorf manner, as he was studying sculpture. In Paris he began to paint, and mastered Couture's tonalist method of brushed-in masses of dark and light on a medium-toned canvas, with stress on edge instead of outline. Then he joined Millet in the rustic village of Barbizon, part of the vanguard of what became a flourishing international art colony with a strong American presence: Winkworth Allen Gay, Edward Wheelwright, William Babcock, George Inness. Hunt established an offshoot of barbizon tonalism in Boston after 1855 through his popularity as a teacher.

James McNeill Whistler arrived in 1855 in Paris from bureaucratic Washington, D.C. He was attracted there by Henri Murger's novel of bohemian life, and plunged with zest into Parisian bohemianism. At the time, debates raged over the relative superiority of classicism or romanticism. Courbet rejected both for raw realism, opposed to which were both naturalism (realistic observation versus naturalistic demonstrable knowledge) and the "art for art" of the aesthetic movement. Factions rediscovered the seventeenth century and found support in Poussin or Rubens, Ribera or Velasquez, and Hals for sheer virtuoso execution. Japanese prints and photography provided novelty. Whistler absorbed it all, and was catapulted into notoriety with the exhibition of his *White Girl* among works rejected by the Salon of 1863. Among the few Americans studying art in Paris then were Foxcroft Cole, D. Ridgway Knight, Joseph Woodwell and Wordsworth

Thomas Eakins, *Max Schmitt in a Single Scull,* 1871, 32¼ x 46¼ in., signed c.r. Courtesy of The Metropolitan Museum of Art, Alfred N. Punnett Fund and Gift of George D. Pratt, 1934.

Thompson, most of them with Gleyre, painting alongside Claude Monet, Alfred Sisley and Auguste Renoir.

The Ecole des Beaux-Arts was overhauled in 1863, and an "atelier system" was introduced. Students were admitted to the guidance of a particular professor from cast drawing to studio painting. Tuition was free, lectures open to all. American students favored Cabanel, Gerome and, a little later, Bonnat.

Gerome required a thorough command of anatomy, perspective, principles of motion, reflection and accuracy; he emphasized value before color—that is, charcoal before paint. His first group of American students in 1866 included Thomas Eakins, Frederick A. Bridgman and H. Humphrey Moore. Eakins later introduced many of Gerome's teaching methods at the Pennsylvania Academy of the Fine Arts. The expatriate Bridgman used them when painting in Africa. Both employed Gerome motifs: rowing, chess-games and so forth. Following Gerome's example of exotic travel, Edwin L. Weeks went as far afield as India, and Moore and Robert Frederick Blum traveled to Japan.

Because they were Republican, not English, and had a reputation for boxing and gun-play, Americans were always cordially received by French students, who were notorious for crude treatment of newcomers. The end of the Civil War and the Paris Exposition of 1867 saw an influx of Americans in such increasing numbers that 20 years later French students felt crowded out of their own school. Stiff language requirements were instituted. But by then they made little difference. Since 1869, academic instruction by established masters had been available at the Academie Julian, open to men and women of all nationalities for a small fee. The Beaux-Arts was for men only.

During the Franco-Prussian war and the era of the Commune there was nothing for artists in Paris. Rome was in turmoil, Dusseldorf in decline. Munich, however, boasted a great collection and a good academy. Frank Duveneck came there in 1869, Walter Shirlaw in 1870, Frank Currier in 1871, William Merritt Chase in 1872. At just that time a club of rebel German artists shared studio, models, fellowship and criticism with Wilhelm Leibl—the Leibl Kreis. Inspired by the clean, unreworked brushwork of Hals and the honest observation of Courbet, they stressed simplicity of execution over subject and painted in the dark tones of the old masters. The Americans were welcomed to this circle. Their work there is indistinguishable from that of the Germans. John White

Frederic Bridgman, *Contemplation,* 1907, 24⅜ x 36¼ in., signed l.l. Courtesy of Raydon Gallery, New York, New York.

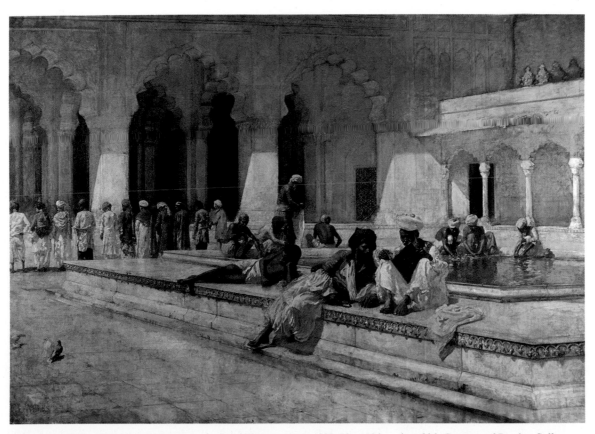

Edwin Lord Weeks, *The Hour of Prayer at the Pearl Mosque, Agra,* 1889, 79 x 119 in., signed l.l. Courtesy of Raydon Gallery, New York, New York.

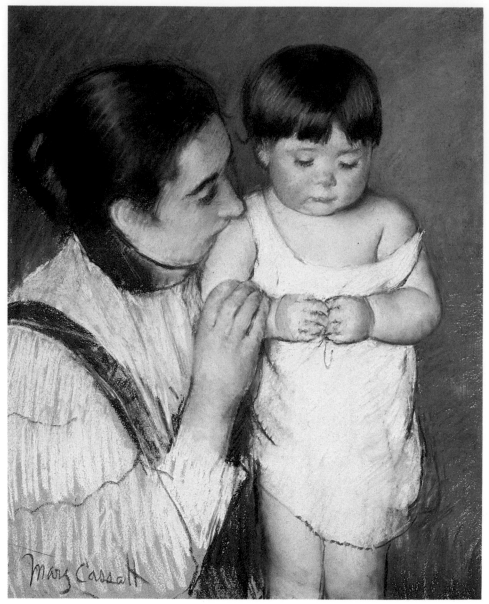

Mary Cassatt, *Young Thomas and His Mother,* 1893, 24 x 20 in., signed l.l. Courtesy of the Pennsylvania Academy of the Fine Arts, Philadelphia, Gift of Mrs. Clement Newbold.

Alexander, John H. Twachtman, Otto Bacher, Theodore Wendel and others formed their own circle around Duveneck. The "Duveneck Boys" worked together in Polling, Florence and Venice in the characteristic Munich manner.

American critics first recognized the emergence of a "new movement" at the Philadelphia Centennial, with paintings by Chase and Shirlaw stamped with the style of Munich, and by Eakins, Bridgman, Moore and Charles Sprague Pearce reflecting the Paris Beaux-Arts style. Treated badly by the National Academy of Design jury of 1877, the "new men" founded the Society of American Artists for independent exhibitions in New York. These exhibitions were so dominated by Chase and the "Duveneck Boys" in New York that the Paris-trained group initiated their own exhibitions in Philadelphia.

Meanwhile, D. Maitland Armstrong and Augustus St. Gaudens, charged with the selection and hanging of American art at the 1878 Paris Exposition, heavily favored the "new men." The lines were drawn: the Cincinnati-Munich style prevailed in New York City at the new Art Students League; Eakins's instruction in Philadelphia was from the Beaux-Arts, modified; the barbizon style held Boston.

The "new movement" was old almost before it was recognized. Americans in Paris admired the direct painting of Carolus-Duran, a swift attack with a paint-loaded brush on a bare white canvas, freer in form and lighter in tone than any prevailing school. Will H. Low, Theodore Robinson, J. Carroll Beckwith and Robert Hinkley invited him to teach them. He agreed—if they hired a studio and models. Young John Singer Sargent joined them

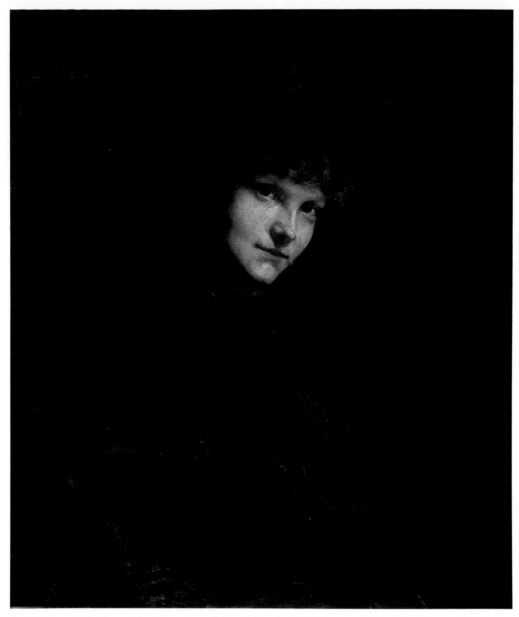

Cecilia Beaux, *Ethel Page (Mrs. James Large),* 30 x 25 in., signed l.r. Courtesy of Frank S. Schwarz & Son, Philadelphia, Pennsylvania.

and soon acquired total mastery of the technique. Simultaneously, Bastein-Lepage gained prominence for his peasant subjects: large figures viewed close and broadly painted out-of-doors. This led Knight and Pearce to attach greenhouses to their permanent French studios, so they could paint peasants among the flowers of the fields all through the year, without dark modeling or shadows. Discovered and encouraged by Degas, Mary Cassatt joined the ranks of the French impressionists after 10 years spent studying in Paris, Ecouen and Parma, copying works of the masters and exhibiting in the Salon. And Whistler, bankrupt from his court trial of Ruskin, surfaced in Venice to do etchings in 1880, finding the "Duveneck Boys." He borrowed their paints and press; they had the fellowship of an extraordinary pioneer of modern art. The association transformed the Munich pal-

ette and the surface treatment of Alexander, Twachtman and Bacher.

A new generation at Barbizon, including Low and Robinson, expanded artistic activity to the nearby villages of Montigny, Moret and Grez, attracted by cheap hotels as much as by the landscape. Bastien's influence prevailed there, as well as in the Breton art colonies of Pont-Aven and Concarneau. When Gauguin arrived with his impressionist followers, Americans had been in Pont-Aven for 20 years and had established a common studio. American painters Robert Wylie, Bridgman, Milne Ramsey and Clement Swift helped Mlle. Julia start her hotel. She, in turn, extended unlimited credit to Americans, like William L. Picknell, who needed painting materials as well as lodging. The first American painting to receive a medal in the reformed Salon was painted in Pont-Aven (by Wylie in

Dennis Miller Bunker, *Dories on Beach, Newburyport, Massachusetts, 1881,* 15 x 21 in., signed l.r. Courtesy of Vose Galleries of Boston, Inc., Massachusetts.

1872), as were some of the earliest to be acquired by the French nation (Henry Mosler, 1879; Alexander Harrison, 1886). Arthur W. Dow, Henry Kenyon and Henry O. Tanner were in Pont-Aven with Gauguin and painted important pictures.

Harrison and Edward Simmons moved on to Concarneau, where Blanche Howard's popular novel *Guenn* (1883), describing artist life, was written in Simmons's studio. It brought Dow, Cecelia Beaux, Robert Henri and Edward Redfield to Concarneau to paint. Crossing the Channel to St. Ives in Cornwall, Simmons then established an art colony that later attracted Elmer Schofield, who with Redfield brought this pearly brand of impressionism to New Hope, Pennsylvania.

But it was at Giverny, in Normandy, that American impressionism was hatched: the fleeting effects of spectral light reflected from surfaces, strokes of pure color blending in the observer's eye, banishment of black in shadow for color complementary to that of the adjacent illuminated surfaces—the opposite of tonalism. Since 1883

Giverny had been the home of Monet. Sargent painted in Monet's garden in Giverny, and brought his friend's technique to the garden of Frank Millet at Broadway, England. Dennis Bunker learned the impressionist method from him at Calcot. So it spread, but the American occupation of Giverny itself was massive. Artists tired of Paris and Barbizon found the village in 1887 and settled in the Hotel Baudy, near Monet's garden. Robinson, Willard Metcalf, Wendel, John L. Breck and Theodore Butler discarded tonalism. Lilla Cabot Perry painted in Monet's garden. Butler married into the Monet family and stayed. A second generation came: Frederick Frieseke, Guy Rose, Edmund Greacen, Karl Anderson and others, with renewed influence from Whistler.

In Paris, aside from Julian and Colarossi and the Beaux-Arts, now Harrison, "Shorty" Lasar, Henri and even Whistler offered instruction to Americans. The "Academy Julia" opened in Pont-Aven, and an American art school in Fontainebleau. An American Academy was established in Rome for advanced study. International

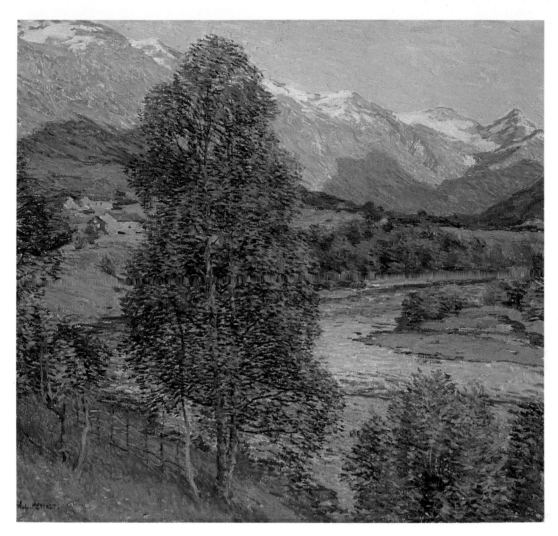

Willard Leroy Metcalf, *Salmon River—Norway,* 26 x 29 in., signed l.l. Courtesy of John H. Garzoli Gallery, San Francisco, California.

interaction revolutionized art in Paris itself with the emergence of the "School of Paris" around 1910. Even before the style of this school was introduced in New York City and Chicago by the Armory Show in 1913, Americans were involved.

Today no American must travel abroad to get to the epicenter of the international art world. What was a necessity for Benjamin West, and up to the end of the nineteenth century, has become a matter of choice. Many have profited from that choice, particularly with the "GI Bill" after World War II. The same war also brought a great influx of European artists to America, to New York City in particular, contributing to the international "New York School." The assimilation was complete. In the last century, Whistler, Cassatt and Sargent were practically the only Americans well known throughout Europe and England, and they were expatriates. Today there is no museum of modern art anywhere in the world that does not have a heavy representation of art made in America.

David Sellin studied art in Stockholm, Rome, Paris and Cologne and received his Ph.D. in art history from the University of Pennsylvania. He has taught at numerous institutions, has been a curator of the Philadelphia Museum of Art and director of the Schools of the Pennsylvania Academy of the Fine Arts, and has been a postdoctoral fellow of the Smithsonian Institution. He has published widely, particularly in the field of international currents in art, and has served as chief curator of the United States Capitol and special curator and consultant for the Smithsonian Institution.

AMERICAN IMPRESSIONISM

RICHARD BOYLE

Mary Cassatt, *Dans la Prairie,* 21½ x 25¾ in., signed l.r. Photograph courtesy of Hirschl & Adler Galleries, Inc., New York, New York.

Toward the end of the nineteenth century, American art and architecture were very much influenced by European, particularly French, styles. Writing in 1893, American novelist Henry James pointed out "that when today we look for American art we find it mainly in Paris. When we find it out of Paris, we at least find a great deal of Paris in it."

In addition to his celebrated and cosmopolitan novels, many of which were about art and artists, James also wrote art criticism. However, in 1893 it did not take an art critic's perception to recognize the French influence. At the popular World's Columbian Exposition in Chicago that year, for example, the fair buildings were designed in the neo-Renaissance style of the French Second Empire

Childe Hassam, *The South Ledges, Appledore,* 1913, 34¼ x 36⅛ in., signed l.r. Courtesy of National Museum of American Art, Smithsonian Institution, Washington, D.C. Gift of John Gellatly.

and Third Republic, and the walls of the international Art Section glowed with the bright color and broken brushwork of French impressionist-derived painting. This was the culmination of an influence that, for Americans, had its beginnings in the early 1870s, when American artists first began flocking in significant numbers to study in Paris.

The French impressionists held their first exhibition in 1874. Despite the initial derision of the press and jeers of the public, impressionism as a style ultimately triumphed and prospered. By the 1880s it was easier to take, and by the 1890s it was practically fashionable. By 1900, the style had gone around the world, but nowhere outside France

was there a greater concentration of impressionist painters than in the United States.

One of the first American painters to adopt impressionism was Mary Cassatt, who lived in France and sat at the feet of Edgar Degas. In addition, she played a key role in persuading American collectors to buy impressionist works.

In the late 1880s, Theodore Robinson stayed with Claude Monet at Giverny and was one of the most famous of the American artists to invade that quiet little town near Paris where Monet lived and worked. If Cassatt was influenced by Degas, Robinson and most subsequent American impressionists were influenced by Monet, and it

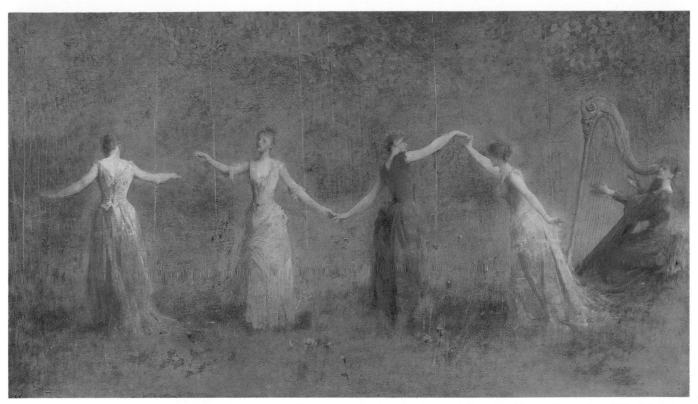

Thomas Wilmer Dewing, *Summer,* 1890, 20½ x 35¾ in., signed l.l. Courtesy of Yale University Art Gallery, New Haven, Connecticut. Gift of the heirs of Mrs. Frances L. Howland.

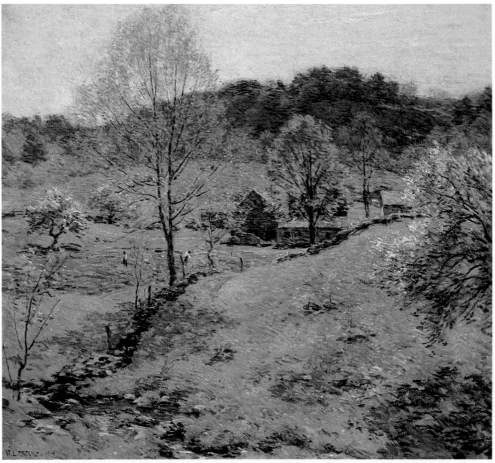

Willard Metcalf, *Maytime, 1919,* 36 x 39 in., signed l.l. Courtesy of Connecticut Gallery, Marlborough.

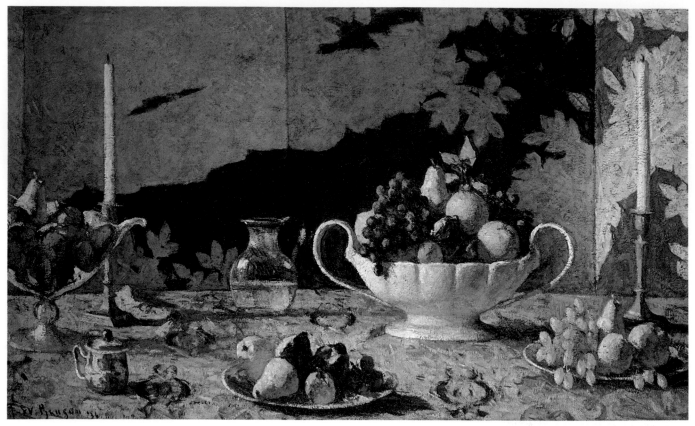

Frank W. Benson, *Table Top Still Life,* 1936, 30 x 50½ in., signed l.l. Courtesy of Taggart, Jorgensen & Putnam Gallery, Washington, D.C.

was his style they brought back home with them.

In New York City in 1897, Childe Hassam, John H. Twachtman and J. Alden Weir resigned from the Society of American Artists because of that organization's conservative ways and formed instead The Ten American Painters. Despite the regional variations in American impressionism, from New York City to Indianapolis, The Ten American Painters constituted a nucleus, a kind of "academy" of American impressionism for the following two decades. Its other seven members were Thomas Dewing, Willard Metcalf, Frank Benson, Edmund Tarbell, Joseph DeCamp, Robert Reid and Edward Simmons. William Merritt Chase joined the group after Twachtman's death.

Like the original French impressionists, "The Ten" (and other American impressionists) practiced varying personal approaches to their work. Unlike the French, however, the Americans were basically conservative in their adoption of the impressionist style.

The impressionist style was an outgrowth of a method based upon the representation of "a fleeting moment in time," a snapshot of movement, light and atmosphere captured through brilliant and broken color and a seemingly casual and improvised brushwork. This depiction of a shifting and constantly changing reality also involved an emphasis on the surface of the canvas and a sensuous feeling for the paint itself. Light and atmosphere were represented through color—color which, in large measure, was

discovered in the nineteenth century by the chemical industry and put into the portable paint tubes invented by American painter John Rand in 1841.

Despite the later conversion to impressionism of American artists, when the Americans went to Paris in the late 1880s and the 1890s they studied with conservative, academic painter-teachers. They were in Paris not to espouse radical painting but to learn their profession, studying in the studios during the winter and painting the French landscape during the summer.

Impressionism was a style particularly well-suited to landscape painting, and landscape painting had a long tradition in America, starting with the Hudson River School. With both their French training and their own landscape tradition behind them, success on an ever-increasing scale finally came to the American impressionists. Novelist and critic Hamlin Garland could write in *Crumbling Idols* (1894), "Every competent observer who passed through the Art Palace at the [Columbian] Exposition was probably made aware of the immense growth of impressionistic or open-air painting." In the same essay, however, Garland also pointed out that "the dead must give way to the living . . . and the impressionists will try to submit gracefully to . . . the iconoclasts who shall come when they in turn are old and sad."

For by the time Garland wrote those words, European impressionism had run its course. Gauguin had already made his first celebrated trip to Tahiti. Van Gogh had one

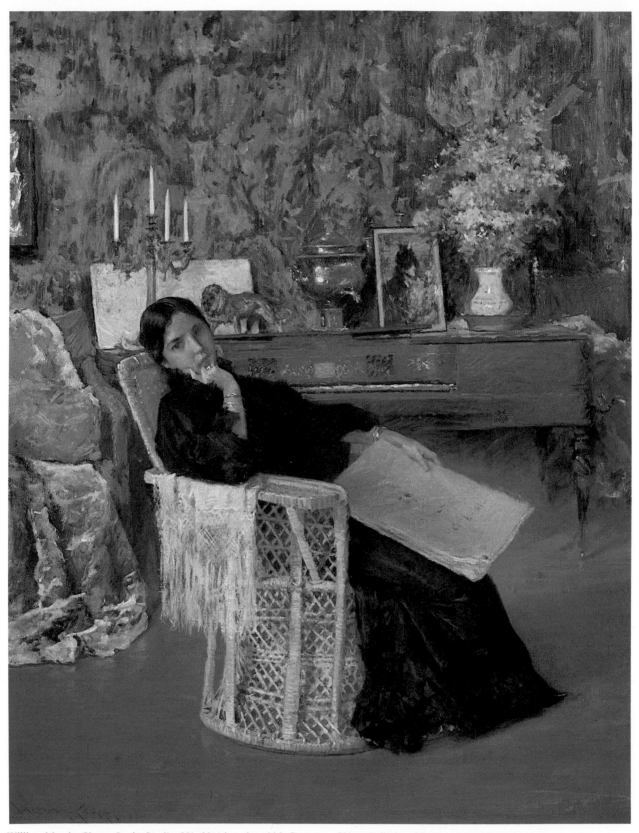

William Merritt Chase, *In the Studio,* 29 x 23½ in., signed l.l. Courtesy of Vose Galleries of Boston, Inc., Massachusetts.

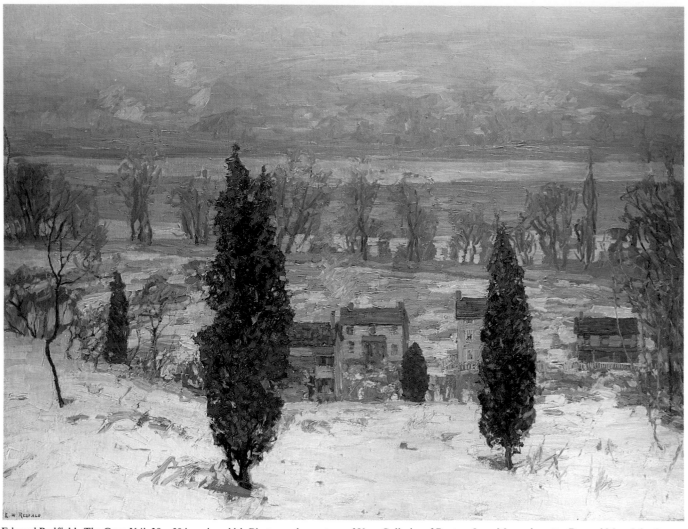

Edward Redfield, *The Gray Veil,* 38 x 50 in., signed l.l. Photograph courtesy of Vose Galleries of Boston, Inc., Massachusetts. Dr. and Mrs. John J. McDonough, Youngstown, Ohio.

year to live. In America, impressionism would soon become the new "academy," and the representation of light and atmosphere through color would be used for sentimental rather than analytical ends.

In any case, the American approach to impressionism was basically romantic and idealistic to begin with. Monet was *the* influence, of course, but no American painter went as far as he did in dissolving form in light—in the "Water Lily" series, to give one late example. John Twachtman came close, but Twachtman, one of the most sensitive and subtle of the American impressionists, was also romantic. Although he painted his landscapes during different times of day and in all seasons of the year as Monet did, Twachtman loved *the subject itself,* and was not using it to analyze the effects on form of changes in light, atmosphere and season. In this, Twachtman was closer, perhaps, to philosophy—to the philosophy, say, of a Chinese painter toward the natural world—than to Monet.

It would appear that what American painters adopted

from impressionism was, for the most part, its technique. They brought back from Paris a set of tools to apply to what they considered the old-fashioned machinery of American art. But it was the surfaces they dealt with; in the brighter color and broken brushwork, they developed a livelier picture surface on which to paint the surface qualities of their subjects—the light on a shiny boot, or the gleam of a polished floor as painted by Chase or Tarbell. The underlying assumption of French impressionism—the concept of a shifting and changing reality, a universe in flux—was either disregarded or not considered applicable to the American scene.

Perhaps nineteenth-century America contained enough change, enough of a certain kind of harsh reality, to cause American artists to continue to seek in nature and in their lives those qualities of stability and permanence that had been so beautifully expressed in earlier American landscape painting. Yet as the impressionist style was adopted by American artists, gaining momentum and general acceptance, few painters were immune to it—even those

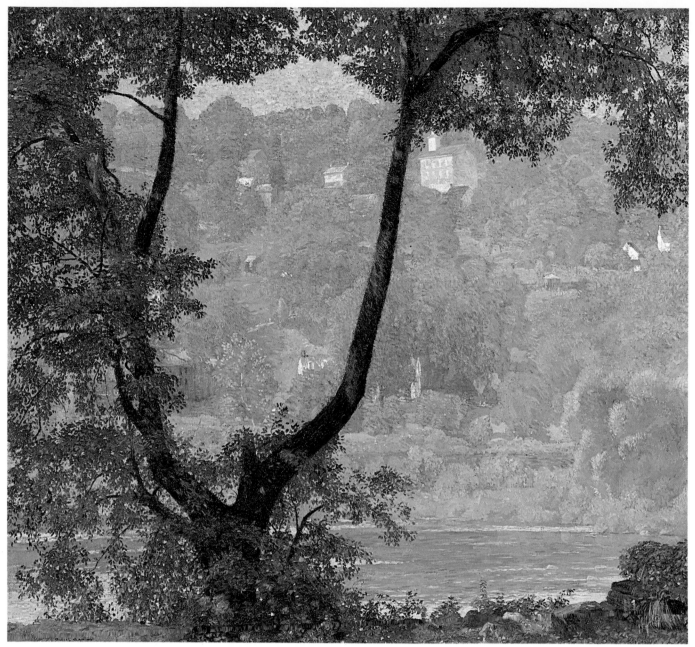

Daniel Garber, *Tohickon,* 52¼ x 56¼ in., signed l.l. Courtesy of National Museum of American Art, Smithsonian Institution, Washington, D.C. Bequest of Henry Ward Ranger through the National Academy of Design.

who were in vehement opposition. American barbizon painter George Inness was furious when the art critic of a Florida newspaper classified him as an impressionist.

Inness considered impressionism as a form of "humbug" and "the original pancake of visual imbecility." Yet the glorious color of Inness's late work is surely indebted to the bright palette of impressionism. But Inness touched on something seemingly inherent in the American painter's temperament when on the same subject, in regard to that critic's statement, he talked about "solidity of objects" and a "breathable atmosphere" through which we are aware of space and distance. He talked of a painting having "a logical connection of parts" which completes the whole and "satisfies the mind."

Inness was speaking of himself, but his statement has relevance to the American impressionists. American painters never wholly lost the feeling for the solidity of objects or for what has come to be called "the quiet observation of fact." This accounts for the conservatism of the American practitioners of the style, their preference for study in the French academic tradition and their own belated acceptance of impressionism. John Singer Sargent summed up this attitude when he said, "I don't dig beneath the surface for things that don't appear before my eyes."

As it evolved, American impressionism, drawing upon the tradition of American landscape painting and the artists' rigorous study with French academic painters, was

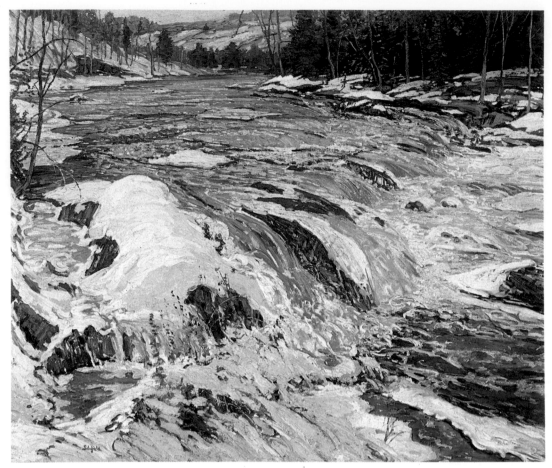

Walter Elmer Schofield, *The Rapids*, 50¼ x 60¼ in., signed l.l. Courtesy of National Museum of American Art, Smithsonian Institution, Washington, D.C. Bequest of Henry Ward Ranger through the National Academy of Design.

expressive of more of what has been called a "holiday atmosphere" than French impressionism. American painters favored the quiet, pleasant aspects of life, and adopted a more genteel, perhaps puritan, approach to style and paint quality than their French counterparts. Overall, American impressionism led to greater emphasis on subject matter than French impressionism.

This treatment of subject matter and conservative and genteel approach to both subject and style mark the major differences between the French and American approaches. The American approach is especially evident in the work produced in some of the more important regional outposts of American painting. For example, in New Hope, Pennsylvania, a picturesque community on the banks of the upper Delaware River, Edward Redfield, Daniel Garber and—to a certain extent—Elmer Schofield painted the local landscape in the French manner but with great particularity as well. And Old Lyme, the artists' colony in Connecticut, the founding of which around 1899 is associated with Henry Ward Ranger, was the site of a peculiarly American dispute between the advocates of tonalism, represented by Ranger, who was aethetic heir to George Inness, and the advocates of impressionism, repre-

sented by Childe Hassam. The work of Willard Metcalf, with its synthesis of both styles (but with an edge toward impressionism) represented neutral territory. Impressionism, however, won out.

Yet, despite charges of imitation from time to time, there were some brilliant American achievements. The best of the American impressionists created intensely personal, even original, styles. The work of such artists as Twachtman, Cassatt, Hassam and Metcalf, for example, contains many memorable images.

And if there is "a great deal of Paris in it," there is also a great deal of New York, Massachusetts, Connecticut, Pennsylvania and Indiana as well.

Richard Boyle is acting director of continuing education at the Philadelphia College of Art, where he is also an instructor in art history. He was formerly director of the Pennsylvania Academy of the Fine Arts. In addition to many articles, he has written *American Impressionism* and *John Twatchman*. He also co-wrote *The Genius of American Painting,* a book about American art for British readers.

EARLY AMERICAN MODERNISM

MATTHEW BAIGELL

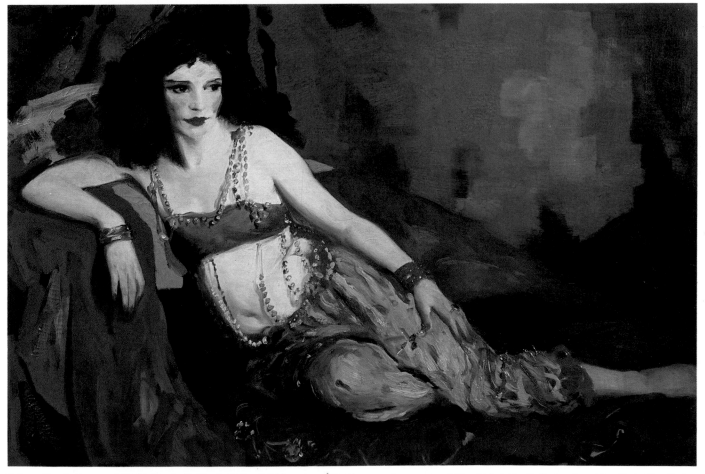

Robert Henri, *Dancer of Delhi (Betalo Rubino),* 38½ x 57½ in., signed l.l. Photograph courtesy of Hirschl & Adler Galleries, Inc., New York, New York.

Around the year 1900, the pulse of America's art life, specifically New York City's art life, quickened. The group called The Ten, composed of impressionists and tonalists, was formed in 1897 to exhibit its works, but even fresher and newer currents were springing to life as well. In 1900, Robert Henri, the charismatic leader of a group of newspaper reporter-artists from Philadelphia, moved to New York City, both preceded and followed by his cohorts. Alfred Stieglitz, photographer and great proselytizer of European avant-garde art, founded the Photo-Secession Group in 1902 and the magazine *Camera Work* and the Little Galleries of the Photo-Secession in 1905. Henri's and Stieglitz's activities symbolically mark the beginning of modern art in America.

Each man became a central figure in the development of early modernism; Henri was the leader of the realists, also called the Ashcan School or The Eight, while Stieglitz promoted the modernists, who worked in cubist, fauvist, futurist and expressionist styles. The realists concentrated on urban views of lower-class and middle-class life, at least until 1910, when they began to grow apart artistically. The modernists explored the pictorial advances initiated by the School of Paris. To say this differently, the realists explored a new urban subject matter in American art, not always glossed over to make it palatable to traditional collectors, connoisseurs and critics; the modernists, a new set of formal and compositional devices developed abroad. It is around these two groups that the fortunes of

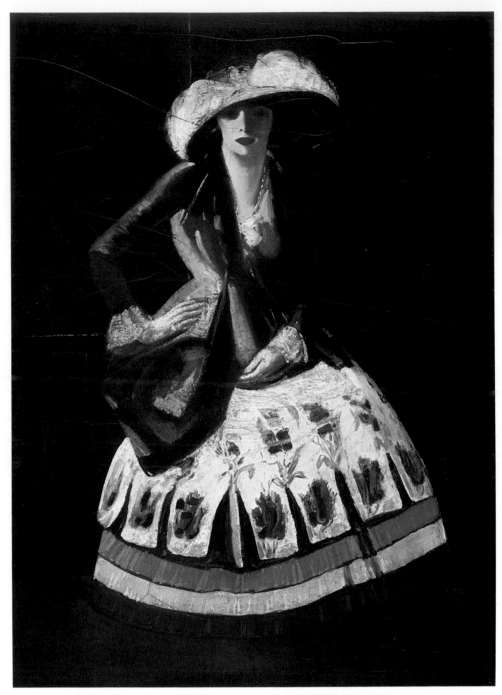

George Luks, *Polish Dancer,* ca. 1927, 66½ x 48 in. Courtesy of The Pennsylvania Academy of the Fine Arts, Philadelphia. Gift of the Locust Club.

American art can be charted most clearly between 1900 and 1920.

Henri arrived in Philadelphia in 1886 to study at the Pennsylvania Academy of the Fine Arts. Within six years, he had befriended William Glackens, George Luks, Everett Shinn and John Sloan, who worked as newspaper illustrators and studied art in their spare time. Rejecting modernist styles, including impressionism, they preferred to develop styles based on Gustave Courbet, on seventeenth-century Dutch painters such as Franz Hals, and on Munich-trained, late-nineteenth-century Americans such as Frank Duveneck. These stylistic antecedents enabled them to convey their interest in human activities as subjects. Their use of tonal harmonies rather than coloristic techniques coincided with their day-to-day assignments as newspaper illustrators.

Henri encouraged his friends to read the work of writers such as Ralph Waldo Emerson and Leo Tolstoy, from whom they might absorb notions of artistic self-confidence and the desire to use art to communicate. Henri especially stressed capturing the life-spirit inherent in his subjects, presumably in landscapes as well as in people, whom he loved to paint. To help convey his excitement before a scene or an individual, he preferred sketch-

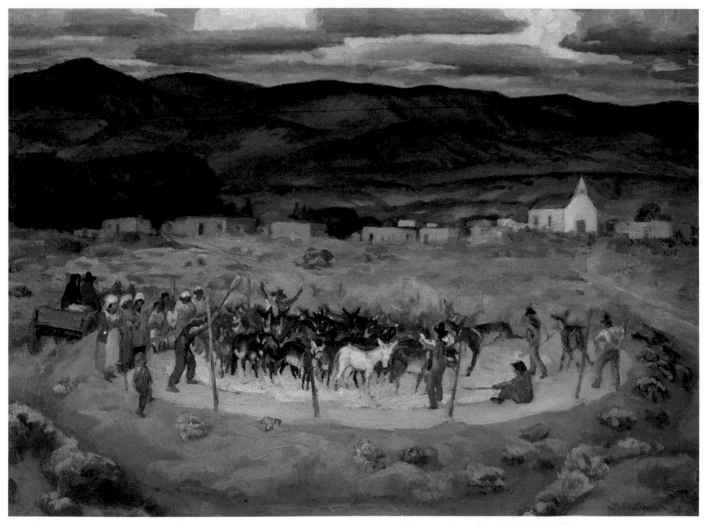

John Sloan, *Burros Threshing*, 24 x 32 in., signed l.r. Photograph courtesy of The Gerald Peters Gallery, Santa Fe, New Mexico.

like finishes and textured surfaces. The other artists in his group painted in a similar manner.

First in Philadelphia and then in New York City, the realists sought their subject matter in the city streets, the ghetto alleyways and the principal thoroughfares. Shinn painted dockside and slum scenes before turning to theatrical subjects around 1902. Even after he adopted an impressionist palette around 1905, Glackens tended to paint wealthier people at leisure or enjoying theatrical outings, shopping and other city activities. In their paintings of vignettes and anecdotal scenes, Luks and Sloan remained closest to the original vision of the group through the first decade of the new century. These two were most important in extending the range of the artist's subject matter to include recreational and business activities in the immigrant neighborhoods. Generally trying to convey a sense of the brisk liveliness as well as the inherent dignity of their subjects, Luks and Sloan did not embellish their paintings with the kind of oppressive social messages common to the social realist painters of the 1930s (although Sloan did include such messages in his graphics works).

An important friend of the original Philadelphia group and disciple of Henri, George Bellows, arrived in New York City in 1904. His vision of the city encompasses—to a greater degree than that of the others—a general sense of the excitement and dynamism of the modern metropolis rather than capturing these qualities through small-scale anecdotal scenes.

Henri, Sloan, Luks, Shinn and Glackens (but not Bellows), along with post-impressionist Maurice Prendergast, symbolist Arthur B. Davies and impressionist Ernest Lawson, achieved notoriety in 1908 when they exhibited together as The Eight. Theirs was one of the first important exhibitions to challenge the artistic dominance of academic tastes associated with the turn-of-the-century American Renaissance movement and the old-fashioned— by 1908—work of The Ten.

The most famous and most challenging exhibition of the period, however, was the International Exhibition of Modern Art in 1913, better known as the Armory Show. It introduced modern European art to a largely bewildered and hostile American public. Since most of the modernists had discovered modern art abroad before

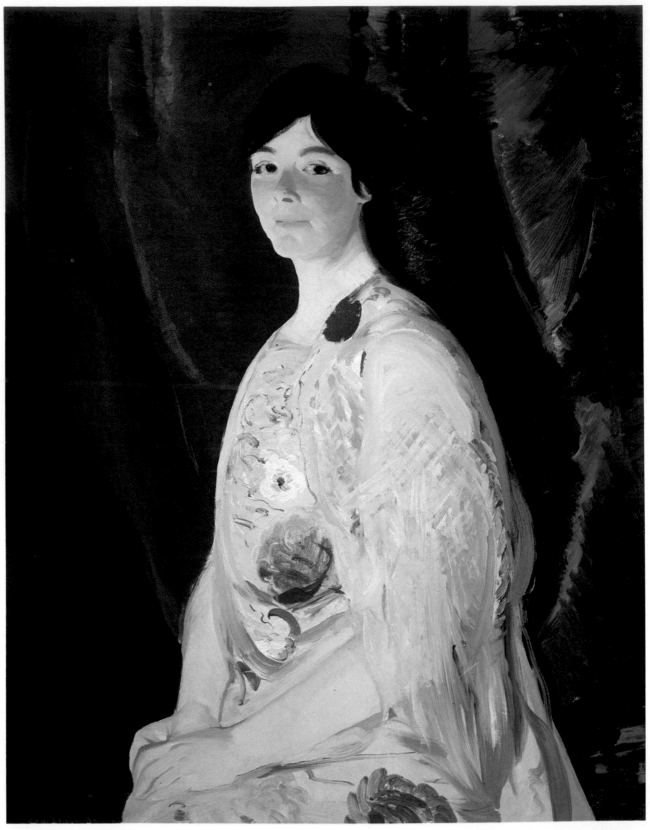

George Bellows, *The Spanish Shawl,* 1914, 38 x 30 in., signed l.l. Photograph courtesy of The Gerald Peters Gallery, Santa Fe, New Mexico.

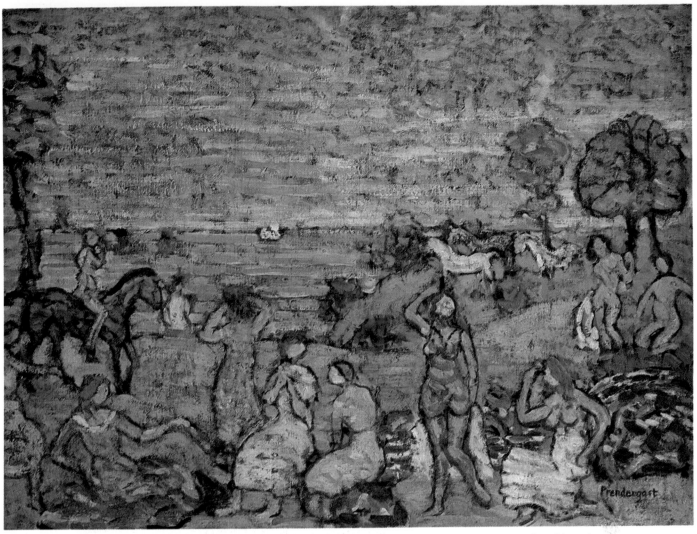

Maurice B. Prendergast, *Picnic by the Sea,* ca. 1915, 24½ x 32⅛ in., signed l.r. Courtesy of Vose Galleries of Boston, Inc., Massachusetts.

1913, the exhibition had a greater effect on the acceptance and collecting of modern art than on artists themselves.

Maurice Prendergast, usually considered the first and most consistent modernist, lived in Boston rather than New York City for most of his career. It is in Boston, therefore, that the first significant impulses of modern taste can be discovered, especially through the teaching and writing of Ernest Fenellosa, Arthur Wesley Dow and Denman Ross. They stressed the importance of intuitive feelings and the significance of Japanese compositional and coloristic devices as artistic guidelines.

But the major development of modern art occurred in New York City, encouraged by Steiglitz with the able assistance of others, including artist-photographer Edward Steichen and cartoonist Marius de Zayas. The first exhibitions of works by Cezanne, Picasso and Matisse took place at Steiglitz's Little Galleries.

Americans did not develop new styles of modernism. Some, like Max Weber, floated from one style to another, influenced in turn by Cezanne or Picasso or other Europeans. But loose groupings did occur among the Americans. Artists such as John Marin, Arthur Dove, Marsden

Hartley and Alfred Maurer favored an emotional or intuitive approach whether they worked in cubist or expressionist styles. Landscape often served as a vehicle for their revelations of states of feeling, conveying a spirit of excitement similar to that found by the Henri group in the faces of their subjects.

Other painters assumed a more cerebral, almost scientific, approach. Chief among these were the synchromists—Stanton MacDonald-Wright, Morgan Russell and Patrick Henry Bruce—who, in 1913 and the immediately succeeding years, developed an art of color painting derived from Robert Delauney, Frantisek Kupka and others. In their work, areas of light and dark color, as well as strong and weak colors, replaced tonal modeling to suggest advancing and receding forms. As most Americans returned to the United States with the outbreak of World War I in 1914, synchromism had a short vogue in New York City. In addition, it contributed to a strong—although momentary—interest in the non-objective or abstract work of artists such as Marin and Hartley.

The arrival in the United States of European artists, including Francis Picabia in 1913 and Marcel Duchamp

Arthur Dove, *Improvision,* 1927. Photograph courtesy of The Gerald Peters Gallery, Santa Fe, New Mexico.

and Albert Gleizes in 1915, also contributed to the more cerebral developments of abstract art in the mid-1910s. Duchamp and Picabia developed a form of dada art in New York City at this time, and a brief "anti-art" movement also appeared, especially in the works of John Covert, Morton Livingston Schamberg and Man Ray. These artists, to a much greater extent than those favored by Stieglitz, critically explored the nature of the art object, the complexities of perception, the relation between art and the machine, and the ambiguous resonances that might emanate from a particular work. They tended to gather around Walter and Mary Arensberg, who lived in New York City from 1914 to 1921, and they influenced the

next generation of artists, including Charles Demuth and Charles Sheeler.

Significant developments outside of New York City could be found in Philadelphia, in figures such as Schamberg, Arthur B. Carles and H. Lyman Sayen. In Chicago, Manierre Dawson was working; along with Dove, he was probably responsible for the first non-objective—or nearly so—American paintings. Neither Dawson nor Dove followed their insights to their logical conclusions, however, but soon returned to figuration.

All of these modernist artists shared certain traits. They used the pictorial surface for purposes of expression rather than description. They replaced traditional depth

Arthur B. Carles, *Abstract,* 16 x 12¾ in., signed u.r. Courtesy of Frank S. Schwarz & Son, Philadelphia, Pennsylvania.

Everett Shinn, *On Stage,* 16½ x 11½ in., signed l.r. Courtesy of The Marbella Gallery, Inc., New York, New York.

cues, atmospheric recession through space and realistic figural groupings with a pictorial logic based on the relationships of directional movements, color patterns and affinities between shapes. Although depth was not entirely suppressed, it was carefully controlled. Often, parts of a painting's surface were left unfinished.

Unlike the surfaces of minimal paintings of the 1960s, those of early modernist canvases create a sense of pulsing, dynamic rhythms, intended to involve the viewer's physical and emotional response mechanisms. In trying to communicate their feelings, artists wanted viewers to recreate in their own minds and bodies the original motivating impulses felt by the artists. Even if the public did not always understand them, the modernists were nevertheless intent on communication. In this regard, they were like the Henri group—they used their art as a way to contend with the impersonal forces and increasing standardization of modern life.

After World War I, new artistic styles and interests appeared. Some of the older modernists returned to figurative styles or accommodated to realistic modes. A few continued in their pre-war styles, but the great, explosive, creative surge had ended for them. Of the many important features of their work, perhaps the most important was their willingness to become part of the developing avant-garde and to become truly contemporaneous with their European counterparts. This at last was America's artistic coming of age in the transatlantic community.

Matthew Baigell holds the rank of professor II of art history at Rutgers University. He has authored and edited numerous books on American art, including *The American Scene: American Painting During the 1930s* and *A Concise History of American Painting and Sculpture,* as well as monographs on Thomas Hart Benton, Charles Burchfield, Thomas Cole and Albert Bierstadt.

Charles Sheeler, *Study for "Canyons 1"*, 1951, 8¼ x 6 in., signed l.r. © 1985 Sotheby's, Inc.

TWENTIETH-CENTURY REALISM: THE AMERICAN SCENE

DIANE TEPFER

Charles Sheeler, *Classic Landscape,* 1931, 25 x 32¼ in., signed l.r. Photograph courtesy of Hirschl & Adler Galleries, Inc., New York, New York.

At the close of 1934, *Time* magazine's cover article (December 24) reported:

> A few years ago many a good U.S. artist was content to borrow from France, turn out tricky intellectual canvases which usually irritated or mystified the public. Today most top-notch U.S. artists get their inspiration from their native land, find beauty and interest in subjects like Kansas farmers, Iowa fields, and Manhattan burlesques.

What paths did American painting take to arrive at this norm in popular taste? How did American artists respond to the Depression? What other "realities" were represented in the period between the First and Second World Wars?

During the 1920s and 1930s, many American painters depicted "The American Scene." Their painting reflected a further development of Robert Henri's instruction to "make sketches of everyday life in the streets, the theater, the restaurant, and everywhere else." Some worked in reaction against European and American cubism and other forms of modernism. Another factor was a search

Leon Kroll, *Quarry Pool,* 1946-1947, 36 x 48 in., signed l.r. Photograph courtesy of ACA Galleries, New York, New York.

for indigenous American culture; by the early 1930s, several artists were developing an art based upon specific regions of the country. After 1933 these undercurrents were strengthened by the New Deal's dictum to make government-supported art a permanent record of the aspirations and achievements of the American people.

During the period when New York City became the center of the United States art world, the life of the teeming city became acceptable subject matter. Guy Pene du Bois, George Bellows, Jerome Myers, Glenn O. Coleman, Stuart Davis, John Sloan and Abraham Walkowitz, among others, painted New York City scenes. They had either been students of Henri, or had absorbed his influence secondhand. Henri's significance was in freeing his students to accept a variety of subjects and styles for their art.

In the 1920s, Charles Demuth, Stuart Davis, Charles Sheeler and other artists under the influence of writers William Carlos Williams, Gilbert Seldes, Matthew Josephson and others who worked in "the American Grain" created an art which was modern, yet different from that of Europe (*The American Grain* was the title of a collection of essays on American culture published by Williams in 1925). They focused on images of advertising, folk art and industry as the most vital and innovative aspects of American culture.

These artists and others incorporated portions of flattened graphics from the new phenomenon of hard-sell advertising into their paintings. Brightly colored and boldly patterned images, labels and billboards of consumer products such as cigarettes and automobiles were used as positive expressions of the exuberance of popular American culture.

In a further development of Picasso's and Braque's use of collaged bits of labels and newspapers, Davis's trompe l'oeil "collage" paintings incorporated cigarette wrappers or patent pharmaceuticals. Demuth's "poster portraits" of his friends, including *I Saw the Figure Five in Gold* (1928, Metropolitan Museum of Art), based on a poem by his friend William Carlos Williams, also uses dynamic principles of advertising design for a fine art painting. Decades before the pop art of the 1960s, American painters combined images drawn from popular culture with the principles of advertising design in order to create a new type of national art.

Edward Hopper, *New York Restaurant,* ca. 1922, 24 x 30 in., signed l.r. Courtesy of The Muskegon Museum of Art, Muskegon, Michigan.

Folk art became significant for some contemporary American artists in the context of the colonial revival which pervaded the United States during the 1920s, resulting in the reconstruction of Colonial Williamsburg and the creation of Henry Ford's Dearborn Village in Michigan. The Downtown Gallery and others nationalistically promoted American folk art as the root of American abstract art.

Folk art was also a source of flattened abstract "pure form." Bernard Karfiol, Yasuo Kuniyoshi, Charles Sheeler, Marguerite and William Zorach and other painters and sculptors fell under the spell of the artifacts they collected in Ogunquit, Maine, in rural Pennsylvania and elsewhere. The Pennsylvania barns, Shaker furniture, weathervanes, paintings and other vernacular objects they admired had been made by anonymous masters. The artists transposed these images and their abstracted, simplified shapes to their own painting and sculpture. This appreciation of paintings by untrained nineteenth-century painters also lent status to several contemporary untrained artists, including John Kane, Anna Robertson "Grandma" Moses and Horace Pippin.

Marcel Duchamp's dada conviction that "the only works of art America has given are her plumbing and her bridges" heralded the third indigenous American subject matter of the 1930s—industrial images. Among the precursors of this type of painting was Joseph Stella. In the wake of Italian futurism, he painted Coney Island in 1914 and his first *Brooklyn Bridge* (Yale) in 1919. Morton Schamberg painted dry, brittle, mechanistic images between 1916 and 1918.

Charles Sheeler, Elsie Driggs, Niles Spencer, Georgia O'Keeffe, Charles Demuth, Ralston Crawford and others made grand structures such as factories, skyscrapers, bridges, mills, highways and power lines into American icons. When Demuth named his painting of grain elevators *My Egypt* (1927, Whitney Museum of American Art), he ironically proclaimed these prominent rural structures to be as significant for his vision of America as the pyramids are for ancient Egypt.

Sheeler's *Classic Landscape* (1931, Hirschl and Adler) is an exemplar of the style known as precisionism. The painting was an outgrowth of an amazing commission to photograph 'the world's first complete assembly line—

John Steuart Curry, *Tornado Over Kansas,* 1929, 46¼ x 60⅜ in., signed l.l. Courtesy of The Muskegon Museum of Art, Muskegon, Michigan.

Henry Ford's River Rouge plant in Detroit. Neither people nor the taint of pollution are present to disturb the starkly geometric, clearly defined, smoothly painted, highly structured, static industrial scene.

Although Sheeler and many of the other artists mentioned above were known in the 1920s and 1930s as the immaculates, the style has also been labeled cubist realism, and is now called precisionism. Its practitioners worked independently, without a manifesto or program. Precisionism attracted the intelligentsia. The paintings of the precisionists feature indigenous American subject matter, without figures or anecdote. They are executed in a manner which precisely and intensely highlights objects rather than their environment. In form, precisionist paintings bear similarity to the contemporary German Neue Sachlichkeit works.

While precisionist painting developed in the United States from European cubism, the more conservative and widespread "studio picture" owes its origin to pre-cubist forms of modernism, particularly impressionism, post-impressionism and aspects of fauvism.

Paintings in this category range from the demimondaine prostitutes sensuously portrayed by Jules Pascin to the decorative yet restrained pastel still lifes of Preston Dickinson. When painting in this mode, Samuel Halpert, Bernard Karfiol, Leon Kroll, Yasuo Kuniyoshi and others revealed their delight in carefully modulating their oil, watercolor or pastels. In emulation of Cezanne, their subject matter is usually limited to the posed nude, the composed still life, the portrait and the landscape. Woodstock, Lake George and other rural retreats served as landscape subjects.

Charles Burchfield, Edward Hopper and many who followed them rejected modern European art and theory. Burchfield and Hopper painted nostalgic observations of small-town America. Burchfield depicted the "goodness and hardness of life," while Hopper ironically exposed alienation in cities and towns. Their critical, realistic images of the pathos and bleakness of rural and middle-class America paralleled the writings of William Faulkner, Edgar Lee Masters, Sherwood Anderson and Sinclair Lewis.

Moses Soyer, *Artists on WPA*, 1935, 36⅛ x 42⅛ in., signed l.r. Courtesy of National Museum of American Art, Washington, D.C., Smithsonian Institution. Gift of Mr. and Mrs. Moses Soyer.

Regionalism in American painting is associated with the patriotic activities of Thomas Hart Benton, John Steuart Curry and Grant Wood. They worked independently to instill pride and confidence in rural Americans, particularly Midwesterners. Their subject matter, combining direct observation from nature with history and imagination, depicted the legends of their shared past.

Curry's *Tornado Over Kansas* is the epitome of regionalist art. The artist explained, "I don't feel that I portray the class struggle, but I do try to depict the American farmer's incessant struggle against the forces of nature." Paintings such as this may appear forthright and even naive. Yet after careful examination, complex color harmonies and baroque compositional devices betray the formal European training of these sophisticated artists.

Benton promoted regionalism to communicate "something significant about America." This type of painting is often considered descriptive, story-telling, politically conservative and strongly nationalistic—the opposite of modernism.

As the *Time* magazine article recognized, regionalism can encompass art from any area of the country which shares a common subject matter or style. Ernest Blumenschein, Andrew Dasburg, Georgia O'Keeffe, Bert Phillips, Maurice Sterne, Walter Ufer and others who came to work around Taos, New Mexico imbued their paintings with a devotion for the native people and their landscape.

In New York City, the Fourteenth Street School artists were as much regionalists of their realm as Benton and his cohorts were of the Midwest. The Fourteenth Street School group included Reginald Marsh, Isobel Bishop, Kenneth Hayes Miller, Raphael Soyer and Guy Pene du Bois. Their regional art depicted the shoppers, bums and office workers who frequented that congested street adjacent to Union Square, as well as the subway, beach, street and theatre.

Many of these artists looked for inspiration, not to modernism, but to the artistic heyday of the Italian Renaissance and its uplifting public mural art. Often the people in the paintings of the Fourteenth Street School show a

Joseph Hirsch, *Window Men, 1956-57,* 80 x 47 in., signed l.r. Courtesy of Kennedy Galleries, New York, New York.

sculptural fullness which harks back to fourteenth-century murals. Artists also heeded the successful example of the contemporary Mexican muralists—Diego Rivera, Jose Clemente Orozco and David Alfaro Siqueiros—in creating a meaningful and recognizable civic art.

Mark Tobey, Morris Graves, Kenneth Callahan and their colleagues worked in relative isolation in the Pacific Northwest of Oregon and Washington. There they succeeded in creating a unique regional style and iconography related to the art of Japan and China, as well as to their own rugged sea, mountains and forests.

In the introduction to the catalog of the landmark 1936 exhibition of New Deal art at the Museum of Modern Art, *New Horizons in American Art,* Holger Cahill, the national director of the Federal Art Project, wrote:

> . . . it is not the solitary genius but a sound general movement which maintains art as a vital, functioning part of any cultural scheme. Art is not a matter of rare, occasional masterpieces. . . . During the early part of the twentieth century it is said that some forty thousand artists were at work in Paris. It is doubtful if history will remember more than a dozen or two of these, but it is probable that if the great number of artists had not been working, very few of these two dozen would have been stimulated to creative endeavor. In a genuine art movement a great reservoir of art is created in many forms, both major and minor.

During the New Deal years of the Depression, the government initiated a variety of exciting art projects designed to provide vital employment for artists. The number of participants and the extent of their output give an idea of the rich artistic environment Cahill applauded. In the decade between 1933 and 1943, more than 5,000 artists nationwide painted more than 4,000 murals and 10,000 easel paintings and made numerous sculptures, prints and photographs. They also taught and exhibited at community art centers. Writers, musicians, actors and other artists were also employed.

Although more than eight New Deal projects were eventually established, they were of two basic types. The Works Progress (later Projects) Administration's Federal Art Project (WPA/FAP, 1935-1943), successor to the Public Works of Art Project (PWAP, 1933-1934), aimed to provide relief work for the greatest number of unemployed artists. On the other hand, the "Section" (1934-1943) and the Treasury Relief Art Project (TRAP, 1935-1939) held competitions for the creation of murals and sculptures "of the highest quality" for post offices and other public buildings.

The PWAP, the initial federal program, had one guideline: "The American scene in all its phases" was prescribed. As a result, the dominant theme of all the subsequent government programs was also the American scene.

Although the competitive post office murals were awarded to the more accomplished and experienced artists, the broadest range of subject matter and style was created on the PWAP and the WPA/FAP. Artists on these projects worked with fewer restrictions. Some were employed to make easel paintings for government and public offices, including schools and hospitals.

In 1944, many government-sponsored paintings which had not been assigned to a permanent location were auctioned for scrap canvas. (Fortunately, a few of them found their way into the hands of devoted collectors. That was the fate of at least one early Jackson Pollock canvas, among hundreds of others.) The National Museum of American Art is now the official repository for the easel paintings and mural sketches created through these programs.

Especially during the 1930s, many artists worked with the conviction that art was a potent agent for social change. Humanitarian concern for the downtrodden became a popular subject of paintings, prints, sculpture and photography; idyllic visions of a utopian future were depicted.

The Passion of Sacco and Vanzetti (1932, Whitney Museum of American Art) by Ben Shahn has become an emblem of the type of painting known as social realism. In the mural and the accompanying series of 23 small gouaches, Shahn reinterpreted the newspaper photographs of the stirring events surrounding the trial of Sacco and Vanzetti and their executions.

In the 1930s, the social realist movement was variously called social viewpoint, social scene and social protest art. It is firmly rooted in American tradition; twentieth-century social realism is a continuation, in its didacticism, of the American strain of moralizing art. It also draws upon nineteenth-century American genre painting.

Philip Evergood, Jacob Lawrence, Shahn, Moses Soyer, Joseph Hirsch, Raphael Soyer and others portrayed the working class and the victims of society and nature with dignity. William Gropper and Jack Levine communicated their message by means of biting satire, avoiding condescension.

William Gropper, *Upper House,* 1944, 18 x 26 in., signed l.r. Courtesy of The Pennsylvania Academy of the Fine Arts, Philadelphia.

By 1940, more personal, introspective concerns frequently appeared in painting. Magic realism is the name given to the American version of surrealism by the Museum of Modern Art in 1943. These paintings share with precisionism a sharp focus and precise representation. They differ, however, in that they often contain figures and are representations of dreams and fantasies, rather than of experienced reality.

Kay Sage and Dorothea Tanning, among others, were closely allied with European surrealism. George Ault, O. Louis Guglielmi, Peter Blume, George Tooker and others were sometimes practitioners of magic realism but at other times painters of the American scene.

The conditions which nurtured the flourishing American scene and American realism movements no longer existed after the outbreak of the Second World War. The presence of European refugee artists in New York during the war provided contact with European modernism. Abstract expressionism soon emerged as a vital international art movement.

In spite of the dominance of abstract expressionism and subsequent formal abstract art movements in the years following World War II, a current of realism has persisted in American art. For example, the work of Leon Golub may be seen as linked to social realism, that of Philip Pearlstein to studio painting, and that of Alex Katz to precisionism. These and other contemporary realists are continuing to develop an art which has affinities with the realism of the first half of the century.

Diane Tepfer, an independent art historian working in Washington, D.C., has been a Smithsonian Research Fellow at the National Museum of American Art and has taught American art history at the University of Michigan, Oberlin College and Colby College. She is particularly interested in the subject of patronage and is completing a major study of the Downtown Gallery.

ABSTRACT EXPRESSIONISM

PIRI HALASZ

Jack Levine, *Levantine Diplomat, 1978,* 24 x 21 in., signed l.l. Courtesy of Kennedy Galleries, New York, New York.

Milton Avery, *Spring Orchard,* 1959, 50 x 64¼ in., signed l.l. Courtesy of National Museum of American Art, Washington, D.C., Smithsonian Institution. Gift of S.C. Johnson & Son, Inc.

Between 1940 and 1955, the United States became the world leader in art. For the previous century and a half, the greatest painting in the Western world—the "mainstream tradition"—had been headquartered in France. American art had taken its cues from Europe, and American artists had been looked down on by sophisticated Europeans as derivative and provincial. All this changed during the decade after World War II, with the emergence of abstract expressionism.

Abstract expressionism represented a reaction by American artists against the more traditional types of paintings popular in America prior to 1940. But far more important, abstract expressionism was an outgrowth of and evolution from earlier European modernism, a continuation of the great European tradition begun in Paris in the 1860s by Edouard Manet, and carried on by the impressionists, Paul Cezanne, Pablo Picasso and Georges Braque, Piet Mondrian and Joan Miro.

The abstract expressionists were motivated by the same desires that had motivated these earlier artists: they wanted to maintain the highest standards of excellence in the presence of the confusions of modern society and to

create an art of deep feeling and visual brilliance. Abstract expressionism achieved these goals and arrived at an accomplishment that has not been rivaled since—except by those few artists who still share abstract expressionism's values and carry on its tradition.

The term "abstract expressionist" was first applied to the American school in 1946 by Robert Coates, art critic for the *New Yorker,* in a review of the work of Hans Hofmann. Coates called Hofmann "one of the most uncompromising representatives of what some people call the spatter-and-daub school of painting and I, more politely, have christened abstract Expressionism." Abstract expressionism has also been called The New York School, because most of its leaders practiced in or near New York City. And in 1952 critic Harold Rosenberg coined the term "action painting" to describe it.

None of these terms is strictly accurate, as the movement consists in essence of a completely abstract development of the automatist branch of French surrealism, with added input from other sources as diverse as Henri Matisse, cubism and Wassily Kandinsky. But "abstract expressionism" reflects the conditions in the Manhattan

Jackson Pollock, *No. 4,* 1949, 35½ x 34⅜ in., signed l.c. Courtesy of Yale University Art Gallery, New Haven, Connecticut, The Katharine Ordway Collection.

art scene when the movement was born and best summarizes its uniqueness and effect.

During the 1930s, the mass media and most large exhibitions had been dominated by more traditional styles, such as American scene painting and social realism. During most of the 1940s, the public eye continued to be captured by these and other more traditional forms of American art. John Sloan, the leader of the Ashcan Schoo , was still active, as were such early American moderns as John Marin and Georgia O'Keeffe, precisionists from the 1920s like Charles Sheeler, and members of the American Abstract Artists group like George L.K. Morris and Byron Browne.

Nevertheless, a general tendency throughout the 1940s prepared the public, at least partially, for the emergence of abstract expressionism. This tendency showed itself in the rise to popularity of three different kinds of painting that were progressively more abstracted, subjective, inward-turning and freely brushed, or "painterly."

The first, which rose to fame between 1940 and 1942, was a romantic style, epitomized by Darrel Austin. The second, which became prominent between 1943 and 1945, was known as "expressionist," although it was still figurative. Max Weber, Marsden Hartley, Abraham Rattner and the three "Boston expressionists"—Jack Levine, Hyman Bloom and Karl Zerbe—were among many who exempli-

Willem de Kooning, *The Wave,* 1942-1944, 48 x 48 in., signed l.r. Courtesy of the National Museum of American Art (formerly National Collection of Fine Arts), Smithsonian Institution. Gift from the Vincent Melzac Collection.

fied the expressionist style.

The third wave, which became popular between 1946 and 1949, was a group of semi-abstract painters whose work was more muted and French-influenced than that of the figurative expressionists. This group consisted of painters like Karl Knaths, Milton Avery, Mark Tobey and Morris Graves. It is in this context that we must understand Coates's use of the term "abstract Expressionist." The type of total abstraction with which the public was most familiar was the cool, hard-edged, linear form of late cubism practiced by members of the American Abstract Artists, but the figurative expressionists had

introduced emotionalism and free brushwork. Thus Coates was describing the newest movement in terms of the two types of advanced or radical painting that the public already knew best.

Meanwhile, out of the public spotlight, the young abstract expressionists had begun growing and developing. They started out in the 1930s by bypassing the popular painting of that time and studying and learning instead from the latest models of European modernism—at the Museum of Modern Art (opened in 1929), in the private commercial galleries of Manhattan, and from teachers such as German-born Hofmann, who had studied in

France in the early years of the century. Hofmann opened his Manhattan art school in 1932 and gave public lectures in the late 1930s. Another important influence was Russian-born painter John Graham, whose book on modern art, *System and Dialectics in Art,* was published in 1937. The future abstract expressionists also studied French art magazines.

With the coming of World War II, many Parisian artists emigrated to America, among them Mondrian, Fernand Leger, Andre Masson, Max Ernst and Sebastian Antonio Echuarren Matta. So did surrealist poet Andre Breton, Peggy Guggenheim, the American-born collector of French art, and Stanley William Hayter, the Englishman who had founded a graphics workshop in Paris in the 1920s and re-established it in Manhattan in the 1940s. Guggenheim opened a gallery called Art of This Century in Manhattan. There, at Hayter's workshop and in other circumstances, the young American artists mingled with the Parisians and learned more about modernism from them.

The leaders of the abstract expressionist school were Jackson Pollock, Arshile Gorky, Willem de Kooning, Mark Rothko, William Baziotes, Robert Motherwell, Clyfford Still, Hofmann, Adolph Gottlieb, Barnett Newman and Ad Reinhardt. These artists were not formally allied, nor did they issue credos or manifestos, but they shared a general direction and understanding.

Jackson Pollock's first one-man show was held at Art of This Century in 1943, with a catalogue statement by James Johnson Sweeney and an enthusiastic review by Clement Greenberg in *The Nation.* The show consisted of semi-abstract, vehemently emotional canvases of figures, animals and so forth, in which Jungian symbols and Greek legends were invoked, but he did not achieve his "break-through" into his most radical poured paintings until 1947. At that time, he began laying his canvases on the floor, and pouring or dripping swirls and skeins of paint upon them.

These poured paintings have been interpreted by Harold Rosenberg as dealing with existential "nothingness," more important for the painter's act than for the finished canvas. However, Pollock himself said that technique was for him only a means of arriving at a statement, and these canvases do make statements. They are vehement and aggressive, yet tender and lyrical, incorporating totally unconscious allusions to tree branches, sand dunes, jazz, food, warfare and sexuality, among other things.

Arshile Gorky exhibited his mature work at the Julien Levy gallery between 1945 and 1948, attracting small amounts of both praise and censure. His biomorphic abstractions, permeated (as Harry Rand has shown) with allusions to landscape, autobiography and his beloved wife, have been called both the first abstract expressionist work and the last great surrealist work. Gorky was a transitional figure.

Willem de Kooning's first exhibition at the Charles Egan gallery in 1948 was greeted with enthusiasm by both Greenberg and *Art News,* as de Kooning's underground reputation had been growing for some time. On this occasion, de Kooning exhibited black-and-white total abstractions; his work of the 1940s is his finest, although he is better known for the agonized, heavily brushed and only semi-abstract "Woman" series he inaugurated in 1950.

Although Mark Rothko's first show was held at Art of This Century in 1945, it consisted of late surrealist compositions. His mature style, of luminous and deeply moving fields of color, was not achieved until 1949. One scholar, Robert Rosenblum, has perceived landscape references in Rothko's mature canvases, and related these works (and abstract expressionism in general) to the northern romantic landscape tradition exemplified by painters in Germany, Scandinavia and the Low Countries in the nineteenth and early twentieth centuries. More recently, Anna Chave, another Rothko scholar, has perceived not only landscape allusions in his work, but also figural references and associations with Pietas.

Robert Motherwell's first show was held at Art of This Century in 1944, as was that of William Baziotes. Baziotes died quite young (as Gorky had), and his work remained essentially within the surrealist tradition of biomorphic dreamscapes. Motherwell's most famous and eloquent series, the "Elegies to the Spanish Republic," was not inaugurated until 1948. The "Elegies" are composed of a row of huge black ovals and vertical rectangles set on primarily white fields, conveying a tremendous feeling of turbulence and power.

Clyfford Still's oddly patchy but stately and luminescent panoramas were exhibited in Manhattan in 1946 and 1947, but did not become well known until the 1950s. Adolph Gottlieb's "pictographs," a fascinating outgrowth of surrealism and primitive art, were exhibited as early as 1942, but his best-known mature works, with their wonderfully ambiguous "sun forms" above and "earth forms" below, were not developed until around 1956.

Hofmann exhibited total abstractions from the mid-1940s onward, but they remained somewhat inchoate until the 1950s. His later works combine blazing colors in combinations of freely brushed areas and disciplined squares that aptly summarize his philosophy of the need for "push-pull" in a painting.

Barnett Newman did not exhibit until 1950, although he had written earlier on abstract expressionism. His first show of "zips," held at the Betty Parsons gallery, stirred much debate within the growing circle of people interested in abstract expressionism. The "zips" utilized thin vertical stripes against solid fields of another color, and their spareness and emptiness carry a maddening but intriguing weight.

In the 1940s, Ad Reinhardt was still painting hard-edged, geometric abstractions of the sort favored by the American Abstract Artists. His most famous and curiously haunting all-black paintings were not achieved until 1960.

Well before 1960, abstract expressionism was attracting more adherents. Franz Kline, Philip Guston and Bradley Walker Tomlin all began to produce abstract expressionist

Mark Rothko, *Orange and Tan,* 1954, 81¼ x 63¼ in. Courtesy of National Gallery of Art, Washington, D.C.

canvases around 1950; in the decade that followed, many other artists (mostly of a lesser caliber) climbed aboard the bandwagon. By the mid-1950s, abstraction was sweeping like wildfire through the art schools.

This development was paralleled and accentuated by the growing degree of public attention focused on the movement. During the 1940s, abstract expressionism had been greeted warmly by only one critic writing for a general readership, Clement Greenberg. The art magazines *Art Digest* and *Art News* had been, on the whole, non-receptive, and the newspapers and general magazines often hostile. The Whitney Museum of American Art had shown some abstract expressionist canvases at its annual exhibitions of recent American painting, and the Museum of Modern Art had bought a few pictures and had included Gorky and Motherwell in its "Fourteen Americans" exhibition of 1946. But in general these activities elicited noncommittal or negative comment.

However, in 1948, *Life* magazine published a "Round Table" on modern art in which James Johnson Sweeney and Greenberg defended abstract expressionist canvases This was followed, in 1949, by *Life's* famous (and controversial) article on Pollock, asking "Is he the greatest living painter in the U.S.?" The 1949 Whitney annual show was dominated by abstract expressionist painting, and *Art News* dramatized this with a highly favorable review featuring de Kooning. This was followed by articles on Pollock and Kline. In 1950, Alfred Barr of the Museum of Modern Art chose Pollock, de Kooning and Gorky to represent the United States at the Venice Biennale in Italy, where Pollock's work created an international sensation.

Other exhibitions followed, as did progressively more favorable reviews. Collectors and museums began to buy, and scholars to pay attention. By 1955, abstract expressionism had, it seemed, arrived—but the apparent triumph may have been, in some respects, premature. Certainly, the movement had been recognized, but at the same time it had not been truly assimilated and understood.

Three decades later, the leading figures of abstract expressionism are world-famous. Their works hang in museums from Europe to Japan, but remain a mystery to most of the general public—and indeed to a very sizable share of the art-loving public as well. Debates over the meaning, means and significance of abstract expressionism still rage in scholarly and critical circles.

Many artists have chosen to react against the movement, producing less memorable art. This reaction began in California around 1950, with the figurative expressionism of Richard Diebenkorn, David Park and Elmer Bischoff. It was followed shortly afterward by the neo-dada of New York City, which began with Robert Rauschenberg, Jasper Johns and Larry Rivers and continued with the pop art of the 1960s, most of minimal art, conceptual art, hyperrealism, and, most recently, neo-expressionism.

Only a small minority of younger painters have continued to strive and build upon the pure abstract expressionist tradition. These artists are usually called the Color-field School, and among them are Helen Frankenthaler, Morris Louis, Kenneth Noland, Jules Olitski, Lawrence Poons, Walter Darby Bannard and Friedel Dzubas. They are more properly termed the leaders of second-generation abstract expressionism, and theirs is the most memorable painting inaugurated since 1952.

Piri Halasz was the art critic for *Time* magazine between 1967 and 1969. She has since received her doctorate from Columbia University and acted as guest curator for the C.W. Post Center-Long Island University "The Expressionist Vision: A Central Theme in New York in the 1940s." She has written for *Arts Magazine, ARTnews, Art in America* and *Smithsonian*.

BIOGRAPHIES

EUGENE HIGGINS
(1874-1958)

Painter and etcher Eugene Higgins was a socially conscious artist of the underprivileged, whose work was marked by a greater degree of sentimentality than that of the European painters who influenced him. His passionate sympathy for the poor led him to generalize situation and locale, painting archetypal situations rather than observed ones.

Born in Kansas City, Missouri in 1874, Higgins was the son of an Irish stonecutter and builder. He received his artistic training in the 1890s in Paris, at the Ecole des Beaux-Arts and the Academie Julien, under Jean Paul Laurens, Benjamin Constant and Jean Leon Gerome.

An entire issue of *Assiette au beurre* (January 9, 1904), the militant journal of social satire in art, was devoted to Higgins's illustrations entitled *Les Pauvres.* He was acclaimed by the poet Edward Markham as "the one powerful painter of the tragic lacks and losses, of the doomed and disinherited—the painter who gives us that pathos of the street and hovel and morgue, as Millet gave us the pathos of the field."

Like Millet, however, Higgins could not help endowing his subjects with heroic stature and dignity which eventually defeated his purpose. *The Black Cloud* (date unknown, National Museum of American Art), for instance, is essentially a rear view of Millet's famous *Les Errants* (Denver Art Museum). Both works memorialize the plight of homeless wanderers—victimized by financial depressions, drought and the flight from fields to cities—in a romantic and sentimental fashion.

Higgins's nineteenth-century approach, combined with a subject matter that looks more European than American, has kept him from having the impact of his American contemporaries. He died at New York Hospital in 1958 after a long illness.

Sibyl, 20⅜ x 14 in., signed l.l. Courtesy of Fogg Art Museum, Harvard University, Cambridge, Massachusetts, Gift of James N. Rosenberg.

MEMBERSHIPS
American Federation of Arts
American Water Color Society
Brooklyn Society of Etchers
Lyme Society of Artists
National Academy of Design
National Arts Club
National Institute of Arts and Letters
New York Water Color Club
Salmagundi Club
Society of American Etchers
Society of American Artists

PUBLIC COLLECTIONS
Bibliotheque Nationale, Paris
Boston Public Library
British Museum, London
Brooklyn Public Library
College of William and Mary
Harrison Gallery, Los Angeles
Library of Congress, Washington, D.C.
Metropolitan Museum of Art, New York City
Milwaukee Art Museum
National Museum of American Art, Washington, D.C.
New York Public Library, New York City
Phillips Collection, Washington, D.C.
St. Louis Art Museum
Whitney Museum of American Art, New York City

SEASON	75-76	76-77	77-78	78-79	79-80	80-81	81-82	82-83	83-84	84-85
Paintings		1	2	9	2	6	4	6	3	2
Dollars		$300	$2,000	$5,500	$1,550	$6,750	$4,400	$4,750	$4,600	$1,400

Record Sale: $3,000, CH, 9/28/83, "Emigrants," 12 x 15 in.

ERNEST L. BLUMENSCHEIN
(1874-1960)

A founder of the famed Taos art colony in New Mexico, Ernest Blumenschein was its dominant spirit and most illustrious member for almost half a century.

His strong, rhythmic, sometimes mystical paintings on Southwestern and Indian themes are renowned. His art reflects his written criteria for artists: large mass, vigorous design, avoidance of set formulas, original concept. He believed that "realistic alone is deadly commonplace."

Born in 1874 in Pittsburgh, Blumenschein was raised in Dayton, Ohio. His father was a composer and organist, and Blumenschein was prepared for a music career.

In 1891, at age 17, Blumenschein attended the Cincinnati College of Music on a scholarship, and also studied at the Cincinnati Art Academy. After a year, he chose art over music.

He went to New York City and supported his studies at the Art Students League by playing first violin in Anton Dvorak's symphony orchestra.

In 1896, Blumenschein was back in New York City, teaching at the Art Students League and doing illustrations for such magazines as *Scribner's, Harper's* and *Century.* He first saw the Taos Valley on assignment for *McClure's* magazine, and was entranced.

In 1900, Blumenschein began to divide his time between Taos, New York City and Europe. He founded the Taos

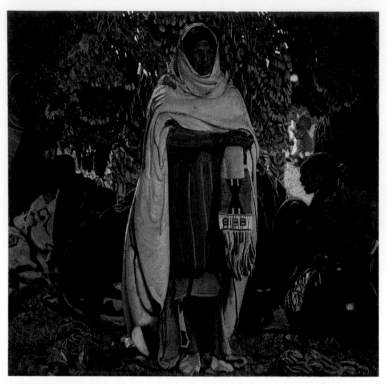

The Gift, 1922, 40½ x 40¼ in., signed l.l. Courtesy of National Museum of American Art, Smithsonian Institution, Bequest of Henry Ward Ranger through the National Academy of Design.

Society of Artists in 1912, and spent 18 summers in Taos before settling there permanently.

Blumenschein's work was in demand; he was a commercial success. He illustrated Jack London's first book, *Love of Life,* as well as books by Stephen Crane, Willa Cather, Joseph Conrad and Booth Tarkington. Between commissions, he painted, taught and entered exhibitions, winning numerous awards.

Blumenschein gradually shed the darker tonal values of the academic mode. From the time of his Taos move, his work took on the strong patterns and

bright, clear colors of the Southwest. Increasingly, he combined intuitive, symbolic elements with observed reality, particularly in his Indian subjects.

In this genre, his best-known work— Blumenschein himself considered it his finest—is *Jury for the Trial of a Sheepherder* (date unknown, Museum of Modern Art).

Blumenschein tended to rework his later paintings, which sometimes resulted in dense pigment surfaces and a ridged pattern of strokes. He also destroyed quite a few of his works, regretting it later.

After a two-year illness, Blumenschein died at age 86 in 1960, at Albuquerque, New Mexico.

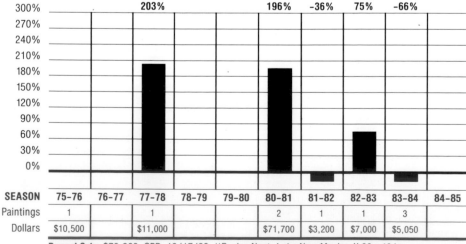

10-Year Average Change From Base Years '75-'76: 62%

	203%		196%	-36%	75%	-66%

SEASON	75-76	76-77	77-78	78-79	79-80	80-81	81-82	82-83	83-84	84-85
Paintings	1		1			2	1	1	3	
Dollars	$10,500		$11,000			$71,700	$3,200	$7,000	$5,050	

Record Sale: $70,000, SPB, 10/17/80, "Eagles Nest, Lake New Mexico," 30 x 40 in.

ROMAINE BROOKS
(1874-1970)

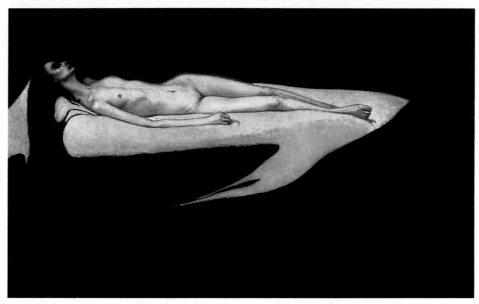

Le Trajet, ca. 1900, 45⅜ x 75⅜ in., signed l.r. Courtesy of National Museum of American Art, Smithsonian Institution, Washington, D.C. Gift of the artist.

It would be virtually impossible to separate Romaine Brooks's art from her life. The miseries of the artist's youth and her later avowed lesbianism are evoked in the color, contour and content of her paintings.

Born in Rome in 1874, Brooks was raised by a wealthy but unstable mother and in the company of an insane younger brother. According to Brooks's dubiously accurate memoirs, *No Pleasant Memories,* her childhood was marked by abandonment and terror. At one point, relegated to the care of the family laundress, the young artist lived in a New York City slum and was forced to sell newspapers on the street.

Brooks was educated in New Jersey, Geneva, Switzerland and Italy. Unable to support herself as an actress and model, she studied art in Rome. In 1902, Brooks inherited the family fortune and moved to Paris, where she had her first one-woman show.

Brooks's portraits record her associa-

tions with the variously overlapping worlds of the French "haute monde," the homosexual elite and the intellectuals. Her portraits of lesbians are among her most interesting works.

As a group, Brooks's portraits have an austere, almost haunting quality. Her use of subtle muted tones prompted Italian writer D'Annunzio to write that Brooks was "the most profound and wise orchestrator of grays in modern painting."

Her *Self-Portrait* (1923, National Museum of American Art) exemplifies Brooks's use of elongated contour and muted tones to create artistic tension. Less well known are her line drawings. Each one a single, unbroken line, the drawings are introspective and expressive.

After 1935, Brooks painted very little. Her last painting is believed to be a portrait painted in 1961, nine years before her death in Nice, France at age 96.

PUBLIC COLLECTIONS
Musee du Petit Palais, Paris
National Museum of American Art, Washington, D.C.

(No sales information available.)

RICHARD MILLER
(1875-1943)

Richard Miller's career as a successful painter and illustrator was distinguished by many honors and awards. By age 35, he had been made a member of the French Legion of Honor, had work purchased for the National Collection, and had received medals from the Paris Salon. Indeed, his first painting shown in the Salon won a gold medal.

Born in St. Louis, Missouri in 1875, Miller began to study art at age 10. He attended the St. Louis School of Fine Arts from 1893 to 1897, when he got a job as artist for the *St. Louis Post Dispatch*. A scholarship allowed him to go to Paris in 1898 to study under Constant and Laurens at the Academie Julien. He left the Academie in 1901 to teach at the rival Academie Colarossi.

Miller stayed in France until 1914, when the outbreak of World War I forced him to leave. During this period he was a member of the American colony of artists in Paris and was one of a group of artists, including Guy Rose, Frederick Frieseke and Lawton Parker, who met at Monet's home in Giverny to paint, critique each other and socialize.

When he returned to the United States, Miller established his studio in Provincetown, Massachusetts. In 1943, the "dean" of the Provincetown art colony died in St. Augustine, Florida.

Miller is often described as an important American impressionist, although his work also shows the influence of the plein-air painters. But as draftsman,

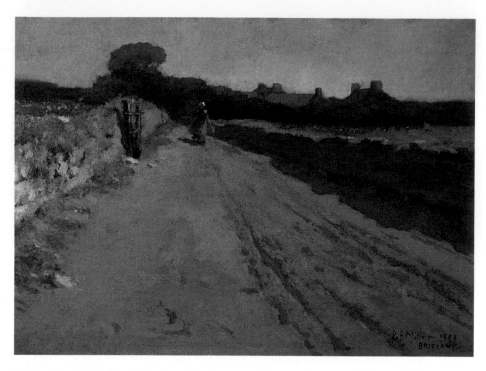

Brittany Road, 1900, 13 x 18 in., signed l.r. Courtesy of Taggart, Jorgensen, & Putman Gallery, Washington, D.C.

technician and colorist, he is allied with the impressionists. His compositions are solidly constructed yet graceful, with interesting light effects.

Miller once stated that "art's mission is not literary, the telling of a story, but decorative, the conveying of a pleasant optical sensation." He further declared that his pictures were meant to be hung not in public galleries but in "the modern homes, the urban apartments, and the country cottage."

MEMBERSHIPS
American Art Association of Paris
American Society of the French Legion
 of Honor
International Society of Painters,
 Sculptors, and Gravers
National Academy of Design
National Association of Portrait Painters
North Shore Arts Association
Paris Society of American Painters
Salmagundi Club
St. Louis Artists' Guild

PUBLIC COLLECTIONS
Albright-Knox Art Gallery,
 Buffalo, New York
Art Institute of Chicago
Carnegie Institute, Pittsburgh
Cincinnati Art Museum
Corcoran Gallery of Art, Washington, D.C.
Detroit Institute of Arts
Musee d'Orsay
Metropolitan Museum of Art, New York City
Pennsylvania Academy of the Fine Arts,
 Philadelphia
St. Louis Art Museum
State Capitol, Jefferson City, Missouri

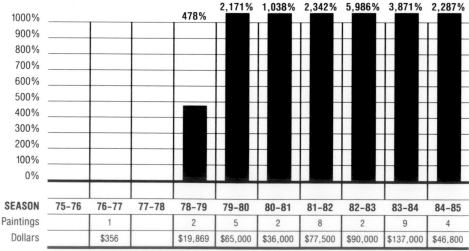

10-Year Average Change From Base Years '76-'77: 2,272%

			478%	2,171%	1,038%	2,342%	5,986%	3,871%	2,287%

SEASON	75-76	76-77	77-78	78-79	79-80	80-81	81-82	82-83	83-84	84-85
Paintings		1		2	5	2	8	2	9	4
Dollars		$356		$19,869	$65,000	$36,000	$77,500	$90,000	$137,000	$46,800

Record Sale: $70,000, BB.SF, 3/24/83, "Portrait of a Young Girl," 36 x 34 in.

MAYNARD DIXON
(1875-1946)

An illustrator, muralist, and painter of the American West, Maynard Dixon was known for his architectural structuring of bold masses combined with dynamic composition and vibrant coloring. Although his style varied according to subject, in the 1920s he developed a cubist-realist manner characterized by angular forms and abrupt color contrasts.

Born in Fresno, California in 1875, Dixon began sketching at age 10. After receiving encouragement from his idol, Frederic Remington, for a sketchbook he had sent, the artist enrolled at the San Francisco Art Association's School of Design in 1891.

He soon became disenchanted with formal training and left school to travel through Arizona, New Mexico and Southeast California. He became a prominent figure in bohemian life, working as a cowpuncher and wrangler.

After the San Francisco earthquake of 1906 destroyed Dixon's early work, he moved to New York City and worked as an illustrator. From 1907 to 1912, he submitted his art to national magazines such as *Scribner's* and *Harper's Monthly.*

Dixon's style, with its strong dramatic forms and clear, vivid colors, was also well suited to murals. His murals were commissioned by the Southern Pacific Railroad Depot in Tucson, Arizona (1907), the Mark Hopkins Hotel in San

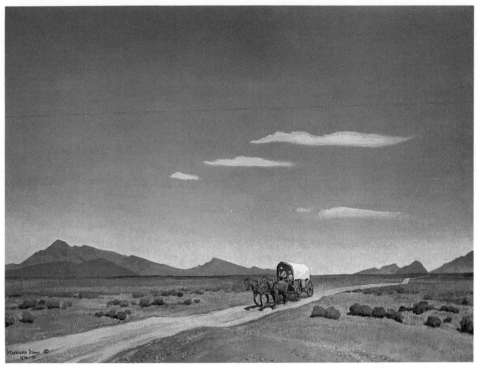

A Lonesome Road, 1936-1944, 30 x 40 in., signed l.l. Courtesy of Vose Galleries of Boston, Inc., Massachusetts.

Francisco (1926), the California State Library in Sacramento (1928), and the United States Department of the Interior in Washington, D.C. (1939).

Dixon returned to San Francisco. With more of his time devoted to easel painting, he was soon considered the leading painter of the Southwestern deserts. His use of a flat, yet crisp and vivid, palette of Southwestern earth and sky colors became his distinctive trademark.

During the 1930s, however, the artist produced a series of powerful paintings which were a departure from this subject matter. Deeply moved by the dislocated and tragic victims of the Depression, Dixon painted *Scab, Destination Unknown,* and *Keep Moving* (dates and locations unknown).

In 1946, Dixon supervised the execution of a large mural of the Grand Canyon for the ticket office of the Santa Fe Railroad in Los Angeles. He died of asthma that year near Tucson.

PUBLIC COLLECTIONS
Amon Carter Museum of Western Art, San Diego
Brooklyn Museum
Southwest Museum, Los Angeles

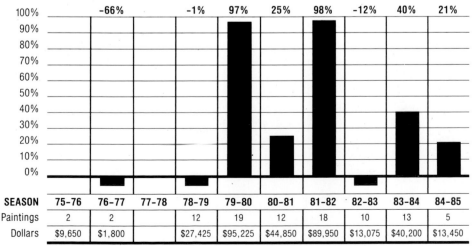

10-Year Average Change From Base Years '75-'76: 22%

	-66%		-1%	97%	25%	98%	-12%	40%	21%

SEASON	75-76	76-77	77-78	78-79	79-80	80-81	81-82	82-83	83-84	84-85
Paintings	2	2		12	19	12	18	10	13	5
Dollars	$9,650	$1,800		$27,425	$95,225	$44,850	$89,950	$13,075	$40,200	$13,450

Record Sale: $40,000, B.P, 7/11/81, "Wide Lands of the Navajo," 24 x 38 in.

721

GORDON GRANT
(1875-1962)

Born in San Francisco in 1875, Gordon Grant was a prominent artist of naval and marine subjects whose painting of *Old Ironsides* hangs in the White House. Grant's oil paintings of ships at sea exhibit authentic detail, while his watercolors achieve a greater freedom of composition and subject matter.

Grant's painting of *Old Ironsides* was commissioned by the navy in 1927 when the ship was falling into decay. Prints of the famous oil painting were sold throughout the nation, and the funds obtained were used to restore the ship.

After graduating from Fife Academy in Scotland, Grant studied for two years in the Heatherly and Lambeth Art Schools in London. He then returned to San Francisco and spent 1895 as a staff artist on the *Examiner* and the *Chronicle.* The next year he went to New York City and worked on the *World* and the *Journal.*

When the Boer War broke out in 1899, *Harper's Weekly* sent Grant as a special artist to the South African front. From 1901 to 1909, he did general illustrations for *Puck* magazine.

In 1907, Grant joined the Seventh Regiment of the New York National Guard; in 1916, he served on the Mexican border. A foot disability kept him from going overseas with his regiment in World War I, but he served as a captain in Washington.

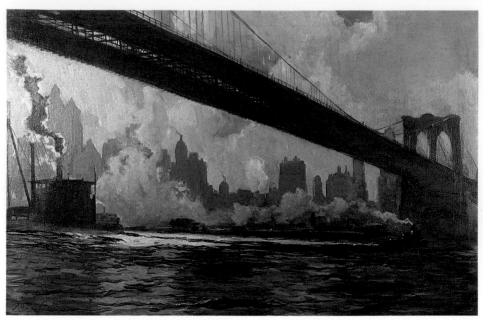

Brooklyn Bridge, 24 x 36 in., signed l.l. Courtesy of Henry B. Holt, Inc., Essex Fells, New Jersey.

In 1925, Grant made a voyage on an old windjammer, the *Star of Alaska,* to Chignik on the Aleutian peninsula. Many of the sketches of salmon fishermen in his book *Sail Ho!* were made on board.

Other books he illustrated were *Greasy Luck,* a whaling sketch book; *Ships Under Sails* and *The Secret Voyage;* and, in collaboration with Henry B. Calver, *The Book of Old Ships* and *Forty Famous Ships.*

Gordon Grant died in 1962.

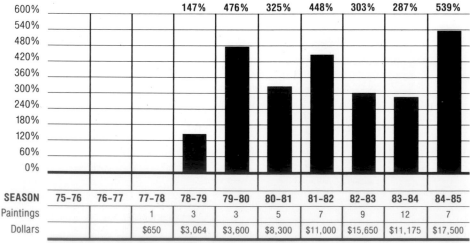

10-Year Average Change From Base Years '77-'78: 316%

		147%	476%	325%	448%	303%	287%	539%

SEASON	75–76	76–77	77–78	78–79	79–80	80–81	81–82	82–83	83–84	84–85
Paintings			1	3	3	5	7	9	12	7
Dollars			$650	$3,064	$3,600	$8,300	$11,000	$15,650	$11,175	$17,500

Record Sale: $5,500, SPB, 12/8/84, "Beach," 13 × 14 in.

MEMBERSHIPS
Allied Artists of America
Allied Art Association
American Federation of Arts
American Water Color Society
Baltimore Watercolor Club
California Society of Etchers
National Academy of Design
National Arts Club
Philadelphia Watercolor Club
Salmagundi Club
Ship Model Society
Society of American Etchers
Society of Illustrators
Washington Watercolor Club

PUBLIC COLLECTIONS
Corcoran Gallery of Art, Washington, D.C.
Joslyn Art Museum, Omaha, Nebraska
Library of Congress, Washington, D.C.
Metropolitan Museum of Art, New York City
New-York Historical Society, New York City
New York Public Library, New York City
White House, Washington, D.C.
United States Naval Academy, Annapolis, Maryland

HANSON DUVALL PUTHUFF
(1875-1972)

Hanson Duvall Puthuff was a realistic California landscape painter who spent the first half of his long life studying and working as a commercial artist, and the second half capturing on canvas the grandeur of the hills and mountains surrounding Los Angeles where he lived. As one critic wrote of his work, "His mountains have weight and volume, his undulating hills and lush valleys seem to throb with the quick, warm vitality of the South. . . ."

He was born Hanson Duvall in Waverly, Missouri in 1875. His mother died when he was two and he was put in the care of her friend Elizabeth Puthuff. When he was six, his father took him to Kentucky to live with a succession of relatives. He also lived briefly with his father in Oklahoma.

At age 14, however, he returned to Elizabeth Puthuff, who was then living in Denver, Colorado. Eventually he took her name and used it for the rest of his life. She encouraged his interest in art, helped him enroll at art school and, through friends, helped him get started in commercial art.

Puthuff worked as a mural painter in Illinois, then as a pictorial artist for advertising agencies in Denver and Los Angeles. He also did backgrounds for model-train exhibits and for animal habitats. These last led to a commission to paint three dioramas for the Theodore Roosevelt Memorial in the American

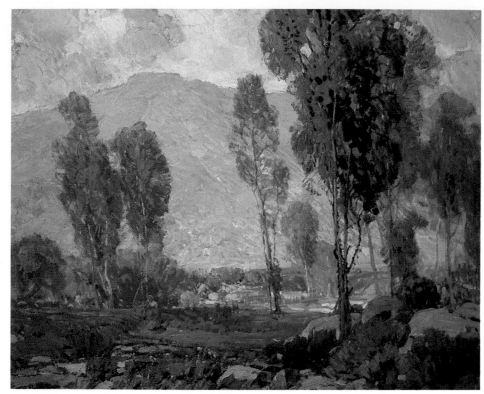

Verdugo Canyon, ca. 1925, 32 x 40 in., signed l.l. Courtesy of Petersen Galleries, Beverly Hills, California.

Museum of Natural History in New York City.

For a time, Puthuff worked as a billboard painter in Los Angeles. He and his helpers would be transported by wagon to remote sites and left for the day. When they had finished the billboard and were waiting for the wagon to

return, they often would set up easels and paint the surrounding countryside. That was the start of an enchantment with the Western landscape that continued until Puthuff's death in 1972.

He preferred to paint outdoors so that he could record the spontaneity of the moment. While most of his work was done near his home, he also painted along the coast, in the desert and in Mexico.

MEMBERSHIPS
California Art Club
Laguna Beach Art Association
Los Angeles Watercolor Society
Painters' and Sculptors' Club
 of Los Angeles
Palette and Chisel Club of Chicago
Pasadena Society of Artists
Salmagundi Club
San Francisco Art Association
Southern States Art League

PUBLIC COLLECTIONS
Muskegon Museum of Art, Michigan
Laguna Beach Museum of Art, California
Pasadena Art Institute, California
Springville Museum of Art, Utah

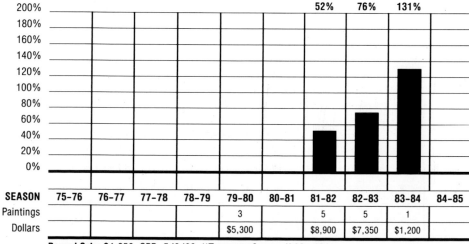

10-Year Average Change From Base Years '79-'80: 65%

SEASON	75-76	76-77	77-78	78-79	79-80	80-81	81-82	82-83	83-84	84-85
							52%	76%	131%	
Paintings					3		5	5	1	
Dollars					$5,300		$8,900	$7,350	$1,200	

Record Sale: $4,250, SPB, 5/3/82, "Toppanga Canyon," 32 x 40 in.

JAMES GUILFORD SWINNERTON
(1875-1974)

Called the "dean of desert artists," James Guilford Swinnerton was born in Eureka, California and raised in Santa Clara, California. He was descended from an old California family—his grandfather was a "forty-niner" who found gold at Dutch Flat.

At age 16, Swinnerton enrolled in the California School of Art in San Francisco. There he delighted in sketching and caricaturing his professors. When William Randolph Hearst saw his sketches, he offered the artist a job on the *San Francisco Examiner*.

Swinnerton began by drawing cartoons of sporting and news events as well as comic little bears to illustrate the weather forecasts. These were among the first comic strips in the United States. "Little Jimmy" and "Little Tiger" were two of the comics Swinnerton drew for Hearst's Sunday supplement. Later he developed a new cartoon, called "Canyon Kiddies," for *Good Housekeeping*.

Suffering from tuberculosis and alcoholism, Swinnerton moved to Palm Springs, California to recover his health. During his stay, he became accustomed to camping in the open; when he was healthy, he continued to travel on foot or on burro through the Southwest.

After 1907, his favorite subjects were the Grand Canyon, Monument Valley, the Navajo Indians and the Hopi Indians. Although collectors first rejected his paintings because they did not resemble the stereotypic view of barren Sahara-like wastes, Swinnerton's desert scenes with smoke trees, boulders and canyon walls soon became very popular. He was the only Western artist to be exhibited at the San Francisco World's Fair.

Swinnerton's later oils took on a new subtlety, blending soft colors with delicate lighting. His work inspired other Western artists, such as George Marks and Bill Bender.

He died in 1974.

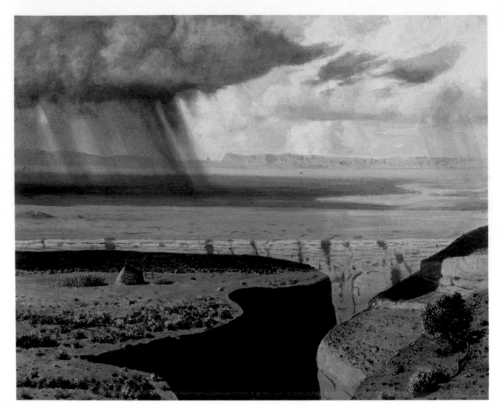

Little Colorado River Scene, 30 x 40 in., signed l.r. Collection of Palm Springs Desert Museum, Palm Springs, California. Gift of Mr. and Mrs. Donald Stevning.

SEASON	75-76	76-77	77-78	78-79	79-80	80-81	81-82	82-83	83-84	84-85
Paintings						4	2		19	1
Dollars						$6,800	$5,700		$46,600	$700

Record Sale: $8,500, BB.SF, 9/22/83, "Arizona Cathedral," 40 × 40 in.

MARTHA WALTER
(1875-1976)

Martha Walter was a well-known, prolific painter of colorful, light-hearted beach scenes and landscapes. Influenced by the French impressionists during her travels abroad, Walter's canvases were spontaneously executed with a palette of vivid colors.

Walter was born in Philadelphia in 1875. She enrolled at the Pennsylvania Academy of the Fine Arts, where she studied under William Merritt Chase. At his insistence, she entered a number of Academy student competitions and eventually won a prestigious Cresson Traveling Scholarship in 1908.

This award enabled her to travel throughout Europe, where she continued her art education at the Grande Chaumiere and later the Academie Julien in Paris. Soon disenchanted with the academicism of these Parisian schools, Walter set up her own studio and began producing plein-air paintings in the manner of the French impressionists.

At the outbreak of World War I, she returned to the United States, and took up painting at various East coast beach resorts such as Coney Island and Gloucester. In her beach scenes of this period, colorful bathing suits, gowns and umbrellas punctuate the tranquil, pastel surfaces. Her expertise in the treatment of light and shadow is evident in her depictions of nursemaids, mothers and children. *Umbrellas on the Beach* (date unknown, Norfolk Society of Art) and *Beach Scene* (date unknown, Milwaukee Art Museum) typify the artist's oceanside paintings.

In 1922, she spent some months painting the hundreds of immigrants kept in the detention hall at Ellis Island. The dreadful, crowded conditions inspired a group of paintings which were exhibited that year in the Galerie Georges Petit in Paris. One was selected for the permanent collection of the Musee de Luxembourg.

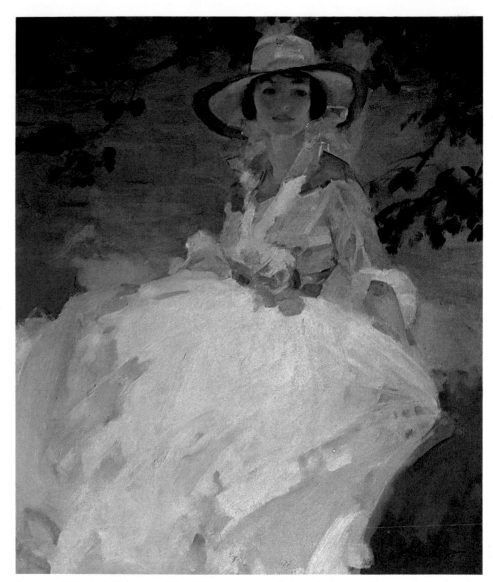

Portrait of Elizabeth Chapman, 47½ x 39½ in., signed l.r. Private Collection, Photograph courtesy of Hirschl & Adler Galleries, Inc., New York, New York.

An exhibition at the Art Club of Chicago in 1941 featured a group of watercolor paintings inspired by the artist's travels through Spain and North Africa. These works were intensely colored visions of such subjects as Algerian street scenes, mosques and Spanish fishermen.

Walter worked well into her nineties, continuing to paint beaches, gardens and marketplaces. Before her death in 1976, she had exhibited widely, and her works were included in major national and international private and public collections.

MEMBERSHIPS
Fellowship, Pennsylvania Academy of the Fine Arts

PUBLIC COLLECTIONS
Art Institute of Chicago
Detroit Institute of Arts
Milwaukee Art Museum
Musee d'Orsay, Paris
Norfolk Society of Art, Virginia
Pennsylvania Academy of the Fine Arts, Philadelphia
Toledo Museum of Art, Ohio

SEASON	75-76	76-77	77-78	78-79	79-80	80-81	81-82	82-83	83-84	84-85
Paintings							1	3	2	2
Dollars							$4,000	$13,000	$8,750	$6,750

Record Sale: $7,750, SPB, 6/22/84, ''Beach Scene,'' 15 × 18 in.

WALTER UFER
(1876-1936)

Walter Ufer was a landscape artist known for his realistic and brilliantly painted depictions of the area around Taos, New Mexico. Although Ufer's training was long and his professional career short, his paintings continue to be admired and are included in the collections of many major museums.

Walter Ufer was born in Louisville, Kentucky, the son of a German-born engraver of gunstocks. In his youth, Ufer worked as an apprentice lithographer. In 1893, Ufer followed his master back to Germany, where he worked as a journeyman printer and engraver before deciding to pursue his career as a painter.

Having decided to broaden his training, Ufer studied from 1895 to 1896 at the Royal Applied Art School, and from 1897 to 1898 at the Royal Academy, both in Dresden. Returning to the United States, Ufer supported himself as a commercial engraver and lithographer, while continuing his studies at the Art Institute of Chicago and the F. Francis Smith Art School in Chicago.

In 1911, Ufer married Mary Fredericksen, a Danish-born artist. Together the couple traveled to Munich, where they studied at the Royal Academy under Walter Thor. In 1913, they traveled extensively, painting in Paris, Italy and North Africa before returning to Chicago.

Back in the United States, Ufer won the admiration of critics and buyers with

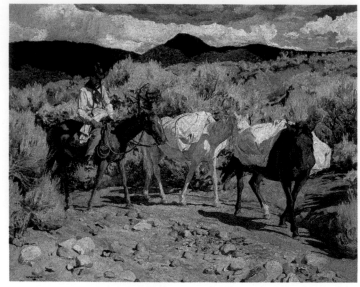

Taos Indian and Pack Horse and His Kit, 25⅛ x 30¼ in. Courtesy of the Stark Museum of Art, Orange, Texas.

the sturdy realism of his paintings. His admirers included the former mayor of Chicago, Carter Harrison, who financed Ufer's first painting trip to the artist colony at Taos, New Mexico.

Ufer traveled to Taos in 1914. Here he found his new home, and began painting the pictures of the landscape and Indians of Taos for which he became well known over the next 10 years. His draftsmanship and coloring won critical praise, and his paintings won medals at major exhibitions in New York, Chicago, Philadelphia and Pittsburgh between 1916 and 1926. They were included in the 1919 United States Exposition in Paris and the 1924 Venice Biennial.

In the early 1920s, Ufer enjoyed sales of his paintings amounting to around $50,000 per year. He traveled regularly

from Taos to art centers in the Midwestern and Eastern United States. However, by the late 1920s, his prices had fallen considerably and he had settled down to a lifestyle of continued creativity and financial decline.

Ufer was by all accounts a colorful personality, who left a deep impression on the residents of Taos, among whom he counted many friends, including his peers, his students and even his Indian models. Even in his late and impoverished condition, he was known for his generosity to his friends and neighbors.

Ufer died of appendicitis in Santa Fe, New Mexico in 1936.

MEMBERSHIPS
Allied Artists of America
American Federation of Arts
Boston Art Club
Chicago Society of Artists
National Academy of Design
National Arts Club
Royal Society of Artists
New Mexico Painters
Salmagundi Club
Taos Society of Artists

PUBLIC COLLECTIONS
Arizona State University Museum, Phoenix
Art Institute of Chicago
Brooklyn Museum
Chicago Municipal Collection
Corcoran Gallery of Art, Washington, D.C.
Illinois State House, Springfield
Maryland Institute College of Art,
 Baltimore
Metropolitan Museum of Art, New York City
Museum of Fine Arts, Houston
Pennsylvania Academy of the Fine Arts,
 Philadelphia
Phoenix Art Museum, Arizona
Stark Museum of Art, Orange, Texas
Thomas Gilcrease Institute of American
 History and Art, Tulsa, Oklahoma

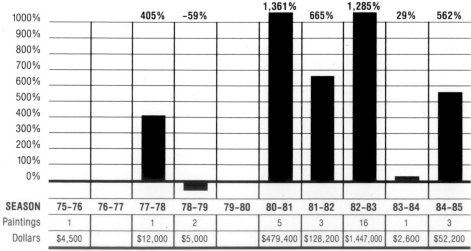

10-Year Average Change From Base Years '75-'76: 531%

SEASON	75-76	76-77	77-78	78-79	79-80	80-81	81-82	82-83	83-84	84-85
(% change)			405%	-59%		1,361%	665%	1,285%	29%	562%
Paintings	1		1	2		5	3	16	1	3
Dollars	$4,500		$12,000	$5,000		$479,400	$128,200	$1,447,000	$2,600	$52,200

Record Sale: $340,000, CH, 10/16/82, "The Bakers," 50 x 50 in.

ALSON SKINNER CLARK
(1876-1949)

Alson Skinner Clark, painter, illustrator, printmaker, teacher and muralist, belongs to no particular school or group. His landscapes, timeless and painterly, record locations of infinite variety with a special genius for capturing the essence of a place. *Giverny* (1910), *Town Dock, Alexandria Bay* (1917), and *California Coast* (1924, all private collections) are typical examples.

He was much influenced by William Merritt Chase, who gave him a good sense of composition and an understanding of color that served him well for the rest of his life.

Clark was born in Chicago in 1876. At age 14, he enrolled in the Art Institute of Chicago, where he stayed for four years. He spent one year at the Art Students League; although he met Chase there, he found it restricting. When Chase seceded from the League to found the Chase School, Clark and a small group of students left to study with him.

He went to Paris in late 1899 for further training, but apparently gained little from study at the Academie Julien and the various studios and schools of Lucien Simon, Cottet, Mucha, Merson and James McNeill Whistler.

In 1901 Clark's painting *The Violinist* (date and location unknown), a rather conventional work, was accepted by the Salon.

He returned to the United States shortly after this recognition, and set up

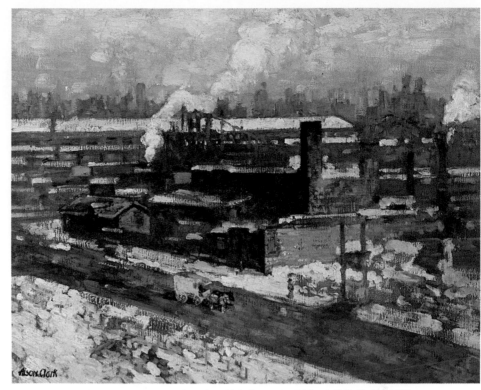

Chicago Industrial Scene, 24½ x 30½ in., signed l.l. Courtesy of Maxwell Galleries, LTD., San Francisco, California.

a studio in Watertown, New York, where he began to explore one of his favorite subjects, snow scenes. For working in the snow when he visited Quebec, he went out with snowshoes and a combination charcoal burner-palette, to prevent the paints from freezing.

In 1904, Clark had a show of his turn-of-the-century Chicago scenes. He received the ultimate accolade from Chase, who bought *The Bridgebuilders*

(date and location unknown) for his own collection.

Seemingly oblivious to the impending danger in Europe, early in 1914 Clark and his wife bought a Hupmobile and returned to Rochefort-en-Terre, a place in Brittany where Clark had done a series of paintings some years before. When German soldiers broke into France, the Hupmobile was given to some mystified but grateful French infantrymen. Later, Clark served as one of the first aerial photographers in the war.

In 1919, Clark settled in California to teach and paint. He died in 1949.

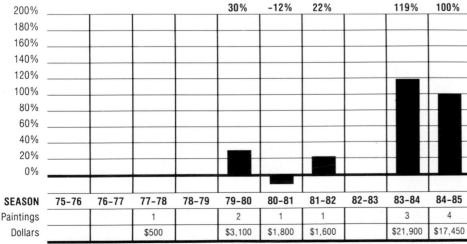

10-Year Average Change From Base Years '77-'78: 43%

	30%	-12%	22%		119%	100%

SEASON	75-76	76-77	77-78	78-79	79-80	80-81	81-82	82-83	83-84	84-85
Paintings			1		2	1	1		3	4
Dollars			$500		$3,100	$1,800	$1,600		$21,900	$17,450

Record Sale: $17,000, B, 6/21/84, ''Village at Urville,'' 25 × 32 in.

LILLIAN MATILDE GENTH
(1876-1953)

During her lifetime, Lillian Matilde Genth was considered to be the most successful painter of female nudes in America. Noted for her studies of nudes in poetic, pastoral settings, Genth was also a very successful portrait painter.

Born in Philadelphia in 1876, Genth studied at home and abroad. She received a scholarship to the Philadelphia School of Design for Women. There she studied under Elliott Daingerfield, graduating in 1900. Genth went to Europe and studied in Paris under James McNeill Whistler; while there, she painted his portrait.

Whistler's influence can be seen in Genth's work. Like Whistler, Genth chose to paint rather academic subjects such as beautiful women with subtle, exotic accents in their dress and surroundings. Both Whistler and Genth painted in a somewhat traditional style, using many of the techniques and some of the innovations of the impressionists. Genth was well received in the art world and achieved great success during her lifetime.

Genth was the recipient of many awards during her career. These included the Mary Smith Prize from the Pennsylvania Academy of the Fine Arts in 1904 and the Shaw Memorial from the National Academy of Design in 1908. Also in 1908, Genth was elected an associate member of the Academy. She died in 1953.

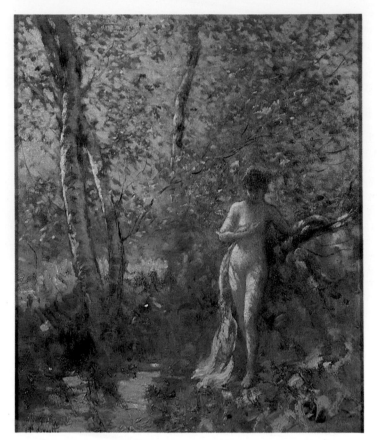

Morning Reverie, 22 x 18 in., signed l.r. Courtesy of Henry B. Holt, Inc., Essex Fells, New Jersey.

MEMBERSHIPS
Allied Art Association
International Society Artists' League
National Academy of Design
National Arts Club
Pennsylvania Academy of the Fine Arts
Royal Society of Arts

PUBLIC COLLECTIONS
Carnegie Institute, Pittsburgh
Metropolitan Museum of Art, New York City
National Gallery of Art, Washington, D.C.
Newark Museum, New Jersey

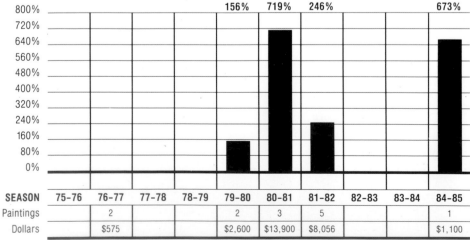

10-Year Average Change From Base Years '76–'77: 359%

SEASON	75-76	76-77	77-78	78-79	79-80	80-81	81-82	82-83	83-84	84-85
					156%	719%	246%			673%
Paintings		2			2	3	5			1
Dollars		$575			$2,600	$13,900	$8,056			$1,100

Record Sale: $12,500, B.P, 11/22/80, "Woman Reading," 35 × 29 in.

EVERETT SHINN

(1876-1953)

Multi-talented Everett Shinn, the youngest and perhaps the most cosmopolitan member of The Eight (whose 1908 exhibition shook the foundations of American art), was born in Woodstown, New Jersey in 1876. A realist who loved the theatrical world and its glitter, many of his subjects are drawn from the stage.

During his colorful life, Shinn was an industrial designer, reporter-artist, illustrator, muralist, cartoonist, amateur acrobat, professional playwright and producer, and motion-picture art director.

Shinn studied mechanical drawing and shop training from 1890 to 1893 at Spring Garden Institute in Philadelphia. He then worked as a designer for a gas-fixtures company.

He became caught up in the era of sensational journalism in 1893, as an artist-reporter for the *Philadelphia Press*. His job was to rush to scenes of news events and quickly sketch the incidents for the paper's next edition. He developed invaluable skill in capturing scenes rapidly and accurately, with a dramatic flair. During this period, he also studied at the Pennsylvania Academy of the Fine Arts.

One evening a week, Shinn and three of his fellow artist-reporters, William Glackens, George Luks and John Sloan, met at the studio of Robert Henri, the inspirational force behind this rebellious group of artists who eventually became known as The Eight. Henri, a born teacher, expounded his beliefs that anything could be the subject of a painting, stating that "the beauty of a work of art is in the work itself."

The young members of this core group of realists, later called the Ashcan School, developed a new urban realism contrary to the beliefs of the academicians. They painted slum residents, workers, the everyday life of ordinary people—subjects viewed as unworthy by other artists. Black was used lavishly in

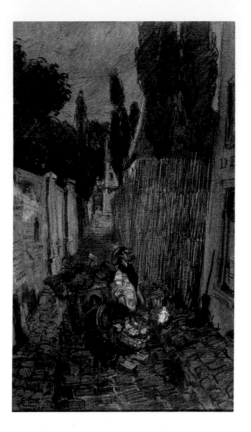

Street Vendor, Paris, 1911, 36 x 25 in., signed l.l.
Courtesy of Kennedy Galleries,
New York, New York.

their work; they were nicknamed "the Revolutionary Black Gang."

A fun-loving and ingenious group, they wrote and staged their own theatricals in Henri's studio. Shinn was featured in a parody of George du Maurier's *Trilby,* a best-selling novel.

Moving to New York City in 1897, Shinn continued as an illustrator for the *New York World* newspaper, but dreamed of having a center-spread illustration published in *Harper's Weekly.* His persistence gained him an interview with the editor, who wanted a color drawing of the Metropolitan Opera House in a snowstorm. After telling the editor he had one at his studio, Shinn rushed out, purchased pastels, and by morning had finished *A Winter's Night on Broadway* (1899, location unknown). *Harper's* featured it in the center spread.

Many commissions followed, including *McClure's* and *Scribner's* publications. In addition to illustrating 28 books and 94 magazine stories, Shinn also painted murals in the City Hall at Trenton, and panels for the Stuyvesant Theater in New York City.

After Shinn's exposure to the theatri-

cal world in Paris in 1901, his work was more inclined toward the glamour of the stage. Important are his *London Hippodrome* (1902, location unknown) and *Theater Box* (1906, location unknown). Influenced by Edgar Degas, Honore Daumier and Jean-Louis Forain, Shinn used predominately pastels in his pictures of slums and the lower classes, whereas theater scenes are often oils.

In February 1908, The Eight's landmark exhibition was held at the Macbeth Gallery in New York City. Shinn, Glackens, Luks, Sloan and Henri were joined by Maurice Prendergast, Ernest Lawson and Arthur B. Davies in the popular show that made history in its revolt against current conventional attitudes. Police had to control the crowds, and the critics struck out with ire.

Shinn savored life to the hilt until his death in 1953 in New York City. In later life he recalled, "I was often accused of being a social snob. Not at all—it's just that the uptown life with all its glitter was more good-looking. . . . "

PUBLIC COLLECTIONS
Albright-Knox Art Gallery, Buffalo
Art Institute of Chicago
Brooklyn Museum
Detroit Institute of Arts
Metropolitan Museum of Art, New York City
Museum of Fine Arts, Boston
New Britain Museum of American Art,
 Connecticut
Phillips Gallery, Washington, D.C.
Whitney Museum of American Art,
 New York City

SEASON	75–76	76–77	77–78	78–79	79–80	80–81	81–82	82–83	83–84	84–85
Paintings		3	4	21	29	23	17	18	19	11
Dollars		$27,400	$17,600	$46,720	$178,800	$147,970	$106,550	$101,700	$303,875	$96,650

Record Sale: $95,000, CH, 6/1/84, "Dress Rehearsal," 17 x 26 in.

JOHN HUBBARD RICH
(1876-1955)

Although he was an Easterner by birth and received his training as a painter there, John Hubbard Rich made his reputation in California. He alternated between figure and portrait painting and still lifes, particularly floral still lifes. Rich was known especially for his portraits of women; for his deftness in reproducing the colors and folds of draperies and flowered materials; and for the way he caught light falling across his subjects.

Some critics, however, saw inconsistency in his work, saying that some of his portraits were outstanding,. while others were no more than routine. One wrote that sometimes Rich "got more out of a daguerreotype than from a living sitter."

Born in Boston in 1876, he studied at the Art Students League in New York City and at the School of the Museum of Fine Arts in Boston. A traveling fellowship from the latter school enabled him to go to Europe for two years to visit museums and study.

Rich moved to California soon after his return to the United States, and taught painting—first at the Otis Art Institute in Los Angeles and later at the University of Southern California. Over the years he painted portraits of many prominent local residents, educators and churchmen.

His work was distinctive for his use of rich colors and for his skill at modeling the human form. He liked the brilliant colors of flowers and fruit, and incorporated them into his portraits whenever possible. His paintings fit well into California homes, said one critic in reviewing the opening of an exhibition of Rich's late work. Rich died at his home in Hollywood in 1955.

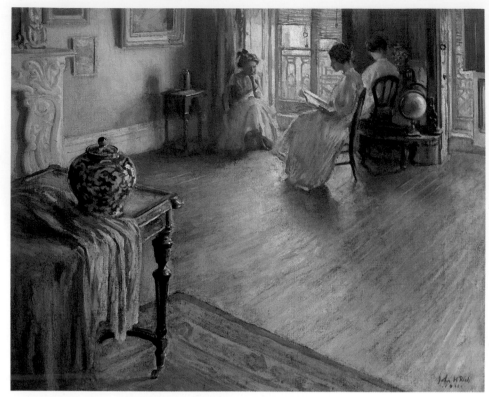

Beacon Hill Interiors, 1911, 25 x 30 in., signed l.r. Courtesy of Vose Galleries of Boston, Inc., Massachusetts.

MEMBERSHIPS
California Art Club
California Watercolor Society
Salmagundi Club

PUBLIC COLLECTIONS
Los Angeles County Museum of Art
Museum of Fine Arts, Boston

SEASON	75-76	76-77	77-78	78-79	79-80	80-81	81-82	82-83	83-84	84-85
Paintings			2						1	
Dollars			$1,500						$28,000	

Record Sale: $28,000, SPB, 5/31/84, "Beacon Hill Interior," 25 × 30 in.

BROR JULIUS OLSON NORDFELDT
(1876-1955)

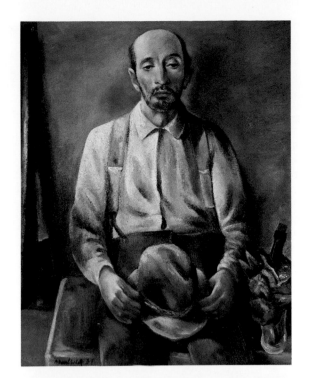

Man with Brown Suspenders, 1937, 36 x 30 in., signed l.l. Photograph courtesy of The Gerald Peters Gallery, Santa Fe, New Mexico.

Born in Sweden in 1876, Julius Nordfeldt etched and engraved, as well as painting in oils. He gained importance as a pioneering modernist for his non-academic handling of American Indians, whom he painted with distortion and abstraction, using bold color. His simple subject matter gave his work an air of mystery, and earned him the reputation of being a romantic expressionist.

Nordfeldt's first job was as a printer's devil with a Swedish-language newspaper in Chicago. His employer urged him to enter the Art Institute of Chicago in 1899. The artist soon became an assistant to Albert Herter, who was painting a mural commissioned by McCormick Harvester Company for the Paris Exhibition, and in 1900 he was sent to France to view its unveiling.

Nordfeldt remained in France, where he studied and taught. He was greatly influenced by the work of Manet, Gauguin and Cezanne. He went on to London to study etching and woodblock cutting under F. M. Fletcher.

Upon his return to the United States in 1903, Nordfeldt worked as a portrait artist in Chicago. He moved East in 1907, then returned to Europe, where he remained until World War I. Nordfeldt settled in Santa Fe, New Mexico in 1917 or 1918. He began painting sympathetic portraits of Spanish-Americans and still lifes.

After 1929, Nordfeldt painted landscapes of the Santa Fe area at the urging of his friend Russell Cowles, but destroyed many of them before leaving Santa Fe in 1940. He used Indian motifs—from pottery and textiles—as design elements in his modernist canvases.

Nordfeldt died of a heart attack in Henderson, Texas in 1955.

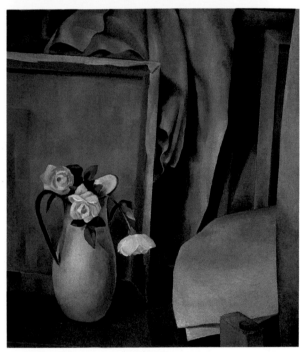

Roses & Canvas, 34 x 30 in., signed l.l. Photograph courtesy of The Gerald Peters Gallery, Santa Fe, New Mexico.

MEMBERSHIPS
Brooklyn Society of Etchers
Chicago Society of Etchers
New Mexico Society of Painters
Taos Society of Painters, Santa Fe Artists

PUBLIC COLLECTIONS
Amon Carter Museum of Western Art,
 Fort Worth, Texas
Art Institute of Chicago
Bibliotheque des Arts et Archeologie, Paris
Corcoran Gallery of Art, Washington, D.C.
Detroit Institute of Arts
Metropolitan Museum of Art, New York City
Museum of Fine Arts, Sydney, Australia
Museum of New Mexico, Santa Fe
New York Public Library, New York City
Toledo Art Museum, Ohio
Toronto Art Museum

SEASON	75-76	76-77	77-78	78-79	79-80	80-81	81-82	82-83	83-84	84-85
Paintings						1	3	2	1	3
Dollars						$7,250	$13,450	$4,000	$5,000	$4,550

Record Sale: $9,000, CH, 4/7/82, "Provincetown," 29 × 36 in.

HAYLEY LEVER
(1876-1958)

Richard Hayley Lever was a dedicated and prolific artist, highly respected for his seascapes, yet never allying himself with any one school of painting. His eclectic assemblage of styles, which stemmed from French impressionism, helped establish him in Europe before 1910.

Born in 1876 in Adelaide, Australia, he made the voyage to England in 1893. After studying art in London for a time, he settled into an artists' colony on the seacoast at St. Ives in Cornwall in 1900. There he began his seascape painting.

During the next 10 years, Lever's paintings reflected the English movement to modify impressionism. His Cornish-coast seascapes, which were executed in the loosely-stated "English impressionist" manner, brought him substantial recognition in Europe during that period.

In 1908, he was profoundly influenced by the works of Vincent Van Gogh. He created a series of paintings called "Van Gogh's Hospital, Holland" (1908), and Van Gogh's influence remained clear in later Lever paintings.

Upon moving to New York City in 1911, Lever developed a prosperous career and reputation, and obtained citizenship. He painted a number of scenes of Manhattan.

He later opened a summer studio in Gloucester, Massachusetts that he would keep for years to come. From 1919 to 1931, he taught at the Art Students League in New York City and entered many exhibitions.

Though his sales dropped during the Depression, Lever continued to paint, even through the ill health of his last years. He died in 1958 in Mount Vernon, New York.

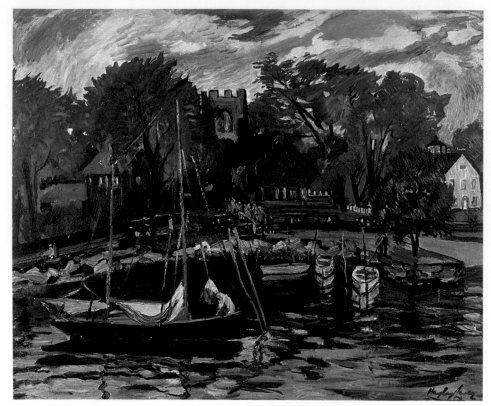

Sunday AM, Stoney Creek, CT., 1950, 24¼ x 29 in., signed l.r. Courtesy of Henry B. Holt, Inc., Essex Fells, New Jersey.

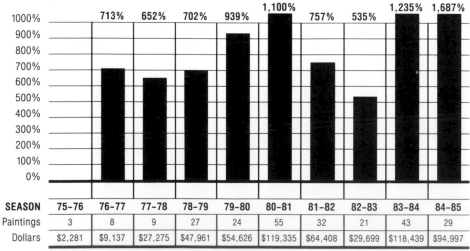

10-Year Average Change From Base Years '75-'76: 832%

SEASON	75-76	76-77	77-78	78-79	79-80	80-81	81-82	82-83	83-84	84-85
		713%	652%	702%	939%	1,100%	757%	535%	1,235%	1,687%
Paintings	3	8	9	27	24	55	32	21	43	29
Dollars	$2,281	$9,137	$27,275	$47,961	$54,626	$119,335	$64,408	$29,699	$118,439	$94,997

Record Sale: $36,000, SPB, 5/31/84, "Armistice Celebration Parade Fifth Ave.," 25 x 30 in.

MEMBERSHIPS
National Academy of Design
National Arts Club
New Society of Artists
Royal British Artists
Royal Institute of Oil Painters
Royal West of England Academy

PUBLIC COLLECTIONS
Baltimore Museum of Art
Brooklyn Museum
Corcoran Gallery of Art, Washington, D.C.
Detroit Institute of Arts
Los Angeles County Museum of Art
Metropolitan Museum of Art, New York City
Pennsylvania Academy of the Fine Arts,
 Philadelphia
Phillips Collection, Washington, D.C.

732

JANE PETERSON
(1876-1965)

During her lifetime, Jane Peterson was one of New York City's most important painters. Her vibrant watercolors provide a vital link between the impressionist and expressionist movements in American art.

Born in 1876 in Illinois, Peterson moved to New York when she was 19. For the next 12 years, she studied at Brooklyn's Pratt Institute and with artist Frank Vincent Dumond.

Aware of the artistic innovations taking place in Europe, Peterson used the money she earned as an art instructor to finance the first of her many trips abroad in 1907. She sought out some of the best teachers of the day, and in Paris she was influenced by fauvism, impressionism, expressionism and the beginnings of the cubist movement.

Upon her return to the United States, Peterson had her first one-woman exhibition in Boston in 1909, with a second successful show occurring shortly after in New York City.

Initially, Peterson's work was stylistically linked with that of Maurice Prendergast. Though Prendergast's brushwork was more neo-impressionistic, both artists selected colorful and festive subjects.

By the 1920s, Peterson had reached the height of her fame. In addition to frequent one-woman shows, her *Toilette* (1922, private collection) was singled out in a review as best of the show by the New York Society of Painters. *Toilette,*

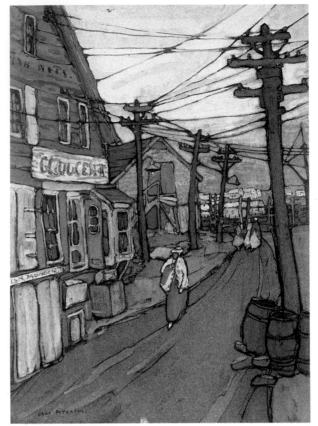

Old Street, Gloucester, ca. 1920, 24 x 18 in., signed l.l. Courtesy of Fogg Art Museum, Harvard University, Cambridge, Massachusetts, Gift - Martin Horwitz.

showing hints of impressionism and of art nouveau, is decidedly individualistic, eschewing overall identification with any specific school.

Peterson, a prolific artist, also continued to teach. From 1912 to 1919, she taught watercolor at the Art Students League, then later taught classes at the Maryland Institute in Baltimore.

In 1925, Peterson began painting what she called her "flower portraits." These still lifes dominated all her subse-

quent exhibitions. Highly stylized, the flower paintings are bold and expressive, echoing the style and fashion of the time. As seen in her *Iris and Petunias* (ca. 1925, private collection) these still lifes often incorporated rich brocades, and included gold and silver backgrounds.

In 1938, Peterson was named the "most outstanding individual of the year" by the American Historical Society for her artistic achievement—only the second woman in the history of the Society to be so honored. The artist was then 62 years old.

Peterson died in New York in 1965.

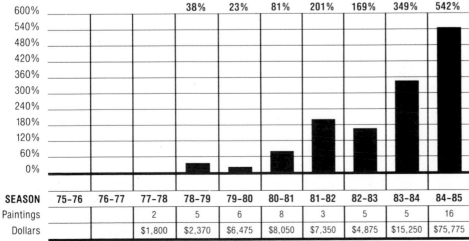

10-Year Average Change From Base Years '77-'78: 175%

		38%	23%	81%	201%	169%	349%	542%

SEASON	75-76	76-77	77-78	78-79	79-80	80-81	81-82	82-83	83-84	84-85
Paintings			2	5	6	8	3	5	5	16
Dollars			$1,800	$2,370	$6,475	$8,050	$7,350	$4,875	$15,250	$75,775

Record Sale: $28,000, B.P. 5/11/85, "Flag Day," 29 x 23 in.

MAURICE BRAUN
(1877-1941)

Maurice Braun was born in 1877 in Nagy Bittse, Hungary, during the height of the impressionist era—a significant fact, as Braun eventually became an American impressionist. If there is such a thing as a "classic" artist's life, Braun had one.

Braun was only three years old when he came with his family to the United States and settled in New York City. At age 14, after an unsuccessful apprenticeship with a jeweler, he convinced his family to let him study painting. He began his art studies by copying works at the Metropolitan Museum of Art.

From 1897 to 1900, he studied at the National Academy of Design under Francis C. Jones, George W. Maynard and Edgar M. Ward, all academic painters. Later he studied for one year with noted artist William Merritt Chase. Another year was spent in Europe, studying the old masters in Berlin and Vienna. When he returned to New York City, he became an established portrait and figure painter.

In 1909 he moved to California, settling near San Diego, where he helped found the San Diego Fine Arts Academy (1912) and the San Diego Art Guild (1915). There he began painting landscapes. This was a time when the Western American landscape offered much fresh material; the rugged rock formations especially appealed to Braun's strong sense of composition and provided endless design challenges.

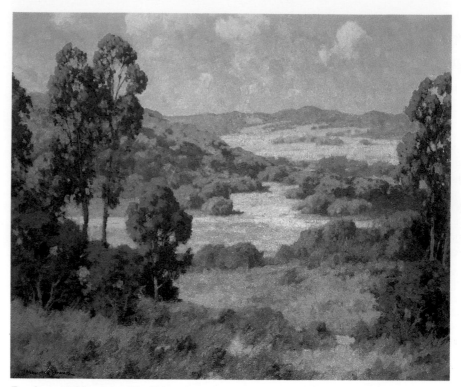

Eucalyptus & Mountains, 25 x 32 in., signed l.l. Courtesy of Maxwell Galleries, LTD., San Francisco, California.

By 1911, Braun had received acclaim in the East for his Southern California landscapes. His work was exhibited at the National Academy of Design, the Carnegie Institute, the Pennsylvania Academy of the Fine Arts, the Detroit Museum of Art and the Art Institute of Chicago.

Braun was a key member of the Southern California landscape school. His works portray rolling hills and eucalyptus trees, painted in muted colors and the short broken brushstrokes typical of impressionism. *Point Loma* (date unknown, San Diego City Schools) is reminiscent of the French impressionists in its emphasis on sunlit colored grasses in the foreground, house and mountains in the background.

Thomas B. Robertson, former director of the San Diego Museum of Art, has said that during Braun's early years in San Diego he made the city's leading contribution to the national art scene.

By 1919, Braun had given up teaching and was devoting all his time to his own work. He sketched outdoors and then completed each work in his studio. In 1921, he lived temporarily in the artists' colonies of Silvermine and Old Lyme in Connecticut. He returned to San Diego in 1924, but spent part of the next five years painting in Connecticut.

Braun died in 1941 in San Diego.

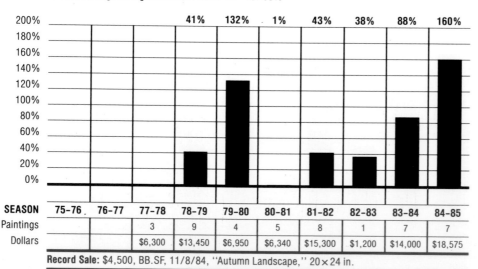

10-Year Average Change From Base Years '77-'78: 63%

	75-76	76-77	77-78	78-79	79-80	80-81	81-82	82-83	83-84	84-85
				41%	132%	1%	43%	38%	88%	160%
SEASON	75-76	76-77	77-78	78-79	79-80	80-81	81-82	82-83	83-84	84-85
Paintings			3	9	4	5	8	1	7	7
Dollars			$6,300	$13,450	$6,950	$6,340	$15,300	$1,200	$14,000	$18,575

Record Sale: $4,500, BB.SF, 11/8/84, "Autumn Landscape," 20 × 24 in.

MARSDEN HARTLEY
(1877-1943)

Marsden Hartley, a private man whose life seemed marked by restless discontent, is regarded today as one of the pioneers of American modern art.

Hartley was born in Lewiston, Maine in 1877. Artistically precocious, he left his native state at age 15 to study under a scholarship at the Cleveland Institute of Art.

In 1898, Hartley went to New York City, where he attended the Chase School. In 1900, he enrolled at the National Academy of Design, studying under Edgar Ward and F.J. Dillman.

During summers, Hartley returned to Maine to paint. Departing from the tradition of naturalism, he rendered the state's mountainous landscape in the post-impressionist "stitch" style of Giovanni Segantini.

These landscapes were first exhibited in 1909 in a one-man show at Alfred Stieglitz's "291" Gallery. In addition to giving Hartley his first exposure, the influential Stieglitz introduced the artist to European modernism. With the help of Arthur B. Davies, Stieglitz financed Hartley's first trip abroad in 1912.

Hartley remained in Europe for three years. In France, he experimented with cubism and fauvism. Then, during two years in Germany, Hartley was influenced by Franz Marc and Kandinsky and exhibited with the Blaue Reiter group. As exemplified by *Painting Number 5* (1914 to 1915, Whitney Museum of American Art), Hartley's works in

(Lobster on Black Background), 1940-1941, 22 x 28 in., signed l.r. Courtesy of National Museum of American Art, Smithsonian Institution, Gift of Mr. Henry P. McIlhenny.

those years were often vivid and mystical, symbolically incorporating motifs from German military life.

Shortly after his return to America, Hartley abruptly turned away from symbolism and abstraction, choosing instead a more cubistic, straightforward style.

Hartley spent the summers of 1918 and 1919 in New Mexico, where he painted representational landscapes. This area, like parts of New England, appealed to Hartley because of its mountains and its intense coloration—two of the artist's favorite pictorial elements.

In 1921, the restless Hartley returned to Europe for 10 years. During that time, he renounced expressionism in art and painted vivid landscape recollections of New Mexico. These paintings show the influence of Albert Pinkham Ryder, whom the artist had long admired. Ryderesque overtones would, in fact, be present in several of Hartley's later works, including *Northern Seascape* (1936 to 1937, Milwaukee Art Center).

After a time in the South of France, where Hartley was strongly influenced by Cezanne, the artist turned his attention almost exclusively to New England subjects. Many believe that Hartley's work during the last 12 years of his life reflects a style exclusively his own. These paintings—still lifes, mountains and rocky coasts—combine deep, expressionistic emotion with blocky, direct forms and intense colors. Hartley died in Maine in 1943.

PUBLIC COLLECTIONS
Barnes Foundation, Philadelphia
Brooklyn Museum
Cleveland Museum of Art
Delaware Art Museum, Wilmington
Metropolitan Museum of Art, New York City
Milwaukee Art Center
Museum of Fine Arts, Boston
Museum of Modern Art, New York City
Museum of New Mexico, Santa Fe
Philadelphia Museum of Art
Phillips Collection, Washington, D.C.
Whitney Museum of American Art, New York City

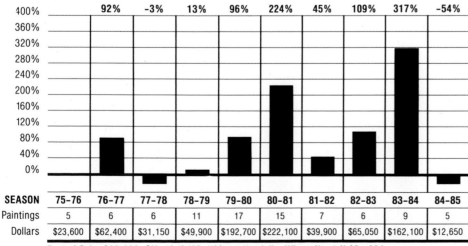

10-Year Average Change From Base Years '75-'76: 84%

	92%	-3%	13%	96%	224%	45%	109%	317%	-54%

SEASON	75-76	76-77	77-78	78-79	79-80	80-81	81-82	82-83	83-84	84-85
Paintings	5	6	6	11	17	15	7	6	9	5
Dollars	$23,600	$62,400	$31,150	$49,900	$192,700	$222,100	$39,900	$65,050	$162,100	$12,650

Record Sale: $80,000, CH, 12/9/83, "Mount Katahdin, Winter No. 1," 22 x 28 in.

JOSEPH STELLA
(1877-1946)

Joseph Stella was born in Muro Lucano, near Naples, Italy. Brought to New York City in 1896, he enrolled in the Art Students League in 1897. Later, in 1898, he studied under William Merritt Chase at the New York School of Art.

Stella's early studies of slum life are Rembrandtesque in technique and attitude. His series on Pittsburgh in 1908 consists of grimly realistic drawings of steelworkers, mills and immigrants.

In 1909, the artist traveled to Europe, where he was greatly influenced by the avant-garde in France and Italy. He studied Venetian techniques with impressionist Antonio Mancini, reinforcing his interest in rich atmospheric coloration. Later, his palette lightened considerably after his exposure to Cezanne and cubism.

Stella returned to New York City in time to participate in the 1913 Armory Show. *Battle of Lights, Coney Island* (1913, Yale University), one of the earliest American works influenced by the Italian futurist artists, owes much to Gino Severini. Through an almost abstract overlaying and overcrowding of detail and color, it depicts the tumult and vitality of a seaside resort in high season. Said the artist, "When in 1912 I came back to New York I was thrilled to find America so rich with so many motives to be translated into a new art."

Obsessed with the noise, light and speed of the urban environment, as well as its transformation by industrial technology, Stella became more stylistically dynamic. *Brooklyn Bridge* (1919, Yale University) recreated the landmark as a "shrine containing all the efforts of the new civilization of America." Meticulously drawn, it allows the beholder to view the bridge from the spanning cables, looking down through a glowing play of light and dark.

In the next few years, Stella's roman-

The Ox, ca. 1929, 18⅞ x 18⅞ in., signed l.r. Courtesy of Bayly Museum of the University of Virginia, Charlottesville, Virginia.

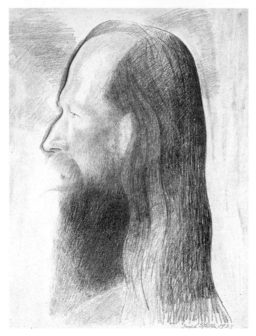

Profile of a Head, 1933, signed l.r. Courtesy of The Pennsylvania Academy of the Fine Arts, Philadelphia, Pennsylvania.

tic view of America cooled and he painted more realistic views in calmer patterns. A series, "New York Interpreted" (1920-1922, Newark Museum), depicts skyscrapers and bridges as decorative, rather than dynamic, emblems of the metropolis.

In the early 1920s, the artist began the first of about 30 collages, using discarded objects and pieces of cardboard. Inspired by Duchamp and the Arensberg circle, these works present another side of the city scene—its unnoticed discards,

representing the detritus of human existence.

In the mid-1920s, Stella again changed direction. His themes ranged from the mystical to the commonplace, set in urban and tropical locales. Often it was charged with religious and sexual symbolism.

Stella died in 1946.

SEASON	75-76	76-77	77-78	78-79	79-80	80-81	81-82	82-83	83-84	84-85
Paintings		2	4	7	16	11	5	9	16	6
Dollars		$5,400	$24,700	$11,175	$65,600	$38,500	$10,450	$32,100	$68,450	$15,350

Record Sale: $32,500, SPB, 10/25/79, "Telegraph Poles with Buildings," 36 × 30 in.

PAUL DOUGHERTY
(1877-1947)

Paul Dougherty was a highly regarded landscape artist of the early twentieth century. His impressionistic and energetically drawn seascapes gained him a reputation as the greatest American marine painter of his time, the heir to Winslow Homer.

Paul Dougherty was born in 1877 in Brooklyn, the son of a prominent lawyer. He earned a law degree from the New York Law School in 1898, before embarking on his career as an artist. In 1900, he gained his family's permission to study art in Europe, and spent the next five years studying in the museums of Paris, London, Florence, Venice and Munich.

Returning to the United States, Dougherty won critical praise in New York City, and was elected to the National Academy of Design in 1907. For the next 20 years, Dougherty enjoyed an enviable career, winning medals at major exhibitions in New York, Pittsburgh and San Francisco. In addition, he took extensive painting trips to England, France, Switzerland, Greece, Puerto Rico, Japan, China, Korea and the Philippines.

Although Dougherty's paintings show some influence of the French impressionists, they are nonetheless notable for their rugged naturalism, and for their sensitivity to the changing moods of nature. In addition to his seascapes,

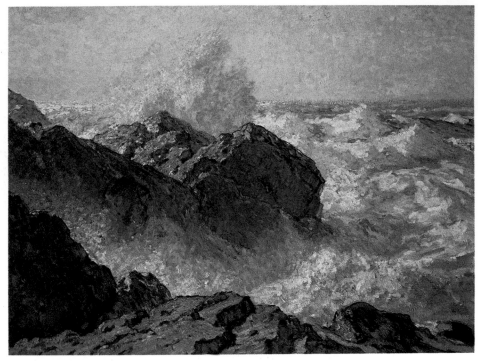

Rocks and Surf, 1919, 36⅛ x 48, signed l.l. Courtesy of John H. Garzoli Gallery, San Francisco, California.

Dougherty also executed some memorable still lifes, and many desert landscapes later in his career.

Dougherty lived and worked in Paris from 1920 to 1927, but returned to the United States in 1928, suffering from arthritis, which plagued him for the remainder of his career. From 1932 to 1942, he resided in Carmel, California, and he died in 1947 in Palm Springs.

MEMBERSHIPS
American Water Color Society
Century Association
Lotus Club
National Academy of Design
National Institute of Arts and Letters
Salmagundi Club

PUBLIC COLLECTIONS
Addison Gallery of American Art,
 Andover, Massachusetts
Carnegie Institute, Pittsburgh
Corcoran Gallery of Art, Washington, D.C.
Fort Worth Art Museum, Texas
Hackley Gallery, Muskegon, Michigan
Minneapolis Institute of Arts, Minnesota
Metropolitan Museum of Art, New York City
National Gallery of Art, Washington, D.C.
National Gallery of Art, Ottawa, Canada
St. Louis Art Museum, Missouri

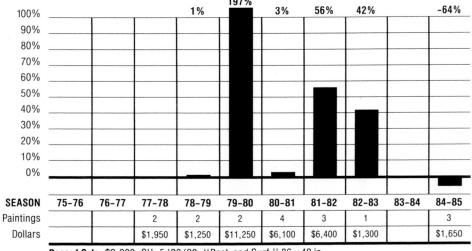

10-Year Average Change From Base Years '77-'78: 34%

	75-76	76-77	77-78	78-79	79-80	80-81	81-82	82-83	83-84	84-85
%			1%		197%	3%	56%	42%		-64%
SEASON	75-76	76-77	77-78	78-79	79-80	80-81	81-82	82-83	83-84	84-85
Paintings			2	2	2	4	3	1		3
Dollars			$1,950	$1,250	$11,250	$6,100	$6,400	$1,300		$1,650

Record Sale: $9,000, CH, 5/22/80, "Rock and Surf," 36 × 48 in.

EDMUND GREACEN
(1877-1949)

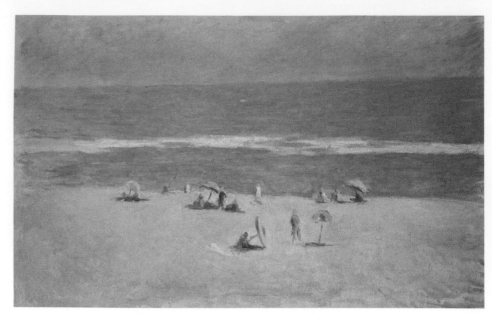

Beach Scene, 26 x 35½ in. Photograph courtesy of Balogh Gallery, Inc., Charlottesville, Virginia.

Edmund Greacen, a notable American impressionist painter, also achieved prominence as a teacher and as the founder of two New York City art schools.

Born in New York City in 1877, Greacen received his bachelor's degree from New York University. After a trip abroad—arranged by his family to distract him from joining the Spanish-American War—Greacen returned to New York. There, he studied at the Art Students League, and under William Merritt Chase and Frank V. DuMond at the Chase School.

Greacen's second European trip, in 1907, most affected the artist's mature style. French art at that time was strongly influenced by impressionism, and for two years, Greacen and his wife rented a house in Giverny, the village which served as home and artistic inspiration for Monet. While there, Greacen apparently met the aging French artist on only one occasion.

As seen in his *The Farm, Giverny* (1907, Janet Fleisher Gallery, Philadelphia), Greacen's paintings, while impressionist in tone, are also highly individual. Using only primary colors and no black, his work is high-key with an almost stucco surface quality.

Although Greacen painted primarily landscapes and figure paintings of young women, he did occasional portraits. In these, tones are muted and the attention is given more to mass than to detail.

Returning to New York City, Greacen had his first one-man exhibition and began his long and influential association with artistic organizations.

In 1924, Greacen founded the Grand Central School of Art; he served as its head for the next 20 years. In addition, he participated in founding the Grand Central Art Galleries and the League of American Artists. Greacen was also a member of the summer colony at Old Lyme, Connecticut.

In 1948, Greacen moved to White Plains, New York, where he died a year later.

MEMBERSHIPS
Allied Art Association
American Water Color Society
National Academy of Design
Painters and Sculptors Gallery Association
Salmagundi Club
Society des Artistes Independents

PUBLIC COLLECTIONS
Butler Art Institute, Youngstown, Ohio
National Arts Club, New York City
Newark Museum, New Jersey

SEASON	75-76	76-77	77-78	78-79	79-80	80-81	81-82	82-83	83-84	84-85
Paintings								2		
Dollars								$22,000		

Record Sale: $11,000, CH, 6/3/83, "La Roche," 26 × 31 in.

738

WALT KUHN
(1877-1949)

Walt Kuhn is known today as a painter of unusual vigor, but he devoted as much as half his time to his variety of other pursuits. He loved the circus and theatre, and designed sets and costumes for many shows. He designed interiors for railway cars. And he advised the rich on collecting paintings.

It is the work of his later years, however—the bold, sometimes garish paintings of clowns and other performers, and still lifes, heavily influenced by Cezanne—that form the bedrock of his reputation.

Born William Kuhn in Brooklyn in 1877, he studied at the Brooklyn Polytechnic Institute for a year, opened a bicycle shop and barnstormed as a bike racer at county fairs for several summers.

In 1899, he went to San Francisco and worked as a cartoonist. It was here that he started signing his name as "Walt," possibly in homage to Walt Whitman.

From 1901 until 1903 he studied in Europe, first at the Academie Colarossi in Paris and then in Munich. From these years, however, only Cezanne's harsh black outlines and planes of color had a lasting effect on Kuhn.

Back in New York, he studied at the Artists' Sketch Class, making his living as a cartoonist for *Life, Puck* and other popular magazines. In 1912, he became executive secretary for the New York City Armory Show, which was being planned for the following year. Kuhn

The White Clown, 1929, 40¼ x 30¼ in., signed l.c. Courtesy of National Gallery of Art, Washington, D.C., Gift of the W. Averell Harriman Foundation in memory of Marie N. Harriman. ©Kuhn/VAGA, New York 1985.

went to Europe, and with Arthur B. Davies, the show's director, selected the radical new art that was to create a sensation when the show opened.

From 1912 to 1920, Kuhn advised John Quinn, a wealthy art patron, on purchases of French art. From 1930 on, he served the same function for Mrs. Averell Harriman, who collected painting with her husband and operated her own gallery. He also advised Lillie P.

Bliss, whose collection later formed the nucleus of the Museum of Modern Art.

Between 1918 and 1923, Kuhn painted an imaginary history of the West, a series of 20 paintings of cowboys and Indians, which showed vestiges of fauvism and German expressionism.

The White Clown (1929, National Gallery of Art) signaled the emergence of Kuhn's mature style. It was the first of many depictions of sad-eyed performers, done in bold planes of strident colors, heavily outlined against dark backgrounds. Even his critics admired them.

Kuhn became increasingly eccentric in his later years. Only a year before his death in 1949, he suffered a breakdown and had to be placed in an institution.

PUBLIC COLLECTIONS
Art Institute of Chicago
Brooklyn Museum
Cincinnati Art Museum
Detroit Institute of Arts
Los Angeles County Museum of Art
Metropolitan Museum of Art, New York City
Museum of Fine Arts, Boston
Museum of Modern Art, New York City
Phillips Collection, Washington, D.C.
Whitney Museum of American Art,
 New York City

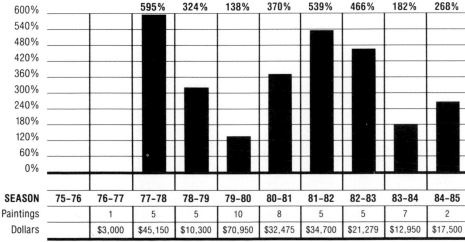

10-Year Average Change From Base Years '76-'77: 320%

| | 595% | 324% | 138% | 370% | 539% | 466% | 182% | 268% |

SEASON	75-76	76-77	77-78	78-79	79-80	80-81	81-82	82-83	83-84	84-85
Paintings		1	5	5	10	8	5	5	7	2
Dollars		$3,000	$45,150	$10,300	$70,950	$32,475	$34,700	$21,279	$12,950	$17,500

Record Sale: $32,500, PB, 3/22/78, "Lavender Plumes," 40 x 30 in.

OLAF CARL SELTZER
(1877-1957)

Many years after the death of his friend and mentor, Charles Russell, one of the foremost painters of the old West, Olaf Carl Seltzer came to be recognized as an important Western painter in his own right. Although he did not have Russell's charismatic personality or his colorful reputation as a cowboy-turned-painter, Seltzer was very much a painter in Russell's style. He used color subtly, and his work shows decisiveness of line.

While the need to work with a magnifying glass impaired his vision in later life, a series of miniatures of Montana history that he painted for an Eastern collector were remarkable because of the amount of detail and the sense of space that he managed to compress into the four-by-six-inch paintings.

Seltzer was born in Copenhagen, Denmark in 1877. His early talent for drawing earned him admission as a special student to the Technical Institute of Copenhagen when he was only 12. His father died shortly afterward, however, and his mother emigrated with her family to Great Falls, Montana.

Seltzer, still only in his mid-teens, worked briefly as a cowboy, and then was hired as an apprentice machinist in the Great Northern Railroad yards in Great Falls. In time he became a locomotive repairman.

He never gave up his love of sketching, however. When he had the time, he would make pen-and-ink drawings of what he saw. A Canadian who liked his work encouraged him to try painting in oils. And Russell, who was a neighbor, also encouraged him. The two sometimes took trips together to paint.

It was not until 1921, when he was laid off by the railroad in the post-war recession, that Seltzer finally tried full-time painting as a way to make a living. His success surprised and delighted him.

When Russell died in 1926, Seltzer traveled to New York to complete several

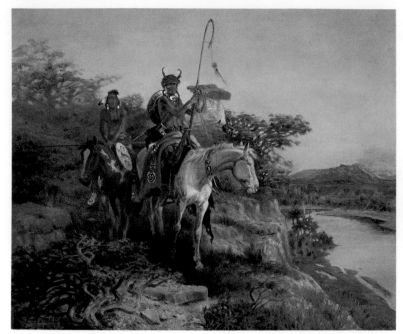

Indian Scouts by the Sunset River, 25 x 29 in., signed l.l. Courtesy of Vose Galleries of Boston, Inc., Massachusetts.

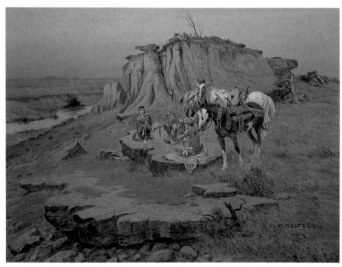

The Medicine Smoke, 28 x 36 in., signed l.r. Courtesy of John H. Garzoli Gallery, San Francisco, California.

of the older man's painting commissions. He stayed for two years, visiting museums and galleries to study the techniques of other artists, and making contacts in connection with his own work.

In 1930, Philip Cole, a wealthy collec-

tor and art patron in Tarrytown, New York, commissioned Seltzer to paint 100 miniatures on life in the early West. The painstaking project so weakened Seltzer's eyes that afterward he could paint only in bright light.

Despite the impairment, Seltzer continued to work, and by the time of his death in Great Falls in 1957 he had completed more than 2,500 paintings.

PUBLIC COLLECTIONS
Gilcrease Institute of Art, Tulsa, Oklahoma
Masonic Library, Helena, Montana
Montana Historical Society, Helena

SEASON	75-76	76-77	77-78	78-79	79-80	80-81	81-82	82-83	83-84	84-85
Paintings				4	11	16	12	6	9	2
Dollars				$80,500	$155,000	$166,100	$200,650	$40,650	$74,400	$16,000

Record Sale: $55,000, SPB, 10/25/79, ''Roping a Steer,'' 20 × 30 in.

JAMES MONTGOMERY FLAGG
(1877-1960)

Dempsey-Willard Fight, 1944, 72 x 216 in., signed l.l. Courtesy of National Portrait Gallery, Washington, D.C., Gift of Mr. and Mrs. Jack Dempsey.

James Montgomery Flagg was one of the most prolific illustrators and caricaturists of his time, frequently turning out a finished illustration in a single day. Humor and satire were his forte. He worked in all media except pastel, which he disliked, but was especially adept at pen and ink.

Flagg was born in Pelham Manor, New York in 1877. At age 12 he sold his first drawings to *St. Nicholas,* a magazine for children. By the time he was 14, he was a regular contributor to such popular magazines as *Life* and *Judge.*

He submitted his drawings for admission to the school of the National Academy of Design, but was turned down. Instead he spent four years at the Art Students League, followed by two years of study in England and France, selling his work all the while.

Flagg, never a modest man, later proclaimed that his six years of study had been a waste of time. "There are no art teachers," he said. "Art cannot be taught . . . I had to be an artist—I was born that way."

Year after year he illustrated stories for nearly every leading magazine in America, many of them written by noted authors. Flagg loved the sophisticated life of New York where famous artists, writers and entertainers were his friends. He painted portraits of many of these celebrities.

Of all his work, however, Flagg is best remembered for a World War I recruiting poster. In it, a very businesslike Uncle Sam, for whom Flagg used himself as the model, is pointing directly at the observer under the headline, "I Want You." Four million of the posters were printed during that war and another two million during World War II.

For most of the first half of the twentieth century, Flagg was the toast of the town, surrounded by beautiful women and his famous friends. In old age, however, denouncing modern art, he drifted into obscurity. Ill and with failing eyesight, he died in 1960.

MEMBERSHIPS
Artists' Guild of the Authors League of America
Lotos Club
Society of Illustrators

PUBLIC COLLECTIONS
Smithsonian Institution, Washington, D.C.

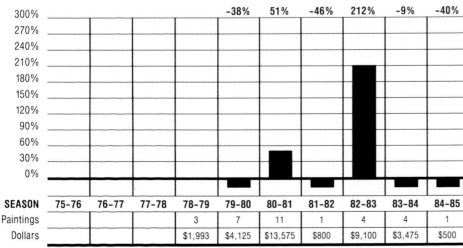

10-Year Average Change From Base Years '78-'79: 19%

				-38%	51%	-46%	212%	-9%	-40%
300%									
270%									
240%									
210%									
180%									
150%									
120%									
90%									
60%									
30%									
0%									

SEASON	75-76	76-77	77-78	78-79	79-80	80-81	81-82	82-83	83-84	84-85
Paintings				3	7	11	1	4	4	1
Dollars				$1,993	$4,125	$13,575	$800	$9,100	$3,475	$500

Record Sale: $7,000, S.W, 10/3/82, "Uncle Sam and American Industry," 38 x 30 in.

MORRIS HALL PANCOAST
(1877-1963)

The paintings of impressionist Morris Hall Pancoast are almost all peaceful New England shore scenes and winter landscapes. Cape Ann and Rockport, Massachusetts were his favorite locations. In *Afternoon on Ipswich Bay* (date and location unknown), children play on mammoth rocks in the foreground, silhouetted against the horizontals of the water and the oblique vertical streaks of the cloudy sky. Judging by the dress a young girl wears, it appears to be the 1920s.

Pancoast was born in Salem, New Jersey in 1877. His father was a partner in a Salem glassworks. Morris attended the Salem Friends' School and the Salem Public Schools, and for two years worked as a shipping clerk.

A turning point came in 1895, when he took a job as a bookkeeper and assistant cashier with the *Philadelphia Public Ledger.* He met illustrator Frederick R. Gruger, who encouraged him to study art.

Despite his studies at night at Drexel University and the Pennsylvania Academy of the Fine Arts, Pancoast felt frustrated. He was tired of his job at the paper, and he could not get work in an art department because of inexperience.

In 1902, he took every penny he had out of the bank and went to Europe. At the Academie Julien in Paris, he studied with Jean Paul Laurens. By the end of three years, after travel throughout Europe, he returned to Philadelphia and got a job with the art department of the *Philadelphia Inquirer.*

By the 1920s, Pancoast and his wife had moved to New York City, where he worked as a freelance illustrator and painter. Pancoast's career was launched. His work was shown at the Pennsylvania Academy, the Brooklyn Museum and the National Academy of Design.

At Gloucester Harbor, 11¾ x 15½ in., signed l.l. Courtesy of Private Collection, Radnor, Pennsylvania.

Rockport Beach in Snow Storm, 28 x 32 in., signed l.l. Courtesy of Arvest Galleries, Inc., Boston.

After the economic crash of 1929, however, the lives of the Pancoasts changed. For about 20 years they wandered through Maine, Florida and Massachusetts, selling antiques. They settled in Cambridge, Massachusetts in 1945, and rented a small house, which Pancoast used as a gallery and studio; his wife operated a tearoom and antique shop.

Pancoast died in 1963.

MEMBERSHIPS
Connecticut Academy of Fine Arts
Gloucester Society of Artists
North Shore Arts Association
Pennsylvania Academy Society of Artists
Philadelphia Art Alliance
Philadelphia Sketch Club
Salmagundi Club

PUBLIC COLLECTIONS
J.B. Speed Art Museum, Louisville, Kentucky
Milwaukee Art Museum, Wisconsin
Municipal Art League, Williamsport, Pennsylvania
Museum of Fine Arts, Houston
Pennsylvania Academy of the Fine Arts, Philadelphia
Reading Public Museum and Art Gallery, Pennsylvania

(No sales information available.)

HOVSEP PUSHMAN
(1877-1966)

Hovsep Pushman was one of those rare artists whose work was appreciated by critics and collectors, and who enjoyed recognition and good fortune. In a 1932 one-man show at New York's Grand Central Art Galleries, the entire display of 16 Pushman paintings was sold before opening day's end.

Pushman, later a naturalized American citizen, was born in Armenia in 1877. At age 11, he held a scholarship at the Constantinople Academy of Art. By 17, he had gone to the United States and started teaching art in Chicago. He traveled for several years in China, immersing himself in oriental art and perhaps philosophy. He then studied in Paris under Lefebvre, Robert-Fleury and Dechenaud. He exhibited his work at the Salon des Artistes Francais in Paris, winning a bronze medal in 1914 and a silver medal in 1921. He also was awarded the California Art Club's Ackerman prize in 1918.

Pushman's artistic identity began to take shape after he opened his own studio in 1921. Robert-Fleury, upon seeing one of Pushman's early studio still lifes, advised the artist, "That painting is you."

Thereafter, Pushman's career was devoted to one subject, oriental mysticism, and one form, the still life. His paintings typically featured oriental idols, pottery and glassware, all glowing duskily as if illuminated by candlelight. They were symbolic, spiritual paintings,

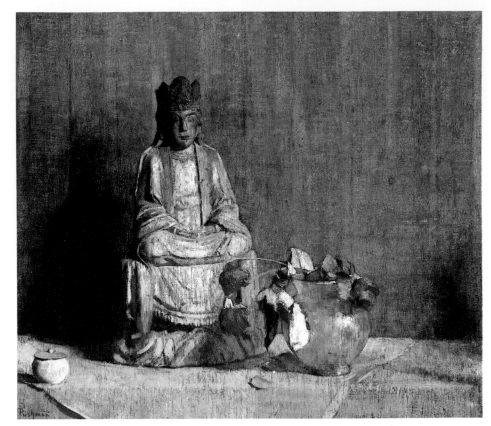

When Evening Comes, 20 x 23½ in., signed l.l. Courtesy of Grand Central Art Galleries, Inc., New York, New York.

and were sometimes accompanied by readings which help explain their allegorical significance. Most important, they were exquisitely beautiful, executed with technical precision. *When Twilight Comes* (date and location unknown) exemplifies the stunning beauty, mysterious mood and impeccable technique that made Pushman's work so highly respected.

Pushman died in 1966 in New York City.

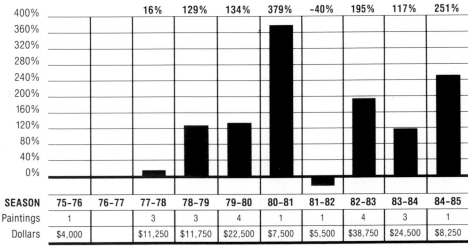

10-Year Average Change From Base Years '75-'76: 131%

	75-76	76-77	77-78	78-79	79-80	80-81	81-82	82-83	83-84	84-85
			16%	129%	134%	379%	-40%	195%	117%	251%
SEASON	75-76	76-77	77-78	78-79	79-80	80-81	81-82	82-83	83-84	84-85
Paintings	1		3	3	4	1	1	4	3	1
Dollars	$4,000		$11,250	$11,750	$22,500	$7,500	$5,500	$38,750	$24,500	$8,250

Record Sale: $20,000, HG.C, 11/14/82, "The Young Prince," 28 x 24 in.

743

FRANK EARLE SCHOONOVER

(1877-1972)

First-hand paintings and illustrations of the far North American frontier gained early recognition for Frank E. Schoonover in his long career as an artist, teacher and writer.

Born in 1877 in Oxford, New Jersey, Schoonover showed early drawing skill and an affinity for wilderness scenes developed during summers in the Pocono Mountains. He attended the Model School at Trenton, New Jersey, and was preparing for the Presbyterian ministry when he saw an advertisement for Howard Pyle's school of illustration. Schoonover promptly enrolled. In 1896, he began art studies at the Drexel Institute in Philadelphia, where Pyle taught.

After his first successful illustration commission in 1899, Schoonover opened his own studio in Wilmington, Delaware. It was near Pyle's studio at Chadds Ford, Pennsylvania, an area colonized by other artists who left Drexel with Pyle, including Maxfield Parrish and N.C. Wyeth.

In 1903, Schoonover made the first of two trips to Canada's Hudson Bay area, reaching his Indian subjects by snowshoe and dog-sled. During his second trip in 1911, he gathered material for articles on Indians and trappers for such magazines as *Harper's Weekly, Century, Collier's, Scribner's* and *McClure's.*

Later in 1911, he visited the Mississippi Bayou country for material for illustrations to Jean Lafitte, the Pirate of the Gulf for *Harper's.*

Schoonover was well known for his Western subjects. He also illustrated World War I subjects for the *Ladies Home Journal* and, from 1920 to 1930, illustrated a series of classic children's books.

In 1930, he experimented with stained glass, a new medium for him.

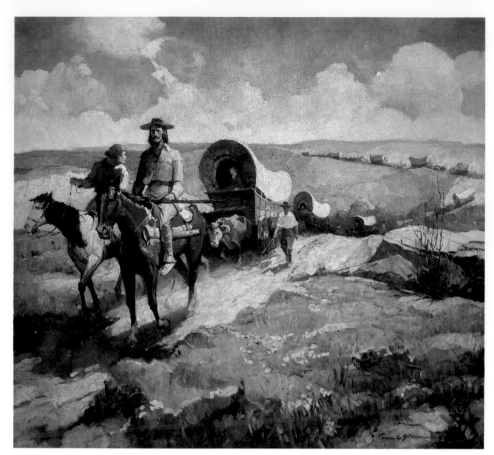

The Wagontrain, 1936, 50 x 54 in., signed l.r. Photograph courtesy of The Gerald Peters Gallery, Santa Fe, New Mexico.

Schoonover taught at the John Herron Art Institute in Indianapolis and at his own studio. In 1942, he opened an art school emphasizing landscape painting of local Brandywine Valley scenes.

Schoonover died in Trenton, New Jersey in 1972.

MEMBERSHIPS
Pennsylvania Academy of the Fine Arts, Philadelphia
Society of Illustrators
Wilmington Society of Fine Arts

PUBLIC COLLECTIONS
Wilmington Society of Fine Arts, Delaware

SEASON	75-76	76-77	77-78	78-79	79-80	80-81	81-82	82-83	83-84	84-85
Paintings	1		5	3	9	10	1	1	1	1
Dollars	$3,200		$31,000	$3,900	$28,750	$39,850	$7,250	$550	$2,600	$3,500

Record Sale: $14,000, SPB, 6/19/81, "Indians Wrestling," 36 × 30 in.

ELLING WILLIAM GOLLINGS
(1878-1932)

Elling William Gollings, known as Bill Gollings, was a Wyoming genre painter whose faithful representations of Old West scenes drew upon his own early experiences as a cowboy.

Gollings was born in Pierce City, Idaho in 1878. His early childhood was spent in Michigan, New York and Idaho. His family moved to Chicago when he was 12, but seven years later Gollings ran off to become a wandering cowboy and sheepherder in Nebraska and South Dakota. "I realized the cowboy days were about over and I longed to be a part of at least the last of it," he later said.

Although Gollings's formal education ended with the eighth grade, he had always been interested in art. As a youngster, he sketched horses on a slate and carved horses' heads out of laundry soap. He also studied Frederic Remington's drawings in *Harper's Weekly;* he admired Remington greatly and acknowledged his influence on his own work.

In 1903, Gollings began working with a set of mail-order paints. Several paintings sold, and he obtained a scholarship to the Chicago Academy of Fine Arts, where he studied briefly before returning to cowboy life in the Cheyenne reservation in Wyoming. Under the tutelage of Hans Kleiber, another Wyoming artist, he mastered the techniques of etching, and many of his etchings appeared on popular Christmas cards.

Gollings gave up ranch life in 1909, when he built a small studio in Sheridan, Wyoming. He continued to paint realistic Western scenes, signing them with the name "Gollings" and a pony-track symbol, until his death at age 54.

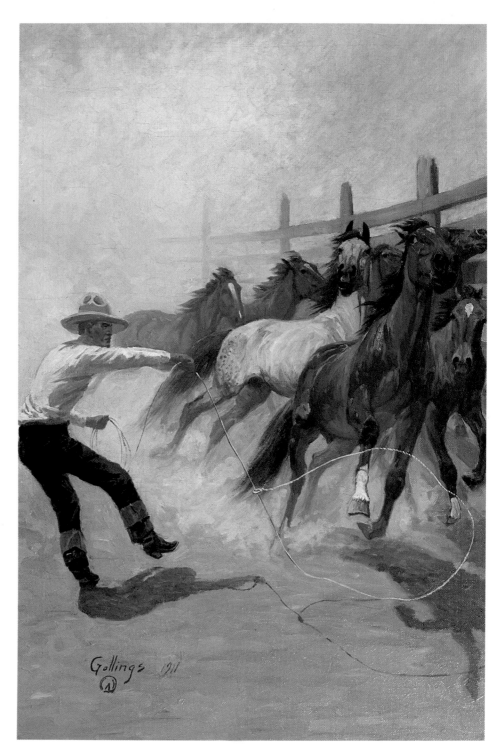

Front Footing, 1911, 29¾ x 20 in., signed l.l. Courtesy of Kennedy Galleries, New York, New York.

SEASON	75-76	76-77	77-78	78-79	79-80	80-81	81-82	82-83	83-84	84-85
Paintings			1	1	3	5	2	4	3	1
Dollars			$6,000	$4,000	$9,250	$24,273	$43,000	$47,750	$29,700	$3,250

Record Sale: $26,000, SPB, 6/2/83, "Roping a Steer," 30 × 23 in.

WILLIAM HERBERT DUNTON
(1878-1936)

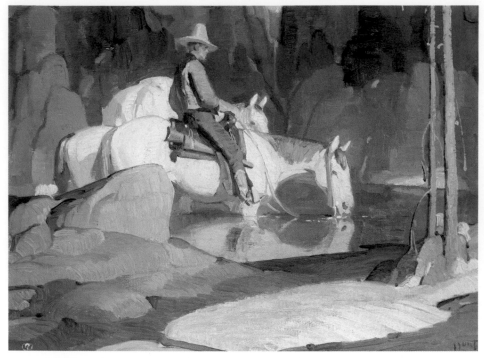

Mountain Pool, 1926, 12 x 16 in., signed l.r. Photograph courtesy of The Gerald Peters Gallery, Santa Fe, New Mexico.

William Herbert Dunton did not live to finish his autobiography, which he intended to be called *The Story of a Happy Life,* but the title is appropriate.

Dunton's career in the late 1890s and early 1900s gave him early prosperity as one of the country's most popular illustrators of Western cowboy and frontier life. He was able to retire at 43 to Taos, New Mexico, where he occupied himself with his greatest pleasures—hunting, camping, painting and writing.

Born in 1878 in Augusta, Maine, Dunton was a self-taught artist. As a boy, he roved the woods and fields with gun, sketchbook and pencil. He had already sold some of his drawings and stories to local periodicals by the time he quit school at 16.

By 1896, he had begun a successful commercial career in New York City. He illustrated sporting magazines and his own published stories. He produced innumerable covers for many major magazines, including *Saturday Evening Post, Woman's Home Companion* and *Harper's Weekly.* He also illustrated 49 books, among them several Zane Grey cowboy classics.

Dunton went West every summer, working on ranches, hunting and sketching from Oregon to Mexico. Every winter, he worked feverishly in New York City.

He attended some classes at Cowles Art School in Boston and the Art Stu-

dents League in New York City, where he studied with Fred Yohn, Frank Dumond and Ernest Blumenschein among others.

Blumenschein introduced Dunton to Taos. By 1912, at age 43, Dunton had accumulated a comfortable fortune. He

left the East and moved to Taos, where, with Blumenschein, he was one of six charter members of the Taos Society of Artists.

Dunton's Taos landscapes and cowboy portraits show his thorough training, but added a new technique of strong, patterned brushstrokes. He continued to write and illustrate his own stories, and began to make detailed lithographs of animals. In the 1920s, Dunton made three lunettes for murals in the Missouri State Capitol building in Jefferson City.

Dunton died at age 58 in 1936 in Taos.

MEMBERSHIPS
American Federation of Arts
Salmagundi Club
Society of Independent Artists
Springfield Art Association
Taos Society of Artists

PUBLIC COLLECTIONS
Harwood Foundation of the University of
 New Mexico
Missouri State Capitol, Jefferson City
Museum of New Mexico, Santa Fe
Witte Memorial, San Antonio, Texas

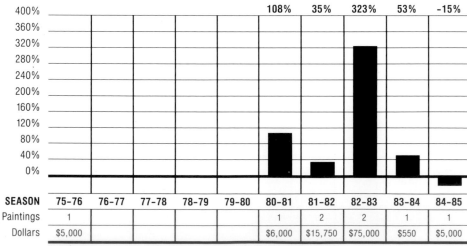

10-Year Average Change From Base Years '75-'76: 84%

						108%	35%	323%	53%	-15%

SEASON	75-76	76-77	77-78	78-79	79-80	80-81	81-82	82-83	83-84	84-85
Paintings	1					1	2	2	1	1
Dollars	$5,000					$6,000	$15,750	$75,000	$550	$5,000

Record Sale: $52,500, SPB, 6/2/83, "Riding the Range," 25 × 30 in.

WILLIAM HENRY DETHLEF KOERNER
(1878-1938)

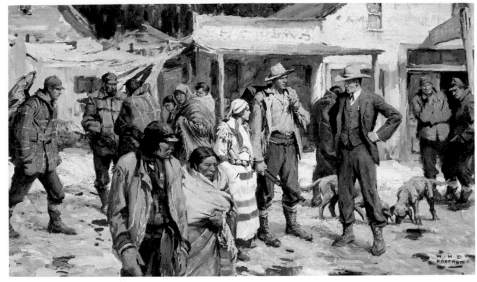

The Sandust Trail, 28 x 48 in., signed l.r. Photograph courtesy of The Gerald Peters Gallery, Santa Fe, New Mexico.

William Henry Dethlef Koerner's illustrations for Emerson Hough's Western stories in the *Saturday Evening Post* were the impetus for his development into one of America's most important Western illustrators of the 1920s.

Son of a poor, immigrant German shoemaker, Koerner settled with his family in Clinton, Iowa in 1880, when he was two years old. As a child, his only interest was in being an artist; drawing and painting were compulsive.

His first opportunity to earn money as an artist came when, with his father's encouragement, he went to Chicago at age 18. Hired by the *Chicago Tribune* as a staff artist, he earned $5 a week.

In Chicago, he attended the Art Institute and the Francis Smith Art Academy. Study at the Art Students League became possible when his family, interested in furthering the youth's career, moved to New York City in 1905. He studied there until 1907. He then moved to Wilmington, Delaware, where he was a pupil of Howard Pyle—known as the father of American illustration—until 1910.

Koerner built an outstanding reputation as a magazine and book illustrator. In 1919, when assigned to illustrate "Traveling the Old Trails" for the *Post* magazine series, his interest in the West blossomed. He diligently tackled the subject by researching in the New York Public Library and Museum of Natural History and taking his family on summer trips to Western states. Roughing it in an old log cabin in Southern Montana near an Indian reservation, he observed, sketched and collected artifacts. He also visited the Southwest and California.

After his death in Interlaken, New Jersey in 1938, his wife preserved his studio, with his hundreds of paintings, drawings, artifacts and sketchbooks intact until 1962. The "Koerner Studio Collection" was made available by his daughter, Ruth Koerner Oliver, for many prominent exhibitions. The works of the man called the "illustrator of the Western myth" are now in many private and museum collections.

MEMBERSHIPS
Art Students League

PUBLIC COLLECTIONS
Amon Carter Museum, Fort Worth, Texas
Delaware Art Museum, Wilmington
Gilcrease Institute of American History and Art, Tulsa
Montana Historical Society, Helena

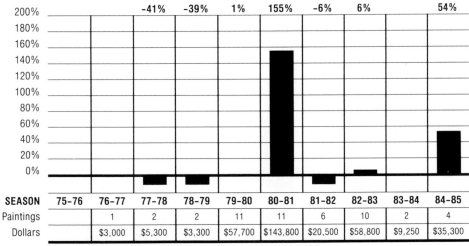

10-Year Average Change From Base Years '76-'77: 14%

	75-76	76-77	77-78	78-79	79-80	80-81	81-82	82-83	83-84	84-85
			−41%	−39%	1%	155%	−6%	6%		54%
SEASON	75-76	76-77	77-78	78-79	79-80	80-81	81-82	82-83	83-84	84-85
Paintings		1	2	2	11	11	6	10	2	4
Dollars		$3,000	$5,300	$3,300	$57,700	$143,800	$20,500	$58,800	$9,250	$35,300

Record Sale: $36,000, P.NY, 11/8/80, "The Hunters," 26 × 39 in.

CHARLES ROSEN
(1878-1950)

Car Shops, 1932, 20 x 40 in., signed l.l. Courtesy of Collection The Whitney Museum of American Art, New York, New York, Purchase.

Charles Rosen is best remembered as a second-generation painter of the New Hope School of American impressionism. For 17 years, he depicted views of the Delaware River and the rolling hills and woodlands of the Bucks County, Pennsylvania region.

Rosen was born in Reagantown, Pennsylvania in 1878. At age 16 he operated a photographic studio in West Newtown, Pennsylvania. In 1898, he moved to New York City to pursue a career in illustration, and studied with Francis Coates Jones at the National Academy of Design.

At the New York School of Art, Rosen studied under William Merritt Chase, well-known American impressionist painter and dynamic art instructor, and Frank Vincent Dumond. Later, Rosen followed Dumond to Old Lyme, Connecticut, a flouishing artists' colony of impressionist painters, including Childe Hassam, Emil Carlson, Ernest Lawson and John H. Twachtman. There, Rosen developed his first interest in landscape painting.

In 1903, Rosen married Mildred Holden and moved to New Hope, Bucks County, a Pennsylvania town and region known for its vernacular architecture and scenic landscape. He came to know many of the local artists, especially Edward Willis Redfield and Daniel Garber. In 1916, Rosen began exhibiting at Phillips Mill with "The New Hope Group." The Group was founded by William Langson Lathrop, and its original members included Rosen, Garber, Rae Sloan Bredin, Morgan Colt and Robert Spencer, whom Rosen had known as a student.

Rosen's best and most typical works are snow scenes of the Bucks County landscape and striking views of the Delaware River. Like those of Redfield and Walter Elmer Schofield, his paintings have been described as "virile" and "sincere," imparting the enduring monumentality and, at the same time, the capriciousness of nature.

While Rosen was greatly influenced by Redfield and Garber, his style remains distinctive when compared to his New Hope contemporaries. Following Redfield's example, Rosen took his large canvases outdoors to paint in fierce weather conditions; but he felt no commitment to record exactly the scene before him, often finishing his works in his studio.

These essentially realistic paintings were executed with a delicate and sensitive brushwork similar to Garber's. Rosen's technique called attention to the picture's surface and gave his works a flat, decorative quality.

By 1918, Rosen felt he had exhausted the formal possibilities of impressionism and gradually abandoned it for abstraction. That same year he joined the faculty of the Art Students League Summer School in Woodstock, New York, where he met young American modernists George Bellows, Eugene Speicher, Henry Lee McFee and Andrew Dasburg.

By 1920, Rosen had settled in Woodstock permanently, and resided there until his death in 1950. In 1922, along with McFee and Dasburg, Rosen operated his own painting school.

MEMBERSHIPS
National Academy of Design
National Arts Club

PUBLIC COLLECTIONS
Butler Institute of American Art, Youngstown, Ohio
City Art Museum, St. Louis
Delgado Museum, New Orleans
Morris Museum of Arts and Sciences, Morristown, New Jersey
Philadelphia Museum of Art, Pennsylvania
University of Michigan Museum, Ann Arbor, Michigan

SEASON	75-76	76-77	77-78	78-79	79-80	80-81	81-82	82-83	83-84	84-85
Paintings						1	1	1		3
Dollars						$5,250	$550	$550		$6,400

Record Sale: $5,250, SPB, 5/29/81, "Delaware, Winter," 32 × 40 in.

MAURICE STERNE
(1878-1957)

Born in Latvia, Maurice Sterne had a highly successful and adventurous career as a painter, sculptor and graphic artist. He emigrated to America in 1889 and settled in New York City. There he studied mechanical drawing at Cooper Union.

To earn a living, Sterne worked as a bartender on Third Avenue. His first commission was for a picture of a foaming stein with the words "5 cents" emblazoned upon it. From 1894 until 1899, Sterne studied at the National Academy of Design in New York City, where he took a weekly class in anatomy from Thomas Eakins.

Sterne first exhibited his oils in 1902. In 1904, he won a National Academy traveling scholarship and began the first of his many exotic trips. Living abroad until the approach of World War I, Sterne worked in Paris, where he was introduced to the art of Cezanne and Monet; in Italy, where he was influenced by the masters of the Italian Renaissance; and in Greece, where he became interested in sculpture. In 1911, he visited Egypt, India, Burma and Bali.

Sterne's style was greatly affected by his studies and travels. He admired Cezanne's structural sense, Piero Della Francesca's modeling, Whistler's use of color, and the classic use of line and composition. During his travels to the Orient, he adopted a somewhat flattened and faceted modern idiom, owing much to Gauguin's Balinese works. He was

Green Apples, 1924, 27½ x 34¾ in., signed l.l. Courtesy of the Museum of Fine Arts, Boston, Massachusetts. Gift of Edward Jackson Holmes.

widely known for his portrayals of India and Bali in this style.

In 1917, Sterne married heiress Mabel Dodge and moved to Taos, New Mexico with her. There he painted landscapes of the American Southwest. Highly praised as a draftsman, he held the first one-man exhibition accorded to an American by the Museum of Modern Art, in 1933.

In the 1940s, now married to a young dancer from Isadora Duncan's troupe, Sterne became ill. When he resumed painting during a summer in Provincetown, Massachusetts in 1945, his style changed dramatically. He produced luminous, richly colored seascapes that were far more spontaneous and intuitive than his previous work. Shortly before his death in 1957, he said, "Here in America, our great contribution to art is in our response to the moment. I try to do in painting what is quick and spontaneous—what happened."

10-Year Average Change From Base Years '76-'77: 171%

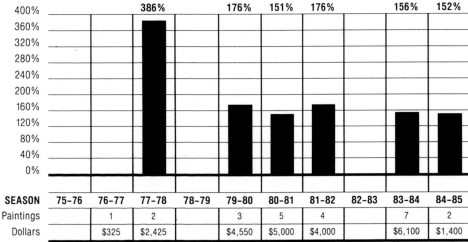

	386%			176%	151%	176%		156%	152%

SEASON	75-76	76-77	77-78	78-79	79-80	80-81	81-82	82-83	83-84	84-85
Paintings		1	2		3	5	4		7	2
Dollars		$325	$2,425		$4,550	$5,000	$4,000		$6,100	$1,400

Record Sale: $2,500, SPB, 1/30/80, "Climbing," 25 × 31 in.

IVAN GREGOREVITCH OLINSKY
(1878-1962)

Equally well known for his portraits and murals, Ivan Gregorevitch Olinsky was born in Russia in 1878. His father, a farmer, brought the family to the United States when Ivan was a small boy.

Olinsky's interest in art became apparent early and he studied at the National Academy from 1893 to 1898. In 1900, he began an association with the famous artist John La Farge that was an education in itself. For eight years, he served as La Farge's assistant, working on stained-glass windows and murals. From 1908 to 1911, Olinsky studied abroad in France and Italy.

Although his own work was, like that of many American artists of that time, influenced by Whistlerian impressionism, Olinsky's painting, particularly his figure compositions, also reflects his Russian origin. His work looks and feels like late-nineteenth-century Russian art. It evokes nostalgia, a kind of Slavicized Tennysonian mood, especially when he portrays women. This romantic-Victorian idealization of women is evident in works such as *Italian Madonna* (date and location unknown), an oil painting of a woman seated beside a statue of the Madonna. Her soft, middle-distance gaze and calm repose reaffirm the peace and contentment of the statue.

Olinsky's portraits are realistic, yet not photographic. Although he sometimes uses vivid color, the coherence of the portraits derives primarily from mass and modeling techniques. He painted leading educators, physicians and industrialists of his time. His most penetrating portrait is of La Farge.

A revered teacher, Olinsky influenced art students when he taught at the National Academy of Design, the Art Students League and the Grand Central Art School, all in New York City. He died in New York in 1962 at age 84.

The Farmer Roscoe, 44 x 36 in., signed l.r. Courtesy of Arvest Galleries, Inc., Boston.

MEMBERSHIPS
American Federation of Arts
Architectural League of New York
Artists' Aid Society
Artists of America
Lotos Club
National Academy of Design
National Arts Club
National Society of Mural Painters
Salmagundi Club

PUBLIC COLLECTIONS
Art Institute of Chicago
Butler Institute of American Art,
 Youngstown, Ohio
Dallas Art Association
Detroit Institute of the Arts
Metropolitan Museum of Art, New York City
Montclair Museum of Art, New Jersey
National Academy of Design, New York City
National Arts Club of New York
Norfolk Art Museum, Virginia
Omaha Society of Fine Arts
St. Thomas Lutheran Church, New York City

SEASON	75-76	76-77	77-78	78-79	79-80	80-81	81-82	82-83	83-84	84-85
Paintings								2	1	1
Dollars								$32,550	$3,000	$2,000

Record Sale: $32,000, CH, 6/3/83, "The Red Coat," 26 × 21 in.

JEAN MacLANE
(1878-1964)

Jean MacLane worked primarily as a portraitist; even her still lifes and street scenes have strong elements of portraiture. She employed an impressionistic style, characterized by its skillful use of white and by its emphasis on decorative form.

MacLane was born in 1878 in Chicago. She studied under John Vanderpoel at the Art Institute of Chicago, from which she graduated in 1897, and then under Frank Duveneck in Cincinnati. Arriving in New York City around 1900, she became a pupil of William Merritt Chase.

In 1905, MacLane married fellow painter John Christen Johansen, whom she had known since their student days, and they set up adjoining studios in New York City. They summered in Stockbridge, Massachusetts, and often visited Europe.

MacLane's early work reflects much of the influence of Duveneck, particularly the dramatic realism he had acquired during his studies in Munich, as in *Park Bench, Washington Square* (date and location unknown), which was painted soon after MacLane's arrival in New York City. *Boy with Goblet* (1907, location unknown) mirrors Duveneck's admiration for Franz Hals.

With a few exceptions, such as the portrait of actor William Gillette for the American Academy and Institute of Arts and Letters, MacLane painted women and children. Her paintings generally suggest freshness and spontaneity, often through the presence of water. She executed many paintings of her own son and daughter.

In 1912, MacLane and her husband were among the 27 artists who founded the National Association of Portrait Painters. She continued to paint until World War II.

MacLane died in 1964 in New Canaan, Connecticut.

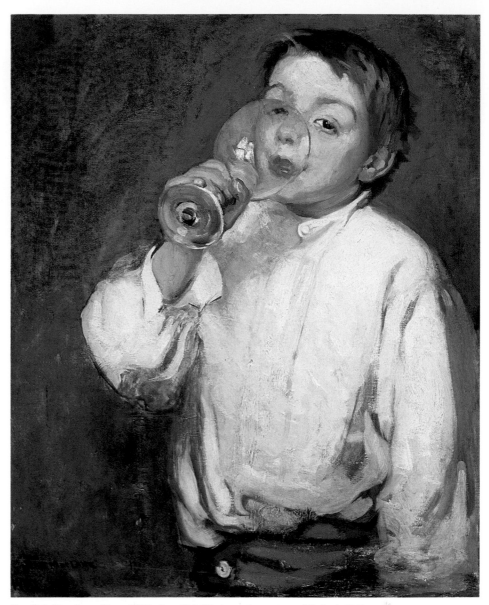

Boy Drinking from Glass, 1887, signed l.l. Photograph courtesy of Balogh Gallery, Inc., Charlottesville, Virginia.

MEMBERSHIPS
American Academy and Institute of Arts
 and Letters
National Academy of Design
National Art Club
National Association of Portrait Painters

PUBLIC COLLECTIONS
Art Institute of Chicago
Museum of Art, Toledo, Ohio
National Gallery of Art, Washington, D.C.
San Antonio Museum, Texas
Syracuse Art Museum, New York

(No sales information available.)

ABRAHAM WALKOWITZ
(1878-1965)

Abraham Walkowitz was one of the first generation of American modernists. Although he experimented with several different styles and subjects, he is best known for his drawings of New York City and of dancer Isadora Duncan; they combine elements of geometric abstraction with an emphasis on the expression of motion through line.

Walkowitz was born in Tyumen, Siberia and emigrated to the United States with his mother around 1889. Settling in Brooklyn, Walkowitz studied painting and etching at the National Academy of Design from 1898 to 1900. He served as an art instructor at the Educational Alliance from 1900 until 1905.

In 1906, Walkowitz traveled to Paris, studying briefly at the Academie Julien, where he was a classmate of Max Weber. Through Weber, Walkowitz was introduced to the artistic circle of Leo and Gertrude Stein, and became acquainted with the works of painters such as Cezanne, Matisse, Rousseau and Picasso.

In 1907, Walkowitz returned to New York City, where he was one of the first painters to promote modern art. He had his first one-man show at the Haas Gallery in 1908. From 1912 to 1917, he exhibited regularly at Alfred Stieglitz's Photo-Secession Gallery. His work was included in the 1913 New York Armory Show and the 1916 Forum Exhibition.

Stylistically, Walkowitz's paintings included fauvist-inspired compositions of people strolling in parks and woods; futuristic paeans to New York City skyscrapers; fluid, dance-inspired improvisations; and works of social realism, painted during the 1920s and 1930s.

By the mid-1930s, failing eyesight greatly curtailed Walkowitz's painting. Nonetheless, he remained active in the New York City art scene throughout the 1940s and 1950s. His work was the subject of a major retrospective at the Brooklyn Museum in 1939. The artist died in Brooklyn in 1965.

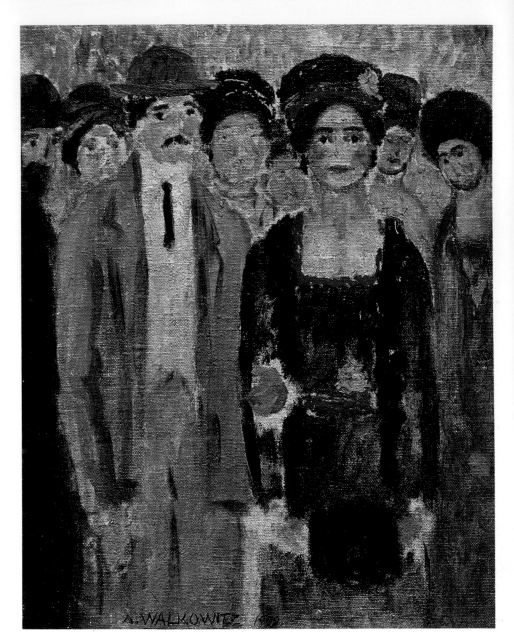

In the Street, 1909, 14⅛ x 11⅛ in., signed l.l. Courtesy of Hirshhorn Museum and Sculpture Garden, Smithsonian Institution.

SEASON	75-76	76-77	77-78	78-79	79-80	80-81	81-82	82-83	83-84	84-85
Paintings				5				11	6	2
Dollars				$4,375				$16,363	$7,100	$1,000

Record Sale: $2,750, SPB, 6/23/83, "Fishermen in Boat," 26 × 40 in.

IRA DIAMOND GERALD CASSIDY
(1879-1934)

Gerald Cassidy excelled in two artistic careers: he was considered an important lithographer, and his painting was recognized as well.

Born in Cincinnati in 1879, Cassidy won his first drawing award from that city's Mechanic Institute when he was 12 years old. The boy was studying at the time under painter Frank Duveneck. After moving to New York City in his late teens, he studied briefly at the National Academy of Design and at the Art Students League, while working as art director for a city lithographer.

Threatened with tuberculosis, Cassidy was forced to move to the warmer, drier climate of New Mexico when he was 20. He earned his living initially by painting pictures of Indians and the Southwest for postcard reproductions. Though largely decorative, these drawings were nonetheless distinctive and stylistically sophisticated.

Cassidy moved to Denver after his health improved, establishing a national reputation as a lithographer by working on magazine illustrations, murals, posters and advertisements.

In 1912, Cassidy returned to New Mexico and set up a studio in Santa Fe. As a painter, he was perhaps best known for his small paintings and the sketches he executed on his frequent forays into Indian country. However, his highest critical acclaim was gained in 1915 when he was awarded a gold medal at the Panama-California International Exposition for his murals at the San Diego Indian Arts Building.

Cassidy died in Santa Fe in 1934.

PUBLIC COLLECTIONS
Freer Collection, Detroit
Museum of New Mexico, Santa Fe
San Diego Museum, California

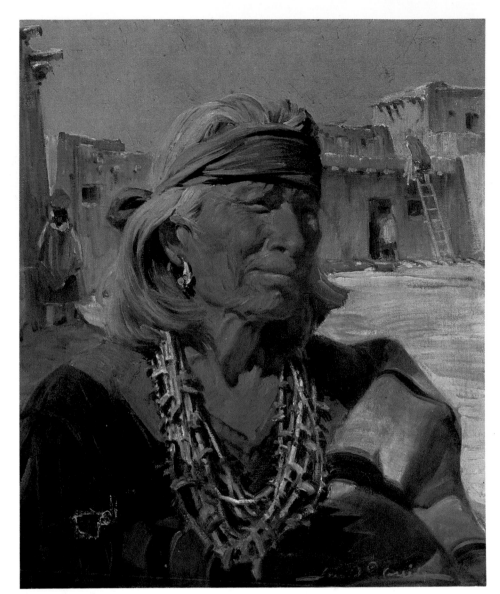

High Cacique of Zuni, 1924, 24⅛ x 20¼ in., signed l.r. Courtesy of National Museum of American Art, Smithsonian Institution, Bequest of Victor J. Evans.

SEASON	75-76	76-77	77-78	78-79	79-80	80-81	81-82	82-83	83-84	84-85
Paintings					1	2	2	1		3
Dollars					$5,500	$8,500	$9,500	$12,000		$21,700

Record Sale: $19,000, CH, 12/7/84, "Pueblo Gossips," 20 × 16 in.

ROBERT SPENCER
(1879-1931)

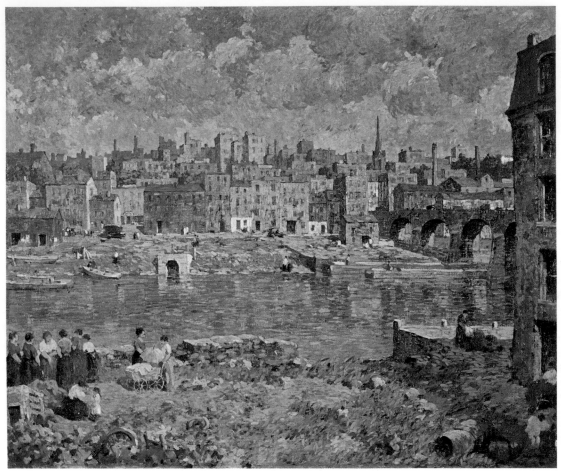

The Other Shore, 30⅛ x 36⅛ in., signed l.r. Courtesy of National Museum of American Art, Smithsonian Institution, Bequest of Henry Ward Ranger through the National Academy of Design.

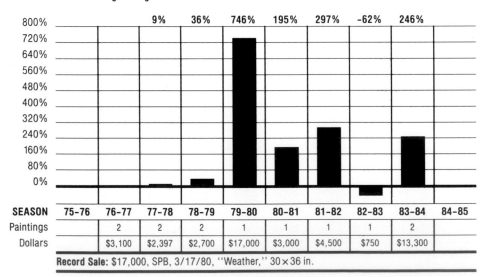

10-Year Average Change From Base Years '76-'77: 183%

		9%	36%	746%	195%	297%	-62%	246%	

SEASON	75-76	76-77	77-78	78-79	79-80	80-81	81-82	82-83	83-84	84-85
Paintings		2	2	2	1	1	1	1	2	
Dollars		$3,100	$2,397	$2,700	$17,000	$3,000	$4,500	$750	$13,300	

Record Sale: $17,000, SPB, 3/17/80, "Weather," 30 × 36 in.

Robert Spencer was the only member of the New Hope School of American impressionism who concentrated on painting the local Bucks County, Pennsylvania architecture instead of the rural landscape. His concern for the region's working class led him to depict their dilapidated tenements and the old stone mills they worked in.

Born in Harvard, Nebraska in 1879, Spencer was the son of a Swedenborgian clergyman who later edited religious essays written by American painter George Inness. The Spencer family constantly moved from parish to parish in Missouri, Virginia and New York.

Spencer studied art at the National Academy of Design in New York City from 1899 to 1901. His teachers included Francis Coates Jones, George Maynard and Robert Blum. From 1903 to 1905, he attended the New York School of Design. His instructors included such distinguished artists as impressionist William Merritt Chase, Robert Henri and Frank Dumond.

While living in New York City, Spencer met Charles Rosen and Rae Sloan Bredin, both of whom later moved to Bucks County and became affiliated with the New Hope School.

In 1909, Spencer studied independently with Daniel Garber, a renowned New Hope impressionist painter and popular instructor at the Pennsylvania Academy of the Fine Arts in Philadelphia. Later that summer Spencer lived with Garber at Cuttalossa Creek in Bucks County before moving to the Huffnagle Mansion, once home of an ambassador of Spain. Spencer renovated the mansion's ballroom into his studio, and lived there until 1914, when he moved to Rabbit Run, just outside of New Hope, with his wife Margaret Fulton.

Spencer's greatest influences were Robert Henri and Daniel Garber. His unique style combines Henri's socially conscious subject matter with the technical advances in American impressionism exemplified by Garber.

Especially noted for his series of old Bucks County mills painted in 1913, Spencer portrayed the depressed working and living conditions of the local residents. In depicting their crowded

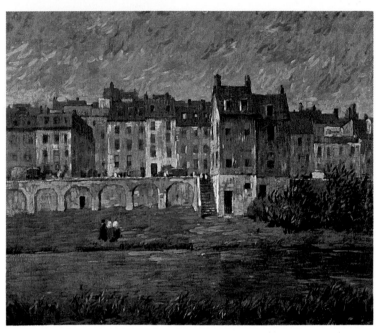

Embancment, 20 x 24 in., signed l.l. Courtesy of Henry B. Holt, Inc., Essex Fells, New Jersey.

tenements, he favored recording intimate and frank views of their dilapidated backyards, where men performed carpentry jobs and women hung out the laundry.

This honest portrayal of rural working and living conditions, the counterpart of Henri's urban realism, was softened by Spencer's impressionistic style. Although his somber color selections of warm grays and blues are unlike Garber's intense, luminist hues, Spencer's tapestry-like paint surfaces are clearly influenced by Garber. He applied pigment in strokes which emphasize the overall flat pattern of his compositions to a greater extent than most of his New Hope contemporaries.

While living in Bucks County, Spencer came to know many of the local artists, especially Edward Willis Redfield, the leader of the New Hope School, and William Langson Lathrop, the School's founder. Under Redfield's influence, he painted several typical Bucks County landscape scenes around 1916.

During the summer of 1925, Spencer joined the faculty of the Pennsylvania Academy of the Fine Arts. That same year he traveled to France, Spain and

Italy, returning to France in 1927. From the 1920s until his suicide in 1931, religious themes appeared in his work with greater frequency.

Spencer was a major figure of the New Hope School, as important for recording architectural scenes as Lathrop, Redfield and Garber were for capturing the region's rustic landscape.

MEMBERSHIPS
Century Association
National Arts Club
National Academy of Design
Salmagundi Club

PUBLIC COLLECTIONS
Art Institute of Chicago
Art Museum, Princeton University, New Jersey
Brooklyn Museum
Corcoran Gallery of Art, Washington, D.C.
Delaware Art Museum, Wilmington
Detroit Institute of Arts
Metropolitan Museum of Art, New York City
Museum of Fine Arts, Houston
National Academy of Design, New York City
National Arts Club, New York City
National Museum of American Art, Washington, D.C.
Philadelphia Museum of Art
Phillips Collection, Washington, D.C.
The Reading Museum and Art Gallery, Pennsylvania
Union League Club of Chicago, Illinois

CARL OSCAR BORG
(1879-1947)

Swedish-born Carl Oscar Borg became a fine genre artist of Southern California and the Southwestern states. His specialty was painting the everyday lives and the ceremonies of Native Americans. He said of them, "The Indians, of course, interested me because to my mind they are the 'only Americans,' a fast disappearing race, and I wanted to try and preserve some of their customs and religious life in a permanent form."

Borg was born in 1879 in Grinstad, Sweden. In 1899 he left his home for Stockholm, where he worked on ships as an apprentice painter. After working as an assistant portrait painter in France and England, Borg arrived in America in 1901. He lived and worked in Norfolk, Virginia, New York City, and Canada before settling in California in 1904. He was employed as a set painter for the fledgling movie industry.

Borg painted throughout California and the Southwest, and his first one-man show was given at the Ruskin Art Club in Los Angeles in 1905.

In 1909, art patron Phoebe Apperson Hearst (mother of William Randolph Hearst) saw Borg's work and was impressed by it. She decided to sponsor him, and offered to send him to Europe for five years to study. In Spain and Egypt, Borg's exposure to the desert was important for his future work.

Borg was a great success in Europe. When he returned, Phoebe Hearst commissioned him to do a series of paintings portraying Indian tribal ceremonies, including the Hopi Snake Dance and the Ninan Kachina Dance.

He was fond of using opaque watercolor (gouache), a fast-drying medium. When he worked among the Indians, his paintings were usually finished on the spot.

Borg died in 1947, at age 68.

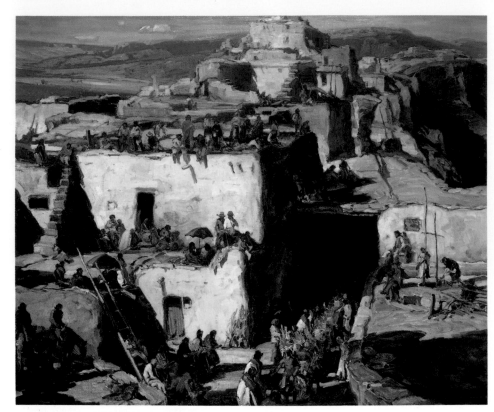

Dance at Walpi, Arizona, 1925, 50 x 60 in., signed l.r. Courtesy of Montclair Art Museum, Montclair, New Jersey.

MEMBERSHIPS
American Federation of Arts
California Art Club
California Water Color Society
International Society of Arts and Letters
Laguna Beach Art Association
Painters of the West
Salmagundi Club
San Francisco Society of Artists
San Francisco Society of Etchers
Print Makers' Society of California

PUBLIC COLLECTIONS
Bibliotheque Nationale, Paris
California State Library, Sacramento
Golden Gate Park Museum, San Francisco
Goteborg Museum, Sweden
Hearst Free Library, Anaconda, Montana
Library of Congress, Washington, D.C.
Los Angeles Museum
Los Angeles Public Library
Milwaukee Art Institute, Wisconsin
Montclair Museum, New Jersey
Oakland Art Gallery, California
Phoenix Museum, Arizona
Seattle Art Museum
University of California, Berkeley

SEASON	75–76	76–77	77–78	78–79	79–80	80–81	81–82	82–83	83–84	84–85
Paintings		1	1	2	5	17	9	5	7	4
Dollars		$4,500	$7,000	$4,800	$10,700	$53,974	$18,633	$15,950	$26,600	$8,489

Record Sale: $13,000, CH, 6/1/84, "Gathering Storm," 23 × 27 in.

GEORGE WILLIAM SOTTER
(1879-1953)

A member of the New Hope School of American impressionism, George William Sotter was an early arrival to this artists' colony situated along the Delaware River in Bucks County, Pennsylvania at the turn of the century. Like many of the artists affiliated with this regional school, especially Edward Willis Redfield, Sotter was noted for his paintings of winter landscapes. He also created stained glass windows for cathedrals, churches and monasteries.

Sotter was born in Pittsburgh in 1879. Although his early art training is unknown, he did teach design and painting at the Carnegic Institute of Technology in his hometown. He first came to New Hope, Pennsylvania in 1898, one of the earliest artists to visit the region in order to study under William Langson Lathrop. Lathrop, a well-known American tonalist painter, was a popular instructor and founder of the New Hope colony.

Sotter continued to summer in New Hope until 1902, when he moved to the area permanently. That year, he studied landscape painting with Edward Willis Redfield, the School's leading artist, at Redfield's home in Center Bridge. Soon after, Sotter enrolled at the Pennsylvania Academy of the Fine Arts in Philadelphia, where he studied under William Merritt Chase, Thomas Anshutz and Henry Keller. He may have come into contact with Daniel Garber, another well-known New Hope impressionist, who was also a student there at the time.

In 1907, Sotter married artist Alice E. Bennett. On an extended wedding trip abroad, the Sotters studied and painted in England and throughout Europe.

Upon their return to New Hope, the couple moved into a converted stone barn, where Sotter painted his landscapes and designed stained glass windows. In 1919, Sotter and his wife moved to Holicong, Bucks County. He

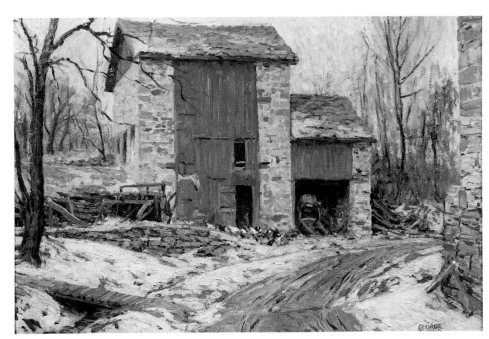

Hill Road, 22 x 26 in., signed l.r. Courtesy of the Reading Public Museum, Pennsylvania.

employed 10 craftsmen in his stained glass studio.

During his residence in Bucks County, Sotter taught at the Philadelphia School of Design. He died in Holicong in 1953.

Sotter was known for his night snow scenes of Bucks County, and for his seascapes painted near Rockport, Massachusetts. He frequently exhibited at Phillips Mill, which was the primary exhibition center for the New Hope artists. Sotter consistently won the favorite-painting ballot at the Mill's fall exhibition—an eminent honor, considering that it was awarded by his colleagues.

Sotter's night winterscapes are unusual when compared to those of Redfield and other New Hope artists who reveled in capturing the harsh daytime weather conditions of the winter season. These subtle night scenes are illuminated by the natural light of the moon and stars, and by the artificial light which emanated from cottage windows.

Stylistically, Sotter emulated Redfield, applying paint in the long, thick brushstrokes characteristic of New Hope impressionism. Nonetheless, his works are more contemporary in feeling than Redfield's, as he often blended his brushstrokes into larger and broader paint areas, a technique which focused more attention on the actual scene rather than on the physical paint surface.

MEMBERSHIPS
Connecticut Academy of the Fine Arts
Pennsylvania Academy of the Fine Arts
Pittsburgh Art Association
Salmagundi Club

PUBLIC COLLECTIONS
New Jersey State Museum, Trenton
Pennsylvania State University Museum
Reading Public Museum and Art Gallery,
 Pennsylvania

(No sales information available.)

GIFFORD BEAL
(1879-1956)

Financially comfortable, well-educated, happily married, contented and confident, Gifford Beal was a solid and significant American artist whose work received recognition both during his life and after his death.

Beal was born in New York City in 1879. He studied with the eminent painter William Merritt Chase from 1891 to 1900, and also attended the Art Students League, where he worked under Dumond and Ranger. In 1900, he graduated from Princeton University, and in 1908 he married and took his only trip abroad, to England and Scotland.

Beal began to receive awards for his work as early as 1903, and continued to do so all his life. He was a member of numerous boards and committees and was president of the Art Students League from 1914 to 1929.

Early in his career, he chose those elements of impressionism which seemed worthy to him, and with independence, dedication and consistency he explored the various permutations of light and color. He did not confine himself to any one subject. Wherever he was, he painted: along the Hudson River Valley, the New England coast, the Caribbean, cityscapes and circuses, ships and the ocean.

Beal's style, though romantic, was straightforward and without guile. Having found what worked for him, he stubbornly continued to follow his personal path, ignoring the ideas and fashions which swept the art world in the wake of impressionism.

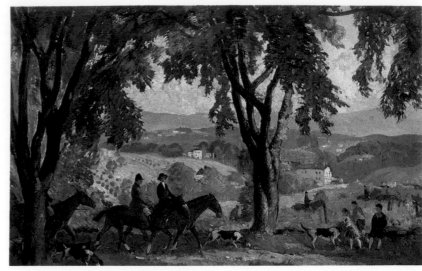

Hunting Scene, 1920, 36 x 58½ in., signed l.r. Courtesy of Kraushaar Galleries, New York, New York.

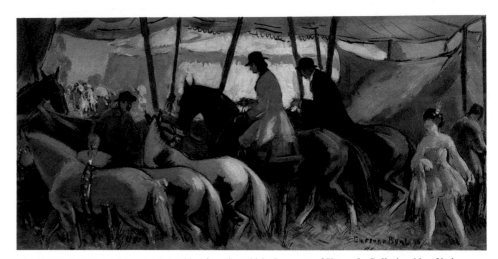

The Horse Tent at the Circus, 16¼ x 32¼ in., signed l.l. Courtesy of Kennedy Galleries, New York, New York.

He died in New York City in 1956, ushered out with laudatory obituaries and respectful memorial exhibitions.

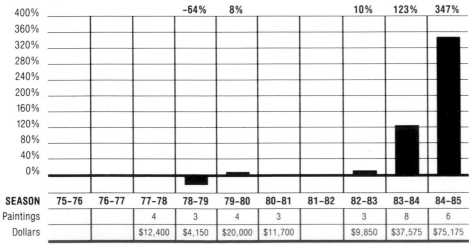

10-Year Average Change From Base Years '77-'78: 61%

SEASON	75-76	76-77	77-78	78-79	79-80	80-81	81-82	82-83	83-84	84-85
				−64%	8%			10%	123%	347%
Paintings			4	3	4	3		3	8	6
Dollars			$12,400	$4,150	$20,000	$11,700		$9,850	$37,575	$75,175

Record Sale: $50,000, SPB, 12/6/84, "Topsfield Fair," 30 x 50 in.

MEMBERSHIPS
American Water Color Society
Century Association
National Academy of Design
National Arts Club
National Institute of Arts and Letters
National Society of Mural Painters
New Society of Artists
New York Water Color Club

PUBLIC COLLECTIONS
Art Institute of Chicago
Brooklyn Museum
Cleveland Museum of Art
Detroit Institute of Arts
Los Angeles County Museum of Art
Metropolitan Museum of Art, New York City
Newark Museum, New Jersey
Phillips Collection, Washington, D.C.
San Francisco Art Institute
Everson Museum of Art, Syracuse, New York
Whitney Museum of American Art, New York City

GEORGE DEMONT OTIS
(1879-1962)

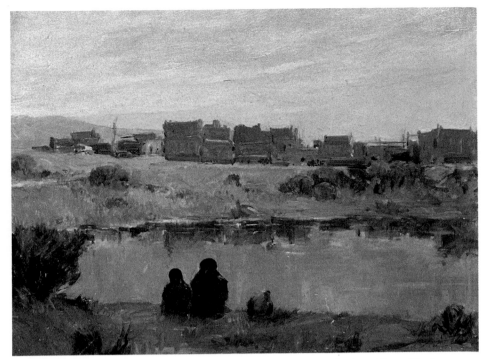

Evening, Taos Indian Village, N.M., ca. 1918, 20 x 24 in., signed l.r. Collection of Grace Hartley.
© 1980 George Demont Otis Foundation.

Determined that his impressionist landscapes should be purely American statements, George Demont Otis studied only at art schools in the United States and painted only on the American continent. He loved America's diversity, and during his long career worked in 38 of the 50 states. In California, however, he found his true home, and he spent more than half his life there, sketching, painting and selling his work direct from his own studio.

Otis was born in Memphis, Tennessee in 1879, two weeks after his father, a railroad engineer, had been killed in a wreck. His mother died when he was six, and he was taken to Missouri by relatives. His maternal grandmother placed him with a family in Chicago, but he ran away after a year and was taken in by another family there.

When he was 14, Otis drew his conception of the Christmas story on a blackboard so well that his work came to the attention of an Illinois senator, which led to a full scholarship at the Art Institute of Chicago and the start of his painting career.

Later he studied at the Art Students League and Cooper-Union in New York City, the Pennsylvania Academy of the Fine Arts in Philadelphia, and privately with several landscape painters. For a time, he supported himself by playing professional baseball in the South, playing in the summer and painting in the winter.

He next painted scenery for the stage and decorative ceilings for a chain of retail stores, and became an art appraiser and picture restorer. In between, he spent as much time as possible making sketches and painting in the open air.

In the 1920s, he moved West, first to the foothills of the Rockies, then to the Arizona-New Mexico desert, and finally to Southern California. Once there, he spent several years as a scene designer for Metro-Goldwyn-Mayer Studios. The desert impressed him so much that he returned often between film assignments. He came to know the Indians well and, while doing some 200 watercolors of them, learned much about their ways.

In 1930, he moved to San Francisco. Two years later he married and, with his wife, discovered Marin County, across the Golden Gate from the city. They built a house there, and later added a studio where he painted until his death in 1962.

Otis was deeply influenced by the work of Winslow Homer and George Inness. Like them, he believed that complete mastery of drawing was an indispensable prerequisite for any accomplished painter, a belief that was clearly evident in his own work.

MEMBERSHIPS
American Society of Artists
California Art Club of Los Angeles
Chicago Society of Artists
Independent Society of Artists of New York
Los Angeles Painters' Society
Marin Society of Artists
Painter and Sculptors Club of Los Angeles
Society of Western Artists

PUBLIC COLLECTIONS
Art Institute of Chicago
Hackley Gallery of Fine Arts, Muskegon, Michigan

10-Year Average Change From Base Years '79-'80: 147%

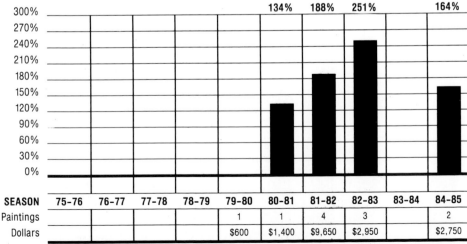

SEASON	75-76	76-77	77-78	78-79	79-80	80-81	81-82	82-83	83-84	84-85
						134%	188%	251%		164%
Paintings					1	1	4	3		2
Dollars					$600	$1,400	$9,650	$2,950		$2,750

Record Sale: $5,750, SPB, 6/29/82, "East Winds," 24 x 31 in.

FRANK VINING SMITH
(1879-1967)

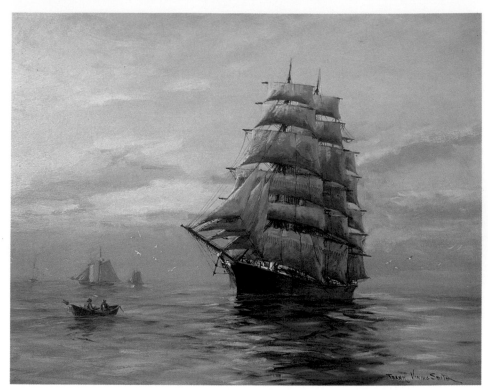

Heading for the Harbor, 24 x 30 in., signed l.r. Courtesy of Arvest Galleries, Inc., Boston, Massachusetts.

Frank Vining Smith combined his love of the sea with his skills as a magazine and newspaper illustrator to produce compelling maritime oils and watercolors.

Born in Massachusetts in 1879, Smith studied at the Boston Museum of Fine Arts School with Frank Benson and Edmund Tarbell. He began his career as an illustrator with the *Boston Globe* newspaper, and he contributed to leading leisure magazines, including *Yachting, Field and Stream* and *Outdoors.*

Smith held his first one-man exhibition in 1922, and was subsequently exhibited regularly in New England and in New York City galleries.

He was a consummate sportsman, enjoying hunting, fishing and sailing. A member of the Blue Water Cruising Club, Smith gained his maritime experiences first-hand—taking to the sea for pleasure and for study.

Though he painted schooners, clipper ships and whalers, the clipper ships held the most appeal for him. The artist painted the ships in oceanic calm as well as the turbulence of stormy seas.

Perceptually authentic, Smith's paintings are largely representational, and yet each is infused with the artist's own experience and imagination. Drawing on the differences of the ships and the varying moods of the sea, each of Smith's paintings is distinctly individualistic.

Smith died in 1967.

PUBLIC COLLECTIONS
Mariners Museum, Newport News, Virginia

SEASON	75-76	76-77	77-78	78-79	79-80	80-81	81-82	82-83	83-84	84-85
Paintings			1	1	2	3	2	2	2	3
Dollars			$3,500	$1,250	$2,700	$10,500	$3,550	$975	$4,000	$2,600

Record Sale: $3,750, SPB, 1/29/81, "Sailing Ship," 30 × 42 in.

GORDON COUTTS
(1880-1937)

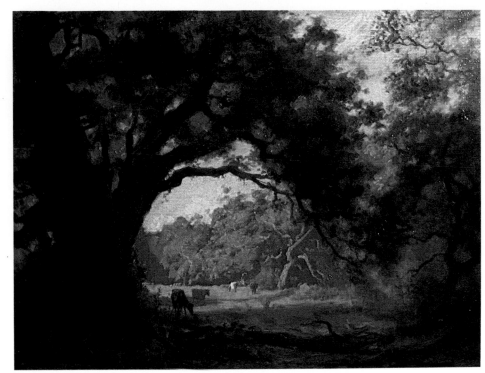

Cattle Beneath the Oak Tree, 14 ¾ x 20 in., signed l.l. Collection of Nan and Roy Farrington Jones.

World traveler, painter and illustrator, the adventurous and versatile Gordon Coutts embodied the ideal he presented in his dramatic and vigorous paintings.

He was born in Aberdeen, Scotland in 1880. He attended art school in Glasgow, but soon left Scotland to embark on his life of travel. He attended the Academie Julien in Paris, studying under Carl Rossi, Jules Lefebvre, Fleury and Deschenot; then he made his way to London, where he made his living as a portrait painter and exhibited at the Royal Academy.

Not content with this (to him) tame success, Coutts went halfway around the world to teach art in Australia for 10 years. After that, he landed in San Francisco, California for a time, but the call of foreign climes soon took him to Morocco, where he lived for some years. He finally settled in Palm Springs, California, where he died in 1937.

Echoes of all the places Coutts visited are apparent in his fully-developed work. His sound academic training, coupled with his affinity for the dramatically picturesque, produced striking and effective paintings.

He acquired early fame as a painter of nudes, making a splash at the 1915 San Francisco Exposition with his reclining nude *Stella* (date and location unknown), and even more of a splash when the painting, insured for the then-astronomical sum of $7,000, was stolen in the 1930s from a Los Angeles gallery.

His sharply-delineated figures posed dramatically in sharp light are always striking, whether the subject is a Moorish desert rifleman, as in *From the Desert* (date and location unknown), a group of Indians on horseback, as in *Indian Scouts on the Mountain* (date and location unknown), or the artist himself: *Self-Portrait* (date and location unknown). The natural flamboyance and vigor of the man equaled and reinforced the strength and narrative fascination of his art.

MEMBERSHIPS
Bohemian Club
Royal Academy

PUBLIC COLLECTIONS
Adelaide National Gallery, Australia
Melbourne Art Gallery, Australia
Cleveland Museum of Art
M.H. de Young Memorial Museum, San Francisco
National Art Gallery, Sydney, Australia

SEASON	75–76	76–77	77–78	78–79	79–80	80–81	81–82	82–83	83–84	84–85
Paintings						12	5	4	2	2
Dollars						$22,940	$7,600	$3,600	$1,200	$3,450

Record Sale: $8,000, BB.SF, 6/24/81, "Ready for the Ball," 48 × 36 in.

JONAS LIE
(1880-1940)

Jonas Lie was an accomplished painter who gained recognition for his colorful, picturesque scenes of New York City and the New England coastlines. Lie espoused a traditional approach to painting, inspired by the light, atmospheric renderings of the French impressionists.

Born in Moss, Norway, Lie was the son of a distinguished Norwegian engineer and an American mother. After his father's death in 1892, Lie was sent to live with an uncle in Paris. Guests of that Parisian household included such famous Norwegians as Edvard Grieg and Henrik Ibsen.

In 1893, Lie came to the United States to join his mother and sister in New York City. There, he pursued an art education which included evening courses at Cooper Union, the National Academy of Design and the Art Students League.

Many of the artist's summers were spent on the coast of New England or Canada; for years he was a prolific exhibitor of intensely colored, scenic views of rocky coves and harbors. These landscapes are characterized by a facile, broad handling of pigment, which conveys an impressionistic sense of light and air.

In 1913, Lie worked for several months on the site of the Panama Canal, recording the last days of its construction. One example from this group of works, which won numerous awards, is *The Conquerors, Panama Canal* (1913,

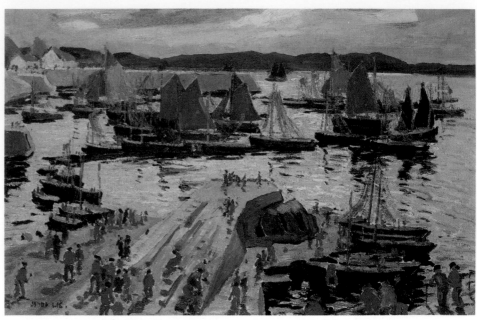

The Quay, 21 x 32 in., signed l.l. Photograph courtesy of M. Knoedler & Co., Inc., New York, New York.

Metropolitan Museum of Art). In 1929, a series of Lie's Panama Canal paintings were given to the United States Military Academy at West Point, in memory of General Goethals.

In addition to his creative interests, Lie was active in New York City's art community as an administrator. Early in his career, he assisted with the organization of the famed New York City Armory show in 1913. Throughout his life, he advocated traditional academic training for aspiring young artists, and was an energetic spokesman for conservative values in art. Before his death in 1940, he was president of the National Academy of Design from 1935 to 1939.

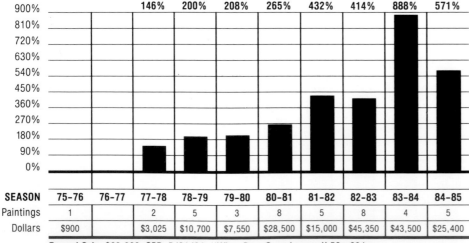

10-Year Average Change From Base Years '75-'76: 347%

	146%	200%	208%	265%	432%	414%	888%	571%

SEASON	75-76	76-77	77-78	78-79	79-80	80-81	81-82	82-83	83-84	84-85
Paintings	1		2	5	3	8	5	8	4	5
Dollars	$900		$3,025	$10,700	$7,550	$28,500	$15,000	$45,350	$43,500	$25,400

Record Sale: $29,000, SPB, 5/31/84, "When Days Grow Longer," 50 × 60 in.

ARTHUR GARFIELD DOVE
(1880-1946)

Arthur Garfield Dove was one of the first American artists to develop a consistently abstract style. In 1910, after having spent two years in France, where he became aware of the work of Cezanne and Matisse, he began to work in a non-representational manner, although he continued throughout his career to derive his themes, forms and light from observations of nature, rather than from intellectual concepts.

Dove was born in 1880 in Canandaigua, New York. He attended Hobart College and then Cornell, where he first studied law and then turned to art. Upon his graduation from Cornell in 1903, he went to New York City and worked as a cartoonist for five years; he was employed by *Harper's, Scribner's* and *Century* magazines. He drew in pastels in his spare time.

In 1907, Dove went to Paris for two years. With his friends, modernist painters Alfred Maurer and Arthur B. Carles, he was exposed to the exhilarating atmosphere of new artistic ideas circulating in Europe. Dove in particular was influenced by the group of artists nicknamed the "fauves" ("wild beasts") for their bright colors.

On his return, Dove met Alfred Stieglitz through Alfred Maurer. Stieglitz, known as a photographer and artists' mentor, took Dove into his select group and included Dove's work in his "Younger American Painters" exhibi-

Round the Bend, 1935, 16 x 21½ in., signed l.c. Photograph courtesy of The Gerald Peters Gallery, Santa Fe, New Mexico.

tion in 1910. In 1910, Dove produced his series entitled "Abstractions," thus becoming the forerunner of the abstract movement and ensuring his importance in art history.

Aided by Stieglitz, Dove continued to paint and exhibit regularly, living in a series of eccentric situations. In 1912, he bought a farm in Westport, Connecticut and attempted to make a living raising chickens; his "Ten Commandments" and "Nature Symbolized" series, mostly pastels, date from this period.

Chickens having failed him, he moved into a 42-foot boat. From 1920 to 1929,

he wandered from port to port in summer and wintered in Huntingdon Harbor on Long Island, New York. During this time he created a series of whimsical collages and constructions, whose small size was undoubtedly influenced by the constraints of his living quarters.

When Dove moved to the second floor of a yacht club in 1929, the scale and maturity of his works increased. During the 1930s, his canvases became somewhat reduced in size, but his forms remained large in scale.

For the last seven years of his life, from 1939 to 1946, he lived in an abandoned post office in Centerport, Long Island, still painting vigorously. Indeed, when in 1946 he suffered a stroke that partially paralyzed him, he doggedly continued painting with his wife's help. He died that year in Huntingdon, New York.

PUBLIC COLLECTIONS
Albright-Knox Art Gallery, Buffalo
Art Institute of Chicago
Brooklyn Museum
Detroit Institute of Fine Arts
Metropolitan Museum of Art, New York City
Museum of Modern Art, New York City
National Gallery, Washington, D.C.
Philadelphia Museum of Art
Phillips Memorial Gallery, Washington, D.C.
Yale University

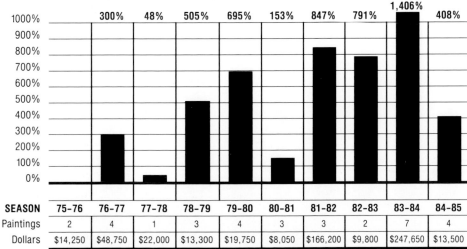

10-Year Average Change From Base Years '75-'76: 515%

	300%	48%	505%	695%	153%	847%	791%	1,406%	408%

SEASON	75-76	76-77	77-78	78-79	79-80	80-81	81-82	82-83	83-84	84-85
Paintings	2	4	1	3	4	3	3	2	7	4
Dollars	$14,250	$48,750	$22,000	$13,300	$19,750	$8,050	$166,200	$9,800	$247,650	$13,500

Record Sale: $160,000, SPB, 10/6/81, "Dancing Trees," 30×45 in.

DANIEL GARBER
(1880-1958)

Daniel Garber's idyllic, lyrical paintings of the tranquil Bucks County, Pennsylvania countryside evoke the natural beauty of the area. They are as appealing to audiences today as in his own time. Garber was a prominent member of the New Hope School of American impressionism, friendly with regional artists William Lathrop and Edward Willis Redfield.

The youngest son of a Mennonite family, Garber was born in North Manchester, Indiana in 1880. At age 16, he sought professional training as an artist, and studied at the Art Academy of Cincinnati from 1897 to 1898. He attended the Darby School in Fort Washington, Pennsylvania during the summers of 1899 and 1900; there he studied under Thomas Anshutz and Hugh Breckenridge.

While studying at the Pennsylvania Academy of the Fine Arts in Philadelphia from 1899 to 1905, Garber came under the influence of Anshutz and American impressionists William Merritt Chase and Cecilia Beaux. Around 1901, he established a studio in Philadelphia. He worked as an illustrator, commercial artist and portrait painter. He continued his studies in the Academy's night classes, where he met and married fellow student Mary Franklin.

In 1904, Garber began teaching drawing classes at the Philadelphia School of Design for Women. His teaching career

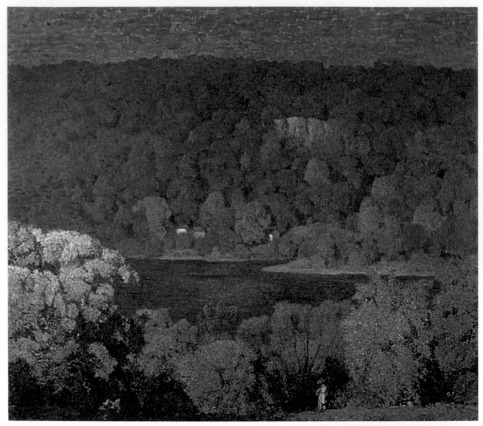

Delaware Hillside, 36 x 40 in., signed l.c. Courtesy of Newman Galleries, Philadelphia, Pennsylvania.

was interrupted in 1905, when he was awarded the William Emlen Cresson Fellowship from the Pennsylvania Academy of the Fine Arts for study abroad. His two-year trip took him to England, France and Italy.

Garber returned to Philadelphia in 1907, and shortly thereafter settled at "Cuttalossa" in Lumberville, Bucks County, just north of New Hope. He resumed his teaching position until 1909, when he joined the faculty of the Penn-

sylvania Academy of the Fine Arts as Anshutz's assistant.

In 1919, Garber began teaching landscape painting at the Academy's summer school in Chester Springs, Pennsylvania, augmenting his traditional, academic courses in cast drawing, still life and figure painting. Upon his retirement in 1950, he had become one of the Academy's most respected and loved instructors.

Garber's paintings of Bucks County

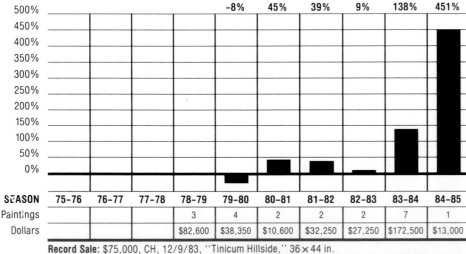

10-Year Average Change From Base Years '78-'79: 96%

					-8%	45%	39%	9%	138%	451%
SEASON	75-76	76-77	77-78	78-79	79-80	80-81	81-82	82-83	83-84	84-85
Paintings				3	4	2	2	2	7	1
Dollars				$82,600	$38,350	$10,600	$32,250	$27,250	$172,500	$13,000

Record Sale: $75,000, CH, 12/9/83, "Tinicum Hillside," 36 × 44 in.

MEMBERSHIPS
American Institute of Arts and Letters
National Academy of Design
National Arts Club
Salmagundi Club
Society of American Etchers

PUBLIC COLLECTIONS
Albright-Knox Art Gallery, Buffalo
Carnegie Institute, Pittsburgh
Cincinnati Art Museum
City Art Museum, St. Louis
Corcoran Gallery, Washington, D.C.
Detroit Institute of Arts
Everson Museum of Art, Syracuse, New York
John Herron Art Institute, Indianapolis
Metropolitan Museum of Art, New York City
National Collection of Fine Arts,
 Washington, D.C.
Pennsylvania Academy of the Fine Arts,
 Philadelphia
Philadelphia Museum of Art
Phillips Gallery, Washington, D.C.

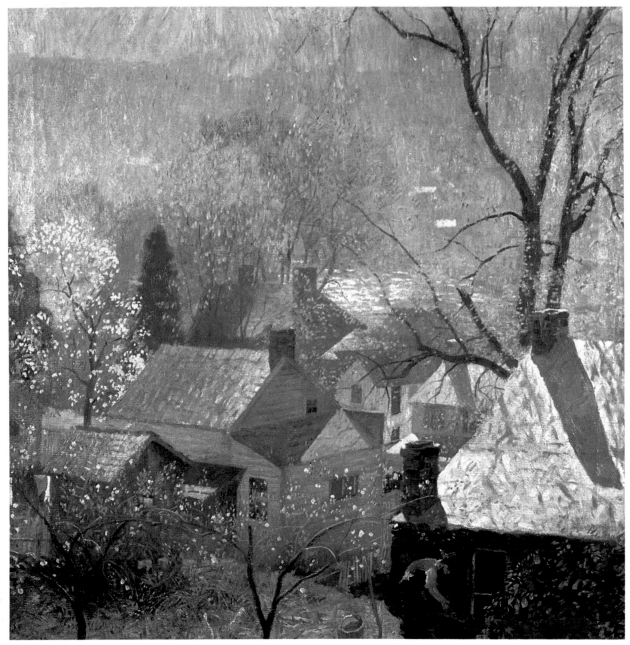

Springtime in the Village, 1916, 30 x 28 in. Courtesy of Henry B. Holt, Inc., Essex Fells, New Jersey.

quarries and his panoramic views of the region's Delaware River are often compared to tapestries. He combined high-key harmonies and delicate nuances of color with the decorative, intricately woven brushwork inspired by his mentor, Julian Alden Weir. Although his education was grounded in the realist tradition, he portrayed the region at its most idyllic, bathed in a crystalline, permeating light that never fully dissolved form.

Garber was unique among the New Hope School. While all these painters were interested in capturing the effects of light and atmosphere, Garber's deliberate, almost painstaking technique opposes the gusty, bravura painting style of the school's leader, Edward Willis Redfield, and his followers. Like Redfield and Lathrop before him, Garber influenced many younger artists who settled in the Bucks County region.

He died in 1958.

LESLIE PRINCE THOMPSON
(1880-1963)

Of the five dozen or so artists who could properly be categorized as members of the Boston School of American impressionist painting, only a handful achieved real individual distinction; the group was dominated by the work and dictates of Edmund C. Tarbell, its leader. Many, if not most, had studied under Tarbell and were thoroughly indoctrinated with his ideas on the importance of skilled draftsmanship, fine painting technique and suitability of subject matter.

In all these respects Leslie P. Thompson was a member in good standing of the Boston School. He could not, however, be labeled a "Tarbellite," the name given to the innermost circle of Tarbell followers.

Thompson was born in Medford, Massachusetts in 1880, and studied under Tarbell at the School of the Boston Museum. He also studied privately with Tarbell, and with Ernest L. Major, a Tarbell disciple. Later he studied in Paris and was influenced by Monet.

Throughout his career, Thompson was a generalist. He was at home in all media—oil, watercolor, pastel and pencil. He painted many pleasant beach scenes and landscapes, as well as portraits, still lifes and, like his mentor, Tarbell, genteel interior genre scenes.

In 1913, when both Tarbell and Frank Benson, who might be called second-in-command of the Boston impressionists, resigned from the Museum School in a dispute with the board of directors, Thompson was considered sufficiently qualified to be appointed painting instructor in their place. He remained on the faculty until 1931.

Thompson ignored the currents of modern art that swirled about him and continued to paint in his traditional style, until his death in Boston in 1963.

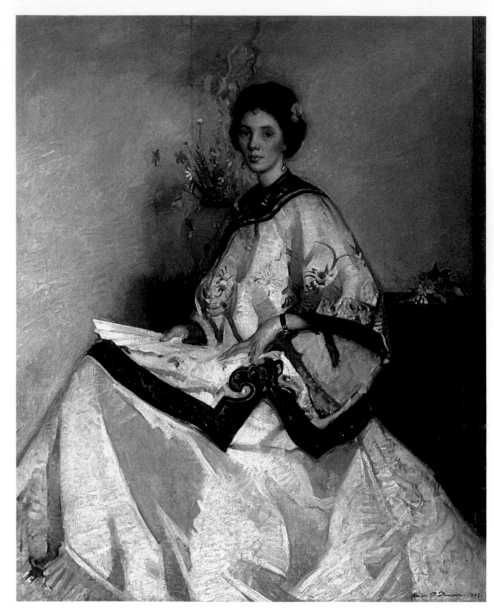

The Chinese Coat, 1925, 56 x 46 in., signed l.r. Courtesy of Vose Galleries of Boston, Inc., Massachusetts.

MEMBERSHIPS
Boston Guild of Artists
National Academy of Design
Newport Art Association
St. Botolph Club, Boston

SEASON	75-76	76-77	77-78	78-79	79-80	80-81	81-82	82-83	83-84	84-85
Paintings						1				2
Dollars						$12,000				$3,300

Record Sale: $12,000, SPB, 5/29/81, "Interior," 30 × 25 in.

HANS HOFMANN
(1880-1966)

Called the most influential art teacher in mid-twentieth-century America, as well as a major abstract painter, Hans Hofmann typifies both the international origins of American painting and its subsequent world influence.

His conviction that "art must not imitate physical life, but must create pictorial life" was exemplified in Hofmann's work. His writing, teaching and painting inspired three generations of American artists—including such luminaries as Burgoyne Diller, Louise Nevelson and Helen Frankenthaler.

Born in 1880 in Bavaria, Germany, Hofmann studied science, mathematics and music in Munich. He acted as assistant to the director of public works of the state of Bavaria, during which time he invented an electromagnetic comptometer. It wasn't until 1903, at age 23, that he decided to study art full-time.

He attended sketch classes at the Academie de la Grande Chaumiere in Paris with Matisse. His friends included Delaunay, Picasso and Braque. During this period, he painted in the cubist style; indeed, he never fully abandoned the precepts of Cezanne. Rather he synthesized the spatial aspects of cubism with the high-key color dynamics of fauvism and Kandinsky.

Hofmann founded his first art school in Munich in 1915. His desire "to clarify the new pictorial approach of modern painting . . . by means of the backward and forward animation of the whole pic-

Flowering Swamp, 1957, 48 x 36 in., signed l.r. Courtesy of Hirshhorn Museum and Sculpture Garden, Smithsonian Institution, Washington, D.C.

ture surface through color, shapes, and rhythm" became influential in American art circles. After teaching summer sessions at the University of California at Berkeley in 1930 and 1931, he moved permanently to New York City in 1932.

In 1934, he opened the Hans Hofmann School of Fine Arts in New York City. Teaching there and in Provincetown, Massachusetts, he emphasized his theory of "push and pull," a way to create depth out of the tension of shapes and colors. Hofmann believed that a painting is a distillation of an artist's dialogue with himself, resulting in a dynamic and exuberant relationship between pigment and canvas.

In the 1930s, many of Hofmann's major works contained recognizable subject matter despite his splashing use of color. His works in the 1940s evoke mythical associations similar to those of the young abstract expressionists, but his loosely brushed and increasingly abstract use of bright color lacks their sense of alienation.

In 1944, Hofmann had his first major American show at Peggy Guggenheim's Art of This Century Gallery. In the 1950s, Hofmann returned to the cubist influence. In his last work, he tried to fuse cubism and expressionism by floating smoothly painted rectangles of pure hues in expressionistic fields of squiggled color.

Hans Hofmann continued to teach until he reached his late seventies. He died in 1966, leaving 75 paintings to the University of California at Berkeley, in gratitude for his first job in America.

MEMBERSHIPS
National Institute of Arts and Letters

PUBLIC COLLECTIONS
Art Institute of Chicago
Baltimore Museum of Art
Cleveland Museum of Art
Dallas Museum of Fine Arts
Metropolitan Museum of Art, New York City
Museum of Modern Art, New York City
Newark Museum, New Jersey
Philadelphia Museum of Art
Solomon R. Guggenheim Museum, New York City
Whitney Museum of American Art,
 New York City

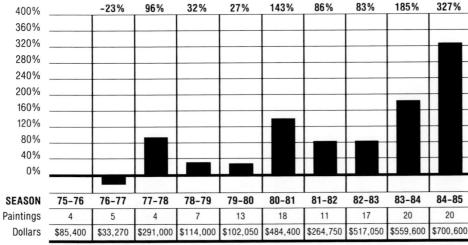

10-Year Average Change From Base Years '75-'76: 96%

	-23%	96%	32%	27%	143%	86%	83%	185%	327%	
SEASON	75-76	76-77	77-78	78-79	79-80	80-81	81-82	82-83	83-84	84-85
Paintings	4	5	4	7	13	18	11	17	20	20
Dollars	$85,400	$33,270	$291,000	$114,000	$102,050	$484,400	$264,750	$517,050	$559,600	$700,600

Record Sale: $250,000, CH, 5/1/85, "Ave Maria," 72 × 48 in.

MAX KUEHNE
(1880-1968)

Max Kuehne was a distinguished American landscape painter. Born in Halle, Germany in 1880, Kuehne moved to the United States when he was in his early teens. His family settled in Flushing, New York, and Kuehne greatly enjoyed swimming, sailing and rowing in the Hudson River area.

Kuehne studied in New York City with Kenneth Hayes Miller and William Merritt Chase at Chase's school and in 1909 and 1910 with Robert Henri. To study paintings of the old masters, he traveled to England, France, Germany, Holland and Belgium, supporting himself by painting commissioned portraits.

Kuehne continued to travel throughout his life. From 1914 to 1917, he and his German wife lived in Spain, where he learned to speak Spanish and collected Spanish paintings and sketches.

Kuehne settled in New York City, and he made friends with many notable artists and collectors, including Edward Hopper, William Glackens, Charles Prendergast and Albert Barnes.

Kuehne's mature style was influenced by Monet and Seurat. He was also strongly influenced by Bonnard's use of color. Kuehne's preference for brilliant colors and his use of an open-air painting technique link his work to that of the European impressionists.

While most of Kuehne's paintings were landscapes, he also painted many still lifes. He was particularly fond of painting floral arrangements. His pri-

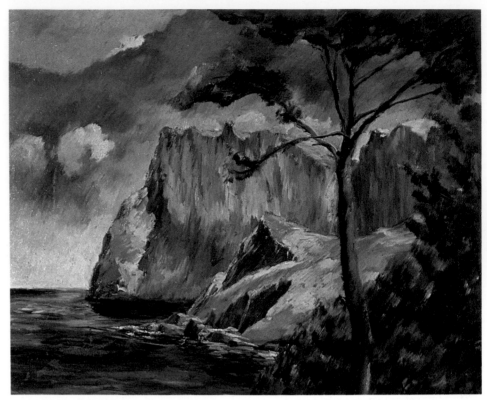

Cape San Vicente, 1924, 25 x 30 in. Courtesy of Collection The Whitney Museum of American Art, New York, New York.

mary medium was oil, but he also painted watercolors and was a fine etcher.

Kuehne spent most of his summers in Rockport and Gloucester, Massachusetts. He frequently painted the harbors and piers of fishing villages.

During the Depression, Kuehne supported himself by creating decorative screens, panels, sculptures and furniture. He became famous for his superb wood-carving and his use of gesso and silver-leaf in decorating furniture.

Kuehne died in 1968.

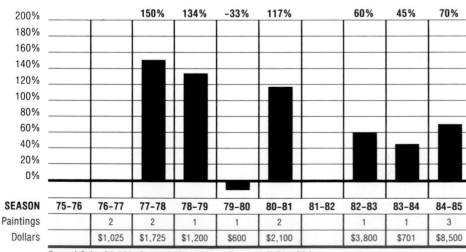

10-Year Average Change From Base Years '76-'77: 68%

SEASON	75-76	76-77	77-78	78-79	79-80	80-81	81-82	82-83	83-84	84-85
		150%	134%	-33%	117%		60%	45%	70%	
Paintings		2	2	1	1	2		1	1	3
Dollars		$1,025	$1,725	$1,200	$600	$2,100		$3,800	$701	$8,500

Record Sale: $6,000, B, 11/8/84, "Mixed Bouquet," 31 × 36 in.

CLARENCE K. CHATTERTON
(1880-1973)

Clarence K. Chatterton, associated for 33 years with Vassar College as a resident artist, chose throughout his career to paint recognizable subjects, such as sun-drenched houses, blue skies and boats. His was a vision of small-town America, innocent and pollution-free. With a deft brush and a good sense of design, Chatterton painted scenes in Poughkeepsie, New York, along the Hudson River, in the New England resort of Ogunquit and in his hometown of Newburgh, New York.

Chatterton never ventured West of New York State, nor did he go to Europe. In spite of his limited geographical experience, he ranks among the respected mid-century realistic painters who maintained their styles through the decades when most of the artistic world embraced abstraction. He studied at the New York School of Art with William Merritt Chase and Robert Henri.

Rather than settle in New York City upon completion of his training, Chatterton returned to Newburgh, where for 16 years he recorded the scenes of that small town in gouache, oil, pen-and-ink and pencil, setting up his easel in the streets and painting while a procession of friends stopped by to chat.

In 1915, a few months after his marriage, Chatterton took the newly created position of artist-in-residence at Vassar, one of the first colleges in America to offer a major course of study in figure drawing and painting. Chatterton used

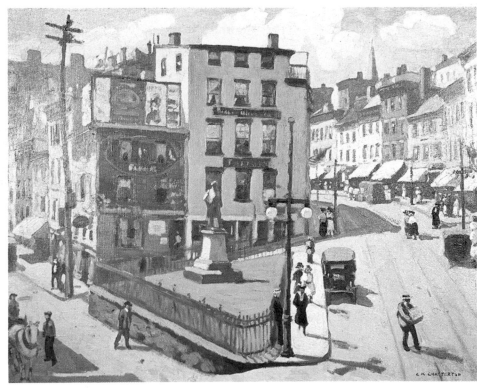

Clinton Square, Newburgh, 1917, 27½ x 35¼ in., signed l.r. Courtesy of Vassar College Art Gallery, Poughkeepsie, New York. Bequest of Leila Cook Barber.

chaperoned nude models in class, a practice requiring special action by the Vassar board of trustees.

During the next 33 years, Chatterton taught some 3,000 students, painting next to them and spending his summers in Ogunquit, recording its picturesque houses and coastline. In 1916, he did a series of fine charcoal drawings of the Barnum and Bailey Circus, and in 1925 he held his first one-man show.

Vassar held a major retrospective of his work in 1947, a year before Chatterton retired to continue painting the tranquil scenes of Poughkeepsie and Ogunquit. He is recognized for his ability to capture sunlight and, in the later years, strong shadows that added strength and depth to his work.

MEMBERSHIPS
Chicago Water Color Club
Salmagundi Club

PUBLIC COLLECTIONS
Brooklyn Museum
National Museum of American Art, Washington, D.C.
Vassar College Art Gallery

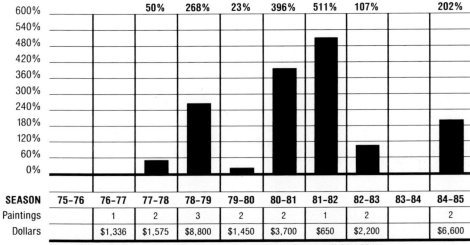

10-Year Average Change From Base Years '76–'77: 195%

	75–76	76–77	77–78	78–79	79–80	80–81	81–82	82–83	83–84	84–85
		50%	268%	23%	396%	511%	107%		202%	
SEASON	75–76	76–77	77–78	78–79	79–80	80–81	81–82	82–83	83–84	84–85
Paintings		1	2	3	2	2	1	2		2
Dollars		$1,336	$1,575	$8,800	$1,450	$3,700	$650	$2,200		$6,600

Record Sale: $6,250, SPB, 4/20/79, ''Chadeayne Place, Cornwall,'' 28 x 36 in.

MORTON LIVINGSTON SCHAMBERG
(1881-1918)

Morton Livingston Schamberg has been called America's first modern painter, an artist who saw the machine not only as a rich and important source of artistic inspiration but also as a dehumanizing force.

Born in Philadelphia in 1881, Schamberg was educated there, taking a degree in architecture at the University of Pennsylvania in 1903 and matriculating at the Pennsylvania Academy of the Fine Arts the same year.

At the Academy he studied under impressionist William Merritt Chase and met the man who became his lifelong friend and confidant, Charles Sheeler. They shared studios in Philadelphia and Doylestown, Pennsylvania. In 1912 they worked as photographers, primarily in portraits, to increase their income.

Schamberg made many trips abroad, and in 1910 he discovered the modern movement in Paris. He shed the influence of his teacher Chase, having become interested in Matisse, Cezanne and the impressionists. Between 1913 and 1915, he went from fauvism to an abstraction based on natural forms, producing works inspired by synchromism or orphism. Early in this period, sections of the human figure were the basis for his bold color compositions, but by 1915 he was painting landscapes.

Schamberg's focus then changed from the plastic and tactile development of color planes to the exploration of curvilinear shapes based on common objects like the camera and the telephone, revealing the influence of Marcel Duchamp and Francis Picabia. His work became increasingly abstract and hard-edged. Producing oils, watercolors and assemblages, Schamberg worked from catalog illustrations, as Picabia had, to create disembodied machine forms. His assemblage *God* (1916, Philadelphia

View from the Side Boxes (Opera), 5½ x 7¼ in. Courtesy of The Pennsylvania Academy of the Fine Arts, Philadelphia.

Museum of Art), composed of a plumbing trap set upside down in a mitre box, is one of the first examples of American dada sculpture.

Schamberg's architectural and photographic training is apparent in his depiction of the machine's intrinsic beauty, which he interpreted in elegant mechanical lines and carefully arranged flat shapes.

Schamberg's promise as one of America's foremost modernists was never realized. He died of influenza in 1918 and was buried on his thirty-seventh birthday.

MEMBERSHIPS
Society of Independent Artists

PUBLIC COLLECTIONS
Philadelphia Museum of Art

(No sales information available.)

RAE SLOAN BREDIN
(1881-1933)

Rae Sloan Bredin was a noted portraitist who was equally well known for his landscape paintings of the Delaware River Valley in Bucks County, Pennsylvania. His depictions of graceful country scenery, populated with genteel people and painted in an impressionistic style, have linked Bredin to the New Hope School of American impressionism.

Bredin was born in Butler, Pennsylvania in 1881. In 1898, he graduated from Pratt Institute; from 1900 to 1903, he studied under William Merritt Chase, Frank Vincent DuMond and Robert Henri in the New York School of Art.

At this time he met Charles Rosen and Robert Spencer, both of whom would later move to New Hope and encourage Bredin to follow suit. Bredin visited Charles Rosen in New Hope as early as 1911, at which time it is thought that he studied landscape painting under William Langson Lathrop, the founder of the New Hope School.

In 1914, Bredin married Alice Price, and the couple spent the summer abroad in France and Italy. Upon their return to the United States, they moved to a home just outside New Hope, close to Robert Spencer at "Rabbit Run."

Bredin occupied many teaching positions. In 1909, he taught at the University of Virginia Summer School. He was co-director of the Manhattan School of Fine Art, and was a faculty member at the New York School of Fine Arts and the Philadelphia School of Design for Women.

Bredin returned to France in 1929, on a portrait commission for Swarthmore College. Upon his return to New Hope, he painted Bucks County landscapes until his death in 1933.

Bredin's portrait works have been eclipsed by his landscape paintings of the Delaware River Valley. He was among the few New Hope impressionists

Portrait of J. Osborne Hunt, 39½ x 31½ in., signed l.r. New Jersey State Museum, Trenton, Gift of Mrs. J. Osborne Hunt.

who allowed figures to play an important role in his landscape paintings; he often painted fashionably dressed women and children, dappled with sunlight and color, in dreamy riverside settings. His decorative impressionistic technique and heightened color palette bear an affinity to Daniel Garber, an important New Hope impressionist and an influential instructor.

Bredin also painted winter scenes of Bucks County, snowbound woodlands and creeks devoid of human life. These striking canvases are reminiscent in subject and style of the work of Edward Willis Redfield, the New Hope School's premier painter.

Bredin occupies a unique position among the New Hope impressionists. Rather than depict the industrial life and dilapidated tenements of Bucks County's working class, as did Robert Spencer and John Fulton Folinsbee, Bredin portrayed the refined leisure activities of a more affluent society.

MEMBERSHIPS
International Society of Arts and Letters
National Academy of Design
National Art Club
National Association of Portrait Painters
Philadelphia Art Alliance
Salmagundi Club

PUBLIC COLLECTIONS
Corcoran Gallery, Washington, D.C.
Minneapolis Art Society
National Arts Club, New York City
New Jersey State Museum, Trenton
Philadelphia Art Club
Salmagundi Club, New York City
Swarthmore College, Pennsylvania

SEASON	75-76	76-77	77-78	78-79	79-80	80-81	81-82	82-83	83-84	84-85
Paintings									1	
Dollars									$8,000	

Record Sale: $8,000, SPB, 6/22/84, "Where the Canal Widens," 25 × 30 in.

PATRICK HENRY BRUCE
(1881-1937)

Patrick Henry Bruce developed a distinctive form of geometric abstraction which is regarded as a spatial metaphor for modern life. However, since Bruce spent most of his life abroad, his work was largely unrecognized in the United States during his lifetime.

Born in 1881 in Virginia, Bruce moved to New York City when he was 20, studying under William Merritt Chase and Robert Henri. The artist left for Europe in 1903—one of a small number of American expatriates in the first decade of the century.

Initially, Bruce painted portraits showing strong stylistic influences of Henri. However, by 1907 Bruce's still lifes and portraits reflect his association—as friend and pupil—with Henri Matisse, combining the high coloration of Matisse with the geometric emphasis of Paul Cezanne. Several of his canvases also show the innovativeness of orphism, resulting from the influence of painters Robert and Sonia Delaunay.

By the time he was in his thirties, Bruce was painting in a completely abstract, innovative style. Although he destroyed many of his canvases during that period, those which survive show unmodulated colors, angled edges and flat forms. Known as "Compositions," these works were exhibited in Paris and in New York.

Bruce's most characteristic paintings are his still lifes dating from the 1920s. As seen in his *Formes sur la Table* (ca. 1925-1926, Addison Gallery of American Art), Bruce painted geometrical objects on table-like bases. Spatial ambiguities were created by the use of contrasting but repeating planes of flat, bold colors, and by the intersecting and angling of forms.

It is not known how many of these monumental still lifes Bruce painted, for in 1933 he destroyed all but 21 canvases.

Forms No. 12 (Still Life), ca. 1927, 35⅛ x 45¾ in. Courtesy of Hirshhorn Museum and Sculpture Garden, Smithsonian Institution.

Although his work was regarded as highly original, Bruce became embittered by the fact that he never received public acclaim. In 1936, he returned to New York City where, three months later, he committed suicide.

MEMBERSHIPS
American Art Association

PUBLIC COLLECTIONS
Addison Gallery of American Art, Phillips
 Academy, Andover, Massachusetts
University of Nebraska Art Gallery
Yale University Art Gallery

(No sales information available.)

WALTER KOENIGER
(1881-1943)

While most landscape painters seek to capture the countryside in the fullness of the growing seasons, Walter Koeniger's passion was for frozen, snow-covered scenes of winter. He lived in the Catskill Mountains of New York State and spent 30 years or more sketching and painting the streams and hills around his home in the icy stillness of winter.

Few particulars of Koeniger's life before he started painting in this country are known. He was born in Germany in 1881. He showed a talent for painting as a boy, but his parents insisted that he follow in his father's footsteps as an architect. Whether he actually had training as an architect is unclear, but he did study painting under Duecker and von Gebhard.

Koeniger arrived in America some time around 1910, and established himself as a member of the artists' colony in Woodstock, New York about 1912. He had no commitment to any particular school of painting; he painted what he saw, but not in a photographic way. He used vigorous, broad brushstrokes in an impressionistic manner to capture the spirit of nature, but not to copy it.

He was especially concerned with the mood of the scenes he was painting and used fresh, glowing colors to convey it. Shadows on the snow in his landscapes often were violet, purple and deep blue. A sky might well be emerald, and the snow lying on the branches of evergreens an almost iridescent silver.

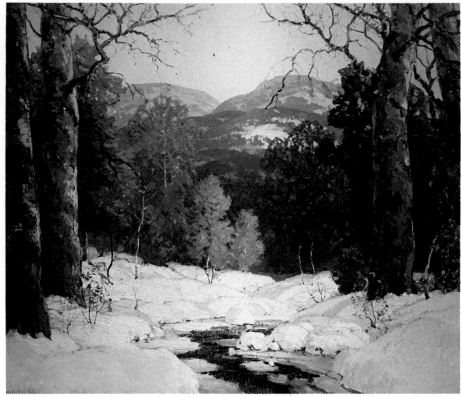

Winter Stream, 38 x 45 in., signed l.l. Photograph courtesy of R.H. Love Galleries, Inc., Chicago, Illinois. Lamb Collection.

Koeniger was a plein-air painter even in the middle of winter, a method that on occasion caused problems. Once, for instance, stepping back to get a better view of his work, he fell into an icy stream, pulling both easel and canvas in with him.

Koeniger's work was popular, and appeared on the covers of such leading magazines as *Literary Digest.* In his later years, Koeniger maintained a studio in New York City as well as in Woodstock. He continued to paint snowscapes until his death in 1943.

MEMBERSHIPS
Salmagundi Club

PUBLIC COLLECTIONS
Toledo Museum of Art

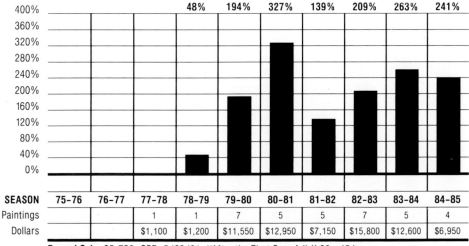

10-Year Average Change From Base Years '77–'78: 178%

		48%	194%	327%	139%	209%	263%	241%

SEASON	75-76	76-77	77-78	78-79	79-80	80-81	81-82	82-83	83-84	84-85
Paintings			1	1	7	5	5	7	5	4
Dollars			$1,100	$1,200	$11,550	$12,950	$7,150	$15,800	$12,600	$6,950

Record Sale: $5,750, SPB, 5/29/81, ''After the First Snowfall,'' 38 × 45 in.

NICOLAI IVANOVICH FECHIN
(1881-1955)

In the years following his birth in Kazan, Russia in 1881, life imposed large obstacles for Nicolai Fechin to surmount. Following a recovery from meningitis at age four, he assisted his wood-working father. By the time he was nine, his designs of religious icons were being acclaimed.

Enrollment at the Kazan Art School was followed by an unusual scholarship to the Imperial Academy of Art in St. Petersburg at age 13. Fechin remained there until age 26, when another scholarship permitted him to travel in Europe to study the masters.

The hardships and limitations of World War I and the Bolshevik Revolution in Russia prompted Fechin's move to New York in 1923. Preceded by his European fame, his show in the Grand Central Galleries generated useful contacts and portrait commissions from celebrities. In 1927, he and his family went to Taos, New Mexico.

Through a turbulent life marked by illness, parental abandonment, several wars, and divorce in 1936, Fechin's artistic scope expanded continuously. Although easel painting was his forte, he continued to work in wood-carving and sculpture.

Fechin's portraits are distinctive for a gripping magnetism captured in the eyes of his subjects, as in his study of Lenin completed before Lenin's rise to power. People in colorful costumes and ethnic

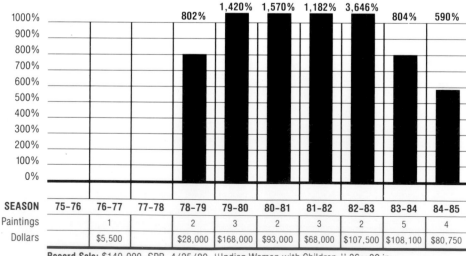

Indian Boy, 30 x 24 in., signed l.r. Photograph courtesy of The Gerald Peters Gallery, Santa Fe, New Mexico.

and foreign surroundings were prominent subjects throughout his life. New Mexico's natives fueled his production. His large output of charcoal drawings included portraits and occasional hand studies.

Fechin's paintings have been said to be uncopiable. He used a porous white ground that absorbed oil from the colors, and often painted with a knife. His work displays a distinctive brilliance. He refused to discuss his unconventional formulas, claiming that they were unimportant to the student.

In 1955, Fechin died in his sleep at his modest house and studio in Santa Monica, California, where he had lived for 19 years. His funeral was drab and poorly attended—an unfitting finale for a man who had been compared to the Renaissance greats.

MEMBERSHIPS
Imperial Academy of the Fine Arts, Petrograd

PUBLIC COLLECTIONS
Albright-Knox Art Gallery,
Buffalo, New York
Colorado Springs Fine Arts Center,
Colorado
National Cowboy Hall of Fame and
Western Heritage Center, Oklahoma City

10-Year Average Change From Base Years '76-'77: 1,252%

SEASON	75-76	76-77	77-78	78-79	79-80	80-81	81-82	82-83	83-84	84-85
%				802%	1,420%	1,570%	1,182%	3,646%	804%	590%
Paintings		1		2	3	2	3	2	5	4
Dollars		$5,500		$28,000	$168,000	$93,000	$68,000	$107,500	$108,100	$80,750

Record Sale: $140,000, SPB, 4/25/80, ''Indian Woman with Children,'' 36 x 30 in.

JOHN D. GRAHAM
(1881-1961)

John D. Graham was born Ivan Gratianovich Dombrovski in 1881 in Kiev, Russia. Imprisoned by the Bolsheviks after the Revolution, he escaped to Poland. In 1920 he reached New York City.

Although there is no evidence of an earlier involvement with art, Graham studied at the Art Students League from 1922 to 1924. Until 1925, he painted American scene subjects with John Sloan. By the mid-1920s, he was traveling frequently in Europe, but he became an American citizen in 1927. His earliest purely abstract paintings, done in the 1930s, were destroyed.

Graham's several American exhibits in the 1920s were less successful than his European shows, which were hailed by French critics Salmon and George. As a connoisseur of African art and with firsthand knowledge of the most advanced European art, Graham influenced and inspired his American associates. He venerated Picasso and condemned the social realists; his activities advanced the development of abstract expressionism. In the April 1937 *Magazine of Art,* Graham summarized his views on ancient art and its effect on modern minds. His book *The System and Dialectics of Art* (1937) commands respect today.

Graham agreed with psychiatrist Karl Jung that the subconscious mind stores images from the distant past. He believed that art provides access to this storehouse of racial memories.

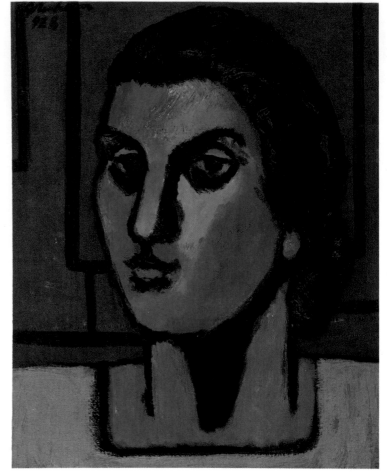

Portrait of Elinor Gibson, 1928, 16¼ x 13 in., signed u.l. Courtesy of National Museum of American Art, Smithsonian Institution, Washington, D.C. Gift of Louis and Annette Kaufman.

During the 1940s, Graham's paintings reflected a withdrawal into personal mysticism. He now reversed his former principles, denouncing Picasso and abstract art. Rejecting modernism, he withdrew from the art world in the late 1940s.

Graham's final style is similar to that of the Renaissance old masters. He is most remembered for the haunting beauty of these works—a curious finale for one so important in launching abstract art in America. He died in London in 1961.

MEMBERSHIPS
American Artists Congress

PUBLIC COLLECTIONS
Baltimore Museum of Art
Carnegie Institute, Pittsburgh
Detroit Institute of Arts
Museum of Modern Art, New York City
Phillips Collection, Washington, D.C.
Whitney Museum of American Art,
 New York City

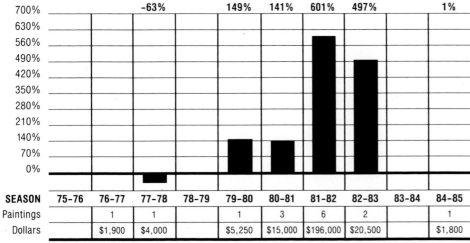

10-Year Average Change From Base Years '76-'77: 189%

	75-76	76-77	77-78	78-79	79-80	80-81	81-82	82-83	83-84	84-85
		-63%			149%	141%	601%	497%		1%
SEASON	75-76	76-77	77-78	78-79	79-80	80-81	81-82	82-83	83-84	84-85
Paintings		1	1		1	3	6	2		1
Dollars		$1,900	$4,000		$5,250	$15,000	$196,000	$20,500		$1,800

Record Sale: $140,000, CH, 11/18/81, "The Horse of the Apocalypse," 72 x 48 in.

MAX WEBER
(1881-1961)

Max Weber was one of the most important early modernist American painters. He was the first American artist to introduce European artistic innovations—including cubism, primitivism, fauvism and futurism—to America.

In addition to exhibiting widely his own revolutionary works, Weber was responsible for arranging Henri Rousseau's first American exhibition at Stieglitz's 291 gallery.

Weber also wrote on art and published *Essays on Art, Cubist Poems* and *Primitives*. His particularly noteworthy *Essays on Art* (1916) was a compilation of his lectures on early modernist aesthetics.

Born in Bialystok, Russia in 1881, Weber came to America and settled in Brooklyn in 1891. From 1898 to 1900, he studied at the Pratt Institute with Arthur Wesley Dow, the most advanced American art teacher of his time, who introduced Weber to Japanese art and the work of Paul Gauguin.

Weber taught art in order to save enough money to go abroad. From 1901 to 1903, he taught in the public schools in Lynchburg, Virginia. From 1903 to 1905, he taught at the State Normal School in Duluth, Minnesota.

In 1905, Weber went abroad on a trip which had a profound influence on his subsequent work. From 1905 to 1906, he studied at the Academie Julien in Paris with Jean Paul Laurens. He then studied

Rush Hour, New Yr., 1915, 36¼ x 30¼ in., signed l.r. Courtesy of National Gallery of Art, Washington, D.C. Gift of the Avalon Foundation.

at the Academie de la Grande Chaumiere and the Academie Colarossi.

In France, Weber became familiar with Cezanne's revolutionary, reductive style of painting, and with the work of the fauves. He became friendly with the primitive painter Henri Rousseau, and he studied under Matisse in 1908. Weber was influenced by Robert Delaunay's use of cubism and Picasso's cubist paintings.

When Weber returned to New York City in 1909, he began two decades of experimentation with fauvism, cubism, futurism, primitivism and synthetic cubism. Directly after his return from Europe, Weber used bright fauve colors and primitive figures. During the 1910s, he produced more abstract, cubist works using solid volumes as subjects. Around

1912, he painted futurist views of New York City, and around 1915 he tried synthetic cubist painting. During the 1920s, he painted a series of monumental nudes which resemble those of Cezanne and Picasso.

Weber's personal style emerged toward the end of the 1920s, and he began to focus on the spirituality of his subjects. He painted scenes of Jewish life, still lifes and landscapes. In the 1930s he painted workers and refugees, and in the 1940s his works became more distorted and expressionistic.

In addition to the vast array of paintings that Weber produced, he also made sculptures and woodcuts. Around 1917, he created some of the first abstract American sculptures, influenced by African and pre-Columbian art.

Weber died in Great Neck, New York in 1961.

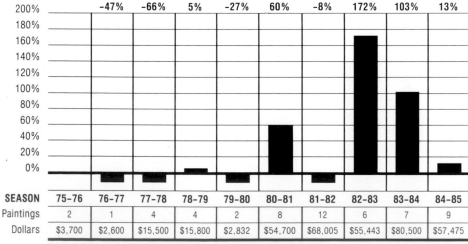

10-Year Average Change From Base Years '75-'76: 21%

SEASON	75-76	76-77	77-78	78-79	79-80	80-81	81-82	82-83	83-84	84-85
		-47%	-66%	5%	-27%	60%	-8%	172%	103%	13%
Paintings	2	1	4	4	2	8	12	6	7	9
Dollars	$3,700	$2,600	$15,500	$15,800	$2,832	$54,700	$68,005	$55,443	$80,500	$57,475

Record Sale: $43,000, SPB, 12/2/82, "Burlesque / 2," 20 × 15 in.

EUSTACE PAUL ZIEGLER
(1881-1969)

A prolific painter, muralist, illustrator and printmaker, Eustace Paul Ziegler portrayed Alaska from its later gold rush days through its statehood in 1959. He painted Indians, Eskimos and prospectors, as well as the majestic· scenery of the Northern land. He was one of the first artists to arrive in Alaska and was able to depict the "Old Alaska" and the men who had pioneered the opening of the territory. In middle age, he moved to Seattle and painted landscapes of the Pacific Northwest. He returned to Alaska every summer, however, and never lost his love for it.

Ziegler was born in Detroit in 1881, the son of an Episcopal clergyman. He and his three brothers also were ordained into the Episcopal ministry. But he was attracted to painting too, and studied at the Detroit Museum of Art under Ida Marie Perrault and others.

As a boy, Ziegler had spent considerable time about the Detroit docks, and later spent his summers working in the logging camps of Northern Michigan. It was not surprising, then, that when he heard the Bishop of Alaska was looking for someone to take charge of a newly-built mission in Chitina, near the Bonanza copper mine, he volunteered for the job. He was then 27 and already had decided that Detroit was not for him. He arrived in January, 1909.

Because the mission was painted red and was dedicated to St. George, it was nicknamed "The Red Dragon."

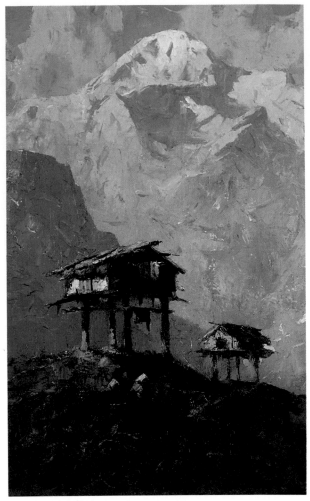

Mount McKinley, 20 x 14 in., signed l.r. Courtesy of Braarud Fine Art, La Conner, Washington.

Ziegler's wit and energy helped to make it a success as an alternative to the surrounding saloons. He stayed until 1924, when he moved to Seattle.

His earliest paintings were realistic watercolors. Unlike many of his later oils, they were done in the field, but they already showed a keen eye and a sensitive hand. Later his academic realism gave way to a looser, more impressionistic style. And in his last years he turned to what were almost abstractions of earlier themes. Trying for atmosphere, not realistic detail, he softened his outlines and muted his colors.

Ziegler also painted murals in several buildings in Alaska and on the steamship *Alaska.* His output of paintings alone, however, can only be called prodigious. He once estimated that he had produced at least 50 paintings a year for 60 years. He ·continued to paint, in fact, until three months before his death in 1969 at age 87.

PUBLIC COLLECTIONS
Anchorage Historical and Fine Arts Museum, Alaska
Charles and Emma Frye Art Museum, Seattle
Seattle Art Museum
University of Alaska Museum, Fairbanks

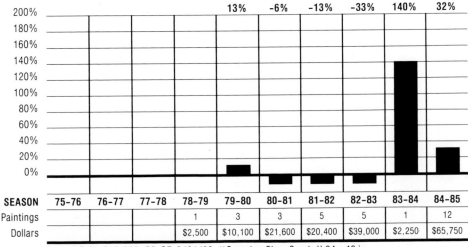

10-Year Average Change From Base Years '78-'79: 19%

				13%	-6%	-13%	-33%	140%	32%	
SEASON	75-76	76-77	77-78	78-79	79-80	80-81	81-82	82-83	83-84	84-85
Paintings				1	3	3	5	5	1	12
Dollars				$2,500	$10,100	$21,600	$20,400	$39,000	$2,250	$65,750

Record Sale: $15,000, BB.SF, 3/24/83, "Crossing Clear Creek," 34 × 40 in.

ROBERT JULIAN ONDERDONK
(1882-1922)

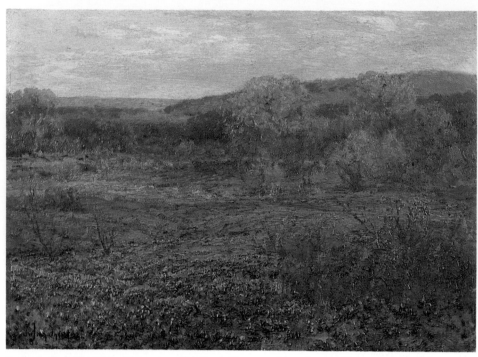

Spring in the Hills, 11¾ x 16 in., signed l.l. Stark Museum of Art, Orange, Texas.

Robert Julian Onderdonk, a painter best known for his landscapes of the Southwest, was born in San Antonio, Texas in 1882. As a child, Onderdonk exhibited artistic talent, and had voiced a desire to be an artist by the time he was five. He received his earliest training from his artist father, Robert Jenkins Onderdonk.

At age 18, he traveled to New York City to study at the Art Students League. There, he was a pupil of Kenyon Cox for one year, before attending William Merritt Chase's Shinnecock Summer School of Art on Long Island. Instruction and criticism from Chase, who had also taught Onderdonk's father, had a lasting impression on the young artist.

At the end of the summer, Onderdonk had decided to attend Chase's New York School of Art. He also studied with Frank Vincent Dumond and Robert Henri. During his student years, Onderdonk painted prolifically to support his studies. Some paintings were signed "Roberto Vasquez."

He married in 1902 and felt increased financial pressures, although he began to achieve some critical success. By 1903, he had work accepted by the Society of American Artists.

In 1906, Onderdonk was hired by the Dallas State Fair Association to organize an art exhibit. He continued working for the fair until his death in 1922.

When Onderdonk moved his family to Texas in 1909, he returned to painting and sketching the Texas landscape he had missed while in New York City. Yet, because he traveled to New York City each summer to organize the art exhibit for the Dallas Fair, Onderdonk continued to have access to the contemporary art world.

Onderdonk's style matured over the last 15 years of his life. He was a severe critic of his own work, and continually painted over earlier canvases that did not meet his exacting standards. By 1914, his panoramic vistas became popular with art collectors in Texas as well as in New York City, Chicago and Los Angeles.

After his sudden death at age 40, Onderdonk's last completed work, *Dawn in the Hills* (1922, San Antonio Museum Association), was exhibited at the National Academy of Design, even though he was not a member of the organization. Later, a public campaign launched by San Antonio friends of Onderdonk raised money to purchase the painting for the city's art museum.

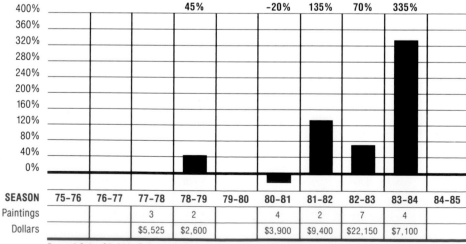

10-Year Average Change From Base Years '77-'78: 94%

SEASON	75-76	76-77	77-78	78-79	79-80	80-81	81-82	82-83	83-84	84-85
				45%		-20%	135%	70%	335%	
Paintings			3	2		4	2	7	4	
Dollars			$5,525	$2,600		$3,900	$9,400	$22,150	$7,100	

Record Sale: $8,000, B.P, 11/7/81, "Purple Hills," 19 × 28 in.

MEMBERSHIPS
Allied Artists of America
Salmagundi Club
San Antonio Art League

PUBLIC COLLECTIONS
Dallas Museum of Fine Arts
Fort Worth Art Association, Texas
Museum of Fine Arts of Houston
San Antonio Museum Association, Texas

GEORGE BELLOWS
(1882-1925)

An athletic man noted for his red-blooded paintings of prize fights, George Bellows personified the raw qualities of early-twentieth-century American realism, especially the artists known as the Ashcan School. More than any of his fellow realists, Bellows caught the drama and excitement of active life in canvases depicting athletic events, crowded streets, men working and buildings under construction or demolition. He chose subjects at times of physical stress, giving his work a quality of throbbing, pulsating life.

Bellows was known to complete two or even three canvases a day in a bravura performance aimed at capturing a vivid moment. His realism, however, did not earn Bellows the same harsh criticism leveled at the Ashcan School artists. On the contrary, the academicians embraced Bellows, electing him the youngest member of the National Academy of Design in 1909.

He was a critical success almost as soon as he set up a studio in New York City, close to an athletic club where he could observe prize fights. This popularity with critics and patrons of the arts was apparently due to the fact that he did not participate in the 1908 showing by the group known as The Eight, who directly challenged academic authority. Nevertheless, Bellows was Robert Henri's star pupil and best friend, a full-fledged member of the second generation of Ashcan artists.

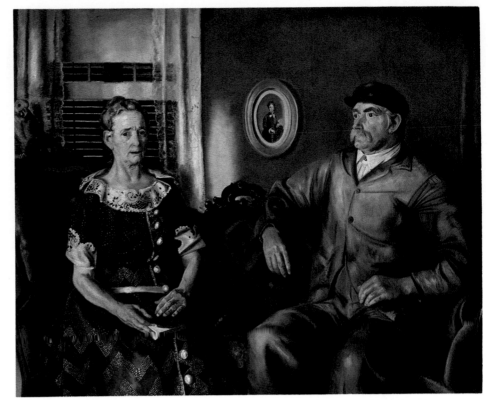

Mr. and Mrs. Phillip Wase, 1924, 51¼ x 63 in. Courtesy of National Museum of American Art, Smithsonian Institution, Gift of Paul Mellon.

Born in 1882 in Columbus, Ohio, Bellows could have become a professional athlete; he played varsity basketball and baseball at Ohio State University. But he wanted to be a painter, and with characteristic vigor he went after his goal, enrolling in the New York School of Art in 1904. He played football on weekends to put himself through art school.

Following his marriage and the birth of two daughters, Bellows's art softened. He did a series of family paintings that are mellow and quiet, compared to the lunatic bloodlust of his fight scenes.

In 1912, he joined the staff of *The Masses,* working as an artist under John Sloan, and in 1916 he turned to lithography, completing a series of lithographs and paintings of war atrocities. About the same time, he experimented with geometric composition, shaping his figures in a grid of horizontal, vertical and diagonal lines, following the mathematical theories of Jay Hambridge.

Throughout his short career, Bellows painted landscapes, including several striking scenes of the Hudson River and New York bridges. In later years, the landscapes became more fantastic, occasionally theatrical. But it was the prize fights with their bloodthirsty spectators that earned Bellows his first and most lasting fame. He died at age 42 of a ruptured appendix.

MEMBERSHIPS
National Academy of Design

PUBLIC COLLECTIONS
Brooklyn Museum
Metropolitan Museum of Art, New York City
National Gallery of Art, Washington, D.C.
Pennsylvania Academy of the Fine Arts,
 Philadelphia

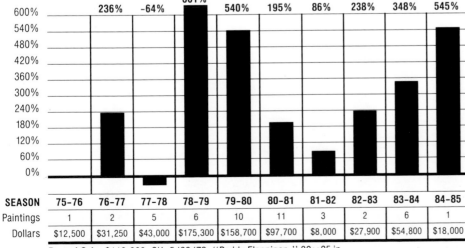

10-Year Average Change From Base Years '75-'76: 279%

	236%	-64%	661%	540%	195%	86%	238%	348%	545%

SEASON	75-76	76-77	77-78	78-79	79-80	80-81	81-82	82-83	83-84	84-85
Paintings	1	2	5	6	10	11	3	2	6	1
Dollars	$12,500	$31,250	$43,000	$175,300	$158,700	$97,700	$8,000	$27,900	$54,800	$18,000

Record Sale: $110,000, CH, 5/23/79, "Paddy Flannigan," 30 x 25 in.

779

NEWELL CONVERS WYETH
(1882-1945)

If anyone could rival his mentor, Howard Pyle, as a prolific and popular illustrator, it was Newell Convers Wyeth, who was referred to simply as N.C. Wyeth. His illustrations for magazine stories, and for such juvenile classics as Robert Louis Stevenson's *Treasure Island* and James Fenimore Cooper's *The Last of the Mohicans,* endeared him to several generations of readers. He also painted many murals, most of them on historical subjects, and late in life turned to easel painting in tempera.

Wyeth was born in Needham, Massachusetts in 1882. He studied at several art schools in the Boston area, but his true vocation for illustration developed when he went to Chadds Ford, Pennsylvania to study with Pyle.

Of all of Pyle's students, Wyeth came closest to emulating Pyle's style, and even portrayed similar subject matter. Like Pyle, he had a zest for life and prodigious energy. In his lifetime he completed more than 3,000 illustrations.

As a young man, Wyeth traveled in the still-untamed West on assignment, and made many sketches of cattle, cowboys and the rugged landscape. His first published illustration, in fact, was a bucking bronco which appeared in the *Saturday Evening Post* in 1903. Years later he drew upon these early sketches for Western genre paintings which commanded high prices.

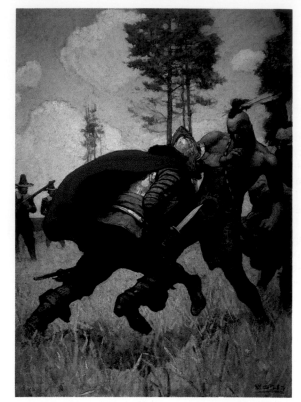

Headlong He Leaped on the Boaster, 40 x 30 in., signed l.r.
Courtesy of Vose Galleries of Boston, Inc., Massachusetts.

Over the years, Wyeth illustrated stories and articles for nearly all the major magazines and many book publishers in the United States. He was able to portray moments of high drama and action with technical brilliance.

When he had attained the pinnacle of success as an illustrator, he felt a need for larger surfaces on which to paint and turned to murals. He was commissioned to paint them for the walls of banks, lobbies of office buildings and public spaces of government buildings. Many of these works dealt with events from American history.

Wyeth is also notable as the founder of what has become an outstandingly successful painting dynasty. Encouraged by their father, three of his five children became painters. One of the three, Henriette, also married Peter Hurd, who had studied with her father and went on to become a noted painter of the Southwest. Wyeth's son, Andrew, has become perhaps the most popular painter in contemporary America, with his evocative landscapes and haunting portraits of country people. And Andrew's son, Jamie, established a remarkable reputation as a realistic painter at an early age.

N.C. Wyeth and one of his grandsons were killed when their car was struck by a train at a grade crossing in 1945. He was at the height of his artistic powers at the time.

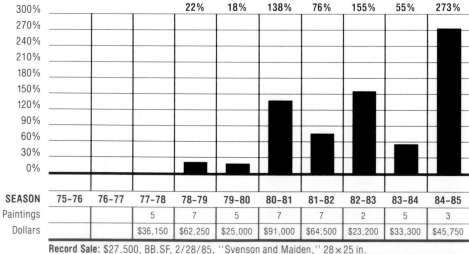

10-Year Average Change From Base Years '77-'78: 92%

			22%	18%	138%	76%	155%	55%	273%

SEASON	75-76	76-77	77-78	78-79	79-80	80-81	81-82	82-83	83-84	84-85
Paintings			5	7	5	7	7	2	5	3
Dollars			$36,150	$62,250	$25,000	$91,000	$64,500	$23,200	$33,300	$45,750

Record Sale: $27,500, BB.SF, 2/28/85, "Svenson and Maiden," 28 x 25 in.

EDGAR PAYNE
(1882-1947)

A master of diverse techniques and media, Edgar Payne was best known as a landscape painter of the Sierra Mountains, Arizona and New Mexico, the Grand Canyon, Canyon de Chelly and the mesas. "There is no painter who would travel further... to bring together in a single collection canvases from so many parts of America and Europe," one observer noted.

Born in Washburn, Missouri in 1882, he left home at an early age and worked as a house and sign painter, a scene painter, and eventually as a mural painter. Although he attended the Art Institute of Chicago for a short time, he considered himself self-taught. His magnum opus was 26,000 square yards of decorated canvas for 11 floors of the Congress Hotel in Chicago, begun in 1917.

In 1911, Payne made the first of many trips to California. A year later, he married artist Elsie Palmer. Payne settled in Laguna Beach, California, where he founded and became first president of the Laguna Beach Art Association. Both the gallery and the association were influential in establishing Laguna Beach as one of the leading art colonies on the West coast.

In the 1920s, Payne traveled in Europe, winning an honorable mention in the 1923 Paris Salon. When he returned to California, he wrote a successful book on landscape painting, *Composition of Outdoor Painting*

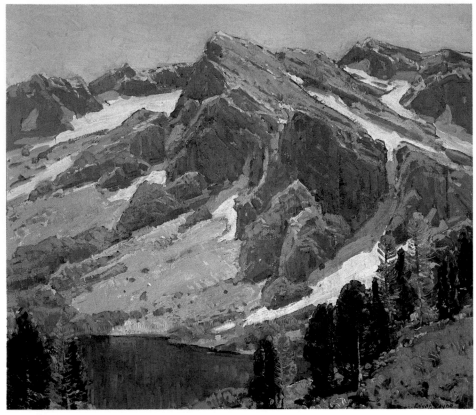

Sierra Divide, 1921, 24 x 28 in., signed l.r. Collection of Mr. and Mrs. James N. Ries, Photograph courtesy of Petersen Galleries, Beverly Hills, California.

(1941), and made a film about the Sierras called *Sierra Journey.*

Payne developed a painting technique in which he added a dark color to all of his mixed colors, rarely using colors directly from the tube. A sense of harmony was thus achieved throughout the composition. To give structure to his subject, his brushstrokes were bold and always painted with bristle, rather than sable, brushes. Payne also used the palette knife.

He died in Hollywood, California in 1947.

MEMBERSHIPS
Allied Artists of America
Alumni Art Institute of Chicago
California Art Club
Chicago Society of Artists
Chisel Club
International Society of Arts and Letters
Laguna Beach Art Association
Palette and Chisel Club
Salmagundi Club
Ten Painters of Los Angeles

PUBLIC COLLECTIONS
American and Empress Theatres, Chicago
Art Institute of Chicago
Clay County Court House, Indiana
Hendricks County Court House, Indiana
Indianapolis Museum of Art
Laguna Beach Museum of Art
National Academy of Design
National Museum of American Art, Washington, D.C.
Northern Hotel, Billings, Montana
Pasadena Art Museum
Queen Theatre, Houston, Texas
Southwest Museum, Los Angeles
Springville Museum of Art, Utah
University of Nebraska Art Galleries

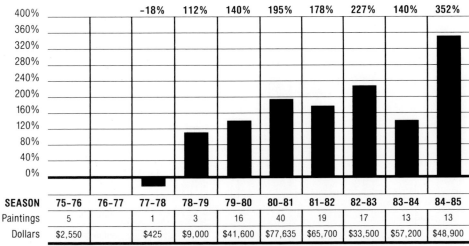

10-Year Average Change From Base Years '75-'76: 147%

		-18%	112%	140%	195%	178%	227%	140%	352%	
SEASON	75-76	76-77	77-78	78-79	79-80	80-81	81-82	82-83	83-84	84-85
Paintings	5		1	3	16	40	19	17	13	13
Dollars	$2,550		$425	$9,000	$41,600	$77,635	$65,700	$33,500	$57,200	$48,900

Record Sale: $10,000, BB.SF, 6/21/84, "Fleet Returning at Day's End," 69 x 94 in.

ARTHUR BEECHER CARLES
(1882-1952)

Like some of his predecessors and contemporaries, Arthur Beecher Carles spent much of his life struggling against the unbendingly conservative views on painting of his native Philadelphia. He painted realistically at first. After several trips to Paris, he became enamored with Matisse and the fauves, and vivid color dominated his compositions. His later work became more and more non-objective as he first explored the relationship between music and painting, and then moved on to geometric abstractions in which each color had a predetermined place.

Carles was born in Philadelphia in 1882 and studied intermittently at the Pennsylvania Academy of the Fine Arts between 1900 and 1907 under Cecilia Beaux, Thomas Anshutz and William Merritt Chase. Chase taught him the importance of impressionism, particularly of Manet, and of the textural quality of paint.

Thanks in part to a traveling fellowship from the Pennsylvania Academy, Carles was able to live in Paris from 1907 to 1911 and to meet the Steins, Marin and Maurer. He also met Matisse and took lessons from him for a time. Steiglitz gave him a one-man show in New York in 1912 and the following year Carles was included in the New York City Armory Show.

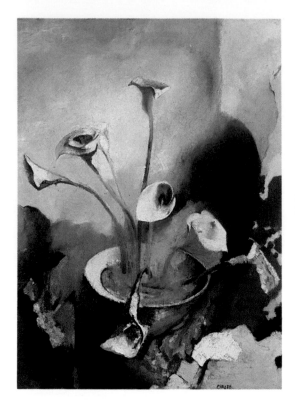

White Callas, 1925, 50½ x 38 in., signed l.r. Courtesy of The Pennsylvania Academy of the Fine Arts, Philadelphia.

For his staid Philadelphia patrons, however, Carles continued to paint realistically. This ambivalence in his style prevented him, in the opinion of one critic, from "achieving a coherent stylistic development." He was a brilliant technician, wrote the critic, but lacked a cohesive psychological center.

After the Armory Show, Carles painted many still lifes, many of them of flowers, that seemed literally to burst with the brilliance of their fauvist colors. From 1917 until 1925 he taught at the Pennsylvania Academy, and students flocked to hear his lectures on how a painting should be constructed through the use of color.

Carles loved riotous living. His two marriages failed, but he was constantly followed by a coterie of adoring women. But his drinking bouts and missed classes led to his dismissal from the Academy. Loyal students and friends responded by coming to him for private lessons.

After 1927, his work became increasingly abstract. In his floral painting *Arrangement* (ca. 1927-1928, Art Institute of Chicago), for example, the flowers became little more than color spots with scant relationship to reality.

Carles suffered a paralytic stroke in 1941 and had to abandon painting altogether. Before his death in 1952, however, he had been recognized as one of the true pioneers of modern art in Philadelphia.

MEMBERSHIPS
Fellowship, Pennsylvania Academy of the Fine Arts

PUBLIC COLLECTIONS
Art Institute of Chicago
Baltimore Museum of Art
Hirshhorn Museum and Sculpture Garden, Washington, D.C.
Pennsylvania Academy of the Fine Arts, Philadelphia
Philadelphia Museum of Art
Whitney Museum of American Art, New York City

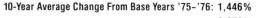

10-Year Average Change From Base Years '75-'76: 1,446%

	942%	430%	263%	161%	3,079%	689%	118%	5,012%	3,770%

SEASON	75-76	76-77	77-78	78-79	79-80	80-81	81-82	82-83	83-84	84-85
Paintings	1	2	2	3	1	2	1	1	2	4
Dollars	$1,000	$1,300	$4,350	$8,400	$425	$54,000	$1,500	$1,500	$74,500	$56,700

Record Sale: $65,000, CH, 12/9/83, "Flowers in Vase," 36 × 32 in.

GEORGE HARDING
(1882-1959)

George Harding was an illustrator, muralist and painter whose career included a number of public commissions. In addition, he taught art for many years.

Harding was born in 1882 in Philadelphia. He attended night classes at the Pennsylvania Academy of the Fine Arts in 1899 and 1900, while working by day in the offices of architect Frederick Mann. Later he was a pupil of illustrator Howard Pyle.

Harding's first sales were to *The Saturday Evening Post,* which published his illustrations beginning in 1903. He served as a roving writer-illustrator for *Harper's Weekly* from 1908 to 1916, traveling around the world. He also illustrated several travel books by Norman Duncan during these years. In 1915, Harding joined the fine arts faculty of the University of Pennsylvania, a post he was to retain until 1935.

From 1916 on, Harding was active as a muralist, painting works in Philadelphia's Customs House and City Hall, a number of Philadelphia banks, and the United States Post Office in Washington, D.C. He executed a prize-winning mural 105 feet in height for the United States Government Building at the 1939 New York World's Fair.

During World War I, Harding served as a staff artist with the American Expeditionary Forces. He was appointed to a similar post with the Marine Corps in World War II, and worked at the front lines in the South Pacific.

Harding· joined the staff of the Pennsylvania Academy of the Fine Arts in 1921, and later became a member of the Academy's board of directors. He also lectured at the Moore Institute and School of Design for Women in Philadelphia. He continued to draw and paint, and his work was widely exhibited.

Harding died in 1959 in Wynnewood, Pennsylvania.

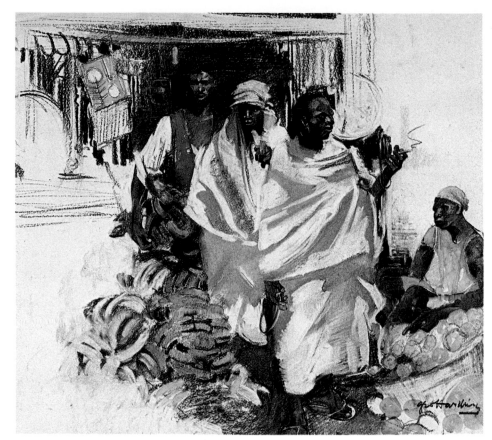

The Market Place Zanzibar, 1919, signed l.r. Courtesy of the Delaware Art Museum, Wilmington.

MEMBERSHIPS
Architectural League of New York
Art Club of Philadelphia
Century Association
National Academy of Design
National Society of Mural Painters
Philadelphia Art Alliance
Royal Geographic Society of Great Britain
Salmagundi Club
Society of Illustrators
Society of Military Engineers

PUBLIC COLLECTIONS
Brandywine River Museum, Pennsylvania
Chrysler Corporation, Detroit
Delaware Museum of Art, Wilmington
Pennsylvania Academy of the Fine Arts, Philadelphia
Philadelphia Museum of Art
Santa Barbara Museum, California
Smithsonian Institution, Washington, D.C.

SEASON	75–76	76–77	77–78	78–79	79–80	80–81	81–82	82–83	83–84	84–85
Paintings			1	3	1	1		1		1
Dollars			$3,258	$1,378	$329	$582		$672		$281

Record Sale: $3,258, S, 11/23/77, "Portraits of Elizabethan Nobleman," 10 × 7 in.

ANTON OTTO FISCHER
(1882-1962)

Anton Otto Fischer was a marine painter whose abilities as a serious artist often were overshadowed by the attention focused on his illustrations for hugely-popular serials and stories in the *Saturday Evening Post* and other magazines. He loved the sea and caught its every mood in his work. He also was skilled at portraying the emotions of the men who followed the sea.

Fischer was born in Munich, Germany in 1882, and was orphaned at age five. He was brought up in a monastery, but ran away to sea when he was 16. He spent eight years sailing on windjammers, in the days when sailing ships were slowly giving way to the more prosaic steam vessels. His voyages took him through the Mediterranean to the Black Sea and around Cape Horn to California.

In 1906, with $600 in savings in his pocket, he signed off a ship in New York City and went to Paris to study art at the Academie Julien. He came back to the United States in 1908 and spent three years racing yachts in Long Island Sound and teaching aboard a school ship.

Fischer had not abandoned painting, however. One day he walked into the offices of *Harper's Weekly* with a painting under his arm and sold it on the spot. That began his long and successful career as a magazine illustrator.

Perhaps his best-known illustrations were for the Tugboat Annie stories that

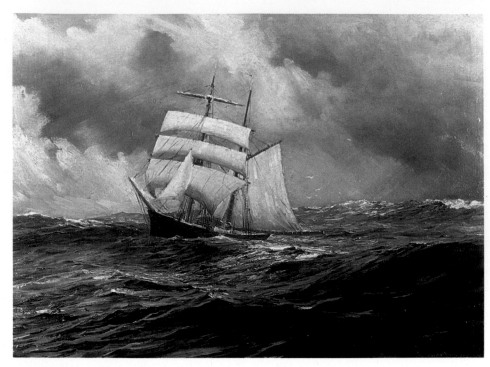

Brigantine Sailing Ship, 22 x 30 in., signed l.r. Courtesy of Henry B. Holt, Inc., Essex Fells, New Jersey.

ran for years in the *Saturday Evening Post,* and for some of Kenneth Roberts's early novels which were serialized in the same magazine.

Fischer was admired for the accuracy

of his marine paintings and for the way he portrayed the very movement of a ship through the water. His subjects ranged from clipper ships to men in small boats and dories.

During World War II, when he was already past 60, Fischer was commissioned as a war artist; he went back to sea in the United States Coast Guard. One cutter he served on rammed a surfaced German submarine and sank it.

Although he loved the sea, for many years Fischer lived far from it, in the Catskill Mountains at Woodstock, New York, where he died in 1962.

MEMBERSHIPS
American Federation of Arts
Society of Illustrators

PUBLIC COLLECTIONS
Brandywine River Museum, Chadds Ford, Pennsylvania
New Britain Museum of American Art, Connecticut

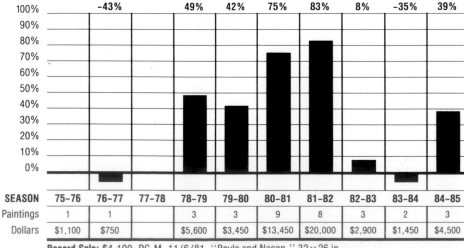

10-Year Average Change From Base Years '75-'76: 24%

	−43%		49%	42%	75%	83%	8%	−35%	39%	
SEASON	75-76	76-77	77-78	78-79	79-80	80-81	81-82	82-83	83-84	84-85
Paintings	1	1		3	3	9	8	3	2	3
Dollars	$1,100	$750		$5,600	$3,450	$13,450	$20,000	$2,900	$1,450	$4,500

Record Sale: $4,100, RG.M, 11/6/81, "Boyle and Nason," 32 × 26 in.

DAVID BURLIUK
(1882-1967)

David Burliuk is known as a major exponent of Russian modernism. He was one of the world's first "hippies"; in 1913 he painted the words "I—Burliuk" on his forehead and stood on street corners reciting poetry.

Born into a privileged class of Russian society—Burliuk's wife was educated with the czar's children—he was in a good position to become an artistic leader. He first studied at the Kazan School of Fine Arts in 1898, followed by domestic studies in Odessa and Moscow, as well as in Munich, and at the Academies des Beaux Arts in Paris. His early fauve works—violent in color and heavy with paint—were exhibited with The Blue Riders in Munich.

Meanwhile, in Russia, Burliuk continued to break artistic convention. In 1911, he was expelled from the Moscow Institute along with poet Vladimir Mayakowsky. With other futurists, they undertook a campaign, giving public lectures, publishing journals and making films depicting the craziness of everyday life.

World War I threw Burliuk's life into turmoil. He was not political, but neither was he enthusiastic about the new regime. In four years, he traveled to Siberia, Japan and the South Seas, where he stayed and painted for two years. He arrived in the United States in 1922, to begin all over again.

Burliuk's varied subjects range from neo-primitive paintings of peasant life in Russia, to cubo-futurist depictions of South Sea fisherman, to vivid canvases of flowers inspired by Van Gogh. Much of his pre-World War I work vanished in the wake of the Russian Revolution. Other products of his 60 years as an artist were left in Europe and in Asia, along the path he took in 1918 to escape Communist Russia.

Throughout his life, Burliuk was continually innovative and imbued with energy. His work, often gay and hopeful, always personal and fresh, represents the triumph of creativity over twentieth-century mechanization.

In the United States, Burliuk developed what is called his "radio-style," an approach that evolved later into symbolism, neo-primitivism and expressionism. But Burliuk's early work in pre-revolutionary experimental art was his most creative.

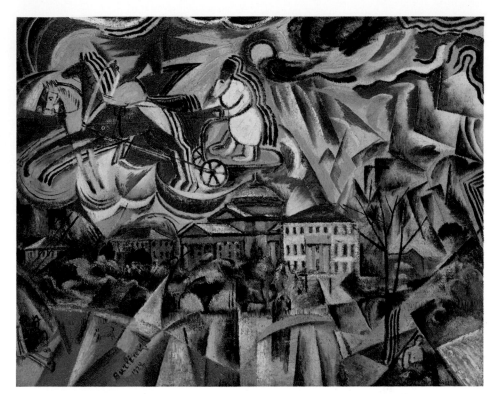

Elias the Prophet (Ilya Prorok), 1924, 30 x 30⅞ in., signed l.l. Philadelphia Museum of Art, Pennsylvania, Given by Christian Brinton.

MEMBERSHIPS
National Institute of Arts and Letters

PUBLIC COLLECTIONS
Brooklyn Museum
Metropolitan Museum of Art, New York City
Museum of Fine Arts, Boston
Phillips Memorial Gallery, Washington, D.C.
Whitney Museum of American Art,
 New York City

SEASON	75-76	76-77	77-78	78-79	79-80	80-81	81-82	82-83	83-84	84-85
Paintings						22	13	11	17	7
Dollars						$27,928	$22,822	$11,530	$23,661	$6,540

Record Sale: $7,500, SPB, 6/4/82, "Foot of Tenth Street and the East River," 25 × 39 in.

EDWARD HOPPER
(1882-1967)

People in the Sun, 1960, 40⅜ x 60⅜ in., signed l.r. Courtesy of National Museum of American Art, Smithsonian Institution, Gift of S.C. Johnson & Son, Inc.

Edward Hopper was perhaps the supreme American realist. While he was of roughly the same generation as the Ashcan School, he was not one of them. There is a starkness, a sense of loneliness and detachment in his work that sets him apart. Though the colors in his paintings are bright, there is no warmth in them.

Hopper was born in Nyack, New York in 1882. From 1900 until 1906, he studied at the New York School of Art under Robert Henri and Kenneth Hayes Miller. Henri taught him to study, observe and record his surroundings, and Hopper acknowledged his debt to him for it.

At heart, however, Henri's optimism and flamboyant technique were alien to Hopper. Much of Hopper's work is profoundly pessimistic and somber in mood. Despite its realism, his compositions often are organized with abstract precision. "The only real influence I've ever had," Hopper once confessed, "was myself."

Between 1906 and 1916 he made three trips to Paris. He admired in particular the luminosity of the light there, but the revolutionary changes in modern art that were going on around him made no impression. Trends in art meant nothing to him.

Although he sold one painting at the 1913 New York City Armory Show, Hopper became discouraged and virtually abandoned painting for the next 10 years. Instead, he concentrated on etchings, developing a style that he would translate successfully into his later paintings.

During these years he made his living as a commercial artist, doing illustrations and graphics. He hated the work, often hoping that he would not be given an assignment, but at the same time knowing how badly he needed the money.

From etchings, Hopper moved to watercolors and then, in his forties, back to oil painting. He was a mature artist now, with a firm grasp of the type of work he wanted to do. His style was refined almost to the point of bleakness.

Lonely streets, all-night restaurants, railroad tracks curving off into the distance, and scenes of the New England coast—all were typical Hopper subjects. The light is harsh. Horizontals, verticals and diagonals emphasize the architectural quality of many of his compositions.

Figures, when they appear at all, are withdrawn, lost in their own thoughts. Often they are two-dimensional, overshadowed by an architectural frame of some sort.

Early Sunday Morning (1930, Whitney Museum of American Art) is one of Hopper's best-known paintings. A row of two-story brick houses stands bathed in cold morning light. Only a barber pole and a hydrant break the emptiness of the sidewalk and street. It is a statement of the barrenness of urban life.

For many years Hopper and his wife summered in Gloucester, Massachusetts. Later they built a house on Cape Cod. One painting, *Cape Cod Morning* (1950, Sara Roby Foundation), comes nearer, in Hopper's own words, "to my thoughts about such things than many others." In it a woman, in profile, stares out the bay window of a white clapboard house. There is a strong feeling of physical barriers in the painting and, as always, of intense loneliness.

Hopper lived frugally and worked in the same studio on Washington Square in New York City for 54 years. He died there in 1967.

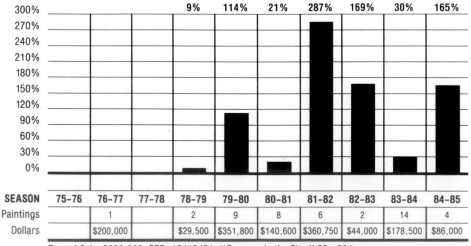

10-Year Average Change From Base Years '76-'77: 99%

	9%	114%	21%	287%	169%	30%	165%

SEASON	75-76	76-77	77-78	78-79	79-80	80-81	81-82	82-83	83-84	84-85
Paintings		1		2	9	8	6	2	14	4
Dollars		$200,000		$29,500	$351,800	$140,600	$360,750	$44,000	$178,500	$86,000

Record Sale: $300,000, SPB, 12/10/81, "Summer in the City," 20 × 30 in.

ROCKWELL KENT
(1882-1971)

Rockwell Kent was a realist painter, illustrator, printmaker and writer who loved the rugged outdoor life, particularly in such remote places as Greenland, Alaska and the extreme tip of South America. The subjects he most liked to paint were windswept mountains, icebergs and snow-covered trees. It was his prints, however, with their bold use of heavy black masses and lines, that brought him the widest recognition.

Born in Tarrytown Heights, New York in 1882, Kent studied architecture for two years at Columbia University. His interests changed, however, and he began to study painting, first under William Merritt Chase and later under such men as Robert Henri, Kenneth Hayes Miller and Abbott Thayer.

Kent's early work showed much of the same vitality as George Bellows's, but as his interest in arctic and winter scenes grew, he turned to smoother, more broadly-massed forms with harsh contrasts of tone.

Kent loved to travel, often leaving his wife to fend for herself in New York for long periods of time. One winter he lived with his young son on a remote Alaskan island, where the temperature was often 30 degrees below zero.

Until he established his reputation in 1920 with the publication of *Wilderness, A Journal of Quiet Adventure in Alaska,* which he wrote and illustrated, Kent made his living between trips by selling illustrations for books and maga-

Cloud Shadows, 1965, 34 x 44 in., signed l.r. Courtesy of Kennedy Galleries, New York, New York.

zines. Sometimes he was forced to work at manual jobs.

Through the 1920s and 1930s, he became known for his stylized-engraving illustrations for such classics as *Moby Dick*. During the same period, he chronicled and illustrated his own travels in a

series of books. His autobiography, *It's Me, O Lord,* was published in 1955.

Kent considered himself a revolutionary, and for many years was involved in radical politics. In 1938, an inflammatory message written in Eskimo, which he had painted into a mural in Washington, was denounced and later expunged. In the 1950s his support of communist-sponsored events was widely criticized in Congress and his passport was voided. He remained embittered by this until his death in 1971.

MEMBERSHIPS
Academy of Fine Arts of the U.S.S.R.
National Institute of Arts and Letters

PUBLIC COLLECTIONS
Art Institute of Chicago
British Museum, London
Brooklyn Museum
Cleveland Museum of Art
Corcoran Gallery of Art, Washington, D.C.
Metropolitan Museum of Art, New York City
Museum of Fine Arts, Boston
Museum of Fine Arts of Houston
Victoria and Albert Museum, London
Whitney Museum of American Art,
 New York City

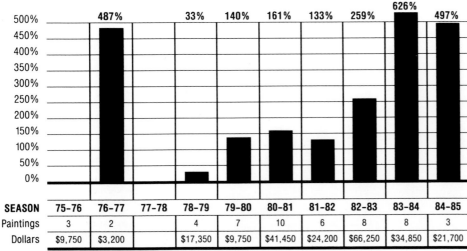

10-Year Average Change From Base Years '75-'76: 260%

| | 487% | 33% | 140% | 161% | 133% | 259% | 626% | 497% |

SEASON	75-76	76-77	77-78	78-79	79-80	80-81	81-82	82-83	83-84	84-85
Paintings	3	2		4	7	10	6	8	8	3
Dollars	$9,750	$3,200		$17,350	$9,750	$41,450	$24,200	$66,250	$34,850	$21,700

Record Sale: $25,000, SPB, 12/2/82, "Corn," 38 x 54 in.

CHARLES DEMUTH
(1883-1935)

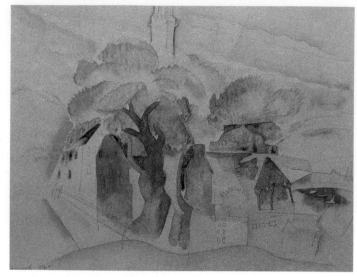

Provincetown, 1916, 7¾ x 9¾ in., signed l.l. Courtesy of Wunderlich and Company, Inc., New York, New York.

Using cold colors and razor-sharp outlines, Charles Demuth was a first-rank precisionist painter and an interpreter of the stark industrial landscape of the early twentieth century. His geometric compositions were strongly influenced by cubism, yet never lost their realism.

Demuth began by painting watercolors and quickly became a master of the technique, simplifying his forms and using subtly shifting intensities of color for emotional impact. During World War I he also did semi-impressionist, strangely sinister watercolor illustrations for works by Zola, Henry James and Edgar Allan Poe.

Demuth was born in 1883 to a family of comfortable means in Lancaster, Pennsylvania, center of a fertile farming and tobacco-growing area. He had a club foot and diabetes, which plagued him in his later years. Despite much time spent in such artistic centers as Paris, New York City and Provincetown, Massachusetts, and many friends in modern art circles, Demuth never really left home. Throughout his life he always came back to Lancaster, and painted much of his best work there.

He studied at Philadelphia's Drexel Institute, went to Europe and then returned to study at the Pennsylvania Academy of the Fine Arts under Thomas Anshutz until 1911. The next year he went back to Paris for more study at the Academie Colarossi and Academie Julien. While there he met Gertrude and Leo Stein and was exposed to the modernism that was sweeping the art world. It was reflected in the flower and figure watercolors that he did at the time.

The influence of Aubrey Beardsley's art nouveau style of illustration could be seen in Demuth's later watercolors and illustrations. He was fascinated by the decadent nightlife of the entertainment world and depicted it in sinuous, often erotic works. *In Vaudeville (Dancer with Chorus)* (1918, Philadelphia Museum of Art) is a particularly good example of his ability to capture the disturbing excitement of a scene.

After returning to the United States in 1914, Demuth became a member of the Arensburg circle of avant-garde artists in New York City. It was there that he met Marcel Duchamp, whose work appealed to him on several levels. He liked Duchamp's obliqueness and the wry, symbolic relationships between his images and titles. Demuth also revealed the disillusionment of his generation over the industrialization of America in titling much of his own work: one example is *Incense of a New Church* (1921, Columbus Gallery of Fine Arts), a faintly cubist view of smokestacks emerging from sinuous billows of smoke.

In the mid-1920s, Demuth frequently was ill with diabetes and turned from his cool, dispassionate architectural paintings to small still lifes and floral studies that seemed to burst with vitality. Around the same time he also painted a group of what now are termed poster portraits of his friends. They were purely symbolic, yet revealed aspects of the lives of the "sitters." The best known, *I Saw the Figure Five in Gold* (1928, Museum of Modern Art), was based on lines from a short poem by his long-time friend, William Carlos Williams.

Demuth died in Lancaster in 1935.

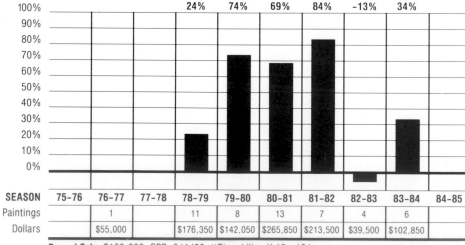

10-Year Average Change From Base Years '76-'77: 39%

SEASON	75-76	76-77	77-78	78-79	79-80	80-81	81-82	82-83	83-84	84-85
				24%	74%	69%	84%	-13%	34%	
Paintings		1		11	8	13	7	4	6	
Dollars		$55,000		$176,350	$142,050	$265,850	$213,500	$39,500	$102,850	

Record Sale: $100,000, SPB, 6/4/82, "Tiger Lilies," 18 x 12 in.

EUGENE EDWARD SPEICHER
(1883-1962)

Eugene Speicher, landscape and portrait artist, was widely exhibited and honored during his life for his artistically orthodox but nonetheless lyrical paintings.

Speicher was born in Buffalo, New York in 1883. Though he showed an early aptitude for art, he received no formal instruction until he was 19. Then, working days in a lumberyard, he took evening art classes at the Buffalo Art School.

In 1906, Speicher moved to New York City, where he continued his studies under Robert Henri and William Merritt Chase at the Art Students League. There he received his first artistic award, for a portrait of fellow student Georgia O'Keeffe. During his years of study, Speicher earned his living by painting "quick" portraits.

As with many of his contemporaries, his greatest artistic influence came from his first European trip in 1910. His subsequent work reflects the influences of both Cezanne and Renoir.

For a number of years after his return to the United States, Speicher devoted himself entirely to portrait painting. Though he continued to associate with artists in New York, many of whom were exploring a more modernist context for their art, Speicher's own works grew increasingly conservative in style and execution.

During that time, he established a summer residence in Woodstock, New York, where in 1907 he had helped to found the Woodstock Art Colony.

As exemplified by his *Marianna* (1937, Whitney Museum of American Art), Speicher often chose women and young girls as his portrait subjects. His brushwork and use of colors was simple but lyrically expressive. He wanted, he said, to express "something that will be a tonic to stir the imagination, a pleasure to the eye, and reflect my sense of quality in life."

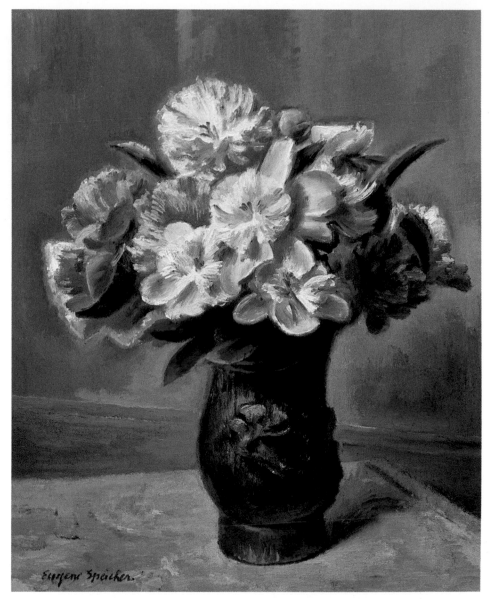

Peonies in a Vase, 21 x 17 in., signed l.l. Courtesy of Kennedy Galleries, New York, New York.

After 1926, Speicher, then critically heralded, became more selective in his choice of portrait subjects, and devoted increasingly more time to painting still lifes and landscapes.

He died in New York City in 1962 at age 79.

SEASON	75-76	76-77	77-78	78-79	79-80	80-81	81-82	82-83	83-84	84-85
Paintings			2	3	4	6	6	4	4	8
Dollars			$2,750	$15,750	$8,150	$18,300	$7,500	$5,100	$7,700	$13,800

Record Sale: $14,000, CH, 5/23/79, "Babette," 57 × 45 in.

GUY CARLETON WIGGINS
(1883-1962)

Guy C. Wiggins was born in Brooklyn, New York in 1883, the son of Carleton Wiggins, who had a long and highly acclaimed career as a landscape painter. The younger Wiggins, who first studied with his father, continued the American landscape tradition, winning many prestigious prizes from 1916 on.

Around 1900, Guy C. Wiggins studied architecture and drawing at the Brooklyn Polytechnic Institute, but went on to study painting at the National Academy of Design. Early recognition came at age 20, when he was the youngest American to have a work accepted into the permanent collection of the Metropolitan Museum of Art.

Old Lyme, Connecticut became Wiggins's summer home around 1920, and he became one of the younger members of the group of painters in Old Lyme who were developing their version of impressionism by fusing French technique with American conventions. Though American art was moving more and more toward realism, Wiggins was dedicated to maintaining his own style; it was based on French impressionism but influenced by Childe Hassam and other American impressionists of The Ten.

Wiggins earned a fine reputation in the 1920s for his city snow scenes, often painted from the windows of offices in Manhattan. His *Washington's Birthday* (1930, New Britain Museum) expresses the feeling of snow quietly hushing the bustling city street.

47th & Broadway, 1922, 12 x 16 in., signed l.l. Courtesy of Henry B. Holt, Inc., Essex Fells, New Jersey.

In her *American Art Review* article of December, 1977, Adrienne L. Walt said of Wiggins that "his resolution was to constantly emphasize color, elevating it above all else and achieving luminosity through it. . . ."

In 1937 Wiggins moved to Essex, Connecticut and founded the Guy Wiggins Art School. During the following years, in addition to teaching, he traveled widely throughout the United States and painted scenes of Montana, Massachusetts and Connecticut.

With the permission of President Dwight D. Eisenhower, he completed two paintings of the Executive Mansion from the lawn of the White House, one of which eventually was placed in the Eisenhower Museum in Abilene, Kansas, after hanging in the president's office.

Wiggins died in Florida in 1962.

MEMBERSHIPS
Connecticut Academy of Fine Arts
National Academy of Design
National Art Club
Lotus Club
Lyme Art Association
Salmagundi Club

PUBLIC COLLECTIONS
Art Institute of Chicago
Beach Memorial Gallery, Storrs, Connecticut
Brooklyn Museum
Dallas Art Association
Hackley Art Gallery, Muskegon, Michigan
Metropolitan Museum of Art, New York City
National Gallery of Art, Washington, D.C.
Reading Museum, Pennsylvania
Syracuse Museum, New York
Wadsworth Atheneum, Hartford, Connecticut

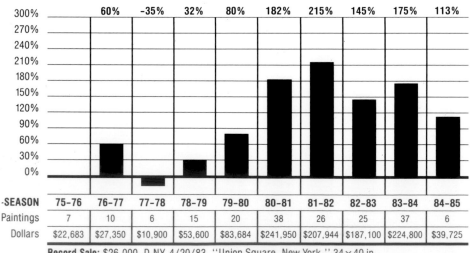

10-Year Average Change From Base Years '75-'76: 97%

	60%	-35%	32%	80%	182%	215%	145%	175%	113%

SEASON	75-76	76-77	77-78	78-79	79-80	80-81	81-82	82-83	83-84	84-85
Paintings	7	10	6	15	20	38	26	25	37	6
Dollars	$22,683	$27,350	$10,900	$53,600	$83,684	$241,950	$207,944	$187,100	$224,800	$39,725

Record Sale: $26,000, D.NY, 4/20/83, "Union Square, New York," 34 x 40 in.

CHARLES SHEELER
(1883-1965)

Charles Sheeler, a painter and photographer born in Philadelphia in 1883, was a major precisionist. He began his studies in Philadelphia at the School of Industrial Art. He attended the Pennsylvania Academy of the Fine Arts from 1903 to 1906, receiving instruction from William Merritt Chase. Sheeler also traveled throughout Europe, once with Chase and later with Morton Schamberg.

There is little doubt that Sheeler was profoundly influenced by Cezanne and the cubist paintings he saw during his European trip in 1909. The 1913 Armory Show offered him another chance to study European modernism, in particular the work of Picasso and Braque.

Sheeler's early style reflects the bold brushwork of Chase. His mature style, however, which began to develop around 1917, was more geometric, as in the conte crayon study *Barn Abstraction* (1917, Philadelphia Museum of Art).

At the time, Sheeler drew his subjects from the rural surroundings and Shaker antiques he found near the Bucks County, Pennsylvania farmhouse he owned with Schamberg. The two divided their time between Philadelphia and the farm until Schamberg's death in 1918. Sheeler then moved to New York City, and began painting skyscrapers and scenes of urban life. He sold the farm in 1923, and began retreating to rural upstate New York.

Winter Window, 1941, 40 x 30 in., signed l.r. Courtesy of James Maroney, New York, New York.

Sheeler became a professional photographer in 1912. His industrial and architectural photographs reflect his fascination with abstract composition. This emphasis on architectural elements would be echoed in his paintings.

He explained the precise, almost invisible brushwork of his mature paintings by saying, "I favor a picture which arrived at its destination without evidence of a trying journey, rather than one which shows the marks of battle. An efficient army burys its dead." He also sought to minimize any representation of his personality in his paintings with his draftsman-like approach.

During the 1920s, Sheeler completed major photographic commissions. He applied the same sharp focus to his paintings as he did to his photographic series of the Ford Motor Company plant at River Rouge, Michigan, completed in 1927. *American Landscape* (1930, Museum of Modern Art) and *River Rouge Plant* (1932, Whitney Museum of American Art) offer a modern version of nineteenth-century landscape painting.

Sheeler died in 1965 in Dobbs Ferry, New York.

PUBLIC COLLECTIONS
Art Institute of Chicago
Brooklyn Museum
Corcoran Gallery of Art, Washington, D.C.
Fine Arts Museums of San Francisco
Hirshhorn Museum and Sculpture Garden, Washington, D.C.
Metropolitan Museum of Art, New York City
Museum of Fine Arts, Boston
Museum of Modern Art, New York City
Pennsylvania Academy of the Fine Arts, Philadelphia
Philadelphia Museum of Art
Whitney Museum of American Art, New York City

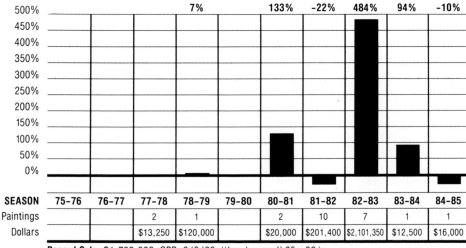

10-Year Average Change From Base Years '77-'78: 98%

		7%			133%	−22%	484%	94%	−10%

SEASON	75-76	76-77	77-78	78-79	79-80	80-81	81-82	82-83	83-84	84-85
Paintings			2	1		2	10	7	1	1
Dollars			$13,250	$120,000		$20,000	$201,400	$2,101,350	$12,500	$16,000

Record Sale: $1,700,000, SPB, 6/2/83, "Landscape," 25 × 32 in.

JOHANN BERTHELSEN
(1883-1969)

Johann Berthelsen painted exquisitely rendered landscapes of New York City, judged "poetic" by contemporary critics. Ironically, though, it was music, not art, to which Berthelsen originally aspired.

A native of Copenhagen, Denmark, Berthelsen was six when his family immigrated to the United States in 1889. When he was 18, Berthelsen studied music and voice for four years at the Chicago Musical College. Following his graduation, he toured the United States and Canada as lead baritone for the Grand Opera Company, after which he taught voice—first at his alma mater and then at the Indianapolis Conservatory of Music. In 1920, Berthelsen opened a private studio in New York City where he gave voice lessons.

Although he devoted most of his time to singing and music, Berthelsen painted—at first for his own pleasure and then, after 1932, on a full-time basis.

Berthelsen initially established his artistic reputation with his work in pastels. Working with small canvases, he found inspiration in New York's Central Park, rendering this setting most effectively in its seasonal transformations. He painted similar scenes in and of Chicago. They also met with critical and popular acclaim.

Having achieved success as a pastelist, Berthelsen turned his attention to oils. He returned to the fundamentals of

Brooklyn Bridge, 16 x 20 in., signed l.r. Courtesy of Henry B. Holt, Inc., Essex Fells, New Jersey.

Wall Street, 9 x 12 in., signed l.r. Courtesy of Henry B. Holt, Inc., Essex Fells, New Jersey.

drawing in order to discover a technique appropriate to the medium. Berthelsen used a heavy impasto to almost palpably render his landscapes and his city and park snowscapes.

Berthelsen also painted still lifes. Unlike his landscapes, these works—again on small canvases—are clearly defined, with colors ranging from bright to low-key.

Berthelsen died in 1969.

MEMBERSHIPS
Allied Artists of America
American Watercolor Society

PUBLIC COLLECTIONS
Terre Haute Museum, Indiana
Wake Forest College, North Carolina

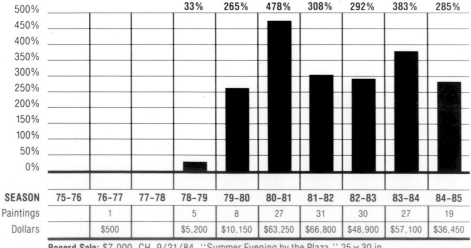

10-Year Average Change From Base Years '76-'77: 256%

			33%	265%	478%	308%	292%	383%	285%

SEASON	75-76	76-77	77-78	78-79	79-80	80-81	81-82	82-83	83-84	84-85
Paintings		1		5	8	27	31	30	27	19
Dollars		$500		$5,200	$10,150	$63,250	$66,800	$48,900	$57,100	$36,450

Record Sale: $7,000, CH, 9/21/84, "Summer Evening by the Plaza," 25 x 30 in.

792

ORRIN A. WHITE
(1883-1969)

Although he was born and brought up in the Midwest and studied art in the East, Orrin A. White made his reputation as a landscape painter in California. In his later years, he also spent considerable time in Mexico, where he painted street scenes, cathedrals and colorful patios, in addition to the lush tropical countryside.

Most of White's work was delicate in color, almost poetic, with an opaline iridescence. Although his paintings were decorative in design, he never did them merely for decoration.

White was born in Hanover, Illinois in 1883, attended the University of Notre Dame in South Bend, Indiana, and then came East to study textile design at the Philadelphia School of Applied Arts. He had already moved to California by the time the United States became involved in World War I. He served for the duration in a camouflage unit.

At the end of the war, White returned to California and resumed his landscape painting. In time he settled in Pasadena and built a studio there. He reveled in painting the High Sierras with their towering, snow-clad peaks and clear, rushing streams and rivers in the valleys. It was as if the vastness and variety of California had no end for him.

Trees had a particular fascination for White, particularly the Monterey oaks, gnarled, twisted and lopsided from years of buffeting by the Pacific winds.

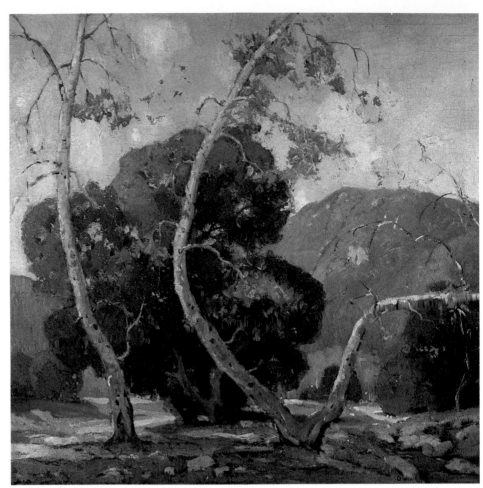

Sycamore Canyon, 36 x 36 in., signed l.r. Photograph courtesy of George Stern, Fine Arts, Encino, California. Collection of James Zidell.

Another favorite was the ubiquitous native eucalyptus. Sometimes he would paint a distant mountain range as seen through the branches and leaves of a row of eucalyptus in the foreground.

White continued to paint until shortly before his death in 1969.

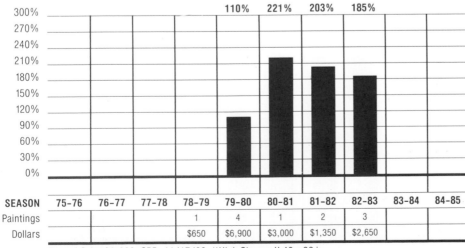

10-Year Average Change From Base Years '78–'79: 144%

SEASON	75–76	76–77	77–78	78–79	79–80	80–81	81–82	82–83	83–84	84–85
					110%	221%	203%	185%		
Paintings				1	4	1	2	3		
Dollars				$650	$6,900	$3,000	$1,350	$2,650		

Record Sale: $3,000, SPB, 11/17/80, "High Sierras," 40 × 30 in.

MEMBERSHIPS
California Art Club

PUBLIC COLLECTIONS
Cleveland Museum of Art
Illinois State Museum, Springfield
Los Angeles County Museum of Art
Montclair Art Museum, New Jersey

ELIOT CLARK
(1883-1980)

Painter Eliot Clark won critical acclaim for his work at a very early age, and his landscapes continued to receive recognition throughout his long career. Clark was also active as a teacher, art historian and officer of artists' organizations.

Clark was born in 1883, the son of landscape painter Walter Clark. By age nine, Clark was exhibiting with the New York Water Color Club, and when he was 13 his work was hung in the National Academy of Design. He was greatly influenced by family friend John Henry Twachtman and studied in Europe between 1904 and 1906, painting in Paris and Giverny. He returned to the United States in 1906 and continued to paint, showing the influence of Whistler, whose work he had seen in London. His own work was distinctly impressionistic.

In 1926 and again in 1935, Clark painted in the Southwest. He traveled to India for two years in 1937, and there executed views of the Himalayas and of Indian scenes, such as *Lake Palace, Udaipur, India* (1938, location unknown). He exhibited widely, and a Virginia landscape variously titled *Rolling Hills* or *Rolling Country* (date and location unknown) was purchased by Woodrow Wilson, appearing in the White House during Wilson's presidency.

Clark began writing early in his career. He published biographies of four American impressionists: Alexander

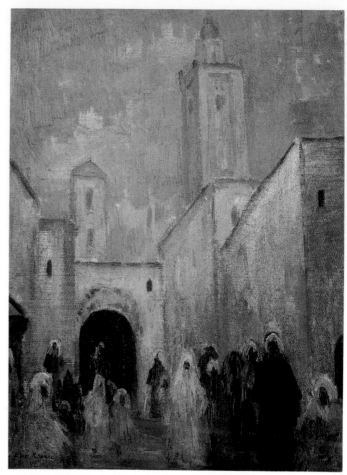

Evening after Ramadan Morocco, 18 x 14 in., signed l.l. Photograph courtesy of Balogh Gallery, Inc., Charlottesville, Virginia.

Wyant (1916), John Henry Twachtman (1924), J. Francis Murphey (1927) and Theodore Robinson (1979). In addition, he published a history of the National Academy of Design (1954) and many essays and reviews.

Clark taught painting at several institutions, including the Art Students League, and lectured on art. He continued to paint, and his later landscapes show a movement away from impressionism toward a realistic treatment. He died in 1980.

MEMBERSHIPS
Allied Artists of America
American Water Color Society
Artists' Fund Society
Connecticut Academy of Fine Arts
National Academy of Design
National Arts Club
Salmagundi Club
Society of Painters

PUBLIC COLLECTIONS
Dayton Museum, Ohio
Fort Worth Museum, Texas
Maryland Institute, Baltimore
Metropolitan Museum of Art, New York City
National Academy of Design, New York City
Smithsonian Institution, Washington, D.C.

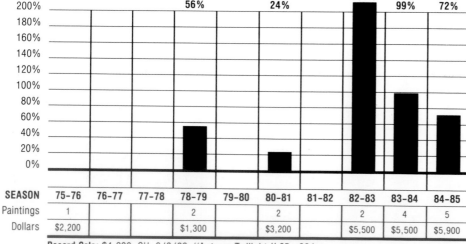

10-Year Average Change From Base Years '75-'76: 76%

SEASON	75-76	76-77	77-78	78-79	79-80	80-81	81-82	82-83	83-84	84-85
				56%		24%		204%	99%	72%
Paintings	1			2		2		2	4	5
Dollars	$2,200			$1,300		$3,200		$5,500	$5,500	$5,900

Record Sale: $4,200, CH, 6/3/83, "Autumn Twilight," 25 × 30 in.

SAMUEL HALPERT
(1884-1930)

Samuel Halpert was born in Russia in 1884 and brought to the United States at age five.

His art training included three years at the National Academy of Design and one year at the Ecole des Beaux Arts in Paris in 1902. His first exhibit was at the Paris Salon in 1903. After his studies in France, he spent the next nine years traveling and studying throughout Europe.

By 1913, Halpert had returned to the United States, and was one of the exhibitors at the New York City Armory Show of 1913, a major exhibition and showcase for the trends toward modern art. Artists like Halpert used the show to introduce the American public to the influences of post-impressionism and fauvism.

Although he studied in Paris under Leon Bonnat, Halpert's style shows the influences of Cezanne and Matisse. Often described as fauvist, Halpert's work really incorporated too many elements to be confined to one style. The results were visually pleasing, avant-garde renderings that easily found public acceptance.

The early 1900s were exciting years for artists in the United States. Alfred Stieglitz and others were beginning to promote a sense of unity and strength among modern artists. Halpert became associated with the group that founded the Society of Independent Artists.

Another artist and art patron, Hamilton Easter Field, befriended many art-

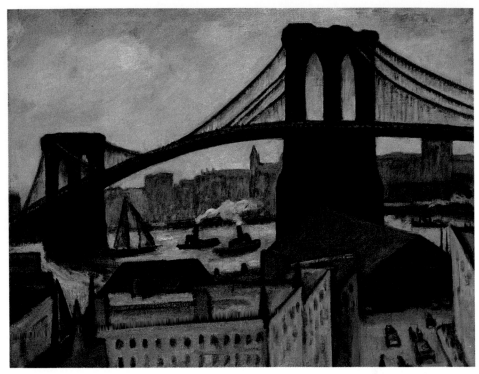

View of the Brooklyn Bridge, 28½ x 36¹/₁₆ in. Courtesy of The Brooklyn Museum, Gift of Benjamin Halpert.

ists such as Karfiol, Kuniyoshi and Zorach, and encouraged them to paint at his summer art school in Ogunquit, Maine. Halpert joined this group, and his paintings became less experimental and more realistic. Perhaps he found that the natural and rugged environment demanded a more conservative approach to painting.

Maintaining a summer residence in Maine, Halpert went on to teach at the Master Institute of United Arts and at the art school of the Detroit Society of Arts and Crafts. He died in Detroit in 1930.

MEMBERSHIPS
New Society of Artists
Societe Salon d'Automne de Paris
Society of Independent Artists

PUBLIC COLLECTIONS
Detroit Institute of Arts
Newark Museum, New Jersey
Pennsylvania Academy of the Fine Arts, Philadelphia
Phillips Collection, Washington, D.C.

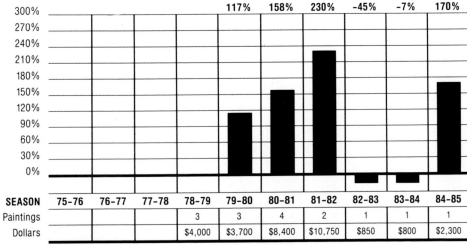

10-Year Average Change From Base Years '78-'79: 89%

SEASON	75-76	76-77	77-78	78-79	79-80	80-81	81-82	82-83	83-84	84-85
					117%	158%	230%	-45%	-7%	170%
Paintings				3	3	4	2	1	1	1
Dollars				$4,000	$3,700	$8,400	$10,750	$850	$800	$2,300

Record Sale: $6,750, SPB, 3/11/82, "Interior," 36 × 28 in.

CARL R. KRAFFT
(1884-1938)

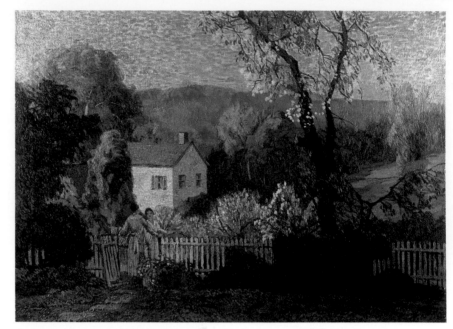

Spring Blossoms, ca. 1916, 30 x 40 in., signed l.l. Courtesy of Whitehall Gallery, Chicago, Illinois.

Carl R. Krafft was a painter of the Midwestern United States, best known for his landscapes and genre paintings of rural Illinois and the Ozark Mountains of Arkansas and Missouri. Working most of his life in Chicago, Krafft exhibited in major museums there, as well as in New York City and other art centers between 1912 and 1938.

Krafft was born in Reading, Ohio, the son of a minister and descendant of the sixteenth-century German sculptor Adam Krafft. Although details are somewhat sketchy, Krafft enjoyed a successful career as a commercial designer before beginning his formal studies at the Art Institute of Chicago and the Chicago Fine Arts Academy.

He was a largely self-taught painter, whose style evolved from a romantic Hudson River School realism to a kind of rough-hewn American impressionism. He was capable of diverse effects, on subjects as varied as wooded winter landscapes, summer seascapes, Mississippi River-boat landings and figure paintings of men at work.

Krafft was active in the artistic life of the Midwest throughout his career. He founded both the Art League of Oak Park, Illinois and the Society of Ozark Painters. During his life, his work was exhibited at the Art Institute of Chicago, the National Academy of Design, the Pennsylvania Academy of the Fine Arts, and the Corcoran Museum in Washington, D.C.

Krafft died in 1938 in Oak Park, Illinois.

MEMBERSHIPS
Austin Art League
Chicago Galleries Association
Cliff Dwellers
Illinois Academy of Fine Arts
Oak Park Art League
Painters and Sculptors of Chicago
Society of Ozark Painters

PUBLIC COLLECTIONS
Chicago Municipal Art League
Illinois State Museum, Springfield
Los Angeles County Museum
Oak Park Art League, Illinois
Peoria Society of Allied Arts, Illinois
Richmond Art Association, Indiana

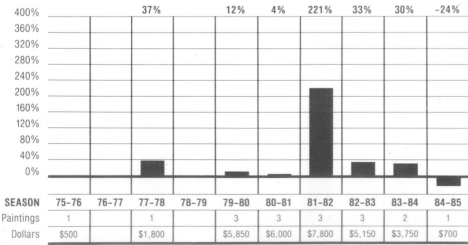

10-Year Average Change From Base Years '75-'76: 39%

	75-76	76-77	77-78	78-79	79-80	80-81	81-82	82-83	83-84	84-85
			37%		12%	4%	221%	33%	30%	-24%
SEASON	75-76	76-77	77-78	78-79	79-80	80-81	81-82	82-83	83-84	84-85
Paintings	1		1		3	3	3	3	2	1
Dollars	$500		$1,800		$5,850	$6,000	$7,800	$5,150	$3,750	$700

Record Sale: $5,500, BB.SF, 10/3/81, "Cliffs at Morning," 28 x 30 in.

(WILLIAM) VICTOR HIGGINS
(1884-1949)

William Victor Higgins, a landscape artist, achieved recognition for his impressionistic scenes of the West, particularly the Indians and countryside around Taos, New Mexico. He was born into a farming family in Shelbyville, Indiana in 1884. By age nine, he had decided to be an artist. At age 15, he left home to study at the Art Institute of Chicago and the Chicago Academy of Fine Arts.

In 1910, he went to Europe to study at the Academie de la Grande Chaumiere in Paris with Rene Menard and Lucien Simon, and in Munich under Haas von Hyeck. When he returned to Chicago, he taught at the Academy of Fine Arts before accepting a commission to do a landscape of Taos.

At the time he traveled to Taos with artist Walter Ufer, that town was gaining a reputation as a remote artists' colony. Higgins and Ufer were accepted by the inner circle of artists, and were admitted to the exclusive Taos Society of Artists, bringing the group's membership to eight. Though he continued to be called a "Chicago artist," Higgins made his permanent home in Taos.

Higgins won many awards and honors with his impressionistic, romantic, somewhat academic style. By 1927, he sought greater artistic expression than he felt was achievable through popular painting formulas. He began restructuring his

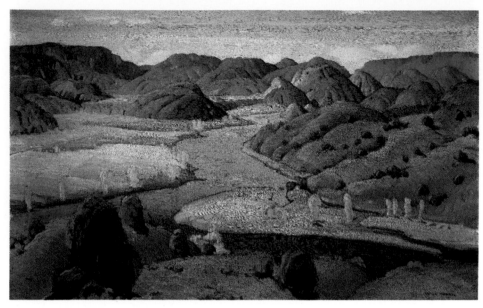

Jicarilla Country, 27 x 43 in., signed l.r. Photograph courtesy of The Gerald Peters Gallery, Santa Fe, New Mexico.

compositions with varying perspectives and planes, adding cubist devices. Higgins's work came to be less strictly representational and more Cezanne-like.

Of all the early Taos artists, Higgins excelled in watercolor. During the 1930s, he developed his own personal representations for clouds, pine trees, adobe and earth. He would drag his brush across dry paper to add vibrancy to his scenes.

In the last five years of his life, Higgins produced small, fresh landscapes that encapsulated his masterful brushwork and his intense artistic vision. He called them "little gems," and they became the most sought-after of all his works. Higgins died in Taos in 1949.

MEMBERSHIPS
Allied Artists of America
Chicago Artists Society
National Academy of Design
Taos Society of Artists

PUBLIC COLLECTIONS
Art Institute of Chicago
Butler Art Institute, Youngstown, Ohio
Corcoran Gallery of Art, Washington, D.C.
Des Moines Association of Fine Arts,
 Iowa
Los Angeles County Museum
Museum of Fine Arts, Santa Fe, New Mexico
Pennsylvania Academy of the Fine Arts,
 Philadelphia

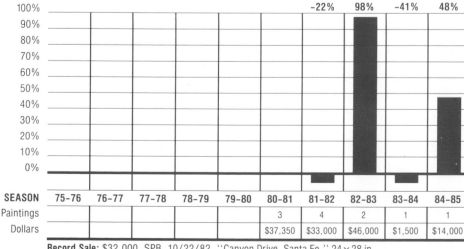

10-Year Average Change From Base Years '80-'81: 17%

	-22%	98%	-41%	48%

SEASON	75-76	76-77	77-78	78-79	79-80	80-81	81-82	82-83	83-84	84-85
Paintings						3	4	2	1	1
Dollars						$37,350	$33,000	$46,000	$1,500	$14,000

Record Sale: $32,000, SPB, 10/22/82, "Canyon Drive, Santa Fe," 24 x 28 in.

HARVEY T. DUNN
(1884-1952)

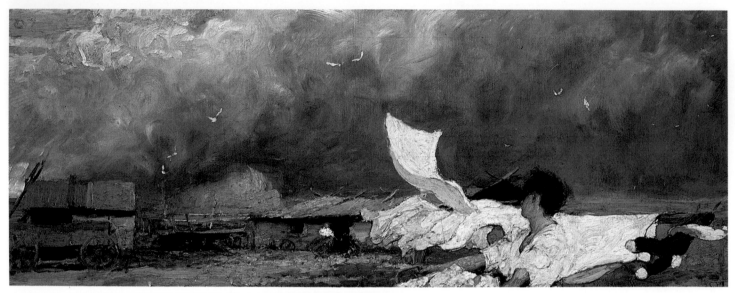

Prairie Wife, Part IV, 12 x 36 in. Photograph courtesy of The Gerald Peters Gallery, Santa Fe, New Mexico.

A painter, illustrator and teacher, Harvey T. Dunn captured the prairie and the people of his native South Dakota in drawings that rank among the most important illustrations of Western subjects.

Dunn avoided the more typical frontier subjects—cowboys and Indians—to focus on the pioneering homesteaders with whom he grew up. From the time he opened his studio in Leonia, New Jersey in 1906, he was an immediate success, appearing in leading magazines and books.

Born in a sod house in Red Stone Val-ley, South Dakota, Dunn decided at age 17 to paint the prairie scenes that fired his imagination. After art studies at State College in Brookings, South Dakota and at the Art Institute of Chicago, Dunn was invited by Howard Pyle, America's foremost illustrator, to study at Pyle's school in Wilmington, Delaware. Pyle was to have a profound influence on Dunn, as did Dunn's early teacher, Ada B. Caldwell.

Dunn's paintings of early South Dakota life quickly established his reputation as a Western illustrator, mural painter and portraitist. His method of figure drawing was to start with the head as the focus of greatest interest and to lay down the overall design in dark tones, filling in color and contrast later.

During World War I, Dunn served in France as a war artist. Following the war, he joined with Charles S. Chapman to open the Dunn School of Illustration in Leonia, where several prominent illustrators were trained. He is recognized for exceptional teaching abilities. He died in 1952.

MEMBERSHIPS
Artists Guild of the Author's League of America
Salmagundi Club
Society of Illustrators

PUBLIC COLLECTIONS
Delaware Art Museum, Wilmington
National Gallery of Art, Washington, D.C.
South Dakota Memorial Art Center, Brookings

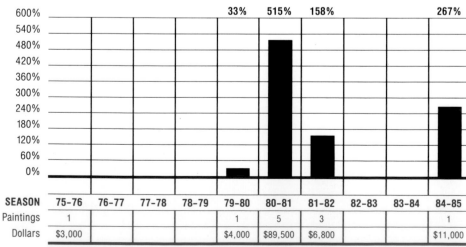

10-Year Average Change From Base Years '75-'76: 195%

| | 33% | 515% | 158% | | | 267% |

SEASON	75-76	76-77	77-78	78-79	79-80	80-81	81-82	82-83	83-84	84-85
Paintings	1				1	5	3			1
Dollars	$3,000				$4,000	$89,500	$6,800			$11,000

Record Sale: $58,000, CH, 4/24/81, "End of the Frontier," 40 × 30 in.

798

WALTER EMERSON BAUM
(1884-1956)

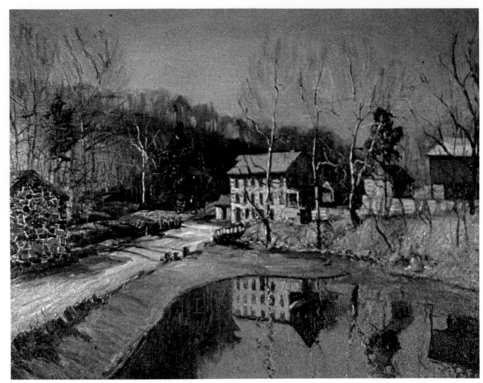

Mill at Hosensack, 30 x 36 in, signed l.l. Courtesy of Newman Galleries, Philadelphia, Pennsylvania.

Walter Emerson Baum was the only member of the New Hope Landscape School who was born in Bucks County, Pennsylvania; he lived approximately 25 miles from this School's nucleus in Center Bridge (near New Hope, Pennsylvania). His paintings have a great affinity to those of the noted American impressionists who recorded the region's seasonal changes with vitality and exuberance.

Born in 1884 in Sellersville, Pennsylvania, Baum remained in his hometown until his death in 1956. He found constant diversity in painting the woodlands and creeks of the countryside, and the indigenous architecture of the small towns surrounding his area, such as stone barns.

Baum's first formal training, from 1904 to 1909, occurred under William Thomas Trego, a skillful American painter of military scenes. He then began study at the Pennsylvania Academy of the Fine Arts in 1910.

Although Robert Henri and his Ashcan School followers had introduced a new "art spirit" into the traditional Academy at the turn of the century, Baum chose the more academic route by studying under Thomas P. Anshutz, Thomas Eakins's direct teaching descendant. Later he was influenced by Daniel Garber, a popular Academy instructor, who was among the prominent members of the New Hope Landscape School.

In 1936, Baum traveled to Southern Germany, France and Switzerland. He visited many museums and painted throughout his tour, but was anxious to return to Sellersville to paint the scenery of the Delaware Valley.

Baum's oeuvre, more than 2,000 works in oil, tempera, watercolor and pastel, may be divided into two distinct groups, different both in style and subject. The majority of his work was landscape painting. He captured the seasonal changes of the Delaware River Valley

and preserved for future generations the uniqueness of the region.

His style may be termed impressionistic, with its broken brushwork and contrasting nuances of color. As one of the youngest New Hope Landscape painters, Baum's style is derivative of the School's leader, Edward Willis Redfield.

The other important portion of Baum's work consists of cityscapes of Allentown and Manayunk, both in Pennsylvania. It reflects their small-town atmosphere, depicting local architecture and quaint streets. Although executed with the same lusty brushwork as his landscapes, the cityscapes display a greater intensity of pure color, with many of the buildings and other objects outlined in black.

Baum began teaching art as early as 1921, eventually locating his classes in Allentown. This led to the founding of the Baum School of Art, which adjoins the Allentown Museum of Art, established in the 1930s. From 1926 until his death in 1956, he served as art editor of the *Philadelphia Bulletin* and wrote more than 500 reviews.

MEMBERSHIPS
American Color Print Society
Bucks-Montgomery Press League
National Academy of Design
Pennsylvania German Folklore Society
Philadelphia Contemporary Club
Philadelphia Sketch Club

PUBLIC COLLECTIONS
Allentown Museum of Art, Pennsylvania
Baum School of Art, Allentown, Pennsylvania
Bucks County Council on the Arts, Doylestown, Pennsylvania
Buck Hill Art Association, Pennsylvania
Philadelphia Museum of Art
Reading Public Museum and Art Gallery, Pennsylvania
Syracuse University Art Collections, Syracuse, New York

SEASON	75-76	76-77	77-78	78-79	79-80	80-81	81-82	82-83	83-84	84-85
Paintings			1			1			3	8
Dollars			$400			$700			$2,075	$18,500

Record Sale: $12,000, CH, 12/7/84, "The Village," 32 × 40 in.

GUY PENE DU BOIS
(1884-1958)

The son of a literary and music critic, Guy Pene du Bois was born in Brooklyn. Throughout his life, he was both a writer and an artist. In both spheres, his tone was one of polite sophistication and social satire. As the artist wrote of himself: "His pictures are inclined to be mincing. His language is. He has inherited carefulness and economy."

Du Bois studied in New York City with William Merritt Chase, Robert Henri and Kenneth Hayes Miller from 1899 to 1905. From 1905 to 1906, he studied in Paris under Theophile Steinlen and became acquainted with the work of painter-draftsman Jean-Louis Forain.

Upon his return to New York, du Bois embarked upon a writing career. He worked successively for the *New York American* as a music and art critic, for the *New York Herald Tribune* as assistant to critic Royal Cortissoz, and as an art critic for the *New York Evening Post*. He also edited *Arts and Decoration* from 1913 to 1920, beginning with a special issue on the 1913 Armory Show (in which he participated as an artist and publicist).

Described as an interpreter and spokesman for the Henri group, du Bois returned to France and lived there from 1924 until 1930. In 1931, he authored monographs on artists John Sloan and William Glackens.

Du Bois was considered a social realist and a follower of the Ashcan School; his earliest works reflect the influence of

Club Meeting, 1936, 24 x 20 in., signed l.r. Courtesy of The Pennsylvania Academy of the Fine Arts, Philadelphia.

Robert Henri. Freely brushed and dark in tone, they depict street scenes, restaurants, night clubs and other realistic settings. However, the artist chose his subjects from the middle and upper classes, injecting a note of dispassionate social commentary.

By 1920, du Bois began to render his people in a volumetric way, reminiscent of the tubular folk sculpture of Elie Nadelman. His smoothly-applied paint, often in the neutral tonality of browns and grays resembling newsprint, accentuated the roundness of his minimally-modeled forms.

His subjects are frozen in time, like mannequins caught in a spotlight. By the 1940s, the outlines of his figures had become less precise and were set against hazy, rather than slick, backgrounds.

Du Bois's autobiography, *Artists Say the Silliest Things,* was published in 1940. He died in 1958.

MEMBERSHIPS
New Society of Arts

PUBLIC COLLECTIONS
Addison Gallery of American Art, Andover, Massachusetts
Detroit Institute of Arts
Los Angeles County Museum of Art
Metropolitan Museum of Art, New York City
Milwaukee Art Museum
Pennsylvania Academy of the Fine Arts, Philadelphia
Phillips Collection, Washington, D.C.
Toledo Art Museum, Ohio
Whitney Museum of American Art, New York City

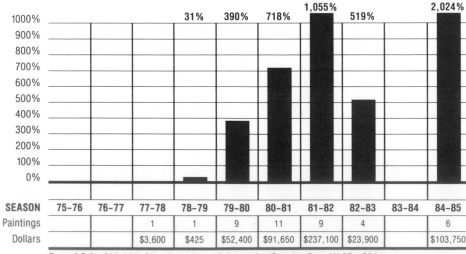

10-Year Average Change From Base Years '77-'78: 677%

SEASON	75-76	76-77	77-78	78-79	79-80	80-81	81-82	82-83	83-84	84-85
				31%	390%	718%	1,055%	519%		2,024%
Paintings			1	1	9	11	9	4		6
Dollars			$3,600	$425	$52,400	$91,650	$237,100	$23,900		$103,750

Record Sale: $60,000, CH, 12/11/81, "Drink at the 'Russian Bear,'" 37 × 29 in.

800

WALDO PIERCE
(1884-1970)

A big, fun-loving man, Waldo Pierce was a painter whose work was, in the opinion of one writer, not great, but not small, either. His paintings often were loose and untidy, yet they caught the spirit of whatever he was painting. One critic characterized them as "the careless overflow of a brimful spirit." After years of traveling and living in Europe and elsewhere, Pierce married for the third time and settled in the United States, and became known especially for his many affectionate paintings of family life, centered on his own wife and children.

He was born in Bangor, Maine in 1884, the son of a weathy lumberman. Attending Harvard, he was known more as a conversationalist and football player than as a student.

In 1910, Pierce left for England on a cattle boat, but changed his mind at the last minute, dove overboard into Boston harbor and swam ashore. In the end he had to go to England anyway to clear former Harvard classmate John Reed, who was being held by the British on suspicion of murder.

Pierce studied painting at the Academie Julien, and lived a rough-and-tumble life around Europe, engaging in such pastimes as canoe racing on the Thames and playing football on a French team in Ireland. When World War I broke out, he became an ambulance driver and won the Croix de Guerre for bravery.

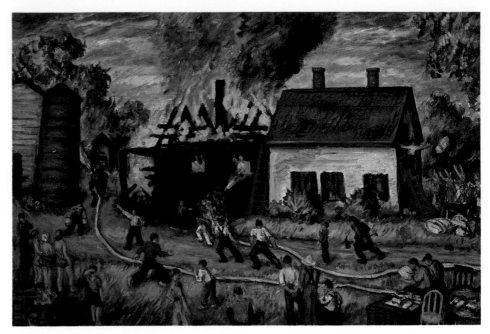

Fire at East Orrington, 1940, 27 x 40 in., signed l.r. Courtesy of William A. Farnsworth Library and Art Museum, Rockland, Maine.

After the war, Pierce toured Spain with former heavyweight champion Jack Johnson, and again with close friend Ernest Hemingway. In Spain, he painted like Zuloaga. Later, in Tunis, his work was more like that of Matisse.

He did not really find his own painting style until he returned to Maine shortly before World War II. It was then that he began to paint his own burgeoning family. He had five children and all of them appeared in his work. He painted hundreds of canvases of them before his death in 1970.

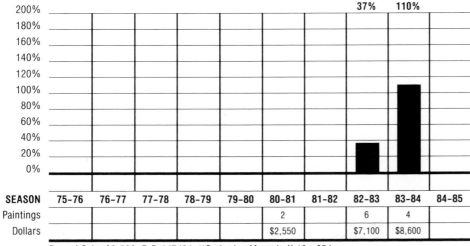

10-Year Average Change From Base Years '80-'81: 49%

SEASON	75-76	76-77	77-78	78-79	79-80	80-81	81-82	82-83	83-84	84-85
Paintings						2		6	4	
Dollars						$2,550		$7,100	$8,600	

Record Sale: $3,500, B.P. 4/7/84, "Gathering Mussels," 18 × 25 in.

MEMBERSHIPS
Harvard Club of New York

PUBLIC COLLECTIONS
Addison Gallery of American Art, Andover, Massachusetts
Bangor Public Library, Maine
Brooklyn Museum
Butler Institute of American Art, Youngstown, Ohio
Columbus Gallery of Fine Arts, Ohio
Farnsworth Library and Art Museum, Rockland, Maine
Metropolitan Museum of Art, New York City
Pennsylvania Academy of the Fine Arts, Philadelphia
Whitney Museum of American Art, New York City

LEON KROLL
(1884-1974)

A painter and noted teacher, Leon Kroll carried the standard of realism through the twentieth century while the artistic mainstream moved toward abstraction. He was a leading artist of the 1920s, imbuing his still lifes, landscapes, and figure paintings with a rich and sensuous humanism. His later work has overtones of Cezanne and Renoir.

Nothing fascinated Kroll more than the human form, which he painted with full, lush strokes. His landscapes have a quality of fecundity. His work, however, lacks the impetuous immediacy of earlier realists. Kroll based his compositions on abstract designs rather than nature; as a result, the subjects tend to be somewhat idealized, particularly in regard to the human figure.

Eschewing abstraction as an end product of the artistic process, Kroll explained that, for him, abstract patterns were only the beginning of a picture. "I like motifs that are warm with human understanding; the natural gesture, the touch of people, landscapes where people live and work and play," he said. His style has been described as "expressive romanticism." Nevertheless, it remains well within the traditions of realism.

Born in New York City, Kroll studied at the National Academy of Design and the Art Students League. He worked his way through art school as a janitor and made mechanical drawings for a living, before being awarded an Academy

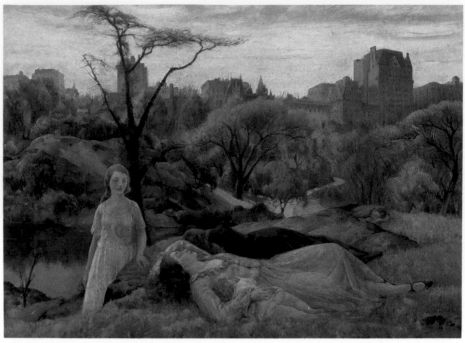

Sleep, ca. 1922, 36 x 48 in., signed l.r. Courtesy of National Museum of American Art, Smithsonian Institution, Bequest of Henry Ward Ranger through the National Academy of Design.

scholarship for study in Paris, where he enrolled at the Academie Julien under Laurens. Back in New York City around 1912, Kroll won popularity as a realistic painter. His early works, cityscapes and industrial scenes, employ a heavy brush.

Kroll exhibited at the Armory Show in 1913 and four years later joined Robert Henri and George Bellows in Santa Fe, New Mexico, where he became as enthralled as they with the local scene.

In the 1930s, Kroll painted several murals, most notably for the Justice Department in Washington, D.C. and the War Memorial Building in Worcester, Massachusetts. His best landscapes were done at Cape Ann, Massachusetts;

they are not "photographic" representations of the Cape, instead combining several scenic locations into one design.

Kroll began winning awards with his early work, and by the end of his lifetime had accumulated as many honors as any other artist of his era.

He never lost the realist's commitment to common humanity: "I sense the 'beyondness,' the wonder, of simple-living people and the things they do. I try to express this feeling without being too obvious about it."

Kroll taught throughout his career at the National Academy and the Art Students League, among other schools.

MEMBERSHIPS
American Academy of Arts and Letters
Boston Art Club
National Academy of Design
National Arts Club
National Institute of Arts and Letters
New Society of Artists
New Society of Etchers
New York Society of Etchers
Philadelphia Art Club
Salmagundi Club
Society of Independent Artists

PUBLIC COLLECTIONS
Art Institute of Chicago
Baltimore Museum of Art
Corcoran Gallery of Art, Washington, D.C.
Dayton Art Institute, Ohio
Detroit Institute of Arts
Indianapolis Museum of Art
Los Angeles County Museum
Metropolitan Museum of Art, New York City
Pennsylvania Academy of the Fine Arts, Philadelphia
Whitney Museum of American Art, New York City

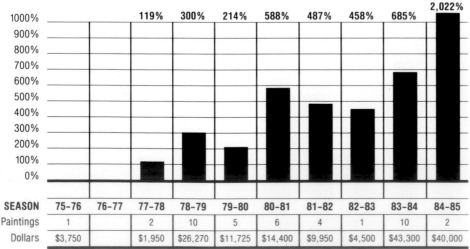

10-Year Average Change From Base Years '75-'76: 541%

| | 119% | 300% | 214% | 588% | 487% | 458% | 685% | 2,022% |

SEASON	75–76	76–77	77–78	78–79	79–80	80–81	81–82	82–83	83–84	84–85
Paintings	1		2	10	5	6	4	1	10	2
Dollars	$3,750		$1,950	$26,270	$11,725	$14,400	$9,950	$4,500	$43,300	$40,000

Record Sale: $24,000, CH, 12/7/84, "Couple by Rocks Near Farmland Lake," 27 x 36 in.

JULES PASCIN
(1885-1930)

A member of the international set which made its headquarters at the famous "Cafe du Dome" in Paris, Jules Pascin was a familiar figure in the Parisian art world before World War I. Although his subjects take a sharp, even pornographic turn, Pascin's range of watercolors, oils and drawings is attractive for its revelation of the artist's observant eye and his easy, fluid command of each medium.

Julius Mordecai Pincas, later known by the anagrammatic name of Pascin, was born in Vidin, Bulgaria in 1885. After schooling in Vienna from 1896 to 1901, he joined his family in Bucharest to work in his father's grain business.

He returned to Vienna, however, to study painting, and in 1903 moved to Munich, where he attended the Heymann Art School and drew cartoons for the German periodicals *Jugend* and *Simplicissimus*. After studying briefly in Berlin, he settled in Paris in 1905. Until 1914, he played an active role in the life of young artists there.

Pascin came to the United States in 1914 to follow the footsteps of Lafcadio Hearn. He became an American citizen and worked in a circle of painters— Alexander Brook, Pop Hart, Walt Kuhn, Yasuo Kuniyoshi, Guy Pene du Bois and Max Weber—who frequented the Penguin Club in New York City.

During the 1920s, he exhibited in both Paris and New York, returning to New York in 1927 in order to retain his American citizenship. Pascin and the German, George Grosz, influenced the American social realists by their use of abrupt tonal contrasts, arbitrary stylization and distortion of forms.

Although Pascin's work received considerable recognition, a series of unfavorable reviews in 1930 discouraged him, and he committed suicide in Paris in June of that year.

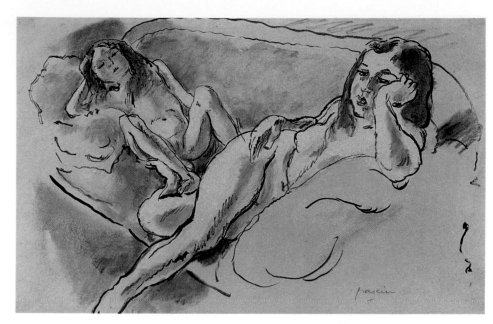

Deux Filles au Sofa, 18¾ x 14⅛ in., signed l.r. Courtesy of Montclair Art Museum, New Jersey.

MEMBERSHIPS
Penguin Club

PUBLIC COLLECTIONS
Museum of Modern Art, New York City
Pennsylvania Academy of the Fine Arts,
 Philadelphia

SEASON	75-76	76-77	77-78	78-79	79-80	80-81	81-82	82-83	83-84	84-85
Paintings	5	4	19	41	42	112	98	75	81	66
Dollars	$66,922	$69,160	$313,282	$380,765	$270,279	$480,222	$315,106	$369,030	$256,963	$188,758

Record Sale: $54,863, 35.P, 3/22/85, "Le Repas de l'Enfant," 26 × 32 in.

CARL JOHN NORDELL
(1885-)

Carl John Nordell, painter of figures, portraits, landscapes and still lifes, was born in Copenhagen, Denmark in 1885. He studied at the Boston Museum School under Edmund Tarbell, under George Bridgman and Dumond at the Art Students League in New York City, and at Rhode Island School of Design. In Paris, he attended the Academie Julien, where he studied under Laurens.

Exhibiting at the Boston Art Club in 1918, Nordell presented a variety of works before a public that had largely regarded him as a portrait and figure painter. Many of the landscapes at this show were views of Gloucester, Massachusetts and the nearby shoreline.

A critic for *The Evening Transcript* praised Nordell's use of bright color in landscapes, and his "strong sense of the open air effect." Nordell's work at this show offered little introspection. Rather, the paintings were called "pictoral with very little of the descriptive or illustrative element." His still lifes were praised as being "not very far removed from the masterpieces of this genre."

Nordell's awards include a silver medal at the 1915 Panama-Pacific Exposition in San Francisco, and a first prize at the Swedish-American Exhibition in Chicago in 1917.

MEMBERSHIPS
Allied Artists of America
Art Students League of New York City
Boston Art Club
Boston Water Color Club
Salmagundi Club
Printmakers Society of California

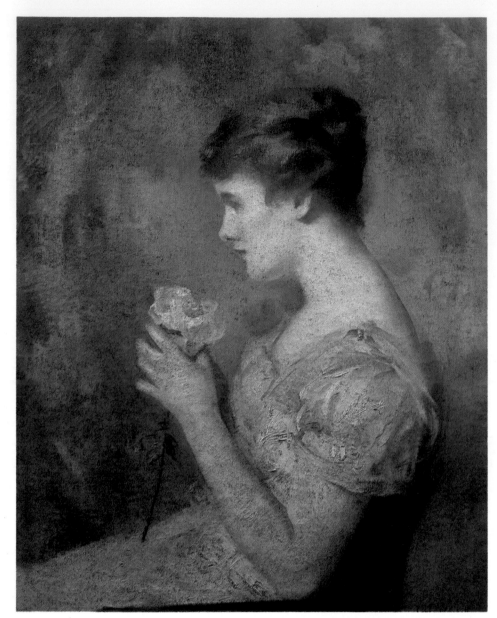

Romance, 32 x 25 in., signed l.r. Courtesy of Daniel B. Grossman, Inc., Fine Art, New York, New York.

SEASON	75–76	76–77	77–78	78–79	79–80	80–81	81–82	82–83	83–84	84–85
Paintings					1	1	1	1	2	2
Dollars					$5,250	$1,400	$10,000	$2,800	$2,900	$3,400

Record Sale: $10,000, SPB, 6/4/82, "The Morning Lesson," 57 × 45 in.

GEORGE BIDDLE
(1885-1973)

George Biddle, born in 1885 to a socially prominent, upper-class Philadelphia family, became known as a realist painter who used his art to champion the cause of social justice.

After receiving a law degree from Harvard University, he decided on a painting career rather than law, studying first at the Pennsylvania Academy of the Fine Arts. He then studied for three years in Munich, and at the Academie Julien in Paris. He was a close friend of fellow-Philadelphian Mary Cassatt.

Biddle left his painting career during World War I, when he was a commissioned officer with the occupation forces in France. After the war, he painted in Tahiti, then returned to France for three years in 1923.

But Biddle decided he wanted to be identified with his country as an American artist; he returned to the United States to continue his career. It was after this move that Biddle's social conscience merged with his artistic career. Influenced by the murals of Mexico's Diego Rivera, Biddle decided to try to bring this form of painting into prominence in the United States.

This interest paved the way for his most notable achievement, the implementation of a federal arts organization as part of the WPA, in 1933. Biddle prevailed on his friend and former classmate, President Franklin Delano Roosevelt, to support the project, particularly mural painting. In a letter to the President, Biddle wrote: "The younger artists of America are conscious as they have never been of the social revolution that our country and civilization are going through; and they would be eager to express these ideals in a permanent art form if they were given the government's cooperation."

Biddle became involved in a controversy over his mural in the Department of Justice building in Washington. He called it *Society Freed Through*

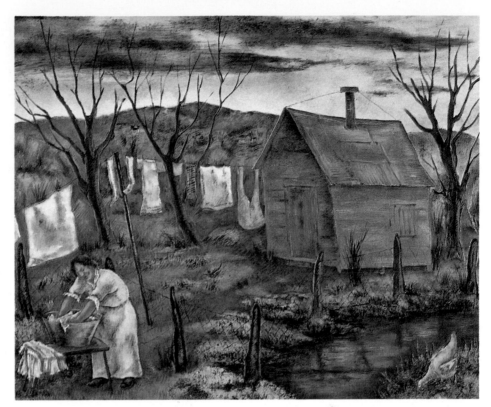

Winter in Tortilla Flat, 1941, 25 x 30 in., signed l.l. Courtesy of Collection, The Whitney Museum of American Art, New York, New York, Purchase (and Exchange).

Justice—the Tenement and Sweatshop of Yesterday Can Be the Life Planned with Justice of Tomorrow. When the National Commission on Fine Arts called the work "inartistic" and submitted its own design, an angry Biddle drew support from other artists. The disagreement was seen as a struggle between conservatives and proponents of social change.

Biddle created another major mural for the Supreme Court building in Mexico City. Subsequently, he taught at Columbia University and the University of California, and was artist-in-residence at the American Academy in Rome. Later in life, he turned to genre subjects, often satirically portrayed. Biddle was also the author and illustrator of *Boardman Robinson, Green Island, Adolph Borie,* and *An American Artist's Story,* which was his autobiography. He died at Croton-on-Hudson, New York in 1973.

MEMBERSHIPS
Society of Mural Painters
Society of Painters, Sculptors and Gravers

PUBLIC COLLECTIONS
Art Institute of Chicago
Dallas Museum of Fine Arts
Fine Arts Museum of San Francisco
Kaiser Fiederich Museum, Berlin
Metropolitan Museum of Art, New York City
Museo D'Arte Moderna, Venice
Museum of Fine Arts, Boston
Museum of Modern Art, New York City
New York Public Library, New York City
Newark Public Library, New Jersey
Whitney Museum of American Art, New York City

SEASON	75-76	76-77	77-78	78-79	79-80	80-81	81-82	82-83	83-84	84-85
Paintings								2	1	1
Dollars								$1,750	$5,800	$400

Record Sale: $5,800, CH, 10/5/83, "Spirituals," 16 × 20 in.

BERNARD KARFIOL

(1886-1952)

A youthful prodigy, teacher, author and exhibitor at the seminal New York City Armory Show in 1913, Bernard Karfiol began his career with great energy and promise.

He was born in Budapest, Hungary to American parents in 1886, and grew up in Brooklyn and Long Island, New York. His father saw and encouraged young Bernard's talent: by age 14, Karfiol had enrolled at the National Academy of Design. At age 15, he went alone to Paris to study with Jean-Paul Laurens at the Academie Julien, later attending the Ecole des Beaux-Arts. He exhibited in Paris at the Grand Salon and the Salon d'Automne; in Paris, he was impressed by the paintings of Paul Cezanne, Pierre Auguste Renoir and Andre Derain.

Having assimilated this wealth of inspiration and education, he returned to the United States in 1906. He became a studio painter of still lifes and nudes, incorporating much of the quality of Picasso's pink and blue periods. He was to spend much of his artistic career refining and toning down his style.

His summers from 1914 on were spent in Ogunquit, Maine. A large group of artists gathered there, converging around artist and patron Hamilton Easter Field.

By the late 1920s, Karfiol's style had become more lush and painterly, reflecting the style of Renoir. But by the mid-1930s, although his earlier work was finally receiving recognition, his painting had become cautious and contrived. Though his canvases were larger, he had become otherwise extremely conservative. He died in 1952 in Irvington-on-Hudson, New York.

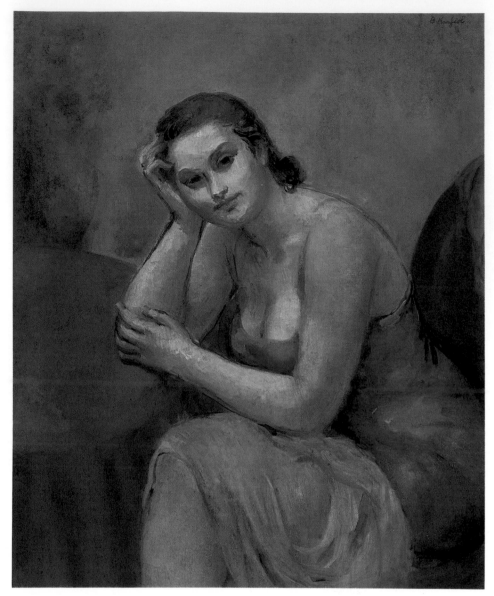

Woman at Table, ca. 1929, 30⅛ x 24¼ in., signed u.r. Courtesy of National Museum of American Art, Smithsonian Institution, Gift of Audrey McMahon.

MEMBERSHIPS
Union of Soviet Socialist Republics,
 Academy of Art

PUBLIC COLLECTIONS
Addison Gallery, Andover, Massachusetts
Carnegie Institute, Pittsburgh
Corcoran Gallery of Art, Washington, D.C.
Detroit Institute of Art
Los Angeles County Museum of Art
Metropolitan Museum of Art,
 New York City
Museum of Modern Art, New York City
Newark Museum, New Jersey
Phillips Collection, Washington, D.C.
Whitney Museum of American Art,
 New York City

SEASON	75-76	76-77	77-78	78-79	79-80	80-81	81-82	82-83	83-84	84-85
Paintings		1	1	2	4				3	1
Dollars		$1,700	$650	$1,500	$5,050				$5,125	$1,300

Record Sale: $3,800, B.P., 11/5/83, "Virginie at Perkins Cove," 27 × 36 in.

MORGAN RUSSELL
(1886-1953)

Morgan Russell, an early and innovative American abstract painter, was one of the founders of synchromism, a school of painting based on color theory.

Born in 1886 in New York City, Russell trained as an architect. He determined to seek a career as a painter, however, when he visited Paris in 1906. There he became interested in the works of the impressionists and Cezanne. During the next few years, he traveled between Paris and New York City, where he enrolled at the Art Students League. In New York, he studied painting under Robert Henri.

In 1909, Russell settled in Paris, where he was to remain for some years, although he exhibited in the United States. He admired Monet, became friendly with Gertrude Stein, Modigliani and Guillaume Apollinaire, and took lessons from Matisse. Interested in sculpture, he studied the works of Michelangelo and Rodin, but turned to painting. In 1911, he met another American painter living in Paris, Stanton Macdonald-Wright, with whom he developed synchromism.

Synchromism—the term was coined by Russell—drew upon certain nineteenth-century theories of color, as well as upon the work of Robert Delaunay, France's leading exponent of the pictorial properties of color. Colors were categorized on the basis of their harmonic relationships, and their emerging (warm) or receding (cool) properties. By manipulating these relationships and properties, Macdonald-Wright and Russell believed, they could create form, depth and movement without traditional linear perspective.

Russell's first exhibited work in this new style was *Synchromie en vert* (1912 to 1913, now lost). It showed the interior of his studio. Soon, however, he turned to nonrepresentational subjects, as in *Synchromy in Deep Blue-Violet* (1913, now lost).

Synchromy, 1915-1917, 12¾ x 10¾ in., signed u.r. Courtesy of Hirshhorn Museum and Sculpture Garden, Smithsonian Institution.

His early interests in architecture and sculpture are reflected in the clear-cut shapes of his mature synchromist work, such as *Synchromy in Orange: To Form* (1913 to 1914, Albright-Knox) and *Synchromy No. 3: Color Counterpoint* (1914, Museum of Modern Art). All these works are characterized by geometric shapes and vigorous color.

Synchromism was a short-lived movement, although it influenced such later painters as Thomas Hart Benton and Andrew Dasburg. From 1916 to 1920, Russell gave up synchromism for a return to figurative painting. He settled in Aigremont, France in 1920, and continued to paint landscapes, nudes and occasional muted synchromistic paintings, which he called *Eidos*.

Russell died in 1953 in Broomall, Pennsylvania.

SEASON	75-76	76-77	77-78	78-79	79-80	80-81	81-82	82-83	83-84	84-85
Paintings				1		3	2		3	
Dollars				$2,600		$8,600	$1,300		$3,300	

Record Sale: $4,500, CH, 10/28/80, "Les Dieux Samusent," 46 × 79 in.

ERNEST M. HENNINGS
(1886-1956)

A lyrical painter, particularly known for his portrayal of American Indians, Ernest M. Hennings was born in Pennsgrove, New Jersey. His family soon moved to Chicago, where he studied at the Art Institute for five years. He graduated with honors and enrolled at the Royal Academy in Munich, where he remained until the outbreak of World War I, working with Angelo Junk and Franz Von Stuck.

Hennings returned to Chicago, where he was referred to Carter H. Harrison, an important local patron of the arts. Harrison, a former mayor of Chicago, and his partner in an art-buying syndicate, meat-packaging czar Oscar Mayer, sent Hennings to Taos, New Mexico.

In 1921, Hennings held a one-man show at Marshall Field and Company, where he met the woman he married. After a 16-month wedding trip in Europe, the couple settled in Taos.

Considered a classicist, with a delicate rather than a bold touch, Hennings blended the academic realism he learned in Munich with a decorative sinuosity of line reminiscent of art nouveau. His favorite subjects were Indians on horseback moving through dappled forest lights. He was most successful in unifying the human figure with a sunshine-filled, happy, natural setting.

His paintings remain bright even with age, due to the techniques he used: he applied his oils thinly, in a sheer layering of strokes. Then he allowed his canvases

Through Sunlit Aspens, 30 x 36 in., signed l.r. Photograph courtesy of The Gerald Peters Gallery, Santa Fe, New Mexico.

to dry for long periods before applying moderate amounts of varnish, thus avoiding cracking or yellowing.

In 1954, Hennings was commissioned by the Santa Fe Railroad to execute a series of paintings at the Navajo reservation in Ganado for later use in calendars. He began this work in 1955, and died soon after its completion in 1956.

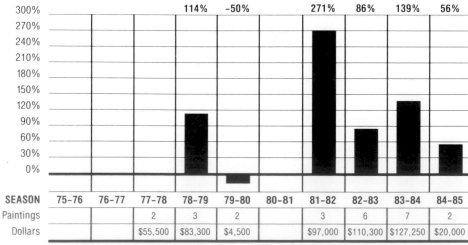

10-Year Average Change From Base Years '77-'78: 88%

		114%	-50%		271%	86%	139%	56%

SEASON	75-76	76-77	77-78	78-79	79-80	80-81	81-82	82-83	83-84	84-85
Paintings			2	3	2		3	6	7	2
Dollars			$55,500	$83,300	$4,500		$97,000	$110,300	$127,250	$20,000

Record Sale: $65,000, SPB, 2/13/82, "Indians in Winter Landscape," 30 x 30 in.

MEMBERSHIPS
Art Institute of Chicago
Chicago Cliff Dwellers
Chicago Galleries Association
Chicago Painters and Sculptors
Salmagundi Club
Taos Society of Artists

PUBLIC COLLECTIONS
Chicago Municipal Collection
Gilcrease Institute of American History and Art, Tulsa
Los Angeles County Museum of Art
Museum of Fine Arts, Houston
State Collection, Springfield, Illinois
Pennsylvania Academy of the Fine Arts, Philadelphia

ARMIN CARL HANSEN
(1886-1957)

Armin Carl Hansen combined his talents as a marine, coastal and figure painter, an etcher and a teacher to become a leading figure in California art circles during the first half of the twentieth century.

Born in 1886 in San Francisco, Hansen inherited his love of art at an early age from his father, H. W. Hansen, a well-known Western painter.

Hansen received his first art lessons from his father; he next studied at the San Francisco Institute of Art under Arthur Mathews for three years. In 1906, Hansen traveled to the Royal Academy in Stuttgart, where he studied two years under Carlos Grethe.

He spent one summer on the North Sea and set up a studio in Nieuport, on the coast of Belgium, where he painted scenes of fishermen's lives.

Returning to the West Coast, Hansen taught for a few months in 1912 at the University of California, Berkeley. In 1918, he was appointed director and instructor of outdoor and landscape summer classes at the California School of Fine Arts. He was a talented and very popular teacher.

The 1920s were considered the "golden era" of California art. Hansen was credited with stimulating much of the artistic and social activity in the Bay area. He was active with the formation of the Carmel Art Association.

Described as a dramatist interested primarily in the expression of life, Han-

Nino, 50 x 60 in., signed l.r. Courtesy of Maxwell Galleries, LTD., San Francisco, California.

sen has won numerous awards for his works. He was best known for his powerful and original interpretations of the fishing communities around Nieuport and Monterey Bay. However, later in his career, Hansen began depicting Indian frontier tribes of the American West.

Hansen died in 1957 in Monterey, California, where he had lived for most of his adult life.

MEMBERSHIPS
Carmel Art Association
National Academy of Design
San Francisco Art Association
Societe des Beaux Arts

PUBLIC COLLECTIONS
Los Angeles County Museum of Art
National Academy of Design, New York City
San Francisco Museum of Modern Art

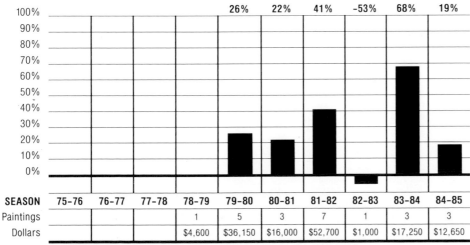

10-Year Average Change From Base Years '78–'79: 18%

SEASON	75-76	76-77	77-78	78-79	79-80	80-81	81-82	82-83	83-84	84-85
					26%	22%	41%	−53%	68%	19%
Paintings				1	5	3	7	1	3	3
Dollars				$4,600	$36,150	$16,000	$52,700	$1,000	$17,250	$12,650

Record Sale: $25,000, BB.SF, 10/3/81, "Making Her Easting," 40 × 50 in.

809

ALDRO THOMPSON HIBBARD
(1886-1972)

Landscape artist Aldro Thompson Hibbard discovered the state of Vermont when he was a young man, and his subject matter never strayed far from its winter scenes for the next half a century.

Much of his work depicts Vermont's covered bridges, ox teams, sugar houses and towns tucked down in snowy mountains. Hibbard consistently drew inspiration from winter landscapes—boats abandoned on the shoreline waiting for the spring thaw, people bundled in wool cutting ice from a frozen river.

Hibbard is also known for landscape paintings done around his home in Rockford, Massachusetts, along the New England coastline, and in the Canadian Rockies. He produced a large body of work during a long career, much of it concerned with sensitivity to light and shadow.

Born in 1886 in Falmouth, Massachusetts, Hibbard spent his boyhood on Cape Cod and in Boston. He studied at Boston's Museum School, where he was a pupil of De Camp, Major and Tarbell. On a Paige traveling scholarship from the Boston school, Hibbard went to Europe.

On his return to the United States in 1915, he discovered the aesthetic qualities of Vermont. Thereafter, he spent every winter in that state, painting in an area around the West River Valley. He returned every spring to his studio in

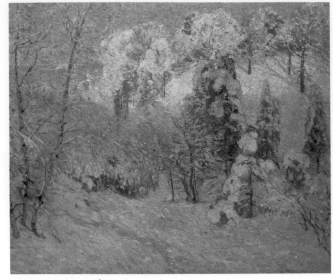

A Morning Hour, 30¼ x 42 in., signed l.r. Courtesy of Vose Galleries of Boston, Inc., Massachusetts.

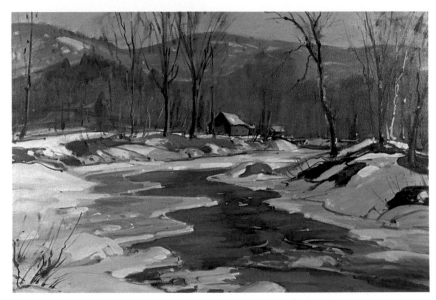

New England Snow Scene, 22 x 32 in., signed l.l. Courtesy of Henry B. Holt, Inc., Essex Fells, New Jersey.

Rockport with a car crammed full of canvases, many of them painted outdoors in the middle of winter.

Hibbard's work is picturesque, full of an innocent love of life and people. He was an avid baseball fan. He died in 1972.

MEMBERSHIPS
Boston Guild of Artists
Connecticut Academy of Fine Arts
New Haven Paint and Clay Club
National Academy of Design
North Shore Art Association

PUBLIC COLLECTIONS
Addison Gallery of American Art, Andover, Massachusetts
Currier Gallery, Manchester, New Hampshire
Metropolitan Museum of Art, New York City
Museum of Fine Arts, Boston
National Academy of Art, Washington, D.C.
Portland Museum of Art, Maine

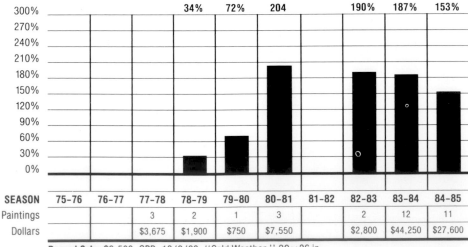

10-Year Average Change From Base Years '77–'78: 120%

	75-76	76-77	77-78	78-79	79-80	80-81	81-82	82-83	83-84	84-85
				34%	72%	204		190%	187%	153%
SEASON	75-76	76-77	77-78	78-79	79-80	80-81	81-82	82-83	83-84	84-85
Paintings			3	2	1	3		2	12	11
Dollars			$3,675	$1,900	$750	$7,550		$2,800	$44,250	$27,600

Record Sale: $9,500, SPB, 12/8/83, "Cold Weather," 30 × 36 in.

HARRY LEITH-ROSS
(1886-1973)

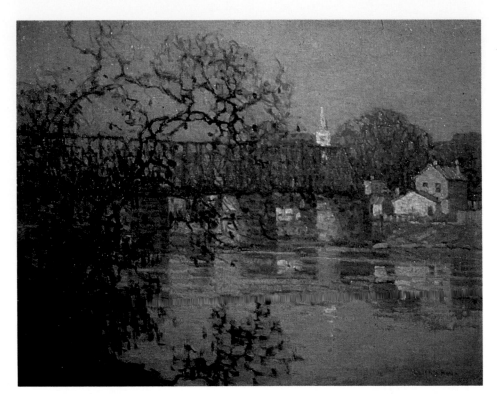

Bridge at New Hope, 16 x 20 in., signed l.r. Courtesy of Newman Galleries, Philadelphia, Pennsylvania.

After at least 19 years of affiliation with the New Hope School of American impressionism, Harry Leith-Ross finally moved to New Hope, a picturesque small town situated along the banks of the Delaware River in rural Bucks County, Pennsylvania. Like many of his New Hope contemporaries, including Edward Willis Redfield and Daniel Garber, Leith-Ross was noted for his exuberant landscape paintings of the region.

Born in 1886 in the British colony of Mauritius in the Indian Ocean, Leith-Ross came to America at age 17, and soon began working as a commercial artist. In 1914, he studied at the Art Students League Summer School in Woodstock, New York under Birge Harrison and John F. Carlson. He continued his studies at the National Academy of Design in New York City with C.Y. Turner, and at the Academie Julien in Paris with Jean Paul Laurens. While abroad, he studied independently with Stanhope Forbes in England.

At the request of John Fulton Folinsbee, a fellow Woodstock student, Leith-Ross came to New Hope in 1916, although he may have visited the area as early as 1912. Sometime during his stay he met his former instructor, Birge Harrison, who spent the winters from 1914 to 1916 in New Hope. In 1935, Leith-Ross moved to the region permanently, and lived in close proximity to most of the artists who comprised the nucleus of the New Hope School. Although he was virtually the last of this group to settle in Bucks County, he had previously exhibited with them at the Pennsylvania Academy of the Fine Arts in Philadelphia, and had long since been considered a member of their colony.

Leith-Ross held several teaching positions during his career. He was an instructor at the Art Students League Summer School, and taught painting classes at Rockport and Gloucester, Massachusetts and New Hope. He was a visiting artist at the University of Buffalo, the University of Utah, and Southern Utah State College. Leith-Ross also wrote *The Landscape Painter's Manual,* published in 1956.

During the 1910s and 1920s, Leith-Ross produced landscape works—many of the Bucks County countryside—using the broad brushstrokes and lusty application of pigment similar to the style of the New Hope School's leading painter, Edward Willis Redfield. During the 1930s, Leith-Ross gradually moved toward a more direct approach in his landscape works, assimilating many of the new ideas of the burgeoning modern movement.

Leith-Ross was also well-known for his watercolors, which are even more spontaneous in expression than his oil paintings. In their clear, crisp colors and fluid washes, they display the influence of Winslow Homer and the late-nineteenth-century Dutch watercolorists, especially Hendrik Willem Mesdag (1831-1915). Mesdag, a prominent Dutch marine artist, was also Leith-Ross's grand-uncle. Leith-Ross recalled visiting Mesdag's studio in Europe as a young boy. He remained inspired by the realism of Mesdag's marine subjects, observed directly from nature.

Like John Fulton Folinsbee, Kenneth R. Nunamaker, and other members of the third and last generation of New Hope artists, Leith-Ross began by working within the traditions of that long-lived regional style of American impressionism, only to respond to and adopt the new contemporary movement in later years.

SEASON	75-76	76-77	77-78	78-79	79-80	80-81	81-82	82-83	83-84	84-85
Paintings					1				2	5
Dollars					$1,300				$5,150	$8,200

Record Sale: $4,300, D.NY, 4/4/84, "The Hoffman House, New Hope," 30 × 36 in.

PETER BELA MAYER

(1887-)

Peter Bela Mayer's work is in the tradition of the impressionist landscape painters, although the fact that his many canvases are undated makes chronological evaluation of his evolution as a painter difficult and conjectural. The bulk of his work consists of views of the countryside and towns of New England and locations near his Long Island home.

Born Bela Mayer in Hungary in 1887 (he added the name Peter in the 1940s to avoid confusion with women painters), Mayer was enrolled at the National Academy of Design in New York City from 1908 to 1915. Several drawings from this period remain, including a figure study and a drawing from a bust of Augustus Caesar.

Mayer's public career began in 1914, when one of his works was exhibited at the Corcoran Gallery in Washington, D.C. In 1916, his *Jersey Hillside* (date and location unknown) was hung at the National Academy of Design. During the 1920s, his work was shown at the Pennsylvania Academy of the Fine Arts, the Art Institute of Chicago and the Brooklyn Museum.

In 1923, Mayer was invited to send his painting *Winter* (date unknown, private collection) to a major international exhibition in Venice. *Winter*, depicting a scene in rural New Jersey, is a study in subtle monochromatic harmonies, as in the work of James McNeill Whistler, but with a thick, bold impasto.

In the catalogue to an exhibition of his work held at the Nassau County Museum, Long Island, in 1984, Mayer is quoted as saying that balance is the most important element in a painting. His compositions reveal his preoccupation with structural features that unify the geological and human components of the scenes, as in *Roslyn in Winter* (date unknown, private collection), which treats rows of houses and hills as related receding planes.

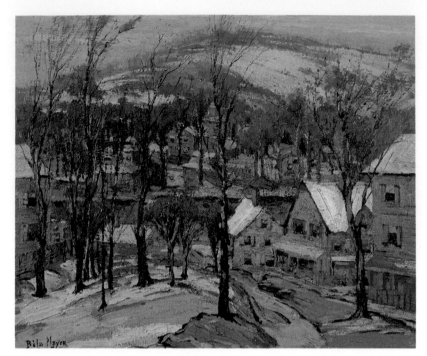

Roslyn in Winter, signed l.l. Courtesy of Nassau County Museum of Fine Art, Roslyn, New York, Collection of Dr. and Mrs. Robert Durell.

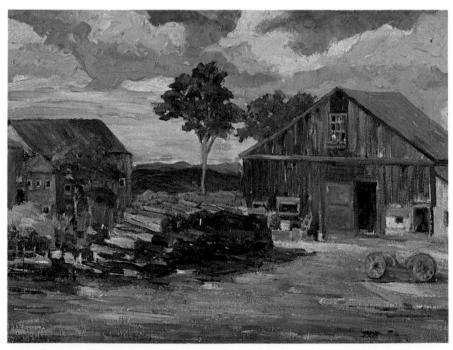

In Vermont, 14 x 18 in., signed l.l. Courtesy of Marbella Gallery, Inc., New York, New York. Photograph by Richard Haynes.

Mayer, who lives in Port Washington, Long Island, remains active as a painter.

MEMBERSHIPS
Allied Artists of America
Guild of American Painters
Salmagundi Club

SEASON	75-76	76-77	77-78	78-79	79-80	80-81	81-82	82-83	83-84	84-85
Paintings						1	2	3	4	
Dollars						$1,900	$1,950	$6,900	$13,850	

Record Sale: $9,250, D.NY, 4/4/84, "Coastal Village," 36 × 40 in.

GEORGIA O'KEEFFE
(1887-)

Judged by many to be America's greatest living artist, Georgia O'Keeffe has at various times been labeled an American abstractionist, a surrealist and a precisionist. Yet her work cannot be categorized. Her mammoth flower pictures are in a class by themselves and her arid, clean landscapes of the New Mexico desert place her among the foremost of the great Western artists.

O'Keeffe was born in Sun Prairie, Wisconsin in 1887. She studied for a year at the Art Institute of Chicago, and then enrolled in the Art Students League in New York City.

In 1912, O'Keeffe enrolled in an art class at the University of Virginia, where she first encountered the ideas of Arthur Dow. In 1914, she went North to study with Dow at Teachers College of Columbia University.

Although the works of teacher and student are radically different, Dow's penchant for the flat patterning and color harmonies of oriental art had a lasting effect on O'Keeffe's mature style. His insistence that an artist should be concerned only with "filling up space in a beautiful way" proved an inspiration to her, and after returning South she began a series of remarkable abstract drawings and watercolors.

O'Keeffe mailed some of these drawings to a friend in New York, who took them immediately to photographer and gallery-owner Alfred Stieglitz. When he first saw the O'Keeffe works, Stieglitz is

Goat's Horn with Red, 1945, 31¹¹/₁₆ x 27⅞ in. Courtesy of Hirshhorn Museum and Sculpture Garden, Smithsonian Institution, Washington, D.C.

said to have exclaimed, "Finally, a woman on paper." Angered because Stieglitz had neglected to get permission before exhibiting her works, O'Keeffe stormed into his gallery to tell him so, thus beginning a life-long association. Stieglitz encouraged her, exhibited her work in his various galleries and used her as a model in hundreds of photographs. In 1924, the two were married.

At first O'Keeffe's paintings were totally abstract, but gradually she began to move toward more realism—but on her terms. In the 1920s, she began to paint flowers, cityscapes and farmhouses, greatly simplified and abstract in feeling. Her flowers are like none seen before, magnified to the point where a single flower fills the entire canvas. Usu-

ally painted in a frontal view, their petals pulsate like human flesh, causing some critics to assume they are sexual metaphors.

In 1929 O'Keeffe took her first extended trip to New Mexico, and immediately fell in love with the harsh, splendid landscape. She visited there each summer until the late 1940s, when she moved there permanently. As presented in O'Keeffe paintings, mountains, canyons, bleached animal bones, black crosses and other Mexican-American religious symbols are enigmas, combining sensuousness with stark austerity. But the artist, disliking the jargon associated with modern art, has always denied that her works contain hidden meaning and symbolism.

10-Year Average Change From Base Years '76-'77: 124%

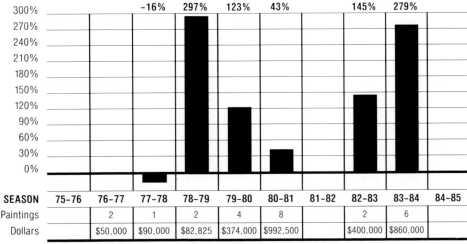

SEASON	75-76	76-77	77-78	78-79	79-80	80-81	81-82	82-83	83-84	84-85
			-16%	297%	123%	43%		145%	279%	
Paintings		2	1	2	4	8		2	6	
Dollars		$50,000	$90,000	$82,825	$374,000	$992,500		$400,000	$860,000	

Record Sale: $300,000, SPB, 12/4/80, "Spring 1948," 48 x 84 in.

GLENN O. COLEMAN
(1887-1932)

Glenn Coleman was a second-generation painter of the Ashcan School. The works of his early and middle years were deeply personal and romantic depictions of everyday life in lower Manhattan. Greenwich Village, the riverfront and Chinatown, with their sometimes exotic atmosphere and human scale of life, all fascinated him. Toward the end of his life, however, the influence of cubism crept into his work, with the monumental architecture of New York's skyscrapers dominating his canvases.

Coleman was born in Springfield, Ohio in 1887. While still in his mid-teens, he became an apprentice newspaper artist in Indianapolis. In 1905, he went East to New York.

He studied briefly with both Robert Henri and Everett Shinn, but for the most part his early years in the city were a struggle for existence. To make ends meet, he had to work at a succession of menial jobs, interrupting his efforts to become a painter.

Coleman's predicament made it easy for him to identify with the poor, and fueled his interest in socialism. For a time, he sold drawings to *The Masses,* a leading Socialist magazine of the day. It was in painting the old neighborhoods and out-of-the-way corners of the city, however, that he found his real strength.

In the mid-1920s, when his painting style was starting to change, Coleman did a series of lithographs based on his earliest sketches of city life. But the lapse of time and the surging currents of modern art made them seem sentimental and dated.

At the same time, his paintings began to lose their preoccupation with people and mood, and instead began to examine the architectural aspects of the city. While the elements remained realistic,

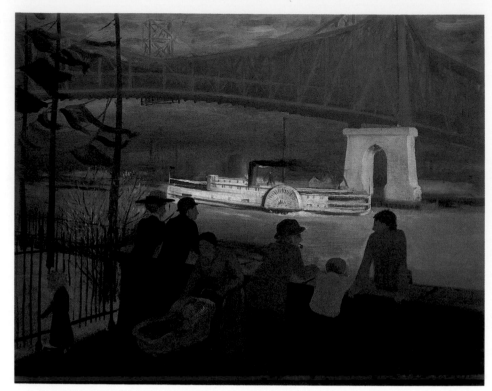

Queensboro Bridge, East River, ca. 1910, 30⅛ x 38⅛ in., signed l.r. Courtesy of Hirshhorn Museum and Sculpture Garden, Smithsonian Institution, Washington, D.C.

Coleman used a cubist approach in superimposing one scene or building on another in stylized compositions.

Not long before his death in 1932, he moved to Long Island and was developing an interest in painting rural landscapes, but this phase of his work never had a chance to become fully realized.

MEMBERSHIPS
New Society of Artists
Society of Independent Artists
Whitney Studio Club

PUBLIC COLLECTIONS
Newark Museum, New Jersey
Whitney Museum of American Art,
 New York City

SEASON	75-76	76-77	77-78	78-79	79-80	80-81	81-82	82-83	83-84	84-85
Paintings					2	1			2	
Dollars					$21,250	$15,000			$18,100	

Record Sale: $17,000, SPB, 12/8/83, "High Road," 34 × 25 in.

LAVERNE NELSON BLACK

(1887-1938)

An illustrator, painter and sculptor, Laverne Nelson Black did not receive recognition for his scenes of the American Southwest until late in his career.

Black was born to a Viola, Wisconsin hotelkeeper in 1887. His frequent childhood companions were Indians from a nearby reservation.

Largely self-taught, Black began to draw and paint as a boy, using vegetable juices, earths and red keel, a soft stone the Indians themselves used in ceremonial decoration.

In 1906, the family moved to Chicago, where Black enrolled in the Chicago Academy of Fine Arts. He won a scholarship there for his second and final year of formal training.

He became a commercial artist and illustrator in Chicago and, for a time, in New York City. He vacationed on Western ranches and reservations, to sketch, paint and sculpt.

Accurate in chacterization, the artist worked in an impressionistic style in the early 1900s, ahead of the trend. His pictures and sculptures of the life and landscapes of the West are broad in execution, capturing the essential realism without including distracting detail. He typically worked in loose strokes of brush or palette knife, laying in blocks of warm color. He worked from life whenever possible.

In the early 1920s, his small bronze action sculptures of mounted cowboys and Indians were the first to be shown after Frederic Remington's at Tiffany's, New York City jewelers.

Ill health led Black to move with his family to Taos, New Mexico. There he did some of his best work, using as subjects local pueblo architecture, Indians, and the Sangre de Cristo Mountains. His work attracted buyers, among them the Santa Fe Railroad.

Still in poor health, Black moved to Phoenix, Arizona in the 1930s. There the Public Works Administration com-

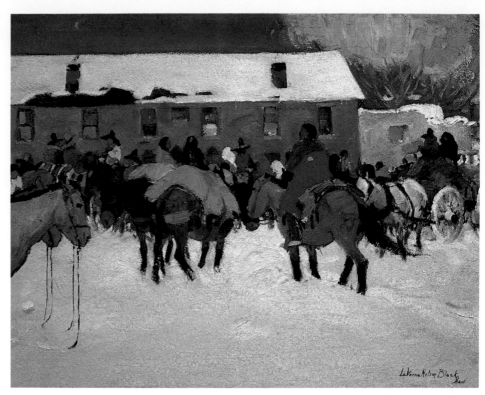

Crowd of Indians in Snow, 10½ x 15½ in., signed l.r. Photograph courtesy of The Gerald Peters Gallery, Santa Fe, New Mexico.

missioned him to paint four murals for the post office, depicting scenes of Arizona's heritage, including pioneers, the Pony Express, and cattle and mining activities. Shortly after completing them in 1938, Black became terminally ill; some believe he contracted paint poisoning. He died in Chicago that year.

PUBLIC COLLECTIONS
Phoenix Post Office Building, Arizona
Treasury Department Building, Washington, D.C.
Stark Museum of Arts, Orange, Texas

SEASON	75-76	76-77	77-78	78-79	79-80	80-81	81-82	82-83	83-84	84-85
Paintings				1	2	2		2	3	
Dollars				$7,000	$9,800	$27,250		$17,000	$66,500	

Record Sale: $55,000, CH, 6/1/84, "Indians at Market," 28 × 33 in.

HERBERT
MORTON
STOOPS
(1887-1948)

They'll Give You a Fresh Life, 30 x 32 in., signed l.r.
The Historical Society of Pennsylvania, Philadelphia.

Herbert Morton Stoops, famous for his scenes of the American West and World War I, was an important illustrator of the 1920s. He painted in the Remington tradition for *Blue Book* magazine.

Stoops, born in 1887, was raised on a ranch in Idaho's Rocky Mountains. He grew up with cowboys and Indians who had seen the great buffalo herds and the Plains Wars. His clergyman father sent Stoops to Utah State College.

After graduation, Stoops, then 18, went to San Francisco; he worked as a feature artist on the *Morning Call* and later *The Examiner.* In 1916, Stoops moved to Chicago to study at the Art Institute of Chicago and work as a staff artist for the *Chicago Tribune,* where he became part of a group that included Ben Hecht and Charles MacArthur.

In 1917, Stoops joined the army, serving as an artillery officer in France. The drawings sent back of tired and grimy soldiers gave him his first national exposure.

After the war, Stoops settled in New York City and began his close association with *Blue Book* magazine, which published adventure fiction. Its wide variety of subject matter let Stoops display his expert knowledge of military subjects, the Old West, animals and human figures, all done as black-and-white dry-brush illustrations regularly for 13 years.

He did not confine himself to *Blue Book,* however; he illustrated for *Collier's, This Week, Cosmopolitan* and many others. He also painted for exhibition. His picture *Anno Domini* (date and location unknown) won the Isador Medal at the National Academy of Design exhibition in 1940. Among his book illustrations, many done for school texts, he is famous for his work in *American—The Life Story of a Great Indian,* by Frank B. Linderman (1930).

Stoops worked until his death in 1948 at his home in New York City.

MEMBERSHIPS
American Arts Professional League
Artists' Guild of New York
Salmagundi Club
Society of Illustrators

SEASON	75-76	76-77	77-78	78-79	79-80	80-81	81-82	82-83	83-84	84-85
Paintings		1		1		4	9	2	5	2
Dollars		$8,000		$1,700		$6,000	$36,925	$2,400	$7,950	$7,350

Record Sale: $25,000, SPB, 10/22/81, "The Hunting Party," 32 × 40 in.

RANDALL DAVEY

(1887-1964)

An influential figure in the Sante Fe art community, Randall Davey painted with disciplined mastery, yet his work retained a sense of immediacy and vitality.

Davey was born in East Orange, New Jersey in 1887. He studied architecture at Cornell University from 1905 to 1907, then left for New York City to attend Robert Henri's School of Painting and the Art Students League.

In 1910, Davey and Henri toured the capitals of Europe, analyzing the works of the old masters. The two artists exhibited at the New York City Armory Show in 1913. In 1915, Davey took the National Academy of Design's Second Hallgarten Prize, and won honorable mention at the Panama-Pacific Exposition.

In 1919, Davey, John Sloan, and their wives headed West in a touring car for an extended trip. Upon arriving in Santa Fe, the travelers fell in love with the surroundings, and the Daveys decided to settle there. Davey purchased an old mill outside of town and converted it into a studio.

Unlike many artists of his time in the West, Davey did not make a practice of painting Indians. His main interest was nudes, which he rendered in a bold, brightly colored, post-impressionistic style.

Davey was also interested in horses, and not always from a spectator's viewpoint. When he taught at the Broadmoor

Steeplechasers Leaving the Paddock, 18 x 22 in., signed l.l. Photograph courtesy of The Gerald Peters Gallery, Santa Fe, New Mexico.

Art Academy in 1924, his salary was twice the standard rate because of his skill in the game of polo. Davey later became interested in horse racing, and he painted many canvases on the subject. His goal in these paintings was to capture the "nervous excitement and intensity" of the racetrack experience.

During his career, Davey was also commissioned to do several murals, some of which are in the Will Rogers Memorial Shrine in Colorado Springs, Colorado.

Outgoing and gregarious, Davey invigorated Santa Fe's artistic and social scene. He died in a car accident in 1964, on the way to California.

10-Year Average Change From Base Years '78-'79: 41%

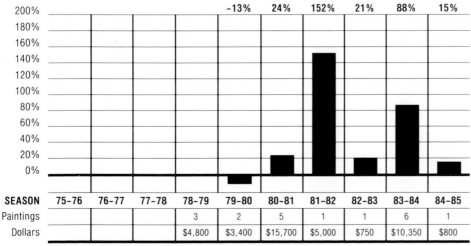

SEASON	75-76	76-77	77-78	78-79	79-80	80-81	81-82	82-83	83-84	84-85
					-13%	24%	152%	21%	88%	15%
Paintings				3	2	5	1	1	6	1
Dollars				$4,800	$3,400	$15,700	$5,000	$750	$10,350	$800

Record Sale: $7,000, SPB, 5/29/81, "Portrait of Young Girl," 34 × 26 in.

MEMBERSHIPS
National Academy of Design
National Association of Mural Painters
National Association of Portrait Painters
Painter-Gravers Society

PUBLIC COLLECTIONS
Art Institute of Chicago
Corcoran Gallery of Art, Washington, D.C.
Cleveland Museum of Art
Delaware Art Museum, Wilmington
Detroit Institute of Arts
Kansas City Art Institute and School of Design, Missouri
Montclair Art Museum, New Jersey
Museum of New Mexico, Santa Fe
Nelson Gallery of Art, Atkins Museum of Fine Arts, Kansas City, Missouri
Whitney Museum of American Art, New York City
Will Rogers Memorial Shrine, Colorado Springs

MARGUERITE THOMPSON ZORACH
(1887-1968)

Marguerite Thompson Zorach was one of the modernist painters who introduced European modes, such as fauvism and cubism, to the United States at the time of the New York City Armory Show in 1913. Although her artistic reputation was overshadowed by that of her husband, painter and sculptor William Zorach, the importance of her work—particularly her early paintings—has recently been acknowledged.

She was born Marguerite Thompson in Santa Rosa, California in 1887. In 1908, she went to Paris to study art. Impressed by the work of non-academic painters, including Matisse and Derain, she enrolled in La Palette, an avant-garde art school where she studied under the Scottish fauve painter John Duncan Fergusson.

Thompson exhibited in the Salon d'Automne and at the Societe des Artistes Independents. Her work of this period shows the influence of the fauves and the German expressionists in its bold use of unconventional color and its startling distortions of shape and line, as in *Judea Hill in Palestine* (1911, private collection), painted during a trip around the world.

Returning to California in 1912, Zorach executed a number of powerful paintings in the Sierra Mountains, including *Windy Day* (1912, private collection) and *Landscape* (1912, private

Portrait of Bill (Bill Zorach), ca. 1925, 72 x 36 in., signed l.r. Courtesy of National Museum of American Art, Smithsonian Instutition, Gift from Collection of the Zorach Children.

collection). She also produced pen-and-ink drawings which reflected her observation of oriental art. Her first solo exhibition was held that year in Los Angeles.

Thompson moved to New York City late in 1912 to marry William Zorach, whom she had met in Paris. Both exhibited in the Armory Show of 1913. Beginning in 1915, Marguerite Zorach experimented with cubism, influenced

by Max Weber. *Provincetown* (1916, private collection) and *Ships in the Harbor* (1917, National Museum of American Art) are typical of the muted palette and awkard line of this period.

By 1920, Zorach had begun to concentrate on large, intricate tapestries, generally featuring arcadian scenes executed in brilliantly-colored silk or wool. She regarded these stitcheries as her primary artistic work throughout the remainder of her life, although she returned to oils after 1930. She also collaborated with her husband in many of his sculptural commissions, providing original designs and sketches, as she did for his *Spirit of the Dance* (1932, Radio City Music Hall).

She died in 1968 in Brooklyn, New York.

MEMBERSHIPS
New York Society of Women Artists

PUBLIC COLLECTIONS
Colby College
J.B. Speed Art Museum, Louisville, Kentucky
Massillon Museum, Massillon, Ohio
Metropolitan Museum of Art, New York City
Museum of Modern Art, New York City
National Museum of American Art, Washington, D.C.
Newark Museum, New Jersey
Whitney Museum of American Art, New York City

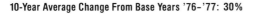

10-Year Average Change From Base Years '76-'77: 30%

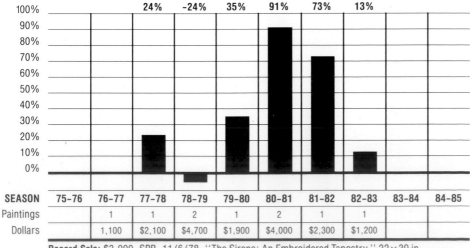

SEASON	75-76	76-77	77-78	78-79	79-80	80-81	81-82	82-83	83-84	84-85
		24%	-24%	35%	91%	73%	13%			
Paintings		1	1	2	1	2	1	1		
Dollars		1,100	$2,100	$4,700	$1,900	$4,000	$2,300	$1,200		

Record Sale: $3,000, SPB, 11/6/78, "The Sirens: An Embroidered Tapestry," 22 x 39 in.

CARL SPRINCHORN
(1887-1971)

Although he was a longtime resident of New York State, Carl Sprinchorn was best known for his paintings and watercolors of the Maine landscape, which were infused with both warmth and vigor.

Born in 1887 in Sweden, Sprinchorn arrived in New York City when he was 16. He enrolled in the New York School of Art, studied under William Chase, and then became a longtime student of Robert Henri. Henri is said to have regarded Sprinchorn as one of his most talented students.

Sprinchorn's work expanded artistically during a 1914 trip to Europe. He painted themes drawn largely from continental night life, including haunting, romantic renderings of the ballet. These themes dominated the canvases in Sprinchorn's first exhibition in 1916.

During the 1920s, Sprinchorn joined a small cultural settlement of Swedish-Americans in Monson, Maine, where he painted and worked as a lumberjack. The state's rustic, rugged landscapes would provide continual artistic inspiration for him, as it had for other painters.

In all his paintings, Sprinchorn depended more on color than on form to evoke drama and lyricism. He died in 1971 in Albany, New York.

Winter Landscape, 14⅞ x 21¼ in., signed l.r. Courtesy of Fogg Art Museum, Harvard University, Cambridge, Massachusetts, Gift of James N. Rosenberg.

MEMBERSHIPS
Salons of America
Society of Independent Artists

PUBLIC COLLECTIONS
American Swedish Historical Museum,
 Philadelphia
Atlanta Art Association
Brooklyn Museum
Dayton Art Institute, Ohio
Museum of Fine Arts, Boston
Museum of Modern Art, New York City
Museum of the City of New York
Philadelphia Museum of Art
Phillips Collection, Washington, D.C.
Rhode Island School of Design, Providence

10-Year Average Change From Base Years '79–'80: 108%

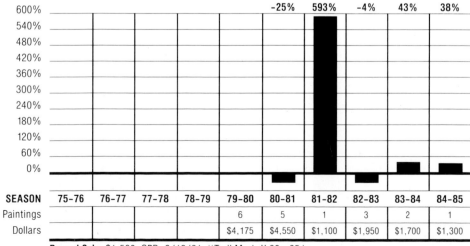

	75-76	76-77	77-78	78-79	79-80	80-81	81-82	82-83	83-84	84-85
						−25%	593%	−4%	43%	38%
SEASON										
Paintings					6	5	1	3	2	1
Dollars					$4,175	$4,550	$1,100	$1,950	$1,700	$1,300

Record Sale: $1,500, SPB, 6/19/81, "Trail Mark," 30 × 25 in.

WILLIAM GROPPER
(1887-1977)

William Gropper was a remarkably versatile artist, skilled in a variety of media and disciplines including cartooning, painting and lithography. Throughout his life, he remained committed to using art as a vehicle to protest social and political injustice. Gropper's subjects, which range from political figures to dispossessed farm workers, were rendered in the blunt and graphic terms associated with Social Realism.

The son of impoverished Jewish immigrants, William Gropper was born in 1887 in New York City. Growing up in the ethnic ghettos of Manhattan's Lower East Side, Gropper experienced firsthand the plight of the underprivileged. He earned enough money to pursue an art education, which included three years at the Ferrer School under the tutelage of Robert Henri and George Bellows. The young artist absorbed their realistic, nonpolitical style and converted it into his own passionate, satirical art.

Gropper was hired by the *New York Tribune* in 1919 as a cartoonist, and later created illustrations and cartoons for a wide range of publications, from *Vanity Fair* to the left-wing newspaper *New Masses*. Through his work as a political cartoonist, he became known as the "American Daumier."

Like many Social Realist artists of the 1930s, Gropper became increasingly involved in the liberal political causes of the time. He had begun to paint privately in 1921, and continued to work in oil throughout the 1930s. The surfaces of his paintings, like the subjects he portrayed, are coarse and unrefined. Line is used to exaggerate gesture, and bold, thick applications of color create striking spatial relationships.

Typical of his work is *The Senate* (1935, Metropolitan Museum of Art), an angry, satirical critique of political hypocrisy. In an earlier work, entitled

Construction of A Dam (Center Panel Mural Study), 1937, 27⅛ x 42 in. Courtesy of National Museum of American Art, Smithsonian Institution, Transfer from United States Department of the Interior, National Park Service.

Migration (1932, University Art Collection, Arizona State University), Gropper turned from urban themes to depicting the condition of migrant farm workers. The figures in this painting are rendered with a cartoon-like simplicity; sharp, angular lines underscore their gauntness.

As a muralist, Gropper completed several commissions, including the United States Post Office in Freeport, Long Island (1938) and the Northwestern Postal Station in Detroit (1941).

During Joseph McCarthy's anticommunist campaign of the 1950s, Gropper was asked to testify before the United States Senate. Despite the resulting adversity, he experienced a renewed popularity during the 1960s. Before his death in 1977, he had gained recognition with his election to the prestigious National Institute of Arts and Letters in 1968.

MEMBERSHIPS
American Art Congress
Artists Equity
Mural Painters
National Institute of Arts and Letters
New York Architectural League
The American Group

PUBLIC COLLECTIONS
Art Institute of Chicago
Hirshhorn Museum and Sculpture Garden, Washington, D.C.
Library of Congress, Washington, D.C.
Los Angeles County Museum of Art
Metropolitan Museum of Art, New York City
Montclair Art Museum, New Jersey
Museum of Modern Art, New York City
Pennsylvania Academy of the Fine Arts, Philadelphia
Wadsworth Atheneum, Hartford, Connecticut
Walker Art Center, Minneapolis, Minnesota
Whitney Museum of American Art, New York City

SEASON	75-76	76-77	77-78	78-79	79-80	80-81	81-82	82-83	83-84	84-85
Paintings		2	1	5	8	16	13	4		3
Dollars		$3,500	$425	$6,350	$19,050	$26,450	$52,150	$10,850		$5,000

Record Sale: $12,000, SPB, 6/4/82, "Not Guilty," 23 × 26 in.

820

NICHOLAS ALDEN BROOKS
(Active 1888-1904)

Nicholas Alden Brooks, a painter of trompe l'oeil still lifes, has been an enigma to art historians. Very little is known of his life. He produced some work in New York City between 1888 and 1904. However, there is no record of him joining any art societies or participating in any exhibits or annual shows.

Brooks's tabletop still lifes have appeared on the New York market in recent years. But it is for his paintings of playbills, money and posters that Brooks has attracted the most attention. His work seems to have been inspired by William Harnett. In fact, some of his paintings were sold as Harnett's after someone added forgeries of Harnett's signature. *Dollar Bill and Playbill* (date unknown, Franklin D. Roosevelt Library, Hyde Park) was presented to President Roosevelt by Nelson A. Rockefeller as a genuine Harnett.

In one case, a painting signed "W.M. Harnett, 1879" was attributed to Brooks only after a study of the subject matter. The iconography showed that a five-dollar bill was clearly from the 1880 series. A letter was addressed to Edwin Booth at the Players Club, New York—which was founded in 1888. The painting also showed evidence of alteration by sanding and overpainting.

Brooks had a particular fascination with the assassination of Abraham Lincoln. He produced several paintings that include playbills and posters from the

Ten Dollar Bill with Saratoga Race Form, ca. 1880, 13 ⅞ x 10³/₁₆ in., signed l.l. Photograph courtesy of the Brandywine River Museum, Chadds Ford, Pennsylvania, Anonymous Collection.

10-Year Average Change From Base Years '75-'76: 176%

| | | -1% | | -2% | -26% | 269% | -62% | 52% | 1,175% |

SEASON	75-76	76-77	77-78	78-79	79-80	80-81	81-82	82-83	83-84	84-85
Paintings	2		1		2	3	1	1	3	2
Dollars	$1,900		$1,000		$3,500	$6,900	$3,750	$1,200	$10,100	$30,250

Record Sale: $24,000, CH, 12/7/84, "Races, Saratoga, Ten Dollar Bill," 14 x 11 in.

Ford Theatre. One features a ticket stub from April 14, the night Lincoln was shot.

Brooks's work foreshadows the analytical cubists of the twentieth century, with spatial arrangements of overlapping flat surfaces. He also exhibits a restrained sense of color.

PUBLIC COLLECTIONS
Allen Memorial Art Museum,
Oberlin College, Ohio
Franklin D. Roosevelt Library,
Hyde Park, New York

HORACE PIPPIN
(1888-1946)

Self-taught artist Horace Pippin is considered one of America's foremost primitive or naive painters. Bold, figurative and powerfully original, his works have been compared to those of French painter Henri Rousseau.

Pippin imaginatively interpreted such subjects as historic events, biblical stories, childhood incidents and his own experiences as an infantryman in World War I. These vivid paintings are concerned less with objective reality than with the artist's subjective, highly personal vision.

Born in West Chester, Pennsylvania in 1888, Pippin began drawing with pencil and crayon at age seven. He started to work at age 14; he was a hotel porter, ironmonger and junk dealer before enlisting in the army in 1917.

Wounded by a sniper's bullet, Pippin returned to West Chester in 1920. He began to rehabilitate his wounded right arm by making burnished designs on wood panels with a white-hot stove poker. He discovered that he could keep his right wrist steady with his left hand, and soon found an outlet in painting.

When he began to paint at age 40, Pippin depicted what was uppermost in his mind—the grim details of his war experiences. His first military painting, and his most famous, is entitled *The Ending of the War: Starting Home* (1931, Philadelphia Museum of Art). In this work, the viewer is effectively engaged in the psychological agonies of the scene.

Other war paintings and burnished wood panels were executed during the 1930s, the decade in which Pippin was discovered and recognized by the art establishment. Christian Brinton, an art critic then living in West Chester, arranged for an exhibition of Pippin's work in the West Chester Community Center, which led to other important shows in Philadelphia, Chicago and

West Chester Courthouse, 1940, 22 x 28 in., signed l.r. Courtesy of The Pennsylvania Academy of the Fine Arts, Philadelphia.

New York City. This exposure helped Pippin establish a relationship with noted art collector Albert C. Barnes, who purchased several of his works.

Pippin next completed a series of works based on recollections of his childhood, such as the painting *Domino Players* (1943, Phillips Collection). This domestic scene is composed of geometric patterns rendered in subdued colors that underscore the artist's intuitive mastery of two-dimensional design. Pippin's paintings of Abraham Lincoln and John Brown, and his still lifes, were also executed during the early 1940s. In his usual style, characterized by large, flat shapes and stark contrasts, Pippin composed *John Brown Going to His Hanging* (1942, Pennsylvania Academy of the Fine Arts).

In the "Holy Mountain" series which was to follow, Pippin delved into allegory. In this series of four works, the artist depicts a man (resembling Pippin) holding a shepherd's crook and dressed in a white robe. Children play in the foreground and animals, both wild and domestic, are grouped symmetrically on either side. Painted during World War II, these works have been described as an expression of Pippin's desire for global peace.

Pippin has been honored as a black artist, a primitive artist, and a Pennsylvania artist. His work recalls a long folk tradition in American art which extends back to the colonial limners. Before his death he had attained a considerable reputation, and his paintings had been purchased by several major museums and private collectors.

PUBLIC COLLECTIONS
Albright-Knox Art Gallery, Buffalo, New York
Allen Memorial Art Museum, Oberlin College
Hirshhorn Museum and Sculpture Garden, Washington, D.C.
Pennsylvania Academy of the Fine Arts, Philadelphia
Phillips Collection, Washington, D.C.

SEASON	75-76	76-77	77-78	78-79	79-80	80-81	81-82	82-83	83-84	84-85
Paintings		1			1	2	2			
Dollars		$17,000			$12,000	$36,500	$60,500			

Record Sale: $52,500, SPB, 10/6/81, "Saturday Night Bath," 25 × 30 in.

FERN ISABELL COPPEDGE
(1888-1951)

Fern Isabell Coppedge enjoyed a reputation as one of the foremost female landscape painters of the United States. She is associated with the New Hope School, and was also a member of "The Ten," a group of female artists who exhibited annually in Philadelphia and throughout the country.

Born in Decatur, Illinois in 1888, Coppedge sought professional training as an artist after attending the University of Kansas. She spent two years at the Chicago Art Institute, and three years at the Art Students League in New York City, where she studied under noted American painter William Merritt Chase. From 1918 to 1919, she attended the Pennsylvania Academy of the Fine Arts in Philadelphia. She also studied privately with John F. Carlson and Henry Bayley Snell, another artist affiliated with the New Hope School.

Coppedge first visited New Hope, in Bucks County, Pennsylvania, in 1917. She became immediately enamored of the area's quaint towns and gently rolling hills dotted with nineteenth-century farmhouses. In 1920, she purchased a studio in nearby Lumberville.

At some point in her artistic career, Coppedge traveled to Europe. She remained unimpressed and, like many of the other New Hope artists, found enough scenes for painting in her own backyard to last a lifetime.

In 1929, Coppedge built a house on Main Street in New Hope, designed after sketches she had made of old Bucks County farmhouses. Her studio was modeled after a nineteenth-century carriage house.

Coppedge gained her reputation as a painter of Bucks County snow scenes, with cozy houses tucked neatly into the hilly countryside. While this motif was used by other New Hope scene painters, Coppedge's works display a unique personality.

A plein-air painter, she worked

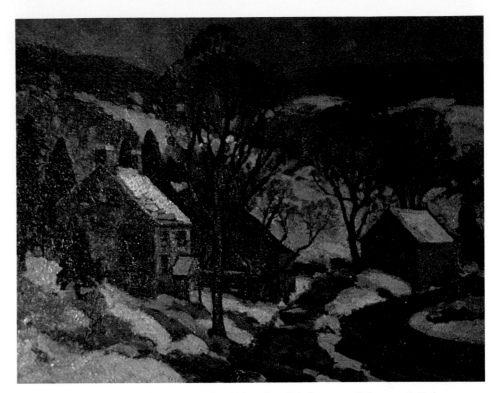

Winter Canal, Lumberville, Bucks County, 25 x 30 in., signed l.l. Courtesy of Newman Galleries, Philadelphia, Pennsylvania.

directly from nature, but did not restrict herself to a literal translation of it. Her landscapes depart from the realist tradition and take on a highly personal note, with iridescent, vibrant colors. Her broad brushwork and flat application of paint are vastly different from the short, broken brushwork of impressionism.

While Bucks County scenes occupied Coppedge's attention until her death in 1951, she also painted a few harbor scenes in Gloucester, Massachusetts. She was the only woman associated with the New Hope School to attain prominence.

MEMBERSHIPS
Art Students League
Gloucester Society of Artists
National Academy of Women Painters and
 Sculptors
Pennsylvania Academy of the Fine Arts
Ten Philadelphia Painters

PUBLIC COLLECTIONS
American Embassy, Rio de Janeiro, Brazil
Bryn Mawr College, Pennsylvania
Detroit Institute of Arts
Pennsylvania Academy of the Fine Arts,
 Philadelphia
Pennsylvania State Capitol, Harrisburg
Reading Museum of Fine Arts, Pennsylvania

(No sales information available.)

FRITZ WINOLD REISS
(1888-1953)

Though he was an accomplished muralist and a successful interior architect, Winold Reiss is best remembered for his sensitive portraits of Plains Indians. A stickler for historically accurate detail, Reiss's pictures provide an invaluable record of a people whose traditional way of life has all but vanished. But even more importantly, his portraits are a quiet testimony to the respect and high regard the artist felt for his Indian subjects.

Reiss, the son of a landscape artist, was born in Germany and grew up in the Black Forest. He studied art in Munich but harbored a lifelong desire to meet and paint real American Indians. In 1913 he came to America expressly for this purpose, but first he had to establish himself in New York, where he painted portraits and landscapes and became a much sought-after interior designer and a muralist of note. In 1919, Reiss took his first Western tour, visiting the Blackfoot Indians on their reservation in Montana.

The German artist was not disappointed in the fulfillment of his boyhood dream. He enjoyed an immediate rapport with his Blackfoot hosts and was soon made an honorary member of the tribe. Reiss was so impressed with his Indian friends, whom he characterized as "the truest man, the most honorable friend that lives," that he returned every summer to add to his pictorial record.

The Great Northern Railroad commissioned a collection of 81 Reiss portraits, which it exhibited in major museums throughout the United States and Europe. In 1935, the Great Northern had 49 of these portraits reproduced in a book titled *Blackfeet Indians,* with a text written by Frank B. Linderman.

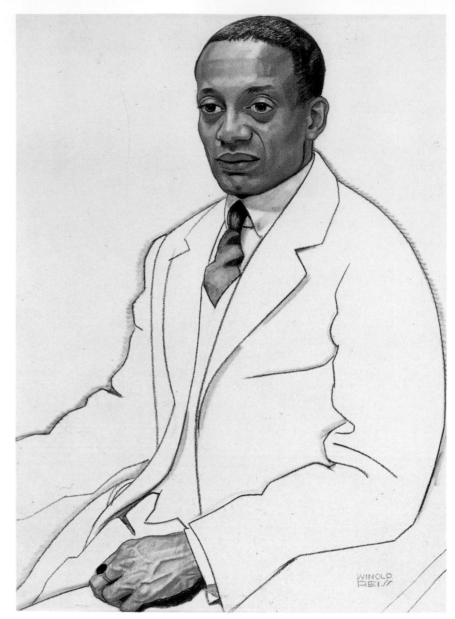

Alain LeRoy Locke, ca. 1925, 29⅞ x 21⅝ in., signed l.r. Courtesy of National Portrait Gallery, Washington, D.C., Gift of Lawrence A. Fleischman and Howard Garfinkle with a matching grant from the National Endowment for the Arts.

Reiss continued working in New York in the winter and traveling during summers to Canada and the American West for years. When he died in 1953, his ashes were scattered over the Blackfoot Reservation.

MEMBERSHIPS
American Design Gallery
Architect's League
Society of Illustrators
Society of Independent Artists

PUBLIC COLLECTIONS
Minneapolis Institute of Art, Minnesota
Museum of Plains Indians, Browning, Montana

SEASON	75-76	76-77	77-78	78-79	79-80	80-81	81-82	82-83	83-84	84-85
Paintings						2	2	7	1	4
Dollars						$21,500	$7,600	$29,300	$2,500	$9,782

Record Sale: $15,500, SPB, 10/17/80, "Cree Indian Spider Bonnet," 39 × 26 in.

STREETER BLAIR
(1888-1966)

Streeter Blair was a primitive painter noted for his innocent, nostalgic portraits of the American past. His paintings—of farmhouses, buggies, children, small towns and historic events—are similar in spirit to those of Grandma Moses.

Many of Blair's paintings portray scenes from his childhood on a farm in Cadmus, Kansas. Others re-create historic scenes, such as a street in the gold-rush town of Virginia City, Nevada, and the first electric street light in Los Angeles. His subjects are well-researched and accurate in minute detail.

Blair discovered that he could paint when he was 60, after a lifetime spent in other pursuits, as a school principal, teacher, coach, editor and owner of an antique business in Los Angeles. The discovery was serendipitous: a customer who was buying an antique asked Blair to describe the Pennsylvania farmhouse from which it came. He tried and failed. Picking up a brush, he painted a picture which the woman bought immediately for $25, setting his artistic career in motion.

For the next 18 years, Blair dropped everything else to paint, earning a reputation as a primitive of some talent. In 1970, a few years after Blair's death, a Beverly Hills art gallery held a retrospective of his work, offering his paintings for sale at up to $25,000 each.

Like Grandma Moses, Blair refused formal art instruction, a fact which is reflected in his treatment of perspective, relative-size and shadowing. His rivers seem to run uphill and his people are often larger than their horses. His work

Meadowlark Ranch—San Diego County, 1951, 40 x 30 in., signed l.r. Courtesy of the Los Angeles County Museum of Art, Gift of Mr. and Mrs. Ozzie Nelson.

displays a sweet, nostalgic glow, the joie de vivre of childhood, as remembered by an adult who has chosen to forget the hardships of life in rural turn-of-the-century America.

A gregarious man, Blair was constantly surrounded by friends who came to sit around his fireplace, drink coffee and eat the prize-winning bread Blair baked, while listening to his stories of the old days in Kansas. Among this group were several young avant-garde artists, including Edward Kienholz and Billy Al Bengston.

PUBLIC COLLECTIONS
Hirshhorn Collection, Washington, D.C.
Los Angeles County Museum of Art
Museum of Fine Arts, San Diego
National Gallery, Washington, D.C.
Santa Barbara Museum of Art, California
Smithsonian Institution, Washington, D.C.

10-Year Average Change From Base Years '78-'79: 63%

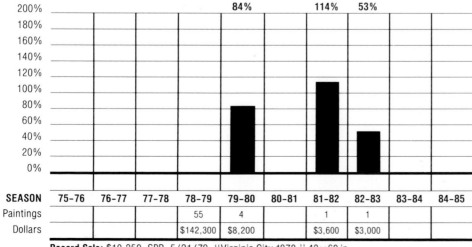

SEASON	75-76	76-77	77-78	78-79	79-80	80-81	81-82	82-83	83-84	84-85
Paintings				55	4		1	1		
Dollars				$142,300	$8,200		$3,600	$3,000		

Record Sale: $10,250, SPB, 5/21/79, "Virginia City 1878," 42 x 60 in.

JULIUS
BLOCH
(1888-1966)

A longtime admirer of Thomas Eakins's portraits, Julius Bloch became a social-realist painter of the working class. For nearly 20 years after leaving art school, he painted chiefly floral still lifes, but when the Depression developed he began to depict the misery and suffering around him with sympathetic honesty. He tried to imbue his subjects with human dignity, regardless of station or circumstances. In doing so, he was one of the first Americans to paint poor blacks with all the formality of expensive commissioned portraits.

Bloch was born in Kehl, Germany in 1888. His parents emigrated to the United States in 1893, and settled in Philadelphia. Despite their meager means, his parents, particularly his mother, encouraged Bloch when he decided to become a painter.

First at the School of Industrial Art and then at the Pennsylvania Academy of the Fine Arts, his talent for draftsmanship was particularly noticeable. At the time, Thomas Anshutz had replaced Eakins as instructor in life class at the latter institution and, although Bloch did not admire his academic elegance, he did profit from the fact that Anshutz placed the same emphasis on drawing as Eakins had.

Like many other artists and intellectuals in the 1920s, Bloch was drawn toward leftist politics and contributed to *New Masses,* the leading socialist publication. This, plus his own scanty finances, helped to spark his interest in the working class and poor people as subjects for his paintings.

When the Public Works of Art Project was started in the early 1930s, he was one of the first painters enrolled. His powerful study *Young Worker* (ca. 1934, Philadelphia Museum of Art) attracted the attention of Eleanor Roosevelt, thus giving his career a big boost.

By the end of the 1930s, Bloch had come under the patronage of two sympa-

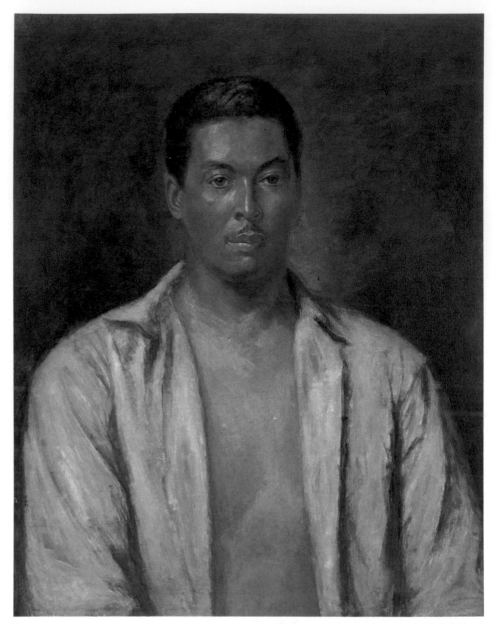

Bobby Fields, 1948, 28 x 22 in., signed u.l. Courtesy of La Salle University Art Museum, Philadelphia, Pennsylvania, Given by the executors of the estate of Julius Bloch.

thetic and generous sisters who built him a rural home and studio and provided him with a stipend. For the first time in his life, he had no financial worries and could paint whatever he wanted. Even so, he continued painting the poor most often.

In the early 1950s, he returned to Europe. The brilliant color and particularly the Byzantine mosaics he saw there changed the style of his work for the rest

of his life. In the last 10 years before his death in 1966, Bloch was recognized as a beloved figure in the Philadelphia art world, encouraging and sharing his knowledge of painting with countless students.

PUBLIC COLLECTIONS
Allentown Art Museum, Pennsylvania
Fleisher Art Memorial, Philadelphia
LaSalle College Art Museum, Philadelphia
Metropolitan Museum of Art, New York City
Pennsylvania Academy of the Fine Arts,
 Philadelphia
Philadelphia Museum of Art
Skillman Library, Easton, Pennsylvania
Whitney Museum of American Art,
 New York City
William Penn Memorial Museum, Harrisburg,
 Pennsylvania

(No sales information available.)

WILLIAM LESTER STEVENS
(1888-1969)

W. Lester Stevens was a New England artist and a member of the Boston School of artists. He earned many awards and memberships during his prolific career.

He was born in 1888 in Rockport, Massachusetts. His first art training was under Parker Perkins, who charged him 50 cents a lesson. Later, Stevens went on to study in a four-year program at the Museum of Fine Arts School in Boston, where he had a scholarship.

At the Museum of Fine Arts School, he was taught by Edmund C. Tarbell. Tarbell's students often painted in a strictly academic approach, in both technique and subject matter. Although Stevens was influenced by Tarbell, his wide range of brushstrokes and impressionistic style prevented him from being classified as a "Tarbellist," as most of Tarbell's followers were called.

Stevens and the Tarbellists were members of a group known today as the Boston School, noted for their traditional approach to art, as opposed to the rising trend of the time toward breaking tradition. Their subject matter was usually portraits, views of everyday life and landscapes.

The Boston School included such artists as William and Elizabeth Paxton, Sarah Sears, Charles Hopkinson, William James and Theodore Wendel, in addition to many other well-known artists of the time.

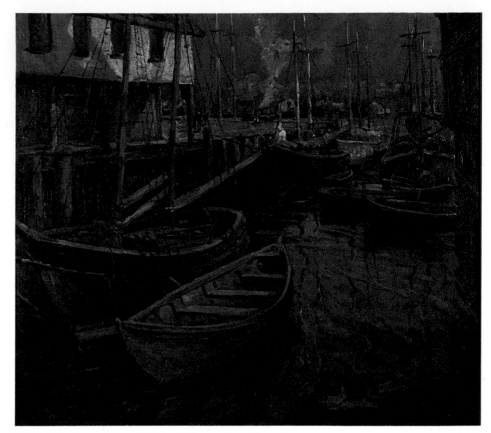

Untitled. Courtesy of Vose Galleries of Boston, Inc., Massachusetts.

Stevens's accomplishments included teaching at Princeton University and Boston University. By 1964, he had won more awards than any other living artist. Stevens died in Springfield, Massachusetts in 1969.

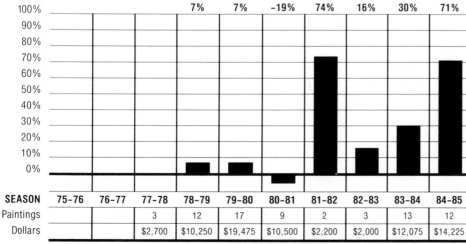

10-Year Average Change From Base Years '77-'78: 23%

			7%	7%	-19%	74%	16%	30%	71%	
SEASON	75-76	76-77	77-78	78-79	79-80	80-81	81-82	82-83	83-84	84-85
Paintings			3	12	17	9	2	3	13	12
Dollars			$2,700	$10,250	$19,475	$10,500	$2,200	$2,000	$12,075	$14,225

Record Sale: $4,500, CH, 1/29/80, "Moore's Corner, N. Leverett, Mass.," 16 × 20 in.

MEMBERSHIPS
American Watercolor Society
Baltimore Watercolor Club
Boston Art Club
Boston Paint and Clay Club
Boston Watercolor Club
Connecticut Academy of Fine Arts
Guild of Boston Artists
National Academy of Design
New Haven Paint and Clay Club
New York Watercolor Club
Rockport Art Association
Springfield Art League
Washington Landscape Club
Washington Watercolor Club

PUBLIC COLLECTIONS
Ashville Museum of Art, North Carolina
Hickory Museum of Art, North Carolina
J.B. Speed Museum of Art,
 Louisville, Kentucky
Museum of Art, Birmingham, Alabama
National Collection of Fine Arts,
 Washington, D.C.
Rochester Memorial Art Gallery, New York
Springfield Museum of Art, Massachusetts

HENRY VARNUM POOR
(1888-1970)

A multi-talented man of widespread interests, Henry Varnum Poor was active in the American art community for more than six decades. Never a darling of the avant-garde, he was nonetheless a respected American realist in the tradition of Thomas Eakins or Winslow Homer.

Poor was born in Kansas, but educated in California. He entered Stanford University in 1906 as an economics major, but halfway through college he changed his major to art. After graduation, he spent some time in Europe, studying for a time in London and Paris.

In 1919, Poor moved from San Francisco to Rockland County, New York, where he designed and built "Crow House," his home and studio, and began his first ventures into the applied arts. An exhibition of his pottery in 1921 was very well received, and projected him headlong into the lucrative design market. His handcrafted bathrooms were especially popular.

By 1929, Poor decided it was time to get back to his first love, painting, and sailed to France with his family. He spent months painting in a small village beside the Mediterranean Sea and in Paris. The exhibition of these paintings in a New York gallery in 1931 was a sensational success, and Poor was considered to be among America's top 10 painters.

In the field of murals, Poor was one of very few American artists working in

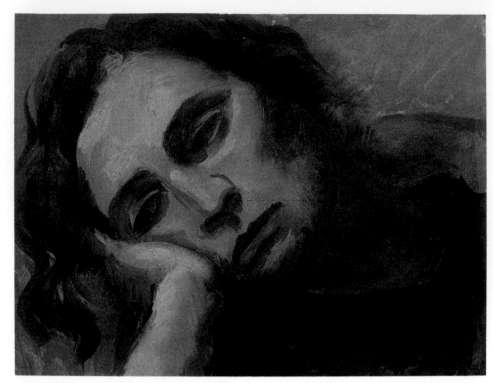

Bessie, 1939, 10¼ x 13¾ in., signed l.r. Courtesy of Collection The Whitney Museum of American Art, New York, New York, Purchase.

true fresco. Invited to take part in "Murals by American Painters and Photographers" at New York's Museum of Modern Art, he submitted a seven-by-four-foot panel titled *The Arts and Crafts.* From this came other major assignments: murals in the Department of Justice and Department of the Inte-

rior buildings, *The Land Grant Frescoes* for Pennsylvania State University, and *Kentucky,* a series of scenes in the lobby of the Courier-Journal Building in Louisville, Kentucky.

A founder and first president of the Skowhegan (Maine) School of Painting and Sculpture, Poor remained active in the community of American artists until his death at age 82 in 1970.

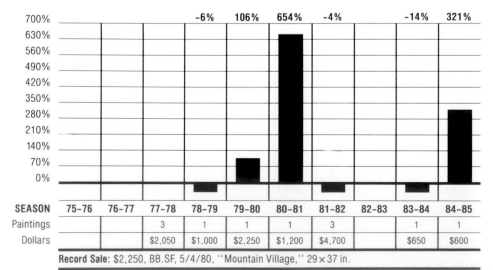

10-Year Average Change From Base Years '77-'78: 151%

	-6%	106%	654%	-4%		-14%	321%

SEASON	75-76	76-77	77-78	78-79	79-80	80-81	81-82	82-83	83-84	84-85
Paintings			3	1	1	1	3		1	1
Dollars			$2,050	$1,000	$2,250	$1,200	$4,700		$650	$600

Record Sale: $2,250, BB.SF, 5/4/80, "Mountain Village," 29 × 37 in.

JOHN EDWARD COSTIGAN
(1888-1972)

Called a pastoralist, John Costigan was a highly successful painter of everyday life on his farm in rural New York State. His paintings have a unity of subject matter, texture and emotional feeling, which invites the viewer to participate and learn.

Costigan was born in Providence, Rhode Island in 1888, of Irish descent.

He had a public-school education and at age 15 went to New York City. For 22 years he worked as a sketch artist for H. C. Miner Lithographing Company. He took up watercolor and oil painting on his own and was completely self-taught.

Like most artists, Costigan explored the galleries and museums, but in 1910 he moved to Orangeburg, New York, where he lived contentedly on his own wooded acres. Costigan died in 1972.

Costigan's pastoral scenes often reflect the joy of motherhood, the security of childhood, and rapport with animals and with nature. In *Early Morning in the Fields* (date and location unknown), a woman rests in a clearing holding her infant son high over her head affectionately, while lambs and goats surround her in peaceful acceptance. Many of Costigan's earliest paintings feature a woman—typically wearing a black blouse and long reddish skirt—walking in the woods with a flock of sheep.

Happiest when working in the woods, Costigan developed a highly individual way of painting the dappled confusion of leaves and branches, and used it most effectively in his backgrounds. He started as a palette-knife painter, but changed over to loading his brush with paint and using it to place short dabs of color on the canvas, creating a vibratory effect similar to that achieved by the impressionists. From a distance, all the variations of his surfaces blend into a smoothness.

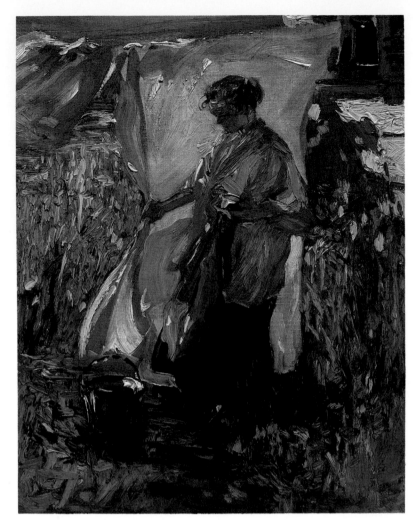

The Laundress, 24 x 20 in. Courtesy of Vose Galleries of Boston, Inc., Massachusetts.

MEMBERSHIPS
Allied Artists of America
American Watercolor Society
Guild of American Painters
Kit Kat Club
National Academy of Design
National Arts Club
New York Watercolor Club
Salmagundi Club
Society of American Etchers
Society of Animal Painters and Sculptors

PUBLIC COLLECTIONS
Art Institute of Chicago
Brooklyn Museum
Delgado Museum, New Orleans
Phillips Gallery, Washington, D.C.
Metropolitan Museum of Art, New York City
Montclair Museum, New Jersey
National Arts Club Collection
New York Public Library, New York City
Rhode Island School of Design, Providence

SEASON	75-76	76-77	77-78	78-79	79-80	80-81	81-82	82-83	83-84	84-85
Paintings			2	7	5	1	3	6	1	1
Dollars			$4,000	$6,850	$10,550	$1,200	$4,400	$6,050	$750	$3,500

Record Sale: $3,500, SPB, 5/22/80, "Bathers," 24 × 33 in.

JOSEF ALBERS
(1888-1976)

Josef Albers was one of the generation of European artists who fled Germany in the early days of Hitler and, through their work and teaching, helped to establish the United States as the center of modern art. His stark, geometric studies in color relationships ultimately gave rise in the 1960s to op and minimal art.

Albers was influential as a teacher as well as an artist. His lifelong interest was, in his own words, "making colors do something they don't do themselves." He worked in many media, but color was always the focus of his attention.

Born in Bottrop, Westphalia in 1888, Albers first studied at the Royal Art School in Berlin, and then at the School of Applied Art in Essen. At Essen he did his first work in lithography and woodcuts, influenced by the expressionists of the day.

After a year at the Art Academy in Munich, he moved to the Bauhaus in Weimar, where he studied from 1920 to 1923. He joined the Bauhaus faculty in 1923 and, with Moholy-Nagy, a geometric painter, took over teaching the basic art course.

Much of the research Albers did for his teaching proved to be seminal in developing ideas manifested in his early work in glass, and in the paintings of his mature years.

In his glass paintings of the 1920s one can see Albers's transition from freeform compositions to formal rectangular patterns, with the relationship of one color to another carefully planned. Using color overlays on opaque milk glass, he created what might be called glass-wall paintings.

When the Nazis closed the Bauhaus in 1933, Albers immigrated to the United States. For the next 16 years he headed the art department of Black Mountain College in North Carolina.

Like the European geometric abstractionists, primarily Mondrian and Malevich, Albers sought to strip the elements of abstract painting to their most fundamental form. In 1949, he began a series of paintings, known as "Homage to the Square," in which he systematically explored the relationship of color squares within color squares. This was among his most important work.

From 1950 to 1958, Albers was chairman of the department of design at Yale University, a position that drew even wider attention to his theories and experiments in color.

Albers's monumental book, *The Interaction of Color* (1963), summarized his artistic philosophy. Although retired, he continued working until his death in 1976.

Homage to the Square: Chosen, 1966, 48 x 48 in. Courtesy of Hirshhorn Museum and Sculpture Garden, Smithsonian Institution.

MEMBERSHIPS
American Abstract Artists
American Institute of Graphic Arts
National Institute of Arts and Letters
Print Council of America

PUBLIC COLLECTIONS
Corcoran Gallery of Art, Washington, D.C.
Detroit Institute of Art, Michigan
Kunstmuseum, Basel, Switzerland
Kunstmuseum, Zurich, Switzerland
Metropolitan Museum of Art, New York City
Museu de Arte Moderna, Rio de Janeiro, Brazil
Museum Folkwang, Essen, Germany
Museum of Modern Art, New York City
Smithsonian Institution, Washington, D.C.
Stedelijk Museum, Amsterdam, The Netherlands

SEASON	75-76	76-77	77-78	78-79	79-80	80-81	81-82	82-83	83-84	84-85
Paintings	7	15	15	9	10	15	14	7	15	13
Dollars	$68,550	$122,379	$198,210	$96,298	$161,994	$300,860	$140,933	$108,000	$199,270	$188,070

Record Sale: $52,000, SPB, 11/8/79, "Homage to the Square:Breathing," 48 × 48 in.

PAUL LAURITZ
(1889-1976)

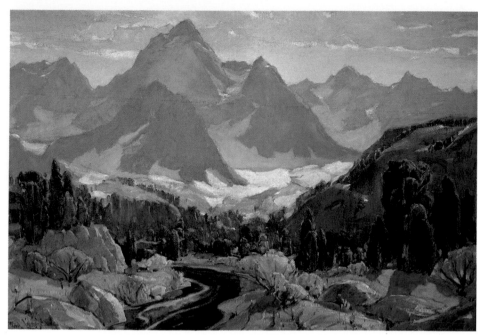

High Sierras, ca. 1925, 35 x 51 in., signed l.l. Courtesy of Petersen Galleries, Beverly Hills, California.

Paul Lauritz was one of Southern California's most popular landscape painters. Born in Lavrik, Norway in 1889, Lauritz struggled before he became successful.

As a young boy, he became interested in art by watching numerous painters working in the picturesque village where he grew up. He took lessons from a British watercolorist, and studied at the Lavrik Art School with Fritz Thoulou and Christian Krogh.

At age 16, Lauritz left Norway and went to his sister's house in Eastern Canada, where he worked as a miner. From there he traveled to Vancouver and began work as a commercial artist, making posters, decorations and promotional maps for the real-estate business. He next went to Portland, Oregon, where he continued in commercial art and also began to paint portraits and landscapes.

Lauritz was eager to devote himself fully to painting, and he decided to pursue a fortune in the Alaska gold rush. Although he lost his money in Alaska, Lauritz made a valuable contact with artist Sydney Laurence. The two artists had a joint show before Lauritz left Alaska.

In 1919, Lauritz moved to Los Angeles, where he resided until his death in 1976. He opened a studio and painted portraits and landscapes. Lauritz also taught at the Chouinard Art Institute and the Otis Institute. He became very active in the California art community.

Lauritz is primarily remembered as a landscape painter. He painted from life and was an expert at capturing natural light, color and atmosphere in his panoramic landscapes. He painted every aspect of nature, from deserts to mountains to ocean waves crashing against a rocky shore. He was particularly famous for his numerous views of California, Nevada and Mexico.

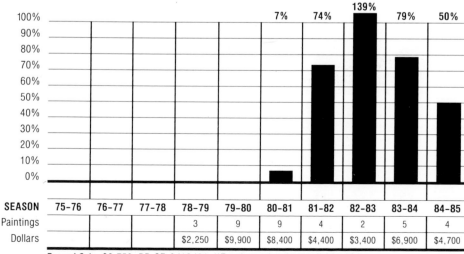

10-Year Average Change From Base Years '78-'79: 50%

SEASON	75-76	76-77	77-78	78-79	79-80	80-81	81-82	82-83	83-84	84-85
						7%	74%	139%	79%	50%
Paintings				3	9	9	4	2	5	4
Dollars				$2,250	$9,900	$8,400	$4,400	$3,400	$6,900	$4,700

Record Sale: $2,750, BB.SF, 2/16/84, "Eucalyptus Landscape," 28 × 32 in.

MEMBERSHIPS
California Art Club
Laguna Beach Art Association
Los Angeles Painters' and Sculptors' Club
Royal Society of Arts
Southland Art Association

PUBLIC COLLECTIONS
Laguna Beach Museum of Art, California
Pasadena Art Institute, California
San Diego Museum of Art, California

YASUO
KUNIYOSHI
(1889-1953)

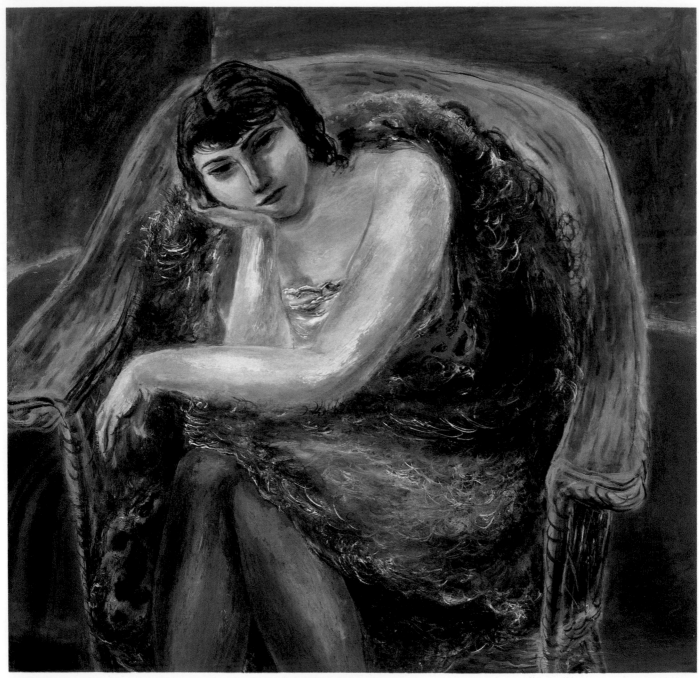

Girl in Fur Coat, 1930, 25 x 28 in., signed u.l. Private Collection, Photograph courtesy of
Kennedy Galleries, New York, New York.

Yasuo Kuniyoshi was an artist whose Eastern sensibility was influenced by Western and European sensuousness. Prohibited from becoming an American citizen, Kuniyoshi was nevertheless intensely loyal to his adopted country and became one of its most prominent artists.

Born in Okayama, Japan in 1889, Kuniyoshi left home to seek his fortune in America. He arrived on the West coast in 1906 and studied at the Los Angeles School of Art and Design from 1907 to 1910.

He continued his studies in New York City, first at the National Academy of Design with Robert Henri. He also studied with Homer Boss at the Independents School of Art, from 1914 to 1916, then with Kenneth Hayes Miller at the Art Students League, from 1916 to 1920.

In 1917, Kuniyoshi began exhibiting with the Society of Independent Artists and met Jules Pascin and Walt Kuhn, two important influences. He also found a patron, Hamilton Easter Field, who situated him in a summer studio in Ogunquit, Maine. Kuniyoshi began exhibiting regularly in 1921, and had his first one-man show in 1922 at the Daniel Gallery.

Kuniyoshi's paintings between 1921 and 1927 were humorous fantasies rendered with a deliberate primitivism. Favorite subjects were landscapes, cows, women and children, as in *Boy Stealing Fruit* (1923, Columbus Museum of Fine Arts). Kuniyoshi regarded these exaggerated, distorted figures as essentially "oriental in tradition."

He traveled to Europe in 1925 and 1928, and studied lithography in France. After 1927, his art departed from fantasy. Influenced by Pascin and Andre Derain, he turned toward a more representational approach.

His still lifes from this period featured unlikely groupings of objects. Even more notable were his nudes—moody, lyrical studies of women in moments of reflection or repose, such as *I'm Tired* (1938, Whitney Museum of American Art). Kuniyoshi visited Japan in 1931 and staged well-received one-man shows in Tokyo and Osaka. In 1935, he traveled to Mexico and Japan on a Guggenheim fellowship. He was involved in the government-sponsored New Deal art projects.

The Japanese militarism of the late 1930s and the outbreak of World War II affected Kuniyoshi deeply. Being Japanese, he was classified as an enemy alien, yet his loyalty was to the United States. His paintings progressively lost their delicacy; still lifes and women were superimposed over landscapes strewn with rubble, evoking a mood of desolation.

By 1947, Kuniyoshi's work returned to fantasy. Carnival themes, like those of Kuhn, were painted boldly in loud, bright colors. Typically, circus performers were depicted wearing strange, leering masks which suggested chaos and emotional turmoil.

Kuniyoshi, who had been an important member of the artists' colony in Woodstock, New York, died in New York City in 1953, the year Japanese aliens were permitted to become United States citizens.

MEMBERSHIPS
American Artists Congress
American Society of Painters, Sculptors,
 and Engravers
Artists Equity
Federal Arts Project
Hamilton Easter Field Foundation
National Institute of Arts and Letters
Salons of America
Woodstock Art Association

PUBLIC COLLECTIONS
Albright-Knox Art Gallery, Buffalo, New York
Art Institute of Chicago
Baltimore Museum of Art
Brooklyn Museum
Cincinnati Art Museum
Cleveland Museum of Art
Dallas Museum of Fine Arts
Delaware Art Center, Wilmington
Detroit Institute of Arts
Honolulu Academy of Arts
John Herron Art Institute, Indianapolis
Library of Congress, Washington, D.C.
Metropolitan Museum of Art, New York City
Museum of Fine Arts of Houston
Museum of Modern Art, New York City
National Museum of Modern Art, Tokyo
Newark Museum, New Jersey
Philadelphia Museum of Art
Phillips Collection, Washington, D.C.
Wadsworth Atheneum, Hartford, Connecticut
Whitney Museum of American Art,
 New York City

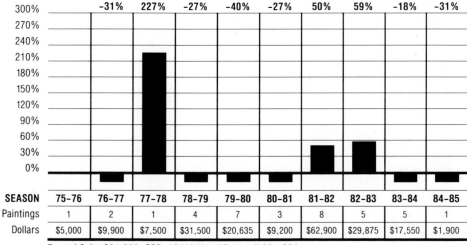

10-Year Average Change From Base Years '75-'76: 16%

	-31%	227%	-27%	-40%	-27%	50%	59%	-18%	-31%	
SEASON	75-76	76-77	77-78	78-79	79-80	80-81	81-82	82-83	83-84	84-85
Paintings	1	2	1	4	7	3	8	5	5	1
Dollars	$5,000	$9,900	$7,500	$31,500	$20,635	$9,200	$62,900	$29,875	$17,550	$1,900

Record Sale: $34,000, SPB, 12/10/81, "Dream," 30 × 20 in.

THOMAS HART BENTON

(1889-1975)

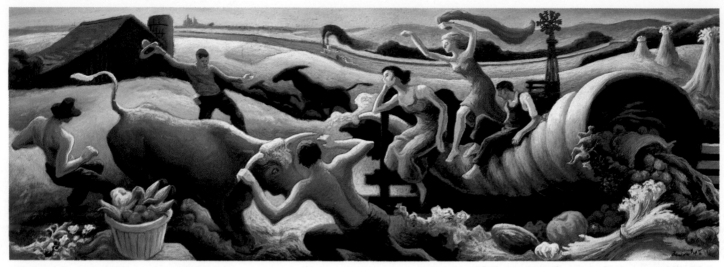

Achelous & Hercules, 1945, 11¼ x 32 in., signed l.r. Photograph courtesy of The Gerald Peters Gallery, Santa Fe, New Mexico.
©Estate of Thomas Benton/VAGA, New York 1985.

During the 1920s, when a number of artists had joined the ranks of the modernist movement, Thomas Hart Benton became one of the staunchest advocates of realism. He believed that the American people needed to be reminded of their strengths. The Great Depression emphasized the importance of his work, and a joint exhibition catapulted Benton, Grant Wood and John Steuart Curry to fame as regionalist painters in 1934.

Benton was born in 1889 in Neosho, Missouri. A great-uncle was the state's first illustrious senator; Benton's father, Maecenas, was a congressional representative. In Neosho, though Benton lived the life of a typical farm boy—enjoying hay rides, turkey shoots, hoedowns and possum hunts—the dinner-table talk was largely of politics. A love of and talent for rhetoric was instilled early and served Benton later in his attacks on the advocates of abstract art.

Benton attended art classes at the Corcoran Gallery of Art as a high-school student in Washington, D.C. Later, he studied at Western Military Academy and the Chicago Art Institute.

The siren call of Europe reached Benton, as well as many other artists of the day, and he sailed for Paris in 1908. He studied at the Academie Julien and the Academie Colarossi. While in Paris, he fell under the influence of Cezanne, Matisse, and the Cubists. He studied El

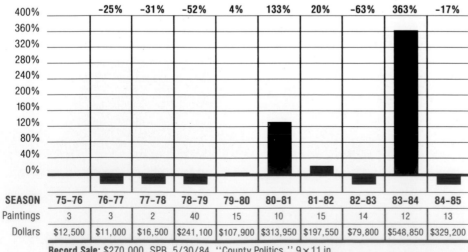

10-Year Average Change From Base Years '75–'76: 33%

	75–76	76–77	77–78	78–79	79–80	80–81	81–82	82–83	83–84	84–85
		−25%	−31%	−52%	4%	133%	20%	−63%	363%	−17%
SEASON	75–76	76–77	77–78	78–79	79–80	80–81	81–82	82–83	83–84	84–85
Paintings	3	3	2	40	15	10	15	14	12	13
Dollars	$12,500	$11,000	$16,500	$241,100	$107,900	$313,950	$197,550	$79,800	$548,850	$329,200

Record Sale: $270,000, SPB, 5/30/84, "County Politics," 9 × 11 in.

834

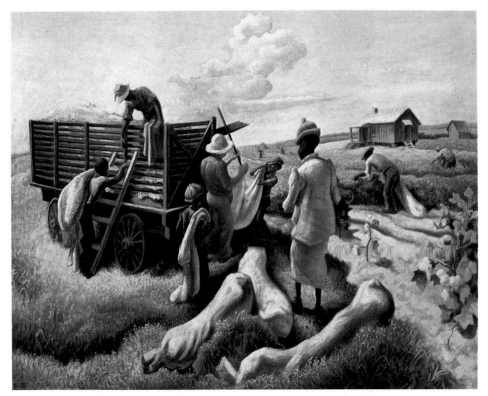

Weighing Cotton, 32 x 39½ in., signed l.l. Photograph courtesy of Hirschl & Adler Galleries, Inc., New York, New York. ©Estate of Thomas Benton/VAGA, New York 1985.

Greco and paintings of the Italian Renaissance, traces of the former appearing in his mature work as distortions of the human figure.

After meeting Stanton Macdonald-Wright, Benton began experimenting with a combination of synchromism and classic composition. His remark from this period is famous: "I wallowed in every cockeyed 'ism' that came along, and it took me 10 years to get all that modernist dirt out of my system." For a while Benton was a dedicated modernist, but in 1913 most of his early work was destroyed in a fire.

Benton was a gallery director and art teacher in New York City in 1917. From 1918 to 1919, he served in the navy. By 1918, while working as a draftsman at the naval base in Norfolk, Virginia, he was painting realistic small-town scenes.

As he developed his work in mural studies during the 1920s, his jerky-figured, long-limbed style emerged; it was meant to represent the mood and character of America at the time—changing and dynamic. It had a vaguely neo-impressionistic appearance, with many spots of color adding energy.

In 1926, Benton began teaching at the Art Students League, where he was a mentor for Mervin Jules and Daniel R.

Celentano. At this time he was working on his mural series, "American Historical Epic."

The term "Regionalist School" was first used when Benton exhibited with John Steuart Curry and Grant Wood in 1934. Benton had found his subject, portraying all the fears and hopes of middle-Western people.

The abstractionists Benton now dismissed as mere makers of geometric designs. His strident, inflexible attitude irritated many people. He leveled a typical diatribe at Alfred Stieglitz and his group of abstract artists, whom he called "...an intellectually diseased lot, victims of sickly rationalizations, psychic inversions, and God-awful self-cultivations."

In 1934, Benton returned to Missouri, where he served on the faculty of the Kansas City Art Institute and School of Design from 1935 to 1940. He produced much more work in the same regional genre throughout the rest of his career.

Benton died in Kansas City in 1975.

PUBLIC COLLECTIONS
Addison Gallery of American Art, Andover, Massachusetts
Brooklyn Museum
California Palace of the Legion of Honor, San Francisco
Canajoharie Library and Art Gallery, New York
City Art Museum, St. Louis
Joslyn Art Museum, Omaha, Nebraska
Metropolitan Museum of Art, New York City
Museum of Modern Art, New York City
Nelson Gallery of Art, Kansas City, Missouri
New Britain Museum of American Art, Connecticut
New School for Social Research, New York City
Pennsylvania Academy of the Fine Arts, Philadelphia
Sheldon Swope Art Gallery, Terre Haute, Indiana
University of Missouri, Columbia
University of Nebraska, Lincoln
Whitney Museum of American Art, New York City

ROBERT WOOD
(1889-1979)

A popular artist in the true sense of the word, Robert Wood painted realistic landscapes of familiar scenes all over the United States, many of them in national parks. He also painted in Mexico and Canada. His paintings often were reproduced lithographically and distributed in the millions by such mass merchandisers as Sears, Roebuck and Company and others in the form of prints, wall murals and even place mats. Using fine detail and rich colors, Wood presented America's natural beauty as people wanted to see it.

He was born in Kent, England in 1889, the son of a painter who was a successful home and church decorator. Although Wood disliked it at first, his father insisted on training him as a painter, keeping him inside in the afternoon instead of letting him out to play with other boys. In time he attended art school for seven years, winning a first or second prize each year.

In 1911, however, Wood and a friend sailed for New York and he never returned to England. Fascinated by the breadth and beauty of his newly adopted country, he traveled widely, often riding in freight cars when his funds were low. To get money he took odd jobs, whether it was work on a farm or hanging wallpaper for housewives. And all the time he kept sketching and painting what he saw.

A dealer bought out the entire contents of Wood's first exhibition and from then on his career was secure. He went to Carmel, California to paint the picturesque coastline and then moved south to Laguna Beach, where he became a leading figure in the growing art colony. Later he and his wife, also a painter, built a home and twin studios in the High Sierras and lived there until his death in 1979.

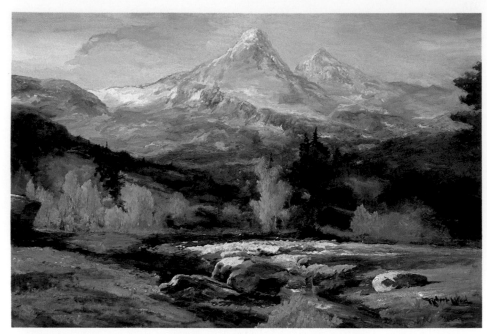

Teton Mountain Scene, 24 x 36 in., signed l.r. Courtesy of Country Store Gallery, Inc., Austin, Texas.

Wood was a prolific painter, but, even so, it was hard for him to keep up with demand for his work. The notoriety that he achieved through the mass reproduction of his landscapes constantly increased the market for his original paintings. Promotional literature for his work states that more of his paintings have been reproduced than those of any other painter, living or dead.

SEASON	75–76	76–77	77–78	78–79	79–80	80–81	81–82	82–83	83–84	84–85
Paintings	2	3	1	6	14	16	16	7	2	5
Dollars	$8,750	$6,950	$3,100	$17,750	$48,050	$61,200	$75,350	$32,100	$1,350	$13,400

Record Sale: $10,000, SPB, 2/13/82, "Desert Cactus," 24 × 59 in.

KENNETH R. NUNAMAKER
(1890-1957)

Kenneth R. Nunamaker was a noted landscape painter who depicted the rustic scenery of Pennsylvania's Delaware River Valley in varying weather and atmospheric conditions. Together with Edward Willis Redfield and Daniel Garber, he was part of the New Hope School of American impressionism.

Born in Akron, Ohio in 1890, Nunamaker worked in the art department of the Akron Engraving Company until 1918. Although he had no formal art training, he devoted himself to the study of nature through direct observation, carrying his easel and canvases outdoors to paint.

He exhibited in several galleries in Ohio before moving to the Philadelphia area in 1918, to work as art director for Hoedt Studios. In 1945, he opened his own graphic design studio in the Beury Building in Philadelphia.

Attracted by the region's unspoiled, bucolic landscape, Nunamaker moved to Center Bridge, near New Hope, Pennsylvania in 1923. He remodeled his century-old home to suit his needs as a landscapist, installing large studio windows which afforded a panoramic view of the surrounding wooded countryside. He lived and painted here until his death in 1957.

Nunamaker soon came to know Edward Willis Redfield, leader of the New Hope Landscape School and his neighbor at Center Bridge. Redfield admired Nunamaker's artistic talent, and assumed the role of unofficial art instructor. Through him, Nunamaker met other artists living in the New Hope area, including Daniel Garber, whom he resembled in his use of pastel hues and muted tonalities. He began exhibiting with these artists at New Hope's Phillips Mill, a gallery which also served as a forum for the group's discussions of aesthetic principles.

Nunamaker excelled in capturing varying weather conditions and seasonal

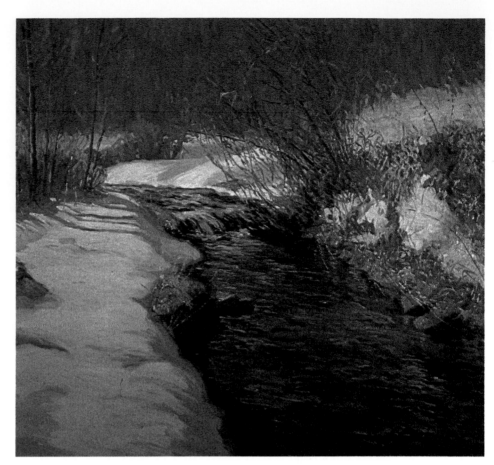

Brook in Winter, 44 x 50 in., signed l.r. Courtesy of Newman Galleries, Philadelphia, Pennsylvania.

changes. He was particularly adept at painting winter scenes, when ice floes spanned the Delaware River and woodlands and creeks were snowbound.

While his impressionistic style is close to Redfield's, Nunamaker's paint surfaces are composed of finer brushstrokes, and his colors are delicately blended. More than any of the other Pennsylvania landscape painters, Nunamaker was able to capture the subtlest atmospheric changes of the region.

Nunamaker exhibited in many major solo and group shows at the Pennsylvania Academy of Fine Arts, Philadelphia; the Phillips Mill Art Association, New Hope; the Corcoran Gallery of Art, Washington, D.C.; the Salmagundi Club and the National Academy of Design, New York; and the International Gallery, Venice, Italy.

(No sales information available.)

JAN
MATLUKA
(1890-1972)

Cityscape, 40⅛ x 32⅛ in., signed l.r. Photograph courtesy of Hirschl & Adler Galleries, Inc., New York, New York.

Jan Matluka's paintings—ranging from the traditional to the abstract—are a measure of the dynamism of American art during the 1920s and the 1930s. Additionally, through his teaching, Matluka was able to interpret this artistic evolution for many of the aspiring artists of the time.

Born in 1890 in Bohemia, Matluka studied art for two years in Prague before coming to the United States with his family in 1907. Shortly after settling in the Bronx, Matluka's parents separated, leaving the young artist and his siblings to be raised by their mother. The family faced financial difficulties.

Matluka attended the National Academy of Design from 1908 to 1917. There he won several awards, and in 1917 he became the first recipient of the Joseph Pulitzer traveling scholarship. This award gave Matluka his first financial independence and enabled him to travel to the Southwest and to Florida.

When he returned to New York City a year later, Matluka's paintings showed a marked change. As seen in his *Indian Dancers* (1917 to 1918, The Anschutz Collection, Denver) a more abstract style had replaced his earlier realism.

Still more artistic change would come for Matluka after his first trip to Paris in 1919. Exposure to cubism would directly affect his work at the time, and the cubist influence can be felt in virtually all of Matluka's subsequent works.

Matluka had his first one-man exhibit in New York City in 1925. His paintings included early watercolors (Matluka almost never dated his works) and cubist-inspired cityscape lithographs.

During this period, Matluka became interested in politics, and he began doing illustrations for *New Masses,* a magazine oriented to the communist experiment. These drawings, often focusing on the plight of the working class, expressed the satiric side of the artist's personality.

From 1929 to 1931, Matluka was an instructor at the Art Students League.

His teachings about abstract art and newly emergent artistic styles inspired a nucleus of later-popular artists, including David Smith, Dorothy Dehner, George McNeil and I. Rice Pereira.

In the late 1930s, Matluka painted abstract murals for the WPA Federal Art Project. As exemplified by his *Still Life Composition* (ca. 1934, National Museum of American Art), his paintings during that decade were often still lifes of enigmatically linked objects, seemingly evocative of the artist's private symbolism.

He continued to paint until his death in New York City in 1972.

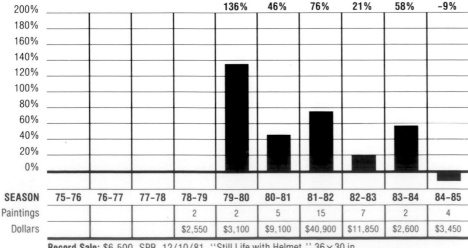

10-Year Average Change From Base Years '78-'79: 47%

	75-76	76-77	77-78	78-79	79-80	80-81	81-82	82-83	83-84	84-85
					136%	46%	76%	21%	58%	-9%
SEASON	75-76	76-77	77-78	78-79	79-80	80-81	81-82	82-83	83-84	84-85
Paintings				2	2	5	15	7	2	4
Dollars				$2,550	$3,100	$9,100	$40,900	$11,850	$2,600	$3,450

Record Sale: $6,500, SPB, 12/10/81, "Still Life with Helmet," 36 × 30 in.

PUBLIC COLLECTIONS
Art Institute of Chicago
Brooklyn Museum
Cincinnati Art Museum
Delaware Art Museum, Wilmington
Detroit Institute of Arts
Fine Arts Museum of San Francisco
Hirshhorn Museum and Sculpture Garden, Washington, D.C.
Metropolitan Museum of Art, New York City
National Museum of American Art, Washington, D.C.
Pennsylvania Academy of the Fine Arts, Philadelphia
Solomon R. Guggenheim Museum, New York City
Whitney Museum of American Art, New York City

STANTON MacDONALD-WRIGHT
(1890-1973)

A major figure among pure abstract painters in the early modernist movement, Stanton MacDonald-Wright was a co-developer of synchromism, a colorist art theory.

For six years after he and artist Morgan Russell propounded synchromism in 1913, Wright explored the propositions that color alone determines form and content and that the use of color is governed by natural laws that have endowed each color with its own character and emotional quality.

By 1920, Wright was dissatisfied with the formal limitations of synchromism. He undertook more than 30 years of experimentation, finally returning to pure abstraction in the mid-1950s.

Born in 1890 in Charlottesville, Virginia, Wright moved with his family to Santa Monica, California in 1900. He ran away to sea in 1904, landing in Honolulu. In 1905, at age 15, he enrolled in the Art Students League in Los Angeles. In 1907, he went to Paris, where he studied briefly at the Colarossi and Julien academies.

By 1910, Wright was interested in scientific color theory. In 1912, a year after he met Russell, Wright exhibited pure-color paintings of abstracted figures at the Salon des Independents. Their undulant design and their receding and advancing visual effects are recurring elements in Wright's work.

In Wright's early synchromist paintings, figures and objects disappeared. But by 1916, figures—and later landscapes and still lifes—were reintroduced.

Wright returned to Los Angeles in 1919, where he taught, worked in many media and became an avant-garde artistic leader. His color abstractions of the 1920s are in an increasingly varied palette, some showing oriental influence. He also produced the first full-length stop-motion film in color, preparing 500 pastel pictures for it, and designed synchromatic theater sets.

From 1922 to 1930, Wright was director of the Los Angeles Art Students League. He was the Southern California WPA director from 1935 to 1937. He taught art history at the University of California in Los Angeles from 1942 to 1954.

In Wright's work from the mid-1950s, his early high-pitched impulsiveness has been replaced by a rich gamut of colors and mature, elegant harmony.

Conception Synchromy, 1914, 36 x 30⅛ in., signed l.r. Courtesy of Hirshhorn Museum and Sculpture Garden, Smithsonian Institution, Washington, D.C.

PUBLIC COLLECTIONS
Art Institute of Chicago
Brooklyn Museum, New York
Carnegie Institute, Pittsburgh
Corcoran Gallery of Art, Washington, D.C.
Detroit Institute of Arts
Metropolitan Museum of Art, New York City
Museum of Fine Arts, Boston
Museum of Modern Art, New York City
Philadelphia Museum of Art
Walker Art Center, Minneapolis
Whitney Museum of American Art, New York City

SEASON	75-76	76-77	77-78	78-79	79-80	80-81	81-82	82-83	83-84	84-85
Paintings	2		2	2	4	4	2		2	
Dollars	$28,200		$9,500	$7,800	$17,750	$11,100	$21,000		$14,400	

Record Sale: $25,000, SPB, 10/20/75, "Synchrony Blue and Green," 36 × 27 in.

MARK TOBEY
(1890-1976)

Although he was not immediately recognized, Mark Tobey was the pioneer in blending elements of occidental and oriental art in his low-key, mystical, calligraphic paintings, which he termed "white writing." For all their quiet unpretentiousness, his works had an impact on much of what followed in modern American art—in particular, the explosive energy of abstract expressionism.

Tobey was born in Centerville, Wisconsin in 1890. As a young man he went to Chicago and worked as an illustrator by day, attending the Chicago Art Institute by night. In 1911, he moved to New York's Greenwich Village and took up portrait painting. He gave it up after a time, however, and instead turned to decorating lamps and screens.

A key event in Tobey's life was his conversion in 1918 to the Baha'i World Faith. This, along with his later study of Zen Buddhism, formed the philosophical basis for most of his work.

In 1923, he went to Seattle to teach art and continued painting in his early, semi-realistic style. Although he was a restless traveler for most of his life, Seattle became his home. It was there that he was first exposed to the elegant grace of oriental calligraphy.

From 1931 to 1938, while artist-in-residence at Dartington Hall, a progressive school in England, he met such intellectual leaders as Aldous Huxley and Rabindranath Tagore, the Indian mystic. In 1934, he went to the Far East, first studying brush-painting in Shanghai and then going on to Japan. A month-long stay in a Zen Buddhist monastery, meditating and studying calligraphy, proved to be the turning point in his artistic thinking.

He came home convinced that "we have to know both worlds, the Western and the oriental." To build a bridge between the two, he developed his white

New York, 1944, 33 x 21 in., signed l.r. Courtesy of National Gallery of Art, Washington, D.C. Gift of the Avalon Foundation.

writing—calligraphy that looped skeins of light paint against a dark field, with lines that formed neither letters nor recognizable subjects, yet filled the space with a sense of movement and depth. Like the surrealists, he tried to "penetrate the mind and clear away all rational processes in an effort to get at the inner recesses of experience."

Despite the fact that he disliked cities, it was the urban congestion of New York City that Tobey interpreted in his earliest white-writing compositions. In *Broadway* (1935, Museum of Modern Art), for example, he attempted to compress the motion, cars, people and excitement of the area into a relatively small, densely linear canvas.

Once Tobey had found his artistic mode of expression, he never wavered from it. Although many thought him isolated from the mainstream of American art, he was not, and in his later years his influence became more and more apparent. In 1960, he moved to Basel, Switzerland, living and painting there until his death in 1976.

MEMBERSHIPS
National Institute of Arts and Letters

PUBLIC COLLECTIONS
Albright-Knox Art Gallery, Buffalo, New York
Art Institute of Chicago
Brooklyn Museum
Detroit Institute of Arts
Metropolitan Museum of Art, New York City
Museum of Fine Arts, Boston
Museum of Modern Art, New York City
Phillips Collection, Washington, D.C.
San Francisco Museum of Art
Whitney Museum of American Art,
 New York City

SEASON	75-76	76-77	77-78	78-79	79-80	80-81	81-82	82-83	83-84	84-85
Paintings	3	7	4	11	17	16	10	8	26	20
Dollars	$55,050	$52,448	$21,916	$35,729	$32,576	$133,913	$32,632	$14,576	$87,903	$53,084

Record Sale: $41,000, SPB, 11/13/80, "Capricorn," 34 × 23 in.

MAN RAY
(1890-1977)

A.D., 1914, 29½ x 37 in., signed l.r. Philadelphia Museum of Art, Pennsylvania, A.E. Gallatin Collection. ©ADAGP, Paris/VAGA, New York, 1985.

Although he had brief periods of conventional art training, Man Ray threw it aside to become one of the foremost painters of the dada and surrealist movements.

He explored new concepts that mocked the tenets of academic art. He produced collages and assemblages which combined totally incongruous elements; in flights of pure sardonic fantasy, he was a master of experimental photography; he produced surrealist films. And, with it all, he created some of the most remarkably sophisticated work ever done by an American artist.

Ray was born Emmanuel Radensky in Philadelphia in 1890. He shortened his name to Man Ray when he became an artist.

Moving to New York City at age 18, he enrolled for a short time at the National Academy of Design to study architecture, engineering and art. While working as an architectural draftsman, he learned the technique of airbrushing, which he later incorporated into his work. He spent short times at two other art schools as well, but essentially he was self-taught.

By 1911, Ray had become enamored of avant-garde art, and he created his first truly non-objective work, a collage of rectangles of cloth. During this period he investigated cubism and expressionism and, after the New York City Armory Show of 1913, briefly explored fauvism.

In 1915, however, he reached a real turning point. He met Marcel Duchamp, one of the high priests of dadaism, who with Francis Picabia had fled the insanity of World War I. The two were in nihilistic revolt against everything the traditional world stood for. To them, the world was a bad joke.

In 1921, Ray moved to Paris, which was to become his spiritual home. While his dadaist style was never actually interrupted, more of his work in the 1920s was in the surrealist vein than at any other time. He exhibited regularly with the surrealists.

The 1920s also marked the period of his greatest activity as a filmmaker and highly inventive professional photographer. In 1921, quite by accident, he produced the first of his "Rayographs," photographs made by placing random objects on photographic paper and exposing it to light. The unpredictable, ghost-like images, floating on black backgrounds, appealed to the surrealist in Ray.

When the Germans overran France in 1940, Ray came back to the United States. He lived in Hollywood until 1952, then returned to Paris. He continued to create tongue-in-cheek assemblages of bizarre elements until his death there in 1977.

MEMBERSHIPS
Societe Anonyme

PUBLIC COLLECTIONS
Museum Boymans-Van Beuningen, Rotterdam
Museum of Modern Art, New York City
Philadelphia Museum of Art
Whitney Museum of American Art,
 New York City
Yale University

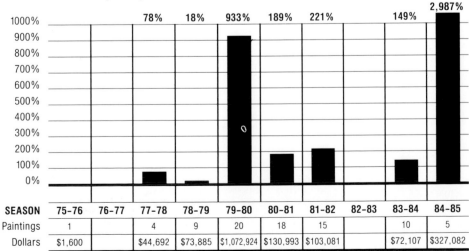

10-Year Average Change From Base Years '75-'76: 572%

SEASON	75-76	76-77	77-78	78-79	79-80	80-81	81-82	82-83	83-84	84-85
			78%	18%	933%	189%	221%		149%	2,987%
Paintings	1		4	9	20	18	15		10	5
Dollars	$1,600		$44,692	$73,885	$1,072,924	$130,993	$103,081		$72,107	$327,082

Record Sale: $750,000, SPB, 11/5/79, "A l'Heure de l'Observatoire: les Amvureux," 39×98 in.

841

PRESTON DICKINSON
(1891-1930)

Born in New York City in 1891, Preston Dickinson had a career which moved forward continuously, but with several changes in direction.

As a youngster, he studied at the Art Students League with Ernest Lawson, after which he spent five years in Europe. He considered his European experience to be his real education. He was affected by the Parisian cubists and the modernists, especially Cezanne. He developed a cubist style, modified by the Cezanne influence and a newly acquired knowledge of oriental art.

The cubist style prevailed in Dickinson's works after his return to New York City. He was one of the early American explorers of the industrial landscape, applying the cubist idea of sharply-faceted forms.

The radical interpretations he applied to the natural and industrial landscapes shortly after his return were later modified. At times he painted near-abstract and fragmented scenes, along with a simplified realism. A Chinese influence entered, with calligraphic draftsmanship and transparent tones. His work was never routine, and was often enhanced by attractive eccentricity.

Around 1922, Dickinson turned to still lifes, painting the customary fruit, flowers, glassware and crockery. Man-made items fascinated him most; he enjoyed the sharp lines of vases and glassware. Variations of reflected and refracted light interested him, and strongly manipulated tonal and light-

The Absinthe Drinker, ca. 1921, 10¾ x 11½ in. Courtesy of Kennedy Galleries, New York, New York.

versus-dark patterns frequently appear in his work of the 1920s, as do the geometric patterning of napkins, tablecloths and wall hangings.

Instead of the smooth, unmodulated surfaces usually associated with this style, graduated tones and brush strokes are present in Dickinson's work.

Dickinson was just reaching full maturity in the plastic use of color when his untimely death occurred in Spain in 1930. His paintings are in many museums and private collections.

PUBLIC COLLECTIONS
Albright-Knox Art Gallery, Buffalo
Brooklyn Museum
Cleveland Museum of Art
Fogg Museum, Cambridge, Massachusetts
Phillips Collection, Washington, D.C.

10-Year Average Change From Base Years '76–'77: 170%

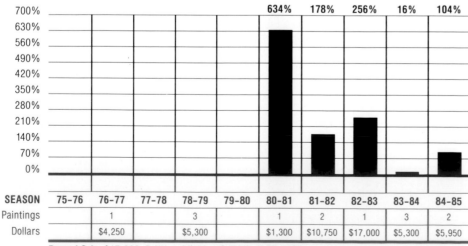

SEASON	75-76	76-77	77-78	78-79	79-80	80-81	81-82	82-83	83-84	84-85
						634%	178%	256%	16%	104%
Paintings		1		3		1	2	1	3	2
Dollars		$4,250		$5,300		$1,300	$10,750	$17,000	$5,300	$5,950

Record Sale: $17,000, D.NY, 4/20/83, "Still Life," 30 x 18 in.

GEORGE AULT
(1891-1948)

The work of George Ault, a painter and lithographer born in Cleveland, Ohio in 1891, shows a marked metamorphosis. The majority of his paintings are in the precisionist mode, although these crisply rendered scenes are imbued with a mysterious and romantic feeling. In his last years, Ault found outlet for his poetic vision in a personal form of surrealism.

Ault was educated in London, where his family moved in 1899. There, he studied at the Slade School of Fine Arts of the University College, and at St. John's Wood Art School. Frequent trips to France introduced him to the advanced art movements of the time. Upon his return to the United States in 1911, Ault lived for a time in New York City before settling in Woodstock, New York in 1937. He also spent many summers in Provincetown, Massachusetts.

Ault experimented with many modern styles, including a thickly brushed style similar to late neo-impressionism. His mature style had evolved into precisionism by the early 1920s, when he became one of the first American artists to paint machines and machine parts.

The buildings of New York City also proved to be rich subject matter for Ault's paintings. His buildings have a primitive, brutish power, even though they appear to be constructed of building blocks.

At times, Ault simplified his images, accentuating the abstract design by eliminating architectural details such as windows. He favored a muted palette of black, gray, green and brown, acutely contrasted with light accents. He used a very precise line, and applied paint to appear smooth and almost textureless.

Ault liked to paint at night, realizing that darkness, illuminated by only the moon or an electric light, simplified contours, such as in *Sullivan Street Abstraction* (1928, Zabriskie Gallery). He occasionally added a touch of the

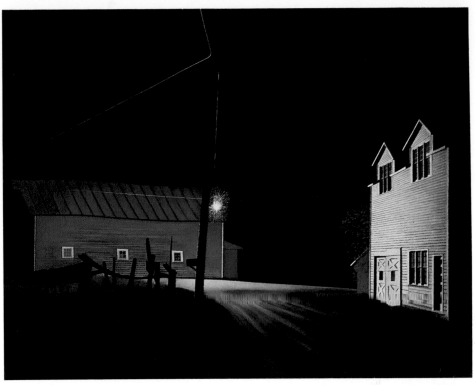

Bright Light at Russell's Corners, 1946, 20 x 25 in. Courtesy of National Museum of American Art, Smithsonian Institution, Gift of Mr. and Mrs. Sidney Lawrence.

romantic to his paintings—by placing a lone figure on a rooftop, for example. His many nocturnes best reflect this feeling, with glimmering night skies and dramatic lighting turning ordinary architectural themes into shadowy, mysterious vignettes.

Yet the work Ault painted at Provincetown often had a light and almost carefree feeling. Flattened forms give these paintings a tapestry-like quality, while non-geometric forms of sailboats or clouds add a picturesque touch.

From 1935 on, Ault showed a keen interest in surrealism. His work of the late 1930s shows a loosening of the tight constraints of precisionism, such as in *Woodstock Landscape* (1938, Brooklyn Museum).

By 1944, Ault felt that he had taken his romanticized precisionism as far as

he could go. From that point until his death in 1948, he experimented with surrealism.

He began painting abstract forms suggested by shadows and other natural effects. He continued to use the smooth, finely rendered technique of his precisionist days, but his subject matter became increasingly idiosyncratic—airless landscapes inhabited by vague geometric shapes, stylized structures, and levitating lines or small flags.

MEMBERSHIPS
Salons of America
Societe Anonyme
Society of Independent Artists

PUBLIC COLLECTIONS
Brooklyn Museum
California Palace of the Legion of Honor, San Francisco
Cleveland Museum of Art
Los Angeles County Museum of Art
Metropolitan Museum of Art, New York City
Museum of Modern Art, New York City
Newark Museum, New Jersey
Pennsylvania Academy of the Fine Arts, Philadelphia
Philadelphia Museum of Art
Whitney Museum of American Art, New York City

SEASON	75-76	76-77	77-78	78-79	79-80	80-81	81-82	82-83	83-84	84-85
Paintings	1			6	1	2	1	1	2	1
Dollars	$2,500			$6,800	$400	$1,800	$850	$2,600	$3,100	$6,000

Record Sale: $6,000, CH, 12/7/84, "New England Landscape," 12 × 16 in.

KARL KNATHS
(1891-1971)

Karl Knaths was one of the few American artists to develop an authentically independent interpretation of cubist design principles.

Born in Eau Claire, Wisconsin in 1891, Knaths spent his early life in the Midwest. Chicago, in particular, provided cultural stimulation for the young artist. Knaths became acquainted with the new modernist works from Paris when he saw the Chicago exhibit of the famed Armory Show in 1913. He gained his formal art training at the Art Institute of Chicago from 1912 to 1916.

Knaths moved to the East coast in 1919, and eventually settled in Provincetown, Massachusetts.

Knaths was profoundly influenced by cubism. By the late 1920s, he had evolved a personal version of the cubist idiom. His designs of varying complexity and texture were typically derived from such subjects as still lifes and seascapes.

Beginning about 1930, he used the Wilhelm Ostwald color theory and systematically selected colors for his palette before beginning the picture. Knaths held that colors, like music, could be organized according to a system of notes. Also, the artist developed a method of color notation.

Provincetown and its environs provided inspiration for works such as *Duck Flight* (1948, Whitney Museum of American Art). The artist's concern for pattern and design is apparent in *Horse*

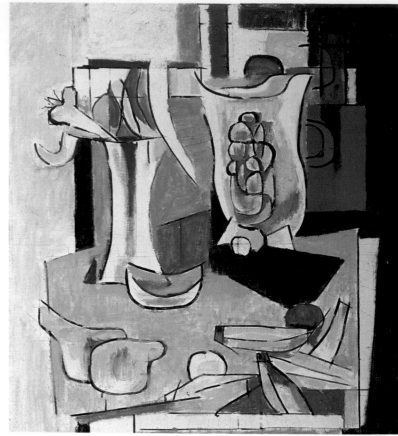

Clock and Crock, 1966, 42 x 30 in., signed l.r. Collection of Mr. Richard Weinberg, Photograph courtesy of Kennedy Galleries, New York, New York.

Mackerel (date and location unknown): a translucent form resembling a giant fish is discernible against a glistening ocean. Waves create a pattern that appear to be scales, suggesting that the entire composition might be a reflection in the flank of an even larger fish. The painting *Indian Blanket* (date and location unknown) is another example of his mature cubist style.

As his art developed, Knaths became an original exhibitor with the American Abstract Artists group in 1936. In addition to painting, the artist maintained several important teaching positions. From 1937 to 1950, he taught an annual six-week course at the Phillips Collection in Washington, D.C. He also instructed at Bennington College, Vermont, and American University, Washington, D.C.

Knaths remained in Provincetown throughout his life and died there in 1971.

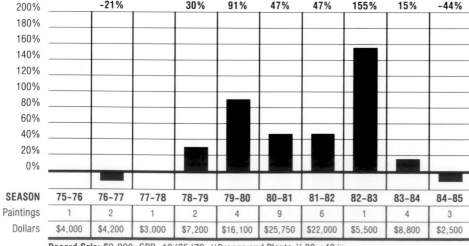

10-Year Average Change From Base Years '75-'76: 32%

	-21%		30%	91%	47%	47%	155%	15%	-44%

SEASON	75-76	76-77	77-78	78-79	79-80	80-81	81-82	82-83	83-84	84-85
Paintings	1	2	1	2	4	9	6	1	4	3
Dollars	$4,000	$4,200	$3,000	$7,200	$16,100	$25,750	$22,000	$5,500	$8,800	$2,500

Record Sale: $9,000, SPB, 10/25/79, "Drapes and Plants," 30 x 42 in.

PUBLIC COLLECTIONS
Albright-Knox Art Gallery, Buffalo
Art Institute of Chicago
Brooklyn Museum
Corcoran Gallery of Art, Washington, D.C.
Delaware Art Museum, Wilmington
Los Angeles County Museum of Art
Metropolitan Museum of Art, New York City
Pennsylvania Academy of the Fine Arts, Philadelphia
Philadelphia Museum of Art
Phillips Collection, Washington, D.C.
Wadsworth Atheneum, Hartford, Connecticut
Walker Art Center, Minneapolis
Whitney Museum of American Art, New York City

ALMA W. THOMAS
(1891-1978)

Although she was always interested in the arts and, in fact, transmitted her love of them to countless children during her years as a high-school art teacher, it was not until she was in her sixties and retired that Alma W. Thomas became a serious, full-time painter. Her early work was representational, but it became more abstract. Influenced by the Washington Color School of painters, many of whom she knew well, her later paintings were exuberant patterns of vibrant color that symbolized her fascination with the world around her.

Thomas was born in Columbia, Georgia in 1891. Her earliest memories were of the beauty of her childhood home and the loving warmth of a large family, most of whose female members, including her mother, were teachers. She was black, however, and educational opportunities were limited in Georgia at that time. Because of this and because of race riots in Atlanta in 1906, her family moved to Washington, D.C. They bought a comfortable house in a pleasant residential section of the city which was to be Thomas's home for the rest of her life.

She studied kindergarten instruction and then taught arts and crafts to children at a settlement house in Wilmington, Delaware. Returning to Washington in 1921, she enrolled as a costume-design major at Howard University, but a professor, who later became a major influence on her career, persuaded her to become the first student in a new fine arts curriculum.

After graduation from Howard, Thomas became an art teacher at Shaw Junior High School in Washington, remaining there until her retirement in 1959. For years her creativity was channeled into classes in arts and crafts, modeling and marionette plays. To gain a graduate degree that would encompass all these interests, she went to New York

Light Blue Nursery, 1968, 50 x 48 in., signed l.r. Courtesy of National Museum of American Art, Smithsonian Institution, Gift of Alma W. Thomas.

City in the summer to study at Columbia's Teachers College.

Her stays in New York City opened her eyes to avant-garde art. As a result she helped to found and support the Barnett-Alden Gallery in Washington, which showed the work of important young contemporary painters. This exposure helped her to find her own visual language when she turned to serious painting.

Ten years before her retirement, Thomas enrolled at American University to study painting and art history. Color dominated her work.

Often she would do 20 watercolors before beginning one of her large acrylic paintings. Her inspiration came from

everywhere—memories of the gardens of her youth, Washington's flower beds in spring and even the United States space program. In time she incorporated her own language of pictographs into her lavishly colored work.

Even when plagued by arthritis in her later years, Thomas continued to work. Although many of her paintings were large, she never had proper studio space in which to work on them. Instead, using her kitchen or living room, she would prop a canvas on her lap and turn it to reach unpainted areas.

Illness interrupted her work frequently during her final year, but she was able to be honored by President Jimmy Carter at the White House only eight months before her death in 1978.

PUBLIC COLLECTIONS
Hirshhorn Museum and Sculpture Garden, Washington, D.C.
Metropolitan Museum of Art, New York City
National Museum of American Art, Washington, D.C.

GRANT WOOD
(1892-1942)

Grant Wood was known as a painter of the American scene because of his middle-Western subject matter, painted in a deliberately primitive style. Although, like others of the Regionalist School, he depicted simple Americans placed in realistic rural settings, Wood's work stands apart. Its insight and wry wit brought both smiles and anger.

Born in Anamosa, Iowa in 1892, Wood first studied under Ernest Batchelder at the Minneapolis Handcraft Guild during the summers of 1910 and 1911. He briefly studied at Iowa State University and at the Art Institute of Chicago before entering the army in 1918. After World War I, he traveled abroad. In Paris, he studied at the Academie Julien in 1923.

When he returned to Iowa, Wood taught art in a Cedar Rapids school. He received his first major commission in 1927, for a stained-glass window for the Cedar Rapids Memorial Building. But Wood ran afoul of the Daughters of the American Revolution by producing the window in Munich, Germany. He added to the controversy by painting the satirical *Daughters of Revolution* (1932, Cincinnati Museum of Art).

It was *American Gothic* (1930, Art Institute of Chicago), another witty view of mid-Westerners (for which his sister and his dentist posed) that brought national acclaim. He was regarded on a national level as a chauvinistic exponent

Black Barn, 1929, 9 x 13 in., signed l.l. Photograph courtesy of The Gerald Peters Gallery, Santa Fe, New Mexico.

of Americana, but in Iowa he was considered a political and social radical.

Another irony is that Wood's "American" style was heavily influenced by Chinese art and by sixteenth-century Flemish painting. In *Midnight Ride of Paul Revere* (1931, Metropolitan Museum of Art), Wood painted clumps of rounded hills covered with bulbous bushes and trees reminiscent of a Chinese-inspired china pattern called Blue Willow.

After the trip to Munich in 1928, Wood was profoundly influenced by the painstaking realism, high color and precise detail of Flemish art. He was also impressed by contemporary objective painters. He developed his own painstaking technique, which enabled him to produce only about two paintings each year.

Wood used fine lines, crisp edges and stylized landscapes in simple compositions to present pictorially the cliches and conventions of American lives. He explained his view in the 1935 essay "Revolt Against the City," saying, "Your true regionalist is not a mere eulogist; he may even be a severe critic." Underlying his work, though, was a profound respect for rural life.

Wood died of cancer in 1942, at the height of his fame.

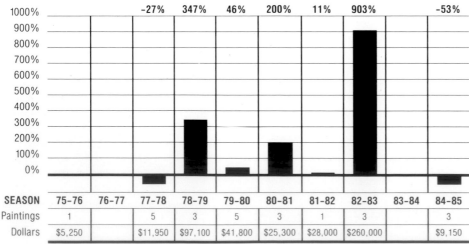

10-Year Average Change From Base Years '75-'76: 178%

		-27%	347%	46%	200%	11%	903%		-53%

SEASON	75-76	76-77	77-78	78-79	79-80	80-81	81-82	82-83	83-84	84-85
Paintings	1		5	3	5	3	1	3		3
Dollars	$5,250		$11,950	$97,100	$41,800	$25,300	$28,000	$260,000		$9,150

Record Sale: $130,000, CH, 3/18/83, "Adolescence," 24 x 15 in.

DEAN
CORNWELL
(1892-1960)

Lighting the First Incandescent Lamp, signed l.l. Photograph courtesy of the Brandywine River Museum, Chadds Ford, Pennsylvania, Collection of General Electric Lighting Business Group.

Muralist and illustrator Dean Cornwell was born in 1892 in Louisville, Kentucky. He was the son of a civil engineer and, as a young boy, used his father's drafting tools as artist's supplies.

When he grew older, poor eyeglasses caused Cornwell to suffer recurring headaches and forced him to abandon his artwork. He pursued an alternate career in music until a new doctor corrected his prescription for glasses. His headaches then disappeared and he was able to return to his art.

Cornwell was influenced by his teachers, Harvey Dunn and Charles S. Chapman. Later, he went to England to study under muralist Frank Brangwyn. Brangwyn relied on Cornwell for assistance when, in 1928, he was unable to complete a large mural for the British House of Lords. At that time Cornwell had already begun on a mural for the Los Angeles Public Library, which he completed after five years in 1932.

Cornwell's work often paid homage to American history, culture and industry. One example is the *Story of Steel* (date unknown), a mural he painted for the Bethlehem Steel Company.

Many of Cornwell's illustrations were published in books and magazines. They won him several prestigious honors and awards, including election to the Hall of Fame of the Society of Illustrators in 1959.

In his more traditional approach to art, Cornwell often used models instead of photographs, but it was the solid application of his abilities to a variety of murals and illustrations which found his work a place in the history of American Art. He was also an important art teacher. He died in 1960.

MEMBERSHIPS
Architect's League of New York
Artists' Guild of the Authors' League of America
Chelsea Arts Club
London Sketch Club
National Society of Mural Painters
Players Club
Royal Society of the Arts
Salmagundi Club
Society of Illustrators

PUBLIC COLLECTIONS
New Britain Museum of American Art, Connecticut
Society of Illustrators, New York City

SEASON	75-76	76-77	77-78	78-79	79-80	80-81	81-82	82-83	83-84	84-85
Paintings						13	8	5	2	1
Dollars						$23,525	$46,000	$23,050	$1,500	$2,000

Record Sale: $30,000, SPB, 12/10/81, "Picnic in the Park," 16 × 37 in.

JOHN FULTON FOLINSBEE
(1892-1972)

River Scene, 24 x 30 in., signed l.r. Courtesy of Newman Galleries, Philadelphia, Pennsylvania.

John Fulton Folinsbee formed part of the third generation of impressionist landscape painters now known as the New Hope School. Like Edward Willis Redfield, Daniel Garber and a host of other artists, Folinsbee was drawn to New Hope, located in rural Bucks County, Pennsylvania, along the banks of the Delaware River. His most successful works depict local industrial life and riverside scenes.

Born in Buffalo, New York in 1892, Folinsbee was stricken with polio in 1906 and confined to a wheelchair for the remainder of his life. In 1912, he studied painting at the Art Students League summer school in Woodstock, New York, where his instructors included Birge Harrison and John F. Carlson.

Folinsbee married Ruth Baldwin in 1914. The couple first came to New Hope in 1916 to visit Harrison, who wintered in Bucks County. Folinsbee and his wife remained in New Hope and built a home on the Delaware River eight years later.

During the 1910s and early 1920s, Folinsbee painted his most successful works. His landscapes, riverside views and portrayals of local working-class life are executed in the broken-brush technique characteristic of impressionism. His renderings of Bucks County factories have been likened somewhat to those of Robert Spencer, another well-known New Hope artist.

Folinsbee's style changed dramatically during the 1930s. His color palette became dark and somber; his small, staccato application of pigment became even more vigorous and personal. He painted directly from nature in a technique which allowed him to record the scene before him as directly and economically as possible.

In 1926, Folinsbee traveled and painted in England and France. He was among the last of three generations of

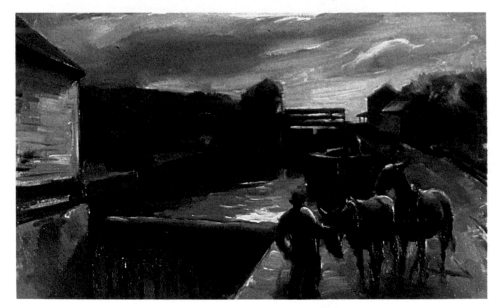

Canal at New Hope, 20 x 30 in., signed l.r. Courtesy of Newman Galleries, Philadelphia, Pennsylvania.

New Hope painters; his work, at first steeped in the impressionistic style of the region, veered off in a new realistic and contemporary direction. He exhibited extensively throughout his career until his death in 1972.

SEASON	75-76	76-77	77-78	78-79	79-80	80-81	81-82	82-83	83-84	84-85
Paintings				1	1		1	1	3	4
Dollars				$2,000	$575		$1,800	$600	$3,200	$5,450

Record Sale: $2,400, D.NY, 4/24/85, "The Outdoor Bar," 16 × 24 in.

CHARLES GREEN SHAW
(1892-1974)

A wealthy man-about-town, poet and minor novelist, Charles Green Shaw was in his thirties before he began to paint seriously, and then went on to become a significant figure in the world of abstract art in America. His nonrepresentational work was highly personal in character.

Shaw was born in New York City in 1892. His parents died when he was young, and he and his twin brother were raised by an uncle. He graduated from Yale, studied architecture at Columbia University, went to the Art Students League to study under Thomas Hart Benton, and finally took private lessons with George Luks.

He served in World War I, lived in Europe during much of the 1920s, and wrote articles for *Smart Set* and *The New Yorker* before he became committed to painting. Once committed, however, he soon was in the very thick of the abstract movement, exhibiting in important avant-garde shows.

Many of Shaw's early paintings were notable for their clarity of form and almost architectural construction. Much of his work, in fact, heavily influenced by Jean Arp, actually was constructed of separate planes of wood and masonite, meticulously joined at the seams, which seem to pass over and under one another.

In the 1930s he did a lively and highly original series of paintings collectively entitled "Plastic Polygon" (last listed in

Composition, 6 x 7 in., signed l.l. Courtesy of Raydon Gallery, New York, New York.

private collections), which is now considered the most significant of all his work. Some are painted wood reliefs in

which he cut planes out of his surfaces and then replaced them as tightly fitting pieces of an abstract composition. He was especially fond of circles and used them often in different connotations.

In the latter part of his life Shaw turned to abstract expressionism. His style grew bolder and showed a strong graphic sense. He died in 1974.

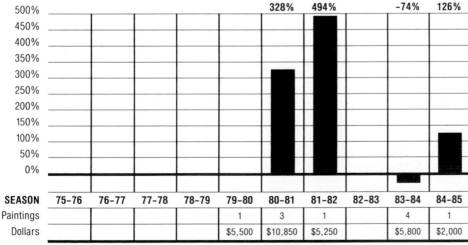

10-Year Average Change From Base Years '79-'80: 175%

SEASON	75-76	76-77	77-78	78-79	79-80	80-81	81-82	82-83	83-84	84-85
						328%	494%		-74%	126%
Paintings					1	3	1		4	1
Dollars					$5,500	$10,850	$5,250		$5,800	$2,000

Record Sale: $5,500, SPB, 4/25/80, "Literary Blasphemies," 28 x 24 in.

VACLAV VYTLACIL

(1892-1984)

An early modernist painter, Vaclav Vytlacil was a brilliant, influential teacher who taught the philosophy as well as the techniques of painting. His compositions are known for their calligraphic lines, cubist spaces and expressive color.

Vytlacil was born in New York City in 1892, the son of Czechoslovakian parents. He moved to Chicago with his parents but returned to New York at age 20 on a scholarship from the Art Students League. From 1913 to 1916, he studied at the League under a variety of teachers, but principally with John C. Johnson, known for his expressive portraits.

Vytlacil undertook his first teaching job, at the Minneapolis School of Art, from 1916 to 1921. This position enabled him to afford a year's sojourn in Paris to study the art of Cezanne.

In 1921, the young artist left for Paris, but ultimately settled in Munich. There he met fellow Americans Worth Ryder and Ernest Thun, who introduced him to famed abstractionist Hans Hofmann. Hofmann, with whom Vytlacil studied from 1922 to 1926, encouraged him to explore the methods and techniques of non-objective painting. Vytlacil's style, which had been a type of figurative expressionism, became completely abstract by 1933.

The artist's teaching career prospered when he returned to America and accepted teaching posts at the Art Students League in 1928, the University of California at Berkeley in 1928 and 1929, and the California College of Arts and Crafts from 1935 to 1936. Among Vytlacil's students were Robert Rauschenberg, James Rosenquist and Tony Smith.

Following his first solo exhibition in Los Angeles in 1930, Vytlacil returned to Europe, where he worked and traveled in France, Italy and Spain. He returned to America in 1935, resumed teaching at the Art Students League, and helped

Construction, 1937, 52 x 24 in. Courtesy of Martin Diamond Fine Arts, New York, New York.

establish the American Abstract Artists group in 1937.

During the 1930s, Vytlacil exhibited a number of mixed-media constructions, such as *Untitled* (1939, estate of John Hirshhorn). Tall, frequently thin, and composed of many layers of painted wood, these constructions incorporate found objects, such as nails, tin and pieces of lumber.

During the 1940s, Vytlacil continued to paint, exhibit and teach at a number of art schools. In 1946, in New York City, he exhibited a group of casein tempera paintings of still lifes, beach scenes, circus characters and female portraits.

In 1951, his first major Pompeiian canvas was shown at the Feigle Gallery in New York City, and later purchased by the Pennsylvania Academy of the Fine Arts. The "Pompeiian Images" constitute a series of paintings inspired

by the artist's visits to the murals of Pompeii. They anticipate the great series of religious paintings begun in the early 1970s. Vytlacil's treatments of traditional Christian subjects, such as *The Entombment, The Washing of the Body* and *The Risen Christ*, represent some of the most striking and beautiful paintings of his career. In these works, Vytlacil masterfully realized the iconography, drama and character of baroque religious art.

Before his death at age 92, Vytlacil received a retrospective exhibition at the Montclair Art Museum in New Jersey in 1975.

MEMBERSHIPS
American Abstract Artists
Federation of Modern Painters
 and Sculptors

PUBLIC COLLECTIONS
Art Students League, New York City
Colorado Springs Fine Arts Center
Dalton School, New York
Metropolitan Museum of Art, New York City
Montclair Art Museum, New Jersey
University of Notre Dame Art Gallery,
 South Bend, Indiana
Whitney Museum of American Art,
 New York City

SEASON	75-76	76-77	77-78	78-79	79-80	80-81	81-82	82-83	83-84	84-85
Paintings					1		4		4	3
Dollars					$3,750		$4,500		$4,600	$2,380

Record Sale: $3,750, SPB, 10/25/79, "The Berkshires," 36 × 40 in.

NILES SPENCER
(1893-1952)

Niles Spencer was a successful painter and a member of the precisionist school of painting, which was similar to cubism. Spencer was influenced by the European cubists.

Born in Pawtucket, Rhode Island in 1893, Spencer studied at the Rhode Island School of Design from 1913 to 1915. In New York City, he briefly studied at the Ferrer School with Robert Henri and George Bellows, and at the Art Students League with Kenneth Hayes Miller. Spencer traveled to Europe in 1921 and from 1928 to 1929. His exposure to European cubism through the works of Cezanne, Braque and Gris undoubtedly influenced his painting.

Much of Spencer's early work was based on the winter scenery in New England seacoast towns. From 1917 to 1921, he spent much time at the art colony in Ogunquit, Maine, where he met sculptor Robert Laurent. Spencer's early paintings of New England emphasized the underlying structure of objects and nature.

In his later work, Spencer used the industrial architecture of New York City as a subject. He painted factories, skyscrapers, warehouses and bridges with the same emphasis on geometric forms as in his earlier works. The later paintings resemble those of Charles Demuth.

During the late 1940s, Spencer's work grew increasingly abstract and cubist. His colors remained muted and somber, and he continued to use carefully constructed color harmonies.

The Silver Tanks, 20 x 30 in., signed l.r. Photograph courtesy of Hirschl & Adler Galleries, Inc., New York, New York.

Spencer's work earned considerable recognition, and it was purchased by numerous prestigious institutions. In 1942, he received the Panama-Pacific award from the Metropolitan Museum of Art in New York. Spencer died in 1952 in Pennsylvania.

PUBLIC COLLECTIONS
Albright-Knox Art Gallery, Buffalo,
 New York
Addison Gallery of American Art,
 Andover, Massachusetts
Metropolitan Museum of Art, New York City
Museum of Modern Art, New York City
Newark Museum, New Jersey
Phillips Collection, Washington, D.C.
Rhode Island School of Design, Providence
San Francisco Art Institute Galleries
San Francisco Museum of Modern Art
Santa Barbara Museum of Art
Whitney Museum of American Art,
 New York City

10-Year Average Change From Base Years '77-'78: 10%

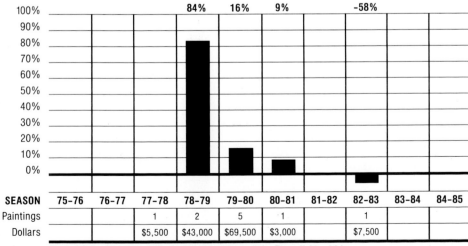

	75-76	76-77	77-78	78-79	79-80	80-81	81-82	82-83	83-84	84-85
				84%	16%	9%		-58%		
SEASON	75-76	76-77	77-78	78-79	79-80	80-81	81-82	82-83	83-84	84-85
Paintings			1	2	5	1		1		
Dollars			$5,500	$43,000	$69,500	$3,000		$7,500		

Record Sale: $34,000, SPB, 10/25/79, "Back of the Town," 30×32 in.

MILTON AVERY
(1893-1965)

Milton Avery was an outstanding colorist who primarily painted luminous seaside scenes and figure studies. A self-taught painter influenced by Matisse, he left his mark on American painting of the 1950s and the 1960s.

Avery, an individualistic painter who learned about modern art at home, stood apart from the social realists of his era. Born in 1893 in Altman, New York, he trained briefly at the Connecticut League of Art Students, but did not go abroad until he was 67. In 1925, he married illustrator Sally Michael, and three years later held his first one-man show at the Opportunity Gallery in New York City.

Avery painted in representational images, but subordinated line to color, using delicately-modulated color shapes to define form. He is considered a supreme American colorist, a bridge to later abstractionists. Each new generation of artists goes back to his work. One of several painters influenced by Avery, his friend Mark Rothko acknowledged the "sheer loveliness" of Avery's paintings.

Avery's shapes appear to be translucent, an effect he achieved by varying the thickness of white paint beneath thin veils of color. At times he used oils like watercolors. The pigment stains flow over flattened forms with fluid contours, creating a composition that is highly abstract, despite its recognizable subject matter. The effect is a lyrical quality of motionlessness and peace.

Fish, Dish and Rose, 1949, 16 x 20 in., signed l.l. Courtesy of Private Collection.

As his career progressed, Avery simplified his shapes, moving away from complex lines, yet maintaining a delicate balance between abstract and representational art. His art helped forge a unique, modern outlook in the United States. Hence, Avery is generally regarded as one of the most important American artists of the twentieth century.

MEMBERSHIPS
American Art Congress
American Society of Painters, Sculptors and
 Engravers
Connecticut Academy of Fine Arts
Society of Independent Artists

PUBLIC COLLECTIONS
Atlanta Art Association
Baltimore Museum of Art
Barnes Foundation, Merion, Pennsylvania
Brooklyn Museum
Dayton Art Institute, Ohio
Honolulu Academy
Houston Museum of Fine Arts
Metropolitan Museum of Art, New York City
Museum of Modern Art, New York City
Pennsylvania Academy of the Fine Arts,
 Philadelphia
Philadelphia Museum of Art
Phillips Gallery, Washington, D.C.
Santa Barbara Museum of Art, California

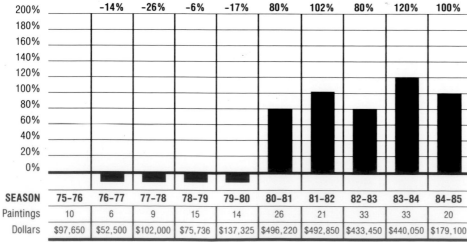

10-Year Average Change From Base Years '75-'76: 42%

		-14%	-26%	-6%	-17%	80%	102%	80%	120%	100%
SEASON	75-76	76-77	77-78	78-79	79-80	80-81	81-82	82-83	83-84	84-85
Paintings	10	6	9	15	14	26	21	33	33	20
Dollars	$97,650	$52,500	$102,000	$75,736	$137,325	$496,220	$492,850	$433,450	$440,050	$179,100

Record Sale: $105,000, CH, 5/5/82, "Black Tree," 36 × 40 in.

852

JOHN BARBER
(1893-1965)

John Barber is noted for his paintings of peasant and urban life, many of which are similar to the works of the social realist painters. Barber's work combines an abstract substructure with figurative subject matter.

Barber was born in 1893 in Galatz, Rumania. His sophisticated, intellectual parents encouraged his early interest in art and introduced him to the work of other artists, notably Jules Pascin, a young painter from Bucharest who would later become a close friend. Barber's grandfather coached him in drawing, especially pictures of horses.

The Barber family came to New York City in 1908, and Barber became a citizen of the United States as soon as possible.

It was a time of artistic ferment in New York, when many painters were moving away from the academic European tradition. Barber enrolled at the Ferrer Center School; he soon discovered the social realist painting of Robert Henri, which was to be a lifelong influence on Barber's own work.

Working in New York City, Barber met and became friendly with other artists, including Pascin and The Eight. In 1917, he became art editor of the socialist magazine *The Masses,* for which he produced a number of illustrations.

Barber spent the years 1918 and 1919 as a conscientious objector in an army prison camp in France. After the war, he traveled and painted throughout Europe. In the early 1920s, he studied with Andre Lhote in Paris; at this time his style moved from literal representation to a more intellectualized, geometric pattern of forms.

After traveling in Holland, Germany, France, Spain, Italy and Portugal, Barber returned to the United States in the mid-1930s and settled in New York City.

All of Barber's paintings reflect his interest in the common man in both

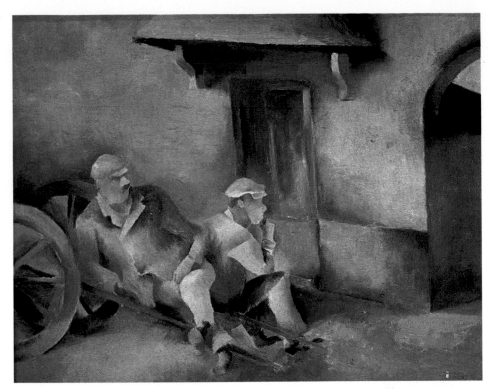

Loafing, 10⅛ x 13 in. Courtesy of Bayly Museum of the University of Virginia, Charlottesville.

rural and urban settings. For Barber, the most important element in any painting was its complex and vibrant composition. A major influence was fourteenth-century Italian painter Piero della Francesca, whose monumental style, like Barber's, employs geometric forms and simple but dignified figures.

Barber married in 1948. He continued to travel and paint; his travels in Mexico inspired a significant body of paintings of peasant life, such as *Tortilla Restaurant* (1956, University of Virginia Art Museum). His health began to fail, however, in Genoa in 1965. Barber died later that year, after returning to the United States.

PUBLIC COLLECTIONS
University of Virginia Art Museum, Charlottesville

(No sales information available.)

CHARLES E. BURCHFIELD
(1893-1967)

Watercolorist Charles Ephraim Burchfield was continuously productive as an artist from his youth until his death at age 74. His highly personal work found wide public acceptance.

Burchfield was born in 1893. His principal formal art education was obtained at the Cleveland Institute of Art from 1912 to 1916, where Henry G. Keller was an important influence. In 1921, he moved from Ohio to Buffalo, New York, where he worked as a wallpaper designer. By 1929, his spare-time painting had become sufficiently lucrative to enable him to become a full-time painter.

Although he painted a few oils, watercolors were Burchfield's forte. He was not reluctant to add ink, pencil and other media to obtain the results he desired.

Burchfield's work falls into three phases. Until 1918, he concentrated mainly on the romantic landscapes and fields of his boyhood. From 1918 to 1943, he painted imaginative treatments of the grimy streets and rundown buildings of Eastern Ohio. Following that period, he went back to his youthful landscapes, incorporating some of them into larger, more powerful works. In his final years, fantastic butterflies and dragonflies were among his subjects.

Burchfield was involved briefly in World War I, and was sensitive to the effects of the Great Depression and World War II. The impact of these events of American society strongly influenced his style. Some of his work contains macabre, morbid, mystical and haunting overtones.

Burchfield's early experimentation with converting the sounds of nature into a system of symbolic brush-strokes later grew to include interpretation of his own thought processes through the same technique. This unique feature appears frequently in Burchfield's work.

Orion in December, 1959, 40 x 33 in. Courtesy of National Museum of American Art, Smithsonian Institution, Gift of S.C. Johnson and Son, Inc.

His career was successful, but Burchfield mingled little with artists' groups or the metropolitan crowd. His papers and many paintings are in the Charles E. Burchfield Foundation in Buffalo, New York. He died in 1967.

MEMBERSHIPS
American Academy of Arts and Sciences
National Academy of Design
National Institute of Arts and Letters

PUBLIC COLLECTIONS
Albright-Knox Art Gallery, Buffalo
Brooklyn Museum
Burchfield Center, Buffalo
Butler Institute of American Art, Youngstown, Ohio
Carnegie Institute, Pittsburgh
Cleveland Museum of Art
Delaware Art Center, Wilmington
Detroit Institute of Arts
Everson Museum of Art, Syracuse
Fine Arts Gallery of San Diego
John Herron Art Institute, Indianapolis
Kalamazoo Institute of Arts, Michigan
Metropolitan Museum of Art, New York City
Museum of Fine Arts, Boston
New Britain Museum of American Art, Connecticut
Newark Museum, New Jersey
Pennsylvania Academy of the Fine Arts, Philadelphia
Phillips Collection, Washington, D.C.
Rhode Island School of Design, Providence
Santa Barbara Museum of Art
Whitney Museum of American Art, New York City
Wichita Art Museum, Kansas

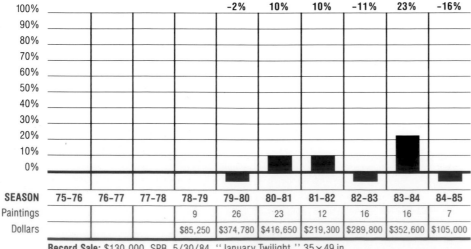

10-Year Average Change From Base Years '78-'79: 2%

| | -2% | 10% | 10% | -11% | 23% | -16% |

SEASON	75-76	76-77	77-78	78-79	79-80	80-81	81-82	82-83	83-84	84-85
Paintings				9	26	23	12	16	16	7
Dollars				$85,250	$374,780	$416,650	$219,300	$289,800	$352,600	$105,000

Record Sale: $130,000, SPB, 5/30/84, "January Twilight," 35 × 49 in.

FORREST K. MOSES
(1893-1974)

The Yellow Store, 1969, 16 x 24 in., signed l.r. Photograph courtesy of Chapellier Galleries, New York, New York.

Forrest K. Moses was the son of celebrated primitive painter Anna Mary Robertson "Grandma" Moses. His work, although less well-known than hers, is markedly similar in style and subject matter.

Moses was born in 1893. Like his mother, he lived in Eagle Bridge, New York, in the Adirondack Mountains. He was a farmer before beginning to paint at age 56.

Moses did not title his paintings, but rather grouped them by season, as "spring pictures," "summer pictures," "snow pictures" and so on. His work has a large element of nostalgia; in an interview in the December 3, 1970 *Christian Science Monitor,* Moses said that he hoped "to show my grandsons, or anyone that's interested, the country that's all gone. I'm fortunate to have seen all those things, steam locomotives, four-horse teams threshing wheat in the fields, sawmills." His subjects are largely rural scenes.

Moses also explained that he preferred to paint only pleasant subjects, avoiding anything that might appear frightening to children. He made a point of including many active figures in each work.

Like "Grandma" Moses, Forrest Moses had no formal artistic training. Like hers, his paintings are primitive in their use of bold, childlike line, bright, uncomplicated color, and disdain for academic perspective and shading technique.

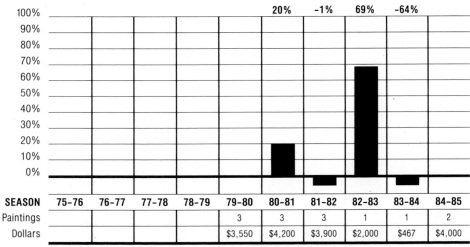

10-Year Average Change From Base Years '79-'80: 4%

SEASON	75-76	76-77	77-78	78-79	79-80	80-81	81-82	82-83	83-84	84-85
						20%	-1%	69%	-64%	
Paintings					3	3	3	1	1	2
Dollars					$3,550	$4,200	$3,900	$2,000	$467	$4,000

Record Sale: $2,400, SPB, 1/31/85, "Time to Make Sugar," 20 x 20 in.

HAROLD VON SCHMIDT
(1893-1982)

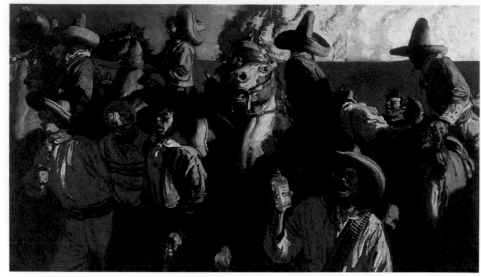

Mexican Raiders, 30 x 50 in. Courtesy of Grand Central Art Galleries, Inc., New York, New York.

For more than half a century, the illustrations and paintings of Harold Von Schmidt were familiar to the American public. His work appeared in the *Saturday Evening Post, Sunset, Cosmopolitan, American* and other magazines for 20 years, beginning in 1925.

He also illustrated Willa Cather's *Death Comes to the Archbishop,* and was commissioned in 1960 to design the Pony Express commemorative stamp for the United States postal service.

Born in 1893 in Alameda, California, Von Schmidt was orphaned at five. He was raised by his grandfather and an aunt who encouraged his interest in art. As a young man, he spent his summers working as a lumberjack, cowpuncher and construction worker.

After two years' study with F.H. Meyers at the California College of Arts and Crafts, Von Schmidt did his first cover design in 1913 for *Sunset* magazine. While attending the San Francisco Art Institute from 1915 to 1918, he became art director at the Foster & Klein advertising agency. He also made paintings for the navy in World War I.

Von Schmidt was a member of the United States rugby team in the 1920 Olympics. That year, he and artists Maynard Dixon, Roi Partridge, Judson Starr and Fred Ludekens set up their own agency. He came East in 1924 to study at the Grand Central Art School in New York City with Harvey Dunn, a former student of Howard Pyle.

During World War II, Von Schmidt was an artist-correspondent for King Features Syndicate and the air force.

He continued to produce non-commercial work, as well as illustrations. He did 12 Gold Rush paintings for the California governor's offices, and five Civil War paintings for the United States Military Academy at West Point, New York.

Von Schmidt was a founder of the Famous Artists School in Westport, Connecticut. He died in 1982.

10-Year Average Change From Base Years '80-'81: 216%

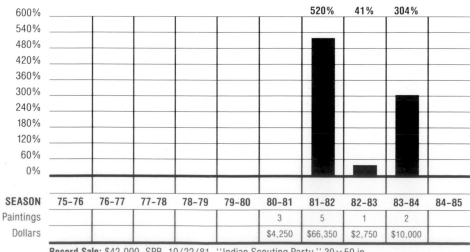

SEASON	75-76	76-77	77-78	78-79	79-80	80-81	81-82	82-83	83-84	84-85
Paintings						3	5	1	2	
Dollars						$4,250	$66,350	$2,750	$10,000	

Record Sale: $42,000, SPB, 10/22/81, "Indian Scouting Party," 30 × 50 in.

MEMBERSHIPS
Artists Guild
Artists Guild of the Author's League
 of America
Society of Illustrators

PUBLIC COLLECTIONS
California State Capital, Sacramento
Montana Historical Society, Helena
National Cowboy Hall of Fame, Oklahoma City
United States Air Force Academy,
 Colorado Springs
United States Military Academy at
 West Point, New York

ERNEST FIENE
(1894-1965)

A successful and respected artist and teacher, Ernest Fiene produced many works in a variety of media. Noted primarily for his landscapes of American scenes, he is also recognized for his portraits, etchings, lithographs, murals and book illustrations.

Called a romantic realist by some, Fiene, unlike many artists of his period, resisted dependence upon the rationalism of geometry or the emotional charge of color. He favored pursuing his vision of man's humanity, through his perceptions of man's environment and the things man has made.

Born in Elberfeld, Germany in 1894, Fiene came to the United States in 1912 and was naturalized in 1927. He studied at the National Academy of Design in New York City from 1914 to 1918; at the Beaux-Arts Institute of Design from 1916 to 1918; at the Art Students League in 1923; at the Academie de la Grande Chaumiere in 1929; and in Florence in 1932.

A noted teacher, Fiene taught at Westchester County Center in New York from 1930 to 1931; at Cooper Union Institute in New York City from 1938 to 1939; and at the Art Students League in New York City from 1938 to 1964. He was also a member of the supervising faculty of the Famous Artists School in Westbury, Connecticut from 1955 to 1965. His book *Painting in Oils* was published in 1964.

Fiene's early work was influenced by

View From My Window, 1930-1931, 60⅛ x 60⅜ in., signed l.l.
Photograph courtesy of ACA Galleries, New York, New York.

Rembrandt, Breugel and Daumier, and his later work by the post-impressionists. Fiene realized early that the masters' works were valuable as exemplars of their historical periods, and he applied their humanism to the contemporary world.

Like major European modernists, he refused to isolate experience from technique. Consequently, he used clarification of design and intensification of color to interpret and express his ideas. The resulting work projected a heightened sensitivity to color and design characteristic of modern urban culture, an important contribution to the American style of precisionism.

Fiene's works generally reflect opti-

mism. However, from 1948 to 1953, skeletons of wrecked ships, like those in *The Wreck at Cuttyhunk* (1952, location unknown), constantly recurred. Fiene reflected that perhaps this resulted from a fascination with shapes and a preoccupation with the fragmentation of modern lives and times. His art demonstrates that realism and abstract geometric shapes can coexist in harmony.

Fiene believed that the artist must address the interaction of man and his environment, that each work of art should speak for itself, and that the message of each should be clear and readable.

He died in Paris in 1965.

MEMBERSHIPS
Artists Equity Association
Art Students League of New York
Century Association
International Institute of Arts and Letters
National Academy of Design
Salons of America

PUBLIC COLLECTIONS
Art Students League, New York City
Brooklyn Museum
Chicago Art Institute
Cleveland Museum of Art
Denver Art Museum
Detroit Institute of Arts
Fogg Museum, Cambridge, Massachusetts
Library of Congress, Washington, D.C.
Los Angeles County Museum of Art
Museum of Fine Arts, Boston
Museum of Modern Art, New York City
Newark Museum, New Jersey
New York Public Library, New York City
Pennsylvania Academy of Fine Arts, Philadelphia
Phillips Memorial Gallery, Washington, D.C.
Whitney Museum of American Art,
 New York City
Tel Aviv Museum, Israel

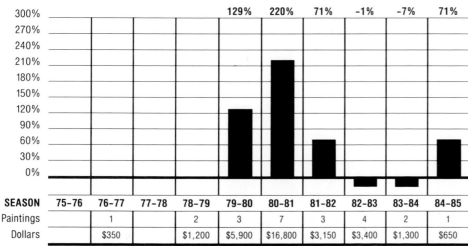

10-Year Average Change From Base Years '76-'77: 60%

					129%	220%	71%	-1%	-7%	71%
SEASON	75-76	76-77	77-78	78-79	79-80	80-81	81-82	82-83	83-84	84-85
Paintings		1		2	3	7	3	4	2	1
Dollars		$350		$1,200	$5,900	$16,800	$3,150	$3,400	$1,300	$650

Record Sale: $6,000, CH, 4/24/81, "Pittsburgh Afternoon," 30 x 36 in.

STUART DAVIS
(1894-1964)

Stuart Davis was one of the first American modernists. His busy, heavily geometric compositions and nonobjective use of color were attempts to find a visual counterpart to the frenzy of American life in the first half of the twentieth century.

Born in Philadelphia in 1894, Davis was introduced to the art world at an early age by his mother, Helen Stuart Foulke, a sculptor, and his father, Edward Wyatt Davis, art editor of the *Philadelphia Press*. It was through his father that Davis met Robert Henri, with whom he studied in New York City from 1910 to 1913.

Davis worked mostly in watercolors, then in the style of the Ashcan School. In 1913, he exhibited five paintings in the Ashcan style at the Armory Show in New York City.

At the Armory Show, Davis was exposed to modernism for the first time. He wrote that it so intrigued him that he abandoned his own representational style in favor of the modernist method. A prime example of Davis's sophisticated early modernist work is *Lucky Strike* (1921, Museum of Modern Art), which employed elements of a cigarette package and simplified geometric shapes similar to a trompe l'oeil cubist collage.

In succeeding years, Davis further simplified his technique, reducing traditional representational elements to collections of hard-edged, unmodulated forms. In 1927, he began his first entirely abstract work—the "Egg-

Int'l Surface No. 1, 1960, 57 x 45 in., signed l.r. Courtesy of National Museum of American Art, Smithsonian Institution, Gift of S.C. Johnson and Son, Inc.

beater" series (Phillips Gallery, Washington, D.C., Whitney Museum of American Art, New York City and elsewhere). It consisted of several versions of an eggbeater, a fan and a glove, each group more abstract than the last, until in the later paintings all representational elements were submerged, leaving only pure form.

Davis visited Paris in 1928, where his ardor for abstraction cooled somewhat. Here he painted unpeopled, semi-representational poster-flat views of cafes, buildings, and other Parisian street scenes. Works of this period include *Rue Descartes* (ca. 1928, location unknown) and *Place Pasdeloup* (1928, location unknown). Upon his return to New York City, however, Davis resumed his pursuit of combining the experience of American life with

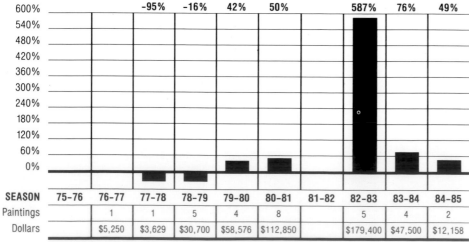

10-Year Average Change From Base Years '76–'77: 87%

		-95%	-16%	42%	50%		587%	76%	49%	
SEASON	75–76	76–77	77–78	78–79	79–80	80–81	81–82	82–83	83–84	84–85
Paintings		1	1	5	4	8		5	4	2
Dollars		$5,250	$3,629	$30,700	$58,576	$112,850		$179,400	$47,500	$12,158

Record Sale: $70,000, CH, 6/3/83, "Town and Country," 10 × 10 in.

858

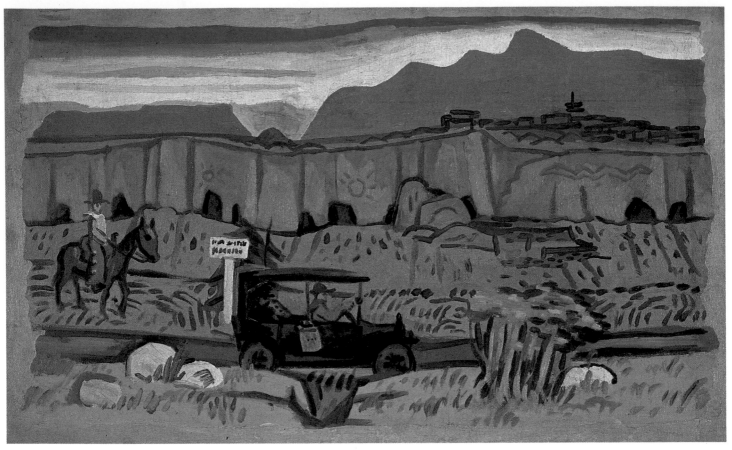

Pajarito, 1923, 22 x 36 in., signed l.r. Photograph courtesy of The Gerald Peters Gallery, Santa Fe, New Mexico.

abstraction to capture a visual, kinetic equivalent of the hectic, fragmented American scene. He was looking for an American style, a pictorial equivalent of jazz, the contemporary American music he avidly followed.

During the 1930s, Davis taught at the Art Students League in New York City; he painted easel paintings and several significant murals for the WPA's Federal Arts Project; he edited *Art Front,* the publication of the Artists Union; and he chaired the American Artists Congress.

Throughout the 1940s, Davis taught at the New School for Social Research in New York City. He also experimented with his style, searching for a compositional openness reminiscent of the overall quality found in Hudson River School and late cubist canvases.

By pursuing a style in which subject matter is secondary to formalistic concerns and color relationships, yet never abandoning a desire to represent the tempo of American life as he experienced it, Davis forged an essential link between early modernism, abstract expressionism and later experiments in pop art. In 1964, he received the first commission awarded to a major artist to design a United States postage stamp. It was issued six months after his death in June of that year.

MEMBERSHIPS
American Artists Congress
Artists Union
Brooklyn Society of Artists
Modern Art Association
Society of Independent Artists

PUBLIC COLLECTIONS
Albright-Knox Art Gallery, Buffalo
American Academy of Arts and Letters,
 New York City
Art Institute of Chicago
Baltimore Museum of Art
Brooklyn Museum
Carnegie Institute, Pittsburgh
Cincinnati Art Museum
Library of Congress, Washington, D.C.
Los Angeles County Museum of Art
Munson-Williams-Proctor Institute, Utica,
 New York
Newark Museum, New Jersey
Pennsylvania Academy of the Fine Arts,
 Philadelphia
Pennsylvania State University
Philadelphia Museum of Art
Phillips Collection, Washington, D.C.
San Francisco Museum of Art
Seattle Art Museum
Solomon R. Guggenheim Museum, New York City
St. Louis Art Museum
Wadsworth Atheneum, Hartford, Connecticut
Walker Art Center, Minneapolis, Minnesota
Whitney Museum of American Art,
 New York City
Wichita Art Museum, Kansas
Yale University

LAWRENCE H. LEBDUSKA
(1894-1966)

A twentieth-century folk painter, Lawrence H. Lebduska's keenest interest was pleasing the friends for whom he painted. Most of his work was devoted to bright, multi-colored animals painted in a style midway between folklore tradition and a spontaneous interpretation of reality. Lebduska's inspiration came from everywhere—childhood recollections, fairy tales, old Bohemian folk stories and even postcards and books of nursery rhymes.

He was born in Baltimore, Maryland in 1894. His father, a Bohemian stained-glass maker, had been sent to America by Fleider & Schneider, the firm in Leipzig for which he worked. When the boy was five, he returned to Europe with his parents and received his schooling there. He learned the fundamentals of stained-glass making at a technical school run by his father's firm and studied decorative painting with Joseph Svoboda in Chrudim, Bohemia.

At age 18, he returned to America. For three years, he painted decorative murals for Elsie de Wolfe, one of the first big-name interior decorators in New York City. After leaving her, he continued the same kind of work on his own. He worked on easel painting when he had the time.

Lebduska began exhibiting his fanciful works in the mid-1920s. Almost immediately they caught the eye of violinist Louis Kaufman, who in time accu-

Temple of Venus, 1932, 21⅛ x 30 in., signed l.r. Philadelphia Museum of Art, Pennsylvania, The Louise and Walter Arensberg Collection.

mulated a large collection of them for his Hollywood home.

Lebduska's interest in horses probably harked back to the days when he lived with an uncle who bred them on his

Maryland farm. Later he would visit the zoo and the Museum of Natural History in New York to study animals. His favorite mode of research, however, was to read books which described animals' forms, colors and habits. This seemed to fire his imagination most of all.

Lebduska's recognition as a painter faded in the decades after 1940, but his work was "rediscovered" shortly before his death in 1966.

MEMBERSHIPS
Aububon Artists

PUBLIC COLLECTIONS
Albright-Knox Art Gallery,
 Buffalo, New York
Baltimore Museum of Art
Brooklyn Museum
Metropolitan Museum of Art, New York City
Museum of Modern Art, New York City
Newark Museum, New Jersey
Wadsworth Atheneum, Hartford, Connecticut
Walker Art Center, Minneapolis, Minnesota
Whitney Museum of American Art,
 New York City

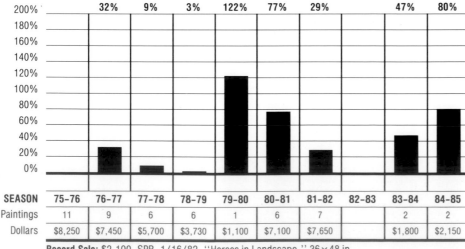

10-Year Average Change From Base Years '75-'76: 44%

	32%	9%	3%	122%	77%	29%		47%	80%	
SEASON	75-76	76-77	77-78	78-79	79-80	80-81	81-82	82-83	83-84	84-85
Paintings	11	9	6	6	1	6	7		2	2
Dollars	$8,250	$7,450	$5,700	$3,730	$1,100	$7,100	$7,650		$1,800	$2,150

Record Sale: $2,100, SPB, 1/16/82, "Horses in Landscape," 36 × 48 in.

PAUL STARRETT SAMPLE
(1894-1974)

A realistic landscape and genre painter as well as an illustrator, Paul Starrett Sample was the antithesis of the stereotypical picture of the starving artist, struggling for recognition. He was a success almost from the start. He illustrated ads for such giants as General Motors and Maxwell House Coffee and articles for leading magazines. He also painted clean-cut landscapes and scenes that reflected the richness and joy of life.

The son of a construction engineer, he was born in Louisville, Kentucky in 1894, but spent his youth living with his family in practically every section of the country. He went to Dartmouth College, where he was an outstanding athlete, particularly as a boxer, and a good saxophonist. He spent the last year of World War I in the navy and then returned to Dartmouth to graduate. Soon afterward he developed tuberculosis and spent the next four years at a sanatorium in the Adirondack Mountains. It was during this period that he settled on a career as a painter. When he regained his health he studied with Jonas Lie.

Sample went to California in 1926 and was on the art faculty of the University of Southern California from 1926 until 1938. He rebelled, however, against painting the typical, popular scenes of the High Sierras and of desert flowers, and developed his own style instead.

In 1938, he was appointed artist-in-residence at Dartmouth College and remained there until his retirement in 1962. It is for his oil and watercolor landscapes of New England and his depiction of warm, human, American scenes that he is best known. He died at his home in Norwich, Vermont in 1974.

Brownington Center, Vermont, 28 x 40 in., signed l.r. Courtesy of Vose Galleries of Boston, Inc., Massachusetts.

MEMBERSHIPS
National Academy of Design

PUBLIC COLLECTIONS
Art Institute of Chicago
Brooklyn Museum
Metropolitan Museum of Art, New York City
Museum of Fine Arts, Boston
Museum of Fine Arts, Springfield,
 Massachusetts
Pennsylvania Academy of the Fine Arts,
 Philadelphia
Smithsonian Institution, Washington, D.C.

SEASON	75-76	76-77	77-78	78-79	79-80	80-81	81-82	82-83	83-84	84-85
Paintings				2	2	1	3		2	1
Dollars				$2,100	$1,550	$850	$4,650		$1,600	$8,750

Record Sale: $8,750, SPB, 12/8/84, "Sapping Time," 30 × 39 in.

861

NORMAN ROCKWELL
(1894-1978)

To millions, Norman Rockwell was the reigning illustrator of small-town America, the friendly chronicler of warm, homey, often humorous events that made middle Americans proud to be what they were.

His covers for the *Saturday Evening Post,* 318 of them over some 40 years, made him the most popular illustrator of his day. His name became synonymous with that magazine, although he did dozens of illustrations for other publications and books, and painted murals besides. His secret was in endowing his subjects with just the right expression or posture to tell the story of the scene in an instant.

Rockwell was born in New York City in 1894, and moved to suburban Mamaroneck with his family when he was nine. He left high school to study at the National Academy of Design's art school, earning his keep by designing cards and teaching actress Ethel Barrymore to paint.

At 16, he transferred to the Art Students League to learn, as he put it, "to paint storytelling pictures." At 17, he was already illustrating books, and at 18, he was art director for the magazine *Boys Life.* To learn more about his craft, he shared a studio for a time with Clyde Forsyth, an established illustrator.

Rockwell was only 22 when he sold his first five covers to George Horace Lorimer, the legendary editor of the *Saturday Evening Post.* Thereafter, he averaged about 10 covers a year for the magazine.

For his covers, Rockwell would make a small sketch of his scene, then make individual drawings of each element that was to make up the painting. Next he would make a full-size charcoal drawing of the entire scene, and finally, before actually starting the painting, color sketches. In later life he also worked from photographs, sometimes projecting them onto the canvas and sketching in the outlines in charcoal.

During World War I, he served in the navy, but spent his time painting official portraits. In the early 1950s, he did patriotic murals on the Four Freedoms for the Nassau Tavern in Princeton, New Jersey. The oil sketch for one of these murals, *Freedom of Speech* (1952), is in the collection of Metropolitan Museum of Art.

From 1960 until his death in 1978, Rockwell spent much of his time doing large painted photomontages of contemporary personages and events.

The Fumble, 30 x 26 in., signed l.r. Courtesy of Vose Galleries of Boston, Inc., Massachusetts.

MEMBERSHIPS
Artists' Guild of the Authors' League of America
Free Lance Artists of America
Salmagundi Club
Society of Illustrators

PUBLIC COLLECTIONS
Delaware Art Museum, Wilmington
Metropolitan Museum of Art, New York City
Society of Illustrators, New York City

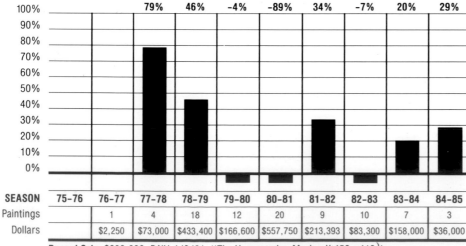

10-Year Average Change From Base Years '76–'77: 12%

	75–76	76–77	77–78	78–79	79–80	80–81	81–82	82–83	83–84	84–85
Change			79%	46%	-4%	-89%	34%	-7%	20%	29%
SEASON	75–76	76–77	77–78	78–79	79–80	80–81	81–82	82–83	83–84	84–85
Paintings		1	4	18	12	20	9	10	7	3
Dollars		$2,250	$73,000	$433,400	$166,600	$557,750	$213,393	$83,300	$158,000	$36,000

Record Sale: $230,000, P.NY, 4/2/81, "The Homecoming Marine," 452×413 in.

PEGGY BACON
(1895-)

Printmaker and painter Peggy Bacon is well known for her illustrations of children's books and her brilliant, satirical caricatures of the New York City art world in the 1920s and 1930s.

Bacon, born in New York City in 1895 to parents who were both artists, trained with illustrator Howard Giles and later with John Sloan at the Art Students League.

She turned from realism early in her career, to develop a unique satirical style using drypoint. Her figures are stylistic and humorous with witty, cutting observations on public personages. She did lithographs, etching and pastels during the first three decades of her career, turning to oil painting in the 1950s.

Throughout her long career, which she sustained past the age of 80, Bacon illustrated 64 books, many of them for children. She also wrote and illustrated 18 books of her own; she is a poet and award-winning novelist, as well as an artist. In 1934, on a Guggenheim Fellowship, she wrote and illustrated *Off With Their Heads!,* a ruthless caricature of leading artists, critics and intellectuals—39 black-and-white portraits, accompanied by vignettes.

Bacon's style favors modernistic, flattened figures, frequently crowded together in a room, distinguished by telling marks—an exaggerated nose, a withering glance, an ill-fitting dress or baggy pants.

In 1920, Bacon married painter Alexander Brooks. Shortly after, the two settled in Woodstock, New York, an art colony striving to integrate modern ideas into American art. In 1923, after a two-person exhibition that established their artistic reputations, the couple returned to New York City, moving at the center of a galaxy of talented, sophisticated artists. Others in the galaxy often found themselves the subjects of her satire; ultimately, to avoid offense, Bacon refused to do magazine assignments.

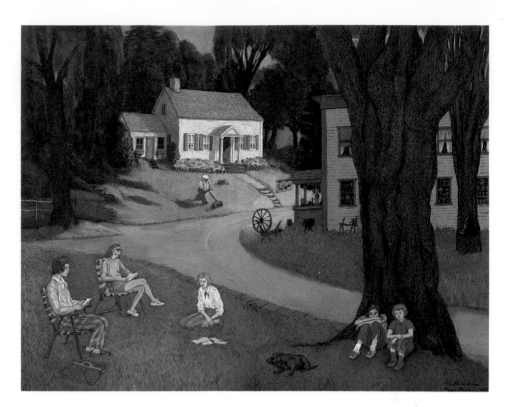

Far From Home, 1967, 19¼ x 25 in., signed l.r. Courtesy of Kraushaar Galleries, New York, New York.

Bacon was a leading figure in the Whitney Studio Club, and in the early 1960s she served as vice president of the National Institute of Arts and Letters. The Guild Hall in East Hampton, New York houses a large collection of her work.

MEMBERSHIPS
Society of Independent Artists
Society of American Etchers

PUBLIC COLLECTIONS
Brooklyn Museum
Guild Hall, East Hampton, New York
Metropolitan Museum of Art, New York City
Whitney Museum of American Art,
 New York City

SEASON	75-76	76-77	77-78	78-79	79-80	80-81	81-82	82-83	83-84	84-85
Paintings				1		3	2	1	2	3
Dollars				$1,600		$5,900	$2,550	$450	$980	$4,300

Record Sale: $3,500, D.NY, 9/24/80, "Going Home," 14 × 10 in.

ADOLF ARTHUR DEHN
(1895-1968)

Lithographer and painter Arthur Adolf Dehn was particularly known for his watercolor landscapes. He was born in Waterville, Minnesota and studied at the Minneapolis Art Institute. Later he moved to New York City and studied at the Art Students League.

After World War I, Dehn taught art. From 1921 to 1929, he worked in Berlin, Paris, London and Vienna.

When Dehn returned to the United States, he concentrated on lithography and black-and-white drawings, primarily of landscapes and satirical subjects. These carried him through the Depression. In about 1936, he began painting in watercolor with great success. Later, he turned to oils.

He traveled often in Europe and the West Indies. He was the author of many books on painting, such as *Water Color Painting* (1945) and *Water Color, Gouache, and Casein Painting* (1955). He also taught at the Famous Artists School in Westport, Connecticut.

Dehn's style was realistic, although expressed with wit and understanding. He did not believe that he had to recreate the world in his own image; rather, he drew and painted what he saw.

Said the author of *The Artist in America,* Carl Zigrosser, "Sensitive, urbane, masterly in technique, he has a unique and personal style. Dehn can render—more successfully than anyone—atmosphere and the subtler moods of nature."

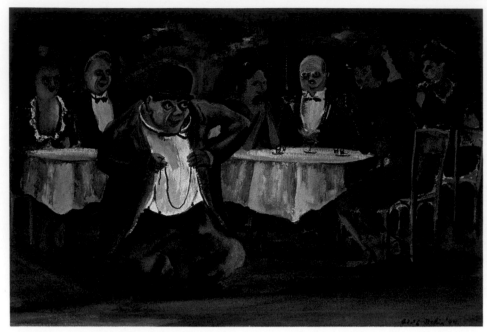

Jimmy Savo and Rope, 1944, 14 x 21 in., signed l.r. Courtesy of Collection The Whitney Museum of American Art, New York, New York.

MEMBERSHIPS
American Art Congress
National Academy of Design

PUBLIC COLLECTIONS
Art Institute of Chicago
British Museum, London
Brooklyn Museum
Cleveland Museum of Art
Metropolitan Museum of Art, New York City
Milwaukee Art Museum
Minneapolis Institute of Arts
Museum of Fine Arts, Boston
Museum of Modern Art, New York City
New York Public Library, New York City

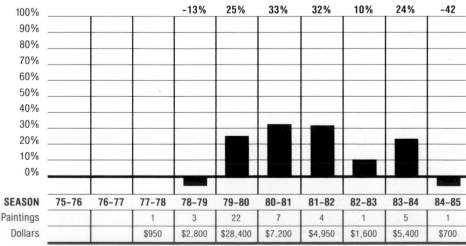

10-Year Average Change From Base Years '77-'78: 9%

SEASON	75-76	76-77	77-78	78-79	79-80	80-81	81-82	82-83	83-84	84-85
				-13%	25%	33%	32%	10%	24%	-42
Paintings			1	3	22	7	4	1	5	1
Dollars			$950	$2,800	$28,400	$7,200	$4,950	$1,600	$5,400	$700

Record Sale: $5,250, SPB, 1/23/80, "Winter in Central Park," 24 × 60 in.

ABRAHAM RATTNER
(1895-1978)

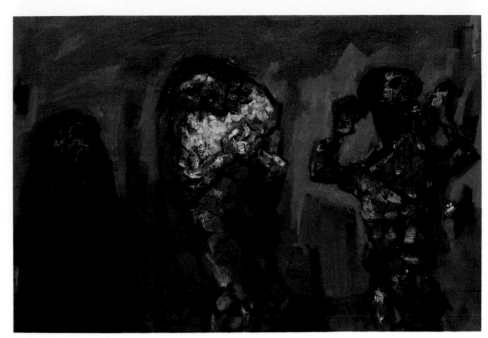

Homage to Goya No. 2 (Composition in Red with Three Figures), 1963, 51 x 77 in., signed l.l. Courtesy of National Museum of American Art, Smithsonian Institution, Washington, D.C. Gift of the Estate of Abraham Rattner.

Although raised in the United States, Abraham Rattner lived in Paris between World War I and World War II, and his work bears the imprint of the cubists. His twisted, angular figures, heavy black lines and jewel-like colors, applied with a heavy impasto, hark back to Roualt. Like Roualt's, too, much of his work was based on religious themes. Romanesque and Byzantine art also seem to have had a role in Rattner's development.

Born in Poughkeepsie, New York in 1895, Rattner began studying architecture at George Washington University in Washington, D.C., and attended classes at the Corcoran School of Art at night. Painting interested him more than architecture, and he soon became a full-time student at Corcoran.

He transferred to the Pennsylvania Academy of the Fine Arts in 1917, but when the United States entered the war, he joined the army and was sent to France as a camouflage artist. At the end of the war he came back to the Academy long enough to win a traveling fellowship which allowed him to return to Europe.

He attended the Ecole des Beaux Arts and other schools in Paris, and met Claude Monet (who was working on his water-lily paintings), but it was Picasso and Roualt whose styles attracted him most.

Much of Rattner's work bears a similarity to stained-glass windows, with small, multi-faceted planes of intense colors. Indeed, in 1955 he was commissioned to design stained-glass windows for a Chicago synagogue. Other times he used sweeping planes of many colors in his carefully-studied compositions.

With the outbreak of war in 1939, Rattner returned to the United States, leaving most of his work behind. His first expedition was a cross-country automobile trip for several months with novelist Henry Miller, whom he knew from Paris. Miller wrote an account of the trip and Rattner illustrated it.

In the postwar years Rattner taught at a succession of institutions, including the American Academy in Rome. He moved away from his cubist-Roualt style and toward abstract expressionism in the years before his death in 1978.

MEMBERSHIPS
National Institute of Arts and Letters

PUBLIC COLLECTIONS
Albright-Knox Art Gallery, Buffalo, New York
Art Institute of Chicago
Baltimore Museum of Art
Detroit Institute of Arts
Newark Museum, New Jersey
Pennsylvania Academy of the Fine Arts,
 Philadelphia
Philadelphia Museum of Art
Phillips Collection, Washington, D.C.
Wadsworth Athenaeum, Hartford, Connecticut
Whitney Museum of American Art,
 New York City

SEASON	75-76	76-77	77-78	78-79	79-80	80-81	81-82	82-83	83-84	84-85
Paintings			1	2		2	2	1	2	1
Dollars			$1,800	$875		$2,350	$7,800	$12,000	$5,000	$2,600

Record Sale: $12,000, CH, 6/3/83, "Crucifixion," 46 × 35 in.

ROBERT PHILIPP
(1895-1981)

Robert Philipp was that rarity in the art world, a painter popular with both the public and the critics.

Called one of the six best American painters by eminent art critic Henry McBride, he won numerous top awards, capturing a National Academy of Design prize at age 27.

Born in New York City in 1895, he lived, studied and painted there for most of his life. At age 15, he entered the Art Students League for four years and then continued his training at the National Academy of Design. Later, he would return to both institutions as a teacher.

Recognition came early to Philipp, and his paintings appear in most major museum collections. Acclaimed as a portrait artist, he painted celebrities, including actress Margaret Sullavan, actor Thomas Mitchell and General Carl Spaatz.

Philipp was married to artist Shelley Post, and the couple had a close relationship. Philipp often used her as a model; her serene, classic beauty is evident in hundreds of his canvases. Striking examples are *Portrait of Rochelle* and *Rochelle at the Window* (dates and location unknown).

Philipp also painted landscapes, still lifes and nudes in various media. *Nude* (1933, Corcoran Gallery of Art), a fine oil, won several prizes. His paintings are lyrical, happy and highly personal in subject matter.

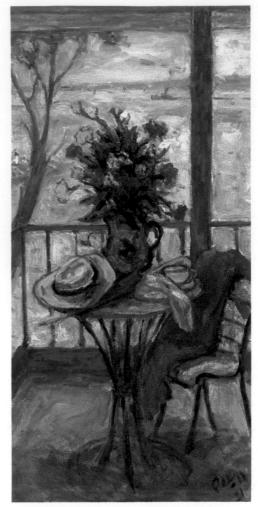

Gloucester Harbor, signed l.r. Courtesy of Chappellier Gallery, Inc., New York, New York.

According to connoisseur Frank Crowninshield, Philipp reached new artistic heights in the 1960s when, diverting from his academic background, "he . . . gained a freer, more unfettered command of both technique and subject matter." His gift for poetic imagery made his paintings highly prized by collectors.

Philipp worked in New York City until his death in 1981.

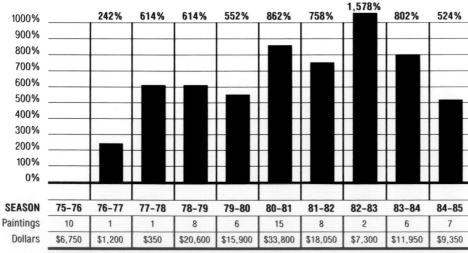

10-Year Average Change From Base Years '75-'76: 655%

SEASON	75-76	76-77	77-78	78-79	79-80	80-81	81-82	82-83	83-84	84-85
		242%	614%	614%	552%	862%	758%	1,578%	802%	524%
Paintings	10	1	1	8	6	15	8	2	6	7
Dollars	$6,750	$1,200	$350	$20,600	$15,900	$33,800	$18,050	$7,300	$11,950	$9,350

Record Sale: $7,500, SPB, 11/6/78, "Olympia," 37×51 in.

MEMBERSHIPS
Lotus Club
National Academy of Design
Royal Society of Arts

PUBLIC COLLECTIONS
Corcoran Gallery of Art, Washington, D.C.
Columbus Museum of Fine Arts, Georgia
Dallas Museum
High Museum of Art, Atlanta
Metropolitan Museum of Art, New York City
University of Illinois, Urbana
Whitney Museum of American Art,
 New York City

EMILE ALBERT GRUPPE
(1896-1978)

Emile Gruppe was the son of landscape artist Charles P. Gruppe, who lived and painted in Europe for 25 years before settling in the United States. Emile Gruppe was born in 1896 in Rochester, New York.

Gruppe had a very strong art background. In addition to being raised by an artistic father, he was also educated in his profession in the Hague in the Netherlands and at the National Academy of Design and the Art Students League in New York City. He also received instruction from artists George Bridgeman, Charles Chapman, Richard Miller and John F. Carlson, with whom he would later found the Gruppe Summer School in Gloucester, Massachusetts in 1942.

Gruppe's artistic career began in 1915, but was briefly interrupted in 1917, when he spent a year in the United States Navy. He made his permanent studio in Gloucester.

Although Gruppe is best known for his variety of impressionistic landscapes, he also painted figures and portraits. His modern style was largely inherited from French impressionist Monet. *Lily Pads* (date and location unknown), one of Gruppe's landscapes, attests to Monet's influence; it is similar to some of the paintings in Monet's "Water Lily" series.

Gruppe's prolific career brought him many awards and memberships. His popular painting *Winter—Vermont* (date and location unknown) won the Richard Mitton Award at the Jordon Marsh Exhibition in Boston in 1943. He died in 1978.

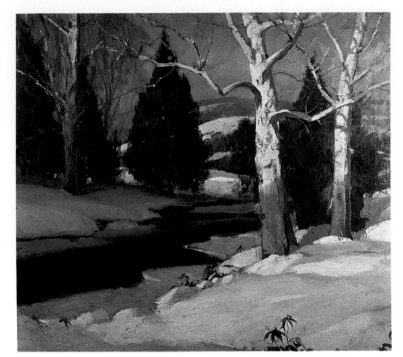

New England Winter Landscape, 30 x 32 in., signed l.l. Courtesy of Henry B. Holt, Inc., Essex Fells, New Jersey.

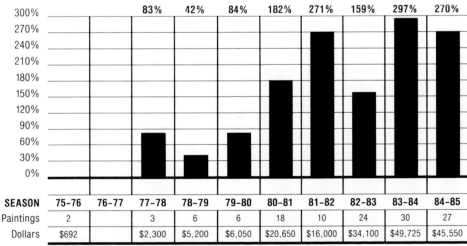

10-Year Average Change From Base Years '75–'76: 154%

SEASON	75-76	76-77	77-78	78-79	79-80	80-81	81-82	82-83	83-84	84-85
(% change)			83%	42%	84%	182%	271%	159%	297%	270%
Paintings	2		3	6	6	18	10	24	30	27
Dollars	$692		$2,300	$5,200	$6,050	$20,650	$16,000	$34,100	$49,725	$45,550

Record Sale: $7,500, P.NY, 2/20/85, "Winter Landscape with Stream," 40 × 40 in.

MEMBERSHIPS
Allied Artists of America
Audubon Artists of America
Connecticut Academy of Fine Arts
Gloucester Society of Artists
Northern Vermont Artists' Association
Rochester Art Association
Salmagundi Club, New York City

PUBLIC COLLECTIONS
Los Angeles County Museum of Art
White House, Washington, D.C.

LOUIS BOUCHE
(1896-1969)

An American artist of French descent, Louis Bouche established his reputation as a muralist and as a painter of representational, picturesque genre scenes. In addition to landscapes, Bouche was intrigued by urban interiors, such as barber shops, bowling alleys, cheap flats and theatrical dressing rooms.

Bouche was born in New York City in 1896. His grandfather was a barbizon painter, a friend of Millet and Daubigny. At age 12, following the death of his father, the young Bouche was taken to France by his mother. In Paris, he studied at the Atelier Colarossi, the Academie de la Grand Chaumiere and the Ecole des Beaux Arts.

Returning to the United States in 1915, Bouche continued his formal art training at New York City's Art Students League until 1916. After serving in the United States Navy, Bouche resumed his painting career. Until 1932, he executed many murals, including those in the Radio City Music Hall in New York City and in buildings of the United States Justice and Interior Departments in Washington, D.C.

In terms of easel painting, Bouche tried to strike a balance between two vastly different trends in twentieth-century art. His style combines the austere geometry of precisionism, an American idiom based on cubism, and the free forms and bright colors of Matisse and the fauves. In his *Still Life*

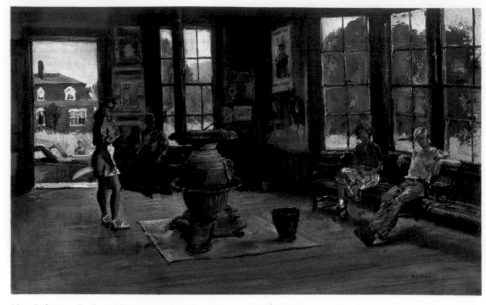

New Lebanon Railroad Station, N.D., 27 x 43 in., signed l.r. Courtesy of National Museum of American Art, Smithsonian Institution, Bequest of Henry Ward Ranger through the National Academy of Design.

with Flowers (1919, Columbus Gallery of Fine Arts), the artist displays a precisionist concern for the geometric arrangement of various compositional elements, such as the vase, jug, pitcher and other containers. This rational, Cezannesque organization is offset by the free forms of the flowers and the scalloped edges of the curtain.

In 1922, Bouche was given his first solo exhibition by Charles Daniel, an exponent of precisionist art, at the Daniel Gallery in New York City. In 1933, upon receiving a Guggenheim fellowship, Bouche traveled to Scandinavia and England. His approach to painting became more conservative.

Skilled in both mural and easel painting, Bouche demonstrated great versatility throughout his career. His works were displayed in numerous American and European exhibitions, and are included in several public and private collections.

Bouche died in Pittsfield, Massachusetts in 1969.

MEMBERSHIPS
National Society of Mural Painters
Society of Painters, Sculptors, and Engravers

PUBLIC COLLECTIONS
American Academy of Arts and Letters, New York City
Cincinnati Museum of Art
Columbus Gallery of Fine Arts, Ohio
Los Angeles County Museum of Art
Metropolitan Museum of Art, New York City
Pennsylvania Academy of the Fine Arts, Philadelphia
Philadelphia Museum of Art
Phillips Collection, Washington, D.C.
Whitney Museum of American Art, New York City

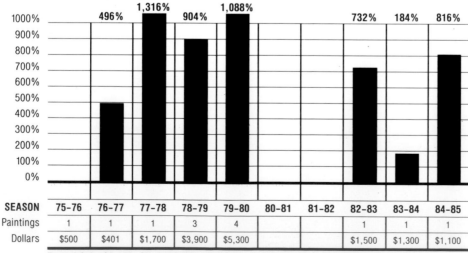

10-Year Average Change From Base Years '75-'76: 692%

SEASON	75-76	76-77	77-78	78-79	79-80	80-81	81-82	82-83	83-84	84-85
		496%	1,316%	904%	1,088%			732%	184%	816%
Paintings	1	1	1	3	4			1	1	1
Dollars	$500	$401	$1,700	$3,900	$5,300			$1,500	$1,300	$1,100

Record Sale: $2,400, CH, 5/22/80, "Self Portrait with Helmet," 29 × 22 in.

AIDEN LASSELL RIPLEY

(1896-1969)

An outdoorsman as well as a painter, Aiden Lassell Ripley was known for his sporting and wildlife scenes. His work was deeply influenced by Frank Benson, a loyal member of Edmund Tarbell's Boston School of American impressionism, who, after 1915, devoted himself to watercolors and etchings of wildlife and hunting subject matter. Ripley developed his own style, however, to communicate the exhilaration and refreshing experiences of outdoor life to his viewers.

He was born in Wakefield, Massachusetts in 1896. Following in the footsteps of his father, a musician, he became an accomplished musician as a boy; in fact, he contemplated a career in music for a time. Instead, however, he enrolled in the Fenway School of Illustration, and studied there until he joined the army at the start of World War I.

On his return, he began the rigorous classical art training program that Tarbell had established at the School of the Boston Museum of Art. There he studied under Philip Hale, another dedicated Tarbellite, and under Benson.

In 1924, Ripley was awarded a Paige Traveling Fellowship by the school; he spent two years abroad, mostly in France, Holland and North Africa. Away from the restricted academic environment of the school, he was able to experiment with watercolors and with the plein-air landscape painting to which Benson had introduced him. His enthusiasm for the new medium was reflected in the freshness of the colors he used and in the spontaneity of his brushwork.

He returned to Boston in 1926 and traveled along the East coast for a time, painting landscapes. He and Benson became close friends, and their association lasted until the older man's death in 1951.

On occasion, Ripley received commissions for historical mural paintings, including a series of 14 murals on the life

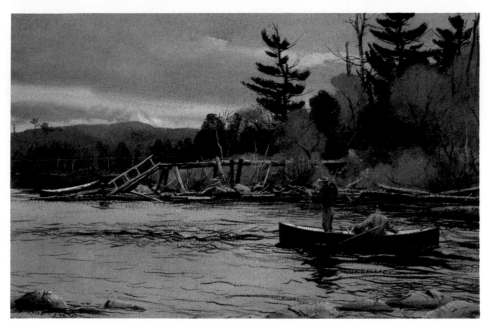

Landlocked Salmon Waters, 26 x 36 in., signed l.l. Courtesy of Kennedy Galleries, New York, New York.

of Paul Revere for the Paul Revere Insurance Company in Worcester, Massachusetts.

In the mid-1930s he settled in Lexington, Massachusetts, where he lived until his death in 1969. Although he frequently hunted in the woods and fields of Eastern Massachusetts, he also was an ardent conservationist and worked tirelessly to preserve wilderness areas and endangered species of wildlife.

MEMBERSHIPS

Allied Artists of America
American Artists' Professional League
American Watercolor Society
Audubon Artists
Boston Watercolor Society
Guild of Boston Artists
National Academy of Design
National Society of Mural Painters

PUBLIC COLLECTIONS

Art Institute of Chicago
High Museum of Art, Atlanta
Museum of Fine Arts, Boston

SEASON	75-76	76-77	77-78	78-79	79-80	80-81	81-82	82-83	83-84	84-85
Paintings						3	2	8	10	3
Dollars						$9,500	$5,600	$5,125	$11,600	$3,650

Record Sale: $4,000, S.W, 6/5/82, "Shooting the Flock," 19 × 28 in.

DONALD TEAGUE
(1897-)

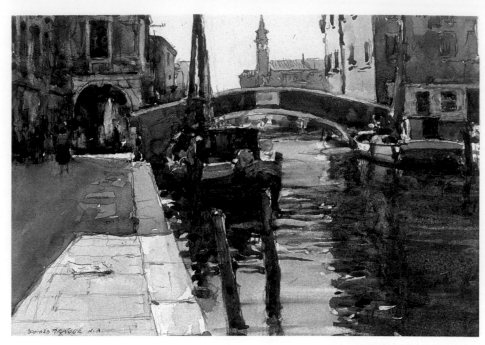

A Canal in Chiogga, 1985, 6 x 9 in., signed l.l. Courtesy of GWS Galleries, Southport, CT.

Donald Teague is considered one of America's most successful magazine illustrators, a success largely due to his attention to authenticity, detail and exactitude.

Born in Brooklyn, New York in 1897, Teague initially studied under George Bridgman and Frank V. Dumond at the Art Students League. After serving in the navy during World War I, Teague studied in England under Norman Wilkinson before returning to the United States. He then began his career as an illustrator.

Teague lived in Hollywood near the motion picture studios in the early days of his career, and he often used the Western props and theatrical sets as part of his subject matter. In addition, the California coastline served as inspiration for his sea illustrations.

Although Teague lived on the West coast, his work was commissioned largely for Eastern-based magazines. His illustrations appeared in *Colliers, McCall's, Saturday Evening Post* and *Woman's Home Companion*. Because of strong magazine rivalry, Teague has occasionally published under the pseudonym Edwin Dawes.

Always using a model for his work, Teague starts with a black-and-white sketch, which he converts to a small color study. He then projects the image onto a larger format before finally rendering it in watercolor or gouache.

Teague was elected to the National Academy of Design in 1948, and was the first artist to twice win the grand award and the gold medal of honor from the American Watercolor Society.

MEMBERSHIPS
American Artists Professional League
Artists Guild of the Authors' League
 of America
Society of Illustrators

PUBLIC COLLECTIONS
Charles and Emma Frye Museum, Seattle
Collection of the State of California,
 Sacramento
Virginia Museum of Fine Arts, Richmond

SEASON	75-76	76-77	77-78	78-79	79-80	80-81	81-82	82-83	83-84	84-85
Paintings							2		1	
Dollars							$21,750		$4,250	

Record Sale: $15,000, P.NY, 10/20/81, "Chuckwagon," 17 × 23 in.

JOHN STEUART CURRY
(1897-1946)

End Run, 1942-1946, 38½ x 59½ in., signed l.l. Courtesy of Kennedy Galleries, New York, New York.

During the Depression years of the 1930s, Americans delved within their heritage for strength and backbone. Abstract art was neglected for a time, and artists such as Thomas Hart Benton, Grant Wood and John Steuart Curry, realistic painters of the American scene, experienced a heady and beguiling popularity.

Curry, the son of Scottish-Presbyterian farmers, was born in Dunavant, Kansas in 1897. His mother fostered his drawing talent.

His education in art was thorough, starting at the Art Institute of Kansas. Then, from 1916 to 1918, he attended the Chicago Art Institute School, studying under E.J. Timmons and John W. Norton. He finished by attending Geneva College in Pennsylvania, from 1918 to 1919, and then studying with the illustrator Harvey Dunn.

Though he became a successful magazine illustrator from 1919 to 1926, Curry's work was too original to confine to illustration, and he left this career in 1926 to go to Paris, where he studied in Basil Schoukhaieff's Russian Academy.

The series of paintings of rural American life that he began soon after his return in 1927 firmly established his reputation, and remain among his best works. In 1932, he traveled with the Ringling Brothers Circus on its New England tour, producing a group of circus paintings.

Curry also painted murals for the federal government in Norwalk, Connecticut and in Washington, D.C., and for the Kansas State House. Though these huge murals received great acclaim when they were painted, they are now regarded as overblown and idealistic.

Curry taught at Cooper Union and at the Art Students League. In 1936 he was appointed artist-in-residence at the Agricultural College of the University of Wisconsin, where he taught until his death in Madison, Wisconsin in 1946.

By then, World War II had jolted America out of its isolationist cocoon and brought about an excessive reaction against the "American Scene" painters. Because of this repudiation, Curry's robust, painterly work has been consistently underrated.

Curry's most enduring paintings sprang from his Kansas farming roots: he excelled at depicting the raging of the weather and the plight of the common man confronted by the elements.

PUBLIC COLLECTIONS
Art Institute of Chicago
Department of the Interior Building, Washington, D.C.
Department of Justice Building, Washington, D.C.
Hackley Art Gallery, Muskegon, Michigan
Kansas State Capitol, Topeka
Metropolitan Museum of Art, New York City
Phillips Academy, Andover, Massachusetts
Whitney Museum of American Art, New York City
Wichita Art Museum, Kansas

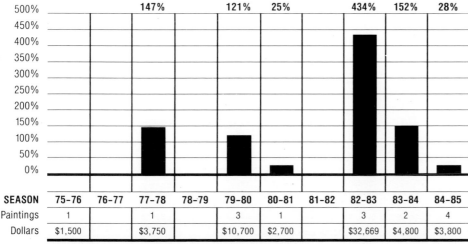

10-Year Average Change From Base Years '75-'76: 130%

	75-76	76-77	77-78	78-79	79-80	80-81	81-82	82-83	83-84	84-85
			147%		121%	25%		434%	152%	28%
SEASON	75-76	76-77	77-78	78-79	79-80	80-81	81-82	82-83	83-84	84-85
Paintings	1		1		3	1		3	2	4
Dollars	$1,500		$3,750		$10,700	$2,700		$32,669	$4,800	$3,800

Record Sale: $19,000, SPB, 6/2/83, "The Cloud," 24 x 30 in.

IVAN LE LORRAINE ALBRIGHT
(1897-)

Ivan Le Lorraine Albright's paintings are laboriously detailed, meticulous in their approach to abrupt tonal contrast and preoccupied with stylistically exaggerated human flesh. His style of "magic realism," which often reflects visceral overtones, displays an almost cryptic surrealism.

Born near Chicago in 1897, he was first exposed to art by his father, a painter who had studied under Thomas Eakins. A student of architecture in his adolescence, Albright turned to art after serving in World War I as a medical illustrator.

He studied painting between 1918 and 1924 at the Ecole des Beaux-Arts in Nantes, the Art Institute of Chicago, the Pennsylvania Academy of the Fine Arts, and the National Academy of Design.

Moving to Warrenville, Illinois in 1927, Albright immediately began to exhibit his lavishly gruesome and controversial paintings. In time, receiving numerous awards, he developed his theme—attacking human vanity by depicting the decay and rot of human flesh. His still lifes have a lost and perplexed aura, bathed in sinister light. In all of his work, there is no room for human comfort, optimism or joy. Known as a moralist in paint, Albright blends mysticism and realism.

Financial independence has given him the time to meticulously consider every square inch of the canvas. For this reason, he has produced relatively few paintings; in 1943 and 1944, it took him seven months to produce the life-sized portrait of Dorian Gray that was used in the MGM film *The Picture of Dorian Gray.*

Albright resides in Woodstock, Vermont.

The Picture of Dorian Gray, 1943-1944, 85 x 42 in., signed l.l.
Gift of the Artist, Courtesy of The Art Institute of Chicago.

MEMBERSHIPS
American Academy of Arts and Letters
American Water Color Society
Art Institute of Chicago Alumni Association
Chicago Society of Artists
Chicago Society of Painters and Sculptors
Laguna Beach Art Association
National Academy of Design
National Institute of Arts and Letters
Pennsylvania Academy of Fine Arts
Philadelphia Water Color Club
Springfield, Massachusetts Arts League

PUBLIC COLLECTIONS
Art Institute of Chicago
Brooklyn Museum
Carnegie Institute, Pittsburgh
Dallas Museum of Fine Arts
Library of Congress, Washington, D.C.
Metropolitan Museum of Art, New York City
Milwaukee Art Institute
Museum of Modern Art, New York City
National Gallery of Art, Washington, D.C.
Philadelphia Museum of Art
Solomon R. Guggenheim Museum,
 New York City
United States Labor Department Building,
 Washington, D.C.
Whitney Museum of American Art,
 New York City

SEASON	75-76	76-77	77-78	78-79	79-80	80-81	81-82	82-83	83-84	84-85
Paintings	1			1	1				1	
Dollars	$17,500			$6,500	$1,500				$8,000	

Record Sale: $17,500, SPB, 12/12/75, "Symbol of Drama, R. Riccardo in Guise," 90 × 42 in.

NICK EGGENHOFER

(1897-1985)

Gunfight at OK Corral, signed l.r. Courtesy of the National Cowboy Hall of Fame and Western Heritage Center, Oklahoma City, Oklahoma.

Foreign artists, especially Germans, were among the most fervent admirers of the American West and its most painstaking portrayers. Nick Eggenhofer, born in Bavaria, Germany in 1897, is a distinguished modern example.

Nurtured on the romantic misinformation exemplified by "Buffalo Bill" Cody's Wild West Show (which had recently toured Europe), as a child Eggenhofer also read any western literature he could find. He had great regard for the work of Western artist Frederic Remington and faithfully viewed the first American Western films when they came to Europe.

When he came to the United States with his family in 1913, at age 16, Eggenhofer's ambitions had been shaped by the popularization of the West. He went on to become one of the leading illustrators of this relatively brief period in American history.

Three years after his emigration, he began night school, attending art classes for four years at Cooper Union in New York City. Simultaneously, he learned lithography on the job at the American Lithography Company.

With his first commission from *Western Story* magazine in 1920, Eggenhofer started on an incredibly prolific career of magazine and book illustration, easel painting and sculpture, producing an estimated 30,000 paintings and drawings, and illustrating 35 books. Though much of his work was done for "pulp" publishers such as Street & Smith, it was distinguished by careful research and accuracy; he even wrote and illustrated a book on Western transportation.

When Eggenhofer married in 1925, he and his wife traveled by Model T to Santa Fe, New Mexico. Though the glory days of the West were long past, he still saw vestiges of the old ways.

He made his home for much of his life in a log cabin he built himself in New Jersey, but he finally moved to the land of his dreams, Cody, Wyoming, in 1965. He died in 1985.

MEMBERSHIPS
National Academy of Western Art

SEASON	75-76	76-77	77-78	78-79	79-80	80-81	81-82	82-83	83-84	84-85
Paintings						5	26	11	10	2
Dollars						$49,700	$96,950	$11,800	$37,175	$3,600

Record Sale: $27,000, SPB, 4/23/81, "The Watchers," 15 × 20 in.

ELSIE DRIGGS
(1898-)

Elsie Driggs was a precisionist painter in the 1920s, one of a group of artists best known as the first generation of abstract painters in the United States. She is noted for her paintings of industrial landscapes in a precise, geometrical style, influenced by the latest trends in European modernism, but almost classical in purity of line and form.

Driggs was born in Hartford, Connecticut, and studied at the Art Students League in New York City from 1919 to 1925, at a time when new movements toward modernism in European painting were beginning to affect a small group of American painters.

In 1922, Driggs traveled to Italy, studying under Maurice Stern in Rome. In Italy, Driggs was deeply impressed with the art of the futurists, who celebrated the power of industrial technology as a force of cultural revolution.

Back in the United States, Driggs became an energetic proponent of the industrial landscape as artistic subject matter. She came to be associated with the precisionist movement of the 1920s, a type of cubist-realism which attempted to synthesize various levels of geometrical abstraction with the treatment of realistic subject matter.

Driggs became best known for her paintings of Pittsburgh steel mills, notable for their emphasis on cylindrical forms, weighty in mass, but classical in purity of line. Another prominent characteristic of Driggs's paintings was the use of ray lines, or lines-of-force, as in the artist's painting *Queensboro Bridge* (1927, Montclair Art Museum).

Driggs's paintings were exhibited and sold through the Daniel Gallery in New York City from 1924 to 1932. During the 1930s, she executed murals for the Federal Art Project, and was awarded a Yaddo Foundation fellowship in 1935. Although she was a prominent early American modernist in the 1920s and 1930s, little has been written about her later career.

Elsie Driggs is the widow of artist Lee Gatch.

Pittsburgh, 1927, 34¼ x 40 in., signed l.r. Courtesy of The Whitney Museum of American Art, New York, New York.

MEMBERSHIPS
New York Society of Women Artists

PUBLIC COLLECTIONS
Montclair Art Museum, New Jersey

SEASON	75–76	76–77	77–78	78–79	79–80	80–81	81–82	82–83	83–84	84–85
Paintings				1	2	2	1	2		2
Dollars				$16,000	$12,000	$1,300	$550	$1,100		$2,000

Record Sale: $16,000, SPB, 4/20/79, "Aeroplane," 44 × 38 in.

REGINALD MARSH
(1898-1954)

Reginald Marsh was a second-generation Ashcan School artist and illustrator, best known for his Depression-era portrayals of New York City life. He remains especially renowned for his depictions of the urban crowd, painted in a style reminiscent of Hogarth and certain of the old masters, yet entirely contemporary in subject matter.

Marsh was born in 1898 in Paris, and grew up in Nutley, New Jersey. He graduated in 1920 from Yale, and continued his studies at the Art Students League of New York under the tutelage of John Sloan, George Luks and Kenneth Hayes Miller.

Throughout the 1920s, Marsh supported himself as an illustrator for the *New York Daily News, Harper's Bazaar* and many other periodicals. Between 1922 and 1925, Marsh produced more than 4,000 illustrations for the *Daily News* alone.

An admirer of Peter Paul Rubens and Eugene Delacroix, Marsh sought in his own painting to depict contemporary urban life in the style of the old masters. While his choice of urban subject matter owed much to his teachers, his fascination with the human crowd in all its sweaty and tawdry aspects was entirely individual for an artist of his time.

Marsh's better-known subjects include crowded subways, burlesque theaters, Bowery bums and amusement parks. His paintings, most often done in watercolor and egg tempera, tend strongly toward phantasmagoric views of crowds of people indulging in vulgar, yet exuberant social rituals.

Marsh's paintings were widely exhibited during his lifetime, and he received many awards. He taught at the Art Students League from 1935 until his death in 1954, in Dorset, Vermont. His work has been the subject of major retrospective exhibits.

End of the Fourteenth Street Crosstown Line. Courtesy of The Pennsylvania Academy of the Fine Arts, Philadelphia.

MEMBERSHIPS
National Academy of Design
National Institute of Arts and Letters

PUBLIC COLLECTIONS
Art Institute of Chicago
Museum of Modern Art, New York City
Whitney Museum of American Art,
 New York City

SEASON	75-76	76-77	77-78	78-79	79-80	80-81	81-82	82-83	83-84	84-85
Paintings		5	1	13	51	99	43	37	42	18
Dollars		$25,300	$3,250	$59,500	$259,146	$361,077	$200,100	$94,025	$223,850	$40,350

Record Sale: $42,000, SPB, 12/8/83, "Band Playing by the Hudson," 24 × 30 in.

PAVEL TCHELITCHEW
(1898-1957)

In the course of his career, Russian-born painter Pavel Tchelitchew worked in many styles and changed his artistic point of view several times. He began painting in the cubist idiom, became a figure painter in the manner of the early Picasso, and then moved on to neo-romanticism, with strong overtones of surrealism in his later work. To create a sense of motion in his work, he developed his own distinctive concept of cubist simultaneity, using multiple views of the same face or figure in a single painting.

Born on his family's estate outside Moscow in 1898, he was studying in Moscow at the time of the 1917 Revolution. He fled to Kiev and enrolled in the Academy of Art where Alexandra Exter, a pupil of Leger, influenced his early thinking.

With the Communists entrenched in Russia, Tchelitchew went to Berlin and worked as a stage designer. Then, in 1923, he went to Paris, where he abandoned cubism altogether and began painting realistic landscapes and portraits. He was much impressed by the paintings of Picasso's pink and blue periods, which Gertrude Stein showed him. Soon he too adopted a muted palette, at times using only earth tones, at other times only black and white. His subjects also took on the same tragic overtones as Picasso's.

In the mid-1920s, he turned to neo-romanticism, and then to his experi-

Interior Landscape, ca. 1949, 20 x 18½ in. Courtesy of Hirshhorn Museum and Sculpture Garden, Smithsonian Institution, Washington, D.C.

ments with multiple images. At the same time, he was commissioned to design sets and costumes for two Diaghilev ballets.

Tchelitchew's recurring interests in childhood and in metamorphosis were combined in what many consider to be one of his most important paintings, *Hide-and-Seek* (1942, Museum of Modern Art). In it the hands, feet and heads of the children playing the game are metamorphosed into the very trees in which they are hiding.

He continued painting in this vein into the early 1950s. In 1954, however, worn out and ill, he moved to Italy. He died there three years later.

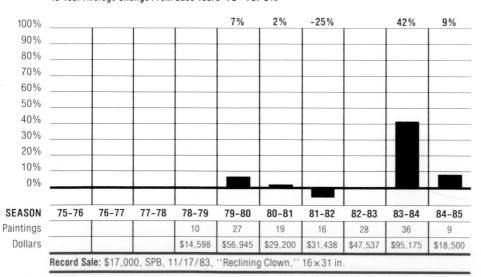

10-Year Average Change From Base Years '78-'79: 5%

SEASON	75-76	76-77	77-78	78-79	79-80	80-81	81-82	82-83	83-84	84-85
					7%	2%	-25%		42%	9%
Paintings				10	27	19	16	28	36	9
Dollars				$14,598	$56,945	$29,200	$31,438	$47,537	$95,175	$18,500

Record Sale: $17,000, SPB, 11/17/83, "Reclining Clown," 16 x 31 in.

PUBLIC COLLECTIONS
Metropolitan Museum of Art, New York City
Museum of Modern Art, New York City
Nelson Gallery of Art, Kansas City, Missouri
Santa Barbara Museum of Art, California
Tretyakow Art Gallery, Moscow
Wadsworth Athenaeum, Hartford, Connecticut

KAY SAGE
(1898-1963)

Although her work was influenced by, and tended to be overshadowed by, that of her husband, surrealist painter Yves Tanguy, Kay Sage was very much a surrealist painter in her own right. At first she did indeed draw on her husband's forms and compositions, but in time she developed a pictorial vocabulary all her own. There was an existentialist emptiness about her infinite landscapes. Complex architectural forms were often hung with lengths of drapery; sometimes the drapery itself formed stiff, independent masses in a desert vastness.

She was born in Albany, New York in 1898. Her parents were divorced when she was a child, and she spent much of her youth traveling and living with her mother in Europe.

She was almost entirely self-taught as an artist. In the early 1920s, while recovering from an unhappy love affair, she was influenced by Onorato Carlandi, an elderly Italian artist and liberal, who taught her the importance of individuality. In 1925, she married a Roman prince, but the marriage ended 10 years later.

She settled in Paris in 1935, and immediately met and became part of the thriving circle of surrealist painters there. It was through this association that her own work began to come into focus, and that she met Tanguy.

When World War II broke out, Sage returned to New York and Tanguy followed her. They were married in 1940 and settled in Woodbury, Connecticut. The 1940s and 1950s were disciplined and productive years for her. Her work was exhibited regularly and she began to be recognized as an artist apart from her husband.

Tanguy died suddenly in 1955 and three years later, after a cataract operation, Sage lost part of her vision. Loath to work without full control of her technique, she attempted suicide, but was revived. In 1963, however, depressed by illness, she shot herself.

Festa, 1947, 18 x 14 in., signed l.r. Courtesy of Jeffrey Hoffeld and Company, New York, New York.

PUBLIC COLLECTIONS
Art Institute of Chicago
California Palace of the Legion of Honor,
 San Francisco
Metropolitan Museum of Art, New York City
Museum of Modern Art, New York City
Whitney Museum of American Art,
 New York City

SEASON	75-76	76-77	77-78	78-79	79-80	80-81	81-82	82-83	83-84	84-85
Paintings	1			1			2		1	
Dollars	$1,166			$19,000			$2,450		$1,200	

Record Sale: $19,000, SPB, 11/1/78, "Point of Intersection," 39 x 32 in.

BEN SHAHN
(1898-1969)

Ben Shahn was a painter and print-maker, photographer and art theorist, considered by many critics to be one of the foremost representatives of social realism in twentieth-century American art.

Shahn was born in Kovno, Lithuania, the son of a woodcarver with strong socialist ideas. His father was exiled to Siberia for political activities, but he escaped and fled to the United States, where he was joined by his family in 1906.

Shahn grew up in Brooklyn, and began his apprenticeship as a lithographer in 1913. He subsequently worked his way up to the level of master lithographer, earning enough to study at the Educational Alliance Art School, the Art Students League, New York University and the National Academy of Design.

In 1925, Shahn traveled to Paris, where he studied at the Sorbonne and at the Academie de la Grande Chaumiere. He remained in Europe for most of the next four years.

Shahn felt alienated by the social detachment of many European abstractionists, to say nothing of the fascist leanings of many European intellectuals. For him abstractionism seemed to be an empty gesture signaling both contempt for all society and the artist's withdrawal from communication.

For Shahn and many others of his contemporaries, the alternative to abstraction was an art of social comment, which came to be known as social realism. It sought to lend artistic expression to socialist criticism of American economic conditions.

Upon his return to the United States in 1929, Shahn became an eloquent spokesman against abstraction and for an art of human and social content. Like other social realists, Shahn sought to dignify the plight of the poor and assault

Blind Accordian Player, 1945, 25½ x 38¼ in., signed l.r. Courtesy of Neuberger Museum, State University of New York at Purchase. Gift of Roy R. Neuberger. © Estate of ben Shahn/VAGA, New York, 1985.

the consciences of the rich. He succeeded far beyond the accomplishments of most of his contemporaries.

Shahn first attained notoriety with his series of biting satires on the trials of Sacco and Vanzetti, painted between 1931 and 1932. In 1933, he worked as an assistant to Diego Rivera on murals for the RCA Building, the Rockefeller Center and the New Worker's School in New York City.

In the mid-1930s, Shahn worked as a photographer for the Farm Security Administration, and in 1938 he completed his first murals for the community center and school building of the resettlement administration housing project at Jersey Homesteads (now Roosevelt), New Jersey.

In the 1940s, Shahn painted murals for the Social Security Building (now the Department of Health, Education, and Welfare) in Washington, D.C. and

served as senior liaison officer for the graphics division of the Office of War Information.

In the 1950s, Shahn published several influential works of criticism, including *The Shape of Content* (1957). His work was included in international circulating exhibitions of the Museum of Modern Art in 1961 through 1963, and was the subject of important retrospective exhibits by the Museum of Modern Art and the Major Gallery of London in 1947, by the New Jersey State Museum in Trenton in 1969, and by the Ishibashi Memorial Hall of Kurume, Japan in 1970.

Shahn died in New York City in 1969.

PUBLIC COLLECTIONS
Albright-Knox Art Gallery, Buffalo, New York
Art Institute of Chicago
Baltimore Museum of Art
Brooklyn Museum
Carnegie Institute, Pittsburgh
Detroit Institute of Arts
Metropolitan Museum of Art, New York City
Museum of Modern Art, New York City
Pennsylvania Academy of the Fine Arts,
 Philadelphia
Phillips Collection, Washington, D.C.
St. Louis Art Museum
Virginia Museum of Fine Art, Richmond
Whitney Museum of American Art,
 New York City

SEASON	75-76	76-77	77-78	78-79	79-80	80-81	81-82	82-83	83-84	84-85
Paintings	2	4	3	6	11	6	5	3	9	4
Dollars	$44,000	$76,000	$34,000	$71,750	$32,100	$16,650	$13,850	$3,200	$16,850	$16,900

Record Sale: $36,000, SPB, 4/20/79, "Carnival," 22 × 29 in.

ALEXANDER CALDER
(1898-1976)

Alexander Calder, internationally famous by his mid-30s, is renowned for developing a new idiom in modern art—the mobile.

His works in this mode, from miniature to monumental, are called mobiles (suspended moving sculptures), standing mobiles (anchored moving sculptures) and stabiles (stationary constructions).

Calder's abstract works are characteristically direct, spare, buoyant, colorful and finely crafted. He made ingenious, frequently witty, use of natural and manmade materials, including wire, sheetmetal, wood and bronze.

Calder was born in 1898 in Philadelphia, the son of Alexander Stirling Calder and grandson of Alexander Milne Calder, both well-known sculptors.

After obtaining his mechanical engineering degree from the Stevens Institute of Technology, Calder worked at various jobs before enrolling at the Art Students League in New York City in 1923. During his student years, he did line drawings for the *National Police Gazette*.

In 1925, Calder published his first book, *Animal Sketches*, illustrated in brush and ink. He produced oil paintings of city scenes, in a loose and easy style. Early in 1926, he began to carve primitivist figures in tropical woods, which remained an important medium in his work until 1930.

In June 1936, Calder moved to Paris. He took some classes at the Academie de la Grande Chaumiere and made his first wire sculptures.

Calder created a miniature circus in his studio; the animals, clowns and tumblers were made of wire and animated by hand. Many leading artists of the period attended, and helped with, the performances.

Calder's first New York City exhibition was in 1928, and other exhibitions in Paris and Berlin gained him international recognition as a significant artist. A visit to Piet Mondrian's studio proved

Four Black Dots, 1974, 29½ x 43 in., signed l.r. Courtesy of Collection The Whitney Museum of American Art, New York, New York, Gift of the Howard and Jean Lipman Foundation, Inc. ©ADAGP, Paris/VAGA, N.Y. 1985.

pivotal. Calder began to work in an abstract style, finishing his first non-objective construction in 1931.

In early 1932, he exhibited his first moving sculpture in an exhibition organized by Marcel Duchamp, who coined the word "mobile." In May 1932, Calder's fame was consolidated by the first United States show of his mobiles. Some were motor-driven. His later wind-driven mobiles enabled the sculptural parts to move independently, as Calder said, "by nature and chance."

Calder returned to the United States to live and work in Roxbury, Massachusetts in June 1932.

From the 1940s on, Calder's works, many of them large-scale outdoor sculptures, have been placed in virtually every

major city of the Western world. In the 1950s, he created two new series of mobiles: "Towers," which included wall-mounted wire constructions, and "Gongs," mobiles with sound.

Calder was prolific and worked throughout his career in many art forms. He produced drawings, oil paintings, watercolors, etchings, gouache and serigraphy. He also designed jewelry, tapestry, theatre settings and architectural interiors.

Calder died in 1976.

MEMBERSHIPS
National Institute of Arts and Letters

PUBLIC COLLECTIONS
Art Institute of Chicago
Guggenheim Museum, New York City
Hirshhorn Museum and Sculpture Garden, Washington, D.C.
Metropolitan Museum of Art, New York City
Museum of Modern Art, New York City
Museum of Science and Industry, Chicago
Museum of Western Art, Moscow
Philadelphia Museum of Art
UNESCO Building, Paris
Whitney Museum of American Art, New York City

SEASON	75-76	76-77	77-78	78-79	79-80	80-81	81-82	82-83	83-84	84-85
Paintings	8		2	68	71	38	49	53	57	35
Dollars	$36,404		$6,107	$161,951	$219,770	$97,107	$165,495	$115,198	$157,314	$115,709

Record Sale: $45,800, GK.Z, 11/11/81, "Circus," 26 x 36 in.

JOHN McLAUGHLIN
(1898-1976)

John McLaughlin was an artist whose work and recognition as a significant painter developed slowly. His strict abatement of imagery, using only the essential geometric forms, made him a hard-edged abstractionist and made his paintings entities unto themselves.

Born in Sharon, Massachusetts in 1898, McLaughlin enlisted in the navy during World War I, thereafter entering the real estate business in Boston and Chicago. In 1935, he went to Japan, where he would stay for many years studying the language and oriental art and philosophy. Upon his return to Boston, he dealt in Japanese prints and began to paint. Only after serving in World War II, from 1941 to 1945, did he decide to devote all of his time to painting.

Returning home in 1945, he built his home and studio in Dana Point, California. In 1952, McLaughlin's work began to appear in West coast group exhibitions, followed by East coast interest in his paintings a few years later. In 1960, he had his first one-man show at the Pasadena Art Museum in California.

McLaughlin's paintings reflect an absorption of European, nonobjective art. With his personal postulation of totally abstract art, which stems from his spiritual search in the Orient, there is a visual serenity which contains the powerful emptiness of Zen. His straightforward approach to simple edges and vividly articulated shapes significantly foreshadowed minimal art by pointing out the importance of seeing the void in tangible forms.

McLaughlin spent his last few years working out of a studio in Laguna Beach, California. He died in 1976.

#1-1974, 1974, 60 x 48 in. Private Collection. Photograph courtesy of Andre Emmerich Gallery, Inc., New York.

SEASON	75-76	76-77	77-78	78-79	79-80	80-81	81-82	82-83	83-84	84-85
Paintings						4	7		1	7
Dollars						$39,500	$34,200		$6,000	$48,000

Record Sale: $14,000, CH, 5/13/81, "1, 1974," 60 × 48 in.

MARGUERITE STUBER PEARSON
(1898-1978)

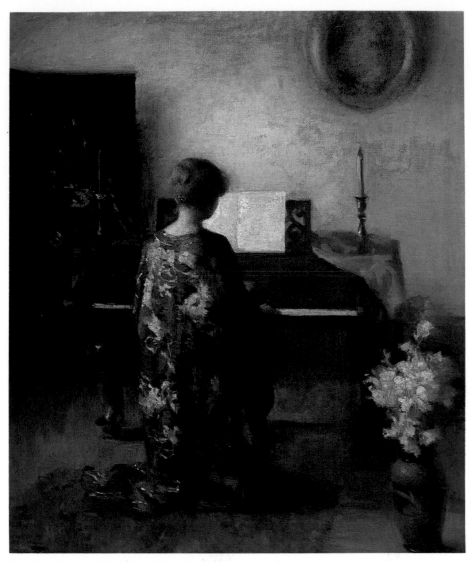

The Music Room, 1924, 36¼ x 30 in., signed l.l. Courtesy of Vose Galleries of Boston, Inc., Massachusetts.

Painter Marguerite Stuber Pearson contracted polio as a young woman during a European trip, and lived as a paraplegic for the rest of her long life. She won so much respect as an artist that her disability proved to be incidental to her career.

Born in Philadelphia, Pennsylvania in 1898, Pearson attended the Boston Museum Art School, studying under William James and Frederick Bosley. She began work as a magazine and newspaper illustrator. She held her first one-man show in 1922 and soon became a successful full-time painter.

Pearson studied figure painting with Edmund C. Tarbell and landscape painting with Aldro T. Hibbard, who influenced her strongly. In addition to concentrated study with several other artists, she belonged to a long roster of arts and artists' groups.

She began summering in Rockport, Massachusetts before 1920, and moved there permanently in 1941. Receiving mostly positive critical notice, she enjoyed a substantial popularity and continued to win awards for her work until her last days; she was also in great demand as an art teacher and juror. Much loved and respected, and an integral part of her community, she died in Rockport in 1978.

Though her subject matter was varied, encompassing portraits, landscapes, still lifes and interior scenes, her style was coherent and assured. The balance of her compositions and the precision of her observation were enlivened by her obvious enjoyment of her craft and her sensitivity to her subjects. Her interior genre scenes, though slightly dated, have enduring qualities of light and life.

MEMBERSHIPS
Allied Artists Association
American Artists Professional League
Art Club of Washington
North Shore Artists Association
Philadelphia Artists Association

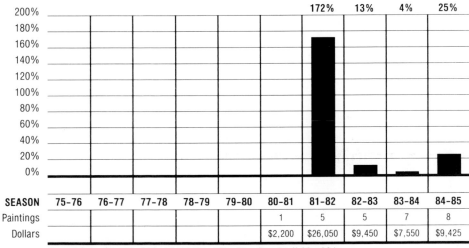

10-Year Average Change From Base Years '80–'81: 43%

SEASON	75–76	76–77	77–78	78–79	79–80	80–81	81–82	82–83	83–84	84–85
							172%	13%	4%	25%
Paintings						1	5	5	7	8
Dollars						$2,200	$26,050	$9,450	$7,550	$9,425

Record Sale: $7,500, SPB, 12/10/81, "The Blue Danube," 30 × 36 in.

881

ROBERT BRACKMAN
(1898-1980)

A highly successful portrait artist, Robert Brackman was known for his sharply realistic style. He painted such notables as John D. Rockefeller, Jr., Charles Lindbergh, Anne Morrow Lindbergh and John Foster Dulles. Other portraits were commissioned by the State Department and the Air Force Academy.

Born in Odessa, Russia in 1898, Robert Brackman emigrated to the United States in 1908. He began his studies at the Ferrer School in San Francisco. Later, he worked under George Bellows and Robert Henri at the National Academy of Design.

Between 1934 and 1944, Brackman mounted seven one-man shows at the Macbeth Gallery in New York City. By 1940, despite the fact that he charged $3,500 for his portraits, he was able to select the three or four sitters he wished to paint each year from the more than 20 who sought his services. Active almost until his death in 1980, Robert Brackman won many coveted awards and is still widely exhibited across the country.

A dedicated teacher, Brackman taught at the Art Students League from 1934 to 1975. He also instructed at the American Art School in New York City, the Brooklyn Museum School, the Lyme Art Academy and the Madison Art School in Connecticut.

Strongly influenced by the post-impressionists in his early years, Robert Brackman maintained his interest in color and form as his style grew more realistic. His compositions are dispassionate, balanced and meticulous, while his subjects are treated in a manner that is both graceful and dignified.

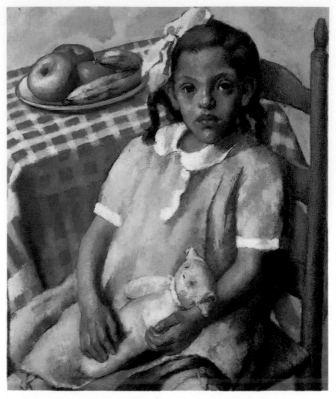

Somewhere in America, ca. 1933-1934, 30⅛ x 25⅛ in., signed u.l. Courtesy of National Museum of American Art, Smithsonian Institution, Transfer from U.S. Department of Labor.

MEMBERSHIPS
Advisory Council of the Huntington
 Hartford Foundation
Allied Artists of America
American Water Color Society
Art Students League
Audubon Society
Connecticut Academy of Fine Arts
National Pastel Society's Hall of Fame
Mystic, Connecticut Academy of Fine Arts
Royal Society of Arts
Wilmington Society of Artists

PUBLIC COLLECTIONS
Atlanta Art Association
Art Museum of the New Britain Institute,
 Connecticut
Brooklyn Museum
Brooks Memorial Art Gallery, Memphis, Tennessee
Bryn Mawr College, Pennsylvania
Canajoharie Library and Art Gallery, New York
Colonial Williamsburg
Davenport Municipal Art Gallery, Iowa
Delaware Art Center, Wilmington
Harry and Della Rockford Gallery,
 Rockford, Illinois
Harvard University
Honolulu Academy
Metropolitan Museum of Art, New York City
Minneapolis Institute of Arts, Minnesota
Montclair Art Museum, New Jersey
New Haven Public Library, Connecticut
Norton Gallery and School of Art,
 Pasadena, California
Princeton University
Toledo Museum of Art, Ohio
United States Military Academy
United States State Department
University of Chicago
University of Connecticut
University of Georgia
University of Rochester
Walter P. Chrysler Museum of Art,
 Norfolk, Virginia
Yale University

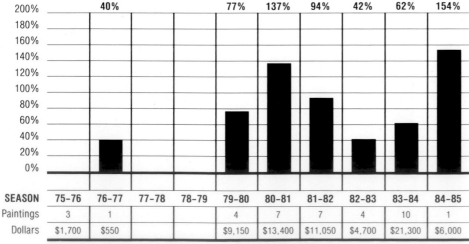

10-Year Average Change From Base Years '75-'76: 76%

SEASON	75-76	76-77	77-78	78-79	79-80	80-81	81-82	82-83	83-84	84-85
		40%			77%	137%	94%	42%	62%	154%
Paintings	3	1			4	7	7	4	10	1
Dollars	$1,700	$550			$9,150	$13,400	$11,050	$4,700	$21,300	$6,000

Record Sale: $6,500, CH, 3/23/84, "Young Women," 50×47 in.

882

OLAF S. WIEGHORST
(1899-)

Olaf S. Wieghorst, the "dean of Western Art," was born in Denmark in 1899, the son of an etcher and engraver. When he was a boy, his father introduced him to both painting and horses, a combination that laid the foundation for his career as a painter in oil of traditional Western scenes and especially as portraitist, illustrator and sculptor of horses.

Wieghorst's first career was as "Little Olaf—the Miniature Acrobat," a career soon ended by World War I. During the war, he was apprenticed first .in a store and then on a farm, where the riding lessons his father had given him proved useful. During these years, the boy became enamoured of the "Wild West," a fascination that was never to leave him.

In New York City in 1918, he jumped the ship he was working on to pursue his dream of the West. Wieghorst enlisted in the cavalry and served three years on the Mexican border. Mustering out, he found work as a ranch hand on the Quarter Circle 2C Ranch, whose brand became his insignia. In 1923, he returned to New York City to marry and spent 20 years there as a policeman assigned to the Police Show Team of the Mounted Division.

Although he painted as a child—his first painting was sold in Denmark for 40 American cents—Wieghorst lacked formal education. In New York, he had continued to. paint from his experiences in the Southwest, and he began to study by visiting museums and galleries.

In 1940, he obtained an agent, and his paintings immediately sold as calendar art and Western illustrations. Wieghorst retired from the police force in 1944 and eventually settled in El Cajon, California, where he changed his style from calendar art to fine art. He stated that Western art had a responsibility, that there was "a story that needed telling . . . a heritage worthy of preservation."

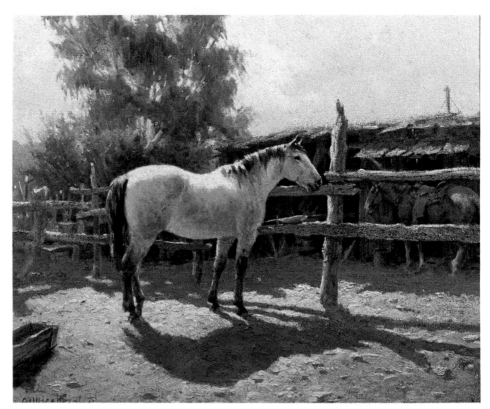

The Gray Horse, 1951, 20 x 24 in., signed l.l. Courtesy of Wunderlich and Company, Inc., New York, New York.

By 1955, there was a waiting list of buyers for Wieghorst's work.

"Horses have been my life," Wieghorst says. And the central image of many of his works is the horse, painted with an authenticity of both anatomy and emotion that could come only from an artist who devoted his life to studying and painting his subjects.

Wieghorst is a master of realism, although his paintings, with their fine flat strokes, have a post-impressionistic quality. Working from sketches made during many travels through the Southwest, Wieghorst insists on authenticity in his work. He has a museum-quality collection of Western artifacts and memorabilia that provide detail for his paintings.

Wieghorst's canvases are held mostly in private collections throughout the world, including those of many public figures from the political and entertainment worlds.

SEASON	75-76	76-77	77-78	78-79	79-80	80-81	81-82	82-83	83-84	84-85
Paintings	1	1	1	2	30	6	9	2	6	5
Dollars	$12,500	$3,000	$3,250	$5,800	$137,975	$108,150	$110,150	$10,000	$23,700	$29,350

Record Sale: $39,000, SPB, 10/17/80, "Late Mail," 36 × 30 in.

PUBLIC COLLECTIONS
Amon Carter Museum of Western Art, Fort Worth, Texas

RAPHAEL SOYER
(1899-)

Farewell to Lincoln Square (Pedestrians), 1959, 60⅜ x 55⅛ in., signed l.r. Courtesy of Hirshhorn Museum and Sculpture Garden, Smithsonian Institution, Washington, D.C.

Russian-born artist Raphael Soyer is best known for his compassionate, naturalistic depictions of urban subjects. His sensitive, penetrating portrayals include a broad range of city dwellers: Bowery bums, dancers, seamstresses, shoppers, office workers and fellow artists. Historically, Soyer is associated with the social realist artists of the 1930s, whose art championed the cause of social justice.

Born in Tombov, Russia in 1899, Soyer emigrated with his family to the United States in 1912. His siblings included a twin brother, Moses, and a brother, Isaac, who became successful artists. After settling with his family in New York City, the young Soyer pursued an art education at Cooper Union from 1914 to 1917, at the National Academy of Design from 1918 to 1922, and intermittently at the Art Students League.

Soyer's earliest work was consciously primitive in manner. Until the late 1920s, he typically used frontal presentations, shallow pictorial space and figures rendered in caricature. Later, he developed a brushy, more gestural style that was tonal rather than coloristic. These early works are reminiscent of the paintings of Edgar Degas.

Soyer's interest in depicting his urban environment was expressed early in his career in works such as *Sixth Avenue* (ca. 1930-1935, Wadsworth Atheneum). As the Depression continued, the artist turned more and more to subjects directly related to the prevailing economic difficulties. One result of the mass unemployment of the 1930s that caught Soyer's imagination was the new role of independent working women. Hemmed in by the crowd, the self-absorbed women in *Office Girls* (1936, Whitney Museum of American Art) are shown walking to or from work. Soyer's sympathetic study of unemployed men in *Transients* (1936, University of Texas) is an example of a less propagandistic social realist work. In addition to paintings, he executed a number of lithographs of Depression scenes.

Soyer developed his subjects from New York City's poorer sections. Unlike the painters of the Ashcan School 25 years earlier, Soyer and his contemporaries did not view the city as a picturesque spectacle. Instead, they dwelt on the grim realities of poverty and indus-

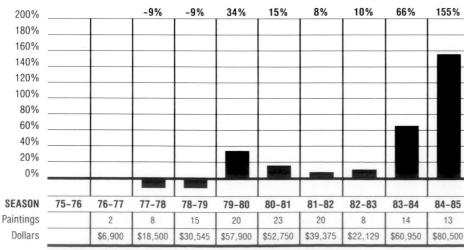

10-Year Average Change From Base Years '76-'77: 30%

		-9%	-9%	34%	15%	8%	10%	66%	155%	
SEASON	75-76	76-77	77-78	78-79	79-80	80-81	81-82	82-83	83-84	84-85
Paintings		2	8	15	20	23	20	8	14	13
Dollars		$6,900	$18,500	$30,545	$57,900	$52,750	$39,375	$22,129	$60,950	$80,500

Record Sale: $45,000, SPB, 12/6/84, "Window Shoppers," 36 × 24 in.

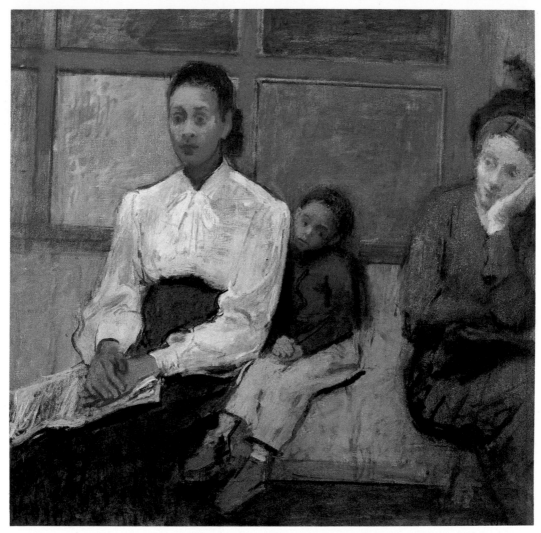

Passengers, 1953, 30 x 31 in., signed l.r. Photograph courtesy of Kennedy Galleries, New York, New York.

trialization. Soyer's work, however, is less issue-oriented than that of fellow social realist artists Philip Evergood and Ben Shahn.

After 1940, Soyer began to concentrate on the subject of women at work or posing in his studio. His technique grew more sketchy during the 1950s, but in his ambitious painting *Homage To Eakins* (1964-1965, National Portrait Gallery), he rendered the figures in a manner typical of his early work.

Between 1953 and 1955, he edited *Reality.* He later wrote *Painter's Pilgrimage* (1962), *Homage to Thomas Eakins* (1966), *Self-Revealment: A Memoir* (1969) and *Diary of an Artist* (1977). In 1967, Soyer was given a retrospective at the Whitney Museum of American Art, and his paintings have been displayed at many museums and galleries. He has taught at the Art Stu-dents League, the New School and the National Academy of Design in New York City.

MEMBERSHIPS
National Academy of Design
National Institute of Arts and Letters

PUBLIC COLLECTIONS
Addison Gallery of American Art,
 Andover, Massachusetts
Albright-Knox Art Gallery, Buffalo,
 New York
Brooklyn Museum
Columbus Gallery of Fine Arts, Ohio
Corcoran Gallery of Art, Washington, D.C.
Detroit Institute of Arts
Metropolitan Museum of Art, New York City
Museum of Fine Arts, Boston
Museum of Modern Art, New York City
Nasjonalgalleriet, Oslo, Norway
Newark Museum, New Jersey
Phillips Gallery, Washington, D.C.
Whitney Museum of American Art,
 New York City

MOSES SOYER
(1899-1974)

Men on the Waterfront 111, 1938, 20 x 30 in., signed u.r. Photo courtesy of ACA Galleries, New York, New York.

Born in czarist Russia in 1899, Moses Soyer was one of three artistic brothers. Raphael was his identical twin. The Soyer brothers were raised in an intellectual atmosphere created by their father, a Hebrew scholar. In 1912, the Soyers emigrated to the United States, and eventually settled in New York City.

Soyer's artistic studies began in 1916, and included classes at the Cooper Union, the National Academy of Design, the Educational Alliance and the Modern School, where he was influenced by Robert Henri and George Bellows.

After traveling in Europe on a fellowship, Soyer taught at several schools until the Depression made such teaching positions scarce.

The Depression, in fact, set the mood for most of Soyer's work. The Works Projects Administration provided him with work and the fellowship of other artists, but the era itself provided the sentiments which permeate most of Soyer's work. Using some of the techniques of his favorite artists, such as Rembrandt and Courbet, he portrayed his subjects in the perseverance of hard work or in the uncertainty of unemployment.

As an artist, Soyer was particularly sensitive to the lack of work during the Depression, when if not for the Works Projects Administration, many artists would have been unemployed. He was

Three Sisters, 1966, 20 x 26 in., signed u.r. Photo courtesy of ACA Galleries, New York, New York.

opposed to landscape painting, and pursued the opportunity to use art for the purpose of making realistic social statements about his time.

Together, Moses and his twin worked on some large projects, such as a mural commissioned by the Works Projects Administration for the Kingsessing Station Post Office in Philadelphia.

After the Depression, Soyer tended towards ballet subjects reminiscent of Degas, yet his painting retained his own style of conveying sentimental moods. His paintings remained popular throughout his life. Soyer died in 1974.

MEMBERSHIPS
Artists' Equity
Audubon Artists
National Academy of Design
National Institute of Arts and Letters

PUBLIC COLLECTIONS
Birmingham Museum of Art, Alabama
Brooklyn Museum
Detroit Institute of Arts
Metropolitan Museum of Art, New York City
Museum of Modern Art, New York City
Newark Museum, New Jersey
Philadelphia Museum of Art
Wadsworth Museum, Hartford, Connecticut
Whitney Museum of American Art,
 New York City

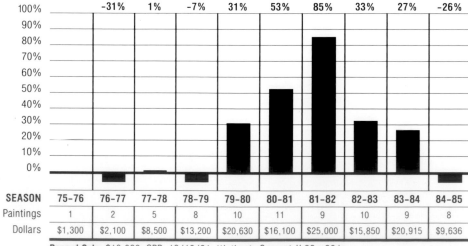

10-Year Average Change From Base Years '75-'76: 17%

	-31%	1%	-7%	31%	53%	85%	33%	27%	-26%

SEASON	75-76	76-77	77-78	78-79	79-80	80-81	81-82	82-83	83-84	84-85
Paintings	1	2	5	8	10	11	9	10	9	8
Dollars	$1,300	$2,100	$8,500	$13,200	$20,630	$16,100	$25,000	$15,850	$20,915	$9,636

Record Sale: $12,000, SPB, 12/10/81, "Intimate Concert," 36 x 38 in.

HADDON H. SUNDBLOM
(1899-1976)

Many commercial artists today, asked about their beginnings, reply simply, "Oh, I began with Sunny out in Chicago."

Haddon Hubbard "Sunny" Sundblom, born in 1899, in Muskegon, Michigan, dominated Chicago's commercial art field from the late 1920s, when he formed the now-famous studio partnership of Stevens, Sundblom & Henry.

His early years were characterized by hard work and drive. He left school at age 13 when his mother died. He went to Chicago, got a job, and attended night school or took correspondence courses to complete his education. Later he studied for four years at the Chicago Art Institute and for three and a half years at the American Academy of Art.

Sundblom's professional apprenticeship began in 1920 at the Charles Everett Johnson Studio in Chicago. He ran errands, washed brushes and generally took care of the needs of such star illustrators as MacLelland Barclay and Andrew Loomis. In 1925, Sundblom, Howard Stevens and Edwin Henry formed their own studio.

Sundblom's style became a hallmark for advertisers such as Coca-Cola, Procter and Gamble, Colgate, Palmolive, Peet & Company and Maxwell House. He developed for Coca-Cola his famous Santa Claus, which appears to have become the standard model for Saint Nicholas likenesses.

According to Frederic Whitaker in a 1956 article in *American Artists* magazine, Sundblom's characters and their settings offer an air of refinement. They are romantic, idealistic, melodious, wholesome, healthy, pleasing. They look good. He gives the human race cause for self-respect.

Sundblom reflected the American spirit in his illustrations as well as his life. He has been critically acclaimed as a genius in commercial art.

He died in 1976.

Good Boys and Girls, 1951, 36 x 30 in. Courtesy of The Archives: The Coca-Cola Company.

SEASON	75-76	76-77	77-78	78-79	79-80	80-81	81-82	82-83	83-84	84-85
Paintings					1	2			1	
Dollars					$900	$12,750			$1,100	

Record Sale: $12,000, SPB, 12/4/80, "Things Go Better with Coke," 40 × 27 in.

AARON DOUGLAS
(1899-1979)

Aspects of Negro Life: From Slavery through Reconstruction, 1934, 45 x 106 in. Courtesy of the Schomburg Center for Research in Black Culture, New York Public Library, New York.

Painter, illustrator, muralist and educator, Aaron Douglas has been called "the father of black American art." He was a major figure in the so-called Harlem Renaissance, the flowering of black art and literature in the 1920s. His work draws on traditional African motifs and subjects, and helped to establish their importance in contemporary black culture.

Douglas was born in Topeka, Kansas in 1899. He earned degrees from the University of Kansas, the University of Nebraska and Columbia University Teachers' College. In New York City, he studied art under Winold Reiss, who encouraged him to accept and celebrate his black heritage, from 1925 to 1927.

A Rosenwald grant took him to Paris in 1931 to study at l'Academie Scandinave and under Despiau, Waroquier and Othon Frieze. Another Rosenwald grant enabled him to tour the American South and Haiti in 1938. He taught art

in high school and at Fisk University in Nashville, Tennessee. Eventually he founded Fisk's art department and served as its chairman for 29 years.

During the 1920s, Douglas illustrated a number of works by emerging black writers: Countee Cullen's *Caroling Dusk*, Paul Morand's *Black Magic*, James Weldon Johnson's *God's Trombones,* Langston Hughes's *The Negro Speaks of Rivers* and others. His drawings in *Crisis, Opportunity, Fire!!* and *Theater Arts* magazines introduced an African design influence and placed Douglas in the forefront of the Harlem Renaissance.

Between 1930 and 1935, Douglas received federal support for several mural commissions, including the Fisk University library, the 135th Street Y.M.C.A. in New York City and the 135th Street branch of the New York Public Library. His murals, with subjects drawn from black history, com-

bined African elements—fetish objects, masks, Negro figures—with the angular art deco format of the period.

As a leading exponent of black iconography in contemporary art, Douglas was regarded as a leader in the development of modern black consciousness. In his foreword to the catalog of Douglas's 1971 retrospective exhibition at Fisk University, Davis Driskell quotes Douglas as saying, "I refuse to compromise and see blacks as anything less than a proud and majestic people."

Douglas retired from Fisk in 1966. He died in 1979 in Nashville.

PUBLIC COLLECTIONS
Bennett College
Fisk University
New York City Public Library, 135th Street
New York City Y.M.C.A., 135th Street
University of California, Berkeley
Yale University

(No sales information available.)

LUIGI LUCIONI
(1900-)

Born in Malnate, Italy in 1900, Luigi Lucioni became one of America's most brilliant landscape painters, whose works have been noted for their heightened realism and photographic attention to detail.

Lucioni came to the United States in 1911. Five years later he began studying at Cooper Union with William Starkweather. In 1920 he studied with William Auerbach Levy at the National Academy of Design.

Lucioni's attention to detail can be traced to his early work as an etcher in 1922; mastering a technique which stressed sharp linear precision was instrumental in developing Lucioni's precise painting style.

In 1924, Lucioni won a Tiffany Foundation Fellowship, which enabled him to go back to his homeland to study Italian primitives. He responded immediately to the realism of early Renaissance painting, which left a lasting impression on his work.

As he incorporated realism into his own work, Lucioni's paintings became more meticulous. His crisp, somewhat flat pattern and detail have been likened to the microscopic approach of the fifteenth-century Flemish masters.

Beginning in 1929, he spent part of each year in Vermont, where he painted still lifes and landscapes of the hills and barns.

Lucioni, who later taught at the Art Students League in New York, won

Still Life with Carved Stone Head, 30 x 24 in. Photograph courtesy of Hirschl & Adler Galleries, Inc., New York, New York.

many honors during his distinguished career. He took first prize in 1939 at the Carnegie International, and his 1941 portrait of John La Farge was voted best painting by visitors to the Corcoran Biennial in Washington, D.C.

Despite his lack of conscious effort toward the experimental or avant-garde, Lucioni's work has always been popular.

Lucioni lives in Union City, New Jersey.

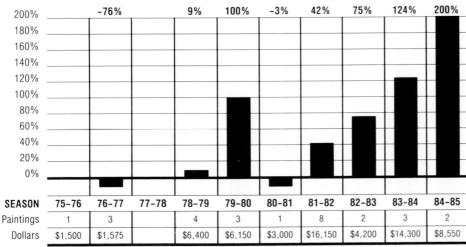

10-Year Average Change From Base Years '75-'76: 52%

	-76%		9%	100%	-3%	42%	75%	124%	200%	
SEASON	75-76	76-77	77-78	78-79	79-80	80-81	81-82	82-83	83-84	84-85
Paintings	1	3		4	3	1	8	2	3	2
Dollars	$1,500	$1,575		$6,400	$6,150	$3,000	$16,150	$4,200	$14,300	$8,550

Record Sale: $7,250, SPB, 6/22/84, "Wine Bottle," 16 x 20 in.

CARL ROBERT HOLTY
(1900-1973)

Known for his floating, luminous color forms, Carl Robert Holty belongs to the school of pure abstract art called geometric abstraction. One of more than a dozen pioneers in this group—of which Piet Mondrian is the most celebrated—Holty was influential as a teacher in the 1930s. Despite an often unsympathetic public, he never abandoned the struggle for acceptance of modern art forms.

Holty's early painting, featuring biomorphic forms, is related to organic surrealism and shows the influence of Jean Arp and Joan Miro. By the late 1950s, he had developed his enduring subject matter—large, soft-edged color forms that mix with, and float on, a lush chromatic stain. He is particularly recognized for his control of color. In his later period, Holty's geometric forms have receded to bare remnants of their former structure.

A native of Germany, Holty came to the United States as an infant, growing up in Milwaukee. He studied at the Art Institute of Chicago and the National Academy of Design in New York City, traveling to Munich in 1926 to enroll in the Hans Hofmann school.

Dedicated to abstract art and always in search of the new, Holty joined the abstract-creation group in Paris in 1932. Like other leaders of geometric abstraction, he found greater artistic acceptance in Europe and stayed there for 10 years, working and exhibiting, before returning to the United States in 1936. He then

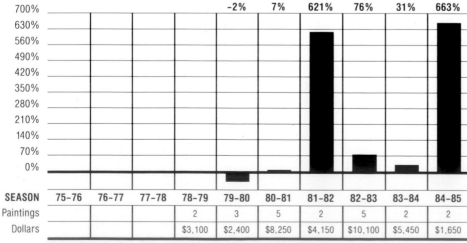

Woman in a Garden, 1955, 30 x 24 in., signed l.l. Courtesy of Hirshhorn Museum and Sculpture Garden, Smithsonian Institution, Washington, D.C.

became an important advocate of abstract art, helping to establish the American Abstract Artists organization.

In the 1950s, Holty painted a series of gem-like 9-by-12-inch canvases of small color squares, superimposed with a fluid line suggesting form. His later work, however, was with large amorphous canvases, in which the vestiges of geometric forms float on a color field.

10-Year Average Change From Base Years '78-'79: 199%

SEASON	75-76	76-77	77-78	78-79	79-80	80-81	81-82	82-83	83-84	84-85
					-2%	7%	621%	76%	31%	663%
Paintings				2	3	5	2	5	2	2
Dollars				$3,100	$2,400	$8,250	$4,150	$10,100	$5,450	$1,650

Record Sale: $3,250, SPB, 1/27/84, "Card Players," 48×40 in.

MEMBERSHIPS
American Abstract Artists
Audubon Artists Society

PUBLIC COLLECTIONS
Butler Institute of American Arts, Youngstown, Ohio
Minneapolis Institute of Arts
Solomon R. Guggenheim Museum, New York City
Whitney Museum of American Art, New York City

HALE WOODRUFF
(1900-1980)

Like other contemporaries who moved to Paris in the 1920s to escape the racial discrimination that persisted in the United States, Hale Woodruff went on to become a successful black artist.

He began as a traditional landscapist, experimented for a time with cubism, and then dealt with historical and social subject matter. In his maturity, however, he became an abstractionist, often incorporating the imagery of African art into his work. Even so, perhaps his best-known work is an early group of murals on black history which he did for the Savery Library at Talledega College in Atlanta in the late 1930s.

Born in Cairo, Illinois in 1900, Woodruff went to Indianapolis after completing high school and found part-time work drawing political cartoons for *The Indianapolis Ledger,* a black newspaper. He studied first at the Herron Art Institute in Indianapolis and then at the Art Institute of Chicago, where he won a $100 prize from the Harmon Foundation in 1926.

The prize brought a measure of recognition and helped him continue his studies at the Fogg Museum School at Harvard, and then, in 1927, to sail for Europe. In Paris he studied at the Academie Scandinave and the Academie Moderne and with Henry Ossawa Tanner, a black American painter who lived in France.

At first Woodruff painted oils and watercolors of the French landscape, interspersed on occasion with fanciful black genre scenes. Before he returned to the United States in 1931, however, he began working in the cubist mode which then dominated the French art world.

In the midst of the Depression, Woodruff went to Atlanta and was asked to organize an art department at Atlanta University. He began a teaching career that continued for more than 40 years. He also organized the Atlanta Annuals, showcases for work by black painters.

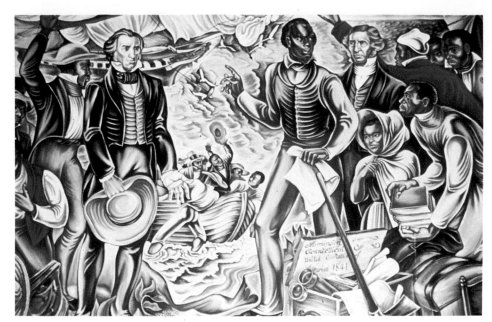

The Return to Africa, 1842, 1934. Courtesy of the Schomburg Center for Research in Black Culture, New York Public Library, New York.

Woodruff produced stark, realistic woodcuts and linoleum prints of the poverty and lynching of blacks in the South. After studying with Diego Rivera in Mexico, he began the Talledega College murals in a style that was reminiscent of both Rivera and Thomas Hart Benton.

A Rosenwald Foundation grant in 1943 enabled Woodruff to go to New York City to study and paint for two years. He then realized the exciting potential of abstract painting. He returned to Atlanta for one more year of teaching, but then, longing for the creative ferment of Manhattan, accepted a faculty position at New York University, where he stayed until his retirement in 1967.

From the 1950s on, Woodruff devoted himself entirely to abstraction. Using tall, narrow panels as his format, he began experimenting with hieroglyphics as an idiom of expression. As his work developed he drew heavily on African art and symbol as source material. Perhaps one of his best examples of this cultural consciousness was *Ancestral Memory* (1966, Detroit Institute of Arts).

Woodruff continued to paint his rhythmic abstractions until his death in New York City in 1980.

MEMBERSHIPS
New Jersey Society of Artists
New York State Council on the Arts
Society of Mural Painters

PUBLIC COLLECTIONS
Atlanta University, Georgia
Detroit Institute of Arts
Howard University, Washington, D.C.
Library of Congress, Washington, D.C.
Newark Museum, New Jersey
New York University, New York City
Talledega College, Atlanta, Georgia

(No sales information available.)

FREDERICK TAUBES
(1900-1981)

During his long and prolific career, Frederick Taubes won critical acclaim for his paintings, prints and highly technical writings about art. Described as a "modern classicist," Taubes was equally inspired by the art of antiquity and by such modern masters as Paul Cezanne and Georgio de Chirico.

Frederick Taubes was born in Lwow, Poland in 1900. At the outbreak of World War I, Taubes's family was forced to move to Austria. The young Taubes, who had received private art lessons in Poland, continued his studies in Vienna at the Academy of Art and the Imperial Museum.

After the war, Taubes took up his art training at the Academy in Munich. Mired in academic tradition, he quit the Munich Academy after one year and enrolled in the famed experimental art school in Weimar, called the Bauhaus.

In 1920 at the Bauhaus, Taubes studied under Johannes Itten, whose theories about color were to influence him throughout his career. Throughout the 1920s, the young artist experimented with a number of modernist trends, such as cubism, dada and expressionism.

Taubes emigrated to the United States in 1930, settling in New York City. During the following few years, he built a solid reputation as a society portraitist, painting such prominent and influential people as Claire Booth Luce, Baron von Romberg and Mrs. William Randolph Hearst.

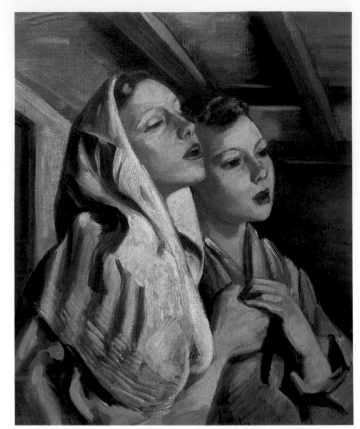

Moment of Prayer, 1946, 24 x 20 in. Courtesy of Raydon Gallery, New York, New York.

A characteristic example of Taubes's mature painting style is *The Rehearsal* (1936, Art Institute of Chicago). In this painting, the strong plastic quality of the two female figures is reinforced by dramatic light and dark contrasts, and the deep background is enlivened by the juxtaposition of complementary warm and cool hues. The animated, variegated surface of the painting is produced by Taubes's skillful application of pigment.

He combined careful underpainting and glazing, techniques derived from fourteenth- and fifteenth-century Flemish masters, with seemingly extemporaneous, gestural brushstrokes and notations. He described the Flemish techniques in his book *The Mastery of Oil Painting.*

Taubes's later work became less studied and contrived as he began to apply color directly onto the wet ground of the canvas. An early interest in surrealism and abstraction was expressed in such works as *The Three Graces* (1962, location unknown) and *Arabesque* (1971, location unknown).

Taubes published articles about painting methodology in *American Artist* magazine from 1943 to 1962. After 1955, he exhibited little, but continued to develop his art until his death in 1981.

MEMBERSHIPS
Royal Society of Arts

PUBLIC COLLECTIONS
Indiana University Art Museum
M.H. de Young Memorial Museum, San Francisco
Metropolitan Museum of Art, New York City
San Francisco Museum of Modern Art,
 San Francisco
Santa Barbara Museum of Art, California
San Diego Museum of Art, California

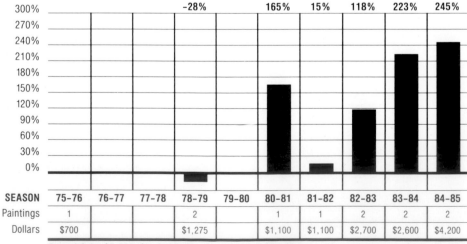

10-Year Average Change From Base Years '75-'76: 105%

| | -28% | | 165% | 15% | 118% | 223% | 245% |

SEASON	75-76	76-77	77-78	78-79	79-80	80-81	81-82	82-83	83-84	84-85
Paintings	1			2		1	1	2	2	2
Dollars	$700			$1,275		$1,100	$1,100	$2,700	$2,600	$4,200

Record Sale: $2,200, CH, 3/15/85, "Huge Valve," 26 × 20 in.

JACK TWORKOV
(1900-)

Abstract expressionist artist and teacher Jack Tworkov, born in 1900 in Biala, Poland, arrived in New York City in 1913, the year of the famous Armory Show. The European modernist reverberations of the show affected Tworkov's early work.

After three years at Columbia University, Tworkov studied at the National Academy of Design from 1923 to 1925 with Ivan Olinsky and Charles Hawthorne. After a summer in Provincetown, Massachusetts with Ross Moffett, he attended the Art Students League from 1925 to 1926 with Guy Pene du Bois and Boardman Robinson.

From 1934 to 1941, Tworkov worked in the WPA Federal Art Project. He did not paint from 1942 to 1945. When he began again, he had put European modernism behind him.

In 1948, he had a one-man show at the Baltimore Museum, began to teach at the American University, and opened a studio next to Willem de Kooning's. His work of the late 1940s reflects de Kooning's influence—brash, bold strokes with fragmented figurative elements. He belonged for some time to "The Club" of avant-garde artists, including Jackson Pollock, de Kooning, Franz Kline, Robert Motherwell and Conrad Marca-Relli.

In the 1950s and early 1960s, Tworkov's developing personal style involved improvisional linear patterning of bold off-colors, strongly brushed. In

The Bridge, 1951, 25 x 20 in., signed l.l. Courtesy of Hirshhorn Museum and Sculpture Garden, Smithsonian Institution, Washington, D.C.

the later 1960s, the casual grids in Tworkov's pictures grew huge, dominating the canvases.

After 1970, Tworkov's approach changed greatly. The linear elements in his paintings are very strongly structured, the grids severe. Colors often nest within geometric shapes. His shimmering pigments are in families of colors—blues, greens, violets.

Tworkov has taught at numerous distinguished colleges, and was chairman of Yale University's art department from 1963 to 1966.

He has had many one-man shows, including two retrospectives at the Whitney Museum of American Art in New York City.

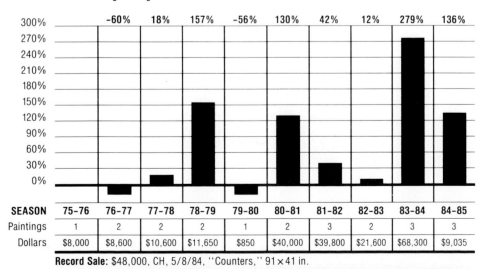

10-Year Average Change From Base Years '75-'76: 66%

	-60%	18%	157%	-56%	130%	42%	12%	279%	136%	
SEASON	75-76	76-77	77-78	78-79	79-80	80-81	81-82	82-83	83-84	84-85
Paintings	1	2	2	2	1	2	3	2	3	3
Dollars	$8,000	$8,600	$10,600	$11,650	$850	$40,000	$39,800	$21,600	$68,300	$9,035

Record Sale: $48,000, CH, 5/8/84, "Counters," 91 x 41 in.

CARL
WUERMER
(1900-)

Carl Wuermer, a successful realist landscape painter, exhibits widely and has been the recipient of many prestigious awards.

Born in Munich, Germany in 1900, Wuermer emigrated to Chicago in 1915. He studied at the Art Institute of Chicago from 1920 to 1924; he was a pupil of Wellington J. Reynolds. He then studied at the Art Students League in New York City.

Wuermer won an honorable mention and the Eisendrath Prize from the Art Institute in 1926. He won the J. Francis Murphy Memorial Prize from the National Academy of Design in 1928. In 1929, he was accepted for artist membership by the Grand Central Art Galleries in New York City.

Wuermer uses a technique which is similar to French pointillism. He paints large landscapes by slowly building up the canvases with small dots of color. He often uses dark outlines to strengthen the contours of trees and other subjects. Seen from a slight distance, the overall effect of his paintings is one of completeness and exactitude.

Wuermer's subjects are generally serene, pastoral views. His compositions lead the viewer's eye back into the deep perspective of his panoramic landscapes.

The Wintry River, 30 x 36 in., signed l.r. Photograph courtesy of Hirschl & Adler Galleries, Inc., New York, New York.

MEMBERSHIPS
Allied Art Association
Art Institute of Chicago Alumni
Illinois Academy of Fine Arts
Salons of America

PUBLIC COLLECTIONS
IBM Corporation Art Collection, Endicott, New York
Municipal Art Collection, City of Chicago

10-Year Average Change From Base Years '77–'78: 226%

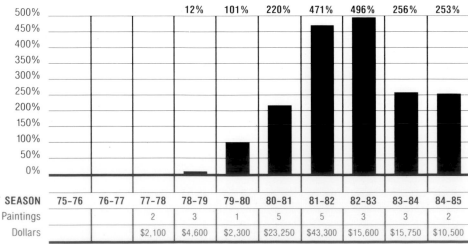

SEASON	75-76	76-77	77-78	78-79	79-80	80-81	81-82	82-83	83-84	84-85
			12%	101%	220%	471%	496%	256%	253%	
Paintings			2	3	1	5	5	3	3	2
Dollars			$2,100	$4,600	$2,300	$23,250	$43,300	$15,600	$15,750	$10,500

Record Sale: $17,000, SPB, 12/10/81, "Winter Scene," 30 × 36 in.

894

WILLIAM H. JOHNSON
(1901-1970)

From impoverished beginnings in Florence, South Carolina, William Johnson rose up and took the art world by surprise. His heritage was partially black and Sioux Indian and his artwork was often a colorful, expressionistic essay on the elements of his background.

Finding an early enjoyment in sketching, Johnson worked hard to create the means to study in New York City. He studied at the National Academy of Design from 1921 to 1926, and at the Cape Cod School of Art under his mentor, Charles Hawthorne. Hawthorne's belief in the young artist led to a fellowship for Johnson to study in Europe.

In 1926, Johnson went to France. Once away from his academic training, his work became influenced by artists like Chaim Soutine and grew more colorful. After his stay in France, Johnson traveled to Denmark and Norway.

In 1929, he returned to the United States and became reacquainted with the imagery of his heritage and childhood. He incorporated these elements into his work, which was rapidly evolving into a unique and primitive expression of black culture.

Johnson returned to Europe and married artist Holcha Krake in Denmark. After many travels together, the couple returned to the United States and Johnson taught art in Harlem.

When his wife died in 1943, Johnson went to South Carolina and then to Scandinavia. A disabling illness required his hospitalization from 1947 until his death in 1970.

MEMBERSHIPS
United American Artists

PUBLIC COLLECTIONS
National Gallery of Art, Washington, D.C.
National Museum of American Art, Washington, D.C.
National Museum, Stockholm

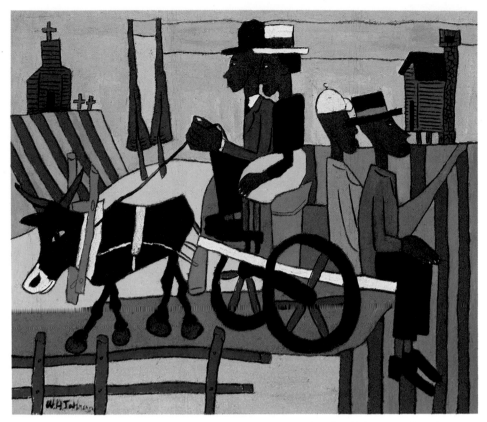

Going to Church, 1940-1941, 38⅛ x 44⅛ in., signed l.l. Courtesy of National Museum of American Art, Smithsonian Institution, Gift of the Harmon Foundation.

(No sales information available.)

FRANCIS CRISS
(1901-1973)

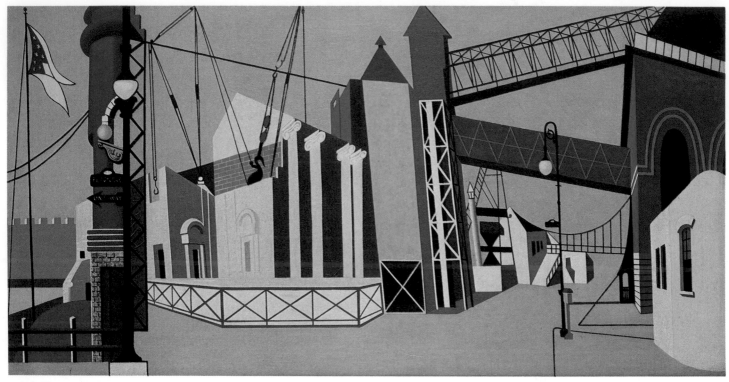

Rhapsody in Steel, 1939, 22 x 42 in. Courtesy of The Pennsylvania Academy of the Fine Arts, Philadelphia.

Francis Criss was a painter preoccupied with architectural forms, particularly those of New York City. Instead of portraying them as they were, however, he filtered out the elements which he considered superfluous, simplified what remained, and then reconstructed the scene in geometric terms. His work was meticulously polished, a trait that identified him with the precisionists in the 1930s.

He was born in London in 1901, but his family moved to Philadelphia when he was three. He had polio as a boy and, while recuperating in the hospital, he began to sketch. His father recognized his talent at once and enrolled him in classes at the Philadelphia Sketch Club. At age 16, he won a four-year scholarship to the Pennsylvania Academy of the Fine Arts.

Later he studied at the Barnes Foundation in Merion, Pennsylvania. After moving to New York City, he worked by day designing screens for decorators— work that he disliked—and attended classes at the Art Students League at night.

During the mid-1930s, Criss traveled to Europe on a Guggenheim Fellowship and then painted a large, abstract mural for the WPA Federal Art Project. It was indicative of his later work, in that recognizable architectural elements were consolidated into a tight, flat design.

To make ends meet, Criss gave up painting almost entirely for 15 years, concentrating instead on commercial art and on teaching. In the early 1950s, however, he returned to art. He accepted some portrait commissions, but cityscapes were still his favorites.

Later, in contrast to his former simplicity and clarity, he adopted a form of pointillism which made his work increasingly complex. He continued in this vein until his death in 1973.

MEMBERSHIPS
An American Group

PUBLIC COLLECTIONS
National Gallery of Art, Washington, D.C.
Nelson-Atkins Museum of Art, Kansas City, Missouri
Philadelphia Museum of Art
Whitney Museum of American Art, New York City

SEASON	75-76	76-77	77-78	78-79	79-80	80-81	81-82	82-83	83-84	84-85
Paintings				1	4	2			1	
Dollars				$5,000	$18,950	$3,700			$1,500	

Record Sale: $7,000, SPB, 4/25/80, "Entrance to the El," 35 × 33 in.

PHILIP EVERGOOD
(1901-1973)

New York Susanna, 36½ x 31 in., signed l.r.
Courtesy of La Salle University Art Museum,
Philadelphia, Pennsylvania, Given by Mrs. J.
Benjamin Yasinow.

Philip Evergood, an important twentieth-century painter who received most of his training in Europe, was a political activist whose work combined fantasy with social realism and criticism.

Although Evergood was born in New York City in 1901, he was raised in England from the age of eight. He attended Eton, where he made many drawings on biblical, literary and historical themes, and in 1921, he entered the Slade School in London. There he studied drawing under Henry Tonks and sculpture under Havard Thomas.

He returned to New York City for a year in 1923, and studied under George Luks and William von Schleggell at the Art Students League; he also learned to etch from Philip Reisman and Harry Sternberg.

Returning to Europe in 1924, Evergood set up a studio in Paris and studied with Jean-Paul Laurens and Andre Lhote at the Academie Julien. That year, a still life of his was accepted by the National Academy of Design in New York City, and he exhibited an etching at the Salon Automne.

Evergood lived in the United States from 1926 until 1930, when he returned to Paris; there he supported himself as a carpenter and boxers' sparring partner while continuing to paint. The next year he traveled in Spain for six months before settling in New York City.

The Great Depression, then at its worst, affected Evergood's work deeply.

He moved from literary themes to social problems, as in *American Tragedy* (1937, Whitney Museum of American Art), a powerful response to a bloody battle between police and picketers at a steel mill. Evergood also became involved in the artist-rights movement, serving as president of the Artists Union.

He worked for the WPA Federal Art Projects from 1934 until 1938 producing such murals as *The Story of Richmond Hill* (1936) for a district library in New York City, and *Cotton from Field to Mill* (1938) for the post-office building in Jackson, Georgia. Evergood was one of 219 artists who organized a strike in 1936 to protest layoffs from the federal art projects.

Evergood's early work has been characterized by bold, clashing color, by deliberately awkward form and arrangement and by a blend of logic and imagination. These stylistic qualities continued in his Depression-era paintings on themes of racial integration and class distinctions. Indeed, while much of

his work can be labeled "social protest," his paintings often convey a sense of joy, humor and energy.

During the 1940s and later, Evergood's work became more dreamlike and less directly concerned with social comment. Symbol and allegory appeared, as in *The New Lazarus* (1954, Whitney Museum of American Art).

He taught at a number of institutions and was regularly represented in exhibitions, including a major retrospective of his work at the Whitney Museum of American Art in 1960. He died in 1973 at his home in Connecticut.

MEMBERSHIPS
American Artists Congress
American Society of Painters, Sculptors,
 and Gravers
An American Group
Artists Committee of Action
Artists Equity Association
Artists League of America
Artists Union
Federal Art Projects: Mural Division,
 Easel Painting Division
National Institute of Arts and Letters
National Society of Mural Painters
United American Artists

PUBLIC COLLECTIONS
Art Institute of Chicago
Baltimore Museum of Art
Brooklyn Museum
Butler Institute of American Art,
 Youngstown, Ohio
Carnegie Institute, Pittsburgh
Corcoran Gallery of Art, Washington, D.C.
Cornell University
Dallas Museum of Fine Arts
Denver Art Museum
Free Library of Philadelphia
Grolier Club, New York City
Kalamazoo Institute of Arts, Michigan
Library of Congress, Washington, D.C.
Los Angeles County Museum of Art
Metropolitan Museum of Art, New York City
Museum of Fine Arts, Boston
Museum of Modern Art, New York City
National Gallery of Victoria, Melbourne, Australia
Pennsylvania Academy of the Fine Arts,
 Philadelphia
University of Louisville, Kentucky
Wadsworth Atheneum, Hartford, Connecticut
Whitney Museum of American Art,
 New York City

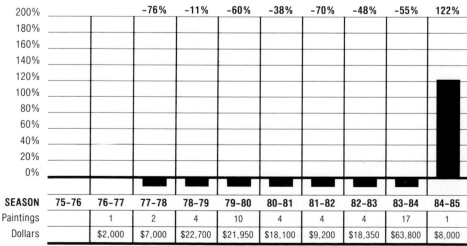

10-Year Average Change From Base Years '76-'77: −25%

		−76%	−11%	−60%	−38%	−70%	−48%	−55%	122%	
SEASON	75-76	76-77	77-78	78-79	79-80	80-81	81-82	82-83	83-84	84-85
Paintings		1	2	4	10	4	4	4	17	1
Dollars		$2,000	$7,000	$22,700	$21,950	$18,100	$9,200	$18,350	$63,800	$8,000

Record Sale: $11,000, CH, 9/28/83, "Two Miners," 49×30 in.

RICHARD LINDNER
(1901-1978)

Painter Richard Lindner's highly idiosyncratic work incorporates elements of his personal history, as well as literary associations. The element of introspection separates his work from pop art.

He was born in Hamburg, Germany in 1901 to an American mother and a German father. After a brief career as a concert pianist, in 1925 Lindner entered the Academy of Fine Arts in Munich. Eventually, he became an art director for Knorr & Hirth, a publisher closely associated with the Nazis. There, Lindner met high-ranking Nazis, including Hitler.

The day after the Nazis came to power in 1933, he fled to Paris, where he was imprisoned. To prove his loyalty, he served in the French and British armies. Finally, in 1941, he arrived in New York City.

Lindner worked as an illustrator for *Vogue, Fortune* and *Harper's Bazaar.* He began painting seriously in 1952, holding his first one-man exhibit in 1954. His style blends a mechanistic cubism with personal images and haunting symbolism.

He used flat areas of rich, sometimes garish, colors separated by hard edges, to present ambiguous perspective. He modeled clothing, faces and body parts.

His favorite subject was bizarre women. Corsets and straps emphasize their sexual qualities. Lindner professed no hatred of women; instead, he said, "I feel sorry for women. When I dress women in these corsets and contraptions in my painting, it's kind of the way I see them wrapping themselves up."

His *Ice* (1966, Whitney Museum of American Art) established a connection between the metaphysical tradition and pop art. The painting shows harsh, flat geometric shapes framing an erotic but mechanical robot-woman.

Lindner's characters—the women, precocious children and men who could be strangers or voyeurs—often are

Untitled, 1961, 9½ x 5½ in. ©1985, Sotheby's, Inc., New York, New York.

posed in slice-of-life scenes. But these scenes are obsessive, rather than normal visions.

Though he became a United States citizen in 1948, Lindner considered himself a New Yorker, but not a true American. However, over the course of time, his continental circus women became New York City streetwalkers. New York police uniforms replaced European military uniforms as symbols of authority.

Lindner taught at the Pratt Institute from 1952 to 1965. He died in 1978.

MEMBERSHIPS
National Institute of Arts and Letters

PUBLIC COLLECTIONS
Art Institute of Chicago
Cleveland Museum of Art
Museum of Modern Art, New York City
Tate Gallery, London
Whitney Museum of American Art, New York City

SEASON	75-76	76-77	77-78	78-79	79-80	80-81	81-82	82-83	83-84	84-85
Paintings								8	7	4
Dollars								$543,900	$243,400	$37,000

Record Sale: $300,000, CH, 5/10/83, "L'As de Trefle," 79 × 71 in.

ISABEL BISHOP
(1902-　　)

One of America's leading humanist painters, Isabel Bishop is recognized along with Reginald Marsh and the Soyer brothers as an outstanding realist of the so-called "Fourteenth Street School" of the 1930s.

Working out of a studio on Union Square, New York City, she has found her subject matter in the strollers, shoppers and derelicts that inhabit the square. Her early style, tonal and realistic, did not suggest movement as much as the momentary suspension of movement—of figures caught in mid-gesture.

Born in Cincinnati, Ohio, Bishop studied at the Wicker School in Detroit. In 1918, she came to New York City to study illustration at the New York School of Applied Design for Women. Learning about the exciting developments in modern art, she transferred to the Art Students League in 1920.

She began working with Max Weber, then in his post-cubist period, but soon switched to Kenneth Hayes Miller, who taught Renaissance techniques adapted to contemporary subject matter. Reginald Marsh and the Soyer brothers were her fellow pupils.

Although her subject matter, urban themes and street scenes, remained strongly influenced by Miller, her style was affected by Max Doerner's book *The Materials of Art* (1934). Her forms lost their solidity and became almost ghostlike and iridescent. Hers became an image of a city in constant yet undefinable flux. She calls it "the implication of unfixity."

Married in 1934 and soon the mother of a son, she continued to commute to her studio in Union Square from her home in Riverdale.

In recent years, her interest in the abstract quality of her work has grown. Figures in these works are almost transparent, giving the effect of rapidly moving, ephemeral shapes peering at each

Young Woman, 30¼ x 22¼ in., signed u.l. Courtesy of The Pennsylvania Academy of the Fine Arts, Philadelphia.

other and the viewer through a kind of mist. A surface richness of complex dots and dashes of paint reflects her interpretation of some of the qualities of abstract expressionism. Her works have a seemingly anachronistic yet brilliantly luminous old-master quality. She is also well-known for her sensitive and introspective nudes.

MEMBERSHIPS
American Academy of Arts and Letters
Audubon Artists
National Academy of Design
National Institute of Arts and Letters
Royal Society of Arts
Society of American Graphic Artists

PUBLIC COLLECTIONS
Baltimore Museum of Art
Brooklyn Museum
Delaware Art Museum, Wilmington
Harvard University
Library of Congress, Washington, D.C.
Museum of Fine Art, Boston
Newark Museum, New Jersey
Pennsylvania Academy of the Fine Arts, Philadelphia
Philadelphia Museum of Art
Whitney Museum of American Art, New York City
Victoria and Albert Museum, London

SEASON	75-76	76-77	77-78	78-79	79-80	80-81	81-82	82-83	83-84	84-85
Paintings					2	1	1		5	1
Dollars					$3,450	$1,100	$500		$3,700	$300

Record Sale: $3,000, SPB, 1/23/80, "Girl at the Drinking Fountain," 15 × 12 in.

LEE GATCH
(1902-1968)

Lee Gatch was a successful painter who is especially well known for his mystical depictions of nature. He was able to combine post-impressionism, cubism and expressionism in creating a unique style of painting.

Born in a rural community near Baltimore in 1902, Gatch spent his childhood in the Chesapeake Bay area. His early exposure to nature led to his use of it as a major theme in his work.

Gatch studied at the Maryland Institute under John Sloan and Leon Kroll. In 1924, he won a fellowship to the American School in Fontainebleau. After studying there, he went to Paris and studied at the Academie Moderne with Andre Lhote and Moise Kisling. Gatch was also influenced by the works of Derain, Vuillard and Bonnard.

In 1925, Gatch returned to America and worked in New York. Most of his works during this period are typically cubist in style, and lack the vision of his later paintings. Around 1930, Gatch began to develop a personal style and symbolism in his work.

Gatch's personal cubism combined elements of post-impressionism and expressionism. His work bears a strong resemblance to the work of Paul Klee. Both Gatch and Klee use deeply personal religious and philosophical symbolism.

Gatch used many textures in his work, and he started experimenting with col-

My Three Aunts, 1930, 17 x 10½ in., signed l.r. Courtesy of the Museum of Fine Arts, Boston, Massachusetts. Anonymous Gift.

lage toward the end of his life. He used pieces of canvas and thick paint, and later tried using thin slabs of stone in his paintings as well.

In 1935, Gatch set up a studio in Lambertville, New Jersey, remaining there until his death in 1968. He had married painter Elsie Driggs, and the two lived in relative seclusion.

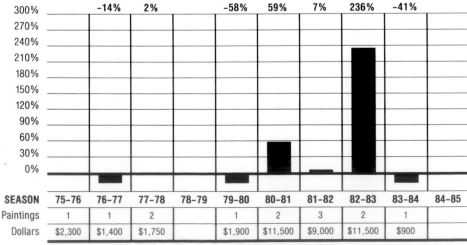

10-Year Average Change From Base Years '75-'76: 24%

	-14%	2%		-58%	59%	7%	236%	-41%		
SEASON	75-76	76-77	77-78	78-79	79-80	80-81	81-82	82-83	83-84	84-85
Paintings	1	1	2		1	2	3	2	1	
Dollars	$2,300	$1,400	$1,750		$1,900	$11,500	$9,000	$11,500	$900	

Record Sale: $7,000, SPB, 5/29/81, "Pompeian Gesture," 31 x 58 in.

MEMBERSHIPS
National Institute of Arts and Letters

PUBLIC COLLECTIONS
Baltimore Museum of Art
Detroit Institute of Arts
Los Angeles County Museum of Art
Metropolitan Museum of Art, New York City
Museum of Fine Arts, Boston
Museum of Modern Art, New York City
Pennsylvania Academy of the Fine Arts, Philadelphia
Philadelphia Museum of Art
Wadsworth Atheneum, Hartford, Connecticut
Whitney Museum of American Art, New York City

KENZO OKADA
(1902-1982)

Japanese-born Kenzo Okada came to the West, it seems, only to discover his deep roots in the East.

Born in Yokahoma, Japan in 1902, the son of a wealthy industrialist, Okada enjoyed a privileged existence in his native land. But young Okada was preoccupied with all things occidental, and in 1924, despite parental misgivings, he journeyed to Paris, where he studied for a time with Foujita. Returning to Japan in 1927, he had his first one-man show at the Michido Gallery in Tokyo. In the following years, he achieved considerable success as a realist painter and a respected teacher.

In 1950, despite his success in Japan, Okada emigrated to the United States, where his work underwent a veritable metamorphosis. He became an abstract painter in the American mode, but in doing so, he finally became reconciled with his traditional past. His canvases began to bear a strong but undefinable oriental cast, with textures reminiscent of Japanese fabric and the subtle, exquisite coloration of traditional Japanese painting.

As Okada matured, he developed a deepening asceticism in harmony with Zen precepts. His paintings became more austere, with both form and color taking on a severity unknown in his previous works. He even began adding figurative elements inspired by the ancient Japanese Noh drama. One of his best latter-day works is called *Hagoromo* (date and location unknown) after the Noh play that inspired it. Another is called simply *Noh*.

Okada enjoyed phenomenal success throughout his lifetime. He was awarded prizes from some of the most prestigious American art institutions, and his works were exhibited at leading galleries and museums. He became a United States citizen in 1960, and died in 1982.

Flower Study, 1958, 51⅞ x 41⅛ in., signed l.c. Courtesy of The Brooklyn Museum, Gift of Joseph Cantor.

PUBLIC COLLECTIONS
Art Institute of Chicago
Baltimore Museum of Art
Brooklyn Museum
Carnegie Institute, Pittsburgh
Metropolitan Museum of Art, New York City
Museum of Fine Arts, Boston
Museum of Modern Art, New York City

SEASON	75-76	76-77	77-78	78-79	79-80	80-81	81-82	82-83	83-84	84-85
Paintings								1	4	3
Dollars								$10,000	$53,000	$28,250

Record Sale: $23,000, CH, 5/8/84, "Assemblage," 86 × 63 in.

ROBERT GWATHMEY
(1903-)

When Robert Gwathmey was given a show at ACA Galleries in New York City in January, 1946, famous black singer Paul Robeson wrote an introduction to the exhibition catalog. He praised the artist, "a white Southerner, for expressing his region in the democratic tradition and in the best fusion of esthetic and social principles."

Gwathmey, a painter and graphic artist who was born in Richmond, Virginia to working-class parents, has been concerned in all of his work with the inequities of the socially and economically oppressed classes, white and black, of his native South. Elements of *Hoeing* (1943, Museum of Art, Carnegie Institute), such as isolated corn plants and fragments of barbed wire, are symbols of the failure of both society and the land. In this powerful painting of human suffering, the central figure, a sharecropper, pauses to wipe his brow while the sun beats down on a parched field.

In *The Hitchhiker* (ca. 1936, Brooklyn Museum), down-and-out men and boys thumb rides in opposite directions, against a background of billboards featuring perfume and cigarette ads with smiling, glamorous women. About this painting, Gwathmey said in an interview, "It is out of my history. It is nothing accidental. . . . All those billboards showed happy prosperity, pretty girls, so forth, etc.; yet it was the rugged Depression pretty insistent."

The Observer, 1960, 48⅛ x 34 in., signed l.c. Courtesy of National Museum of American Art, Smithsonian Institution, Gift of S. C. Johnson & Son, Inc. ©Gwathmey/VAGA, New York 1985.

Gwathmey's subject matter has remained the same, but his style has become progressively more flattened and geometric, his figures more distorted.

The artist was born in 1903. He took odd jobs as a young man in order to support his widowed mother and family.

Between 1924 and 1930, he studied at North Carolina State College, the Maryland Institute of Design and the Pennsylvania Academy of the Fine Arts.

He has taught at Beaver College, the Carnegie Institute of Technology, Boston University, Syracuse University, and for 25 years (between 1942 and 1968) at Cooper-Union in New York City.

10-Year Average Change From Base Years '75-'76: 97%

	-19%	24%	679%		29%	4%	98%	62%	-1%

SEASON	75-76	76-77	77-78	78-79	79-80	80-81	81-82	82-83	83-84	84-85
Paintings	1	1	1	1		2	1	1	1	1
Dollars	$2,500	$2,000	$900	$1,800		$9,500	$650	$1,600	$1,500	$750

Record Sale: $6,000, SPB, 6/19/81, "Portrait of the Confederacy," 25×36 in.

902

JOHN
WHORF
(1903-1959)

John Whorf is considered by some to be one of the greatest American watercolorists. He used the medium to transcend realism and infuse his subjects with atmosphere and emotion.

Born in Boston in 1903, Whorf decided at a young age to be an artist. Initial encouragement and early instruction were provided by his father, Harry Whorf, an artist and graphic designer.

When Whorf was 14, he began formal art lessons at the St. Botolph Studio and then, briefly, at the Museum of Fine Arts School in Boston. Though he would study under some of the major artists of his time, Whorf eschewed formal education even as a boy, believing that the best way to learn painting was simply to paint. This philosophy endured throughout his life.

Still 14, Whorf moved to Provincetown, Massachusetts. The Cape Cod town held a dual attraction for Whorf. Its seaside setting and natural starkness provided constant inspiration, and Provincetown was a burgeoning art center where Whorf met some of the country's finest painters, including Max Bohm, Charles W. Hawthorne and E. Ambrose Webster.

Although Whorf longed to travel abroad, his plans were postponed when, at 18, he was temporarily paralyzed in a serious fall. Though he fully recovered, Whorf claimed the accident was responsible for his even greater enthusiasm for painting. "While other people took out

Courtyard Summer Nude, 14¾ x 21¾ in. Courtesy of Arvest Galleries, Inc., Boston, Massachusetts.

their adventure in play and pleasure, I had to take it out in my work."

Later that year, Whorf was finally able to begin his travels. He wandered through France, Portugal and Morocco, constantly painting and occasionally returning to Paris for brief study. During this time, Whorf began painting with watercolor, having previously worked only in oils.

Watercolor was better suited, Whorf thought, to his peripatetic life, and also to capturing the subtle blend of natural

colors and the elusive play of shadow and light.

In 1924, Whorf had his first one-man exhibition at Boston's Grace Horne Gallery. More than 50 of his paintings were sold, and he was heralded as Boston's leading watercolorist. Until his death, Whorf would be exhibited in New York City and Boston galleries. In 1947, he was elected a member of the National Academy of Design.

Although Whorf traveled throughout his life and painted street scenes, cities, people and mountains, his freshest inspiration always seemed to come from the Cape Cod landscape. He ultimately settled in Provincetown and died there in 1959.

MEMBERSHIPS
American Water Color Society
National Academy of Design
Provincetown Art Association

PUBLIC COLLECTIONS
Art Institute of Chicago
Brooklyn Museum
Fogg Art Museum, Harvard University
Los Angeles County Museum of Art
Metropolitan Museum of Art,
 New York City
Museum of Fine Arts, Boston
Museum of Modern Art, New York City
Pitti Palace, Florence
Whitney Museum of American Art,
 New York City

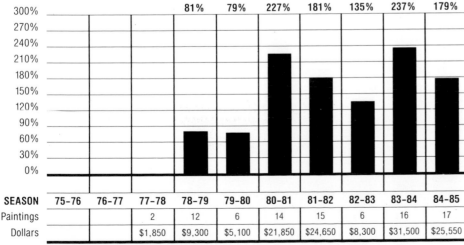

10-Year Average Change From Base Years '77-'78: 140%

			81%	79%	227%	181%	135%	237%	179%

SEASON	75-76	76-77	77-78	78-79	79-80	80-81	81-82	82-83	83-84	84-85
Paintings			2	12	6	14	15	6	16	17
Dollars			$1,850	$9,300	$5,100	$21,850	$24,650	$8,300	$31,500	$25,550

Record Sale: $3,500, B, 9/22/83, "Nude in a Sylvan Landscape," 22 x 18 in.

MARK ROTHKO
(1903-1970)

Blue, Orange, Red, 1961, 90¼ x 81¼ in. Courtesy of Hirshhorn Museum and Sculpture Garden, Smithsonian Institution, Washington, D.C.

Mark Rothko was a leading artist among the American abstract expressionists of his generation. His mature color-field paintings, evoking personal, almost transcendental images, exemplified another side of abstract expressionist art.

Born Marcus Rothkowitz in 1903, the artist emigrated from his native Russia with his family in 1913. Raised in Portland, Oregon, Rothko apparently did not manifest an artistic interest until he attended Yale University. After two years there he abandoned formal academic study and moved to New York City. Though he studied briefly with Max Weber at the Art Students League, the artist considered himself largely self-taught.

Rothko's first one-man exhibition was held in 1933. Two years later, he and Adolf Gottlieb co-founded The Ten, a group of expressionist painters who held exhibits hoping to popularize their style over that of the then-prevailing abstract artists. In 1936, Rothko worked for a year on the WPA Federal Art Project.

In the 1930s, Rothko's work was realistic, stressing urban figures in lonely isolation. However, before the end of the decade, the artist had abandoned realism altogether, influenced by surrealism, mythology and Jungian psychology. Rothko was attempting, he said, to express "man's primitive fears and motivations no matter in which land or in what time."

These symbolic works were characterized by muted colors and soft brushstrokes. He often worked in watercolor to achieve a luminous atmospheric quality unattainable with oils.

By the end of the 1960s, Rothko's work went beyond surrealism into total abstraction. Amorphous shapes were replaced by more simplified, arbitrary ones. By 1950, he further simplified his work—enlarging shapes to blurry-edged rectangles, placing them symmetrically and extending them to the borders of the canvas. The neutrality of the rectangle enhanced the primacy of color.

It was through color that Rothko attempted to communicate. His approach could be densely melancholy or radiantly luminous, as in his *Orange and Tan* (1954, National Gallery).

Paint was often applied in superimposed washes and the artist's canvas was often huge. "I paint large pictures because I want to create . . . intimacy," Rothko said.

By the end of the 1950s, Rothko's work was known throughout the world and was included in virtually every international exhibition. In 1961, he had a retrospective at the Museum of Modern Art in New York City. He also taught at several colleges and universities.

But by the early 1960s, Rothko's work became increasingly dark and meditative. He was then commissioned by the deMenil family in Houston, Texas to paint 14 murals for a chapel. He considered these murals—austere and dense—to be the culmination of his career.

In Rothko's noncommissioned paintings, color evaporated. Gray, then black, rectangles reached to the very edges of his canvases. In 1970, the artist committed suicide in New York City.

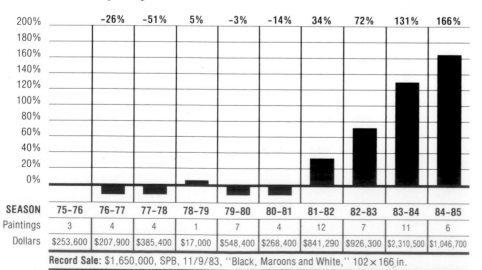

10-Year Average Change From Base Years '75-'76: 31%

	-26%	-51%	5%	-3%	-14%	34%	72%	131%	166%	
SEASON	75-76	76-77	77-78	78-79	79-80	80-81	81-82	82-83	83-84	84-85

SEASON	75-76	76-77	77-78	78-79	79-80	80-81	81-82	82-83	83-84	84-85
Paintings	3	4	4	1	7	4	12	7	11	6
Dollars	$253,600	$207,900	$385,400	$17,000	$548,400	$268,400	$841,290	$926,300	$2,310,500	$1,046,700

Record Sale: $1,650,000, SPB, 11/9/83, "Black, Maroons and White," 102 × 166 in.

ADOLPH GOTTLIEB
(1903-1974)

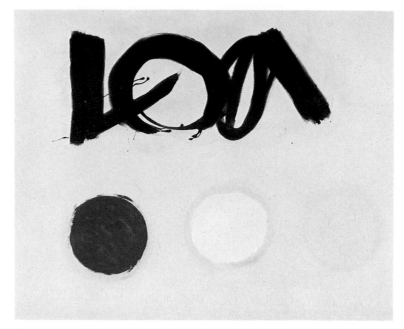

Three Discs, 1960, 72 x 90 in. Courtesy of National Museum of American Art, Smithsonian Institution, Gift of S.C. Johnson & Son, Inc.

Like Mark Rothko and Barnett Newman, Adolph Gottlieb, an important abstract expressionist, was chiefly concerned with color relationships in his later work. Early on, however, he used earth-toned primitive pictographs in horizontal and vertical patterns to evoke a Jungian archetype. Later, in what he called "imaginary landscapes," these primitive forms gave way to vivid circular forms above broad horizontal bands of color. In the final two decades of his life, the vibrancy of his abstractions brought him several commissions for stained-glass works in synagogues and elsewhere.

Unlike most modern American painters, for whom New York City was only an adopted home, Gottlieb was born there in 1903. He studied at the Art Students League under John Sloan and Robert Henri in 1920. The next year he left unexpectedly for Europe and continued his studies at the Academie de la Grande Chaumiere in Paris. After brief stays in Berlin and Munich, he returned to New York in 1923, and completed his training at the Parsons School of Design.

His earliest work was expressionist-realist in style, but he was drawn more and more toward the avant-garde. From 1935 to 1940, he exhibited with The Ten, a group that included Rothko and Ilya Bolotowsky.

In the late 1930s, Gottlieb lived for a time in Tucson, Arizona, where his interest in primitive art was stimulated. He began to collect it and for 10 years, starting in 1941, his work was centered around the pictographs which reflected this primitive aesthetic.

When the art critic of *The New York Times* wrote that he could not understand either Gottlieb's or Rothko's paintings, the two responded with a letter that was, in effect, a manifesto for American abstract art. They declared, "It is our function to make the spectator see the world our way—not his way." It did not matter what one painted, they added, as long as it was painted well.

Through his career Gottlieb held fast to these principles. Writing in *Art in America* in 1954, he maintained that "the modern artist does not paint in relation to public needs or social needs—he paints only in relation to his own needs."

By 1951, his focus had shifted to grids and imaginary landscapes in which single totemic masses dominated his canvases. Often the foreground might hint at a landscape, with an ovoid celestial body hovering above. *The Frozen Sounds, Number 1* (1951, Whitney Museum of American Art) was an early example of this evolution.

After 1957, Gottlieb entered an entirely new period, in which vertical arrangements replaced the earlier horizontality. These paintings, collectively called "bursts," on which he worked until his death in 1974, were dominated by bursting shapes that might be compared to cosmic explosions. Sometimes tight and precise, at other times amorphous, they represented his most refined work with color values and hues.

10-Year Average Change From Base Years '75-'76: 151%

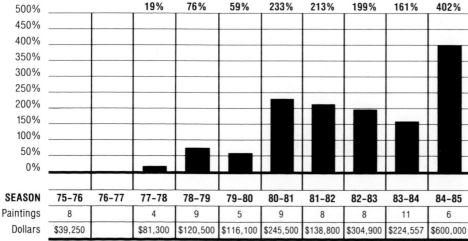

| | 19% | 76% | 59% | 233% | 213% | 199% | 161% | 402% |

SEASON	75-76	76-77	77-78	78-79	79-80	80-81	81-82	82-83	83-84	84-85
Paintings	8		4	9	5	9	8	8	11	6
Dollars	$39,250		$81,300	$120,500	$116,100	$245,500	$138,800	$304,900	$224,557	$600,000

Record Sale: $220,000, CH, 11/1/84, "Apaqugue," 72 × 90 in.

ALFRED JULIO JENSEN
(1903-1981)

In its strange beauty, the art of Alfred Jensen seems a paradox. Although visually pleasing, with lush color and impastoed paint, its complex patterns challenge the viewer.

Indeed, Jensen's checkerboard designs—featuring contrasting colors, squares, circles and triangles, overlaid with numerical concepts—defy easy interpretation. Variously described as a metaphysical artist, an abstract expressionist and a pioneer of minimal painting, he remained an independent spirit not aligned with any school of painting.

Born in California in 1903 to a Danish father and a German-Polish mother, Jensen was sent to Denmark at age seven for his education.

At age 14 he went to sea, later tried farming in Guatemala, and eventually returned to California, where he graduated from the San Diego Fine Arts School.

He then attended Hans Hofmann's school in Munich, where he learned to draw in the style of the old masters and acquired a wealthy patron, Mrs. Saidie May. The couple studied in Paris, traveled and collected until her death in 1951.

May's support enabled Jensen to study the ancient cultures, philosophy, mathematics and science. Profoundly influenced by certain writers, he devoted 20 years to Goethe's study of color theory, *Zur Farbenlehre*. Jensen's notated diagrams were transmuted to canvas and

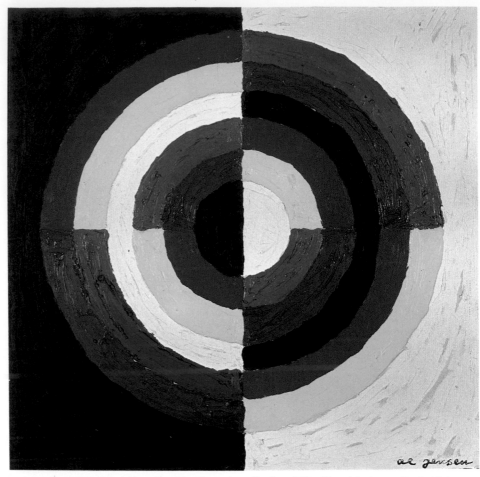

Color Wheel, 1959, 24 x 24 in., signed l.r. From the collection of The Chase Manhattan Bank, N.A., New York, New York.

appeared in his first one-man show, at the John Heller Gallery in New York City in 1953.

A set of 20 fine lithographs, *A Pythagorean Notebook* (1965), was produced while Jensen was a Tamarind Fellow; in the same year he executed a series of gouaches titled *Hekatompedon*.

Jensen's first major retrospective was held only a few years before his death in New Jersey at 77. *Paintings and Diagrams From the Years 1957-1977* was exhibited at the Albright-Knox Gallery in Buffalo, and represented the United States at the XIV International Sao Paulo Bienal in Brazil. The exhibition also toured major American museums.

PUBLIC COLLECTIONS
Baltimore Museum of Art
Dayton Art Institute, Ohio
Museum of Modern Art, New York City
Solomon R. Guggenheim Museum, New York City
Whitney Museum of American Art,
 New York City

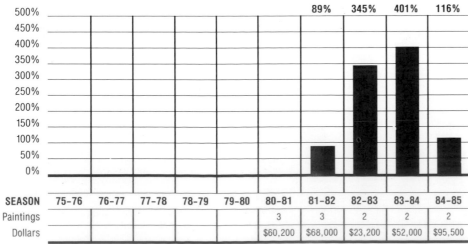

10-Year Average Change From Base Years '80-'81: 190%

						89%	345%	401%	116%
500%									
450%									
400%									
350%									
300%									
250%									
200%									
150%									
100%									
50%									
0%									

SEASON	75–76	76–77	77–78	78–79	79–80	80–81	81–82	82–83	83–84	84–85
Paintings						3	3	2	2	2
Dollars						$60,200	$68,000	$23,200	$52,000	$95,500

Record Sale: $60,500, SPB, 5/2/85, "Mayan Mat Patterns Number Structures," 72×72 in.

PAUL CADMUS

(1904-)

Paul Cadmus is a painter and engraver best known for his Depression-era satires of American manners, which employed techniques of the Renaissance masters to treat contemporary subject manner.

Born in New York City, Cadmus studied etching and printmaking at the National Academy of Design from 1919 to 1926, and at the Art Students League in 1928. From 1931 to 1933, Cadmus traveled extensively in France, Spain and Italy, where he continued his study of the European masters and began to paint his first mature satires.

Returning to the United States, Cadmus gained instant national notoriety in 1934. In a highly-publicized incident, a WPA-funded satire depicting drunken U.S. sailors on leave was removed from a public showing and later destroyed, following the vigorous protests of a U.S. admiral, who denounced the work as undignified, sordid and depraved.

Following this affair, Cadmus continued to produce Hogarth-like satires of vulgar American manners, in oil, egg tempera and etching, featuring crowded scenes of men and women in grotesque attitudes and raucous behavior. Although regularly condemned by unsophisticated critics, Cadmus found himself celebrated in the popular media for his insouciance, and admired by serious art critics for his technical virtuosity.

Although best known for his satirical works, Paul Cadmus has also been praised for his considerable body of non-satirical drawings—in pencil, ink and wash—of nudes, ballet dancers and familiar household items, as well as portraits of family and friends. Relaxed in attitude and devoid of caricature, Cadmus's drawings have been associated with the early development of photo realism in the United States after World War II.

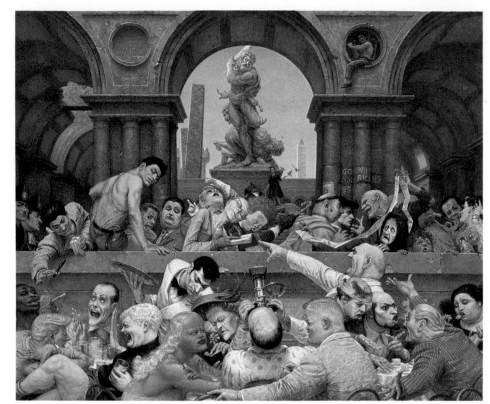

Bar Italia, 1955, 37½ x 45½ in. Courtesy of National Museum of American Art, Smithsonian Institution, Washington, D.C. Gift of S.C. Johnson and Son, Inc.

MEMBERSHIPS
National Academy of Design
National Institute of Arts and Letters

PUBLIC COLLECTIONS
Metropolitan Museum of Art, New York City
Museum of Modern Art, New York City
Whitney Museum of American Art,
 New York City

SEASON	75-76	76-77	77-78	78-79	79-80	80-81	81-82	82-83	83-84	84-85
Paintings				4	5	2	3		5	1
Dollars				$5,025	$16,900	$2,600	$2,900		$7,900	$1,400

Record Sale: $9,500, SPB, 10/25/79, "Self-Portrait," 16 × 12 in.

GEORGIO CAVALLON

(1904-)

Born in Italy, abstract painter Georgio Cavallon was influenced early in his career by Dutch modernist Piet Mondrian. In New York City during the 1930s and 1940s, he was closely associated with Arshile Gorky, Willem de Kooning and other abstract expressionists.

Cavallon was born in Sorio, near Vicenza, in 1904. He first came to the United States with his family in 1906, but returned to Italy in 1910 following the death of his mother.

At age 16, Cavallon emigrated to the United States and undertook an art education. He attended the National Academy of Design from 1926 to 1930, and studied with Charles W. Hawthorne in Provincetown during the summer of 1927. When the Depression made it impossible for him to find employment, he returned to Italy, having already obtained his United States citizenship, and lived there from 1930 to 1933.

Cavallon returned to New York City in 1933, and resumed his art training. He studied at the Hans Hofmann School of Fine Arts in the evenings from 1934 to 1936. An accomplished abstractionist, Cavallon received the first of many solo exhibitions at the ACA Gallery in New York in 1934.

During the mid-1930s, the artist joined the WPA Federal Art Project, and worked for a time as an assistant to abstract painter Arshile Gorky. He was a founding member of American Abstract

Untitled, 1959, 65¼ x 37¼ in., signed l.r. Courtesy of The Whitney Museum of American Art, New York, New York. Gift of the Friends of the Whitney Museum of American Art.

Artists, an organization in which he was involved from 1936 to 1957.

Attracted early in his career to such cerebral abstractionists as Piet Mondrian and Jean Helion, Cavallon brought a more random, gestural approach to his work after 1950. He has remained remarkably consistent, however, in his application of geometric grids and bars of color, inspired by Mondrian, in order to structure and organize his surfaces.

The geometric forms in a relatively late work, *Untitled* (1959, Whitney Museum of American Art), have been compared to the color shapes of the early work of Matisse. Since the late 1960s and 1970s, Cavallon has framed his surfaces with small, dark shapes in order to control the large, unified rectangles of light color.

Cavallon's paintings have been described as exuding a subtle, atmospheric light reminiscent of Mediterranean villages.

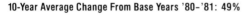

10-Year Average Change From Base Years '80-'81: 49%

SEASON	75-76	76-77	77-78	78-79	79-80	80-81	81-82	82-83	83-84	84-85
							29%	85%	35%	97%
Paintings						1	7	1	4	2
Dollars						$1,100	$49,650	$14,000	$54,975	$15,900

Record Sale: $28,000, SPB, 5/10/84, "It Is—Number 3," 70×39 in.

WILLEM DE KOONING
(1904-)

Willem De Kooning, one of the recognized masters of abstract expressionism, was a founder of the New York School of action painting. Born and raised in tidy, neat Holland, De Kooning created art that is the antithesis of calm. His paintings seem to retain the force of instantaneous creation, with images continuing to grow out of other images.

Born in Rotterdam in 1904, De Kooning received a solid background in the applied arts as an apprentice, first for a commercial art firm and then for a display and sign painter. Through the latter, he was exposed to the de Stijl geometric design movement, led by Mondrian, and to the cubist revolutionaries of Paris.

Working by day, he studied painting in evening classes at the Rotterdam Academy of Fine Arts and Techniques. In 1924, he went to Belgium for further study; two years later, as a stowaway, he came to the United States.

De Kooning settled in Hoboken, New Jersey and supported himself as a house painter. His early paintings were experimental. Although he admired the order and purity of Mondrian's work, his own showed no trace of it.

In 1933, he became a friend of Arshile Gorky, with whom he shared an intense admiration for cubism and Picasso. Gorky had a far-reaching influence on De Kooning's development.

In the late 1930s, De Kooning worked for the WPA Federal Art Project and, for the first time, earned his living as an artist. It was not until 1948, however,

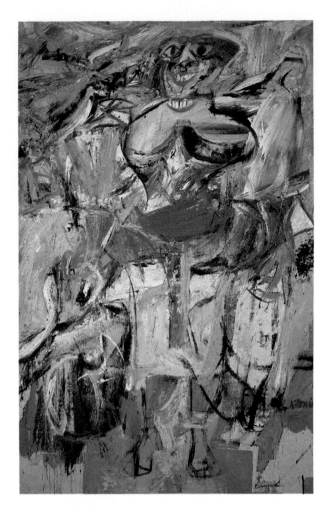

Woman and Bicycle, 1952-1953, 76½ x 49 in., signed l.r. Courtesy of Collection, The Whitney Museum of American Art, New York, New York, Purchase.

that he was ready for his first one-man show of masterful black paintings with white-line drawing.

That same year, his friend Gorky committed suicide. It was a stunning blow to De Kooning and yet, at the same time, a liberation. Paintings, sardonic and violent, began to pour from his brush.

In 1952, obsessed with interest in the human figure, De Kooning began a long series of paintings of women, the most

powerful work that he had yet done.

He explored the theme over and over again. Sometimes it was woman as sex symbol; other times, as in *Woman 1* (1952, Museum of Modern Art), she is depicted as a repellent, sharp-fanged, horn-bosomed vampire. Each time, De Kooning seemed to attack the canvas savagely, letting paint drip and dribble down the surface. Since the 1960s, he has alternated between pure abstractions and paintings of women.

"Art never seems to make me peaceful or pure," De Kooning once said. "I always seem to be wrapped up in the melodrama of vulgarity."

MEMBERSHIPS
National Institute of Arts and Letters

PUBLIC COLLECTIONS
Albright-Knox Art Gallery, Buffalo
Art Institute of Chicago
Baltimore Museum of Art
Guggenheim Museum, New York City
Hirshhorn Museum and Sculpture Garden, Washington, D.C.
Metropolitan Museum of Art, New York City
Museum of Modern Art, New York City
Phillips Collection, Washington, D.C.
Walker Art Center, Minneapolis
Whitney Museum of American Art, New York City

10-Year Average Change From Base Years '80-'81: 198%

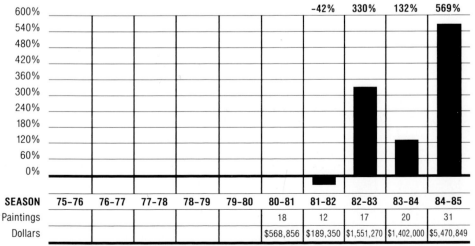

SEASON	75-76	76-77	77-78	78-79	79-80	80-81	81-82	82-83	83-84	84-85
							-42%	330%	132%	569%
Paintings						18	12	17	20	31
Dollars						$568,856	$189,350	$1,551,270	$1,402,000	$5,470,849

Record Sale: $1,800,000, CH, 11/1/84, "Two Women," 22 × 28 in.

909

BALCOMB GREENE
(1904-)

Balcomb Greene, whose artistic style has shifted from the purely abstract to the figurative, was one of the founders and the first chairman of the American Abstract Artists Society.

Born in 1904 in Niagara Falls, New York, Greene studied psychology and taught English literature before he began his artistic career. In 1931, he spent a year painting in Paris, a professional transition strongly encouraged by Greene's wife, Gertrude Glass, a sculptor and painter.

While in Paris, Greene worked independently at the Academie de la Grande Chaumiere, and had his first one-man exhibition. He never received any formal artistic training.

Returning to America in 1933, Greene worked for three years painting murals for the WPA's Federal Art Project. His style at that time—totally abstract, a combination of cubism and constructivism—is evident in the murals he created for the Federal Hall of Medicine at the New York World's Fair and for the Williamsburg housing project in New York.

In 1936, Greene founded and became first chairman of the American Abstract Artists Society, a group of painters organized to promote and popularize abstract art in the United States.

During the early 1940s, Greene began introducing figurative elements into his paintings, while still giving strong emphasis to linear form. It was not until 1947 that the artist had his first one-man show in New York. By then, his style had become even further modified. As seen in *The Wreck, No. II* (1958, Brooklyn Museum), the human form, often nude, is set against deeply shadowed abstract images. Color emphasis is on whites, deep reds and softened shades of gray.

In addition to his painting, Greene taught art history and aesthetics at New York University from 1943 to 1957.

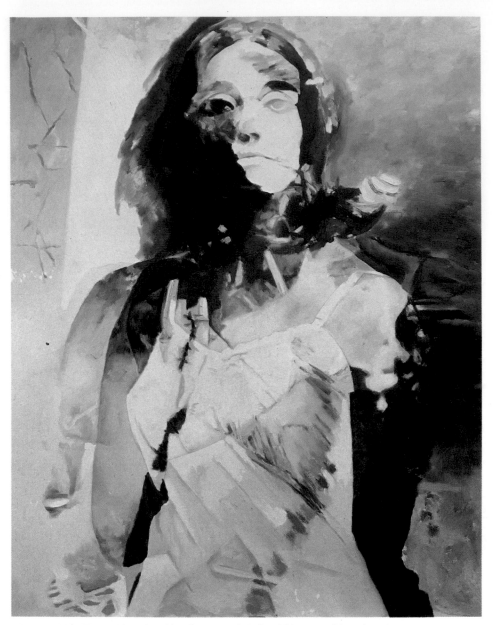

Woman, 1966, 49¾ x 40 in., signed l.r. Courtesy of National Museum of American Art, Smithsonian Institution, Gift of Mr. and Mrs. Gustave King.

MEMBERSHIPS
American Abstract Artists
Artists Union
Federation of Modern Painters and Sculptors
International Institute of Arts and Letters

PUBLIC COLLECTIONS
Art Institute of Chicago
Baltimore Museum of Art
Brooklyn Museum
Carnegie Institute, Pittsburgh
Metropolitan Museum of Art, New York City
Museum of Modern Art, New York City
National Collection of Fine Arts,
 Washington, D.C.
Solomon R. Guggenheim Museum, New York City
Whitney Museum of American Art,
 New York City

SEASON	75-76	76-77	77-78	78-79	79-80	80-81	81-82	82-83	83-84	84-85
Paintings					1	2	3	1		1
Dollars					$1,000	$3,800	$5,400	$750		$1,800

Record Sale: $2,800, CH, 12/5/80, "California Coast," 40 × 50 in.

PETER HURD
(1904-1984)

A native of the arid, majestic country of the Southwest, Peter Hurd returned there as a painter to capture the color, light and variety of the land and the people that he loved. He was also an accomplished portrait painter and book illustrator.

Born in Roswell, New Mexico in 1904, Hurd at first wanted a military career. He attended the military academy at West Point for two years. Having failed a mathematics course, he was tutored for an entire summer to regain his status as a cadet, but then decided he would rather become a painter.

He attended the Pennsylvania Academy of the Fine Arts in Philadelphia and studied for several years with N. C. Wyeth, the well-known illustrator, in nearby Chadds Ford, Pennsylvania. He married Wyeth's eldest daughter, herself a painter, and became a member of the clan that has had a considerable impact on the world of representational art.

Hurd stayed in Chadds Ford for 12 years, but eventually the lure of his beloved New Mexico became too strong and he moved his family back there. He began to experiment with painting in egg tempera on gesso board, a technique that gave an unusual luminosity to the scenes that he painted. It enabled him to catch the Southwest's crystalline air, blazing sun and bold shadows.

"What motivates me is a constant sense of wonder," Hurd said after returning to New Mexico. "It is hard to

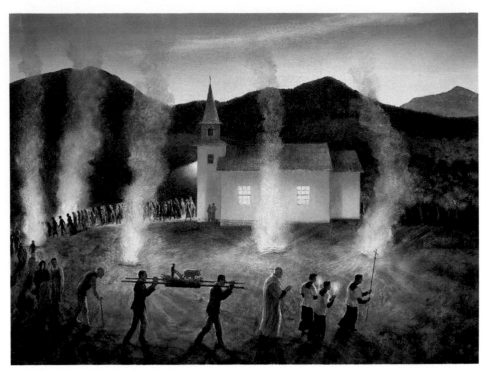

The Eve of San Ysidro at San Patricio, 36 x 48 in., signed l.l. Photograph courtesy of The Gerald Peters Gallery, Santa Fe, New Mexico.

tell anyone just how painting can be a religious experience, but it is with me."

By the late 1930s, Hurd's work was widely recognized. He received several commissions for murals in public buildings. During World War II he was sent overseas to record wartime activities for *Life* magazine.

In 1967, Hurd was commissioned to paint an official portrait of President Lyndon B. Johnson, which the president rejected. The director of the National Portrait Gallery thought it a good likeness, however, and the painting now hangs there.

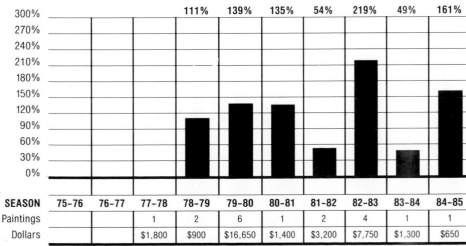

10-Year Average Change From Base Years '77-'78: 109%

				111%	139%	135%	54%	219%	49%	161%

SEASON	75-76	76-77	77-78	78-79	79-80	80-81	81-82	82-83	83-84	84-85
Paintings			1	2	6	1	2	4	1	1
Dollars			$1,800	$900	$16,650	$1,400	$3,200	$7,750	$1,300	$650

Record Sale: $3,800, CH, 5/22/80, "Windmill and Fence," 17 x 23 in.

DALE NICHOLS
(1904-)

Versatile artist Dale Nichols is recognized as a painter, graphic artist, watercolorist, designer, writer, illustrator and lecturer. He is also known as an early champion of better art in advertising and illustration.

Born in David City, Nebraska in 1904, he studied at the Chicago Academy of Fine Arts, with Carl Werntz at the Art Institute of Chicago, and with Joseph Binder in Vienna. His Nebraskan background is the inspiration for his artistic interpretation of rural America.

His varied career has included the 1935 publication of *A Philosophy of Esthetics,* detailing his theories on art; serving as Carnegie Professor of Art at the University of Illinois in 1939; and creating artwork for direct-mail industrial advertising in the 1930s and 1940s.

In the 1930s, Nichols won the Hearst Award at the Art Institute of Chicago for his painting *The End of the Hunt* (date unknown, Metropolitan Museum of Art). From 1942 to 1948, he served as art editor of the *Encyclopedia Britannica,* succeeding American artist Grant Wood. He also wrote and illustrated several books, including *Figure Drawing* (Watson-Guptill Publications, 1957).

During the 1960s, Nichols moved to Guatemala. He was captivated by the country's tropical beauty, heritage of Spanish colonial culture, and unchanged Mayan way of life.

Nichols switched from oils to watercolors during his years in Guatemala.

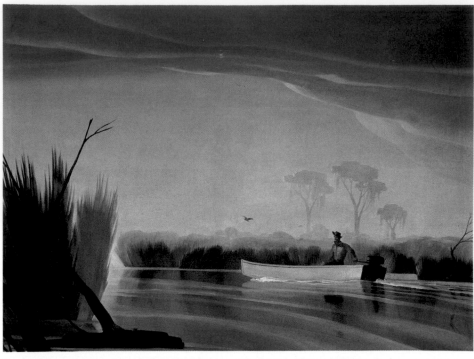

Bayou Fisherman, 30 x 40 in., signed l.l. Courtesy of Grand Central Art Galleries, Inc., New York, New York.

Although he sketched outdoors, the final work was done in his studio, so that he could inject his own psychology into his theme. In tempera, oil, watercolor, ink and pencil, Nichols's work utilizes numerology, magic squares and psychic symbols.

His work represented in private collections. Nichols has had 18 one-man shows in museums and galleries, and has exhibited in more than 80 regional and national shows.

MEMBERSHIPS
American Artists Professional League
Brownsville Art League
Grand Central Galleries
Society of Typographic Arts

PUBLIC COLLECTIONS
Art Institute of Chicago
Metropolitan Museum of Art, New York City
Victoria and Albert Museum, London

10-Year Average Change From Base Years '77-'78: 100%

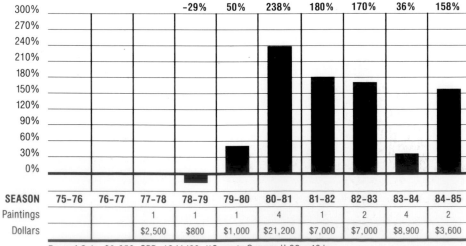

	-29%	50%	238%	180%	170%	36%	158%

SEASON	75-76	76-77	77-78	78-79	79-80	80-81	81-82	82-83	83-84	84-85
Paintings			1	1	1	4	1	2	4	2
Dollars			$2,500	$800	$1,000	$21,200	$7,000	$7,000	$8,900	$3,600

Record Sale: $8,250, SPB, 12/4/80, "Come to Supper," 30 × 40 in.

912

ARSHILE GORKY
(1904-1948)

Arshile Gorky was an Armenian exile whose art of the 1940s is considered one of the germinating forces of abstract expressionism. Heavily influenced successively by Cezanne, Picasso and Miro, he is a major link between European cubists and surrealists and their American counterparts.

Gorky was born Vosdanig Manoog Adoian in 1904, in a small village in fertile central Armenia. He had a happy childhood, rich in the tradition of Armenian art, music, dancing and folklore. He started to draw at age six.

The conflagrations that swept across the Middle East during World War I destroyed his world. Gorky's father and older sisters managed to escape to America, but Gorky, his mother and his younger sister became refugees in Russia. In 1919, his mother died of starvation in her son's arms. The next year Gorky and his sister made their way to America and rejoined their father and older sisters.

In his new land, Gorky studied first at the Rhode Island School of Design, the New School of Design in Boston, and later at the Grand Central Art School in New York City, where he also taught. He changed his name in 1925, thinking it more appropriate for a painter.

Critic Harold Rosenburg once characterized Gorky as an artist in exile for whom art became a homeland. Some of his earliest paintings, such as the three versions of *The Artist and His Mother* (1926 to 1929, Whitney Museum of American Art), reflect his sense of loss and nostalgia.

Throughout the 1920s, Gorky was principally a champion of cubism, studying Cezanne's style intently. By the 1930s, however, he had become an ardent disciple of Picasso, whom he considered the greatest living painter. Gorky's *Organization* (1932, location unknown) was directly inspired by Picasso's *The Studio*.

The Artist and His Mother, 1926-1929, 60 x 50 in., signed l.r. Courtesy of Collection The Whitney Museum of American Art, New York, New York, Gift of Julien Levy for Maro and Natasha Gorky in memory of their father.

In 1933, three Gorky still lifes were included in an exhibition of work by artists under 35 at the Museum of Modern Art, and shortly afterward the Whitney Museum of American Art purchased one of his paintings.

In 1935, under the WPA Federal Art Project, Gorky was commissioned to paint a mural at Newark Airport. Its cubist forms, aerial-photographic images and surrealist organic shapes created a controversy at first, but were later praised. He received another commission for a mural in 1939, this time in the Aviation Building at the New York World's Fair.

By the early 1940s, the surrealist emphasis on dreams and the subconscious as sources of images had liberated Gorky, enabling him finally to develop the style that was to be uniquely his own.

His mature work has an extraordinary freedom in its washes and bursts of color. Encoded in its abstract forms are ideograms laden with biological, metamorphic and erotic symbolism. One of the best examples is *The Liver is the Cock's Comb* (1944, Albright-Knox Art Gallery).

Tragedy dogged the last years of Gorky's life. In 1946, his studio in Connecticut burned, destroying most of his work. Soon afterward he had an operation for cancer, from which he recovered. In 1948, however, an automobile accident left his painting arm paralyzed. His marriage deteriorated and his wife left him. In July 1948, Gorky committed suicide.

PUBLIC COLLECTIONS
Albright-Knox Art Gallery, Buffalo, New York
Art Institute of Chicago
Metropolitan Museum of Art, New York City
Museum of Modern Art, New York City
Oberlin College, Ohio
University of Arizona, Phoenix
Utica Museum, New York
San Francisco Museum of Art
Washington University, St. Louis
Whitney Museum of American Art,
 New York City

SEASON	75-76	76-77	77-78	78-79	79-80	80-81	81-82	82-83	83-84	84-85
Paintings	2	9	6	6	6	8	35	3	7	7
Dollars	$141,200	$59,300	$28,550	$225,300	$119,050	$145,300	$870,600	$18,900	$313,500	$112,400

Record Sale: $280,000, SPB, 11/4/81, "Study for Agony," 40 × 51 in.

CLYFFORD STILL
(1904-1980)

Clyfford Still was a major figure in the development and popularization of abstract expressionism. Although critics have cited the influence of the surrealists on Still's early work, he vehemently rejected the entire European artistic tradition, including surrealism.

Still was born in Grandin, North Dakota in 1904. His early years were spent in Spokane, Washington and Bow Island, Alberta, Canada. The grandeur and vastness of the Pacific Northwest and the Canadian prairie impressed him deeply and are reflected in many of his paintings.

In 1924 or 1925, Still visited New York City in the hope of studying art. He spent less than an hour at the Art Students League, however, before deciding that it was not for him. He returned to the West, where he studied art at Spokane University and at Washington State College. He also began teaching painting, sculpture and art history.

Still received a fellowship for study at the Trask Foundation in Saratoga Springs, New York in 1934. There he completed a series of figure studies. Upon returning to Washington State College, Still continued during the late 1930s to work toward his mature painting style.

Although Still's early paintings used rich textures and rapid, sweeping brushstrokes to achieve an emotionally expressive effect, they also contained elements of realism. Many showed gaunt figures in arid landscapes; these are the works which have been linked to surrealism. During the 1930s, Still's paintings lost their figurative quality as his images grew progressively more abstract. He did not name his canvases, identifying them only by the year in which they were painted and a letter of the alphabet to indicate their order within the year.

Between 1943 and 1945, while teaching in Virginia, Still produced a series of

1946-H, or Indian Red and Black, 1946, 78 x 68 in. Courtesy of National Museum of American Art, Smithsonian Institution, Museum Purchase From the Vincent Melzac Collection.

21 lithographs, and a number of sculptures and watercolors. He also began painting canvases that abandoned depth and the illusion of space for massive, floating images without discernible figure-ground relationships; large areas of color of similar intensity and hue created the appearance of a flat painted surface.

He exhibited at the San Francisco Museum of Art in 1943, and at the Art of This Century Gallery in New York City in 1946. From 1946 to 1950, he taught at the California School of Fine

Arts, where he was influential in promulgating abstract expressionism.

Typical of Still's mature work are *Painting* (1951, Detroit Institute of the Arts), with its brown and yellow palette, and *1957-D No. 1* (1957, Albright-Knox), with its violent, jagged shapes and impenetrable surface.

Still taught at a number of institutions, including the Brooklyn Museum School and the University of Pennsylvania. He died in 1980.

SEASON	75-76	76-77	77-78	78-79	79-80	80-81	81-82	82-83	83-84	84-85
Paintings		1	1						2	2
Dollars		$165,000	$80,000						$63,000	$1,375,000

Record Sale: $797,500, SPB, 5/2/85, "Untitled," 117 × 101 in.

THEODORE ROOSEVELT LAMBERT

(1905-1960?)

A restless, solitary, driven man, the painter Ted R. Lambert grew up in the heart of settled America but seemed destined for pioneer country. When he found Alaska, he found a land that claimed him as its own.

He was born in Zion, Illinois in 1905, to a supportive mother and a domineering father, and from the start he was unable to play the part of the good boy. He did poorly in all his studies except art, and began his wandering life at age 14, when he ran away from home with a friend for six weeks, ending up in Denver, Colorado. Though he returned home for a time and worked as a sign painter and engraver, he left home permanently at age 17 and worked his way through the West. In 1925 or 1926 he arrived in Alaska without money, managing by sheer toughness to survive in the wilderness territory.

He worked as a miner, trapper, logger, postman (by dog sled) and book designer, but he also always worked as an artist. He managed to make enough money working for the Fairbanks Exploration Company as a roving artist and photographer to study at the American Academy of Art in Chicago, Illinois in 1931, and later to study under the artist Eustace Ziegler in Seattle, Washington for a winter.

Though Lambert could not bear to submit for long to the strictures of the civilized world, he imposed a merciless discipline on himself as far as his art was concerned, going on long solitary painting trips to perfect his eye. His brushstrokes were vigorous and forceful and he avoided unnecessary detail, but he placed great emphasis on verisimilitude. Alaskans valued his fidelity to reality and his understanding of the wildness of the country, and he began to acquire some recognition as an artist.

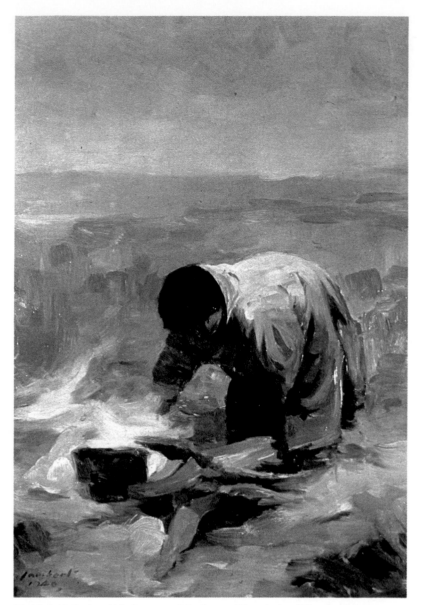

Untitled, 1940, signed l.l. Courtesy of Anchorage Historical and Fine Arts Museum, Arkansas.

He met and married a young teacher and attempted to settle down. But it was as though he was a wild animal that could not be domesticated. His wife, alarmed by his gradually increasing paranoia and isolation, took their baby daughter and left him. Their divorce alienated him even further from the civilized world, and he sought the solace of a cabin on the west coast of Alaska, more and more cut off from his few remaining friends.

In 1960 he disappeared mysteriously, leaving behind stacks of unfinished paintings and a 250,000-word manuscript. No trace of him has ever been found.

SEASON	75-76	76-77	77-78	78-79	79-80	80-81	81-82	82-83	83-84	84-85
Paintings						1	1	2		
Dollars						$4,500	$6,500	$16,750		

Record Sale: $13,000, BB.SF, 9/23/82, "Native Fishcamp at Anvik, Alaska," 28 × 39 in.

PUBLIC COLLECTIONS
Anchorage Historical and Fine Arts Museum, Alaska
Charles and Emma Frye Art Museum, Seattle

JOHN FERREN
(1905-1970)

John Ferren lived and worked in Paris in the 1930s, when artists were forming theories about abstract art. Among his friends were Picasso, Braque, Kandinsky, Ernst, Mondrian, Miro and Klee.

Ferren was born in Pendleton, Oregon in 1905, but grew up in San Francisco and Los Angeles. In 1923, he graduated from the Polytechnic High School in Los Angeles. He did some portrait heads of his friends when he was a teenager, and studied art briefly at a school in San Francisco. He then apprenticed himself to an Italian stonecutter, from whom he learned how to make ornamental building blocks and carve tombstones.

In 1929, Ferren went to Paris to study at the Sorbonne, the Academie de la Grande Chaumiere and the Academie Colarossi. He came back briefly to the United States, but soon returned to Paris, staying this time until 1938. He gravitated to the most avant-garde artists, experimented with various modes of painting, and assimilated ideas from each.

By the 1930s, Ferren had established himself as a geometric abstractionist. In his *Untitled* (1937, Solomon R. Guggenheim Museum), the forms are completely abstract, yet there is a sense of two individuals present. The painting has an intensely sculptural quality.

About 1935, Ferren adapted a technique that had been conceived by William Stanley Hayter in Paris. Hayter was printing etchings on plaster, and Ferren began to do this also, using color and carving into the lines to give them the appearance of bas-reliefs.

In the early 1950s, he began to use delicate pale washes on raw canvas. Often he used a calligraphy which resembled Chinese writing. Writing in *ARTnews,* Lawrence Campbell said of Ferren's work: "A thread runs through

Watercolor, 1934, 12⅜ x 18½ in., signed l.r. Courtesy of Martin Diamond Fine Arts, New York, New York.

it all: a strong inclination for order and an intuitive feeling for color."

For a time in the mid 1950s, Ferren felt a need to return to realistic images. Hatching brushstrokes behind vertical bands of color took the form of vases. Ferren himself did not understand why this came about; as he said, "Creative workers live close to mystery."

He died in 1970 in Southampton, New York.

MEMBERSHIPS
Advisory Council to the School of Art and
 Architecture, Yale University
Century Association

PUBLIC COLLECTIONS
Allentown Art Museum, Pennsylvania
Cleveland Museum of Art
Detroit Institute of Arts
Hirshhorn Museum and Sculpture Garden,
 Washington, D.C.
Museum of Modern Art, New York City
Philadelphia Museum of Art
Solomon R. Guggenheim Museum, New York City
Wadsworth Atheneum, Hartford, Connecticut
Whitney Museum of American Art,
 New York City
Yale University Art Gallery

SEASON	75–76	76–77	77–78	78–79	79–80	80–81	81–82	82–83	83–84	84–85
Paintings			1	4	2		5			2
Dollars			$650	$5,650	$3,300		$5,000			$5,500

Record Sale: $5,000, CH, 5/2/85, "The Windows," 63 × 75 in.

BARNETT NEWMAN
(1905-1970)

Although he experimented with biomorphic forms in his early paintings, it was not until he had discarded all symbols and refined his work into flat planes of color, divided in almost classical harmony by a vertical band or bands of another color, that Barnett Newman was grudgingly accepted as a major figure in American art. In struggling to find a mode of expression free from all taint of the past, he did much to help American art come of age.

Newman is today recognized as the link between abstract expressionism and the color-field and minimalist painters. In the opinion of some critics, it was he, more than anyone else, who established the legitimacy of color-field painting.

Newman was born in New York City in 1905. While in high school and college, he also studied at the Art Students League. Instead of pursuing a career in art, however, he became a partner in his father's clothing manufacturing business for 10 years.

But Newman never forsook his interest in art. He visited art galleries and museums and even worked at times as a substitute art teacher. He painted, too, but destroyed most of his early work.

Around 1944, Newman began a series of calligraphic, surrealist drawings which, in turn, led to his first serious painting. Using biomorphic shapes that resembled ova, spermatozoa and budding seeds, he examined the very meaning of existence.

Covenant, 1949, 48 x 60 in. Courtesy of Hirshhorn Museum and Sculpture Garden, Smithsonian Institution, Washington, D.C.

In 1948, while seeking a simplified way to convey the idea of creation, Newman painted *Onement 1* (private collection), in which a vertical orange stripe separates two red-brown fields of pure color. On studying the work closely, he realized it was complete. At last he had found the means of addressing the unknowable that he had been seeking. Over the next few years, continuing in this vein, he painted some of his finest work.

Recognition did not come easily, however. His first two shows of this work were disasters. His paintings were dismissed as merely "decorative" and even "fraudulent." It was not until a retrospective show in 1958 that the seriousness of his purpose was finally accepted.

Between 1958 and 1966, he attempted to explore the notion of life after death in a series of 14 black-and-white paintings based on the Stations of the Cross. In the final years before his death in 1970, Newman also turned to sculpture. *Broken Obelisk* (1963 to 1967, one version in the Museum of Modern Art) is considered his best piece. It is an inverted obelisk balanced on a pyramid, symbolizing, some think, Newman's belief in classical order and stability.

PUBLIC COLLECTIONS
Detroit Institute of Arts
Hirshhorn Museum and Sculpture Garden,
 Washington, D.C.
Kunstmuseum, Basel, Switzerland
Moderna Museet, Stockholm
Museum of Modern Art, New York City
Stedelijk Museum, Amsterdam
Whitney Museum of American Art,
 New York City

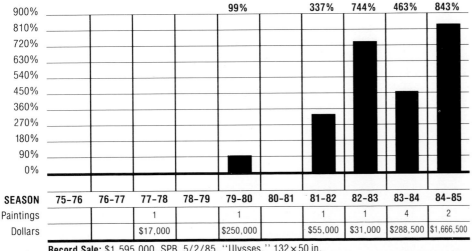

10-Year Average Change From Base Years '77–'78: 414%

SEASON	75–76	76–77	77–78	78–79	79–80	80–81	81–82	82–83	83–84	84–85
					99%		337%	744%	463%	843%
Paintings			1		1		1	1	4	2
Dollars			$17,000		$250,000		$55,000	$31,000	$288,500	$1,666,500

Record Sale: $1,595,000, SPB, 5/2/85, "Ulysses," 132 × 50 in.

GEORGE L.K. MORRIS
(1905-1975)

George Lovett Kingsland Morris was a founder and the chief spokesman for American Abstract Artists, a group formed in 1936 to advance the movement of modernism. Abstract painter, art critic, sculptor, teacher and writer, he was president of the radical group from 1948 to 1950, and edited its publication, *The World of Abstract Art*.

Born in New York City in 1905, Morris graduated from Yale in 1928, then studied at the Art Students League until 1930 with John Sloan and Kenneth Hayes Miller. Paris studies followed, under Fernand Leger and Amedee Ozenfant at the Academie Moderne.

A one-man show of Morris's work, the first of many exhibitions during his career, was held in New York in 1933.

Morris felt a kinship with the work of Hans Arp, his co-editor of *Plastique,* the French art magazine. Morris also edited the *Partisan Review* and the *Bulletin of the Museum of Modern Art.*

Morris said that he wanted to "strip art inward to those very bones from which all cultures take their life." He used bright, unmodulated colors, and shapes that were hard-edged, though not necessarily geometrical, limiting the depth of his work.

Morris taught at the Art Students League from 1943 to 1944, and at St. John's College in Annapolis from 1960 to 1961. He died in New York in 1975.

MEMBERSHIPS
American Abstract Artists

PUBLIC COLLECTIONS
Brooklyn Museum
Corcoran Gallery of Art,
 Washington, D.C.
Metropolitan Museum of Art,
 New York City
North Carolina Museum of Art,
 Raleigh
Pennsylvania Academy of the Fine Arts,
 Philadelphia
Philadelphia Museum of Art
Phillips Collection, Washington, D.C.
Whitney Museum of American Art,
 New York City

Industrial Landscape, 1936-1950, 49½ x 63½ in., signed l.r. Courtesy of National Museum of American Art, Smithsonian Institution, Gift of Anonymous Donor.

SEASON	75-76	76-77	77-78	78-79	79-80	80-81	81-82	82-83	83-84	84-85
Paintings		1			1	1	5	1		1
Dollars		$1,900			$4,500	$8,000	$27,200	$5,750		$15,000

Record Sale: $15,000, CH, 12/7/84, "Composition No. 9," 18 × 14 in.

OGDEN PLEISSNER
(1905-1983)

Ogden Pleissner, although city-bred and trained, craved the outdoors. An artist of great technical skill who brings order and clarity to his landscapes, he has admitted to believing himself weak in drawing and perspective. It is as though he perceived his upbringing and basic nature to be liabilities and set himself the task of overcoming them in his work.

Born in Brooklyn in 1905, Pleissner was educated in New York City's Art Students League. When his studies were completed, he immediately headed for the wide open spaces. His first paintings were of the Grand Teton Mountains in Wyoming. In 1932, the Metropolitan Museum of Art purchased one of his oil paintings, making him the youngest artist in its collection at that time.

During the 1930s, Pleissner's lifelong fascination with the transparency of watercolor began. During World War II, he worked for the United States Air Force, painting Aleutian bases. He also illustrated the Normandy breakthrough for *Life* magazine. After the war, he began to concentrate on urban European scenes in France, Italy and Spain; he has firmly established his reputation on that subject matter.

Pleissner is an elegant realist. His paintings have an almost photographic coldness and precision, but they are not mere records or painstaking substitutes for snapshots. His clarity and purity of light, his sense of composition, and his

Grouse Shooting by the Old Stone Wall, signed l.l. Courtesy of The Shelburne Museum, Shelburne, Vermont.

knack for selecting only those pictorial elements which contribute to the overall picture permit his subjects to speak for themselves, unimpeded either by sentimentality or by the distractions of technique.

A consummate outdoorsman, Pleissner liked to combine Western painting expeditions with hunting and fishing, but his first home, New York City, remained his headquarters.

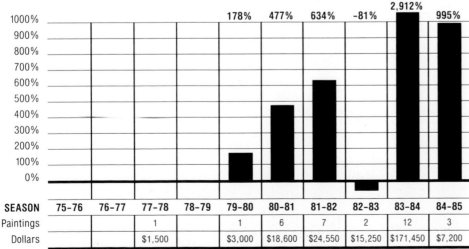

10-Year Average Change From Base Years '77-'78: 731%

SEASON	75-76	76-77	77-78	78-79	79-80	80-81	81-82	82-83	83-84	84-85
					178%	477%	634%	-81%	2,912%	995%
Paintings			1		1	6	7	2	12	3
Dollars			$1,500		$3,000	$18,600	$24,550	$15,250	$171,450	$7,200

Record Sale: $50,000, CH, 6/8/84, "Quail Shooting," 24 × 36 in.

PETER BLUME
(1906-)

The work of surrealist painter and muralist Peter Blume combines detail with visionary conceptions. Much of his small body of work reflects contemporary events or politics.

Blume was five years old when he immigrated with his family to New York City from Smorgon, Russia. By the time he was 13, his art education was under way; he studied at the Educational Alliance School of Art, the Beaux-Arts Institute of Design, and the Art Students League. He became a citizen of the United States in 1921. Blume's early work has been compared with that of certain precise painters of the 1920s, especially Charles Sheeler, but Blume's paintings evolved toward realistic subject depiction, with surrealistic overtones.

His reputation as one of the early American surrealists was enhanced in 1934, when he won the Carnegie International Award with *South of Scranton* (1931, Metropolitan Museum of Art). The painting depicted his impressions of a motor trip made in a Model-T Ford from the coal-mining region outside Scranton, Pennsylvania, to the port of Charleston, South Carolina. It drew criticism as well as praise.

Blume's major work, *The Eternal City* (1937, Museum of Modern Art), was far more controversial. It originated in his reactions to Italy, where he lived from 1932 through 1934 on the first of his two Guggenheim fellowships. Observing the tenth anniversary of the Fascist March on Rome, Blume expressed his ideas in his oil painting.

Dominating the 34-by-48-inch oil is a jack-in-the-box depiction of a green-headed Mussolini, surrounded by intricately detailed Roman columns, broken statuary, a bandaged old poor woman and other images of despair and danger. The Corcoran Gallery Biennial rejected the painting in 1939; it was considered too politically inflammatory to exhibit, despite protests by artists' groups. Some

Vegetable Dinner, 1927, 25¼ x 30¼ in., signed l.c. Courtesy of National Museum of American Art, Smithsonian Institution, Museum Purchase. ©BILD-KUNST, Germany/VAGA, New York 1985.

believed the work to be an incitement to revolution against the Italian regime.

Other Blume paintings include *Parade* (1930, Museum of Modern Art), *Light of the World* (1932, Whitney Museum of American Art) and *The Rock* (1948, Art Institute of Chicago).

Blume also designed murals for government buildings, including post offices in Canonsburg, Pennsylvania and Geneva, New York, and the courthouse in Rome, Georgia.

MEMBERSHIPS
American Academy of Arts and Letters
American Art Congress
American Society of Painters, Sculptors and Engravers
National Academy of Design
National Institute of Arts and Letters

PUBLIC COLLECTIONS
Art Institute of Chicago
Cleveland Museum of Art
Metropolitan Museum of Art, New York City
Museum of Fine Arts, Boston
Museum of Modern Art, New York City
Newark Museum, New Jersey
Whitney Museum of American Art, New York City

SEASON	75-76	76-77	77-78	78-79	79-80	80-81	81-82	82-83	83-84	84-85
Paintings						1				
Dollars						$700				

Record Sale: $700, SPB, 6/19/81, "Connecticut Rocks," 10 × 9 in.

JAMES BROOKS
(1906-)

James Brooks's career has been prolific and artistically diverse. Yet it is his later style, combining chromatic lyricism and special sensitivity, which has ensured his position as one of America's foremost abstract expressionist painters.

Brooks was born in Missouri in 1906. When he was 17, he attended Southern Methodist University in Dallas and studied under Martha Simkins at the Dallas Art Institute. Eager to shed his provincialism, Brooks moved to New York City in 1926 and enrolled in the Art Students League.

For most of the 1930s, Brooks painted scenes of the West and Midwest, rendering them in the then-popular social realist style. To support himself, he worked as a commercial letterer and spent five years as a muralist for the WPA's Federal Art Project.

During that period, the artist's most impressive work was a huge mural, 12 by 235 feet, which he painted for the rotunda of New York's La Guardia Airport. Titled *Flight*, it presaged the artist's interest in abstraction; it also brought Brooks his first critical recognition. It was later destroyed.

Brooks left the WPA in 1942 to serve in the war. When he resumed painting three years later, he had all but abandoned his social-realist themes, painting initially in a cubist style reminiscent of Picasso.

Soon feeling confined by the rigidity of cubism, and undoubtedly influenced

Harmagh, 1967, 47¾ x 60¼ in., signed l.r. Courtesy of National Museum of American Art, Smithsonian Institution, Gift of Mr. and Mrs. David K. Anderson, Martha Jackson Memorial Collection.

by the work of his friend Jackson Pollock, Brooks began to allow more spontaneity and fluidity in his works.

By the early 1950s, Brooks had reached his mature style. As seen in *Boon* (date unknown, Tate Gallery), Brooks allows the pigment itself—

swirling or blotting—to define the painting's expression. Continuously exploring form and color, Brooks's paintings remain subtly tempered by classic control.

Now living in East Hampton, New York, Brooks has been widely exhibited. He has taught at Pratt Institute and Columbia University, and has served as visiting critic of advanced painting at Yale University.

MEMBERSHIPS
Century Association
National Institute of Arts and Letters

PUBLIC COLLECTIONS
Albright-Knox Art Gallery, Buffalo
Art Institute of Chicago
Carnegie Institute, Pittsburgh
Dallas Museum of Fine Arts
Detroit Institute of Arts
Metropolitan Museum of Art, New York City
Museum of Fine Arts, Boston
Museum of Modern Art, New York City
Pennsylvania Academy of Fine Arts, Philadelphia
Solomon R. Guggenheim Museum, New York City
Tate Gallery, London
Whitney Museum of American Art,
 New York City

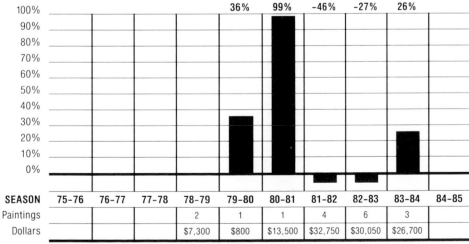

SEASON	75-76	76-77	77-78	78-79	79-80	80-81	81-82	82-83	83-84	84-85
					36%	99%	-46%	-27%	26%	
Paintings				2	1	1	4	6	3	
Dollars				$7,300	$800	$13,500	$32,750	$30,050	$26,700	

Record Sale: $21,000, CH, 5/8/84, "Merrygandering," 60 × 72 in.

KENNETH CALLAHAN
(1906-)

Transitions, 1956, 19¼ x 25 in., signed l.r. Courtesy of Collection The Whitney Museum of American Art, New York, New York, Living Arts Foundation Fund.

Like Mark Tobey and Morris Graves, Kenneth Callahan is a product of the forested, misty grandeur of the Pacific Northwest. He was largely self-taught as a painter, and his early works realistically depicted the works of nature and people at work. Later, however, influenced by Tobey and Graves, his work became non-representational, with human figures and natural forms merging and evolving, often swirling around what appear to be cosmic voids.

Callahan was born in Spokane, Washington in 1906. At various times in his youth he went to sea, attended the University of Washington, traveled to Mexico and Europe, and worked as a logger and ranger in the woods of his home state. All the while he developed his technique as a painter.

During the 1930s, he received several commissions for murals in post offices from the WPA Federal Art Project. From 1933 to 1953, he served on the staff of the Seattle Art Museum as curator and assistant director. Since then he has taught at a number of colleges.

Callahan feels a strong kinship with nature, but tries to see it with what he calls his "inner and outer eye." Usually he begins a painting as a loose, abstract pattern and then lets it develop on its own. His subject matter, he says, reflects "humanity evolving in and out of nature."

In the 1970s, Callahan's work changed somewhat. In place of mellifluous swirls, he began to use more jagged forms and unexpected juxtapositions of elements. However, the strain of mysticism that runs through much of his work remains.

MEMBERSHIPS
National Academy of Design

PUBLIC COLLECTIONS
Art Institute of Chicago
Brooklyn Museum
Corcoran Gallery of Art, Washington, D.C.
Detroit Institute of Arts
Metropolitan Museum of Art, New York City
Museum of Modern Art, New York City
Pennsylvania Academy of the Fine Arts,
 Philadelphia
Philadelphia Museum of Art
Solomon R.Guggenheim Museum, New York City
Whitney Museum of American Art,
 New York City

(No sales information available.)

O. LOUIS GUGLIELMI
(1906-1956)

Born in Egypt in 1906 of Italian parents, O. Louis Guglielmi was sensitive to the changing social scene during his 50-year life. The family soon moved to Italy, traveling as required by the father, a violinist. In 1914, they made Harlem's Italian slum in New York City their home. Personal experience with homelessness, hunger and society's unfortunates strongly affected young Guglielmi's artistic direction.

At age 11 he decided to be a sculptor. In 1920, he commenced several years of classes at the National Academy of Design, concurrent with sculpture studies at the Beaux Arts Institute and a Tiffany Foundation fellowship. He painted murals and had several jobs in commercial art.

The WPA and the Public Works Administration employed him between 1934 and 1939. During these years, Guglielmi combined symbolism with his manipulation of light, color, space and scale. After three years in the army he quickly resumed painting, winning prizes and appearing in major exhibitions.

With excellent educational credentials and years of living with America's less fortunate people, Guglielmi was well-equipped to attain and justify his designation as "America's social surrealist." Critics and the public praised his work. In his hands, social surrealism proved a medium for communicating ideas, blending realism and surrealism to suit his mood and subject.

Guglielmi's art was comprehensible to the man on the street. His surrealist talent complemented his realism, permitting generalized statements using allegory and symbolism.

A reputation for social conscience enhanced reception of his already-recognized superior work. His *Memory of Charles River* (date and location unknown) protested the controversial trial and execution of Sacco and Vanzetti

Connecticut Autumn, 1937, 23 ⅞ x 30 ⅛ in., signed l.r. Courtesy of National Museum of American Art, Smithsonian Institution, Transfer from Museum of Modern Art.

in 1927. Included in a collection of modern art for a traveling exhibit abroad, Guglielmi's *One Third of a Nation (Tenements)* (date and location unknown) shocked the State Department into cancelling the tour.

In Guglielmi's final years, his imagery became less specific, eliminating deep space. An abstract, more decorative style entered, but the city continued as his theme.

Before his death in 1956, Guglielmi taught at Louisiana State University and the New School for Social Research in New York City.

PUBLIC COLLECTIONS
Metropolitan Museum of Art, New York City
Museum of Modern Art, New York City
National Museum of American Art, Washington, D.C.
Newark Museum, New Jersey
Whitney Museum of American Art,
 New York City

SEASON	75–76	76–77	77–78	78–79	79–80	80–81	81–82	82–83	83–84	84–85
Paintings				2			1	1		
Dollars				$6,000			$24,000	$18,000		

Record Sale: $24,000, SPB, 6/4/82, "The Persistent Sea," 30 × 24 in.

RALSTON CRAWFORD
(1906-1978)

Blue + White, 1938, 20 x 24 in., signed l.r. Courtesy of Kennedy Galleries, New York, New York.

Ralston Crawford, an early modernist painter particularly noted as a precisionist, was born in 1906 in St. Catherines, Ontario, Canada. He lived in Buffalo, New York from 1910 to 1926, where he later taught at the School of Fine Arts.

Crawford sailed the Great Lakes in his youth. He also visited Caribbean and Pacific shores when he sailed on a tramp steamer in 1926 and 1927.

Crawford first studied art at the Otis Art Institute in Los Angeles in 1927, and also worked at the Walt Disney Studio. His studies continued in Philadelphia at the Pennsylvania Academy of the Fine Arts and the nearby Barnes Foundation in Merion, Pennsylvania.

The years 1932 and 1933 found him attending the Academie Colarossi and the Academie Scandinave in Paris. Later, in 1951 and 1952, he worked in lithography in Paris.

Crawford's association with precisionism spanned the 1930s and beyond. His work was characterized by austere shapes, sharp outlines and flat color. He used abstract treatments of industrial sites, grain elevators, ships and machines, creating unique perspectives and movement. Industrial buildings of harbor cities were a frequent theme.

The influence of his military work with the weather division in World War II, as chief of the visual-presentation unit preparing weather charts, is detected occasionally in Crawford's pictures.

Crawford was guest director of the Honolulu School of Arts in 1947, and taught at many other schools and universities throughout his long career. His work has appeared in numerous one-man exhibitions and several retrospectives.

PUBLIC COLLECTIONS
Albright-Knox Art Gallery, Buffalo
Cincinnati Art Museum
Library of Congress, Washington, D.C.
Metropolitan Museum of Art, New York City
Museum of Fine Arts, Houston
Newark Museum, New Jersey
Phillips Collection, Washington, D.C.
San Francisco Museum of Art
Toledo Museum of Art, Ohio
Whitney Museum of American Art,
 New York City

SEASON	75-76	76-77	77-78	78-79	79-80	80-81	81-82	82-83	83-84	84-85
Paintings					1				3	1
Dollars					$4,100				$395,000	$13,000

Record Sale: $170,000, CH, 12/9/83, "Industrial Landscape, Buffalo," 25 × 30 in.

AARON BOHROD
(1907-)

Aaron Bohrod's work has not been limited to one style or medium. Initially recognized as a regionalist painter of American scenes, particularly of his native Chicago, Bohrod later devoted himself to detailed still-life paintings rendered in the trompe l'oeil style. He also worked for several years in ceramics and wrote a book on pottery.

Born in 1907, Bohrod began his studies at Chicago's Crane Junior College in 1925, and two years later enrolled in the Art Institute of Chicago. But it was at the Art Students League in New York City, from 1930 to 1932, that he studied under the man believed to be his most significant early influence, John Sloan. Sloan's romantic realism is reflected in the many depictions of Chicago life which comprised most of Bohrod's early work.

These paintings emphasized architecture unique to the Chicago area and featured Chicagoans engaged in such everyday activities as working, playing or going to the theatre. The romantic aspect was conveyed by the use of misty colors, and the realism by attention to detail.

In 1936, Bohrod won the Guggenheim Fellowship award in creative painting. It enabled him to travel the United States, producing similar regionalist paintings on a much broader range of subjects. Nevertheless, most of his early work—such as *Chicago Street in Winter* (1939, location unknown)—centered on Chicago and the urban Midwest.

Junk Yard, 1939, 24⅛ x 30⅛ in., signed l.c. Courtesy of National Museum of American Art, Smithsonian Institution, Bequest of Frank McClure.

In 1943, Bohrod was commissioned by *Life* magazine to cover the battlefronts as a war correspondent and artist. His war paintings uniquely conveyed the feeling of battle. Skirmishes in the South Pacific and the liberation of Normandy were among the many subjects he painted before his commission ended in 1945.

Three years later, Bohrod succeeded another regionalist painter, John Steuart Curry, as artist-in-residence at the University of Wisconsin, Madison. Bohrod's first artistic endeavors there were typically depictions of the local scene.

Then, quite untypically, fantasy started to appear in his work. Elements of surrealism, supposedly inspired by his concurrent involvement in ceramics with F. Carlton Ball, began influencing his landscapes.

By 1953, Bohrod had completely ceased painting landscapes, turning instead to often symbolic still-life subjects. He abandoned his earlier romantic realism to paint in the luminous trompe l'oeil tradition of William Harnett. The sharp observation found in his earlier paintings evolved into a strident exactitude. Bohrod has continued to produce these meticulously-crafted fantasies exclusively.

Since taking his position at the University of Wisconsin, Bohrod has painted covers for *Time* magazine and has authored two books, *A Pottery Sketch-book* (1959) and *A Decade of Still Life* (1966), in which are reproduced many of his trompe l'oeil paintings.

MEMBERSHIPS
National Academy of Design

PUBLIC COLLECTIONS
Art Institute of Chicago
Art Museum of the New Britain Institute, Connecticut
Brooklyn Museum
Butler Institute of American Art, Youngstown, Ohio
Corcoran Gallery of Art, Washington, D.C.
Cranbrook Academy of Art, Bloomfield Hills, Michigan
Davenport Municipal Art Gallery, Iowa
MacNider Museum, Mason City, Iowa
Madison Art Center, Wisconsin
McNay Art Institute, San Antonio, Texas
Metropolitan Museum of Art, New York City
Museum of Fine Arts, Boston
Museum of Fine Arts, Springfield, Massachusetts
Norton Gallery and School of Art, West Palm Beach, Florida
Pennsylvania Academy of the Fine Arts, Philadelphia
St. Lawrence University, New York
Swope Art Gallery, Terre Haute, Indiana
University of Arizona, Phoenix
University of Wisconsin, Madison
University of Wyoming, Laramie
Whitney Museum of American Art, New York City

10-Year Average Change From Base Years '75-'76: 40%

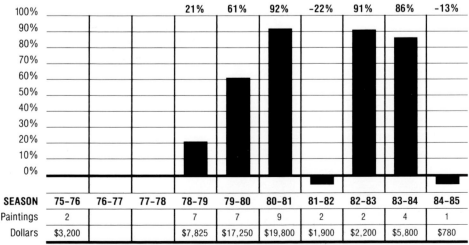

	21%	61%	92%	-22%	91%	86%	-13%

SEASON	75-76	76-77	77-78	78-79	79-80	80-81	81-82	82-83	83-84	84-85
Paintings	2			7	7	9	2	2	4	1
Dollars	$3,200			$7,825	$17,250	$19,800	$1,900	$2,200	$5,800	$780

Record Sale: $4,000, SPB, 11/18/80, "The Sea Chest," 16 x 20 in.

925

STEVAN DOHANOS

(1907-)

A prolific painter, Stevan Dohanos has had a long and successful artistic career. His illustrations have appeared in virtually every major magazine, and he has also designed 25 United States postage stamps.

Born in 1907 in Lorain, Ohio, Dohanos studied at the Cleveland School of Art before becoming an apprentice letterer and beginning studio work.

When he was 27, Dohanos received his first national assignment—a watercolor for *McCall's* magazine. He was then commissioned to paint murals for public buildings in West Virginia, Florida and the Virgin Islands.

Dohanos achieved prominence as an illustrator from 1943 to 1959. His scenes, often renderings of daily life in small-town America, appeared in major magazines and on more than 100 covers of the *Saturday Evening Post*.

Victimized twice by tuberculosis, Dohanos has designed Christmas seals for the National Tuberculosis Association. One of his most recent commemorative stamps for the United States Post Office is *Crusade against Cancer*.

Dohanos served as president of the Society of Illustrators from 1961 to 1963, and was elected to the Society's hall of fame in 1971. He lives in Westport, Connecticut.

MEMBERSHIPS
American Watercolor Society
Society of Illustrators

PUBLIC COLLECTIONS
Dartmouth College, Hanover, New Hampshire
Hood Museum of Art
Whitney Museum of American Art,
 New York City

Lumberjack, 15¼ x 12 in., signed l.r. Gift of the University of North Carolina, Chapel Hill.

SEASON	75-76	76-77	77-78	78-79	79-80	80-81	81-82	82-83	83-84	84-85
Paintings					1	4				
Dollars					$5,750	$20,400				

Record Sale: $8,500, P.NY, 11/8/80, "Birthday Party," 42 × 33 in.

MILLARD SHEETS

(1907-)

Born in Pomona, California in 1907, Millard Sheets is a California artist who has specialized in depicting the West coast urban poor, in such paintings as *Tenement Flats* (1934, National Museum of American Art). His use of light and color distinguishes him from East coast contemporaries.

Sheets attended the Los Angeles School of Art as the pupil of F.T. Chamberlain and Clarence Hinkle. After graduating in 1929, he had his first solo exhibition at Dalzell Hatfield Galleries in Los Angeles. While he was director of the fine arts exhibition of the Los Angeles County Fair from 1931 to 1959, the artist exhibited in California and Chicago, receiving awards and prizes in both cities.

Sheets served as a war artist for *Life* magazine, covering the Burma-India front from 1943 to 1944. Upon his return to California, he executed mosaic murals throughout the 1950s and 1960s.

In addition, Sheets has done the architectural design for many buildings, illustrated for national magazines, and handled production design for Columbia Pictures. During this time, he served as director of arts at Scripps College, in Claremont, California.

Sheets sees his work as a synthesis of cubism and impressionism. He has traveled through Europe, Central America, Mexico, the United States, the Pacific and the Orient, but continues to live in Gualala, California.

Tenement Flats (Family Flats), ca. 1934, 40¼ x 50¼ in., signed l.l. Courtesy of National Museum of American Art, Smithsonian Institution, Transfer from Department of Interior, National Park.

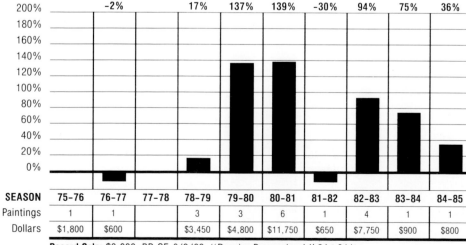

10-Year Average Change From Base Years '75-'76: 52%

SEASON	75-76	76-77	77-78	78-79	79-80	80-81	81-82	82-83	83-84	84-85
		-2%		17%	137%	139%	-30%	94%	75%	36%
Paintings	1	1		3	3	6	1	4	1	1
Dollars	$1,800	$600		$3,450	$4,800	$11,750	$650	$7,750	$900	$800

Record Sale: $3,000, BB.SF, 6/9/83, "Russian Processional," 34 × 34 in.

MEMBERSHIPS
American Watercolor Society
Bohemian Club
California Water Color Society
National Academy of Design
Society of Motion Picture Art Directors

PUBLIC COLLECTIONS
Art Institute of Chicago
Brooklyn Museum
Carnegie Institute, Pittsburgh
Cleveland Museum of Art
High Museum of Art, Atlanta
Houston Museum of Fine Arts
Los Angeles County Museum of Art
Metropolitan Museum of Art, New York City
Museum of Modern Art, New York City
Wood Art Gallery, Montpelier, Vermont
Hackley Art Center, Muskegon, Michigan
San Francisco Museum of Art
Seattle Art Museum
Whitney Museum of American Art,
 New York City

BYRON BROWNE
(1907-1961)

Byron Browne is noted for his abstract variations on the human figure, particularly studies of heads based on Greek and Roman classical models. He represents a synthesis of abstract, cubist and expressionist styles, showing the influence of Picasso, mixed with elements of Mondrian and Miro. He expressed syncopated visual rhythms on canvas.

Browne was born in 1907 in New York City. His first artistic training was at the National Academy of Design, where he studied from 1925 to 1928 under Charles Hinton, Charles Hawthorne, Charles Courtney Curran, Ivan Olinsky, Robert Aitken and Alice Murphy. His work of this period was conventional; in 1928, however, he destroyed much of his early work in a rejection of academicism.

Around the same time, Browne met Arshile Gorky, who introduced him to abstract art. During the 1930s, he worked on abstract collages, such as *Ionic Reticule* (1935, location unknown). He was given a one-man show at the Whitney Museum of American Art in 1933.

Like Picasso, whom he admired, Browne was not a purist in abstraction. He used the human figure liberally, considering it the artist's most challenging subject matter. Only gradually did figures recede into a nearly pure abstract pattern during the last decade of his work. Even so, viewers familiar with Browne's work may identify in these late paintings the symbols and figures of his early art.

White Still Life, 1947, 30¼ x 24⅛ in., signed l.r. Courtesy of National Museum of American Art, Smithsonian Institution, Gift of Katie and Walter C. Louchheim.

The majority of Browne's images derive from the classical world, transformed by his personal brand of cubism. Roman and Greek hairstyles, laurel wreaths and draped clothing appear in a multitude of head-and-shoulder paintings. Much of his later work appears to have been inspired by ancient myth, as shown by titles such as *Bacchanale* (1950, location unknown) and *Dionysiac* (1956, location unknown). Other symbols were drawn from the primitive art of Mesoamerican cultures; the glyph for the Aztec rain god, Tlaloc, appears in several paintings.

Although Browne experimented with transparency, letting paint and ink flow freely, for the most part his work is characterized by bold forms, high color and hard edges. He was versatile with curvilinear lines and geometric shapes.

At the height of his career in 1940, when Browne was doing his strongest and most characteristic work, the Museum of Modern Art refused to exhibit American abstractionists. Browne was one of the artists who picketed in protest. Today art historians are reconstructing his contribution to the development of abstract art, including his role as one of the founders of American Abstract Artists.

When Browne died in 1961 at age 54, he had completed nearly 1,000 works.

MEMBERSHIPS
American Abstract Artists

PUBLIC COLLECTIONS
American Academy of Arts and Letters, New York City
Brooklyn Museum
Dallas Museum of Fine Arts
Hirshhorn Museum and Sculpture Garden, Washington, D.C.
Museum of Fine Arts, Boston
Museum of Modern Art, New York City
Pennsylvania Academy of the Fine Arts, Philadelphia
Whitney Museum of American Art, New York City

10-Year Average Change From Base Years '78-'79: 401%

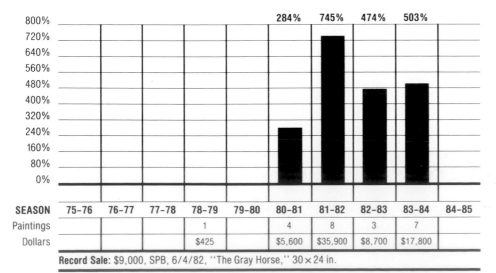

SEASON	75–76	76–77	77–78	78–79	79–80	80–81	81–82	82–83	83–84	84–85
						284%	745%	474%	503%	
Paintings				1		4	8	3	7	
Dollars				$425		$5,600	$35,900	$8,700	$17,800	

Record Sale: $9,000, SPB, 6/4/82, "The Gray Horse," 30 × 24 in.

928

WALTER MURCH
(1907-1967)

Throughout the middle decades of the twentieth century, when abstract art held center stage and representational art was relegated to the wings, Walter Murch steadfastly painted still lifes. He was a realist, but—in the opinion of some—with romantic overtones. While he painted occasional traditional fruit or flower compositions, his preference was for unusual and mundane subjects, such as machine and motor parts, broken dolls and light bulbs.

Murch was born in Toronto in 1907. He attended Toronto Technical High School, learning, among other subjects, woodworking and architectural drafting. His first art training came at the Ontario College of Art.

After moving to New York City, he worked by day as an assistant stained-glass designer. By night, he studied, first at the Art Students League and then the Grand Central Art School under Arshile Gorky. Murch and Gorky became close friends, and it is said that Gorky had considerable influence on Murch's career. He did not, however, deter Murch from the path of realism.

For close to 20 years, Murch worked as a commercial artist and illustrator. He painted murals in apartments, hotels and restaurants, and still lifes only when he could find the time. After his reputation was secure and he was able to abandon commercial art, he continued to teach at a succession of universities.

In the 1930s a friend gave Murch a group of old photographs. In studying them and emulating the softness of their lighting and the apparent timelessness of their subjects, Murch developed his own mature style. His still lifes, usually close-ups against neutral backgrounds, seemed endowed with a patina of age.

In the last few years before his death in 1967, Murch's work changed subtly. There was a softening, almost a dematerialization, of some of his subjects.

The Universe, 26 x 17 ⅞ in., signed l.r. Private Collection, Photograph courtesy of Kennedy Galleries, New York, New York.

PUBLIC COLLECTIONS
Albright-Knox Gallery of Art,
 Buffalo
Barnes Foundation, Merion, Pennsylvania
Brooklyn Museum
Corcoran Gallery of Art,
 Washington, D.C.
Metropolitan Museum of Art,
 New York City
Museum of Modern Art,
 New York City
National Museum of American Art, Washington, D.C.
Pennsylvania Academy of the Fine Arts,
 Philadelphia
Whitney Museum of American Art,
 New York City

SEASON	75-76	76-77	77-78	78-79	79-80	80-81	81-82	82-83	83-84	84-85
Paintings				1	2	2	2	4		1
Dollars				$4,500	$20,000	$15,500	$15,500	$21,250		$4,200

Record Sale: $14,500, SPB, 12/2/82, "Cylinder and Pear," 18 × 24 in.

I. RICE PEREIRA
(1907-1971)

I. Rice Pereira is regarded today as one of the pioneers of American nonobjective painting. The innovative use of objects in various geometric combinations was her way of expressing her view of infinity in the context of an increasingly scientific civilization.

Born Irene Rice in Boston in 1907, Pereira settled in New York City with her family when she was still very young. Her inauspicious adolescence found her working as an accountant's assistant to support the family after her father's death in 1923.

At night, Pereira took art classes, and as a result of her interest she enrolled in the Art Students League in 1927. During three years there, she was influenced by students who would later become leaders of the American abstract movement.

In 1931, Pereira left the first of her three husbands and traveled to Europe. Bored with the curriculum at the Academie Moderne in Paris, she embarked on a pivotal journey into Africa's Sahara Desert, where in the arid vastness she had a vision of eternity. For the remainder of her career, Pereira would attempt to artistically convey this vision.

Returning to New York City in 1932, Pereira initially painted semi-abstract canvases of the relationship between machines and men. These culminated in her first one-woman show in 1933 at the A.C.A. Gallery.

It was as a founder and teacher for the WPA's Federal Art Project Design Section that Pereira, under the influence of

Bright Depths, 1950, 30 x 34 in., signed l.r. Courtesy of Hirshhorn Museum and Sculpture Garden, Smithsonian Institution, Washington, D.C.

German Bauhaus, turned toward geometric abstraction. She experimented with a variety of materials, spatter paint and pure·geometric forms. All her subsequent work would reflect this experimentation with form and texture.

Most notable, perhaps, are Pereira's multi-media paintings superimposed on panes of glass. As seen in *Transversion* (1946, Phillips Collection), the artist used layers of glass to explore resonating light.

In addition to painting, Pereira wrote 10 books on mysticism, light and space before her death in Spain in 1971.

MEMBERSHIPS
American Abstract Artists

PUBLIC COLLECTIONS
Phillips Collection, Washington, D.C.
Whitney Museum of American Art,
New York City

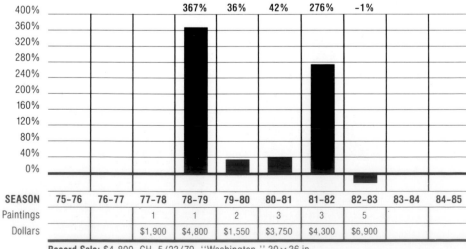

10-Year Average Change From Base Years '77-'78: 120%

	367%	36%	42%	276%	-1%

SEASON	75-76	76-77	77-78	78-79	79-80	80-81	81-82	82-83	83-84	84-85
Paintings			1	1	2	3	3	5		
Dollars			$1,900	$4,800	$1,550	$3,750	$4,300	$6,900		

Record Sale: $4,800, CH, 5/23/79, "Washington," 30 × 36 in.

FAIRFIELD PORTER
(1907-1975)

Prominent realistic artist Fairfield Porter is best known for his richly painted, sunlit views of interiors and landscapes.

Porter was born in Winnetka, Illinois in 1907. A graduate of Harvard University, he augmented his Ivy League education with formal art training from 1928 to 1930. He studied for a time with Boardman Robinson and Thomas Hart Benton at the Art Students League in New York City.

In 1949, Porter moved to Southampton, Long Island. Keenly sensitive to the effects of nature, he painted works which reflected the calm amiability of his life as a country dweller. Described as a modernized American impressionist, Porter combined a soft, pastel palette with a broad, placid brushstroke. Like other realists of his generation, such as Larry Rivers and Alex Katz, Porter created paintings that were non-problematic in content, almost suburban in disposition.

A characteristic example of his work is *The Garden Road* (1962, Whitney Museum of American Art). The light, dappled forms, composed of both small and large planes of color, are volumetric, yet arranged in a shallow space. This composition emphasizes the surface of the painting and creates a subtle ambiguity, as forms may be read both in depth or as flattened shapes. The last two characteristics reflect the influence of abstract expressionism as well as,

Katie and Anne, 1955, 80⅛ x 62⅛ in., signed l.r. Courtesy of Hirshhorn Museum and Sculpture Garden, Smithsonian Institution, Washington, D.C.

more distantly, that of French impressionism and the work of Pierre Bonnard and Edouard Vuillard.

In Porter's work there is no attempt at trompe l'oeil representation or verisimilitude. His lopsided bottles and awkward figures are clearly made of paint, and are carefully planned to contribute to the overall formal structure of the paintings. In addition to landscapes and still lifes, Porter painted a number of portraits. His subjects included such art world luminaries as Andy Warhol, Larry Rivers and poet John Ashbery.

Porter published art criticism in the major art journals during the 1940s and 1950s, and wrote a monograph on Thomas Eakins (1959). He died in 1975 in Southampton, following a long and prolific career as an artist and writer.

10-Year Average Change From Base Years '76-'77: 840%

SEASON	75-76	76-77	77-78	78-79	79-80	80-81	81-82	82-83	83-84	84-85
Paintings		1		2	1			2	4	8
Dollars		$1,700		$3,800	$1,100			$24,800	$47,800	$342,500

Bar values: 78-79: 327%, 79-80: 246%, 82-83: 1,319%, 83-84: 1,431%, 84-85: 1,714%

Record Sale: $140,000, B.P, 9/22/84, "The Harbour—Great Spruce Head," 20 x 36 in.

ILYA BOLOTOWSKY
(1907-1981)

Ilya Bolotowsky was a Russian emigre geometric abstractionist painter who readily acknowledged his debt to Piet Mondrian. His early paintings showed a typical blend of synthetic cubism, Russian suprematism and traces of the art of Joan Miro. Later, however, he concentrated on the order and simplicity of neoplasticism.

Bolotowsky was born in St. Petersburg in 1907. He spent most of his childhood in Baku on the Caspian Sea, where his father was a lawyer. After the Communist Revolution, however, his family had to flee, first to the Republic of Georgia and then, only hours ahead of the Soviets, to Constantinople.

The Bolotowskys arrived in New York City in 1923, and the young Ilya entered the National Academy of Design to study. He stayed until 1930.

Although he went to Europe in 1932, it was not until he was back in New York the following year that Bolotowsky first saw the work of Mondrian. It was a turning point. From then on, he produced the geometric paintings and constructions in primary colors, blacks and grays that have become synonymous with his name.

"In my paintings I avoid all associations," Bolotowsky once wrote. "I try for perfect harmony, using neutral elements. I want things absolutely pure and simple."

In the early 1930s, he became a member of The Ten, a group of artists committed to modern art. Several years later he was a co-founder of American Abstract Artists. During the mid-1930s, he was employed by the WPA Federal Arts Project and did one of its first abstract murals. He did many later murals.

Increasingly influenced by Mondrian's work, in the 1940s Bolotowsky dropped extraneous forms and diagonals, and concentrated on horizontal-vertical patterns. In 1947, he began to

Vibrant Reds, 1971, 72⅛ x 48¼ in., signed l.r. Courtesy of National Museum of American Art, Smithsonian Institution, Gift of Ira S. Agress. ©Estate of Ilya Bolotowsky/VAGA, New York 1985.

use diamond-shaped canvases, and then even ovals and rhomboids. Stretching his imagination still further, some 15 years later he turned to three-dimensional pieces in which the painting enfolds all four sides of a construction.

Besides painting, Bolotowsky also made prints and experimental films and taught at many colleges. He died in 1981.

MEMBERSHIPS
American Abstract Artists
American Academy of Arts and Letters
Federation of Modern Painters and Sculptors

PUBLIC COLLECTIONS
Cleveland Museum of Art
Guggenheim Museum, New York City
Hirshhorn Museum and Sculpture Garden, Washington, D.C.
Metropolitan Museum of Art, New York City
Museum of Modern Art, New York City
National Museum of American Art, Washington, D.C.
Philadelphia Museum of Art
Phillips Collection, Washington, D.C.
San Francisco Museum of Art
Solomon R. Guggenheim Museum, New York City
Whitney Museum of American Art, New York City

SEASON	75-76	76-77	77-78	78-79	79-80	80-81	81-82	82-83	83-84	84-85
Paintings								2	3	2
Dollars								$27,250	$25,700	$21,250

Record Sale: $24,500, SPB, 5/21/83, "Untitled," 17 × 47 in.

932

LOREN MacIVER
(1909-)

Almost entirely self-taught as a painter, Loren MacIver has never felt encumbered by any particular school of painting or by aesthetic theories. She has followed her own intuition and, in doing so, she has created a body of work that blends poetry, symbolism and design. If she has had an artistic relationship with any group at all, it has been with the imagist poets of the first half of the twentieth century, such as e.e. cummings and Lloyd Frankenberg, her husband.

Critic James Thrall Soby once characterized MacIver's work as "shy, tiptoe art." In her own words, she has tried to "make something permanent out of the transitory."

She was born in New York City in 1909. Her mother, Julia MacIver, never adopted the surname of her husband, Charles Newman, and Loren MacIver has always used her mother's surname. She began painting as a child, and at 10 she was enrolled in Saturday classes for children at the Art Students League. A year of this constituted her entire formal art training.

All through high school she continued to paint, although not with the idea of making a career out of it. She married Lloyd Frankenberg when she was 20, and went to live in Greenwich Village.

The earliest of MacIver's surviving work dates from 1929. It was naive in its drawing and had a quality of childlike fantasy, which her work never lost; her paintings have always been evocative of children's art.

In the summers, MacIver and her husband would go to Cape Cod to live in a shack they built out of driftwood. Some of her first paintings were based on what she found there along the beach or on the dunes.

During the 1930s, she worked under the Federal Art Project. She had her first one-woman show in New York City

Skylight Moon, 1958, 50 x 39¾ in., signed l.l. Courtesy of Hirshhorn Museum and Sculpture Garden, Smithsonian Institution, Washington, D.C.

in 1938. Even when she was painting such an ordinary object as a window shade, or street asphalt marked for a game of hopscotch, she imbued her work with a mysterious symbolism that gave it several levels of meaning.

As her reputation grew through the 1940s, she was commissioned to paint covers for national magazines and mural panels for several ships. This enabled her to travel in Europe for the first time. After the 1950s, perhaps due to Euro-

pean influence, her paintings became bolder and more abstract. In this mature work colors blend and bleed together, obscuring outlines, and some critics rank MacIver as one of the forerunners of abstract expressionism.

MEMBERSHIPS
National Institute of Arts and Letters

PUBLIC COLLECTIONS
Art Institute of Chicago
Baltimore Museum of Art
Brooklyn Museum
Corcoran Gallery of Art, Washington, D.C.
Detroit Institute of Arts
Los Angeles County Museum of Art
Metropolitan Museum of Art, New York City
National Gallery of Art, Washington, D.C.
Philadelphia Museum of Art
Whitney Museum of American Art,
 New York City

SEASON	75-76	76-77	77-78	78-79	79-80	80-81	81-82	82-83	83-84	84-85
Paintings						2				
Dollars						$14,000				

Record Sale: $10,000, SPB, 5/29/81, "Corner of Houston and Bedford," 48 × 40 in.

ALLAN ROHAN CRITE
(1910-)

Irked by what he considered the stereotypical depiction of blacks either as poor sharecroppers in the South or as Harlem jazz musicians, Allan Rohan Crite painted street scenes which captured the life and spirit of the ordinary people among whom he lived. That the people in his paintings were black was coincidental. Crite was deeply religious and, along with painting street preachers and churches, he also wrote several books on religion and executed prints and lithographs on religious themes.

Born in Plainfield, New Jersey in 1910, Crite grew up in Boston and has spent nearly his whole life there. He graduated from the Boston Latin School and studied for six years at the School of the Museum of Fine Arts in Boston and then at the Massachusetts School of Art.

During the Depression years, when he was starting his career, Crite was aided by federal and state art programs; however, he resigned as a WPA artist rather than apply for certification of eligibility for relief. One of his best-known paintings, *School's Out* (1936, National Museum of American Art), was done during this period and was included in the Museum of Modern Art's pioneering exhibition "New Horizons in American Art." It is a happy picture of young black girls playing and talking together on a warm afternoon. Painting everyday life in established black neighborhoods in prewar Boston, Crite was documenting scenes that 20 years later would be destroyed in the sweep of urban renewal.

During World War II Crite abandoned painting and worked as a technical illustrator to support himself and his mother. After the war he taught at various colleges. He later worked as a part-time librarian at the Harvard Extension School, where he earned a bachelor's degree in 1968.

Crite's paintings are characterized by smooth brushwork and a sparseness of composition that focuses attention on

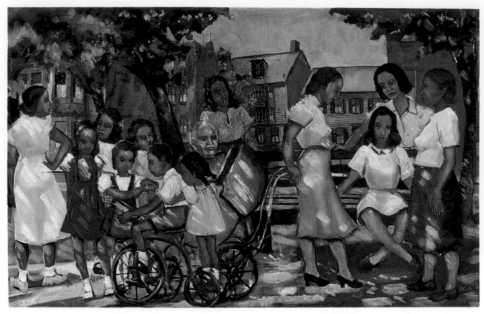

Shadow and Sunlight, 1941, 25 x 38 in., signed l.r. National Museum of American Art, Smithsonian Institution, Museum Purchase.

his subject matter. The combination of objectivity and depth of feeling in his work reflects his interpretation of the harsh and the beautiful in life.

PUBLIC COLLECTIONS
Fitchburg Art Museum, Massachusetts
National Museum of American Art,
 Washington, D.C.

(No sales information available.)

934

MORRIS GRAVES
(1910-)

Morris Graves is a leading proponent of the Northwest School, which he helped to establish. His work is highly symbolic, at times even surrealistic. Most often he uses birds as his theme. His colors are muted and somber.

Influenced by the "white writing" calligraphy of Mark Tobey, another native of the Northwest, Graves's work also exhibits his interest in Zen Buddhism and other Eastern philosophies. His paintings frequently seem very old; as one observer put it, some have the look almost of fossil rubbings.

Graves was born in Fox Valley, Oregon in 1910, and grew up around Puget Sound. Water, animals and birds were a part of his life from the beginning. He never went to art school; aside from a short period of study with Tobey, he was self-taught.

Between 1928 and 1930, he made three trips to the Far East as a seaman aboard mail ships, his first exposure to the Eastern culture which was to become so important in his life.

Graves began as an oil painter; his paint was heavily handled and thickly applied. Later, however, he gravitated to tempera, gouache, watercolor, ink and wax on thin paper in a technique akin to Oriental scroll painting.

In 1933, he won his first prize in the Northwest Annual Exhibition at the Seattle Art Museum. Three years later he had his first one-man show there. After a stint working in the WPA Federal Art Project, he joined the museum staff, thus getting a chance to study its magnificent collection of oriental art.

Graves was awarded a Guggenheim Fellowship in 1946 for study in Japan but, with that country still occupied, military authorities would not allow his visit. Instead, he went to Hawaii and studied the oriental art collection at the Honolulu Academy of Art. A radiant group of paintings came from this experience.

Wheelbarrow, 1934, 31⅛ x 35⅛ in., signed u.r. Courtesy of National Museum of American Art, Smithsonian Institution, Transfer from the United States Department of Labor.

Young Gander, 1952, 48 x 35 in., signed l.r. Courtesy of Hirshhorn Museum and Sculpture Garden, Smithsonian Institution, Washington, D.C.

Graves spent an entire winter at Chartres, France, studying and painting the majestic cathedral. Dissatisfied with this work, he destroyed everything he painted there.

Craving solitude, Graves has traveled and lived in many places. Through Zen, Taoism and other philosophies, he has sought, as he describes it, "to still the surface of the mind and let the inner surface bloom."

In place of representational imagery, today Graves uses abstract interpretations of motion and space. Birds recur most frequently, at times rendered almost human. At other times they are blind, wounded, or "maddened by the sound of machinery in the air."

PUBLIC COLLECTIONS
Albright-Knox Art Gallery, Buffalo, New York
Art Institute of Chicago
Cincinnati Art Museum
Cleveland Museum of Art
Detroit Institute of Arts
Hirshhorn Museum and Sculpture Garden, Washington, D.C.
Metropolitan Museum of Art, New York City
Museum of Fine Arts, Boston
Museum of Modern Art, New York City
Whitney Museum of American Art, New York City

SEASON	75-76	76-77	77-78	78-79	79-80	80-81	81-82	82-83	83-84	84-85
Paintings			2	10	10	1	6	2	4	1
Dollars			$6,400	$27,850	$31,450	$25,000	$13,750	$5,400	$15,250	$4,500

Record Sale: $25,000, BB.SF, 5/3/81, "Preening Sparrow," 53 × 26 in.

JOSEPH HIRSCH
(1910-1981)

A social realist and humanist, Joseph Hirsch painted the common man through the generations from the Depression to Vietnam. Using the human form often as a symbol, Hirsch represented such universal themes as questing, plundering and interracial friendship.

His well-known painting *Two Men* (1937, Museum of Modern Art) places the figures of a white worker and his black companion against an empty background, a technique that highlights the humanistic message. The figures are not specific people but monuments to an idea. "I want to castigate the things I hate and paint monuments to what I feel is noble," said Hirsch of his artistic philosophy.

Born in 1910 in Philadelphia, Hirsch first studied at the Philadelphia Museum School of Industrial Design and then with George Luks in New York City. In 1935, he traveled to Europe and the Orient to sketch, spending some time at the American Academy in Rome.

In the 1930s, he worked for the WPA Federal Art Project, painting several murals in Philadelphia, including those in the Municipal Court Building and the Amalgamated Clothing Workers Building. During World War II, as an artist-correspondent for the Navy, Hirsch did 75 paintings and drawings in the South Pacific, Africa and Italy.

Stylistically, Hirsch used caricature and exaggeration; nevertheless, he managed to convey heroic images of ordinary people doing everything from washing windows to fighting for their rights. His early work found subject matter in the labor movement. Later in his career, he drew inspiration from the Vietnam War and the student rebellions of the 1960s and early 1970s.

Hirsch died in 1981.

Death of a Woman, 1975, 39 in. diameter, signed l.r. Courtesy of Private Collection.

MEMBERSHIPS
Artist's Equity
National Academy of Design
National Institute of Arts and Letters
Philadelphia Watercolor Club

PUBLIC COLLECTIONS
Corcoran Gallery of Art, Washington, D.C.
Metropolitan Museum of Art, New York City
Museum of Fine Arts, Boston
Museum of Modern Art, New York City
Philadelphia Museum of Art
Whitney Museum of American Art,
 New York City

SEASON	75-76	76-77	77-78	78-79	79-80	80-81	81-82	82-83	83-84	84-85
Paintings				1	1	2	2		2	5
Dollars				$9,500	$5,000	$22,000	$13,500		$9,000	$32,400

Record Sale: $18,000, SPB, 5/29/81, "Four Artists," 35 × 51 in.

FRANZ KLINE
(1910-1962)

"Aggressive," "powerful," "vehement" and "violent" are typical adjectives used to describe the style of Franz Kline, an abstract expressionist from Pennsylvania's coal region.

Originally a representational artist, Kline discovered artistic merit in isolated pictorial elements. This discovery, enhanced by the influence of abstractionist Willem de Kooning, propelled Kline into nonrepresentational art and to the forefront of the "action painting" movement.

Franz Kline was born in 1910 in Wilkes-Barre, Pennsylvania. He attended Boston University from 1931 to 1935. From 1937 to 1938, he studied at the Heatherly School of Fine Art in London.

Upon his return, Kline settled in New York City. He was soon exhibiting his work in Washington Square art shows and at the National Academy of Design, where his landscapes won awards in 1943 and 1944.

Kline's paintings in the 1930s and early 1940s were traditional in content and execution. In 1940, he was commissioned by the Bleecker Street Tavern to paint a series of four-by-four-foot murals, now considered his best figurative work.

The transition to nonrepresentational art occurred in stages, but quickly enough to be dramatic. Through the influence of friend de Kooning, Kline

C & O, 1958, 77 x 110 in. Courtesy of National Gallery of Art, Washington, D.C., Gift of Mr. and Mrs. Burton Tremaine.

began experimenting with abstract art in 1946.

His work over the next few years showed an increasing interest in pigment and spatial relationships, and a decreasing interest in identifiability of the subject. *Nijinsky* (1948, location unknown) shows the artist in transition; while the image is recognizable, there is a new boldness of brushstroke and visual pattern.

The final stage came in 1949, while Kline was studying one of his sketches with an opaque projection. A portion of the sketch, greatly enlarged and reversed, was projected on a wall. Kline saw in the fragment, magnified and removed from its context, new creative direction. With this perception as inspiration, Kline began developing his own abstract style.

His first one-man show was in 1950 at the Charles Egan Gallery in New York City. The works exhibited were all abstract and monochromatic.

As his style and philosophy of "action painting" developed, Kline eliminated the center of focus and the distinction between image and background. His application of paint grew much more vigorous, as the canvases grew larger; *Requiem* (date and location unknown) is nearly nine feet high.

Theories as to the realities behind Kline's abstractions abound. Kline, however, denied any basis in objective reality, maintaining that he was "painting experiences." His sole criterion for art was "whether or not the painter's emotion comes across."

A heart condition took Kline's life when he was 52 years old.

10-Year Average Change From Base Years '75-'76: 223%

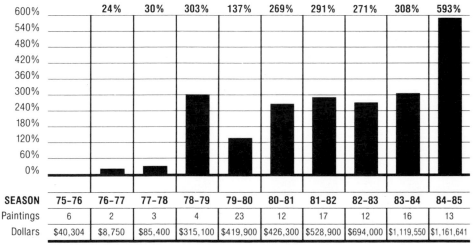

SEASON	75-76	76-77	77-78	78-79	79-80	80-81	81-82	82-83	83-84	84-85
		24%	30%	303%	137%	269%	291%	271%	308%	593%
Paintings	6	2	3	4	23	12	17	12	16	13
Dollars	$40,304	$8,750	$85,400	$315,100	$419,900	$426,300	$528,900	$694,000	$1,119,550	$1,161,641

Record Sale: $800,000, CH, 5/1/85, "Untitled," 116 × 79 in.

PUBLIC COLLECTIONS
Albright-Knox Art Gallery, Buffalo
Art Gallery of Toronto
Baltimore Museum of Art
Carnegie Institute, Pittsburgh
Cleveland Museum of Art
Kunsthalle, Basel, Switzerland
Metropolitan Museum of Art, New York City
Munson-Williams-Proctor Institute, Utica, New York
Museum of Fine Arts, Houston
Museum of Modern Art, New York City
North Carolina Museum of Art, Raleigh
Philadelphia Museum of Art
Rockefeller Institute, New York City
Solomon R. Guggenheim Museum, New York City
Tate Gallery, London
Walter P. Chrysler Museum of Art, Norfolk, Virginia
Whitney Museum of American Art, New York City
William Rockhill Nelson Gallery of Art, Kansas City, Missouri

JOHN KOCH
(1910-1978)

John Koch was a traditional, romantic artist who built his reputation on portraits of the prominent art patrons of New York City.

A self-taught painter, Koch was born in Toledo, Ohio in 1910. His education included travel in Great Britain and France. The city of Paris drew Koch back to its environs, where he set up a summer residence and studio.

Koch's paintings are characterized by a soft, misty surface. He created luminous effects by underpainting in egg tempera and glazing with oils. This rich, lustrous appearance is reminiscent of the work of seventeenth-century Dutch master Vermeer.

A successful artist, Koch attracted the wealthy elite of New York City to his studio. His approach to portraiture was to create a likeness which was aesthetically pleasing as well as becoming to the sitter. Mrs. Reginald Marsh, depicted in *The Bridge* (date and location unknown), posed in Koch's studio, which overlooked the Queensboro Bridge in New York. Koch also posed his subjects in elegant interiors, appropriate to their social position.

Koch taught at the Art Students League in New York City and served as chairman of the school committee for the National Academy of Design. He died in 1978.

(Family Group), 1951, 24 x 20 in., signed l.r. Courtesy of National Museum of American Art, Smithsonian Institution, Gift of Barbara Wood.

MEMBERSHIPS
Audubon Artists
Century Association
Lotus Club
National Academy of Design

PUBLIC COLLECTIONS
Art Institute of Chicago
Art Students League, New York City
Butler Institute of American Art,
 Youngstown, Ohio
California Palace of the Legion of Honor,
 San Francisco
Detroit Institute of Arts
Metropolitan Museum of Art, New York City
Museum of Modern Art, New York City
National Academy of Design, New York City
Toledo Museum of Art, Ohio

SEASON	75-76	76-77	77-78	78-79	79-80	80-81	81-82	82-83	83-84	84-85
Paintings				1		2	1	2	1	1
Dollars				$2,100		$35,600	$4,750	$10,500	$7,000	$1,000

Record Sale: $34,000, SPB, 12/4/80, "The Connoisseurs," 25 × 30 in.

938

RALPH CAHOON
(1910-1982)

MARTHA CAHOON
(1905-)

New England Summer, 22 x 28 in., signed l.r. Courtesy of Driscoll & Walsh Fine Art, Boston, Massachusetts.

"Grandma Moses with tongue in cheek" is the way one critic described the contemporary primitive paintings of Ralph and Martha Cahoon. The two shared idea, but always painted individually, although in remarkably similar styles. Theirs was a more sophisticated style than Grandma Moses', however. Particularly in Ralph Cahoon's work was a wit and sometimes even a mildly satiric bawdiness seldom, if ever, associated with true primitives.

Ralph Cahoon's paintings abound with early-nineteenth-century sailors and mermaids in all sorts of fanciful situations. Martha, on the other hand, was interested in the Orient. Chinese and Japanese influences can often be found in her work, which tended to be softer, more romantic and less whimsical than her husband's.

Ralph Cahoon, a direct descendant of the first·Dutch settlers on Cape Cod, was born in Chatham on the Cape in 1910. He liked to draw as a boy and later studied both fine and commercial art at the School of Practical Art in Boston.

Born in Boston in 1905, Martha Farham moved to Cape Cod with her family when she was 10. In Boston her father had done decorative painting on furniture for prestigious interior design-

ers, and he continued this after moving. In time he taught his daughter and son to help him.

Ralph and Martha were married in 1931 and soon began to sell antique furniture, which they had restored and decorated. Much of their early work followed the traditional patterns of Pennsylvania Dutch and Swedish painted furniture, but with shells and sea-related themes predominating. Later, however, they began painting whole scenes on trays and on the fronts of bureaus and secretaries.

When Joan Whitney Payson, sister of art collector John Hay Whitney and the owner of a Long Island art gallery, saw their work, she told them it should be framed and sold as paintings. The Cahoons' first consignment to Payson's gallery was sold out immediately and she clamored for more.

Soon the couple gave up furniture decoration altogether and devoted themselves to painting. As with the original primitive painters, they made no attempt to create a third dimension in their work through light, shade or a blending of colors. Rules of perspective were ignored.

It became commonplace for exhibitions of Cahoon paintings to be sold out, sometimes within hours of the opening. To satisfy demand, the couple often produced as many as 200 paintings in a single year. Sometimes, at the request of a gallery owner, they would tailor their subject matter to a particular regional market.

Husband and wife continued painting together on Cape Cod until Ralph's death in 1982.

10-Year Average Change From Base Years '79-'80: 152%

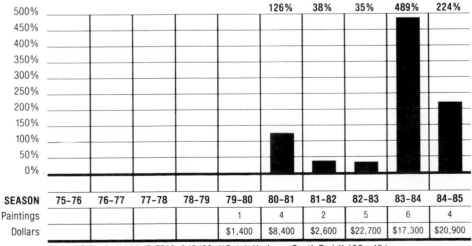

SEASON	75-76	76-77	77-78	78-79	79-80	80-81	81-82	82-83	83-84	84-85
						126%	38%	35%	489%	224%
Paintings					1	4	2	5	6	4
Dollars					$1,400	$8,400	$2,600	$22,700	$17,300	$20,900

Record Sale: $10,000, E.EDM, 8/5/82, "Cotuit Harbour, South End," 132 x 45 in.

PUBLIC COLLECTIONS
Heritage Plantation, Sandwich, Massachusetts

ERIC SLOANE
(1910-1985)

Painter, illustrator and muralist Eric Sloane produced many landscapes of the Southwest and especially of New England. He wrote and illustrated a number of books on Americana. An interest in meteorology and aviation led to his development of the "cloudscape."

Sloane was born Everard Jean Hinrichs in New York City in 1910. His father was a wholesale meat broker and Sloane grew up in a household without any interest in the arts. He had the opportunity, however, to observe the work of a neighbor, sculptor George Gray Bernard. Later, after his family moved to Long Island, Sloane lived near type designer Frederic Goudy, who taught him lettering.

The young man determined upon a career in the arts and, in 1925, he borrowed his father's Model T and traveled West, painting signs, trucks and store windows as he went. He spent time in the Pennsylvania Amish country and in New Orleans' Vieux Carre before reaching Taos, New Mexico. There he executed pen-and-ink drawings until urged by painter Leon Gaspard to try oils. Sloane used masonite as a painting surface, a practice he followed throughout his career.

In 1929, Sloane attended the Yale School of Fine Art, and he joined the Art Students League in New York City the following year. At that time he adopted the name Sloane. He enrolled in the New York School of Fine and

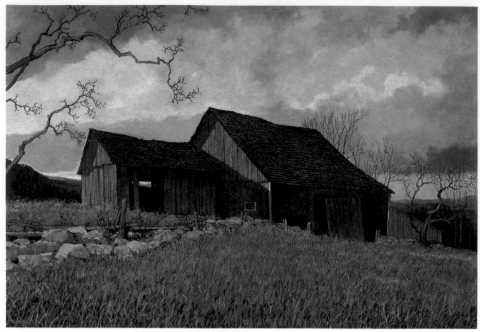

Red Barn, 32 x 17¼ in., signed l.l. Collection of Mr. and Mrs. Haig Tashjian. Photograph courtesy of Sterling Regal, Incorporated, New York.

Applied Arts in 1935.

During the 1930s, Sloane's interest in aviation and weather led to the painting of cloud formations, which he christened "cloudscapes," and to the study of meteorology at the Massachusetts Institute of Technology. He published several illustrated books on weather.

While studying old diaries for weather information, Sloane became interested in early American farming and craftsmanship. He collected and sketched handmade tools, and published several

dozen books illustrating tools, covered bridges, barns and other Americana. Good examples of this work are found in his books *An Age of Barns* (1967, Funk & Wagnalls) and *I Remember America* (1971, Funk & Wagnalls).

Influenced by the Hudson River School in his painting, Sloane concentrated on landscapes, as in *Pennsylvania Yesterday* (date unknown, Gilcrease). He worked quickly, with rapid strokes, and often used a pencil or a razor blade to work the wet paint.

As a muralist, Sloane worked in the Biltmore Hotel and the Morton Salt Building in New York City, and in the American Museum of Natural History. In 1975, he executed a mural for the new Air and Space Museum in Washington, D.C.

Sloane died in New York City in 1985.

MEMBERSHIPS
Lotos Club
National Academy of Design
Salmagundi Club

PUBLIC COLLECTIONS
American Museum of Natural History,
New York City
Gilcrease Museum, Tulsa, Oklahoma
National Air and Space Museum,
Washington, D.C.
Sloane-Stanley Museum, Kent, Connecticut

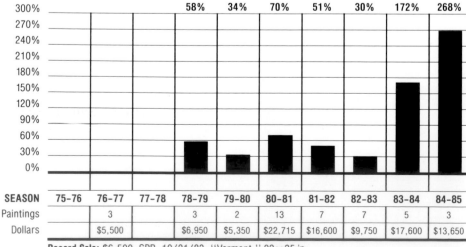

10-Year Average Change From Base Years '76-'77: 85%

	75-76	76-77	77-78	78-79	79-80	80-81	81-82	82-83	83-84	84-85
				58%	34%	70%	51%	30%	172%	268%
SEASON	75-76	76-77	77-78	78-79	79-80	80-81	81-82	82-83	83-84	84-85
Paintings		3		3	2	13	7	7	5	3
Dollars		$5,500		$6,950	$5,350	$22,715	$16,600	$9,750	$17,600	$13,650

Record Sale: $6,500, SPB, 10/21/83, "Vermont," 23 × 35 in.

940

ALEXANDER DZIGURSKI
(1911-)

Yugoslavian-born Alexander Dzigurski's realistic landscapes and seascapes have broad popular appeal. He has traveled widely in the United States, and has painted in such scenic locations as the Rockies, Glacier National Park, the Grand Teton Mountains and New England, as well as along picturesque stretches of the East, West and Gulf coasts. A *New York Times* critic once characterized him as "poet of the sea," and commented, "Few marine painters have been able to tell the story of the sea so beautifully. His water is wet, deep and alive."

Dzigurski was born in Stari Becej, Yugoslavia in 1911. He studied at the School of Art in Belgrade, and then at the Academy of Art in Munich, Germany. At the start of his career in Yugoslavia, he painted portraits and decorated the interiors and altars of seven Serbian Orthodox churches.

World War II disrupted his life when the Germans invaded his homeland. At its conclusion, he fled Tito's communist government with his wife and daughter; they made their way to Italy as displaced persons. Several years later, they sailed from Naples for the United States.

Dzigurski went to work for the International Art Publishing Company in Detroit, which published reproductions of his work and helped to arrange exhibitions of it in leading galleries. In these early days in the United States he also decorated the interiors of nine churches.

By 1952, Dzigurski's work was selling well enough that he could afford to begin traveling about the country, painting landscapes. Eventually he settled in California with his family and devoted considerable time to painting along the rugged coasts of Northern California and Oregon.

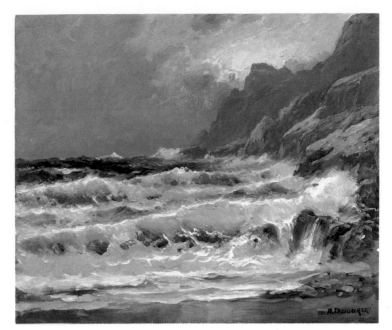

Sunset Brilliance, 20 x 24 in., signed l.r. Courtesy of Simic Galleries, Carmel, California.

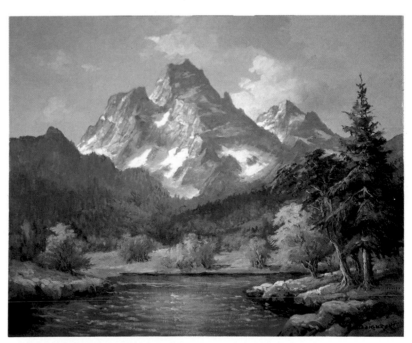

Cascade Splendor, 24 x 30 in., signed l.r. Courtesy of Simic Galleries, Monterey, California.

SEASON	75-76	76-77	77-78	78-79	79-80	80-81	81-82	82-83	83-84	84-85
Paintings				1	1	4	3	2		1
Dollars				$1,000	$800	$4,000	$4,000	$1,500		$500

Record Sale: $1,400, SPB, 6/29/82, "Seascape," 24 × 36 in.

DONG KINGMAN
(1911-)

Dong Kingman is a Chinese-American watercolorist whose paintings, principally cityscapes, combine elements of both East and West. His subjects are clearly recognizable, yet they are abstract in the sense that he rearranges components at will to achieve the composition he wants.

Kingman was born in Oakland, California in 1911. When he was five, his family moved to Hong Kong. At school there, Kingman excelled in calligraphy and watercolor painting.

The headmaster of one school he attended was a painter who had studied in Paris and knew both Chinese and Western art. He introduced the young Kingman to the work of Matisse, Van Gogh and Cezanne, and taught him basic theories of composition, brushwork and color.

At 18, Kingman returned to Oakland, unsure what he wanted to do. Among other jobs, he worked for a time as houseboy for a San Francisco family and sketched in his free time.

At one art school which he attended briefly, an instructor saw his oil paintings and told Kingman that he would fail as an artist. His watercolors, however, made the instructor change his mind. Kingman never painted in oils again.

When he got a job with WPA Federal Arts Project in the mid-1930s, Kingman was able to work full-time as a painter, improving his watercolor technique. Recognition came after a local collector bought some of his work to donate to major museums.

In 1942, Kingman won a Guggenheim Fellowship to travel and paint throughout the United States. That same year he had his first one-man show in New York City. He has lived and taught there ever since.

Kingman paints urban scenes, because architectural forms fascinate him. He was apprenticed once to an architect; while spurning it as a career,

Station Platform, 14½ x 13 in., signed l.r. Courtesy of Hirshhorn Museum and Sculpture Garden, Smithsonian Institution, Washington, D.C.

he has, he says, never stopped painting architecture.

MEMBERSHIPS
American Watercolor Society
National Academy of Design

PUBLIC COLLECTIONS
Art Institute of Chicago
Brooklyn Museum
Delaware Art Museum, Wilmington
De Young Memorial Museum, San Francisco
Metropolitan Museum of Art, New York City
Museum of Fine Arts, Boston
Museum of Modern Art, New York City
San Diego Museum of Art
San Francisco Museum of Modern Art
Wadsworth Atheneum, Hartford, Connecticut
Whitney Museum of American Art,
 New York City

SEASON	75–76	76–77	77–78	78–79	79–80	80–81	81–82	82–83	83–84	84–85
Paintings				8	5	4	1	3	4	2
Dollars				$10,250	$7,800	$7,350	$1,700	$2,400	$6,300	$1,400

Record Sale: $5,250, SPB, 6/19/81, "Moon and Locomotive," 20 × 29 in.

ATTILIO SALEMME

(1911-1955)

Attilio Salemme was born in Boston in 1911. His father died when he was young; when he finished junior high school, he left school to help support his mother and sister.

In 1927, he enlisted in the Marine Corps by lying about his age. He was stationed in Port-au-Prince, Haiti, where the colorful costumes and lives, amidst the dull daily routine, impressed him and may have influenced his later work.

Salemme had trouble finding work after leaving the Marines. He moved to New York City with his mother and sister in 1930, where he held several odd jobs to support the family. He came into contact with the artistic community in Greenwich Village, where he lived, and began to take a serious interest in art.

In the hope of becoming a chemical engineer, he was diverted from art and studied the science. However, studies did not last long and he returned to art.

In 1942, he became a framemaker for the Guggenheim Museum of Non-objective Art, where he was able to meet, and become a part of, a group of contemporary artists which included his future wife, Lucia.

Although his work has been compared to that of De Chirico and Klee, Salemme's paintings are unique because they are neither wholly abstract nor realistic. His meticulous spatial compositions of geometric forms often represent a social relationship of beings or esoteric themes, usually expressed in the titles of the paintings. His paintings seem to capture a loneliness that De Chirico called a metaphysical solitude.

In his short career as an artist, Salemme felt he had accomplished what he had hoped to in painting. He had also gained respect and recognition among his peers.

Salemme died at age 43 of a heart attack.

Enigma of Joy, 1947, 51 ⅞ x 79 ⅞, signed l.r. Courtesy of National Museum of American Art, Smithsonian Institution, Gift of United States Maritime Administration.

PUBLIC COLLECTIONS
Brooklyn Museum
Metropolitan Museum of Art, New York City
Museum of Modern Art, New York City
Whitney Museum of American Art,
 New York City

SEASON	75-76	76-77	77-78	78-79	79-80	80-81	81-82	82-83	83-84	84-85
Paintings	1	1		2			2			2
Dollars	$5,000	$3,000		$8,500			$9,400			$7,100

Record Sale: $5,000, PB, 5/28/76, ''Abstract,'' 22 × 34 in.

LEE KRASNER
(1911-1984)

A major retrospective exhibition of the work of abstract expressionist painter Lee Krasner was touring at the time of her death in 1984, at age 73. The show marked her standing as a major force in the New York City art world.

Krasner was the widow of painter Jackson Pollock, who died in 1956. Recognition of her status as a pioneer of abstract art was delayed because she was so long in the shadow of her famous husband. The acclaim she received, primarily in her last decade, is credited partly to exhibitions of her work and partly to the effects of the women's movement.

She was born Lenore Krassner in Brooklyn in 1911 to hard-working Russian Jewish immigrants. From 1926 to 1929, she studied at the Women's Art School of Cooper Union; this was followed by three years at the National Academy of Design. She learned the rudiments of cubism during her studies with Hans Hofmann from 1936 to 1940.

The WPA Federal Arts Projects offered Krasner the opportunity to work full-time as an artist from 1934 to 1943, assisting muralist Max Spivak.

When she met Jackson Pollock in 1942, Krasner was well known in the Greenwich Village art world and helped to further his career. They married in 1945 and moved to an old farmhouse in East Hampton, Long Island.

Over the years, Krasner worked in numerous styles, notably her hieroglyphic paintings, or "Little Images,"

Composition, 1949, 38 x 28 in. Philadelphia Museum of Art, Pennsylvania, Given by the Aaron E. Norman Fund, Inc.

completed between 1945 and 1950, and her collages of the 1950s, composed of her own slashed paintings or scraps of Pollock's works.

In the 1950s, her scale became larger. Her feeling for color has been compared to Matisse and Bonnard. According to art critic Barbara Rose, Krasner is "one of the very few women who has really expressed violence and aggression in her work."

Supporter Piet Mondrian told Krasner in 1940, "You have a very strong inner rhythm; you must never lose it." Her career proves that this "inner rhythm" and strength of will was reflected throughout her lifetime.

Major museums throughout the world hold Krasner's work.

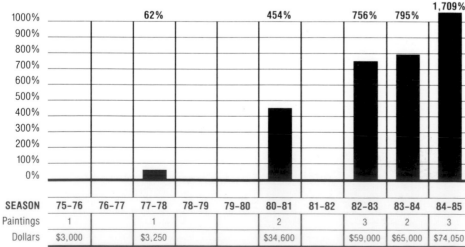

10-Year Average Change From Base Years '75-'76: 629%

SEASON	75-76	76-77	77-78	78-79	79-80	80-81	81-82	82-83	83-84	84-85
			62%			454%		756%	795%	1,709%
Paintings	1		1			2		3	2	3
Dollars	$3,000		$3,250			$34,600		$59,000	$65,000	$74,050

Record Sale: $60,500, SPB, 5/2/85, "Equation," 39 x 58 in.

PUBLIC COLLECTIONS
National Gallery of Art, Washington, D.C.
Philadelphia Museum of Art
Whitney Museum of American Art,
New York City

SUZY FRELINGHUYSEN
(1912-)

Artist Suzy Frelinghuysen was born Estelle Condit Frelinghuysen in 1912, a member of a prominent New Jersey family.

Without formal art training, her talent developed through keen interest and a discerning eye. Her earliest work was as a realist, but marriage in 1935 to art critic and abstract painter George L.K. Morris converted her to painting in a cubist-abstract style.

Her oil and collage paintings of the 1940s exhibited some characteristics of Parisian painter Juan Gris, but the post-World War I work of Braque was also an influence.

While her art was based on cubist principles of geometric form, she adhered to a belief, shared by contemporaries Stuart Davis, A.E. Gallatin and Charles Shaw, that "most art comes from nature."

Using corrugated paper, clippings from magazines and printed papers, she created restrained, elegant collages, such as *Still Life* (1944, Ertegun Collection) and *Composition, 1943* (location unknown).

Although she held early memberships in the American Abstract Artists and the Federation of Modern Painters and Sculptors, formed to promote public acceptance of modern art, she was not a political activist. Unlike many artists of the 1930s and 1940s, she did not make political statements through her art, which was personal and intuitive rather than ideological.

A versatile woman, she had a brief but successful career as a concert singer while still painting seriously.

Frelinghuysen exhibited yearly in the American Abstract Artists exhibitions, and was one of an elite group of women artists to be sponsored in an exhibition by art patron Peggy Guggenheim.

Currently, she lives and works in New York City and Lenox, Massachusetts.

Composition 1942, 16 x 12 in. Private Collection, Photograph courtesy of Hirschl & Adler Galleries, Inc., New York, New York.

MEMBERSHIPS
American Abstract Artists
Federation of Modern Painters and Sculptors

PUBLIC COLLECTIONS
Philadelphia Museum of Art

SEASON	75-76	76-77	77-78	78-79	79-80	80-81	81-82	82-83	83-84	84-85
Paintings							1	1		1
Dollars							$7,500	$14,000		$2,400

Record Sale: $14,000, P.NY, 6/1/83, "Still Life," 20 × 24 in.

AGNES MARTIN
(1912-)

Agnes Martin is today considered one of the forerunners of minimal art. She is best known for her grid paintings; her work since the time of her first one-woman exhibit has been marked by a near-mystical geometric purity.

Born in Saskatchewan, Canada in 1912, Martin decided to become an artist while attending Columbia University in New York City in the 1940s. After graduating with a master of fine arts degree, she continued to live and paint in New York for the next two decades, with several intermittent teaching breaks in New Mexico.

Initially a landscape and figure painter, Martin developed her mature artistic style by the time of her first one-woman exhibit in 1958. Her paintings were individualistic, hard-edged and austere. Stylistically, they exhibited a dramatic departure from the popular abstract expressionism.

By the early 1960s, Martin had relinquished much of her compositional rigidity and begun working with a grid format. Since 1964, this format has been explored in most of her paintings.

Martin's earliest grid paintings were large and delicate, often painted on bare canvas. Initially, the artist used color in her grids, but over time color gave way to monochromatic variations.

Many of Martin's grids were applied with pencil strokes. Always vertical and horizontal, they evoked both classicism and premeditated organization. Artistic impact was achieved through subtlety: irregularity of spacing, variation of border, slight shifts of linear clarity.

In talking about the continuous patterns in her paintings, Martin has suggested that her work is evocative of repeating patterns in nature, such as in the sea or a waterfall. "Nature," she said, "is like parting a curtain. You go into it."

Martin has achieved considerable success. From 1958 to 1967, she was exhib-

"*Gray Stone II*", 1961, 72 x 72 in., signed L.L.

ited annually in one-woman shows. In addition, her work was exhibited in 50 prestigious group shows in the United States and Europe.

In 1967, Martin abruptly left New York City and moved to New Mexico, where she currently resides.

PUBLIC COLLECTIONS
Los Angeles County Museum of Art
Museum of Modern Art, New York City
National Museum, Jerusalem
Solomon R. Guggenheim Museum,
 New York City
Wadsworth Atheneum, Hartford,
 Connecticut
Whitney Museum of American Art,
 New York City

SEASON	75-76	76-77	77-78	78-79	79-80	80-81	81-82	82-83	83-84	84-85
Paintings			1	3	2	2	4	1	8	3
Dollars			$3,500	$12,400	$8,500	$55,000	$60,800	$12,500	$142,990	$68,000

Record Sale: $95,000, SPB, 11/9/83, "Trumpet," 72 × 72 in.

JACKSON POLLOCK
(1912-1956)

Jackson Pollock is generally considered one of the leading American artists of the twentieth century, yet to some his work is as controversial today as when it was first exhibited.

In the period of his most dazzling creativity, Pollock placed enormous canvases on the floor of his studio and poured, splattered and dripped paint on them. The results were the ultimate in nonobjectivity—virtually limitless fields of painstakingly-balanced colors and densities that seemed to pulse with life. It was as if they were painted in a lyrical frenzy that, some said, revealed the very soul of the artist.

Pollock was born in Cody, Wyoming in 1912. While he was still a baby his family moved, first to Arizona, then to California. It is thought that an older brother, who had left home to work and study art, was the first to spark young Jackson's interest in painting.

At age 18, Pollock moved to New York City to study at the Art Students League under Thomas Hart Benton, whose early influence on him soon dwindled. "He drove his kind of realism at me so hard I bounced right into nonobjective painting," Pollock explained later.

New York City seethed with new artistic ideas and Pollock was in the midst of it, seeking his own style. While painting under the WPA Federal Art Project, he also worked in a mural workshop run by David Siqueiros, the Mexican painter.

November 1, 1950 (Lavender Mist), 87 x 118 in., signed l.l. Courtesy of National Gallery of Art, Washington, D.C.

Not only was Siqueiros working on a large scale, but he was also experimenting with spraying, dripping and splattering paint in much the same way that Pollock would later do.

Pollock had developed a drinking problem as a teenager, and during psychiatric treatment for it in 1937 he became interested in Carl Jung's theories on the importance of myths and symbols to the subconscious mind. Around the same time he met Robert Motherwell, who was delving into surrealist theory, and found many similarities between surrealism's underlying philosophy and his own evolving ideas, particularly with regard to allowing the subconscious to control the hand in painting.

In 1943, Pollock met Peggy Guggenheim, the patroness of modern art, who had her own gallery. Not only did she exhibit some of his work, but she arranged to pay him a modest monthly stipend so he could paint whatever he wanted.

With modern art developing in so many conflicting directions, however, Pollock still had problems with the course of his own work. The event that helped coalesce his thoughts was the Kandinsky retrospective exhibition at the Guggenheim Museum in 1945.

He realized at last that what he wanted was, in fact, a totally new approach to painting. Rather than the forms themselves on the canvas, it was to be the very process of creating the forms that would make up the content of his painting.

Sounds in the Grass, Shimmering Substance (1946, Museum of Modern Art) was one of the first of his new paintings. It foreshadowed the most fruitful period of Pollock's career. The canvases over which he poured and dripped paint followed in ever more astonishing succession.

In 1951, he reverted to more representational images, most done in black and white paint. By 1953 he had changed direction again, this time going back to earlier themes, reworking them often in even more frenzied renditions of some of the drip paintings. He was still working in this vein when he was killed in an automobile accident in 1956.

10-Year Average Change From Base Years '78-'79: 21%

SEASON	75-76	76-77	77-78	78-79	79-80	80-81	81-82	82-83	83-84	84-85
					22%	13%	4%	29%	20%	62%
Paintings				3	4	3	4	3	5	8
Dollars				$52,500	$762,300	$15,950	$359,000	$340,000	$344,000	$804,500

Record Sale: $550,000, CH, 5/16/80, "Four Opposites," 72 x 50 in.

PUBLIC COLLECTIONS
Art Institute of Chicago
Brooklyn Museum
Dallas Museum of Fine Arts
Kunstsammlung Nordrhein-Westfalen,
 Dusseldorf, West Germany
Los Angeles County Museum of Art
Metropolitan Museum of Art, New York City
Museum of Modern Art, New York City
Solomon R. Guggenheim Museum, New York City
Whitney Museum of American Art,
 New York City

MORRIS LOUIS
(1912-1962)

Faces, 1959, 91¼ x 136 in. Courtesy of National Museum of American Art, Smithsonian Institution, Museum Purchase from the Vincent Melzac Collection.

Morris Louis, a post-abstract expressionist painter, challenged traditional assumptions about drawing and three-dimensionality. His works after 1954 demonstrate fresh implications about the nature of pictorial space and the functions of line and color. They have been described as pure color, continuous and unbroken, flowing effortlessly into the very weave of the canvas.

Born Morris Bernstein in Baltimore, Maryland, the artist studied at the Maryland Institute of Fine and Applied Arts from 1929 to 1933, and worked on a WPA Federal Art Project in the late 1930s. He lived in New York City from 1936 to 1940, after which he lived in Baltimore and Washington.

He chose to isolate himself from the New York art world, teaching and concentrating upon the development of his work. He was instrumental in the formation of the Washington School of color-field painting.

In the 1950s, Louis was influenced by action painters Jackson Pollock and Robert Motherwell. Then, in 1954, he was introduced to the work of New York artist Helen Frankenthaler. Fascinated by her open color work and her process of staining, in which a new kind of color-space emerged without foreground and background, he found a means of dealing with color and space beyond Pollock's achievement.

Louis dealt with the problem of creating shapes without suggesting depth for the rest of his life. Although he destroyed most of his work from 1955 through early 1957, he created four major series, "Veils" (1954, 1957 to 1959), "Florals" (1959 to 1960), "Unfurled" (1960) and "Stripes" (1961 to 1962).

Louis spilled many layers of thinned acrylic paints across unprimed canvas, sometimes folding or pleating it and sometimes using a stick to guide the flow of pigments. The result is a transparency of hue, involving complete integration of paint and canvas. Edges seem to be part of a continuum; it is impossible to follow the chronological or figurative deployment of shapes, so that time and depth are destroyed.

The artist died at age 50, at the height of his powers. His last series, "Stripes," in which his colors are densely massed in vertical arrangements leading to the center of the blank canvas, would seem to indicate that he was on the verge of new discoveries.

PUBLIC COLLECTIONS
Allentown Art Museum, Pennsylvania
Detroit Institute of Arts
Museum of Fine Arts, Boston
Museum of Modern Art, New York City
Philadelphia Museum of Art
Phillips Collection, Washington, D.C.
Solomon R. Guggenheim Museum,
 New York City
Whitney Museum of American Art,
 New York City

SEASON	75-76	76-77	77-78	78-79	79-80	80-81	81-82	82-83	83-84	84-85
Paintings	1	3	4	3	4	4	3	4	5	6
Dollars	$26,200	$147,600	$193,000	$285,650	$263,500	$330,000	$670,000	$440,000	$917,500	$626,000

Record Sale: $430,000, CH, 5/8/84, "Sigma," 103 × 170 in.

WILLIAM BAZIOTES
(1912-1963)

One of the first abstract expressionists, William Baziotes worked organic shapes into surrealistic backgrounds. His use of space and color evoke a submarine environment populated by amoeba-like forms, squiggly shapes and webs.

Baziotes was the first abstract expressionist to win critical acclaim at a Chicago exhibition of abstract and surrealist art in 1948, and his work continued to influence artists into the 1960s and 1970s.

Born in Pittsburgh in 1912, Baziotes worked for a stained-glass company before enrolling for serious study in 1933 at the National Academy of Design, where he worked under Leon Kroll. At age 24, Baziotes was employed by the WPA's Easel Painting Division, where he stayed for five years. At that time, he employed a style like Cezanne's. Figures and still lifes bored him, and for a year he was unable to complete a single work.

The breakthrough came during a summer vacation on the Hudson River. Asked to paint a large mural on the porch wall of the cottage where he was staying, Baziotes went to work on some old weather-beaten panels. Letting his imagination run wild, he made forms out of every crack and mildew stain. In a day, the mural was painted. "I felt like someone unexpectedly let out of jail," he said later.

By 1942, influenced by Roberto

Scepter, 1960-1961, 66 x 78⅛ in., signed l.r. Courtesy of National Museum of American Art, Smithsonian Institution, Gift of S.C. Johnson & Son, Inc.

Matta Echaurren and Joan Miro, and having thoroughly explored surrealism, Baziotes had evolved his mature style. Biomorphic forms spread across the canvas, emerging from fluid, luminous colors laid down in translucent veils of paint.

Each of his paintings, although they appear to be carefully planned, represent journeys into the unknown. Baziotes claimed never to have followed a system for evoking images: "Each beginning suggests something. . . . Once I sense the suggestion, I begin to paint intuitively."

Baziotes taught at New York University, the Brooklyn Museum of Modern Art, the Museum of Modern Art and Hunter College. He was co-founder of a school, "Subjects of the Artist," in New York City in 1948. He died in 1963.

PUBLIC COLLECTIONS
Albright-Knox Art Gallery, Buffalo
Baltimore Museum of Art
Art Institute of Chicago
Detroit Institute of Arts
Guggenheim Museum, New York City
Metropolitan Museum of Art, New York City
Museum of Modern Art, New York City
Newark Museum, New Jersey
San Francisco Art Association
Seattle Art Museum
Whitney Museum of American Art,
 New York City

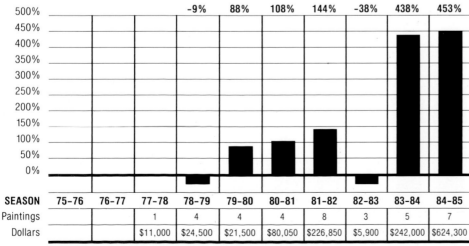

10-Year Average Change From Base Years '77-'78: 148%

SEASON	75-76	76-77	77-78	78-79	79-80	80-81	81-82	82-83	83-84	84-85
				-9%	88%	108%	144%	-38%	438%	453%
Paintings			1	4	4	4	8	3	5	7
Dollars			$11,000	$24,500	$21,500	$80,050	$226,850	$5,900	$242,000	$624,300

Record Sale: $253,000, SPB, 5/2/85, "Phantasm," 60×72 in.

949

CONRAD MARCA-RELLI

(1913-)

Although Conrad Marca-Relli began his artistic career as a painter, he is recognized as one of the American masters of collage and part of the first generation of abstract expressionism. Self-taught, except for a brief stint at Cooper Union in New York City, he has exhibited often in New York City, Europe and Latin America.

Marca-Relli was born in Boston of Italian parents. From 1935 to 1938, he worked for the WPA Federal Art Project. He spent four years in the army before settling in New York City. Although he traveled in Europe, the United States and Mexico, his frequent trips to Italy had the greatest effect on his early paintings.

Marca-Relli's early cityscapes, still lifes, circus themes and architectural motifs are reminiscent of Italian surrealist painter Giorgio de Chirico. The subdued palette and architectural starkness of these paintings create a sense of loneliness and emptiness typical of the surrealists.

Marca-Relli's monumental-scale collage works combine oil painting and collage, with materials sometimes consisting of vinyl plastics and cut-out aluminum.

His collage paintings of the early 1950s are characterized by abstract or suggested figures, reclining or seated. These early works of canvas and pigment were created by first sketching forms onto bare canvas; they were then cut out and pinned to a supporting canvas. The pinning allowed the positioning of the cut-outs, so that accident and chance mingled with the artist's initial ideas. Carefully structuring the collage elements, Marca-Relli employed intense colors, broken surfaces and expressionistic spattering.

In the 1960s, he experimented with metal and vinyl sheets for an industrial effect. Shapes were outlined with painted or actual nail holes, stressing their three-dimensional plasticity.

Over the years the collages developed an abstract simplicity, evidenced by black or somber colors and rectangular shapes isolated against a neutral backdrop.

Marca-Relli has taught at Yale University (from 1954 to 1955 and from 1959 to 1960) and at the University of California at Berkeley (1958). His first one-man show was in New York City in 1948, and in 1967 the Whitney Museum of Modern Art gave him a retrospective show.

Rome Coliseum, ca. 1941, 22 x 25½ in., signed l.l. Courtesy of Montclair Art Museum, Montclair, New Jersey.

PUBLIC COLLECTIONS
Art Institute of Chicago
Carnegie Institute, Pittsburgh
Cleveland Museum of Art
Detroit Institute of Arts
Metropolitan Museum of Art, New York City
Minnesota Museum of Art
Museum of Modern Art, New York City
National Collection of Fine Arts, Washington, D.C.
Pennsylvania Academy of the Fine Arts, Philadelphia
San Francisco Museum of Art
Solomon R. Guggenheim Museum, New York City
Whitney Museum of American Art, New York City

SEASON	75-76	76-77	77-78	78-79	79-80	80-81	81-82	82-83	83-84	84-85
Paintings			1	2	2	3	3	4	1	3
Dollars			$4,500	$4,950	$2,650	$9,500	$5,650	$6,500	$6,000	$4,080

Record Sale: $6,000, CH, 11/9/83, "Untitled," 44 × 58 in.

DOROTHEA TANNING
(1913-)

Dorothea Tanning produced some of the most fascinating surrealist works of any non-European artist. She built her career around the theme of the joys and fears of childhood and manhood. Unfortunately, recognition of her work may have been slighted because of her marriage to better-known artist Max Ernst.

Tanning was born in 1913 in Galesburg, Illinois. A precocious child, she quickly became bored with school, escaping through Poe and Dickinson and other writers into a fantasy world. The images she visualized from her reading would shape her work for years to come.

She attended Knox College and the Art Institute of Chicago before moving to New York City. There she lived a bohemian existence, working at odd jobs, studying Indian culture and philosophy, and painting.

A 1936 exhibit of surrealism at the Museum of Modern Art had a pronounced effect on her work, affirming her tendency towards fantasy imagery. By the early 1940s, Tanning had become part of the surrealist community in New York City, making ends meet with freelance drafting and advertising jobs.

Her work was shown at such places as the Julien Levy Gallery, and in 1943 she was one of 31 women in an exhibition staged by Peggy Guggenheim, who at the time was married to Ernst. The exhibition threw Ernst and Tanning together in a relationship that lasted until Ernst's death.

Tanning's paintings during this period portrayed a precise realism within a surrealist framework. Women and children were featured prominently, often floating freeform in a veil of smoke or flowers or rumpled fabrics. Sexuality underlies much of her work, as in *Palaestra* (1947, location unknown).

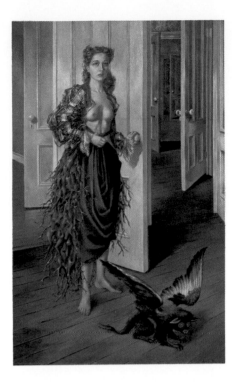

Birthday—1942, 40 x 25½ in., signed l.r. Courtesy of Dorothea Tanning Gallery, Schlesinger-Boisante, New York, New York.

Daughters, 1983, 51¼ x 38½ in., signed l.r. Courtesy of Dorothea Tanning Gallery, Schlesinger-Boisante, New York, New York.

In the 1950s, Tanning's paintings became more obscure and somewhat amorphous in content, still revolving around the same theme. By this time, she and Ernst had moved to Paris, where she still resides part-time.

In recent years, she has taken up surrealistic soft sculpture.

PUBLIC COLLECTIONS
Art Institute of Chicago
Museum of Modern Art, New York City

SEASON	75-76	76-77	77-78	78-79	79-80	80-81	81-82	82-83	83-84	84-85
Paintings	1	1	1	3	2		3	3	5	
Dollars	$6,000	$1,881	$13,800	$3,276	$2,400		$42,000	$11,607	$14,927	

Record Sale: $15,000, SPB, 11/5/81, "The Game of Chess," 17 × 17 in.

AD REINHARDT
(1913-1967)

Number 90, 1952 (Red), 132 x 240 in. Courtesy of Hirshhorn Museum and Sculpture Garden, Smithsonian Institution, Washington, D.C.

One of the forerunners of minimalism, Ad Reinhardt pioneered many new concepts in modern art and its philosophies.

Born in Buffalo, New York in 1913, he studied with Meyer Shapiro at the National Academy of Design, and later with Francis Criss, Carl Holty and Karl Anderson. In 1945, he spent a year with navy photographer Alfred Salmony.

Reinhardt traveled a great deal through Europe and Asia. Absorbing Zen philosophy during his travels probably had a significant effect on his attitudes toward painting.

Often categorized as cubism, abstractionism or minimalism, Reinhardt's work was associated with that of many others in modern art. Early in his career he was influenced by Stuart Davis and Mark Tobey, but later his work was compared to that of Rothko, Mondrian and Albers. His paintings were closest in style to those of Barrett Newman. When closely examined, however, Reinhardt's work contained many unique elements.

Its prime focus was the isolation of forms from any kind of relative association. His paintings did not represent abstracted images or exploratory techniques with brushstrokes or color. He wished to remove qualities from his work that would allow his paintings to be interpreted as anything other than what they were. His own words were, "Art of Art, Art for Art."

Until his death in 1967, Reinhardt spent 15 years perfecting his ideas in a series of monochromatic paintings. By 1960, these paintings had become uniformly square, and lent themselves well to the ordered placement of square forms painted in values which were extremely close to each other. Because he chose black or dark colors for this series, they are referred to as his "black" paintings, appearing to be completely monochromatic at first glance, the pattern revealing itself only gradually.

Black Painting No. 34, 1964, 60¼ x 60⅛ in. Courtesy of National Gallery of Art, Washington, D.C.

MEMBERSHIPS
American Abstract Artists
Asia Society
Chinese Art Society

PUBLIC COLLECTIONS
Albright-Knox Art Gallery, Buffalo, New York
Baltimore Museum of Art
Dayton Art Institute, Ohio
Los Angeles County Museum of Art
Museum of Modern Art, New York City
Philadelphia Museum of Art
San Francisco Museum of Art
Toledo Museum of Art, Ohio
Whitney Museum of American Art,
 New York City

SEASON	75-76	76-77	77-78	78-79	79-80	80-81	81-82	82-83	83-84	84-85
Paintings		1	5	2	3	5	2	1	7	4
Dollars		$13,000	$66,730	$17,500	$140,752	$47,850	$45,000	$70,000	$327,500	$75,810

Record Sale: $130,000, CH, 11/9/79, "Red Painting," 60 × 80 in.

PHILIP GUSTON
(1913-1980)

Philip Guston is known primarily as a major abstract expressionist painter of the 1950s and 1960s. He gained increased stature in the last decade of his life, when he combined expressionistic style on a large scale with a new interest in representational subject matter.

Some of his work reflects subtle social and political comment. It incorporates a number of stylistic influences ranging from the Renaissance masters to California surrealism to Mexican art.

Guston was born in Montreal, Canada in 1913 to Russian-immigrant parents. The family moved to Los Angeles in 1919, and in 1927 Guston became friendly with Jackson Pollock in high school. A year later, the two were expelled for circulating a satirical pamphlet. Guston supported himself as a movie extra while continuing to study and paint on his own.

In 1930, Guston attended the Otis Art Institute in Los Angeles for three months. He met and was influenced by Reuben Kadish and Lorser Feitelson; he also attended meetings of the John Reed Club. Impressed by David Alfaro Sisqueiros's controversial murals, Guston, Kadish and others created fresco mural panels on the theme of the American Negro; Guston's panel depicted a Ku Klux Klansman whipping a bound black man. The panels were destroyed by outraged local authorities.

Guston and Kadish traveled to Mexico in 1834 and painted a mural, *The Struggle Against War and Fascism,* in the former imperial summer palace. Guston went on to paint murals for the WPA Federal Art Project from 1935 through 1942.

During the 1930s, he also worked on easel paintings, including *Bombardment* (1937-1938, location unknown), a powerful statement about the Spanish Civil War. His first solo exhibition was held in 1945, and that year he also took first prize in the Carnegie Institute annual exhibition. After traveling in Europe, he settled in New York City in 1950.

At this point, Guston turned from figurative painting to abstract expressionism, or action painting. His significant 1953 exhibition featured a series of "white" paintings, which combined Mondrian-like construction with impressionistic color and brushstrokes.

Over the next two decades, his abstract paintings increased in size as narrative images were replaced by disembodied, heavily-textured areas of color, like those of *Dial* (1956, Whitney Museum of American Art). Grays and blacks became dominant during the 1960s, as in *Close-up III* (1961, Metropolitan Museum of Art).

A surprising change of style and content appeared in Guston's 1970 exhibition. The artist returned to literal subjects, painting squalid urban scenes and menacing gangster-like figures in a deliberately awkward style. These later works combine Guston's early interest in social themes with the abstract expressionist's concern for shape and color.

Guston taught at a number of schools, including Yale and Columbia Universities. From 1973 until his death in 1980, he was a member of the Boston University faculty and an influential figure in the Boston art community.

Painting No. 6, 1951, 32 x 46 in., signed l.l. Courtesy of National Museum of American Art, Smithsonian Institution, Museum Purchase.

PUBLIC COLLECTIONS
Allentown Art Museum, Pennsylvania
Art Institute of Chicago
Baltimore Museum of Art
Cleveland Museum of Art
Detroit Institute of Arts
Los Angeles County Museum of Art
Metropolitan Museum of Art, New York City
Museum of Modern Art, New York City
National Museum of American Art, Washington, D.C.
Phillips Collection, Washington, D.C.
Solomon R. Guggenheim Museum, New York City
St. Louis Art Museum
Whitney Museum of American Art,
 New York City

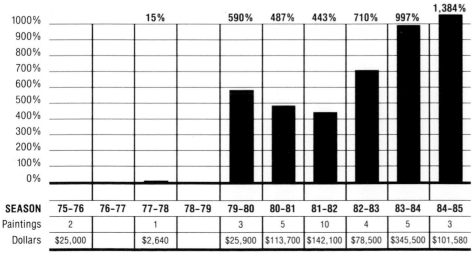

10-Year Average Change From Base Years '75-'76: 578%

| | 15% | | 590% | 487% | 443% | 710% | 997% | 1,384% |

SEASON	75-76	76-77	77-78	78-79	79-80	80-81	81-82	82-83	83-84	84-85
Paintings	2		1		3	5	10	4	5	3
Dollars	$25,000		$2,640		$25,900	$113,700	$142,100	$78,500	$345,500	$101,580

Record Sale: $220,000, CH, 5/8/84, "No. 10, 1952," 51 × 48 in.

ROMARE BEARDEN
(1914-)

Romare Bearden, painter and collage maker, fills his works with the symbols and myths of the American black experience.

Bearden was born in Charlotte, North Carolina in 1914. Soon after his birth, his family moved to New York City's Harlem. During the mid-1930s, when Bearden was a student of George Grosz at the Art Students League, he founded the "306 Group" for black artists living in Harlem.

After he served in the army during World War II, Bearden's work appeared in several well-publicized shows. During the 1940s, he combined African symbols, such as masks and "conjur women" with stylized realism. In 1950, he went to Paris and enrolled at the Sorbonne. In Paris he met James Baldwin, Constantin Brancusi and George Braeque, all of whom influenced his work. He returned to New York City in 1954.

After his stay in Paris, Bearden's work became more abstract. He used oil paint almost as if it were watercolor, layering washes of indistinct shape over thickened bars of woven colors. Shapes seem to float on the surface, in part because of their softened, muted tones.

Bearden was profoundly influenced by the civil rights movement of the 1960s. During this period he used collage to express the rhythms of black music. Symbolic masks and faces float in interiors and landscapes.

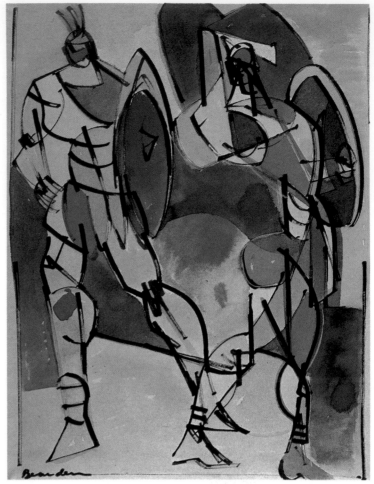

Warriors at a City Gate, 1947, 24 x 18 in., signed l.l. Courtesy of Raydon Gallery, New York, New York.

In 1963, Bearden began work on the "Prevalence of Ritual" series. *Prevalence of Ritual: Tidings* (1973, North Carolina National Bank Corporation), a collage of cut and torn paper with poly-

mer paint, is typical of the way he mingles abstract shapes and landscapes to evoke his memories of the customs and ceremonies of the black south.

Throughout his career, Bearden has promoted opportunities for black artists. He has served as art director of the Harlem Cultural Council, and helped organize the Cinque Gallery. In 1969, he wrote *The Painter's Mind* with Carl Holty.

MEMBERSHIPS
National Institute of Arts and Letters
New York State Council on the Arts

PUBLIC COLLECTIONS
Akron Art Institute, Ohio
Albright-Knox Art Gallery, Buffalo, New York
Brooklyn Museum
Flint Institute of Arts, Michigan
Metropolitan Museum of Art, New York City
Museum of Fine Arts, Boston
Museum of Modern Art, New York City
Philadelphia Museum of Art
St. Louis Art Museum
Whitney Museum of American Art,
 New York City

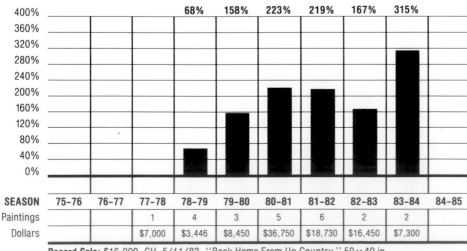

10-Year Average Change From Base Years '77-'78: 164%

			68%	158%	223%	219%	167%	315%	

SEASON	75-76	76-77	77-78	78-79	79-80	80-81	81-82	82-83	83-84	84-85
Paintings			1	4	3	5	6	2	2	
Dollars			$7,000	$3,446	$8,450	$36,750	$18,730	$16,450	$7,300	

Record Sale: $16,000, CH, 5/11/83, "Back Home From Up Country," 50 × 40 in.

WALTER STUEMPFIG

(1914-1970)

Walter Stuempfig was knowledgeable in literature and music as well as art, and was highly esteemed as a teacher, critic and painter. His work, never allied with any artistic movement, made him known as a romantic realist and an important contributor to American art.

Born in the Germantown section of Philadelphia in 1914, Stuempfig graduated from the Germantown Academy in 1930. He spent a year at the University of Pennsylvania studying architecture. During this period, he decided to make art his life's work, enrolling in the Pennsylvania Academy of the Fine Arts in 1931 and earning a Cresson Scholarship for foreign travel in 1933.

In 1949, Stuempfig joined the faculty at the Pennsylvania Academy of the Fine Arts, where he would remain as a teacher and critic, respected by students and peers, for the rest of his life.

Stuempfig's popularity as a painter was based on his landscapes of the Philadelphia area and the New Jersey shore. Often thought of as a twentieth-century Thomas Eakins, he had the ability to combine the old with the new on canvas, without surrendering to modern trends. Stuempfig was not at all interested in the abstract.

A well-traveled man, Stuempfig often visited Europe, his favorite haunts being Italian cities such as Milan and Naples. Upon his return from these travels, he would impart to his students all he had learned from viewing the past. He believed it was important to observe all aspects of history, while keeping one's own art and identity intact. Eakins, Degas and Caravaggio were his heroes.

At his death in 1970, Stuempfig left a prolific output, more than 1,500 works.

Norristown, 30 x 25 in. Courtesy of Newman Galleries, Philadelphia, Pennsylvania.

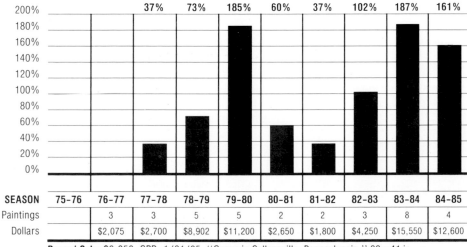

10-Year Average Change From Base Years '76-'77: 94%

SEASON	75-76	76-77	77-78	78-79	79-80	80-81	81-82	82-83	83-84	84-85
		37%	73%	185%	60%	37%	102%	187%	161%	
Paintings		3	3	5	5	2	2	3	8	4
Dollars		$2,075	$2,700	$8,902	$11,200	$2,650	$1,800	$4,250	$15,550	$12,600

Record Sale: $6,250, SPB, 1/31/85, "Scene in Collegeville, Pennsylvania," 23 × 41 in.

MEMBERSHIPS
Century Association
National Academy of Design
National Institute of Arts and Letters

PUBLIC COLLECTIONS
Art Institute of Chicago
Corcoran Gallery of Art, Washington, D.C.
Metropolitan Museum of Art, New York City
Museum of Modern Art, New York City
Philadelphia Museum of Art
Whitney Museum of American Art,
 New York City

JACK LEVINE
(1915-)

Painter Jack Levine is a social satirist who has chosen to remain independent of schools and movements. His well-populated canvases, unmistakable for their translucent, dappled appearance and distortion of human form, are meant to reveal the evils of insincerity, triviality, corruption and hypocrisy.

Levine was born in 1915 to Lithuanian parents in the South End of Boston. As Levine liked to point out, living in the slums was strangely congenial: "It was rough, but it wasn't rough on me. . . . I would see drunks getting arrested—that sort of thing. The life of the streets. No objection to it. Life was interesting."

In 1923, when the family moved to suburban Roxbury, Massachusetts, Levine felt out of place. But he soon familiarized himself with the Boston Museum of Fine Arts, and took classes with Harold Zimmerman. In 1929 he met Harvard professor Denman Ross, who noticed his work and introduced him to the paintings of Titian, Rembrandt, Daumier and Degas. In this way, Levine gained a thorough knowledge of color and technique.

In 1935, during the Depression, Levine was one of the youngest artists working on the Massachusetts WPA Federal Arts Project. His first paintings were protest pictures in a style reminiscent of Rouault and Soutine.

One of his best-known works, *The Feast of Pure Reason* (1937, Museum of

Trio at Copley Plaza, 20 x 27½ in., signed l.l. Courtesy of Vose Galleries of Boston, Inc., Massachusetts.

Modern Art), was done when the artist was only 22. It is a savage attack. Stereotypical crooked characters—cop, banker and ward boss—are pictured in Depression-era connivance. The title phrase was used by eighteenth-century poet Alexander Pope and later by writer James Joyce to warn against the abuse of power in high places.

This painting and *Gangster's Funeral*

(1953, Whitney Museum of American Art) can serve as bellwethers of Levine's changes of attitude toward his own work. Fifteen years after he painted *Feast,* he said it was the work "most like me." But more recently he has said that it was "fired out of one barrel, and based on the bitter assumptions of a boy of 22."

Gangster's Funeral, in which politicians and the police pay tribute around a mobster's coffin while light shines down on them through colored panes of stained glass, verges on caricature rather than indignation.

MEMBERSHIPS
American Academy of Arts and Letters
Artists Equity Association
National Institute of Arts and Letters

PUBLIC COLLECTIONS
Art Institute of Chicago
Brooklyn Museum
Harvard University
Metropolitan Museum of Art, New York City
Museum of Fine Arts, Boston
Museum of Modern Art, New York City
Phillips Academy, Andover, Massachusetts
State University of Iowa, Iowa City
Walker Art Center, Minneapolis, Minnesota
Whitney Museum of American Art, New York City

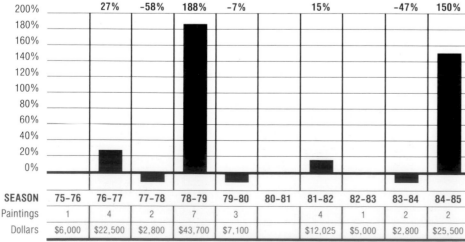

10-Year Average Change From Base Years '75-'76: 30%

	27%	-58%	188%	-7%		15%		-47%	150%	
SEASON	75-76	76-77	77-78	78-79	79-80	80-81	81-82	82-83	83-84	84-85
Paintings	1	4	2	7	3		4	1	2	2
Dollars	$6,000	$22,500	$2,800	$43,700	$7,100		$12,025	$5,000	$2,800	$25,500

Record Sale: $17,500, SPB, 12/6/84, "Spring Quartet," 20 x 27 in.

ROBERT MOTHERWELL
(1915-)

A leading exponent of American abstract expressionism, Robert Motherwell has served as a vital spokesman for the avant-garde of the mid-twentieth century. He introduced the term "abstract expressionism" into the United States, and helped crystallize the direction of the new movement with his painting and writing.

An abstractionist from the beginning of his career, Motherwell worked primarily in the medium of collages. His best-known works—more than 100 canvases, including monumental oil paintings and small drawings—are represented under the series title "Elegies to the Spanish Republic."

Born in Aberdeen, Washington, Motherwell studied at the Otis Institute and the California School of Fine Arts, before moving permanently to the East coast as a young man. He studied philosophy at Harvard and art history at Columbia, deciding at age 26 to become a painter. In 1942, following a trip to Mexico, he settled in New York City to begin professional painting.

Deeply influenced by the modernist European painters who gathered in New York during World War II, particularly Chilean surrealist Matta Echaurren, Motherwell began experimenting with surrealism and automatism, evolving his own unique style. With a technique he called "plastic automatism," Motherwell created images and collages by free association, on which he imposed a later formal composition. His early work, architecturally structured, is reminiscent of Mondrian; later productions were done with freer brushwork.

In the course of a long and prolific career, Motherwell tried his hand at a wide variety of styles, including drip-and-spatter expressionism and color-field combinations. But, for the most part, his abstractionism remains carefully structured, with a tendency toward geometric images. The "elegies" theme, done almost exclusively in black and white, has black ovoid shapes suspended between vertical panels.

Motherwell found his medium in 1943 when noted art patron Peggy Guggenheim asked three American artists, including Motherwell, to contribute to the first all-collage show held in this country. Motherwell set to work with paper, scissors and paste, an experience that galvanized him to adopt collage as his continuing mode of expression. One year later, he held his first one-man show at the Art of This Century Gallery. Since then, he has been included in every major exhibition of American abstract art.

Black in Hiding, 1976, 72 x 24 in., signed u.l. Courtesy of The Pennsylvania Academy of the Fine Arts, Philadelphia. ©Motherwell/VAGA, New York 1985.

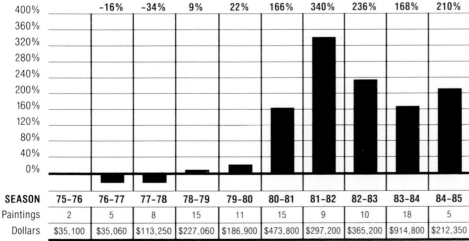

10-Year Average Change From Base Years '75-'76: 110%

	75-76	76-77	77-78	78-79	79-80	80-81	81-82	82-83	83-84	84-85
%		-16%	-34%	9%	22%	166%	340%	236%	168%	210%
SEASON	75-76	76-77	77-78	78-79	79-80	80-81	81-82	82-83	83-84	84-85
Paintings	2	5	8	15	11	15	9	10	18	5
Dollars	$35,100	$35,060	$113,250	$227,060	$186,900	$473,800	$297,200	$365,200	$914,800	$212,350

Record Sale: $210,000, SPB, 11/9/83, "Wall Painting," 54 x 72 in.

PUBLIC COLLECTIONS
Art Institute of Chicago
Baltimore Museum of Art
Cleveland Museum of Art
Metropolitan Museum of Art, New York City
Museum of Fine Arts, Boston
Whitney Museum of American Art,
 New York City

ALFONSO OSSORIO

(1916-)

Alfonso Ossorio began his artistic career as a painter influenced by both the surrealist and abstract expressionist schools; he later moved from painting to sculpture, and the bulk of his mature work consists of large sculptural assemblages which he calls "congregations." He has also exhibited watercolors dating from the late 1970s.

Ossorio was born in 1916 in Manila, on the island of Luzon in the Philippines. The son of a wealthy sugar planter, he was educated in England and in the United States, where he studied at Harvard and the Rhode Island School of Design. He became an American citizen in 1939.

During the 1940s, Ossorio's paintings reflected his interest in Salvador Dali and Pablo Picasso. Early works, such as *Red Star* (date and location unknown), display morbid and violent imagery, perhaps inspired by Ossorio's wartime service in the medical corps and his own poor health.

In 1949, Ossorio met Jean Dubuffet, who was to be a major influence on his work. Dubuffet introduced Ossorio to l'art brut, the so-called "raw art" created by non-professional artists: children, criminals, primitive tribespeople. Ossorio adopted their spatial distortions and naive drawing style. He was also influenced by the drip-paintings of his friend Jackson Pollock, whose spontaneity he admired.

Poem: Elegy: Sunt Lacrimae Rerum, 1982, 96 x 48 in. Courtesy of Oscarsson Hood Gallery, New York City, New York.

Ossorio returned to the Philippines in 1950 to paint a large mural for the interior of the Church of St. Joseph there. He was at that time absorbed in the study of Christian iconography and liturgy, and religious imagery has continued to figure in his work.

In 1951, Ossorio bought "The Creeks," a Long Island estate once owned by artist Alfred Herter. He has devoted much of his energy since then to developing a botanical and sculpture garden on the estate and to furnishing it with his own collages and sculptures.

Ossorio's work at "The Creeks" for the most part follows the style of the large assemblages he began creating in the late 1950s. Such works as *Circled Head* (1963, location unknown), *Siblings* (1972, location unknown) and *Contains* (1982, location unknown) feature juxtapositions of skeletons, broken glass, toys, art objects and glass eyes. Although they have been grouped with other "junk art" pieces, Ossorio calls them "congregations," emphasizing their thematic rather than random interconnections.

Ossorio has continued to exhibit his congregations as well as recent watercolors.

PUBLIC COLLECTIONS
Metropolitan Museum of Art, New York City
Museum of Modern Art, New York City
New York University
Philadelphia Museum of Art
Rose Art Museum, Waltham, Massachusetts
Wadsworth Atheneum, Hartford, Connecticut
Whitney Museum of American Art,
 New York City
Yale University Art Gallery, New Haven,
 Connecticut

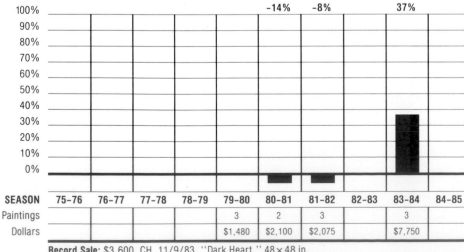

10-Year Average Change From Base Years '79-'80: 4%

					-14%	-8%		37%	

SEASON	75-76	76-77	77-78	78-79	79-80	80-81	81-82	82-83	83-84	84-85
Paintings					3	2	3		3	
Dollars					$1,480	$2,100	$2,075		$7,750	

Record Sale: $3,600, CH, 11/9/83, "Dark Heart," 48 x 48 in.

RICHARD POUSETTE-DART
(1916-)

Cavernous Earth with 27 Folds of Opaqueness, 1961-1964, 79½ x 115 in. Courtesy of Hirshhorn Museum and Sculpture Garden, Smithsonian Institution, Washington, D.C.

An accomplished nonobjective painter, Richard Pousette-Dart has been compared to such renowned abstract artists as Mark Tobey and Jackson Pollock. His early work incorporated elements of cubist spatial definition. As his painting matured, his work became increasingly abstract and expressionistic.

Born in St. Paul, Minnesota in 1916, Pousette-Dart spent his early years in Valhalla, New York. Although he had no formal art training, he did learn much from his father, an artist and writer. By age 20, he was a serious artist, and in 1938 he moved to New York City to pursue his career. His earliest works combine cubist spaces with surrealist imagery, primitive hieroglyphs, and decorative signs and symbols.

Throughout the 1940s and 1950s, he had numerous one-man shows. During this period, he developed his private symbolism in a series of large-scale paintings. These works are characterized by thick encrusted surfaces, structured by small, jewel-like forms set against a web of thin lines. A typical example is *Number 11: A Presence* (1949, Museum of Modern Art). The overtones of totem and ritual have been likened to Jackson Pollock's early work.

Throughout the 1950s, the forms in Pousette-Dart's paintings became less identifiable. In *In the Forrest* (1957, Albright-Knox Art Gallery), the thick surface overwhelms the various biomorphic shapes and enframing linear web. By 1960, form had largely dematerialized into a continuous sheath of texture and disembodied color. In these later works, one typically finds many layers of thinly-washed color, troweled areas of heavily built-up pigment, and subtly interwoven colors that alternately conceal and reveal form.

Pousette-Dart's over-worked surfaces emphasize the process of creation rather than the resultant artifact, and illustrate the artist's belief that art is a means of self-discovery rather than self-expression. In many of his mature works, he achieved effects of sensuous beauty; in others, there is a sense of violent agitation.

Richard Pousette-Dart has been widely exhibited in the United States and abroad; his works have been included in Documenta 11, Kassel, Germany (1959) and the San Paolo Biennial (1961). He has taught at the School of Visual Arts in New York City, Columbia University and Sarah Lawrence College.

PUBLIC COLLECTIONS
Addison Gallery of American Art,
 Andover, Massachusetts
Albright-Knox Art Gallery,
 Buffalo, New York
Museum of Modern Art, New York City
National Museum of American Art, Washington, D.C.
Whitney Museum of American Art,
 New York City

SEASON	75-76	76-77	77-78	78-79	79-80	80-81	81-82	82-83	83-84	84-85
Paintings	1				1	1	6	1	3	
Dollars	$8,000				$900	$46,000	$61,450	$8,000	$45,700	

Record Sale: $46,000, CH, 5/13/81, ''No. I 1951,'' 42 × 85 in.

ROBERT GOODNOUGH
(1917-)

Blue Expansion, 1975-1976, 72⅛ x 131⅞ in. Courtesy of Hirshhorn Museum and Sculpture Garden, Smithsonian Institution, Washington, D.C.

Since the mid-1950s, painter Robert Goodnough's work has moved through several phases of contemporary art to a concentration on pure abstraction.

Born in 1917 in Cortland, New York, Goodnough began art training at Syracuse University, drawing from life and studio casts and painting portraits. In 1946 and 1947, he studied in New York City with French painter Amedee Ozenfant and abstract expressionist Hans Hofmann.

Goodnough soon became interested in Pablo Picasso's cubism and, a bit later, the abstractions of Dutch painter Piet Mondrian. Although he produced paintings in a combination of the cubist and abstract expressionist styles during the 1950s, he resisted purist rigidities and the contemporary trend towards abstract expressionism.

Goodnough's one-man show was held in 1953. That year he also began to make collages. In 1954, he started to sculpt constructions of human figures, birds and dinosaurs.

Until the late 1950s, Goodnough generally started a painting with an object or figure. In many, he abstracted it into a shape receding into its field. The resulting tension between the altered "real" object and its echo, between surface and depth, projects a sense of energy. In the late 1950s, he produced some large, firm-edged, "cut-out" forms.

In the 1960s, his "Bird Series" contains clear references to figures, but Goodnough also turned to the mural-sized canvases of complete abstraction that became typical of his work from the 1970s onward. These canvases feature flocks of geometric shapes drifting across great expanses of light color. Critics have praised Goodnough's acute color sense and described his later works as elegant.

The artist taught at Cornell and New York Universities and the Fieldston School, New York City. He was a critic for *Art News Magazine* from 1950 to 1957. He lives in New York City.

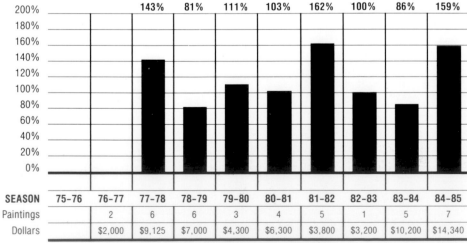

10-Year Average Change From Base Years '76-'77: 105%

SEASON	75-76	76-77	77-78	78-79	79-80	80-81	81-82	82-83	83-84	84-85
			143%	81%	111%	103%	162%	100%	86%	159%
Paintings		2	6	6	3	4	5	1	5	7
Dollars		$2,000	$9,125	$7,000	$4,300	$6,300	$3,800	$3,200	$10,200	$14,340

Record Sale: $3,500, PB, 3/30/78, ''The Frontiersman,'' 68 × 60 in.

JACOB LAWRENCE

(1917-)

Jacob Lawrence's work combines realism with abstract decorative design and deals primarily with the black experience in America. In narrative series of paintings, he has highlighted the lives of outstanding blacks and chronicled contemporary black history.

Lawrence paints in tempera on composition board, using highly-stylized figures, vivid primary colors and sharp contrasts. While still in his twenties, he was the first black artist to be honored with a one-man show at the Museum of Modern Art in New York City.

Lawrence was born in Atlantic City, New Jersey in 1917, and spent his infancy in Easton, Pennsylvania. When he was three, his mother took him to live in Harlem, then an active center for the arts.

The young Lawrence began studying art at an early age, first in after-school programs and later at the Harlem Art Workshop. For much of this time black artist Charles Alston was his mentor. In 1937, Lawrence received a scholarship to the American Artists School; the next year, when he turned 21, he was accepted as a painter in the WPA Federal Art Project.

Through the late 1930s and early 1940s, Lawrence completed carefully-researched series of paintings on the lives of Toussaint L'Ouverture, Frederick Douglas and Harriet Tubman. He followed these with paintings that traced the Northward migration of blacks after the Civil War and depicted events in Harlem.

During World War II, he served in the Coast Guard. Afterward, he painted still another series, this one based on wartime experiences.

The civil rights movement and the desegregation of the South during the late 1950s and 1960s provided Lawrence with themes for later paintings. At the same time, he undertook the first of many teaching assignments.

The Migration of the Negro, Panel 1: During the World War There was a Great Migration North by Southern Negroes, 1940-1941, 11½ x 17½ in. Courtesy of The Phillips Collection, Washington, D.C.

Even Lawrence's mature paintings have retained an almost childlike simplicity. This, combined with his ability to capture expressive human gestures, gives his work a subdued strength.

A trip to Nigeria in 1964 provided him with material that, for the first time, did not deal with the American black. In recent years Lawrence's paintings have dealt less with social commentary, and his more purely decorative side has come to the fore.

MEMBERSHIPS
National Academy of Design
National Institute of Arts and Letters

PUBLIC COLLECTIONS
Baltimore Museum of Art
Hirshhorn Museum and Sculpture Garden, Washington, D.C.
Metropolitan Museum of Art, New York City
Milwaukee Art Center, Wisconsin
Museu de Arte Moderna, Sao Paulo, Brazil
Museum of Fine Arts, Boston
Museum of Modern Art, New York City
Phillips Collection, Washington, D.C.
Virginia Museum of Fine Arts, Richmond
Whitney Museum of American Art, New York City

SEASON	75-76	76-77	77-78	78-79	79-80	80-81	81-82	82-83	83-84	84-85
Paintings				1		1	4	1	2	
Dollars				$7,000		$13,000	$29,800	$1,000	$4,350	

Record Sale: $18,000, SPB, 6/4/82, "The Brown Angel," 24 × 20 in.

ANDREW NEWELL WYETH
(1917-)

Andrew Wyeth is generally credited with two major distinctions: He is the most popular of all American artists, and his haunting painting *Christina's World* (1948, Museum of Modern Art) is probably the best-known work by an American artist of the twentieth century.

Wyeth was born in Chadds Ford, Pennsylvania in 1917—the youngest of five children of well-known artist and illustrator Newell Convers Wyeth. Frail as a child, Wyeth was educated at home rather than at school. In addition to conventional studies, the boy received early art training from his father, who stressed anatomy, traditional artistic tone and balance and visual acuity.

When Wyeth was seven, New Mexico artist Peter Hurd came to Chadds Ford to study for two years with Wyeth's father. It was he who taught the young Wyeth the exacting egg tempera technique which Wyeth would use in his mature works. Another profound influence occurred when Wyeth, at age 16, saw the paintings of Winslow Homer for the first time. Although Wyeth's early style was distinctive, Homer's influence can be seen in his choice of subject matter and overall tone.

At age 20, Wyeth had his first one-man exhibition at New York City's Macbeth Gallery. He showed watercolors inspired by family summers in Maine.

Young America. Courtesy of The Pennsylvania Academy of the Fine Arts, Philadelphia.

Within 24 hours, the show was a complete sellout.

Wyeth's subsequent paintings reflect a marked shift in tonality—a seriousness enhanced by the death of his father in 1945. After his show, Wyeth continued to work for a while with watercolor, then turned exclusively to tempera. His style shifted from the painterly to a mode that was sometimes symbolic, and almost always precise and linear.

Wyeth often uses muted colors in his work. Ambers, browns and greens so dark they appear nearly black—all add a somber tone to even sunlit scenes.

For his subjects, Wyeth draws on his two principal environs—his home in rural Chadds Ford and his summer residence in Maine. The people he portrays are often poor, sometimes elderly or infirm; even in his genre paintings, battered or isolated objects are set in muted context.

At times, Wyeth's paintings can seem outwardly symbolic, as in *A Crow Flew By* (1950, Metropolitan Museum of Art). Here, a black man in tattered garb is the subject, with a crow (symbol of death) flying nearby. Like many of his other works, this is rendered from a precarious visual angle, lending foreboding to the mood of the painting.

Wyeth's overall artistic style defies ready characterization. Some art critics have called him a "magic realist," and Wyeth himself has said that he's more than a simple realist: "If you can combine realism and abstraction, you've got something terrific."

Wyeth was the first artist to appear on the cover of *Time* magazine.

MEMBERSHIPS
American Academy of Arts and Letters
Audubon Artists
National Academy of Design
National Institute of Arts and Letters

PUBLIC COLLECTIONS
Art Institute of Chicago
California Palace of the Legion of
 Honor, San Francisco
Dallas Museum of Fine Arts
Museum of Fine Arts, Boston
Museum of Fine Arts, Houston
Museum of Modern Art, New York City
National Gallery, Washington, D.C.
Philadelphia Museum of Art
Phillips Academy, Andover,
 Massachusetts
The Wadsworth Atheneum, Hartford,
 Connecticut

10-Year Average Change From Base Years '78-'79: 60%

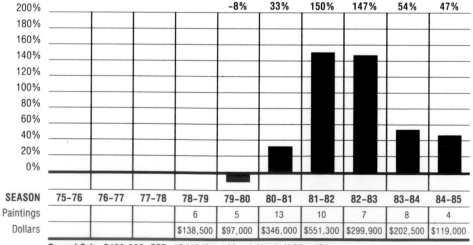

	-8%	33%	150%	147%	54%	47%

SEASON	75-76	76-77	77-78	78-79	79-80	80-81	81-82	82-83	83-84	84-85
Paintings				6	5	13	10	7	8	4
Dollars				$138,500	$97,000	$346,000	$551,300	$299,900	$202,500	$119,000

Record Sale: $420,000, SPB, 12/10/81, "Marsh Hawk," 30×45 in.

962

STEPHEN GREENE

(1918-)

Stephen Greene is regarded as a highly individual painter whose work, modern in style, explores spirituality through symbols drawn from Christianity and the humanistic tradition of the arts. Many of his canvases appear to illustrate torment, despair, isolation or alienation.

Greene was born in 1918 in New York City. He attended the National Academy School of Fine Arts in 1936 and 1937 and the Art Students League in 1937 and 1938.

The years of early maturity, immediately after World War II, were marked by the rise of existentialism, a philosophy that had great impact on the sensitive young artist. Albert Camus, the celebrated French philosopher, was struggling with an internal tide of utter pessimism. Indeed, the end of the war and the revelation of Naziism's depravity seemed justification for a blanket condemnation of mankind.

Greene's early works reflect this struggle. Like Camus, he used episodes from the life of Christ to illustrate man's guilt. His early religious paintings were inspired by the great Renaissance masters, but conveyed the artist's own vision of the modern human condition. The figures in his 1946 *The Flagellators* were deliberately stylized and coldly modeled. They appear to be hallucinations.

For several years the artist continued in this vein. His paintings were personal interpretation of time-honored conventions and symbols. For instance, the ladder (standard iconography in crucifixion paintings) was used to connote desperate upward striving and rapid descent; the rope was indicative of the serpent in the Garden of Eden; the arch denoted the vaulted heavens; and man himself was shown as a helpless puppet in an endless and futile struggle.

Later, Greene's symbolism grew somewhat more abstract. For example, a crescent-shaped area in *Howl* (1960, private collection) suggests the moon, but does not offer an obvious interpretation.

Eventually, Greene's artistic language changed completely. His figures became freed of their outlines, and were transformed into presences rather than images. By 1957, anatomical outlines had been completely obliterated and Greene's imagery was translated into a language of color. But the climate of anxiety, even terror, remains in his abstractions, just as it ruled his religious paintings.

Edifice, 1965, 68 x 68 in., signed l.l. Courtesy of the Collection of Whitney Museum of American Art. Gift of Mrs. William W. McPeak in memory of William W. McPeak.

SEASON	75-76	76-77	77-78	78-79	79-80	80-81	81-82	82-83	83-84	84-85
Paintings			1			6			1	1
Dollars			$3,000			$7,100			$1,800	$750

Record Sale: $3,000, PB, 11/30/77, "White Color," 46 × 46 in.

WILLIAM COPLEY
(1919-)

William Copley (known professionally as CPLY) is an American-born surrealist with a highly developed sense of humor. His best works are peopled with curvaceous, cartoon-like ladies, sometimes pursued by small Chaplinesque men in derby hats. His theme is sex in its cheeriest, best-humored form.

Copley was born in New York City in 1919. The adopted son of a newspaper tycoon, Copley seemed destined to be a writer but, as he once said, he needed something "more revolutionary."

In 1948, he opened an art gallery in Los Angeles devoted exclusively to the works of refugee artists like Man Ray and Max Ernst. When the gallery failed, Copley bought many of the paintings himself, and moved to Paris. In the meantime, he had begun painting, adopting the improvised, free-associative spirit of his surrealist friends.

A sophisticated modern, Copley finds inspiration in many of the common vagaries of daily American life. Comic strips, Hollywood zanies (Mae West, W.C. Fields and the Marx Brothers appear frequently in his paintings), advertising slogans (he transformed THINK into a solid wall of naked ladies), newspapers (the crossword puzzle), and Robert Service ballads ("The Shooting of Dan McGrew") have all been grist for his mill.

Copley lived in Paris from 1951 until 1964, but since 1964 this quintessentially

Tenderesse, 1969, 26 x 32 in., signed l.l. Philadelphia Museum of Art, Pennsylvania, Given Anonymously.

American artist has made New York City his home. He has been characterized as the "Pop of pop art."

PUBLIC COLLECTIONS
Art Institute of Chicago
Centre Georges Pompidou, Paris
Los Angeles County Museum of Art
Museum of Modern Art, New York City
Nagaoka City Museum, Japan
Philadelphia Museum of Art
Stedelijk Museum, Amsterdam
Tate Gallery, London
Whitney Museum of American Art,
 New York City

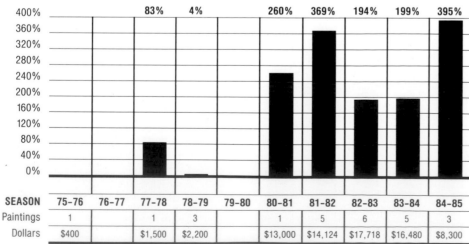

10-Year Average Change From Base Years '75–'76: 188%

	75-76	76-77	77-78	78-79	79-80	80-81	81-82	82-83	83-84	84-85
%			83%	4%		260%	369%	194%	199%	395%
SEASON	75-76	76-77	77-78	78-79	79-80	80-81	81-82	82-83	83-84	84-85
Paintings	1		1	3		1	5	6	5	3
Dollars	$400		$1,500	$2,200		$13,000	$14,124	$17,718	$16,480	$8,300

Record Sale: $13,000, SPB, 10/2/80, "The Last Supper," 89 × 50 in.

964

LESTER JOHNSON
(1919-)

Lester Johnson began his painting career as an abstract expressionist, but in the mid-1950s abandoned that style for a distinctive figurative approach in which he pays homage to the modern everyman. Using a somber, limited palette—often only brown, black and dull blue—and applying his paint thickly, he produces strong, powerful canvases which convey a sense of the isolation of the individual.

Johnson was born in Minneapolis in 1919. He began his studies at the Minneapolis School of Art, then went to the St. Paul School of Art, and finally to the Art Institute of Chicago. He moved to New York City in 1947 and had the first exhibition of his abstract paintings there four years later.

For years, Johnson had a studio in the Bowery so that he could study the despair and hopelessness of the men who lived there, rejected by society. His aim, as his style evolved, was to give them dignity.

"I wanted to prove that man is more than a man—to put him on a pedestal," he explained. "The human and the monumental are contradictory, but I wanted to put them together."

He succeeded developing a monumental sense of the human figure, unlike anything done before. His figures, many of them in hats, wearing nondescript black or brown suits, usually are massed against monochromatic or white backgrounds. They seem to crowd in on one

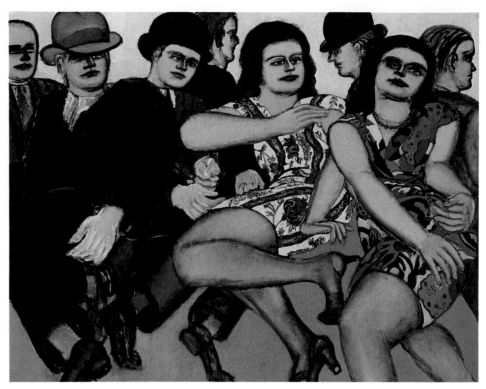

City Women, 1973, 39⅞ x 50 in., signed l.r. Courtesy of National Museum of American Art, Smithsonian Institution, Gift of Mr. and Mrs. David K. Anderson, Martha Jackson Memorial Collection.

another. Heads, hands and sometimes feet loom.

The faces of Johnson's figures are generalized. He makes little effort to contrast one with another. Above all, he makes no comment of his own on their condition.

Drawing plays an important part in Johnson's art. It brings out the image and determines scale. But it is the way he handles paint that gives his work its raw strength. He piles it on, overpaints, scrapes and scores it with his brush handle. There are even occasional vestiges of his abstract phase, in drips of paint he uses to create effects.

Johnson's work is repetitive, however. He uses the same images over and over, changing only the light and the mood.

Over the years Johnson has taught at various schools and universities. Since 1964, he has been director of studies in graduate painting at Yale University.

PUBLIC COLLECTIONS
Albright-Knox Art Gallery, Buffalo, New York
Baltimore Museum of Art
Chrysler Museum of Art, Norfolk, Virginia
Dayton Art Institute, Ohio
Museum of Modern Art, New York City
National Museum of American Art, Washington, D.C.
Philbrook Art Center, Tulsa
Phoenix Art Museum, Arizona
Wadsworth Athenaeum, Hartford, Connecticut
Walker Art Center, Minneapolis

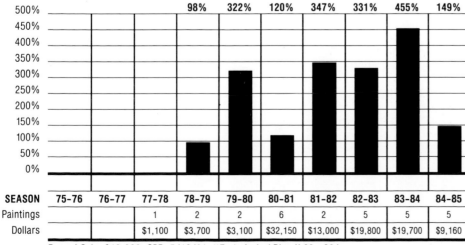

10-Year Average Change From Base Years '77-'78: 228%

				98%	322%	120%	347%	331%	455%	149%
SEASON	75-76	76-77	77-78	78-79	79-80	80-81	81-82	82-83	83-84	84-85
Paintings			1	2	2	6	2	5	5	5
Dollars			$1,100	$3,700	$3,100	$32,150	$13,000	$19,800	$19,700	$9,160

Record Sale: $13,000, SPB, 5/12/81, "Early Arrival Blue," 80 x 90 in.

NORMAN BLUHM
(1920-)

Thamyris, 1972, 81¼ x 114⅜ in. Courtesy of National Museum of American Art, Smithsonian Institution, Gift of Mr. and Mrs. David K. Anderson, Martha Jackson Memorial Collection.

Norman Bluhm is one of a group of painters who form the second generation of abstract expressionists, continuing in the mode of action painting pioneered by Jackson Pollock and others. His works are noted for their density, energy, and abstract shapes which evoke the human figure.

Bluhm was born in Chicago in 1920 and lived in Italy for eight years as a child. He trained as an architect, studying with Mies van der Rohe at the Illinois Institute of Technology before and after his service in the Air Force in World War II.

He also studied briefly in Florence before moving in 1947 to Paris, where he lived until 1956. There he studied at the Ecole des Beaux Arts, became friendly with leading French painters, and acted in Jean Cocteau's film *Orphee.* While working in Paris, Bluhm developed an interest in painting the nude, which was to be a continuing theme in his canvases.

He returned to the United States in 1956, setting up a studio in New York City, and continued to paint. At this time he became friendly with poet Frank O'Hara, with whom he collaborated in 1960 on a spontaneous collection of 26 poem-paintings, now owned by New York University.

Bluhm's first American museum show was held in 1969, at the Corcoran Gallery in Washington, D.C. Such paintings as *The White Sheik, Santa Fe,* and *Brizo* (dates and locations unknown) demonstrated his allegiance to the earlier generation of abstract expressionists. At the same time, his use of rich color and space to create an impression of movement was recognized.

"A painting should generate energy from within and without," Bluhm said at the time. "The viewer should be able to feel the impact of its forces on the paint, and surrounding ceiling, walls, and floor."

During the 1970s, Bluhm's work turned from angular, sometimes violent, shapes to dense, sensual forms suggestive of nudes, often using such colors as pink, purple, blue and green. Typical of his more recent work are *Bar Room Lil* (1975, location unknown) and *Salome* (date and location unknown). He has exhibited widely in Europe and the United States and lives in Milbrook, New York.

PUBLIC COLLECTIONS

Albright-Knox Art Gallery, Buffalo
Baltimore Museum of Art
Corcoran Gallery of Art, Washington, D.C.
Dallas Museum of Fine Arts
Dayton Art Institute, Ohio
High Museum of Art, Atlanta
Hirshhorn Museum and Sculpture Garden, Washington, D.C.
Massachusetts Institute of Technology
Metropolitan Museum of Art, New York City
Museum of Modern Art, New York City
National Gallery of Victoria, Melbourne, Australia
National Museum of American Art, Washington, D.C.
Nelson-Atkins Museum of Art, Kansas City, Missouri
Phillips Collection, Washington, D.C.
Phoenix Art Museum
Whitney Museum of American Art, New York City

SEASON	75-76	76-77	77-78	78-79	79-80	80-81	81-82	82-83	83-84	84-85
Paintings						10	8	2	1	1
Dollars						$38,450	$8,340	$2,300	$5,000	$6,500

Record Sale: $9,000, SPB, 11/13/80, "Emergency," 72 × 60 in.

JOHN
KACERE
(1920-)

Kelly (red), 40 x 62 in. Courtesy of O.K. Harris Works of Art, New York, New York.

John Kacere was an abstract painter from 1950 to 1963, but moved to a realistic style; he has been considered a photo-realist or hyper-realist, although he has not adopted the methodology of these schools. Since 1963, he has concentrated on the subject of woman.

Kacere was born in 1920 in Walker, Iowa. He showed artistic ability as a child and did his first professional sign-painting job at age 12. Attending art school in Chicago from 1938 through 1940, he studied commercial art at first. Exposure to fine art at the Art Institute of Chicago and other museums, however, inspired Kacere to shift the direction of his own work to the fine arts.

At first, Kacere was especially interested in the work of Van Gogh, Degas and Toulouse-Lautrec. He also cites Holbein and Ingres as favorite artists.

Before he entered the army, Kacere held his first one-man show in Cedar Rapids, Iowa. Stationed in California during the war years, he began to study the work of the European moderns: Picasso, Miro, Klee and Matisse. Upon leaving the army, Kacere studied fine arts at the University of Iowa.

He began his teaching career in 1950 at the University of Manitoba in Winnipeg, Canada. Since then he has taught at the University of Florida, Arizona State University, the Rhode Island School of Design, New York University, the University of New Mexico, and Cooper Union and the Parsons School of Design in New York City.

Kacere does not consider himself a photo-realist, although his highly detailed work is sometimes called photo- or hyper-realistic. Unlike the photo-realist painters, who work from detail to detail of their canvases, Kacere works on all areas of the canvas at the same time and builds up layers of paint.

Despite criticism from feminists, some of whom have labeled his work sexist, Kacere has continued to specialize in paintings of the female body since 1963. "Woman is the source of all life, the source of regeneration," he has said. "My work praises that aspect of womanhood."

Kacere has had many one man shows in New York City. He has also shown in Paris and Hamburg, and his work has been enthusiastically received in Europe. It is held in private collections worldwide.

(No sales information available.)

PUBLIC COLLECTIONS
J.B. Speed Museum, Louisville, Kentucky
Portland Art Museum, Oregon
Stedeljik Museum, Amsterdam
Wadsworth Atheneum, Hartford, Connecticut

WAYNE THIEBAUD
(1920-)

French Pastries, 1963, 16 x 24 in., signed l.l. Courtesy of Hirshhorn Museum and Sculpture Garden, Smithsonian Institution, Washington, D.C.

Wayne Thiebaud, an artist often associated with the pop movement of the 1950s and 1960s, was born in Mesa, Arizona in 1920. Thiebaud grew up in Long Beach, California, where he developed an interest in theater design. His association with the stage would prove influential in his approach to art.

Until the mid-1950s, Thiebaud was active in some phase of the theater, as a student, independently, and as a teacher at Sacramento City College. He became involved with elaborate set designs for corporate, as well as theatrical, sponsors.

Thiebaud's decision to pursue art as a career came after a stint with Universal Studios following World War II. He joined the Rexall Drug Company as a layout artist. There he met Robert Mallory, who inspired him to become an artist.

By the early 1950s, Thiebaud was using an abstract expressionist style to portray common objects like gumball machines; hence the link to pop art. As his career matured, however, his still lifes took on a more realistic, simplified nature.

Concentrating on everyday objects like soup cans, pies and cakes, Thiebaud utilized oils of a thick texture. It was the process of painting, not the subject matter, that interested him. In a carryover from his theater days, he felt that all painting presented a problem of light and space.

By the end of the 1960s, Thiebaud turned from still lifes to figures. With an uncluttered, straightforward approach borrowed once more from the theater, he experimented with color and light, often producing harsh, sparkling illumination.

In 1973, Thiebaud's career took yet another direction. Influenced by Richard Diebenkorn's landscapes, he created his own portraits of San Fran-cisco. While his still lifes were done from memory and his figures from direct observation, his landscapes were a combination of the two methods.

Thiebaud utilized on-site sketches to create a series of panoramas. In the studio, he integrated the sketches into a finished product. Free from the constraints of exact representation, Thiebaud was able to create an entirely new environment on canvas, similar to the style of Edward Hopper.

PUBLIC COLLECTIONS
Albright-Knox Art Gallery, Buffalo, New York
Art Institute of Chicago
Corcoran Gallery of Art, Washington, D.C.
Metropolitan Museum of Art, New York City
Museum of Fine Arts, Dallas
Museum of Fine Arts, Houston
Museum of Modern Art, New York City
Newark Museum, New Jersey
Oakland Art Museum, California
Philadelphia Museum of Art
San Francisco Museum of Art
Wadsworth Atheneum, Hartford, Connecticut
Whitney Museum of American Art,
 New York City

SEASON	75-76	76-77	77-78	78-79	79-80	80-81	81-82	82-83	83-84	84-85
Paintings			1		1	2	4	2	11	4
Dollars			$7,500		$21,000	$167,500	$120,500	$112,000	$121,200	$55,800

Record Sale: $130,000, CH, 5/13/81, ''Four Pinball Machines,'' 68 × 72 in.

GEORGE TOOKER

(1920-)

Bleak urban environments and the isolation of people trapped within them are dominant themes in the paintings of George Tooker. Tooker's work, often identified with social realism, goes beyond exact depiction into a dreamlike version of reality. He creates an eerie "narrative surrealism" in which the commonplace is transformed to nightmare through contrast of traditionally rendered human figures dominated by unyielding geometries of concrete and steel.

Tooker, born in Brooklyn in 1920, graduated in 1942 from Harvard University. He was a Marine in World War II in Europe.

Tooker returned to study at the Art Students League. Among his teachers were Reginald Marsh, Kenneth Hayes Miller and Paul Cadmus. Cadmus, a leader of the "magic realism" movement, was a great influence on Tooker. Tooker, like Miller, prefers the classic egg tempera medium.

Tooker settled on his predominant approach in the late 1940s, choosing not to join the trend to modernism and abstract expressionism.

An archetypal work is *Subway* (1950, Whitney Museum of American Art). In it, a collection of static figures (some of them duplications of themselves) are immobilized in the subway's barren labyrinth of cells, cubicles and barred gates. Underlining the compelling effect of airless terror, the only live element in

The Waiting Room, 1959, 24 x 30 in., signed l.l. Courtesy of National Museum of American Art, Smithsonian Institution, Gift of S.C. Johnson & Son, Inc.

the picture is the sick apprehension in the eyes of one person.

Tooker taught at the Art Students League in New York City from 1965 to 1968. Exhibited frequently, his work is in numerous leading museums and collections. The Whitney Museum of American Art gave a retrospective of his paintings in 1974.

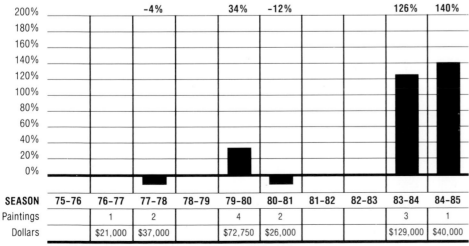

10-Year Average Change From Base Years '76-'77: 47%

SEASON	75-76	76-77	77-78	78-79	79-80	80-81	81-82	82-83	83-84	84-85
			-4%		34%	-12%			126%	140%
Paintings		1	2		4	2			3	1
Dollars		$21,000	$37,000		$72,750	$26,000			$129,000	$40,000

Record Sale: $70,000, CH, 6/1/84, "Highway," 23 x 18 in.

MEMBERSHIPS
National Academy of Design

PUBLIC COLLECTIONS
Dartmouth College, Hanover, New Hampshire
Museum of Modern Art, New York City
National Collection of Fine Arts,
 Washington, D.C.
Walker Art Center, Minneapolis, Minnesota
Whitney Museum of American Art,
 New York City

JIMMY ERNST
(1920-1984)

In the course of his career, Jimmy Ernst's paintings passed through a number of metamorphoses. He began as a surrealist, then sought to interpret jazz improvisations in terms of ·color, and then progressed to working solely with black-on-black and white-on-white color schemes. While retaining the compositional and linear qualities of his earlier work, he next returned to the use of color in his rococo and gothic periods. Out of this evolved his late work, in which broad areas of color were crossed and recrossed with lines and grids painted with linear precision and logic. The end result was an important body of formal abstract paintings, in an idiom distinctly Ernst's own.

Ernst had a distinguished heritage. He was born in Bruehl, Germany, near Cologne, in 1920, the son of Max Ernst, one of the most influential dada and surrealist painters, and Louise Strauss Ernst, an art critic and journalist. His parents were divorced when he was two, and he was raised by his mother in a world filled with artists and art talk.

At first, Ernst had no intention of becoming a painter. Indeed, he never received any training in painting whatsoever. During a visit to Paris with his mother in 1938, however, he saw Brueghel's *The Flight of Icarus* and Picasso's *Guernica,* and realized that painting might be what he wanted to do.

With war imminent, Ernst's mother arranged for her son to come to the

Silence at Sharpeville, 1962, 66 x 72 ¼ in., signed l.r. Courtesy of National Museum of American Art, Smithsonian Institution, Gift of S.C. Johnson & Son, Inc.

United States, sponsored by Gladys Reichard and Franz Boas, both illustrious anthropologists. Two years later, Max Ernst also came to this country, aided by his son and by friends and admirers. Mrs. Ernst, however, remained in Europe and ultimately died in the Auschwitz concentration camp, a fact movingly memorialized in one of her son's last paintings.

Gladys Reichard was doing field work among the Navajo Indians when the young Ernst arrived here, and he spent his first three months among the Indians in Colorado. He later returned to the Southwest many times, and its influence can be seen in some of his last work.

Ernst's earliest surrealist work had a good sense of design and showed real imagination, but his colors were garish and his technique was dismissed by critics as "too slick." In his next period, when he was attempting to interpret the

sound of jazz, he used cold metallic colors and driving rhythms. But all of this was submerged in his almost monastic experiments with blacks and whites, which lasted into the early 1950s.

Like the action painters of abstract expressionism, Ernst did not begin to work with a preconceived idea. This idea came as the work progressed. The subject matter, he once explained, often was dormant within the color areas of the painting, waiting to be released.

Ernst was a vigorous proponent of his ideas on painting and politics, and was in demand as a teacher and visiting artist on college campuses. In his opinion, artists and poets were on the cutting edge of life. They were the "raw nerve ends of humanity," he said.

In 1984, while waiting to appear as a guest on a radio show in New York City, Ernst died of a heart attack.

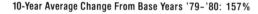

10-Year Average Change From Base Years '79-'80: 157%

SEASON	75-76	76-77	77-78	78-79	79-80	80-81	81-82	82-83	83-84	84-85
						153%	85%	266%	222%	214%
Paintings					1	5	2	1	3	4
Dollars					$475	$6,250	$1,300	$600	$3,082	$6,200

Record Sale: $2,100, P.NY, 10/30/84, "Wall," 8 × 13 in.

MEMBERSHIPS
American Academy of Arts and Letters

PUBLIC COLLECTIONS
Albright-Knox Art Gallery,
 Buffalo, New York
Art Institute of Chicago
Brooklyn Museum
Dallas Museum of Fine Arts
Guggenheim Museum, New York City
Hirshhorn Museum and Sculpture Garden,
 Washington, D.C.
Metropolitan Museum of Art, New York City
Museum of Modern Art, New York City
Pennsylvania Academy of the Fine Arts,
 Philadelphia
Whitney Museum of American Art,
 New York City

GENE DAVIS
(1920-)

Gene Davis, a painter associated with the Washington Color Painters, is a self-taught artist whose early work represents several phases of experimentation, including abstract expressionism, neo-dada and proto-pop.

Davis was born in Washington, D.C. in 1920. He spent most of his adult life in that city: until the late 1950s Davis was a journalist, serving as a White House correspondent and a sportswriter.

His involvement with art began early in the 1950s when he visited the Washington Workshop and worked with Jacob Kainen, whom he regards as his guide and mentor.

During his experiments of the 1950s, Davis produced irregularly shaped masonite panels and panels embedded with rocks and gravel. One work featured a "Peanuts" comic strip covered with blue and white stripes. Davis is perhaps best known for his edge-to-edge paintings of vertical stripes, which he first began to produce in 1958. That first stripe painting, considered at the time a maverick work, was approximately 12 by 8 inches, with straight yellow, pink and violet stripes, of uneven width, but alternating with regularity.

From this prototype, Davis has continued to paint variations of different sizes. His micro-paintings of the mid-1960s were no more than two inches square, and were commonly grouped together on one wall. More often, Davis chooses a large canvas or mural, such as

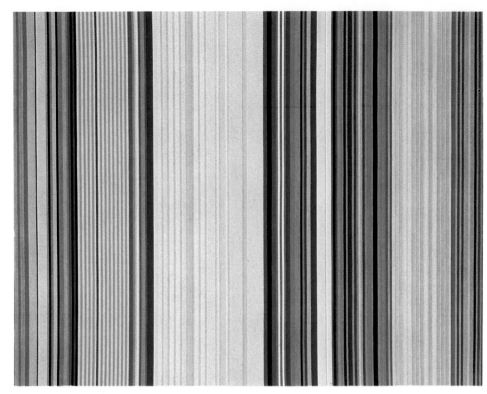

Study for Franklin's Footpath, 1971, 96 x 120 in. Philadelphia Museum of Art, Pennsylvania, Given by the Artist and Mrs. William Wolgin.

South Mall Project for the New York State Capitol, executed in 1969.

In the larger paintings, Davis uses placement and pattern of stripes to create complex rhythms and sequences of colors. The stripes themselves vary in width from one-half inch to eight inches.

Davis considers the vertical stripe as a vehicle for color that follows no preexisting chromatic scale. By varying the hue and intensity of the stripes, Davis creates a sense of a figure on a ground, as in *Red Screamer* (1968, Des Moines Art Center).

Of the stripes, he has written, "There is no simpler way to divide a canvas than with straight lines at equal intervals. This enables the viewer to forget the structure and see the color itself."

Davis has taught at the Corcoran School of Art in Washington, D.C., and at various other institutions.

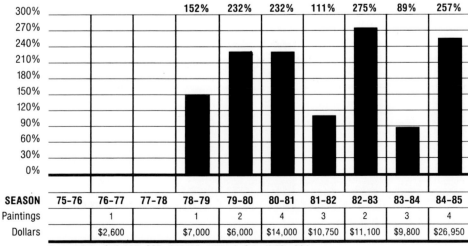

10-Year Average Change From Base Years '76-'77: 169%

SEASON	75-76	76-77	77-78	78-79	79-80	80-81	81-82	82-83	83-84	84-85
				152%	232%	232%	111%	275%	89%	257%
Paintings		1		1	2	4	3	2	3	4
Dollars		$2,600		$7,000	$6,000	$14,000	$10,750	$11,100	$9,800	$26,950

Record Sale: $16,500, SPB, 5/3/85, "King's Gate," 72 × 96 in.

ERNEST
BERKE
(1921-)

Sam's Barn, 1966, 32 x 44 in., signed l.r. Collection of Frank A. Augsbury, Jr., Photograph courtesy of Kennedy Galleries, New York, New York.

The artist Ernest Berke, entirely self-taught, approaches the subject of the American West as if he were an anthropologist. He has immersed himself in the lore and skills of the American Indian, learning to make their tools and clothing and to live as they do, but always preserves an objective detachment.

Berke's paintings and bronze sculptures are carefully observed. The emotion and poignancy they convey are entirely those of the subject, and are neither exaggerated by romanticism nor distorted by ignorance. Yet Berke's dispassionate knowledge of his material has been nurtured not in a life on the trail but in the canyons of New York City.

Born in that city in 1921, he showed artistic talent as early as age six, and was encouraged in it by his father. He worked for some years as an advertising illustrator at Sears, Roebuck and Company, cherishing meanwhile a growing fascination with the West.

Berke became part of an enthusiastic circle of Western aficionados who met for weekly discussions at the Latendorf Book Store in New York City. When a show of his works at that store attracted many customers and was reviewed in the *New York Times,* he quit his job and followed his avocation.

His optimism was justified. He had a successful show at Kennedy Galleries and was commissioned by Doubleday and Company to write and illustrate two books on the American Frontier and on Indians.

Currently, Berke's summers are spent in the West, researching and observing, and his winters in New York City.

SEASON	75-76	76-77	77-78	78-79	79-80	80-81	81-82	82-83	83-84	84-85
Paintings					1	1	1	1		
Dollars					$1,800	$11,000	$14,000	$3,400		

Record Sale: $14,000, SPB, 10/22/81, "The Tactitians," 27 × 42 in.

RICHARD DIEBENKORN
(1922-)

Man and Woman in a Large Room, 1957, 71⅛ x 62½ in., signed l.l. Courtesy of Hirshhorn Museum and Sculpture Garden, Smithsonian Institution.

Although considered a member of the California School of Realism, Richard Diebenkorn, who abandoned abstract expressionism in 1955, has continued to gravitate between the two styles. He often employs elements of pure geometric and symbolic abstraction in his work.

Born in 1922 in Portland, Oregon, he was not encouraged, either at home or in school, to pursue painting as a career. However, in his third year at Stanford University, he enrolled in painting courses conducted by Daniel Mendelowitz and Victor Arnautoff.

When drafted in 1943, he was stationed near Washington, D.C., and spent many hours visiting the Phillips Gallery in that city. This collection, particularly the works of Henri Matisse, was the single greatest influence on Diebenkorn.

Reentering civilian life in 1945, he studied at the California School of Fine Arts (now the San Francisco Art Institute) until 1946. He then returned to Stanford, earning a bachelor of fine arts degree in 1949. From there he went on to the University of New Mexico, where he was awarded a master's degree in 1952.

Diebenkorn's paintings of 1946 and 1947 were expressionistic abstracts, incorporating nuances of surrealism and cubism, and improvisationally integrating shapes and figures.

The "Albuquerque Paintings," executed from 1950 to 1952, reflected Diebenkorn's greatest change in style. He introduced calligraphy and symbolism into them. These abstract landscapes, although broadly and simply conceived, are softer, clearer and more rhythmical than the earlier works; the brushwork is more articulated.

In 1955, Diebenkorn began experimenting with small still lifes, arranging recognizable shapes and objects upon bright broad bands of color, representative of table tops or other articles of furniture. These paintings demonstrate his success in reconciling the complexities of tangibility and mood within a framework of necessary distortion.

The later still lifes are much larger. Human figures, faceless or turned from the observer, are introduced. These figures are marked by a sense of sadness and a strange psychological and spatial isolation from the surroundings they occupy. Good examples of this work are *Woman in a Window* (1957, Albright-Knox Art Gallery) and *Figure on a Porch* (1959, location unknown).

In the 1960s, Diebenkorn returned to painting increasingly abstract landscapes, which, nevertheless, retained vestiges of distinguishable feature and form, as in *Landscape I* (1963, San Francisco Museum of Art).

His work of the 1970s is geometrical, based on the vertical-horizontal placements of Mondrian, but suggestions of landscapes remain present.

Diebenkorn is never static, never repetitive, and has never attempted to mask or obliterate his mistakes, with the result that even his flaws are transmuted into emotional illuminations for the observer.

Asked once why he paints, he replied: "It is a great experience to violate my overall conception of what a picture has to be and find that in doing so, it has changed me."

MEMBERSHIPS
American Academy of Arts and Letters
National Council on the Arts

PUBLIC COLLECTIONS
Albright-Knox Gallery, Buffalo
Baltimore Museum of Art
University of California at Berkeley
Cincinnati Art Museum
Cleveland Museum of Art
Hirshhorn Museum and Sculpture Garden, Washington, D.C.
Los Angeles County Museum of Art
Oakland Art Museum, California
Oberlin College/Allen Memorial Art Museum, Oberlin, Ohio
Olivet College, Michigan
Pasadena Art Museum, California
Pennsylvania Academy of the Fine Arts, Philadelphia
Phillips Collection, Washington, D.C.
Phoenix Art Museum, Arizona
San Francisco Museum of Art
Stanford University, Palo Alto, California
Whitney Museum of American Art, New York City

10-Year Average Change From Base Years '78-'79: 503%

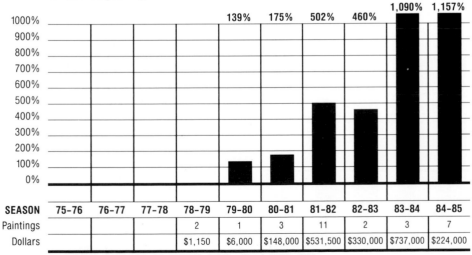

SEASON	75-76	76-77	77-78	78-79	79-80	80-81	81-82	82-83	83-84	84-85
					139%	175%	502%	460%	1,090%	1,157%
Paintings				2	1	3	11	2	3	7
Dollars				$1,150	$6,000	$148,000	$531,500	$330,000	$737,000	$224,000

Record Sale: $400,000, CH, 5/8/84, "Yellow Porch," 70 × 67 in.

EUGENE GARIN
(1922-)

Crashing Surf and Spray, signed l.l. Courtesy of Simic Galleries, Carmel, California.

Eugene Garin is a Russian-born painter who has specialized since the beginning of his artistic career in seascapes. His polished technique, particularly his skill in depicting transparent water in motion, is much admired and has influenced other seascape painters.

Garin was born in Odessa, Russia in 1922. His father was an amateur artist who encouraged his son's interest in the arts. From an early age Garin was determined to be a professional artist.

He was trained by Peter Efremovich Fedotov at the Fine Arts Academy of Odessa. There he studied the works of the old masters and perfected their techniques of glazing and underpainting. Influenced by the work of Russian marine painter I.K. Aivazowsky, Garin began to specialize in seascapes of the Black Sea coast around Odessa and of western Russia.

His career was interrupted by World War II; the German forces occupied Odessa and Garin was sent to Italy as part of the German forced-labor plan. After the war, fearful of being sent to Siberia, he escaped from a train bound for Russia and returned to Italy, where he married a Russian nurse.

Garin and his wife then moved to Argentina, where Garin became a leading figure in the Buenos Aires art community. In 1959, with the fall of the Peron government, he brought his family to the United States, settling first in Florida and eventually in California, where he now lives.

A prolific painter who can finish a painting in just days, Garin emphasizes the importance of imagination and fantasy in creating his compositions. Although he draws upon both photographs and his own extensive travels for individual images, he combines them to create imaginary scenes in most of his canvases. Often his works have a narrative quality, as in *Storm's Victory* (date unknown, Simic Galleries), which shows a shipwrecked sailing vessel foundering on jagged rocks. He has said that he wants his work to affect the viewer as a good novel might.

Certain themes or elements appear often in Garin's work: the Golden Gate Bridge, which he has painted many times in all seasons and weather conditions; shipwrecks, usually of old-fashioned sailing ships; storms and mist. His most distinctive characteristic, however, is the multi-hued, transparent wave, usually laced with foam, which has been called "the Garin wave."

Garin's work is widely held by private collectors and is also represented in the Russian consulate in San Francisco and in the presidential palace of Panama.

(No sales information available.)

LEON A. GOLUB

(1922-)

Leon Albert Golub is a modernist figure painter whose provocative social commentary made him the most important artist to emerge from the Chicago Monster School of the 1950s. His paintings show the vulnerability of man in the elements, struggling wildly against invisible forces.

Golub was born in 1922 in Chicago. He received a bachelor's degree in art history from the University of Chicago. After four years in the army during World War II, he studied at the Art Institute of Chicago until 1950.

In the early 1950s, Golub's paintings were of kings, seers and the like, mostly single figures assuming frontal positions. By 1954, his subjects became more muscular, reaching proportions more in tune with classical statuary. They lacked any semblance of grace, however, and they were often portrayed as limbless and brutalized in some morbid manner. To accentuate his statements, Golub used lacquer which produced gutted surfaces not unlike his subjects.

In 1960, he switched to acrylics, acquiring a looser treatment of body parts and surface textures. *The Colossal Man* (1961, Art Institute of Chicago) shows broken but awesome figures, whose very appearance sheds doubt on man's ability to use his physical power in anything but destructive ways.

By the mid 1960s, the arena of the warrior preoccupied his work. In the "Gigantomachies Series" between 1965 and 1968, Golub produced a modern version of the traditional battle painting, utilizing heroically-scaled nude warriors.

He developed this theme further with the "Assassin Series" in 1972 and 1973; it depicted Golub's vision of United States involvement in Southeast Asia. To emphasize the failure of American policy and the brutality it fostered, his figures were reduced by cutting away

Head XXI, 1959, 52 x 42 in. Courtesy of the Chase Manhattan Bank, N.A., New York, New York.

sections of the canvas, shaping them into grotesque caricatures.

In the 1980s, Golub continued to develop the theme of man's savagery, this time with a series on mercenaries and political torture.

MEMBERSHIPS
American Academy of Arts and Letters
National Institute of Arts and Letters

PUBLIC COLLECTIONS
Allentown Art Museum, Pennsylvania
Amon Carter Museum of Western Art, Fort Worth
Archer M. Huntington Art Gallery, University of
 Texas, Austin
Art Institute of Chicago
Grunewald Foundation, Los Angeles
Hirshhorn Museum and Sculpture Garden,
 Washington, D.C.
Kent State University, Ohio
La Jolla Museum of Art, California
Los Angeles County Museum of Art
Museum of Modern Art, New York City
Nashville State University, Tennessee
National Museum of American Art, Washington, D.C.
National Gallery of Victoria, Melbourne
William Rockhill Nelson Gallery of Art,
 Kansas City, Missouri
Pasadena Art Museum, California
Tel Aviv Museum of Art, Israel
Tennessee Fine Arts Center, Nashville, Tennessee

SEASON	75-76	76-77	77-78	78-79	79-80	80-81	81-82	82-83	83-84	84-85
Paintings			1	1		2	2	1		
Dollars			$1,700	$1,200		$2,000	$11,000	$1,359		

Record Sale: $6,250, SPB, 10/16/81, "Two Heads," 80 × 130 in.

GRACE HARTIGAN

(1922-)

Grace Hartigan is a leading member of the second generation of New York City abstract expressionist painters. Along with Jackson Pollock, Willem de Kooning, Franz Kline, Lee Krasner, Mark Rothko and others, she is internationally recognized for carrying figurative painting into abstraction.

Born in Newark, New Jersey in 1922, Grace Hartigan married and became involved in art at age 17.

She attended the Newark College of Engineering, and worked at mechanical drafting in an airplane factory from 1942 until 1947. During this period, she began studying at night with painter Isaac Lane Muse. When Muse moved from Newark to New York City, Hartigan followed and became an active member of the group of abstract painters which included Jackson Pollock, Willem de Kooning and others.

Hartigan's abstract paintings are always based on nature. Her images range from city life to mythological subjects. Primarily working with oil on canvas, or watercolor and collage, Hartigan uses brilliant colors, sometimes outlined in thick black paint reminiscent of stained-glass windows. Within the abstract paintings, parts of figures, scenes of city life, plants, animals and other objects may often be found.

Since Hartigan's artistic debut in 1950 and her first solo show at the Tibor de Nagy Gallery in 1951, she has achieved great success. She has had at least 18 solo exhibitions and has appeared in many group shows. Her work has been exhibited at the Metropolitan Museum of Art, the Whitney Museum of American Art and many other prestigious institutions. In 1958 she was the only woman chosen for the historic "New American Painting," show at the Museum of Modern Art.

Inclement Weather, 1970, 78¼ x 88¼ in., signed l.r. Courtesy of National Museum of American Art, Smithsonian Institution, Washington, D.C. Gift of Mr. and Mrs. David K. Anderson, Martha Jackson Memorial Collection.

Hartigan moved to Baltimore in 1960, and became artist-in-residence at the Maryland Institute in 1967. Her paintings are among the most important abstract works of the twentieth century.

PUBLIC COLLECTIONS
Albright-Knox Art Gallery, Buffalo
Art Institute of Chicago
Baltimore Museum of Art
Brooklyn Museum
Carnegie Institute, Pittsburgh
Metropolitan Museum of Art, New York City
Minneapolis Institute of Arts
Museum of Modern Art, New York City
Pennsylvania Academy of the Fine Arts,
 Philadelphia
Pennsylvania Museum of Art
Rhode Island School of Design, Providence
Whitney Museum of American Art,
 New York City

SEASON	75-76	76-77	77-78	78-79	79-80	80-81	81-82	82-83	83-84	84-85
Paintings			2	1	1	2	3	1	2	2
Dollars			$9,500	$3,500	$9,500	$11,000	$14,400	$836	$3,300	$14,500

Record Sale: $9,500, CH, 11/9/79, "On Orchard Street," 70 × 80 in.

JULES OLITSKI
(1922-)

Jules Olitski, preoccupied as he is with color to the exclusion of form and structure, has moved abstract expressionism into a new realm. By flooding his canvases with mists of color, he seemingly transforms them into pure atmosphere; and by eliminating brushstrokes, he succeeds in uniting color with canvas until the two become an inseparable unit.

Olitski was born in Russia in 1922, but his parents brought him to America while he was still an infant. He grew up in New York and earned a master of arts degree from New York University, after which he studied portrait painting at the National Academy of Design.

In 1948, he went to Paris and studied at the Academie de la Grande Chaumiere with Ossip Zadkine until 1951. While he was in Paris, Olitski's paintings became increasingly abstract. By 1959, he was producing highly impastoed works with rounded blotch forms at the center and elements of figuration around the perimeter.

But Olitski's style was continually evolving and by the mid-1960s he had abandoned defined forms entirely. He emphasized and exaggerated the importance of color by making subtle changes in hue and slight variations in value and by applying different colors over one another.

In 1964, he began to use the spray gun to do away with shapes altogether. The structure of his paintings depended entirely upon the shape of his canvas. Many of his early spray paintings are done in a tall, narrow format; others are horizontal.

Olitski's paintings succeed on a purely sensuous level. The viewer is obliged to suspend reality and immerse himself in the bright, impenetrable haze that seems to eminate from the canvas. Only by embracing the theory that color is all can one hope to appreciate Olitski's work.

Purple Mekle Lippis of Beauty Mouth-2, 1972, 80 x 59 in. Courtesy of The Pennsylvania Academy of the Fine Arts, Philadelphia. ©Olitsky/VAGA, New York, 1985.

PUBLIC COLLECTIONS
Albright-Knox Art Gallery, Buffalo
Cleveland Museum of Art
Hirshhorn Museum and Sculpture Garden, Washington, D.C.
Museum of Modern Art, New York City

SEASON	75-76	76-77	77-78	78-79	79-80	80-81	81-82	82-83	83-84	84-85
Paintings	5	5	8	2	10	7	5	12	9	4
Dollars	$59,060	$37,750	$64,517	$16,600	$84,700	$57,794	$29,270	$190,900	$138,400	$54,500

Record Sale: $55,000, CH, 11/11/82, "Optimum," 116 × 152 in.

RAYMOND PARKER

(1922-)

An abstract expressionist of the New York School, Ray Parker was born in South Dakota in 1922, and educated at the University of Iowa, where he received a master of fine arts degree. Before moving to New York in 1955, he taught in Iowa, Minnesota and Tennessee. Since then, he has taught at Hunter College, and served as guest critic at Columbia University and Bennington College.

Parker's primary concern in his work is color and its properties. His early works display many of the characteristics of cubism, but even before the mid-1950s he was moving away from the devices employed by cubists in his search for "innocence." Parker paints at random, and hopes for fortunate accidents to produce a work so real that it has no hint of anything that has been done before.

An accomplished jazz musician, Parker approaches painting in much the same way that he approaches music. Improvisation is the key to fulfillment in both areas; Parker, the painter, would have to make a conscious effort to make a bad picture, much as a jazz musician would have to make an effort to blow a bad note, because traditional ideas of right and wrong have no place in either the artistic or musical medium.

The vividness and placement of Parker's color is unique, as is his use of all the qualities of color. Value, intensity and texture are as important to him as hue. Even the unpainted background is a matter of prime importance. The white space of untouched canvas is an integral part of his paintings, a source of drama and a means of space definition.

Pictures of the sort painted by Parker succeed in one of two ways. The viewer either responds to the passion embodied in their unfettered freedom, or is moved by their vivid color.

Untitled, 1956, 83 x 49 in., signed l.r. Courtesy of Collection The Whitney Museum of American Art, New York, New York, Gift of the Uris Brothers Foundation, Inc.

SEASON	75-76	76-77	77-78	78-79	79-80	80-81	81-82	82-83	83-84	84-85
Paintings	1		4	2	4	1	1		1	3
Dollars	$600		$10,900	$2,400	$6,500	$3,600	$1,200		$3,800	$6,750

Record Sale: $3,800, SPB, 7/6/83, "Painting No. 66," 71 × 87 in.

THEODOROS STAMOS

(1922-)

Theodoros Stamos is a leading figure in the American abstract expressionist movement. His lyrical abstractions, executed in a quietistic mode, are reliant more on biomorphic shapes than geometric forms.

Born in 1922 in New York City to Greek immigrant parents, Stamos was awarded a scholarship to the American Artists School in 1936. He studied sculpture, but received no formal painting training.

At age 20, Stamos held his first one-man exhibition. His works for this exhibition were already distinctly abstract in tone and drawn from surreal mythological images and modified biological forms.

Stamos began to paint things he found washed up on Massachusetts beaches. The stones, shells, starfish and pieces of wood were first realistically rendered. Gradually, though, Stamos began to distort the forms, arranging them into symbolic, abstract patterns. These almost primordial images often seemed unconnected—a sense enhanced by the undifferentiated color-tone clusters.

Stamos may have received artistic inspiration during this period from surrealist painters, Paul Klee in particular. Stamos had extensive exposure to Klee's works while he was running a New York frame shop.

By the early 1950s, Stamos introduced dark, sweeping brushstrokes into his paintings. As seen in his *Greek Orison* (1952, Whitney Museum of American Art), the deliberate brushwork against a hazy background evoked a strong sense of structure and substance, so that even Stamos's small canvases seemed monumental in scope.

Stamos's paintings during the next decade consisted of large boxes painted in modulated color and filling almost the entire canvas. Still, the sense in what the artist called his "Sun-Box Series" is that of the organic and the natural. In fact, those biomorphic references—to sky, to water and to landscape—have never left Stamos's work.

Stamos himself has steadfastly maintained that all his pictures ". . . are painted from nature. I consider myself a realist."

Stamos, widely exhibited, received a retrospective of his work in 1958 at the Corcoran Gallery of Art. He taught during the 1950s at Black Mountain College in North Carolina and at the Art Students League in New York.

Sea Images, 1947, 60 x 36 in., signed l.l. Courtesy of National Museum of American Art, Smithsonian Institution, Washington, D.C. Gift of United States Maritime Administration.

PUBLIC COLLECTIONS

Addison Gallery of American Art, Andover, Massachusetts
Albright-Knox Art Gallery, Buffalo, New York
Art Institute of Chicago
Baltimore Museum of Art
Corcoran Gallery of Art, Washington, D.C.
Detroit Institute of Arts
Hirshhorn Museum and Sculpture Garden, Washington, D.C.
Metropolitan Museum of Art, New York City
Museum of Modern Art, New York City
Phillips Collection, Washington, D.C.
San Francisco Museum of Art
Walker Art Center, Minneapolis
Whitney Museum of American Art, New York City

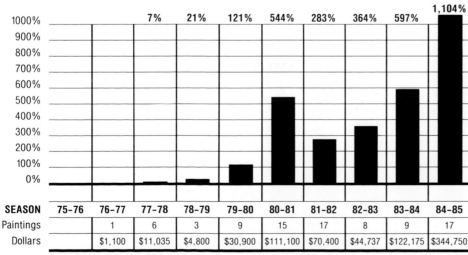

10-Year Average Change From Base Years '76-'77: 338%

	75-76	76-77	77-78	78-79	79-80	80-81	81-82	82-83	83-84	84-85
Percentages		7%	21%	121%	544%	283%	364%	597%		1,104%
SEASON	75-76	76-77	77-78	78-79	79-80	80-81	81-82	82-83	83-84	84-85
Paintings		1	6	3	9	15	17	8	9	17
Dollars		$1,100	$11,035	$4,800	$30,900	$111,100	$70,400	$44,737	$122,175	$344,750

Record Sale: $90,750, SPB, 5/2/85, "Levant No. 5," 80×70 in.

SAM FRANCIS
(1923-)

Sam Francis, noted for his lyrical, colorful abstract works, was one of the first American artists to experiment with "empty-center" painting.

Born in 1923 in San Mateo, California, Francis attended the University of California in Berkeley from 1941 to 1943, when he joined the Air Force.

In 1945, hospitalized in San Francisco after an injury, he began painting under the influence of David Park. He had already developed an abstract style before returning to Berkeley for formal art studies in 1949 and 1950. In school, Francis developed the propensity for vivid blots of color and thinned pigments that is reflected in his mature work.

In the 1950s, Francis traveled extensively, with Paris as his base. He has lived abroad so much that he is considered as much an international painter as an American one.

In France, Francis produced some pale monochromatic works. His characteristic brilliant colors soon returned in overlapping and dripping profusion in the dense, unified style typical of his work up to the mid-1950s. His paintings in the 1956 "Twelve Americans" exhibit at the Museum of Modern Art in New York City gained him a worldwide reputation.

Japanese influence is seen in Francis's unique early 1960s experimentation with empty-center painting. Vast canvases with unpainted central areas are defined, accented, or dominated by strokes and drips in bold colors around the extremities of the canvas.

From the 1970s on, Francis returned to centered painting, in which color puddles out in a galaxy effect on monumental canvases.

Blue Out of White, 1958, 78 x 90 in. Courtesy of Hirshhorn Museum and Sculpture Garden, Smithsonian Institution, Washington, D.C.

PUBLIC COLLECTIONS
Dayton Art Institute, Ohio
Museum of Modern Art, New York City
Musee d'Art Moderne, Paris
National Gallery, Washington, D.C.
National Museum of Western Art, Tokyo
Pasadena Art Museum, California
Stockholm National Museum, Sweden
Tate Gallery, London
Whitney Museum of American Art,
 New York City

10-Year Average Change From Base Years '75-'76: 111%

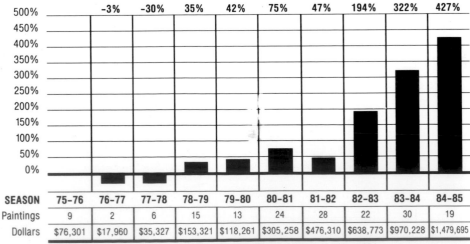

SEASON	75-76	76-77	77-78	78-79	79-80	80-81	81-82	82-83	83-84	84-85
(% change)		-3%	-30%	35%	42%	75%	47%	194%	322%	427%
Paintings	9	2	6	15	13	24	28	22	30	19
Dollars	$76,301	$17,960	$35,327	$153,321	$118,261	$305,258	$476,310	$638,773	$970,228	$1,479,695

Record Sale: $700,000, CH, 11/1/84, "Towards Disappearance," 117 × 126 in.

PAUL JENKINS

(1923-)

Paul Jenkins, an artist originally associated with abstract expressionism, exhibits in his mature works a redefining of color, light and space on the canvas surface.

Born in Kansas City, Missouri in 1923, Jenkins worked as a teenager in a ceramics factory, where he was first exposed to color intensity and the creation of form. From age 14 to 18, he studied drawing and painting at the city's Art Institute.

Initially interested in drama, Jenkins received a fellowship to the Cleveland Playhouse, then continued his dramatic studies in Pittsburgh at the Drama School of the Carnegie Institute of Technology.

Deciding to become an artist, Jenkins moved to New York City in 1948 and studied at the Art Students League. During Jenkins's three years at the League, Yasuo Kuniyoshi and Morris Kantor were his influential instructors.

While Jenkins continued to live and paint in New York City, his personal explorations took a metaphysical turn, which would ultimately become dominant in his work.

P.D. Ouspensky's *In Search of the Miraculous* changed the artist's thoughts on human growth and limitations, while the Chinese *I Ching,* through its thematic emphasis on constant change, heightened his interest in flowing paint on canvas.

Painting for Jenkins became an intui-

Phenomena Reverse Spell, 1963, 77 x 115¾ in. Courtesy of Hirshhorn Museum and Sculpture Garden, Smithsonian Institution, Washington, D.C.

tive, almost mystical process. He commented, "I paint what God is to me."

In 1953, Jenkins traveled to Paris, where, a year later, he had his first one-man show. While working at the American Artists Center, he continued to experiment with flowing paints, pouring pigment in streams of various thicknesses, with white thin spills as linear overlays.

Jenkins's intent was to deny stasis and create a literal and metaphysical sense of dynamism, while maintaining a sense of

unity. Beginning in 1958, Jenkins titled each canvas *Phenomena,* with additional identifying words. He believed the work to be descriptive of the discovery process inherent in each painting.

Paralleling his beliefs, the artist's paintings have undergone subtle but definite changes. Beginning in the early 1960s, a shift of color saturation and exposure of the white areas gave Jenkins's canvases an enhanced feeling of illumination.

If Jenkins's technique is unorthodox, he is in many other ways a traditional artist. He works in an acrylic medium on traditional linen canvas or fine rag paper. Often he uses an ivory knife or a brush for finishing, but never allows a stroke to show.

Widely exhibited, Jenkins now lives alternately in Paris and New York City.

PUBLIC COLLECTIONS
Brooklyn Museum
Corcoran Gallery of Art, Washington, D.C.
Dallas Museum of Fine Art
Hirshhorn Museum of Modern Art,
 New York City
Museum of Modern Art, New York City
Solomon R. Guggenheim Museum,
 New York City
Stedelijk Museum, Amsterdam
Tate Gallery, London
Whitney Museum of American Art,
 New York City

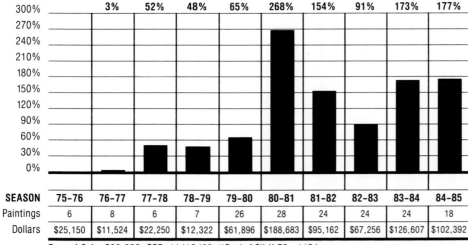

10-Year Average Change From Base Years '75-'76: 103%

		3%	52%	48%	65%	268%	154%	91%	173%	177%
SEASON	75-76	76-77	77-78	78-79	79-80	80-81	81-82	82-83	83-84	84-85
Paintings	6	8	6	7	26	28	24	24	24	18
Dollars	$25,150	$11,524	$22,250	$12,322	$61,896	$188,683	$95,162	$67,256	$126,607	$102,392

Record Sale: $36,000, SPB, 11/13/80, "Pool of Oil," 78 × 115 in.

ELLSWORTH KELLY
(1923-)

Red White, 1961, 62¾ x 85¼ in. Courtesy of Hirshhorn Museum and Sculpture Garden, Smithsonian Institution, Washington, D.C.

Ellsworth Kelly is recognized as one of the first artists to explore a style known as hard-edge painting. From the early 1950s to the present, Kelly has explored the relationships between color, form and object, and their degrees of inseparability. Hard-edge painting, with its emphasis on the formal properties of color and the surface of the canvas, prefigured and is considered part of the minimal art of the 1960s.

Kelly was born in Newburgh, New York in 1923. He studied at Pratt Institute from 1941 to 1942, before serving in the army in France. On his return to the United States, Kelly continued his education at the Boston Museum School, where he developed an expressive, realistic style. His earliest works include portraits, still lifes and figure studies.

In 1948, the artist returned to Paris. He remained there for six years, studying for a time at the prestigious Ecole des Beaux-Arts. Despite his persistent exploration of representational imagery, Kelly's interest in the purely visual elements of painting began to develop and gain priority.

Within a year of his arrival in Europe, Kelly began to experiment with alternate creative processes and to investigate the element of change in pictorial terms. These experimental techniques included automatic drawing, collage, and the use of abstract designs based on the simplified shapes of road signs, windows and shadows. By 1949, these inter-

ests were expressed in works such as *Window* (1949, Museum of Modern Art, Paris), a painting which combines literal interpretation and abstraction.

Non-objective painting became Kelly's primary form of expression from the 1950s to the present. By 1951, he had begun to make grid paintings. In *Spectrum Colors Arranged by Chance* (1952-1953), Kelly arrived at a composition on the basis of an arbitrary selection of colors. In *Colors for a Large Wall* (1951, Museum of Modern Art), the artist divided an 8-foot-square canvas into 64 unmodulated color squares. In these important works, Kelly sought to explore the precise relationships between colors, and in so doing, converted color into form and content.

Kelly returned to the United States in 1954, recognized as a true representative

of hard-edge painting. This style differed drastically from the more painterly trend of abstract expressionism. Hard-edge painters, unlike the abstract expressionists, shunned gestures, brush strokes and spatial relationships which describe foreground and background.

As Kelly developed his hard-edge style, he began to re-examine the properties of black and white in his compositions. In addition, he utilized curved shapes and fragments of images cropped by the perimeters of his canvas; he also began to experiment with large, shaped canvases.

Throughout the 1960s, Kelly further reduced his imagery, as in *Blue Red Green* (1962-1963, Metropolitan Museum of Art). In this important painting, the artist returned to arrangements of monochromatic color panels and a severely limited palette. Kelly's sculpture of the 1950s and later resembles his paintings; these three-dimensional works are composed of brightly-colored geometric shapes, frontally presented.

PUBLIC COLLECTIONS
Albright-Knox Art Gallery, Buffalo
Art Institute of Chicago
Cincinnati Art Museum, Ohio
Los Angeles County Museum of Art
Metropolitan Museum of Art, New York City
Museum of Modern Art, New York City
Museum of Modern Art, Paris
Milwaukee Art Center
Joslyn Art Museum, Omaha
Rhode Island School of Design, Providence
Rijksmuseum Kroller-Muller, Otterlo, Holland
Solomon R. Guggenheim Museum, New York City
Tate Gallery, London
Walker Art Center, Minneapolis

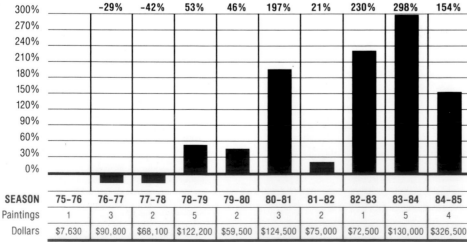

10-Year Average Change From Base Years '75-'76: 93%

	-29%	-42%	53%	46%	197%	21%	230%	298%	154%	
SEASON	75-76	76-77	77-78	78-79	79-80	80-81	81-82	82-83	83-84	84-85
Paintings	1	3	2	5	2	3	2	1	5	4
Dollars	$7,630	$90,800	$68,100	$122,200	$59,500	$124,500	$75,000	$72,500	$130,000	$326,500

Record Sale: $115,500, SPB, 5/2/85, "White Diamond with Black," 90 x 120 in.

ROY LICHTENSTEIN
(1923-)

Roy Lichtenstein is a pop art painter whose works, in a style derived from comic strips, portray the trivialization of culture endemic in contemporary American life. Using bright, strident colors and techniques borrowed from the printing industry, he ironically incorporates mass-produced emotions and objects into highly sophisticated references to art history.

Born in New York City in 1923, Lichtenstein studied briefly at the Art Students League, then enrolled at Ohio State University. After serving in the army from 1943 to 1946, he returned to Ohio State to get a master's degree and to teach.

In 1951, Lichtenstein came back to New York City and had his first one-man show. He also continued to teach, first at the New York State College of Education at Oswego, and later at Douglass College, a division of Rutgers University in New Jersey.

Through the 1950s, Lichtenstein used the basic techniques of abstract expressionism, but incorporated into his compositions such themes as cowboys and Indians and paper money. In 1961, however, while at Douglass College, impressed by the work of colleague Allan Kaprow, he turned to the use of comic-strip and cartoon figures by which he is known today. *Flatten . . . sandfleas* (1962, Museum of Modern Art) was the first important example of his new style.

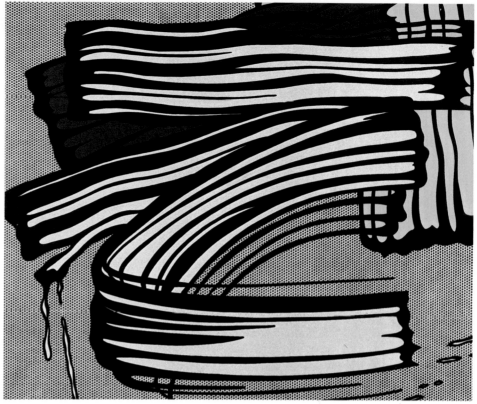

Little Big Painting, 1965, 68 x 80 in. Courtesy of Collection The Whitney Museum of American Art, New York, New York, Gift of the Friends of the Whitney Museum of American Art. ©Lichtenstein/VAGA, New York 1985.

Primary colors—red, yellow and blue, heavily outlined in black—became his favorites. Occasionally he used green. Instead of shades of color, he used the benday dot, a method by which an image is created, and its density of tone modulated in printing. Sometimes he selected a comic-strip scene, recomposed it, projected it onto his canvas and stenciled in the dots. "I want my painting to look as if it had been programmed," Lichtenstein explained.

Despite the fact that many of his paintings are relatively small, Lichtenstein's method of handling his subject matter conveys a sense of monumental size. His images seem massive.

Since 1962, he has turned to the work of artists such as Picasso, Mondrian, and even Monet as inspiration for his work. In the mid-1960s, he also painted sunsets and landscapes in his by-now-familiar style. In addition, he has designed ceramic tableware and graphics for mass production.

"I'm interested in portraying a sort of antisensibility that pervades society," Lichtenstein says, summing up his work.

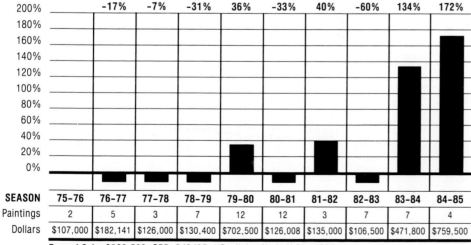

10-Year Average Change From Base Years '75-'76: 23%

SEASON	75-76	76-77	77-78	78-79	79-80	80-81	81-82	82-83	83-84	84-85
		−17%	−7%	−31%	36%	−33%	40%	−60%	134%	172%
Paintings	2	5	3	7	12	12	3	7	7	4
Dollars	$107,000	$182,141	$126,000	$130,400	$702,500	$126,008	$135,000	$106,500	$471,800	$759,500

Record Sale: $522,500, SPB, 5/2/85, ''Reclining Nude,'' 84 × 120 in.

PUBLIC COLLECTIONS
Art Institute of Chicago
Brooklyn Museum
Detroit Institute of Art
Museum of Modern Art, New York City
Philadelphia Museum of Art
Solomon R. Guggenheim Museum, New York City
Stadtlisch Kunsthalle, Dusseldorf
Stedelijk Museum, Amsterdam
Tate Gallery, London
Whitney Museum of American Art,
 New York City

LARRY RIVERS
(1923-)

Painter and sculptor Larry Rivers was born in New York City in 1923. In the 1950s, he became one of the first artists to explore the figurative style which follows abstract expressionism.

With the use of illustrative material from advertising and familiar paintings, Rivers produced works that have a broader public appeal than those of pure abstraction. His landscapes, portraits and figure studies of the early 1950s were considered reactionary by contemporary critics because of their realistic drawings and structure.

Rivers's art training began in the 1940s, after he turned away from a career as a jazz saxophonist. From 1947 to 1948, he studied at New York University with Hans Hoffman and William Baziotes. He then toured England, France and Italy. Upon his return, he became an integral part of the New York City art scene, designing sets for a Frank O'Hara play in 1954, and for Igor Stravinsky's *Oedipus Rex* in 1966.

While Rivers's style strikes a balance between abstract expressionism and realistic renderings, his work retains the influence of Hoffman in its free, painterly brushwork. Tightly drawn images float ambiguously in space with blurred images and smears. These blurred, smudgy images were not accidental, but part of a deliberate process. About them, Rivers once said, "I have had a bad arm and am not interested in the art of holding up mirrors."

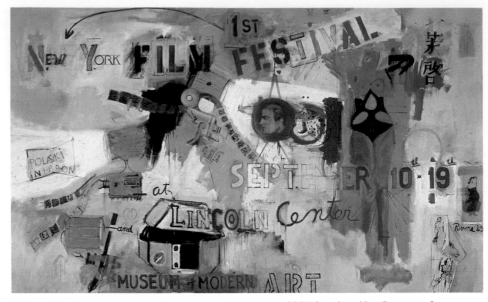

Billboard for the First New York Film Festival, 1963, 114⅛ x 286⅛ in., signed l.r. Courtesy of Hirshhorn Museum and Sculpture Garden, Smithsonian Institution, Washington, D.C. ©Rivers/ VAGA, New York 1985.

Areas of canvas sometimes remain bare and devoid of color. Rivers's use of these bare areas has been compared with Cezanne's watercolor technique. The intentionally unfinished areas emphasize the process of painting.

While Rivers's paintings can be interpreted as a comment on the politics of the current art scene, they also represent

personal experimentation with new forms. *Washington Crossing the Delaware* (1953, Museum of Modern Art) represents an attempt by Rivers to shock artists into reacting in new ways.

Double Portrait of Birdie (1955, Whitney Museum of American Art) represents another variation in the central conflict of his work—the contrast between representational drawing and abstractionism. Here, Rivers offers the same figure in two different poses in one painting.

Rivers began sculpting in 1953, and has produced life-size outdoor figures in welded metal, with subsequent works in plexiglas and wood.

PUBLIC COLLECTIONS
Art Institute of Chicago
Baltimore Museum of Art
Brooklyn Museum
Corcoran Gallery of Art, Washington, D.C.
Hirshhorn Museum and Sculpture Garden, Washington, D.C.
Metropolitan Museum of Art, New York City
Museum of Modern Art, New York City
National Gallery of Art, Washington, D.C.
North Carolina Museum of Art, Raleigh

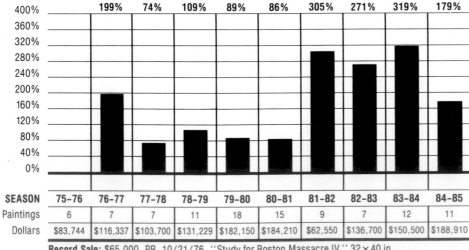

10-Year Average Change From Base Years '75-'76: 163%

SEASON	75-76	76-77	77-78	78-79	79-80	80-81	81-82	82-83	83-84	84-85
		199%	74%	109%	89%	86%	305%	271%	319%	179%
Paintings	6	7	7	11	18	15	9	7	12	11
Dollars	$83,744	$116,337	$103,700	$131,229	$182,150	$184,210	$62,550	$136,700	$150,500	$188,910

Record Sale: $65,000, PB, 10/21/76, "Study for Boston Massacre IV," 32 × 40 in.

984

MICHAEL GOLDBERG
(1924-)

In the 1950s, according to critic Robert Rosenblum, Michael Goldberg was a painter of the second generation of abstract expressionism "who dared to master the wildest fringe of abstract expressionist spontaneity, turning the canvas into a nearly literal illustration of Harold Rosenberg's famous metaphor of the canvas as an arena of action."

Since then, however, Goldberg's work has passed through several evolutions, including the use of metallic powders to give it luminescence. While his paintings may not have had a stylistic unity in the strict sense of the word, they have been rooted in a personal vocabulary which has, in the words of another writer, "persisted as the painter has given shape to experience."

Goldberg was born in New York City in 1924. He attended the Art Students League from 1938 to 1942, when he joined the army. During the Second World War he served as a paratrooper, first in North Africa and then making 80 jumps behind Japanese lines in Burma.

After his discharge, he returned to New York City and resumed his studies, first with Jose de Creeft and then for two years with Hans Hofmann. His earliest work reflected the influence of Gorky, Matta and especially Hofmann.

Eventually, however, even Goldberg himself acknowledged that Willem de Kooning exerted the greatest influence on his work. "De Kooning offered a way to translate cubism into the American consciousness," he said. "His fusion

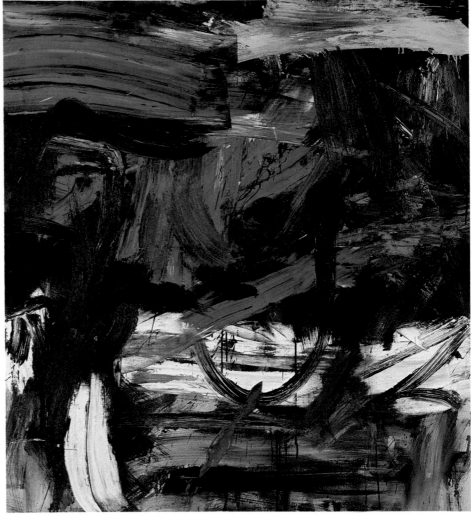

The Creeks, 1959, 52 x 47¾ in. Courtesy of National Museum of American Art, Smithsonian Institution, Gift of Mr. and Mrs. David K. Anderson, Martha Jackson Memorial Collection.

between gesture and structure, his physical flow of color, offered a clue to the way painting could be extended."

Around 1960, Goldberg painted two broadly brushed series of monochromatic works, one black, the other red. They were as abstract as he could make them.

In his next phase, he added bands of white across the black fields. Then he went back to monochromaticism again, using bronze powders with clear alkyds on which he later inscribed rough, grid-like patterns.

In the 1970s, he began to paint almost calligraphic images. These, in turn, evolved into bright bands of color which suggest architectural forms.

In discussing these metamorphoses of his work, Goldberg once commented, "I think of my art as being a little like a slinky toy. It expands and then gathers itself into the same shape."

PUBLIC COLLECTIONS

Albright-Knox Art Gallery, Buffalo, New York
Baltimore Museum of Art
Chrysler Museum of Art, Norfolk, Virginia
De Cordova and Dana Museum, Lincoln, Massachusetts
Walker Art Center, Minneapolis

10-Year Average Change From Base Years '78-'79: 83%

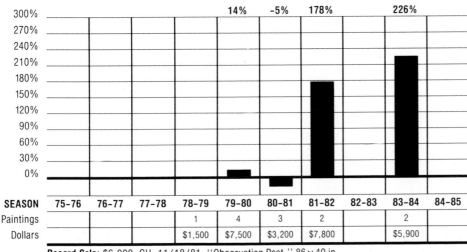

SEASON	75-76	76-77	77-78	78-79	79-80	80-81	81-82	82-83	83-84	84-85
					14%	−5%	178%		226%	
Paintings				1	4	3	2		2	
Dollars				$1,500	$7,500	$3,200	$7,800		$5,900	

Record Sale: $6,000, CH, 11/18/81, "Observation Post," 86 × 40 in.

KENNETH NOLAND
(1924-)

Whether Kenneth Noland's work is categorized as minimal art or color-field art, it stands among the most powerful in its use of color as a structural, rather than a decorative, element. It is also notable for its ability to bring all shapes on a canvas, including the framing edge, into lively interaction with each other. At various times he has worked with circles, ovals, chevrons and bands of vivid, carefully selected colors to achieve the intensity he seeks.

Noland was born in Asheville, North Carolina in 1924. When he was a teenager his father, an amateur painter, took him to the National Gallery of Art in Washington, a visit that did much to set the direction of his life.

He served in the Air Force during World War II and then returned to Asheville to enroll at Black Mountain College for two years, where he studied under Josef Albers and Ilya Bolotowsky. It was Bolotowsky, Noland said later, who influenced him most, heightening his awareness of color as a medium of expression.

After more study with Ossip Zadkine in Paris, Noland returned to the United States and settled in Washington, D.C. There he first attended classes, and then taught, at the Institute of Contemporary Art. Until 1957, however, Noland's artistic compass fluctuated widely, drawn first to the theories of one teacher, then another, and then to such influ-

Another Time, 1973, 102½ x 102½ in. Courtesy of National Gallery of Art, Washington, D.C., Gift of the Collectors Committee.

ences as Klee, Matisse and abstract expressionism in general.

One event that helped to clarify his thoughts about art was a visit with painter Morris Louis to Helen Frankenthaler in 1953. Both were deeply impressed by her use of washes of paint on unprimed canvas to create her stained paintings. Noland adopted the technique immediately, using recently developed acrylic paints thinned with water.

By the late 1950s he had found the mode of expression he was searching for.

Ex-Nihilo (1958, collection of the artist) was the first of a series in which he used jagged concentric circles of intense color to create an illusion of dynamic tension. Later he turned to chevrons of color, some of them assymetrically placed, others filling the entire surface of the canvas. These, in turn, were supplanted by horizontal stripes. And for several years in the 1970s he explored the effects of intersecting vertical and horizontal bands of color.

In explaining his artistic credo in 1968, Noland said, "The thing in painting is to find a way to get color down, to float it without bogging the painting down in surrealism, cubism or systems of structure . . . In the best color painting, structure is nowhere evident, or nowhere self-declaring . . . It's all color and surface. That's all."

MEMBERSHIPS
American Academy of Arts and Letters

PUBLIC COLLECTIONS
Albright-Knox Art Gallery, Buffalo
Detroit Institute of Arts
Solomon R. Guggenheim Museum, New York City
Hirshhorn Museum and Sculpture Garden, Washington, D.C.
Museum of Modern Art, New York City
National Gallery of Art, Washington, D.C.
Pasadena Art Museum, California
St. Louis Art Museum
Tate Gallery, London
Whitney Museum of American Art, New York City

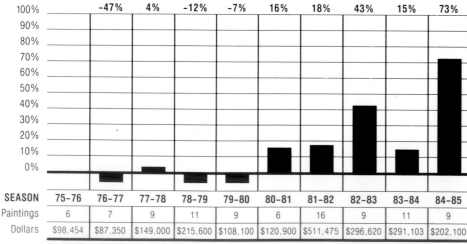

10-Year Average Change From Base Years '75-'76: 10%

	75-76	76-77	77-78	78-79	79-80	80-81	81-82	82-83	83-84	84-85
		-47%	4%	-12%	-7%	16%	18%	43%	15%	73%
SEASON	75-76	76-77	77-78	78-79	79-80	80-81	81-82	82-83	83-84	84-85
Paintings	6	7	9	11	9	6	16	9	11	9
Dollars	$98,454	$87,350	$149,000	$215,600	$108,100	$120,900	$511,475	$296,620	$291,103	$202,100

Record Sale: $300,000, SPB, 11/19/81, "Empyrean," 81 x 82 in.

PHILIP PEARLSTEIN

(1924-)

Hailed at age 16 as a precocious realistic painter in the manner of Reginald Marsh, Philip Pearlstein later launched his professional career as an abstract expressionist. By 1960, however, he had swung back to realism, although admittedly it was a realism on which he placed his own unique stamp. He calls himself, in fact, "a post-abstract realist."

Born in Pittsburgh in 1924, Pearlstein attended a secondary school that encouraged special programs in the arts, also enrolling in Saturday morning art classes at Carnegie Institute.

After entering Carnegie Institute, Pearlstein studied with both Samuel Rosenberg, a prominent social realist painter, and Roy Hilton, a more direct realist. Hilton's approach suited Pearlstein better than Rosenberg's narrative style.

When he was drafted into the army in 1943, Pearlstein was assigned to a training-aids unit in Florida, where he worked with experienced graphic-design specialists. A military assignment in Italy enabled him to see the great art that was being brought out of wartime hiding.

After the war, he moved to New York City to study at New York University's Institute of Fine Arts. Putting realism behind him for some 10 years, he painted abstract expressionist landscapes in a style reminiscent of Chaim Soutine. By 1962, however, he was exhibiting figural works again, but still with strong expressionist undercurrents.

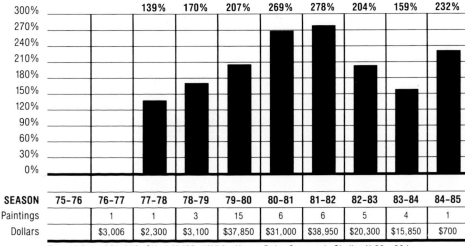

Female Model on Oriental Rug with Mirror, 1968, 60 x 72 in., signed l.l. Courtesy of Collection The Whitney Museum of American Art, New York, New York, 50th Anniversary Gift of Mr. and Mrs. Leonard A. Lauder.

His work became starkly realistic, but he is not a traditional figure painter. As one critic said, "He is a painter who uses the figure for the structure of his painting."

Bodies and limbs often bisect Pearlstein's paintings to create abstract units.

He sometimes arranges his figures in contorted positions and frequently lets the edge of the canvas slice off part of a body or head.

Pearlstein never idealizes, whether his subject is a female nude or a portrait of a robed college president. Sometimes he poses male and female nudes together in such a way as to deny even a suggestion of erotic attraction. He is trying, he explains, simply to paint dynamic compositions that happen to involve nude people.

PUBLIC COLLECTIONS
Art Institute of Chicago
Colorado Springs Fine Arts Center
Corcoran Gallery of Art,
 Washington, D.C.
Des Moines Art Center, Iowa
Hirshhorn Museum and Sculpture Garden,
 Washington, D.C.
Milwaukee Art Museum, Wisconsin
Museum of Modern Art, New York City
Newark Museum, New Jersey
Speed Art Museum, Louisville, Kentucky
Whitney Museum of American Art,
 New York City

10-Year Average Change From Base Years '76-'77: 184%

SEASON	75-76	76-77	77-78	78-79	79-80	80-81	81-82	82-83	83-84	84-85
			139%	170%	207%	269%	278%	204%	159%	232%
Paintings		1	1	3	15	6	6	5	4	1
Dollars		$3,006	$2,300	$3,100	$37,850	$31,000	$38,950	$20,300	$15,850	$700

Record Sale: $25,000, CH, 5/5/82, "White House Ruin, Canyon de Chelley," 60×60 in.

JAMES FETHEROLF
(1925-)

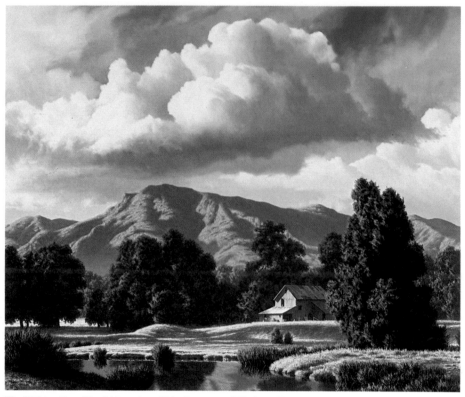

The Waking Day, 20 x 24 in., signed l.l. Courtesy of Simic Galleries, Carmel, California.

Landscape painter James Fetherolf's work is noted for its precise rendering of fine detail, a skill he may have mastered during his years as a background artist for several Hollywood film studios.

Fetherolf was born in Nazareth, Pennsylvania in 1925. He attended Syracuse University, and after graduating in 1949 he moved to California, hoping for an acting career. The difficulty of finding acting jobs, however, eventually convinced him that his future in the arts lay in painting.

For five years, while struggling to develop his acting career, Fetherolf had worked as a part-time matte artist for Twentieth Century Fox Studios. Now he returned to Fox full-time. In 1957, he went to Walt Disney Productions.

Fetherolf claims that his years at Disney were educational in several ways—partly because the standards of perfection were very high, and partly because his work was tied to deadlines. He produced detailed paintings on glass, usually three or four feet in size, of cities or landscapes scenes. These "matte shots" were later combined with live action. His work appeared in such classic films as *Zorro, Pollyanna, Mary Poppins* and *Third Man on the Mountain.*

After a visit to a local art gallery, during which he decided he could do at least as well as the artists represented, Fetherolf turned to the fine arts. He began by painting seascapes, which were enthusiastically received. These and his landscapes had become so popular by 1969 that he left the film industry and devoted himself to oil painting.

Fetherolf's paintings are distinguished by clarity of detail; for example, individual timbers are discernible inside a distant barn and cacti on the horizon are individually painted. He is also known for the moist, billowing quality of the clouds in his large skies, as in *Spirit of Summer* (date unknown, Simic Galleries), a quality he achieves by working on the sky in each painting in one sitting, while the paint is wet.

He has received seven gold medals from the Franklin Mint Gallery of American Art, and was selected to paint the centerpiece work, *America! America!,* for the Mint's "America the Beautiful" series. His work was also represented in the Bicentennial exhibition of the R.W. Norton Museum in Shreveport, Louisiana.

(No sales information available.)

ROBERT RAUSCHENBERG
(1925-)

Process, object, environment and artist intertwine in Robert Rauschenberg's work. He embodies most of the ideas of this century's modern art, yet his powerful, idiosyncratic works are like those of no other artist.

Born Milton Rauschenberg in Texas in 1925, he received a sound art education. He attended Kansas City Art Institute in 1947, and then the renowned Academie Julien in Paris in 1948.

He returned to the United States to attend Black Mountain College in North Carolina in 1949. There he studied under abstract painter Josef Albers, one of the emigres who, seeking refuge in the United States from Europe's devastation, had galvanized American art. There, too, he formed professional relationships with avant-garde composer John Cage and choreographer Merce Cunningham.

Rauschenberg continued on to New York City, where he studied at the Art Students League until 1952. From then until 1953, he traveled in Northern Africa and Italy.

His first works included collage, and he was involved in the production of perhaps the first impromptu theatrical "happening," a performance of John Cage's *Theater Piece #1* (1952). His "combine paintings" of the 1950s combined, at first, paint and objects from his own past, but later included more "found" materials like photographs that had no personal connection with the art-

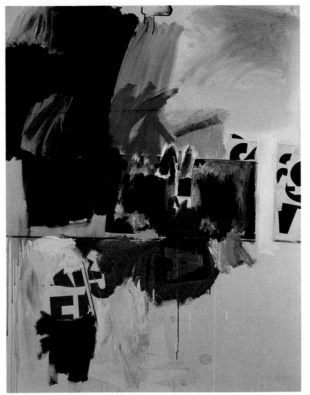

Summer Rental Number 2, 1960, 70 x 54 in. Courtesy of Collection The Whitney Museum of American Art, New York, New York, Friends of the Whitney Museum of American Art. ©Rauschenberg/VAGA, New York, 1985.

ist. He turned to planning and costuming stage performances, particularly dance, in the 1960s, and in the 1970s he produced constructions of fragile and ephemeral materials.

From the beginning, Rauschenberg's work contained nontraditional materials, was exhibited in a nontraditional setting, and refused categorization. Although he rejected the serious, self-important, personal emotionality of the abstract expressionist painters, his brushwork is expressive and emotive. His incorporation of mundane objects—such as bed linens, license plates, or tires—into his assemblages heavily influenced the growth of pop art and neo-dadaism in

the 1960s, but the effect is neither banal and cynical like pop, nor deliberately chaotic and negative like dada.

Unlike his contemporaries Larry Rivers and Jasper Johns, Rauschenberg's restless inventiveness makes his works difficult to categorize. He has always been willing to explore new possibilities, including combining paintings with music or performance, and using blueprints, electronics, silkscreen and—most recently—ephemeral materials such as cardboard in his paintings.

Rauschenberg's work is contradictory. He sees the artist as a participant or reporter rather than a creator, but the stamp of his style and personality is evident in each of his paintings. Though his is an art of the concept, the idea, there is evident enjoyment in his engagement with the medium of expression and the material world. Whatever the judgment of later generations, Robert Rauschenberg is regarded as a tremendously influential force in twentieth-century art.

PUBLIC COLLECTIONS
Albright-Knox Art Gallery, Buffalo, New York
Moderna Museet, Stockholm, Sweden
Museum of Modern Art, New York City
National Museum of American Art, Washington, D.C.
San Francisco Museum of Art
Tate Gallery, London
Wadsworth Atheneum, Hartford, Connecticut
Whitney Museum of American Art,
 New York City

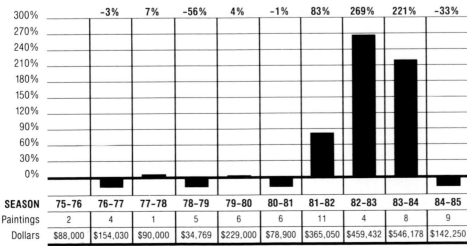

10-Year Average Change From Base Years '75-'76: 49%

	-3%	7%	-56%	4%	-1%	83%	269%	221%	-33%

SEASON	75-76	76-77	77-78	78-79	79-80	80-81	81-82	82-83	83-84	84-85
Paintings	2	4	1	5	6	6	11	4	8	9
Dollars	$88,000	$154,030	$90,000	$34,769	$229,000	$78,900	$365,050	$459,432	$546,178	$142,250

Record Sale: $420,000, CH, 11/8/83, "The Red Painting," 70×48 in.

JOAN MITCHELL
(1926-)

Chicago-born painter Joan Mitchell is recognized as one of the leaders of the second generation of abstract expressionists. In the late 1940s and 1950s, New York City replaced Paris as the world art center. Prominent abstract expressionists of the New York School included Jackson Pollock, Arshile Gorky, Franz Kline and Willem de Kooning; they influenced Joan Mitchell and others of her generation.

Mitchell's large canvases reveal a sense of light and nature, inspired by her feelings for landscapes. Her paintings—suggested by memories of summers in Michigan's Northern woods or the frozen Chicago lakefront of her childhood—contain no actual objects, specific forms or realistic images. She terms herself a traditionalist because she works purposely toward a design structure in her paintings.

She attended Smith College; she also received a bachelor's degree in fine arts from the Art Institute of Chicago in 1947 and a master's degree in 1950. In 1948, she won a traveling scholarship to study in Europe. Mitchell moved to New York City in 1950, where she painted and exhibited regularly. Since 1955, she has been living and painting in France.

Mitchell's paintings contain vibrant oranges, pinks and golds set against the greens, browns and deep blues inspired by light and the flowers in her garden in suburban Paris. The bright colors are often accented with vertical paint drips.

My Landscape II, 1967, 103 x 71½ in., signed l.r. Courtesy of National Museum of American Art, Smithsonian Institution, Gift of Mr. and Mrs. David K. Anderson, Martha Jackson Memorial Collection.

Although her pictures are energetic, dynamic and large, she creates slowly and methodically, working with preliminary charcoal drawings. She produces about 20 paintings a year.

Mitchell's paintings of the 1970s contain a greater sense of architectural structure, with an overall light-color texture interjected with large accents of deeper or contrasting colors. She has also painted many multi-paneled compositions that suggest her concept of the passage of time.

Her achievement was recognized when the Whitney Museum of American Art gave her a major one-woman show in 1974.

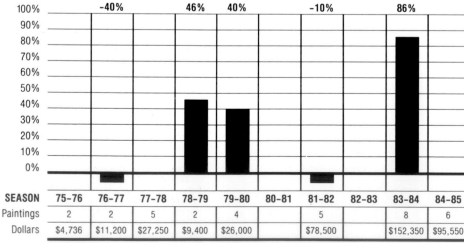

10-Year Average Change From Base Years '75-'76: 15%

SEASON	75-76	76-77	77-78	78-79	79-80	80-81	81-82	82-83	83-84	84-85
		−40%		46%	40%		−10%		86%	
Paintings	2	2	5	2	4		5		8	6
Dollars	$4,736	$11,200	$27,250	$9,400	$26,000		$78,500		$152,350	$95,550

Record Sale: $47,000, SPB, 11/9/83, "The Fourteenth of July," 49×110 in.

JACK YOUNGERMAN
(1926-)

Some critics compare Jack Younger-man's clean, vibrantly colored minimal abstractions to Georgia O'Keeffe's late nature images, while others see in them a closer relationship to the bold, clean cut-outs of Matisse's last years. In fact, there may well be some influence from both in Youngerman's work. Like O'Keeffe, he is interested in "organic form," relating not to specific objects, but rather to "living things in general." Enigmatic suggestions of leaves, plants and even flames often appear in his paintings.

At first he produced powerful, ragged-edged images which, as one critic put it, seemed to burst beyond the limits of the canvas. Later, still using raw, brilliant colors, he simplified his forms and flattened them, thus prompting comparisons with Matisse's cut-outs.

Youngerman was born in Louisville, Kentucky in 1926. He studied at the University of North Carolina from 1944 to 1946 under a wartime navy training program, and graduated from the University of Missouri in 1947. For the next year he studied at the Ecole des Beaux Arts in Paris, where his painting was influenced by constructivism.

From 1952 to 1956, he worked on projects in Europe, Lebanon and Iraq for Michel Ecochard, a French architect. On his trips to the Middle East, he

July 26, 1961, 97½ x 79⅝ in. Courtesy of National Museum of American Art, Smithsonian Institution, Gift of S. C. Johnson & Son, Inc. © Youngerman/VAGA, New York, 1985.

was strongly impressed by the brilliance of the sunlight and the clarity and voluptuousness of the atmosphere.

At first, Youngerman's forms were strongly geometric. As he developed, however, they became more abstract, and rushed and flowed across his canvases. Next, he reduced the number of elements in his paintings, concentrating usually on a very few large, diagonal forms rather than on a variety of smaller ones. For a time he used thick applications of paint, but then abandoned this in favor of smooth, untextured surfaces.

Youngerman has also made many drawings. Although some of the forms in his drawings may appear later in his large paintings, this is coincidental, not intentional. To him, the drawings are an end in themselves. Here again, however, his forms are abstract, with movement occurring sometimes within a given shape and at other times between two shapes. As in his paintings, his control of his medium is always evident. Out of the tension between conflicting elements in his works, there always emerges a clear sense of harmony.

PUBLIC COLLECTIONS
Albright-Knox Art Gallery, Buffalo, New York
Art Institute of Chicago
Corcoran Gallery of Art, Washington, D.C.
Hirshhorn Museum and Sculpture Garden, Washington, D.C.
Museum of Modern Art, New York City
National Museum of American Art, Washington, D.C.
Solomon R. Guggenheim Museum, New York City
Virginia Museum of Fine Arts, Richmond
Wadsworth Athenaeum, Hartford, Connecticut
Whitney Museum of American Art, New York City

737, YOUNGERJ, YOUNGERMAN, JACK

10-Year Average Change From Base Years '76-'77: 85%

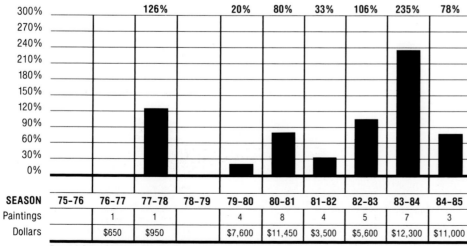

SEASON	75-76	76-77	77-78	78-79	79-80	80-81	81-82	82-83	83-84	84-85
		126%		20%	80%	33%	106%	235%	78%	
Paintings		1	1		4	8	4	5	7	3
Dollars		$650	$950		$7,600	$11,450	$3,500	$5,600	$12,300	$11,000

Record Sale: $6,000, CH, 11/2/84, "Scythia," 75 × 50 in.

ALEX KATZ
(1927-)

Alex Katz is a leading figure painter of the new realism movement in contemporary art. He is best known for his realistic portraits of friends and family, notable for their relaxed attitudes and uncomplicated bearing.

Katz was born in New York City, and studied art at the Cooper Union from 1945 to 1949. In the late 1950s, he found himself among a growing number of artists dissatisfied with the then-dominant stream of abstract expressionism, with its emphasis on formal abstraction.

The rebellion against abstract expressionism, which continued through the 1960s, took several forms. The most celebrated was the pop art of Andy Warhol, Robert Rauschenberg and others, who sought to mine the motherlodes of media imagery and consumer culture for the content of their art.

In contrast to the pop artists, with their emphasis on the consumer icon, a number of painters in the mid-to-late 1950s, including Larry Rivers and Alex Katz, had begun to find their own inspiration in the literal rendition of human figures.

Katz's paintings from the late 1950s to the present have been characterized by such literal, yet expressive, portrayals of human figures. Stylistically, his figures are simplified in form, but not caricatured or rendered grotesque. On the contrary, one of the hallmarks of Katz's figures is their apparent normalcy.

Katz's figures are typically presented

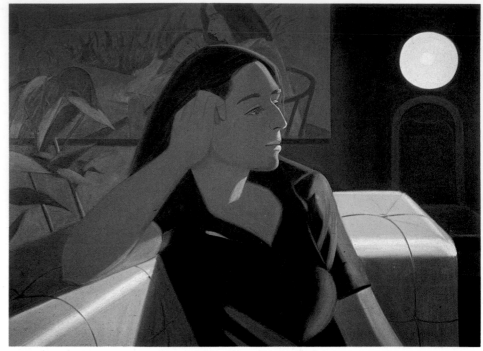

Night, 1976, 72 x 96 in. Courtesy of The Pennsylvania Academy of the Fine Arts, Philadelphia.

at close range from a frontal perspective, and in a flattened manner somewhat suggestive of a Polaroid snapshot.

Filling up the spaces of his canvases, his figures address the viewer head-on, creating a sense of familiarity reinforced by the subjects' relaxed attitudes.

Katz taught painting throughout the 1960s at such institutions as the Pratt Institute, the School of the Visual Arts in New York, and the New York Studio School. He designed stage sets and costumes for the Paul Taylor Dance Company at the Festival of Two Worlds in Spoleto in 1960 and 1964.

In the 1970s, his paintings have been highly influential to the development and popularization of the new realism as a discrete movement in contemporary art.

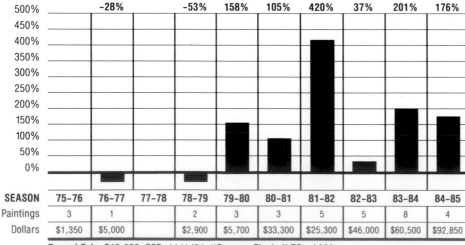

10-Year Average Change From Base Years '75-'76: 113%

	75-76	76-77	77-78	78-79	79-80	80-81	81-82	82-83	83-84	84-85
		-28%		-53%	158%	105%	420%	37%	201%	176%
SEASON	75-76	76-77	77-78	78-79	79-80	80-81	81-82	82-83	83-84	84-85
Paintings	3	1		2	3	3	5	5	8	4
Dollars	$1,350	$5,000		$2,900	$5,700	$33,300	$25,300	$46,000	$60,500	$92,850

Record Sale: $40,000, SPB, 11/1/84, "Summer Picnic," 78 × 144 in.

PUBLIC COLLECTIONS
Art Institute of Chicago
Hirshhorn Museum and Sculpture Garden, Washington, D.C.
Museum of Modern Art, New York City

ALFRED LESLIE
(1927-)

Alfred Leslie is a painter whose work has veered between the two opposite poles of modern art. He started as an abstract expressionist, progressed through a crisper, more geometric style, and then became—and still is—a realist.

His abstract works often were done on a huge scale, and even his harshly-lighted portraits and groups of figures now are heroic in size. His *Self-Portrait* (1967, Museum of Modern Art), for instance, although not a full figure, is nine feet high.

Leslie was born in New York City in 1927. He studied art at New York University and then began to paint in earnest. Almost immediately, he was regarded as one of the most aggressive of the second generation of abstract expressionists, a true "hard-core" action painter.

Although the paint in some of his earlier work seemed literally to explode on the canvas, his compositions actually were carefully structured within a geometric framework. By sometimes putting several canvases together to form an enormous whole, he imposed what seemed like a physical grid on it.

The change in Leslie's style began in the early 1960s, with the geometric elements in his work becoming more dominant. Realistic collage elements began to emerge, side by side with abstract forms. By 1964, his transformation to purely realistic painting was complete. His figures are hard and precise, with even such surfaces as skin seeming to have the sheen of metal or vinyl.

Since the mid-1970s Leslie has borrowed heavily from Caravaggio, even to adapting some of his masterful compositions to modern themes, in his avowed belief that art should be used for moral edification.

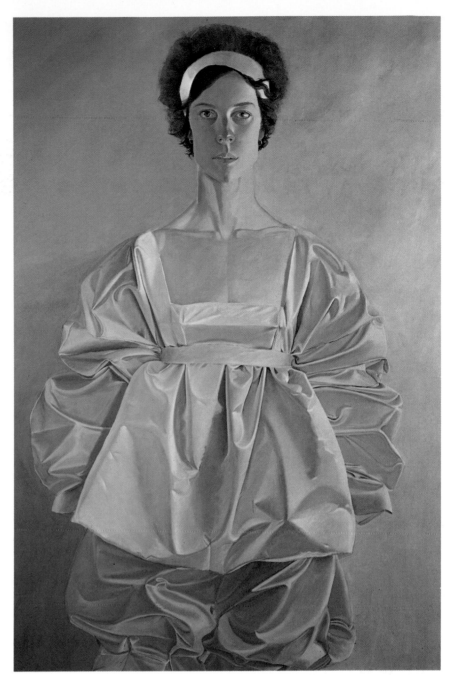

Constance West, 1968-1969, 72 x 54 in. Photograph courtesy of Oil & Steel Gallery, New York. Collection of Robert C. Scull.

SEASON	75-76	76-77	77-78	78-79	79-80	80-81	81-82	82-83	83-84	84-85
Paintings							2	1	2	3
Dollars							$2,937	$1,400	$21,000	$6,600

Record Sale: $12,000, CH, 11/8/83, "Warm Left," 60 × 66 in.

GORDON PHILLIPS
(1927-)

Gordon Phillips, painter, illustrator and sculptor, is a noted contemporary Western painter whose work has achieved success beyond a regional market.

Born in Boone, North Carolina in 1927, Phillips studied art at the Corcoran School of Art in Washington, D.C. As a commercial artist, he had work published in major magazines, including *Look, Time, Newsweek* and *Life;* he was art director for an advertising agency before opening his own studio in Crofton, Maryland to devote himself full-time to fine art.

For 15 years, Phillips made annual trips West. During these extensive forays, he collected Western artifacts and developed a strong sense of landscape, people and the unique Western way of life. But he rarely painted or even sketched during the trips.

"I found that I got a much better feeling for the West when I backed away from it and saw it only in my mind's eye," Phillips said. "Sometimes, one can stand so close to his subject that he is apt to miss the true essence by being overwhelmed by the nuances."

Phillips, proficient in watercolor, goache and pencil, prefers to work in oil. Whether he is painting a mountain snowscape or cowboys galloping across the plains, his style is realistic and his work often highly detailed. But Phillips has said that, to him, the ultimate object is to "paint beyond the detail, so each time a person looks at a painting he will see something new."

Phillips had his first solo exhibition at the Kennedy Gallery in New York City and he has worked on commission for the Smithsonian Institution and the National Geographic Society.

Phillips has also received two gold medals from the Franklin Mint for his pewter and bronze sculptures. His pew-

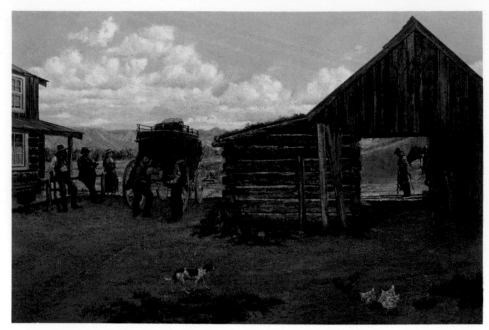

Getting Ready to Go, 1984, 24 x 36 in., signed l.l. Courtesy of Wunderlich and Company, Inc., New York, New York.

ter work *The Holdup of the Overland Stage* carefully details a halting stagecoach, eight human figures and nine horses; it took almost a year to complete.

"Sculpting is therapy," Phillips once said. "I use it as a relief from the two-dimensional surface of the canvas."

PUBLIC COLLECTIONS
Buffalo Bill Museum, Cody, Wyoming

SEASON	75-76	76-77	77-78	78-79	79-80	80-81	81-82	82-83	83-84	84-85
Paintings				1		4	1			
Dollars				$3,800		$24,250	$4,000			

Record Sale: $10,000, SPB, 4/23/81, "Welcome Sight," 23 x 32 in.

HELEN FRANKENTHALER
(1928-)

Helen Frankenthaler pioneered a new movement in modern art with a form of abstraction called "stain painting." Color-field artists of the 1960s followed her lead, soaking their canvases in diluted paints so that areas of color, playing off against one another, became the painting.

In Frankenthaler's work, the image and the canvas are intimately blended. Areas of raw canvas, where the weave shows through, contend with colored areas of varying densities. The whole is pulled together with lines that structure the painting without creating a representational image.

The finished canvas looks as though it were created in a flash of inspiration. Actually, it is the end product of a long process of editing and selecting from more labored works. One painting may be based on 10 previous canvases at which Frankenthaler has worked intuitively to achieve the right balance and color.

The daughter of New York Supreme Court Justice Alfred Frankenthaler, Helen Frankenthaler was born in New York City and attended exclusive private schools. At the progressive Dalton School, she studied under Mexican painter Rufino Tamayo. At Bennington College, she worked with Paul Freeley, learning cubism.

From the start, Frankenthaler was attracted to Kandinsky, Miro, Gorky and de Kooning, and her early work

Small's Paradise, 1964, 100 x 95⅝ in. Courtesy of National Museum of American Art, Smithsonian Institution, Gift of George L. Erion.

shows all these influences. About 1950, she encountered Jackson Pollock, a meeting that was destined to change the direction of her career and that of others who followed her. Seeing the black paint Pollock had soaked into his unprimed canvas, Frankenthaler suddenly realized that a new potential for artistic development lay before her.

She decided to take Pollock's beginning and stretch it. Using highly diluted paints and working with the canvas flat on the floor, Frankenthaler dripped, poured and soaked colors into sailcloth. Many of her canvases are huge, as much as 10 feet high. The scale creates an expansiveness and grandeur suggestive of landscapes.

In 1952, Frankenthaler created a remarkable picture, *Mountains and Sea* (1952, National Gallery of Art). It was the outcome of a visit to Nova Scotia, where Frankenthaler spent the summer sketching mountains and coastline. The painting broke new ground with its areas of delicate coral, blue and grey-green colors, soaked into raw canvas.

Critics were less than enthusiastic. It was not until Frankenthaler won first prize for a painting at the 1959 Paris Biennal that they accepted her work. Within the next decade, she was recognized as the forerunner of a new and important movement.

In her later work, the artist began using acrylics, in a thicker paste, which she rolled or dripped onto the canvas. Rather than making stains, the paints create islands of color that could be lyrical abstractions of canyons or glaciers. This period of her work was influenced, in part, by Hans Hofmann.

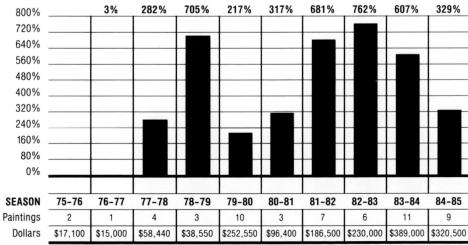

10-Year Average Change From Base Years '75-'76: 390%

	3%	282%	705%	217%	317%	681%	762%	607%	329%	
SEASON	75–76	76–77	77–78	78–79	79–80	80–81	81–82	82–83	83–84	84–85
Paintings	2	1	4	3	10	3	7	6	11	9
Dollars	$17,100	$15,000	$58,440	$38,550	$252,550	$96,400	$186,500	$230,000	$389,000	$320,500

Record Sale: $80,000, CH, 11/11/82, "Approach," 82 × 78 in.

RALPH GOINGS
(1928-)

Diner Interior with Coffee Urns, 1982, 38 x 52 in., signed l.r. Courtesy of O.K. Harris Works of Art, New York, New York.

A photo-realist, Ralph Goings reproduces often-banal urban and suburban settings with a sharp clarity devoid of emotion. Goings is considered one of the most skillful photo-realists, attempting in his paintings to break away from past styles to achieve artistic objectivity.

Born in 1928 in California, Goings received his undergraduate degree in art from the California College of Arts and Crafts and his master's degree from Sacramento State University. In 1960,

Goings had his first one-man exhibit at the Artists Cooperative Gallery in Sacramento.

Photo-realism had its advent in the post-Vietnam era. Subjects are photographically recorded, then exactingly reproduced on the canvas. It is an objective rendering; the paintings lack emotion or irony.

Goings is perhaps best known for his interiors. As in his *Diner* (1980, O.K. Harris Gallery, New York) a brilliance

and clarity superseding photography often marks his works. Details are rendered more meticulously than actual seeing would allow.

In Goings's recent diner pictures, there is never more than one person—a subject often old or unattractive. Their human imperfections stand in sharp contrast to the chrome efficiency of the setting itself.

Goings has had several one-man exhibitions and innumerable group shows. He currently lives in Charlotteville, New York.

SEASON	75-76	76-77	77-78	78-79	79-80	80-81	81-82	82-83	83-84	84-85
Paintings							5	2		1
Dollars							$55,700	$13,800		$2,500

Record Sale: $20,000, SPB, 5/4/82, "Jeep," 44 × 62 in.

PUBLIC COLLECTIONS
University of Miami
University of Nebraska
University of Pennsylvania

AL HELD
(1928-)

Early in his career, Al Held acknowledged his intention to use space "as an actual extension of the canvas . . . that bridges . . . the gulf that separates the painting from the viewer." No painter of his generation has produced starker, more forceful and epic works, paintings that cross space to impart disturbing feelings to the viewer.

Held was born in 1928 in Brooklyn. He studied at the Art Students League in New York City from 1948 to 1949 and at the Grande Chaumiere in Paris from 1949 to 1952. He was a member of the faculty at Yale University from 1962 to 1978.

In the late 1940s, Held was influenced by the work of Jackson Pollock and Dutch abstractionist Piet Mondrian. Abandoning a politically oriented socialist-realist mode, he worked toward combining the subjectivity of Pollock with the objectivity of Mondrian; his work of the 1950s is a synthesis of Pollock's calligraphic ideas and Mondrian's classical space. Although his paintings were already massive in scale, he moved toward larger, simplified, geometric forms in bold, clear colors. His work assumed mural dimensions.

However, Held abandoned this abstract-expressionist manner and in 1960 redefined his individual expressionism. Although associated with colorfield painting at this time, Held's style combined heavy pigment, European geometric abstraction, and the abstract symbolism of American hard-edge painters Kenneth Noland and Ellsworth Kelly. The result was a severely controlled, bright-colored, flat-planed geometrical formalism.

In his later works, Held has deserted color for a dramatic black-and-white framework reminiscent of Renaissance experiments in perspective drawing.

Volta V, 1977, 96 x 143⅞ in. Courtesy of Hirshhorn Museum and Sculpture Garden, Smithsonian Institution, Washington, D.C.

Held considers himself a realist. He has continued to define his first vision of the painting as reality, as an object rather than an illusion of something else. And he has continued to work toward bridging the space between painting and viewer.

PUBLIC COLLECTIONS
Albright-Knox Art Gallery, Buffalo
Dayton Art Institute, Ohio
Everson Museum of Art, Syracuse, New York
Greenville County Museum of Art,
 South Carolina
Kunsthalle, Basel, Switzerland
Museum of Modern Art, New York City
San Francisco Museum of Art
Whitney Museum of American Art,
 New York City

SEASON	75-76	76-77	77-78	78-79	79-80	80-81	81-82	82-83	83-84	84-85
Paintings	2		2	6	2	1	3			6
Dollars	$6,275		$28,900	$27,080	$4,400	$2,800	$14,250			$43,900

Record Sale: $30,000, CH, 2/23/85, "Triangle Circle," 60 × 42 in.

ROBERT INDIANA
(1928-)

Ballyhoo, 1961, 60 x 48 in. Photograph courtesy of M. Knoedler & Co., Inc., New York, New York.

"There have been many American SIGN painters, but there never were any American sign PAINTERS." This exercise in emphasis sums up Robert Indiana's position in the world of contemporary art. He has taken the everyday symbols of roadside America and made them into brilliantly colored geometric pop art. In his work he has been an ironic commentator on the American scene. Both his graphics and his paintings have made cultural statements on life and, during the rebellious 1960s, pointed political statements as well.

Born Robert Clark in New Castle, Indiana, in 1928, he adopted the name of his native state as a pseudonymous surname early in his career. During his typically Midwestern boyhood, highway signs had a symbolic importance for him. His father worked for Phillips 66 gas and, when he left his wife and son, he did so down Route #66. And the diner which his mother subsequently operated had the familiar "EAT" sign looming overhead.

Indiana studied first at the Herron School of Art in Indianapolis and then at the Munson-Williams-Proctor Institute in Utica, New York. From there he went to the School of the Art Institute of Chicago where he received a degree in 1953 and won a traveling fellowship to Europe. In 1954, he attended Edinburgh University and Edinburgh College of Art in Scotland.

Back in America, Indiana settled in the historic Coentes Slip area on the New York waterfront in 1956 and showed his first hard-edged paintings the following year. From the start he worked with bold, contrasting, sometimes clashing, colors that mirror familiar signs along the highways.

A moralist at heart and an admirer of Longfellow, Whitman and Melville, Indiana often wryly prods his viewers. In a billboard-like triptych dedicated to Melville, for example, he reminds them of Manhattan's past and suggests they walk around the island-city. He also feels a strong kinship with such earlier precisionist painters as Charles Demuth and showed his admiration in *The Demuth American Dream No. 5* (1963, Art Gal-

lery of Ontario, Toronto). Although painted in Indiana's own idiom, it was clearly inspired by Demuth's well-known *I Saw the Figure 5 in Gold* (1928, Metropolitan Museum of Art).

The American dream has been a recurring theme in Indiana's work, and he has used it to both celebrate and criticize the national way of life. In the midst of all the gaudy, star-spangled color of *The American Dream #1* (1961, Museum of Modern Art), for instance, he highlights the words "Take All" and "Tilt" as reminders both of Americans' materialism and of the tendency of some to cheat, as they do on pinball machines.

In his paintings and constructions he has given new meaning to such basic words as "Eat", "Die" and "Love". Using them in bold block letters in vivid colors, he has enticed his viewers to look at the commonplace from a new perspective. One indication of his success was the appearance of his immensely popular multi-colored "Love" on a United States postage stamp in 1973.

10-Year Average Change From Base Years '76-'77: 45%

SEASON	75-76	76-77	77-78	78-79	79-80	80-81	81-82	82-83	83-84	84-85
		256%	74%	14%	31%	-33%	15%	-5%	51%	
Paintings		2	1	1	6	6	1	4	3	3
Dollars		$12,900	$2,104	$18,000	$33,900	$75,400	$1,400	$46,700	$36,500	$37,109

Record Sale: $23,000, SPB, 11/13/80, "Love," 48 x 48 in.

PUBLIC COLLECTIONS
Albright-Knox Gallery of Art, Buffalo, New York
Detroit Institute of Arts
Indianapolis Museum of Art
Los Angeles County Museum of Art
Louisiana Museum of Art,
 Humlebaek, Denmark
Metropolitan Museum of Art, New York City
Museum of Modern Art, New York City
Stedelijk Museum, Amsterdam, The Netherlands
Whitney Museum of American Art,
 New York City

CY TWOMBLY
(1928-)

Cy Twombly is one of the most significant American painters of the twentieth century. His list of exhibitions is tremendously long, and it includes shows in Italy, Germany, France, Switzerland, Belgium and The Netherlands as well as the United States.

Born in Lexington, Virginia in 1928, Twombly studied in several institutions, including Washington and Lee University in Lexington, the Boston Museum School and the Art Students League in New York City. In 1951, he worked with Franz Kline and Robert Motherwell at Black Mountain College in North Carolina.

From 1951 to 1953, Twombly traveled and lived in North Africa, Spain and Italy. In 1957, he settled in Rome, where he now lives.

Twombly is best known for his unique style of drawing and painting. Developed during the 1950s, his use of paint, crayon and pencil to create calligraphic marks and squiggles has often been referred to as "doodle" art. The marks he makes are both abstract and extremely energetic; occasionally they are also erotic, as in *The Italians* (1961, Museum of Modern Art). Twombly incorporates words and numbers in many of his pictures, and his titles often refer to Roman mythology. By simultaneously painting in an abstract manner and alluding to ancient myths, Twombly unites his modern paintings with classical traditions.

Untitled, 1982-1984, 44¼ x 30 in. Courtesy of Sperone Westwater, New York, New York. Photography: Zindman/Fremont.

Twombly is gaining recognition in the United States. In 1979, the Whitney Museum of American Art held a major retrospective exhibition of his work. The successful show included work from the previous 25 years.

PUBLIC COLLECTIONS
Museum of Modern Art, New York City

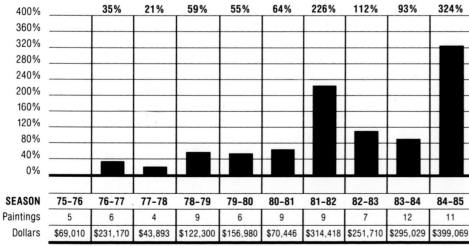

10-Year Average Change From Base Years '75-'76: 99%

SEASON	75-76	76-77	77-78	78-79	79-80	80-81	81-82	82-83	83-84	84-85
		35%	21%	59%	55%	64%	226%	112%	93%	324%
Paintings	5	6	4	9	6	9	9	7	12	11
Dollars	$69,010	$231,170	$43,893	$122,300	$156,980	$70,446	$314,418	$251,710	$295,029	$399,069

Record Sale: $180,000, SPB, 10/31/84, "Lala," 45 x 53 in.

NICHOLAS KRUSHENICK
(1929-)

Hard-edged, overlapping geometric shapes, painted in even, bold colors and outlined in black, characterize the mature works of Nicholas Krushenick.

Though collage is not a large portion of Krushenick's output, its influence is evident in his progression from cubism to the abstract expressionism of his later work. The layering of his characteristic style has a collage effect directly related to his cut, stapled and pasted early collages.

Born in 1929 in New York City, Krushenick drew at an early age and decided at age 17 on an art career. After a stint in the army, he attended the Art Students League from 1948 to 1950, and the Hofmann Art School in 1950 and 1951. In the 1950s, he supported himself as a window and stage-set designer, construction worker and antique-store proprietor.

Until 1960, Krushenick's work was curvilinear, even undulating. Around 1959, he switched from oil paints to almost-fluorescent acrylic liquitex as a medium.

His style became bold, aggressive and rigidly angular. Some elements have a machined, three-dimensional look, appearing to come forward out of the picture plane. A series of paintings after the mid-1960s have the appearance of vast cut-outs.

Contemporary with the pop artists, Krushenick's work has the look of pop art's mass-media forms, but he depicts no commercialized or real objects. He instead suggests the existence of invented "objects" in his canvases through the use of shapes, whole or apparently chopped off.

Measure of Red, 1971, 90 x 70 in. Courtesy of Hirshhorn Museum and Sculpture Garden, Smithsonian Institution, Washington, D.C.

PUBLIC COLLECTIONS
Albright-Knox Art Gallery, Buffalo
Dallas Museum of Fine Arts
Los Angeles County Museum of Art
Metropolitan Museum of Art, New York City
Museum of Modern Art, New York City

SEASON	75-76	76-77	77-78	78-79	79-80	80-81	81-82	82-83	83-84	84-85
Paintings	1	1	2		3	5	3	4	2	1
Dollars	$1,212	$3,000	$4,400		$8,700	$7,700	$5,250	$7,350	$3,110	$1,200

Record Sale: $3,500, SPB, 10/2/80, "Orange Block Co.," 59 × 50 in.

1000

JASPER JOHNS
(1930-)

At a time when younger painters were becoming disillusioned by what they perceived as a sameness that had settled over abstract expressionism, Jasper Johns and Robert Rauschenberg startled the art world by introducing mundane objects into their work, sometimes painting them realistically, at other times actually attaching the objects themselves to the work. In doing so, individually and together they deflected the course of abstract expressionism and paved the way for pop art and the minimal art that was to follow.

Although Johns's work became more and more abstract as he developed, there always has been an intellectual searching behind it. From the very outset he has been involved in reexamining the meaning of objects. In doing so, he has become one of the most important painters of the second half of the twentieth century.

Johns was born in Allendale, South Carolina in 1930. He never had any formal art training. He attended the University of South Carolina for two years, then moved to New York City, but soon was drafted for a two-year stint in the army. Returning to New York, he became a close friend of Rauschenberg, dancer Merce Cunningham and composer John Cage—all of whom have become known for new, perhaps even radical, approaches to their respective art forms.

One of Johns's first paintings to attract major attention was *Flag* (1955, Museum of Modern Art). In it, a thickly painted United States flag takes up the entire field of the canvas. Flat, two-dimensional, totally removed from any emotional or political context, it becomes simply a pattern of stars and stripes. Over the next few years he did the same thing with such everyday symbols as numbers and targets. In each case, however, he raised paradoxical questions about the objects themselves

0 through 9, 1961, 54⅛ x 41⅜ in. Courtesy of Hirshhorn Museum and Sculpture Garden, Smithsonian Institution, Washington, D.C.

and the way in which he had treated them.

After 1961, the paradoxes in his work became more complex. Instead of following the prevalent trend toward hard edges, his work became more and more abstract. Taking a cue from the surrealists and dadaists, he sometimes included extraneous objects, or even painted statements about the act of painting itself. In *Device* (1960-1961, Dallas Museum of Fine Arts), for instance, he includes the pieces of wood used to describe the circles that are an integral part of the painting.

In addition to these works, which are more properly assemblages than paintings, Johns has done sculptures of equally mundane objects as well. Perhaps the most straightforward—and best known—is his *Painted Bronze (Beer Cans)* (1960, private collection), which has a direct link to pop art.

Johns has always worked in encaustic. He is interested in rich color and in the texture of his surfaces. There is a sensuousness about his work, despite its flatness and seeming impersonality.

In seeking to explain how he works, Johns once said simply, "Take an object, do something to it, do something else to it." But in another statement that recalls his lifelong search for new meanings in whatever he paints, he has also said, "What it is—subject matter—is simply determined by what you're willing to say it is. What it means is simply a question of what you're willing to let it do."

MEMBERSHIPS
National Insitute of Arts and Letters

PUBLIC COLLECTIONS
Albright-Knox Art Gallery, Buffalo, New York
Dallas Museum of Fine Arts
Kunst Museum, Basel, Switzerland
Metropolitan Museum of Art, New York City
Moderna Museet, Stockholm
Museum of Modern Art, New York City
Tate Gallery, London
Victoria and Albert Museum, London
Wadsworth Athenaeum, Hartford, Connecticut
Whitney Museum of American Art, New York City

SEASON	75-76	76-77	77-78	78-79	79-80	80-81	81-82	82-83	83-84	84-85
Paintings				1		1	2	1	1	2
Dollars				$19,000		$16,000	$115,000	$330,000	$55,000	$74,000

Record Sale: $330,000, SPB, 5/20/83, "In Memory of My Feelings—Frank O'Hara," 40 × 60 in.

ROBERT NATKIN

(1930-)

Robert Natkin's paintings are expressionist abstractions, intensely colorful, with loosely defined forms hanging in unlimited space. As an art student, he was inspired by the color of Henri Matisse and Pierre Bonnard, as well as by Paul Klee's use of cubism's shapes and forms. He was also influenced by New York School artists Willem de Kooning, Philip Guston and Mark Rothko.

Born in Chicago in 1930, Natkin graduated from the Art Institute of Chicago in 1952. In 1957, he married painter Judith Dolnick and they settled in Chicago. Natkin and a friend opened the Wells Street Gallery, which created an opportunity for young Chicago artists to exhibit their experimental work. The gallery closed in 1959, and Natkin went to New York City to participate in the Whitney Museum's show "Americans Under 35." During the late 1950s and early 1960s, he held one-man shows in Los Angeles, Boston and Philadelphia.

Natkin's paintings tend to run in series. The "Apollo" series continued through the 1960s. Reminiscent of the colorful brilliance of impressionist Pierre Bonnard, the "Apollo" series is the focal point of Natkin's work and his growth as a painter. These paintings are sunny and light, invoking the lyricism of Apollo, the Greek god of poetry and light. They contain vertical strips of color which are both thick and thin, decorative and textured.

Apollo Series, 1978, 18 x 24 in. Photograph courtesy of Gimpel & Weitzenhoffer Galleries, New York, New York.

Hitchcock Series, 1985, 30 x 42 in., signed l.r. Photograph courtesy of Gimpel & Weitzenhoffer Galleries, New York, New York.

His other series are titled "Steps and Grids," "Field Mouse and Intimate Lighting," "Bath and Face" and "Bath Apollo." Natkin's themes recur in many of these series: overlapping patchwork, snake forms, heart and doughnut shapes, columns, grids and shifting planes.

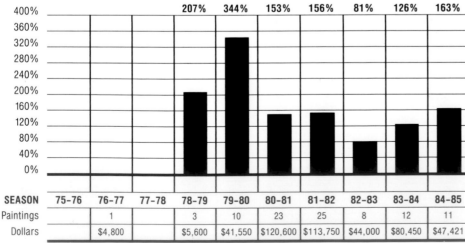

10-Year Average Change From Base Years '76-'77: 154%

	207%	344%	153%	156%	81%	126%	163%

SEASON	75-76	76-77	77-78	78-79	79-80	80-81	81-82	82-83	83-84	84-85
Paintings		1		3	10	23	25	8	12	11
Dollars		$4,800		$5,600	$41,550	$120,600	$113,750	$44,000	$80,450	$47,421

Record Sale: $18,000, SPB, 11/13/80, "Bern Series," 89 x 95 in.

GLOSSARY

A

Abstraction. Art which makes no direct, immediately discernible reference to recognizable objects. In abstract art, the formal arrangement of colors and forms is independent of, and more important than, the subject matter.

Academic. Pertaining to the arts as taught in academies and schools of art according to established rules. Since the high tide of conservatism in the late nineteenth century, the term has become synonymous with traditional thinking and opposition to fresh and innovative ideas in art.

Acrylic. A widely used water-based polymer paint. Because of its chemical composition, it combines the characteristics of traditional oil and watercolor paints and can be used for washes and for heavy impasto. It is relatively odorless, quick-drying and extremely resistant to deterioration.

Action painting. The vigorous, often improvisatory, gestural slash and drip paintings made most notably by Jackson Pollock, Willem de Kooning and Hans Hofmann. The term is often used to describe the entire abstract expressionist movement, including the more consciously planned canvases of Mark Rothko, Barnett Newman and others.

Aquatint. Like etching, a method of engraving which uses acid to eat into a metal plate. Unlike etching, however, it is a tone, rather than a line, process. The porous ground of the plate allows the acid to form a network of extremely fine lines, creating transparent effects comparable to those of watercolor painting.

Armory Show. The International Exhibition of Modern Art held in 1913 at the 69th Regiment Armory in New York City and later in Boston and Chicago. It introduced avant-garde European and contemporary American painting to the American public and critics. Enormous in scope (approximately 1,600 paintings) and highly controversial, it proved to be the turning point in the development and appreciation of modern art in the United States.

Art Institute of Chicago. Established in 1879 as an art school, it has grown into one of the major art institutions of the United States. Approximately 4,000 students attend its classes annually. Its collections—particularly of Spanish, Flemish, Dutch, French and American paintings and of Near Eastern and oriental decorative arts—place it among the outstanding museums of the world.

Art nouveau. A decorative linear style which appeared in all media throughout Europe and in the United States at the end of the nineteenth century. Characterized by sinuously curving organic forms, it was often used to depict mysterious landscapes, women and symbolist subjects.

Ashcan School. The work of a group of late-nineteenth- and early-twentieth-century realist American painters who, disdaining the prevailing aestheticism of the academics, determined to bring painting back into touch with the life of the common man. Often collectively called The Eight, they depicted the seamy life of the streets, taverns and prize-fight rings, thus gaining the distinctly derogatory designation of their school.

Assemblage. Mixed-media combinations of found objects (rather than traditional art objects of paint, canvas, carved stone and cast bronze). Primarily assembled, rather than painted, modeled or carved, these works question the nature of art and often break down the traditional distinctions between painting and sculpture.

B

Barbizon. The style developed by a group of landscape painters in mid-nineteenth-century France who lived and worked in Barbizon, a village on the edge of the forest of Fountainebleau. Opposed to the prevailing classical conventions of landscape painting, they strove to depict peasant life and the surrounding country-side exactly as it was, without prettification. The best-known of the group were Millet and Rousseau.

Baroque. An opulent style, religious in origin, that prevailed in the Roman Catholic countries of Europe, particularly in France and Italy, from the end of the sixteenth century until the early eighteenth century. In its truest form it was a union of architecture, painting and sculpture, all designed to evoke a strong emotional response. Through skillful use of substance, light, color and texture, baroque artists sought to create an illusion of the actuality and truth of a subject.

Bauhaus. A utopian school founded in 1919 in Weimar, Germany to promote the unity of the arts and harmony between craftsmanship and artistry in a modern technological society. The school moved to Dessau in 1925, was closed by Hitler in 1933, and has been continued in the United States at Harvard University and the Illinois Institute of Technology. The teachings of Josef Albers, first at the Black Mountain School and later at Yale University, promoted the Bauhaus ideal.

Blaue Reiter (Blue Rider). A pre-World War I artistic alliance established in Munich in 1911, it was founded by Vasily Kandinsky and Franz Marc, who also published the *Blaue Reiter Almanac*. The style of the group, which turned toward the symbolic semi-abstraction of bold and strident color, was used by American painter Marsden Hartley for his "German Officer" series. Together with Die Bruecke (the Bridge), established in Dresden in 1905, the Blaue Reiter composed the foundations of German expressionism.

Boston School. A group of American impressionist painters who studied or worked in Boston around 1900, several of whom were also members of The Ten. The dominant

figures were Edmund C. Tarbell and Frank W. Benson. Although impressionist landscape paintings were popular in Boston as early as the late 1880s, the impressionist figure paintings of the Boston School were not well received there until after 1900.

Brandywine School. Initially a term used to denote the work of Howard Pyle and the many illustrators he taught and influenced through his hand-picked classes in Wilmington, Delaware and Chadds Ford, Pennsylvania, both located on the Brandywine River. Because several of the progeny of N.C. Wyeth, perhaps Pyle's best-known student, have continued to live in the area and paint in a distinctive representational manner, the term now has come also to include succeeding generations of the Wyeth family, most notably Andrew Wyeth, and similarly influenced local painters as well.

C

Ca. Abbreviation for circa, meaning "about" or "approximately."

Century Association. An organization founded in New York City in 1847 when members of the Sketch Club asked 100 men (hence the name) to form a new club oriented toward the arts. Its membership now includes educators and other professionals in addition to practicing artists. Its clubhouse, which includes galleries for frequent exhibitions, is at 7 West 43rd Street in Manhattan.

Chromolithography. A method of surface-printing lithographs in many colors which involves no engraving. A different stone or plate is used for each color and each is printed in exact register with the others. It is widely used, particularly for posters and other forms of commercial art.

Classical. A term used to describe art which conforms to the standards and principles established in ancient Greece and Rome. Generally speaking, such work is characterized by its simplicity, symmetry and dignity.

Color field. Organic, sensuous and joyous abstract painting developed in the United States during the 1960s in which color is both the form and the subject (also identified with post-painterly abstraction). The very large, fluid, stained or sprayed areas of color often allude to landscapes; some of them seem devoid of passion or emotional expression.

Constructivism. A radical movement begun in Russia by 1917 by the brothers Naum Gabo and Antoine Pevsner, who used industrial materials in three-dimensional sculpture. Transplanted to Paris and Germany, it was picked up by American artists; its formal anti-expressionism dominated American abstract art of the early 1930s.

Conte crayon. A proprietary name for a man-made chalk which is widely used in sketching. It is available in black, brown and red and was named for Nicholas Conte, who developed the first lead pencil in 1790.

Cos Cob, Connecticut. One of several communal art colonies which were developed by plein-air American impressionists in picturesque locales accessible by railroad (and later by automobile) from New York City. Other such colonies included Old Lyme, Connecticut, Appledore, Isle of Shoals, New Hampshire, and the Shinnecock Hills of Long Island, New York.

Cubism. A style which originated in the search by Picasso and Braque for methods of representation to replace the sensuous pictorial realism of the impressionists. Derived from the perceptual realism of Cezanne, cubism developed into an austere, very logical technique by which the permanent structure of an object was analyzed and then fragmented into planes to reveal its whole structure. Rather than depicting objects as they appear, the cubists superimposed several different views of the same object to express the idea of the object instead.

D

Dada, New York. A 1915 forerunner of the irreverent international avant-garde dada movement, led by French-born Marcel Duchamp, Cuban-born Francis Picabia and American-born Man Ray. The concepts underlying their activities, publications, paintings and readymades (nihilistic or ironic sculptures based on manufactured objects) became the basis for later pop and conceptual art.

Daguerrotype. The earliest successful photographic process. Developed in France by Louis Daguerre in the mid-nineteenth century, it made use of a silver or silver-covered copper plate which was made sensitive to light through the use of chemicals.

Decorative. A general term for all arts in which decoration is added to a functional object. In the context of painting, it frequently is applied to work that is intended to embellish or ornament a given space. Purists traditionally disdain decorative work as not a part of the fine arts of painting and sculpture.

Dusseldorf. Between 1840 and 1860 many prominent American artists—including Albert Bierstadt, George Caleb Bingham, Eastman Johnson, Emmanuel Leutze and Richard Caton Woodville—were attracted to the study of sentimental genre painting at the Dusseldorf Academy. The Dusseldorf style is typically hard and dry. After the Civil War, a shift toward realism led younger students to Munich and Paris instead.

E

The Eight. A group of eight relatively dissimilar realist painters, led by Robert Henri, who banded together in 1908 to exhibit their work independently after the work of three of them had been rejected for exhibition at the National Academy of Design. They exhibited together only once, but the name remained with them; they were also known as members of the Ashcan School. The Eight were Henri, William Glackens, George Luks, Everett Shinn, John Sloan, Arthur Davies, Ernest Lawson and Maurice Prendergast.

Encaustic. An ancient painting technique, mentioned by Pliny, in which colors were mixed with wax which in turn was heated so that the colors were absorbed into the wall. The same technique was used for a time in Egypt in the first century A.D. for small portraits on mummy cases. Leonardo da Vinci attempted without success to revive the process in the early sixteenth century, and several artists also attempted to use the method in the late nineteenth century.

Engraving. A term which has come to refer to all the processes for multiplying prints. While there are distinct differences between individual methods of engraving, the chief difference is between reproductive and original engravings. The former reproduce an idea or work of an artist other than the engraver, while original engravings are unique works of art created by engraver himself.

Etching. A widely used form of engraving in which the etcher draws on a copper plate which has been covered with an acid-impervious resinous ground, exposing the copper wherever he wants a line. When the plate is placed in an acid bath, the exposed parts are eaten away. By controlling the depth of the acid "bite," subtle variations in the strength of lines may be achieved. Prints are then made by inking the plate, removing the ink from its surface, and pressing paper onto the plate; the picture is made by the ink in the etched-away lines.

Expressionism. A late-nineteenth- and early-twentieth-century northern European movement away from the representation of the observed world to the expression of personal emotional intensity. Its subjective, exaggerated and distorted colors and forms were further developed in the abstract expressionism of Willem de Kooning and others and, in the 1980s, in the work of the neo-realists.

F

Fauvism. The spontaneous use of pure bright color (rather than tone), expressively applied with distortions in flat patterns. Work in this style by Henri Matisse and others was first exhibited in the Paris Salon d'Automne of 1905; the furor it aroused caused a critic to label these artists the "fauves" (wild beasts). Max Weber helped Matisse organize a short-lived school in 1907, which was attended by Patrick Henry Bruce and other Americans.

Federal period. A phase of neo-classicism in design and architecture in the United States which lasted from approximately 1780 until approximately 1820. It was based primarily on the work of Robert and James Adam in England. Its most distinguishing features were: graceful, slender proportions; small but delicate ornaments; and curvilinear elements, such as eliptical rooms and sweeping circular staircases.

Folk art. Paintings, objects and decorations made in a distinctive or traditional manner by artists or craftsmen who have had no formal training. In general, it is looked upon as an autonomous tradition which is seldom affected by changes in fashion or trends in professional art.

Fourteenth Street School. A relatively small group of realist painters who, in the late 1920s and 1930s, had studios in the vicinity of Union Square and 14th Street in New York City. In sharply different styles they continued in the tradition of the Ashcan School and portrayed boisterous, vulgar crowds, lonely individuals and the hopelessness of people in breadlines. The group was founded by Kenneth Hayes Miller, but its most substantive work was done by Reginald Marsh, Raphael and Moses Soyer and Morris Kantor.

Futurism. An artistic program which arose in Italy shortly before the outbreak of World War I and sought to simulate the dynamism of the modern urban technological world through exploding faceted cubist form. Joseph Stella used the style for his monumental depictions of the Brooklyn Bridge.

G

Gouache. An opaque watercolor paint. The effects achieved with it are closer to those of oil paint than of watercolor. A disadvantage of gouache is the fact that it lightens as it dries.

H

Hudson River School. A succession of American painters who, between 1840 and the late nineteenth century, established for the first time a true tradition of landscape painting in the United States. Many of the scenes they painted were in the Hudson River Valley and the adjoining mountains of New York State and Vermont. Their work, derived from European romantic landscape painting, was marked by a meticulous rendering of detail and by an almost religious reverence for the magnificence of the American wilderness.

I

Impasto. A thick application of oil paint on canvas or a panel. The heaviness of the paint, often clearly showing the marks of individual brushstrokes, is thought to add character and vigor to the painting.

Impressionism. One of the most important artistic movements of the nineteenth century in France and in many ways the precursor of much of modern art. It began as a loose association of brilliantly innovative painters, such as Monet, Renoir and Sisley, whose primary purpose was to record their immediate emotional responses to a scene, rather than to create a conventional record of nature. The styles of impressionist painters varied widely, but they were united by their desire to capture the spontaneity of the moment and to avoid the constrictions of formal compositions.

L

Limner. A designation used originally in the Middle Ages for an illuminator of manuscripts. Beginning in the sixteenth century it took on new meaning to include painters of miniature portraits and sometimes painters in general. In this last context the term has been obsolete since the nineteenth century. Early American folk artists were sometimes called limners.

Lithography. The only major process of surface printing in which no engraving or cutting-out of the surface of the plate is involved. The design is put on the surface of a stone with a greasy chalk; the stone is wetted and then covered with a greasy ink, which is rejected by the wet surface and clings only to those areas which already are greasy.

Lotos Club (also Lotus Club). A New York City club dedicated to the cultivation of the arts. Since its founding in 1870 it has honored many distinguished writers, musicians, actors and others in the arts with testimonial dinners. Its quarters are at 5 East 66th Street.

Luminism. An effect that is obtained in painting when a light or reflective undercoat of paint is visible through a thin or transparent outer layer. The technique was developed in the mid-nineteenth century in America by painters, such as George Caleb Bingham, who had a particular interest in the character of light as an element in painting.

M

Macchiaioli. An important school of Italian painters who worked in Florence between 1850 and approximately 1865. In revolt against academic painting and influenced by the realism of Corot and Courbet, they employed individual touches or daubs of color to achieve their desired effect. Some of the group were landscape and genre painters, while others did costumed history scenes.

Magic realism. An American variant of surrealism which uses sharp focus and precise representation to portray imaginary subjects.

Mannerism. A sophisticated, sixteenth-century, elongated style used most elegantly in Italy and elsewhere for international court portraits. Seventeenth-century colonial portraits were often based on English prints of mannerist portraits and on Italian mannerist treatises filtered through England.

Minimal art. Reductive movements of the 1960s, including color-field painting, op art, hard-edge painting and serial imagery. They arose as a further development of the cool, formal, abstract expressionist art of Mark Rothko, Barnett Newman and others, and as a reaction against autobiographical gestural action painting.

Modernism. A term used to describe innovations in art brought about by two factors: a strong sense of detachment from the past and a deliberate desire to replace past aesthetic concepts with an artistic expression more in accord with the contemporary ideas and beliefs. Sometimes reaction to prevailing aesthetic concepts can take the form of a return to those of an earlier period. Although the requisite sense of detachment from the past has been especially strong through much of the twentieth century, the term "modernism" can be applied to innovations in any art period.

Munich School. A group of radical young German painters under the leadership of Wilhelm Liebl in Munich in the latter half of the nineteenth century. Their work was characterized by a choice of commonplace subject matter, loose and vigorous brushwork and a relatively dark and restricted palette. This style had a strong influence on many young Americans who came to Munich to study in the 1870s, notably Frank Duveneck and William Merritt Chase.

N

Nabis. Young French painters between 1889 and 1899 who were influenced by Eastern motifs, esoteric ideas and the art of Paul Gauguin. Their goal was to devise decorative techniques to adorn "a plane surface covered with colors brought together in a certain order." Their name comes from the Hebrew word for "prophet."

National Academy of Design. Founded in New York City in 1826 by Samuel F.B. Morse and others as a rebellion against the dictatorial administration of an earlier American Academy of Fine Arts. Over the years the National

Academy became a bastion of conservatism and the works of innovative young artists were frequently excluded from its exhibitions. Most trends in twentieth-century American art have developed independently of the Academy.

Neoclassicism. An eighteenth-century attempt to revive the classical art—and thereby the glory—of ancient Greece and Rome. In the United States it was consciously adopted for the art (especially the architecture) of the early republic.

New Deal Art. Art produced between 1933 and 1943 under the auspices of various government programs, including the Works Progress Administration's Federal Art Project (WPA/FAP) and the Treasury Relief Administration Project (TRAP), which employed more than 5,000 artists. The subject matter of most of the thousands of murals and easel paintings these programs generated was interpretations of the prescribed American scene.

New Hope School (Pennsylvania impressionists). A group of American landscape painters with strong inclinations toward impressionism who settled and painted in the region around New Hope, a small town on the Delaware River in rural Bucks County, Pennsylvania, for several generations beginning in 1898. Although he did not live in New Hope, Edward Redfield is considered the leader of the group. Because of their focus on scenes of the countryside and country life, the group now is looked upon as a rural counterpart to the urban Ashcan School of painters, with whom they were contemporaries.

New York School. The name given to the group of bold, highly innovative painters who lived and worked in New York City during the 1940s and 1950s and who collectively developed abstract expressionism. Also known as action painting, the work of this school had as far-reaching an effect on artists as cubism had had on earlier generations of painters.

O

Old Lyme impressionists. A loosely defined group of early-twentieth-century American impressionist landscape painters who worked in the area of Old Lyme, Connecticut, a picturesque old town at the mouth of the Connecticut River. Childe Hassam was one of the early members and the catalyst around whom the group coalesced. Several other members of The Ten, among them J. Alden Weir and John H. Twachtman, were also considered Old Lyme impressionists.

Op art. An abbreviation for optical art, a term first used to define work in "The Responsive Eye" exhibition at the Museum of Modern Art in 1965. It covers a broad range of sophisticated, geometric, abstract painting styles which exploit perceptual ambiguities and shock or distort what is perceived by the viewer.

Orientalism. In its earliest connotation, the interest in the exotic colors and savage passions of the Middle East and North Africa that first appeared in the work of Delacroix in the 1820s and later became an important element in romantic painting. In a later context, it refers to the influence of oriental art and design, particularly of Japanese prints, on the work of such painters as Whistler, Van Gogh and Gauguin after the United States gained access to Japanese ports in 1854. The universal values embodied in oriental art, calligraphy and philosophy have been adapted or reflected in American painting most recently in action painting and the work of some painters of the Northwest.

Orphism. A completely abstract type of color painting created by French artist Robert Delaunay in 1912-1913. His work contained no reference to the visual world; he believed that "color alone is form and subject."

P

Painterly. The tendency to depict form as patches of colored light and shade, in which edges merge into the background or into one another, best exemplified by the work of Rembrandt. Its opposite, linear, which denotes an emphasis on outline and drawing, is considered characteristically American.

Panorama. A complete depiction of a landscape or historical scene, often mounted on the inside of a large cylindrical surface, such as a curved wall or round room. It may also be a scene that is passed before a spectator in such a way as to show the various parts of the whole in continuous succession.

Pennsylvania Academy of the Fine Arts. The oldest continuously operative art institution in the United States. Modeled after the Royal Academy in London, it was founded in Philadelphia in 1805 by Charles Willson Peale, sculptor William Rush and a group of prominent local business and professional men. In addition to the Academy's continuing teaching functions, its museum is recognized for its comprehensive collection of American painting.

Photo-realism. Also known as superrealism, a style of figurative painting and sculpture of photographic exactitude that gained prominence in the United States and England during the 1960s and 1970s. It was usually characterized by banal contemporary subject matter and a glossy finish. Unlike naturalism, however, its aim was to create a sense of unreality through an almost hallucinatory wealth of detail and sometimes through altered scale.

Plein-air. The French phrase for "open air." The term refers to painting which is done outdoors, directly from nature. It is also used sometimes to describe a style of painting which conveys a feeling of openness and spontaneity.

Pop art. Art which uses symbols, images and objects of mass production and contemporary popular culture—normally seen on supermarket shelves, in mass-media advertising and in comic strips—in the context of the fine arts. It appeared in England in the mid-1950s, but reached its apex in the United States during the 1960s in the work of painters like Andy Warhol, Jasper Johns and Robert Rauschenberg and sculptors like Claes Oldenburg. Much of its effect on the viewer is based on the shock value of seeing the commonplace displayed as serious art.

Post-impressionism. A term invented by English art critic Roger Fry when he organized an exhibition in London of such modern French masters as Cezanne, Manet and Matisse in 1910. The term underscored the fact that these painters had rejected the principles of impressionism and had instead focused their attention on creating form rather than imitating natural form.

Post-modernism. A general term used to cover such contemporary phenomena as pop art and pop design, which appeared in the 1960s as a reaction against the values established by the acknowledged masters of modern art. The initiators of post-modernism felt that modern art and the functionalism of modern design did not fulfill the psychological and emotional needs of ordinary people as they were reflected in the popularity and near-universal acceptance of mass-produced consumer goods.

Pre-raphaelitism, American. An association, organized in 1863 in emulation of John Ruskin's British Pre-Raphaelite Brotherhood in order to promote landscape, still-life and nature painting with the photograph as a standard of accuracy. John William Hill and William Trost Richards were two of the members of the Association for the Advancement of Truth in Art who published the American pre-raphaelite manifesto in *The New Path.*

Precisionism. Known in the 1920s and the 1930s as cubist realism, the work of Charles Sheeler and other "immaculate" painters featured indigenous American subject matter executed in a sharp, precise linear manner, without figures or anecdotal elements.

Primitive art. A term which often is applied to paintings and other art in three distinctly different categories: 1) Dutch and Italian painters working before the Renaissance, or before about 1500 A.D. 2) The work of peoples, such as African blacks, Eskimos and Pacific islanders, whose art matured unaffected by any influence from the traditional great centers of culture. 3) The work of artists, primarily European and American, who have received little or no formal training, yet have developed their own unsophisticated, nontraditional style.

R

Realism. In one context, this term refers to the depiction of life as it is—even the squalid and ugly—instead of conventionally beautiful or idealized subjects. In another context, it means representational painting, as against that painting which is deliberately abstract or distorted. In the late nineteenth and early twentieth centuries, the term "social realism" was coined to apply to representational painting which contained a specific political or social message.

Regionalism. Associated with the patriotic efforts of Thomas Hart Benton and others, especially in the 1930s, to communicate something significant about America by making the legends of a region's shared past the subject matter of their art. Various areas of the country, including the Midwest, the Pacific Northwest and New York City, had their own brands of regionalism.

Rococo. A graceful, yet florid, style of interior decoration and ornamentation that replaced the excessive ostentation associated with Louis XIV and the Palace of Versailles after his death in 1715. It was characterized by curves and counter-curves, prettiness and gaiety. The style lasted in France only until the mid-eighteenth century, but flourished longer in Germany and Austria.

Romanticism. A cult of feeling and individual imagination which originated in mid-eighteenth-century English philosophy and spread throughout the arts in Europe. America's first romantic, Washington Allston, brought to the United States the inspiration to paint seascapes and landscapes imbued with the sublime power of nature, as well as moralistic history paintings.

S

Salon. For many years the only officially recognized exhibition of paintings in Paris. It derived its name from the fact that it was originally held in the Salon d'Apollon in the Louvre. It has undergone many transformations over the years, but for the most part its organizers have been traditionalists who have been hostile to and have excluded new and innovative paintings. In 1863, the outcry from those whose work had not been accepted was so vehement that Napoleon III ordered a special Salon des Refuses which was equally controversial and was held only once.

Scumbling. A technique in painting of softening or modifying the color of a surface by applying an upper layer of opaque color. The upper layer is thin or irregular enough to allow some of the color beneath to show through.

Serigraphy. A stenciling process more commonly known as silk-screen printing. Paint or ink is brushed over unmasked areas of stretched silk on which the design has been fixed. By using successive masks on the same screen, multi-colored prints can be achieved. The process is widely used in commercial art and in the textile industry.

Social realism. Direct and critical portrayals of social, political and economic issues in art works, particularly during the 1930s.

Surrealism. Based on the depiction of dreams and the subconscious, and founded by Frenchman Andre Breton in 1924, surrealistic art aims for "the systematic dismantling of establishment values." Its principle of automatism (the depiction of pure thought) helped pave the way for the improvisatory character of American action painting.

Synchromism. The sole modern movement founded by American artists before World War I. Synchromism means "with color," and Morgan Russell and Stanton MacDonald-Wright used color alone to generate form, meaning and composition. Their work was based in part on the color theory of French painter Robert Delaunay.

T

Tachism. A term coined in 1952 by French art critic Michel Tapie to describe paintings in which dabs and splotches of color appear to have been applied at random, with no regard for form or construction. It is now frequently applied to action painting and to any painting technique that strives to be completely spontaneous and instinctive.

Taos Colony. An art colony in Taos, New Mexico, which began in 1912 when a small group of painters, led by Henry Sharp, formed the Art Society of Taos. Tired of European traditions, these artists sought intrinsically American subjects to paint and found them in the local Spanish and Pueblo Indian cultures and in the spectacular scenery of the Southwest. Members of the original group continued to work until 1927, and Taos continues today as a popular center for artists.

Tempera. A method of painting on surfaces prepared with gesso in which dry pigments are mixed with egg yolks, whites or sometimes whole eggs to form a water-soluble yet binding medium. It was the commonest painting technique until the late fifteenth century. The medium dries almost immediately and is permanent.

The Ten. A group of 10 late-nineteenth-century Boston painters who exhibited together from 1898 until 1918. Initially they banded together to protest what they considered to be the too-strict academic tastes of the city. While the styles of these painters varied widely (some were not American impressionist painters at all), as a group they are now thought of generally as the Boston School of American impressionists.

Tonalism. A poetic, meditative style developed primarily between 1880 and 1910. Tonalist paintings often used intimate interiors or sylvan settings, depicted as if photographed behind a veil or shrouded in mist.

Trompe l'oeil. French for "deceive the eye." The term is applied to easel or decorative painting whose purpose is to fool the eye as to the composition or the reality of the objects represented—as with painted money that appears to be real, and the like. In easel painting the technique is normally restricted to surfaces in or near the plane of the picture.

SELECTED BIBLIOGRAPHY

AUCTION RECORDS

Hislop, Richard, ed. *Annual Art Sales Index.* Weybridge, Surrey, England: Art Sales Index Ltd. (Published annually.)

Leonard's Annual Index of Art Auctions. Newton, Massachusetts: Leonard's Index of Art Auctions. (Published annually.)

Mayer, E. *International Auction Records.* New York: Editions Publisol. (Published annually.)

DICTIONARIES

Baigell, Matthew. *Dictionary of American Art.* Reprint with corrections. New York: Harper and Row, 1982.

Brewington, Dorothy E.R. *Dictionary of Marine Artists.* Peabody Museum of Salem, Massachusetts and Mystic Seaport Museum, Connecticut, 1982.

Cummings, Paul. *Dictionary of Contemporary American Artists.* New York and London: St. Martin's and St. James, 1977.

Groce, George C., and David H. Wallace. *The New York Historical Society's Dictionary of Artists in America.* New Haven: Yale University Press, 1957.

Mantle Fielding's Dictionary of American Painters, Sculptors and Engravers. Revised by Glenn B. Opitz. Poughkeepsie, N.Y.: Apollo Book, 1983.

Murray, Peter and Linda. *Penguin Dictionary of Art & Artists.* Penguin Books, 1959.

Samuels, Peggy and Harold. *Illustrated Biographical Encyclopedia of Artists of the American West.* New York: Doubleday, 1976.

HISTORIES AND GENERAL REFERENCES

Ashton, Dore. *The New York School: A Cultural Reckoning.* New York: Viking Press, 1972.

Baigell, Matthew. *The American Scene: American Painting of the 1930s.* New York: Praeger, 1979.

_____. *A Concise History of American Painting and Sculpture.* New York: Harper and Row, 1984.

Barker, Virgil. *American Painting: History and Interpretation.* New York: Macmillan, 1951.

Berman, Greta, and Jeffrey Wechsler. *Realism and Realities: The Other Side of American Painting, 1940-1960.* New Brunswick: Rutgers University Art Gallery, 1981.

Bermingham, P. *American Art in the Barbizon Mood.* Washington, D.C., 1975.

Bizardel, Y. *American Painters in Paris.* New York, 1960.

Boyle, Richard. *American Impressionism.* Boston: New York Graphic Society, 1974.

Broder, Patricia Janis. *The American West: The Modern Vision.* Boston: New York Graphic Society/Little, Brown and Co., 1984.

_____. *Great Paintings of the Old American West.* New York: Abbeville Press, 1981.

Brown, Milton H. *American Art to 1900.* New York: Harry N. Abrams, 1978.

_____. *American Painting from the Armory Show to the Depression.* Princeton, N.J.: Princeton University Press, 1955.

Campbell, Mary Schmidt. *Tradition and Conflict: Images of a Turbulent Decade, 1963-1973.* New York: Studio Museum in Harlem, 1985.

Cohen, George M. *A History of American Art.* New York: Dell, 1971.

Corn, Wanda M. *Grant Wood: The Regionalist Vision.* New Haven: Yale University Press for the Minneapolis Institute of the Arts, 1983.

Czestochowski, John S. *The American Landscape Tradition: A Study and Gallery of Paintings.* New York: E.P. Dutton, 1982.

Davidson, Abraham A. *Early American Modernist Painting 1910-1935.* New York: Harper and Row, 1981.

Dunlap, William. *A History of the Rise and Progress of the Arts and Design in the United States.* New York, 1934. 2 Vols. Edited by Rita Weiss. Introduction by James T. Flexner. 3 Vols. New York: Dover Publications, 1969.

Fine, Elsa Honig. *The Afro-American Artists: A Search For Identity.* New York: Holt, Rinehart and Winston, 1973.

Flexner, James T. *American Painting: First Flowers of Our Wilderness.* Boston: Houghton and Mifflin, 1947.

_____. *American Painting: The Light of Distant Skies, 1760-1835.* New York: Harcourt Brace, 1954.

_____. *America's Old Masters: First Artists of the New World.* New York: Viking Press, 1939.

_____. *Nineteenth-Century American Painting.* New York: Putnam's, 1970.

_____. *That Wilder Image: The Painting of America's Native School from Thomas Cole to Winslow Homer.* Boston: Little, Brown, 1962.

Frankenstein, Alfred V. *After the Hunt: William Michael Harnett and Other American Still Life Painters, 1870-1900.* 2nd Edition. Berkeley and Los Angeles: University of California Press, 1969.

Hassrick, Peter. *Treasures of the Old West.* New York: Harry N. Abrams, Inc., 1984.

_____. *The Way West: The Art of Frontier America.* New York: Harry N. Abrams, Inc., 1977.

Hills, Patricia. *Social Concern and Urban Realism: American Painting of the 1930s.* Boston: Boston University Art Gallery, 1983.

Hoopes, Donelson. *The American Impressionists.* New York: Watson-Guptill, 1973.

Geldzahler, Henry. *American Painting of the Twentieth Century.* New York: The Metropolitan Museum of Art, distributed by the New York Graphic Society, 1965.

Gerdts, William. *American Impressionism.* New York: Abbeville Press, 1984.

Gerdts, William H., and Russell Burke. *American Still Life Painting.* New York: Praeger, 1971.

Gerdts, William H. *Down Garden Paths: The Floral Environment in American Art.* London and Toronto: Associated University Presses, 1983.

_____. *Painters of the Humble Truth: Masterpieces of American Still Life 1801-1939.* Columbia, Missouri: University of Missouri Press, 1981.

Goodrich, Lloyd, and John I. H. Baur. *American Art of Our Century.* New York: Praeger, 1961.

Greenberg, Clement. *Art and Culture: Critical Essays.* Boston: Beacon Press, 1961.

Harmsen, Dorothy. *American Western Art.* Harmsen Publishing Co., 1977.

Homer, William I. *Alfred Stieglitz and the American Avant-Garde.* Boston: New York Graphic Society, 1977.

Howat, John K. *The Hudson River and Its Painters.* New York: Viking Press, 1972.

Kenin, Richard. *Return to Albion: Americans In England, 1760-1940.* New York: Holt, Rinehart and Winston; Washington, D.C.: The National Portrait Gallery, Smithsonian Institution, 1979.

Larkin, Oliver W. *Art and Life in America.* New York: Holt, Rinehart and Winston, 1966.

Levin, Gail. *Synchromism and American Color Abstraction.* New York: Braziller, 1978.

Lewis, Samella. *Art: African American.* New York: Harcourt, Brace, Jovanovich, 1978.

Lipman, Jean, and Tom Armstrong, eds. *American Folk Painters of Three Centuries.* New York: Hudson Hills Press/Whitney Museum of American Art, 1980.

Marling, Karal Ann. *Wall-to-Wall America: A Cultural History of Post Office Murals in the Great Depression.* Minneapolis: University of Minnesota Press, 1983.

Meixner, Laura. *An International Episode: Millet, Monet and Their North American Counterparts.* Exhibition catalog. Memphis, Tennessee: Dixon Gallery and Gardens, 1982.

Miles, Ellen, ed. *Portrait Painting in America: The Nineteenth Century.* New York: Main Street/Universe Books, 1977.

Novak, Barbara. *American Painting of the 19th Century.* 2nd Edition. New York: Harper and Row, 1979.

_____. *Nature and Culture: American Landscape and Painting, 1825-1875.* New York: Oxford University Press, 1980.

Park, Marlene, and Gerald E. Markowitz. *New Deal for Art: The Government Art Projects of the 1930s With Examples from New York City and State.* Hamilton,

New York: The Gallery Association of New York State, Inc., 1977.

Porter, James A. *Modern Negro Art.* New York: Dryden Press, 1943.

Portraits from "The Americans": The Democratic Experience—An Exhibit at the National Portrait Gallery Based on Daniel J. Boorstin's "The Americans". New York: Random House, 1975.

Portraits USA 1776-1976: An Exhibition Celebrating the Nation's Bicentennial. University Park, Pennsylvania: Museum of Art, Pennsylvania State University, 1976.

Prown, Jules D. *American Painting: From Its Beginnings to the Armory Show.* Cleveland, Ohio: World Publishing, 1969.

Quick, M. *American Expatriate Painters of the Late Nineteenth Century.* Dayton, Ohio, 1978.

Richardson, Edgar P. *American Romantic Painting.* Edited by Robert Freund. New York: E. Weyhe, 1944.

_____. *Painting In America, From 1502 to the Present.* New York: Thomas Crowell, 1965.

Ritchie, Andrew C. *Abstract Painting and Sculpture in America.* New York: Museum of Modern Art, 1969.

Rose, Barbara. *American Painting: The Twentieth Century.* Cleveland, Ohio: World Publishing, 1969.

Rossi, Paul, and David Hunt. *The Art of the Old West.* New York: Alfred A. Knopf, 1971.

Sandler, Irving. *The Triumph of American Painting: A History of Abstract Expressionism.* New York: Harper and Row, 1970.

Seitz, William C. *Abstract Expressionist Painting in America.* Cambridge, Massachusetts: Harvard University Press, 1983.

Sellin, David. *Americans in Brittany and Normandy, 1860-1910.* Phoenix Art Museum, 1982.

Shapiro, David. *Social Realism: Art as a Weapon.* Critical Studies in American Art. New York: Frederick Unger, 1973.

Sheldon, George W. *American Painters.* New York, 1879.

Soria, Regina. *Dictionary of Nineteenth Century American Painters in Italy: 1760-1914.* East Brunswick, New Jersey: Fairleigh University Press, 1982.

Stein, Roger B. *Seascape and the American Imagination.* New York: The Whitney Museum of American Art, 1975.

Sweeney, J. Gray. *Great Lakes Marine Painting of the Nineteenth Century.* Washington, D.C.: National Gallery of Art, 1980.

Tuckerman, Henry T. *The Book of the Artists: American Artist Life.* New York: Putnam's, 1867. Reprint. New York: James F. Carr, 1966.

Wein, Frances Stevenson, ed. *National Portrait Gallery Permanent Collection Illustrated Checklist.* Washington, D.C.: Smithsonian Institution Press, 1980.

Wilmerding, John. *American Art.* London and New York: Penguin Books, 1976.

_____, et al. *American Light: The Luminist Movement, 1850-1875.* Washington, D.C.: The National Gallery of Art, 1980.

_____. *A History of American Marine Painting.* Salem, Massachusetts: Little, Brown for the Peabody Museum of Salem, 1968.

Wynne, G. *Early Americans in Rome.* Rome, 1966.

PERIODICALS

American Art Journal, New York, New York.

Antiques, New York, New York.

Art & Antiques, New York, New York.

Art & Auction, New York, New York.

Art in America, New York, New York.

Art Journal, New York, New York.

ARTnews, New York, New York.

Art Students League News, New York, New York.

Maine Antique Digest, Waldoboro, Maine.

Winterthur Portfolio, Chicago, Illinois.

AUCTION HOUSES

CODE	AUCTION HOUSE	CODE	AUCTION HOUSE	CODE	AUCTION HOUSE
A	Aldridges—Bath	CG.V	Champion-Gondran—Vienna	GF.L	Galerie Fischer—Lucerne
A.D	Adams—Dublin			GG.S	Geoff. Gray—Sydney
A.R	D'Anjou—Rouen	CH	Christie—New York	GG.TA	Gordon Galleries—Tel Aviv
A.T	Arnaune—Toulouse	CJ.N	Courchet, Palloc & Japhet—Nice		
AAA.S	Australian Art Auctions—Sydney	CL.E	Champin & Lombrail—Enghien	GGL.L	Genin, Griffe, Leseuil—Lyon
AG	Anderson & Garland—Newcastle	CR.T	Chassaing, Rivet—Toulouse	GK.B	Galerie Kornfeld—Bern
AMG.C	Appay, Mainon-Gairoared et G.—Cannes	CS.L	Chenu & Scrive—Lyon	GK.Z	Galerie Koller—Zurich
		CSK	Christie's, South Kensington—London	GM.B	Galerie Moderne—Bruxelles
AN.Z	Auktionshaus Am Neumarkt—Zurich	D.B	Commissaires-Priseurs—Bordeaux	GS.B	Galerie Stuker—Bern
AW.H	Arno Winterberg—Heidelberg	D.H	Dupuy—Honfleur	GSP	Graves, Son & Pilcher—Hove
B	Bonham—London	D.NY	William Doyle—New York	GT	Garrod Turner—Ipswich
B.A	Paul Brandt—Amsterdam	D.R	Denesle—Rouen	GT.A	Gerrard-Tasset—Angouleme
B.G	Blache—Grenoble	D.V	Dorotheum—Vienna	GV.G	Goteborgs Auktionsverk—Goteborg
B.M	Boscher—Morlaix	DA.B	Darmancier—Bourges		
B.P	Barridoff Galleries—Portland	DA.R	Dapsens—Reims	GV.P	Gilles Vergnault—Parthenay
B.S	Bukowski—Stockholm	DH	Dacre, Son & Hartley—Ilkley	H.AP	Hours—Aix-en-Provence
B.T	Beaumont—Tours	DI..Se	Delpeint & Lemaitre—Saint Etienne	HB	Heathcote Ball—Leicester
B.V	Blache—Versailles	DM.D	Du Mouchelle—Detroit	HG.C	Hanzell Galleries—Chicago
BB	Richard Baker & Baker—Birkenhead	DO.H	Dorling—Hamburg	HMA.L	Herment-Mochon & Anaf—Lyon
BB.SF	Butterfield & Butterfield—San Francisco	DV.G	De Vos—Ghent	HN.H	Hauswedel & Nolte—Hamburg
		DWB	Dreweatt, Watson & Barton—Newbury	HS	Henry Spencer—Retford
BC	Bannister & Co.—Haywards Heath	E	Edmiston—Glasgow	J	Jollys—Bath
BFA	Barber's Fine Art—Woking	E.EDM	Eldred—East Dennis, Mass.	J.M	Joel—Melbourne
BL.N	Bailly, Loevenbruck—Nancy	EC	Entwistle—Southport	JSS	Jackson, Stopps and Staff—London
BMM	Button, Menheinett & Mutton—Wadebridge	EG	Elliott Green—Lymington	JT	James Thompson—Kirkby
BR	Bracketts—Tunbridge Wells	F.M	Finarte—Milan	K.B	Kaczorowski—Brive-La Gaillarde
BR.CS	Bretaudiere et Raynaud—Chalon-sur-Saone	F.P	Freemans—Philadelphia	K.BB	Kohn—Bourg-en-Bresse
		F.R	Finarte—Rome		
BV	Bradley & Vaughan—Haywards Heath	FB.M	Fraser Bros.—Montreal	K.N	Klinger—Nurnberger
BW	Biddle & Webb—Birmingham	FO.R	Fournier—Rouen	K.S	Kvalitetsauktion—Stockholm
		G	Grant—Stourport		
C	Christie, Manson Woods—London	G.G	Gaucher—Grenoble	KC	King & Chasemore—Pulborough
C.A	Campo—Antwerp	G.L	Galateau—Limoges	KC.R	King & Chasemore—Roermond
C.LIA	Calvet—L'Isle Adam	G.S	Goodman—Sydney		
C.V	Chapelle—Versailles	G.SB	Guichard—Saint Brieuc	KF.M	Karl & Faber—Munich
CB	Charles Boardman & Son—Haverhill	G.Z	Germann—Zurich	KH.K	Kunsthallens Kunstauktioner—Copenhagen
CBS	Chrystal Brothers—Isle of Man	GA.L	Guillaumot & Albrand—Lyon		
CE	Christie Edmiston—Glasgow	GC	Geering & Colyer—Hawkhurst	KK.B	Kornfeld & Klipstein—Bern
CG.P	Charles Galleries—Pontiac	GD.B	Galerie Dobiaschofsky—Bern	KM.K	Kunsthaus Am Museum—Cologne
		GDA.G	Galerie D'Horlogerie Ancienne—Geneva		

CODE	AUCTION HOUSE	CODE	AUCTION HOUSE	CODE	AUCTION HOUSE
KV.L	Kunstgalerij De Vuyst—Lokeren	PC	Phillips—Chester	VT.M	Villebrun & Tournel—Marseilles
KV.S	Kvalitetsauktion—Stockholm	PE	Phillips—Edinburgh	W.M	Weinmuller—Munich
L	Lane & Sons—Penzance	PG	Phillips—Glasgow	W.T	Waddington—Toronto
L.C	Lelieve—Chartres	PJ.M	Phillips-Jacoby—Montreal	W.W	Weschler—Washington
L.K	Lempertz—Cologne	PK	Phillips—Knowle	WA.B	Watine & Arnault—Berthune
L.SG	Louiseau—Saint Germain-en-Laye	PL	Phillips—Leeds	WK.M	Galerie Wolfgang Ketterer—Munich
L.SM	Lerond—Saint Maur	PS	Phillips In Scotland—Edinburgh	WSW	Warner, Sheppard & Wade—Leicester
LE	Locke & England—Leamington Spa	PWC	Parsons, Welsh & Cowell—Sevenoaks	WW	Woolley & Wallis—Salisbury
LM	Lalonde Martin—Bristol	PX	Phillips—Exeter	WWL	Warren & Wignall—Leyland
LP	Lalonde Brothers & Parham—Bristol	R.G	Rosset—Geneva	YG.P	Youngs Gallery—Portsmouth,N.H.
LS	Love & Sons—Perth	R.I	Renner—Issoudon	12.P	De Cagny—Paris
M.LA	Massart—L'Isle Adam	R.K	Rasmussen—Copenhagen	15.P	Cornette De St. Cyr—Paris
M.LF	Manson—La Fleche	R.M	Regis—Marseilles	16.P	Ferri—Paris
M.NO	Mortons—New Orleans	R.V	Rijaud—Vernon	17.P	Lemee—Paris
M.V	Martin—Versailles	RB.HM	Richard Bourne—Hyannis, Mass.	21.P	Pillias—Paris
MA.V	Maynards—Vancouver	RG	Rowland Gorringe—Lewes	23.P	Jozon—Paris
MC.A	Martin & Courtois—Angers	RG.M	Raynaud & Gamet—Marseille	28.P	Morelle—Paris
MCB	McCartney, Morris & Barber—Ludlow	S	Sotheby—London	29.P	Ledoux-Lebard—Paris
MCC	McCartney, Morris & Barker—Ludlow	S.BM	Skinner—Bolton, Mass.	32.P	Chalvet De Recy—Paris
MM	Morrison, McChlery—Glasgow	S.D	Sadde—Dijon	33.P	Boisgirard—Paris
MMB	Messenger, May & Baverstock—Godalming	S.J	Sausverd—Joigny	35.P	Ader, Picard & Tajan—Paris
MS.P	Martinot & Savignat—Pontoise	S.O	Savot—Orleans	36.P	Deurbergue—Paris
MV.LH	Mabile-Vankemriel—Le Havre	S.Tr	Strange—The Rocks, Australia	37.P	Englemann—Paris
MVT.L	Mercier, Velliet & Thullier—Lille	S.W	Sloan—Washington	4.P	Le Blanc—Paris
MW.A	Mak Van Waay—Amsterdam	SB	Sotheby Belgravia—London	40.P	Tilorier—Paris
N	Neale & Son—Nottingham	SBA	Sotheby Beresford Adams—Chester	42.P	Libert—Paris
N.M	Neumeister—Munich	SKC	Sotheby, King & Chasemore—Pulborough	45.P	Oger—Paris
O	Oliver—Sudbury	SMG	Shakespear, McTurk & Graham—Leicester	50.P	Binoche—Paris
O.F	Osenat—Fontainebleau	SPB	Sotheby—USA	54.P	Delaporte—Paris
OL	Outhwaite & Litherland—Liverpool	SY	Sotheby Parke Bernet, O/S of USA & UK	56.P	Ribault-Menetiere—Paris
OT	Osmond, Tricks—Bristol	SYB	Sotheby Bearnes—Torquay	6.P	Audap, Godeau & Solanet—Paris
P	Phillips—London	T.B	Thierry—Brest	60.P	Rogeon—Paris
P.LF	Pillet—Lyons-La-Foret	TH.B	Thelot—Blois	61.P	Millon—Paris
P.M	Phillips Ward Price—Montreal	TL	Lawrence—Crewkerne	62.P	Renaud—Paris
P.NY	Phillips—New York	TRS	Thomson Rose & Spenser—York	63.P	Laurin, Guilloux & Buffetaud—Paris
P.T	Phillips Ward Price—Toronto	UA.Z	Uto Auktions A.G—Zurich	66.P	Loudmer & Poulain—Paris
PB	Sotheby Parke Bernet—USA	V	Vost's—Colchester	7.P	Robert—Paris
		V.LH	Viel—Le Havre	73.P	Labat—Paris
		V.P	Verhaeghe—Poitiers	75.P	Couturier & Nicolay—Paris
		VMB.H	Van Marle & Bignell—The Hague	77.P	Delorme—Paris
		VN.R	Vendu Notarishuis—Rotterdam	81.P	Boscher—Paris

INDEX

Pages 1-330 are found in Volume I; pages 333-666. in Volume II; and pages 669-1002, in Volume III. Where more than one page number is cited for an artist, the first citation refers to the main biographical entry; subsequent citations refer to additional color plates.